TAOISM

AND THE ARTS OF CHINA

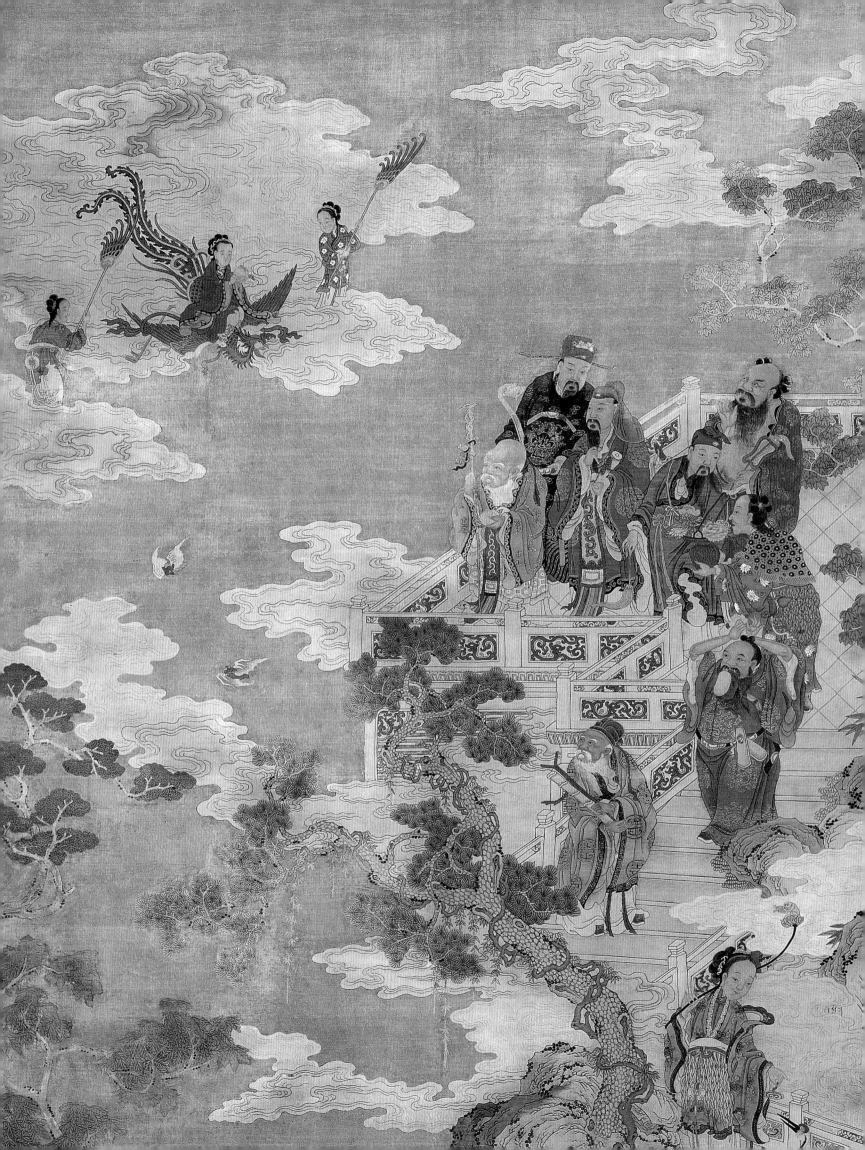

TAOISM

AND THE ARTS OF CHINA

STEPHEN LITTLE
WITH SHAWN EICHMAN

WITH ESSAYS BY

PATRICIA EBREY
KRISTOFER SCHIPPER
NANCY SHATZMAN STEINHARDT
WU HUNG

THE ART INSTITUTE OF CHICAGO

IN ASSOCIATION WITH

UNIVERSITY OF CALIFORNIA PRESS

This book was published in conjunction with the exhibition "Taoism and the Arts of China," organized by The Art Institute of Chicago and presented in the museum's Regenstein Hall from November 4, 2000, to January 7, 2001. The exhibition was also presented at the Asian Art Museum of San Francisco from February 21 to May 13, 2001.

"Taoism and the Arts of China" was supported by the E. Rhodes and Leona B. Carpenter Foundation, the Estate of William Bronson Mitchell and Grayce Slovet Mitchell, the Henry Luce Foundation, the Freeman Family Foundation, and The W. L. S. Spencer Foundation.

Major funding was provided by the National Endowment for the Humanities and the National Endowment for the Arts, dedicated to expanding the understanding of cultural and artistic heritage.

First edition
Printed in Belgium

05 04 03 02 01 00 9 8 7 6 5 4 3 2 1

Published by
The Art Institute of Chicago
111 South Michigan Avenue
Chicago, Illinois 60603
in association with
University of California Press
2120 Berkeley Way
Berkeley, California 94720

Produced by the Publications Department of The Art Institute of Chicago, Susan F. Rossen, Executive Director
Edited by Robert V. Sharp, Associate Director of Publications, and Catherine A. Steinmann, Special Projects Editor, assisted by Faith Brabenec Hart
Production by Sarah E. Guernsey, Production Coordinator, assisted by Stacey A. Hendricks, Production Assistant
Unless otherwise noted, all photographs are by the Department of Imaging, Alan B. Newman, Executive Director
Designed and typeset by Ed Marquand and Susan E. Kelly, Marquand Books, Inc., Seattle, Washington
Separations by Professional Graphics, Inc., Rockford, Illinois
Printed and bound by Snoeck-Ducaju & Zoon, Ghent, Belgium

COVER AND BACK COVER: details, *Ordination Scroll of Empress Zhang* (cat. no. 57); FRONTISPIECE, P. 2: detail, *The Eight Immortals, the Three Stars, and the Queen Mother of the West at the Turquoise Pond* (cat. no. 118).

CONTENTS

FOREWORD

JAMES N. WOOD

TAOISM AND THE ARTS OF CHINA is occasioned by the first major exhibition ever held on the theme of Taoism and its influence in Chinese art. This catalogue and the exhibition it accompanies have drawn upon several decades of pioneering research on Taoism by scholars of Chinese religion working in America, Europe, and Japan. Both explore the pivotal role Taoism has played in traditional China, where change has always been seen as a fundamental aspect of reality. Taoism is of primary importance in Chinese social and political history, and the exhibition has been organized in the belief that an understanding of Taoism in traditional China will enable us better to comprehend modern China. This goal seems particularly relevant as Taoism enjoys a renascence in China today and as Asian-based religions attract increasing interest and following in the West.

Throughout the history of Taoism, works of art of the highest quality have been created for didactic and ritual purposes. *Taoism and the Arts of China* explores two complementary modes of Taoist practice: Taoism that serves the spiritual needs of the community, and Taoism that serves the spiritual needs of the individual. The over 150 works of art presented here enable us to explore key conceptual and artistic achievements in the history of Taoism.

The Art Institute deeply appreciates the many individuals and institutions whose generous loans, financial support, and intellectual guidance have made this exhibition possible. They are thanked in more detail in the Acknowledgments. Here I can acknowledge only a few. First, I would like to express my gratitude to Dr. Emily Sano, Director, Asian Art Museum of San Francisco, the only other venue for this exhibition. The partnership of this museum, given its outstanding holdings and the importance of Chinese culture in northern California, is particularly gratifying.

The idea of this pathbreaking exhibition was presented to me five years ago by Stephen Little, Pritzker Curator of Asian Art at The Art Institute of Chicago. In order to provide a solid intellectual and historical context for the works of art presented here, Dr. Little brought together leading scholars of Chinese religion, history, and art as participants in the planning of the exhibition and as contributors to this publication. To find and arrange to borrow the most significant Taoist art objects, he crisscrossed the globe, making numerous visits to Asia and Europe, where cooperation and hospitality were granted to him and where the understandings he gained proved invaluable. Dr. Little's skills as a curator, art historian, historian, and linguist—together with his sheer indefatigability—enabled him to achieve what heretofore might have seemed impossible, and for this we thank him.

Finally, such an undertaking required major financial support, which was provided by generous grants from a number of foundations and cultural agencies. For their help in realizing this project, we are deeply grateful to the E. Rhodes and Leona B. Carpenter Foundation; the Estate of William Bronson Mitchell and Grayce Slovet Mitchell; the Henry Luce Foundation; the Freeman Family Foundation; and the W. L. S. Spencer Foundation. The federal cultural agencies, the National Endowment for the Humanities and the National Endowment for the Arts, awarded major grants to this project, providing an important endorsement of our efforts.

At a moment when new paths of communication and exchange are being forged between China and the United States, we offer this publication and the exhibition it accompanies in the hope that visitors and readers will come away with new understanding of the role the visual arts have played in Taoist belief and practice over the last two millennia, and a new appreciation for one of the world's most influential philosophical and religious traditions.

James N. Wood, *Director and President*
The Art Institute of Chicago

"TAOISM AND THE ARTS OF CHINA" was an undertaking of such magnitude that it could never have been achieved without the help of many individuals and institutions. My deepest thanks go to James N. Wood, Director and President of The Art Institute of Chicago, for the enthusiastic support he has given the project from its inception. I am profoundly grateful to him for providing me the opportunity to realize this exhibition.

Two meetings of the Committee of Humanities Specialists, funded by a Planning Grant from the National Endowment for the Humanities, allowed for extensive discussion of the exhibition's conceptual structure. The exhibition owes a great deal to a distinguished group of advisors: Charles Hartman, Terry Kleeman, Lothar Ledderose, Kristofer Schipper, Nathan Sivin, Wu Hung, and Eric Zürcher. Shawn Eichman, coordinator for the exhibition at the Art Institute, wrote many of the catalogue entries. His vast knowledge of Taoism made it possible to explore aspects of Taoist art that would have remained thoroughly esoteric without his involvement.

We are also deeply grateful to many renowned scholars of Chinese culture with whom we discussed the project, and who freely shared their knowledge with us: Richard Barnhart, T. H. Barrett, Stephen R. Bokenkamp, Phyllis Brooks, Pierre-Henry de Bruyn, Suzanne Cahill, Jonathan Chaves, Patricia Ebrey, Donald J. Harper, Stanley E. Henning, Susan Huang, Kobayashi Masayoshi, Livia Kohn, Paul Kroll, John Lagerwey, Thomas Lawton, Lin Shengzhi, Oliver Moore, Julia Murray, Susan Naquin, Isabelle Robinet, Harold D. Roth, Michael Saso, Nancy Shatzman Steinhardt, Jason Steuber, Stephen Teiser, Franciscus Verellen, Ann Waltner, and Judith Zeitlin. I would like to thank Angelika Borchert, Simone Griessmeyer, Petra Roesch, and Joachim Osse, graduate students at the University of Heidelberg, and De-nin Lee, a graduate student at Stanford University, for their many contributions to the initial research that led to the catalogue.

The insights and suggestions of Roger Keyes, the late David Kidd, Liu Dan, Morimoto Yasuyoshi, and Richard Pegg all helped me enormously. Patrice Fava kindly made his films of Taoist rituals and sites in China available to me; my thanks go to him and to the Centre National pour la Recherche Scientifique, Paris, for allowing us to use footage from his films in the exhibition.

In Beijing thanks go to Wang Limei, Deputy Director of the Foreign Affairs Section of the Administrative Bureau of Museums and Archaeological Data in the Ministry of Culture; Yang Yang, Chen Xiaocheng, Lei Congyun, and Zhang Jianxian of the Department of Foreign Affairs, Art Exhibitions China; Sun Tongchuan and Wang Yi'er of the Baiyun Guan; Yang Xin, Shan Guoqiang, Kong Chen, and Shi Anchang of the Palace Museum; and Yu Qin of the China National Museum of Fine Arts. I am grateful to Chen Songchang of the Hunan Provincial Museum, Changsha; T. T. Tsui and Catalina Chor of the Tsui Art Foundation, Hong Kong; Stephen McGuinness of Plum Blossoms (International) Ltd., Hong Kong; Shan Guolin, Zhong Yinglan, and Zhou Yanchun of the Shanghai Museum; Chen Zhuo of the Tianjin Municipal Art Museum; Ba Wu of the Shanxi Provincial Museum, Taiyuan; and Zhang Tong of the the Administrative Bureau of Museums and Archaeological Data of Shaanxi Province, Xi'an. In Taipei I thank Ch'in Hsiao-i, Chang Lin-sheng, Lin Po-t'ing, and Wang Yao-t'ing of the National Palace Museum.

In Japan I am grateful, in Tokyo, to Hayashi On and Suzuki Norio of the Agency for Cultural Affairs; and Nishioka Yasuhiro and Minato Nobuyuki of the Tokyo National Museum. Also to be thanked are Yuyama Ken'ichi, Nakagawa Hisayasu, Nishigami Minoru, and Melissa M. Rinne of the Kyoto National Museum; Nobuo Miyaji and Moriyasu Osamu of the Okayama Prefectural Museum of Art; and Mino Yutaka and Nakagawa Kenichi of the Osaka Municipal Museum of Art. I am also grateful to the abbots of the Chion-ji, Kyoto, and the Reiun-ji, Tokyo.

In England I would like to acknowledge, in London, the help of Frances Wood and Beth McKillop of the Oriental and India Office Collections at the British Library; Robert Knox, Anne Farrer, Jessica Harrison-Hall, and Carol Michaelson of the British Museum; and Rose Kerr, Verity Wilson, and Ming Wilson of the Victoria and Albert Museum. To be thanked in Paris, France, are Jacques Giès and Laure Feugere of the Musée National des Arts Asiatiques Guimet and Monique Cohen and Natalie Monet of the Bibliothèque Nationale de France. In Germany I am grateful to Adele Schlombs of the Museum für Ostasiatische Kunst, Cologne; and Bruno Richtsfeld of the Staatliches Museum für Völkerkunde, Munich. In Switzerland I thank Albert Lutz and Helmut Brinker of Museum Rietberg, Zurich. In Canada I am grateful to Klaas Ruitenbeeck and Ka-bo Tsang of the Royal Ontario Museum, Toronto.

In the United States I wish to thank Hiram Woodward of the Walters Art Gallery, Baltimore; Mr. and Mrs. Wan-go H. C. Weng; Richard and Nancy Rosenblum; Wu Tung and Erin Bennett of the Museum of Fine Arts, Boston; Robert Mowry, Anne Rose Kitagawa, and Melissa Moy of the Arthur M. Sackler Museum, Harvard University, Cambridge; James K. M. Cheng and Chun Shum of the Harvard-Yenching Library; Bennet Bronson and Chui-mei Ho of the Field Museum, Chicago; Ellen Avril and Barbara K. Gibbs, both formerly of the Cincinnati Art Museum; Chou Ju-hsi of the Cleveland Museum of Art; George Ellis and Julia White of the Honolulu Academy of Arts; Marc Wilson and Yang Xiaoneng of the Nelson-Atkins Museum of Art, Kansas City; J. Keith Wilson, June Li, and Victoria Blyth-Hill of the Los Angeles County Museum of Art; Robert Jacobsen of the Minneapolis Institute of Arts; Laurel Kendall and Ann Porter of the American Museum of Natural History, New York; Wen Fong, Maxwell Hearn, and Judith Smith of the Metropolitan Museum of Art, New York; Howard Rogers and Arnold Chang of Kaikodo, New York; Amy Heinrich of the C. V. Starr East Asian Library, Columbia University, New York; Zhou Yuan and William Alspaugh of the University of Chicago Library; Felice Fischer and Adriana Prozer of the Philadelphia Museum of Art; Cary Y. Liu of the Art Museum, Princeton University; Caron Smith, David Kencik, and Song Yu of the San Diego Museum of Art; Emily Sano, Michael Knight, He Li, Pauline Yao, and Hanni Forester of the Asian Art Museum of San Francisco; Mimi Neill Gates and Jay Xu of the Seattle Art Museum; and Milo Beach, Joseph Chang, Jan Stuart, and Stephen Allee of the Arthur M. Sackler Gallery, Smithsonian Institution, Washington, D.C.

Special thanks go to the members of the Art Institute's Asian Art Department for their support of this project: Mary Albert, Ryan Gregg, Bernd Jesse, Deanna Lee, Craig McBride, Pratapaditya Pal, Elinor Pearlstein, Betty Seid, Betty Siffert, and Beth Tekell. I am deeply grateful to Edward W. Horner, Jr., Karin Victoria, Meredith Hayes, and Jennifer Harris of the Development Department, who were instrumental in securing the essential financial support for this undertaking. Denise Gardner and Julia Perkins conducted valuable audience research for this project. In addition, I extend my gratitude to Dorothy Schroeder in the Office of the Director and President; Mary Solt, Martha Sharma, and the installation crew of the Registrar's Office; Christopher Gallagher, Robert Hashimoto, Robert Lifson, Alan B. Newman, and Gregory A. Williams of the Department of Imaging; Barbara J. Hall, Suzanne R. Schnepp, and Emily P. Dunn in Conservation; Harriet Stratis and Brigitte Yeh in Prints and Drawings; Lyn DelliQuadri and her staff in Graphic Design and Communication Services; Jack Brown and his staff in the Ryerson Library; and Eileen Harakal and her staff in Public Affairs, in particular, John Hindman and Chai Lee.

I am deeply grateful to the Publications Department's Robert V. Sharp and Catherine A. Steinmann, who, assisted by Faith Brabenec Hart, edited this daunting and lengthy manuscript with deep commitment, exacting care, and tireless dedication; Sarah E. Guernsey, who expertly managed the production of this beautiful book; and Stacey A. Hendricks, who managed photography editing and assisted with production. Susan Kelly and Ed Marquand of Marquand Books, Seattle, were responsible for the superb design of the catalogue. Thanks are also due to Pat Goley of Professional Graphics, Rockford, who created outstanding separations for this catalogue; thanks go also to Cyndi Richards, who assisted him. John Vinci produced an equally outstanding installation design for the exhibition. Finally, special thanks go to Jane Clarke of the Department of Museum Education, who acted as liaison to an enthusiastic staff to develop a rich variety of interpretive programs for the exhibition.

Stephen Little, *Pritzker Curator of Asian Art*
The Art Institute of Chicago

Romanization of Chinese Words

The romanization of Chinese words in this catalogue follows the pinyin system, with the exception of the words "Tao" (pronounced "Dao," translated as "the Way"), "Taoism" (Daoism), and "Taoist" (Daoist), which are rendered in the Wade-Giles system because of the greater familiarity with this usage. Chinese names, terms, and phrases in quotations are spelled according to the pinyin system, regardless of the way in which they were originally published. Chinese characters corresponding to romanized words (with the exception of book and text titles) are provided in "Chinese Names and Terms" (pp. 384–91).

Translations

There are few standard English translations for Taoist terms. The Chinese word *zhen* (real, realized, realization, true, perfected, perfection), for example, is generally translated here as "realized" or "realization." The preferences of individual authors and the requirements of different contexts result in inevitable variations in such translations, however; the reader will find *zhenren*, for example, translated not only as "realized being" but as "true person" and "the perfected." All translations are by the respective authors of the essays or catalogue entries, unless otherwise noted.

Works Cited

Full bibliographic information for all works cited is given in the bibliography (pp. 392–405).

Dates

Dates of individuals and of Chinese dynasties and periods are provided on first mention within each text; a chronological table is included on p. 11.

Place-names

Place-names mentioned in the text can be found on the map of China on p. 10.

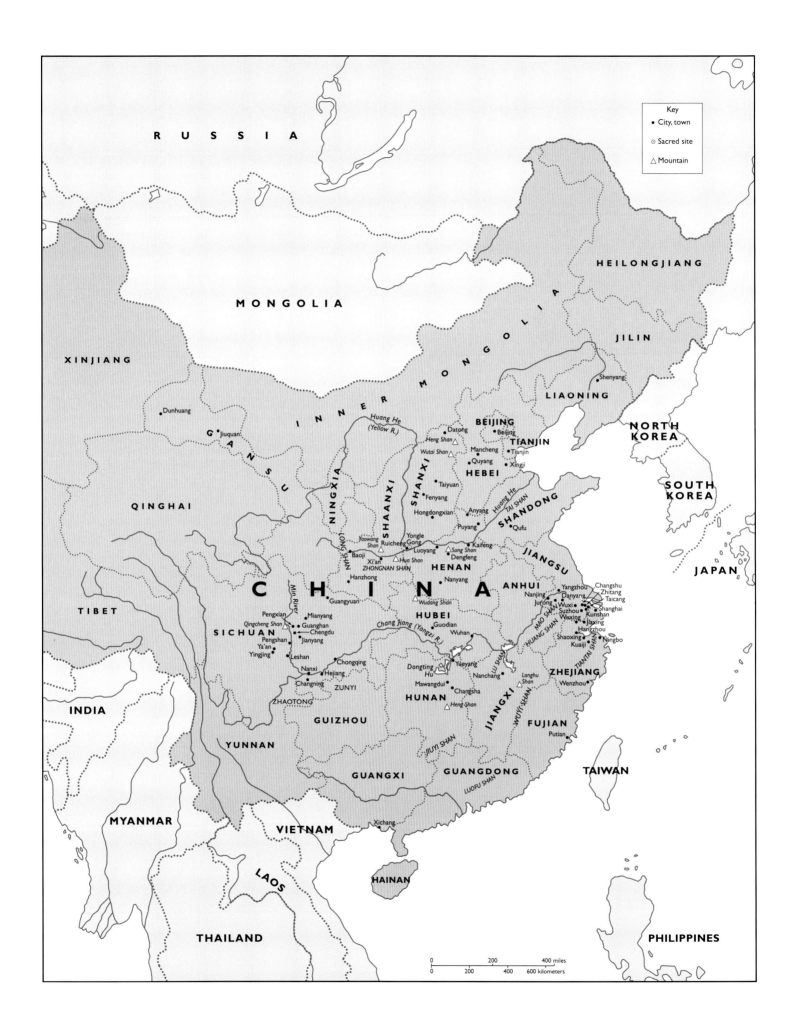

RUSSIA

MONGOLIA

XINJIANG

HEILONGJIANG

INNER MONGOLIA

JILIN

GANSU

Dunhuang

Jiuquan

QINGHAI

NINGXIA

SHANXI

SHAANXI

Huang He (Yellow R.)

Datong

Heng Shan

Wutai Shan

BEIJING

Beijing

Mancheng

Quyang

TIANJIN

Tianjin

Xingji

LIAONING

Shenyang

NORTH KOREA

SOUTH KOREA

HEBEI

Taiyuan

Fenyang

Hongdongxian

Anyang

Huang He

TAI SHAN

Puyang

SHANDONG

Qufu

JIANGSU

TIBET

Yaowang Shan

Ruicheng

Yongle Gong

Luoyang

Song Shan

Dengfeng

Kaifeng

JAPAN

LONG SHAN

Xi'an

ZHONGNAN SHAN

Hua Shan

HENAN

Nanyang

CHINA

Baoji

Hanzhong

Guangyuan

Wudang Shan

ANHUI

Nanjing

Jurong

Yangzhou

Danyang

Changshu

Zhitang

Taicang

Wuxi

Suzhou

Wuxing

Shanghai

Kunshan

Jiaxing

Hangzhou

Ningbo

MAO SHAN

HUANG SHAN

TIANTAI SHAN

Min River

Pengxian

Qingcheng Shan

Mianyang

Guanghan

Chengdu

Jianyang

HUBEI

Guodian

Wuhan

Pengshan

SICHUAN

Ya'an

Yingjing

Leshan

Nanxi

Hejiang

Chongqing

Chang Jiang (Yangzi R.)

Yueyang

LU SHAN

Shaoxing

Kuaiji

ZHEJIANG

Wenzhou

Dongting Hu

Mawangdui

Changsha

Nanchang

Longhu Shan

Changning

ZUNYI

HUNAN

Heng Shan

JIANGXI

WUYI SHAN

FUJIAN

Putian

ZHAOTONG

GUIZHOU

JIUYI SHAN

INDIA

MYANMAR

YUNNAN

GUANGXI

GUANGDONG

LUOFU SHAN

TAIWAN

VIETNAM

Xichang

HAINAN

PHILIPPINES

LAOS

THAILAND

0 200 400 miles
0 200 400 600 kilometers

SHANG DYNASTY: C. 1600–C. 1050 B.C.

ZHOU DYNASTY: C. 1050–256 B.C.

 Western Zhou: C. 1050–771 B.C.

 Eastern Zhou: 770–256 B.C.

 Spring and Autumn (Chunqiu) period: 770–476 B.C.

 Warring States (Zhanguo) period: 475–221 B.C.

QIN DYNASTY: 221–207 B.C.

HAN DYNASTY: 206 B.C.–A.D. 220

 Western Han: 206 B.C.–A.D. 8

 Xin (Wang Mang): 9–23

 Eastern Han: 25–220

THREE KINGDOMS: 220–280

 Wei kingdom: 220–265

 Shu kingdom: 221–263

 Wu kingdom: 222–280 (Wu not absorbed by Jin until 280)

JIN DYNASTY: 265–420

 Western Jin: 265–316

 Eastern Jin: 317–420

NORTHERN AND SOUTHERN DYNASTIES: 386–589

 Northern Dynasties: 386–581

 Northern Wei: 386–534

 Eastern Wei: 534–550

 Western Wei: 535–557

 Northern Qi: 550–577

 Northern Zhou: 557–581

 Six Dynasties (Southern Dynasties): 420–589

 Liu-Song: 420–479

 Southern Qi: 479–502

 Liang: 502–557

 Chen: 557–589

SUI DYNASTY: 581–618

TANG DYNASTY: 618–906

FIVE DYNASTIES AND TEN KINGDOMS: 907–960

LIAO DYNASTY: 916–1125

SONG DYNASTY: 960–1279

 Northern Song: 960–1126

 Southern Song: 1127–1279

JIN DYNASTY: 1115–1234

YUAN DYNASTY: 1260–1368

MING DYNASTY: 1368–1644

Reigns

 Hongwu: 1368–98

 Jianwen: 1399–1402

 Yongle: 1403–24

 Hongxi: 1425

 Xuande: 1426–35

 Zhengtong: 1436–49

 Jingtai: 1450–56

 Tianshun: 1457–64

 Chenghua: 1465–87

 Hongzhi: 1488–1505

 Zhengde: 1506–21

 Jiajing: 1522–66

 Longqing: 1567–72

 Wanli: 1573–1620

 Taichang: 1620

 Tianqi: 1621–27

 Chongzhen: 1628–44

QING DYNASTY: 1644–1911

Reigns

 Shunzhi: 1644–61

 Kangxi: 1662–1722

 Yongzheng: 1723–35

 Qianlong: 1736–95

 Jiaqing: 1796–1820

 Daoguang: 1821–50

 Xianfeng: 1851–61

 Tongzhi: 1862–74

 Guangxu: 1875–1908

 Xuantong: 1909–11

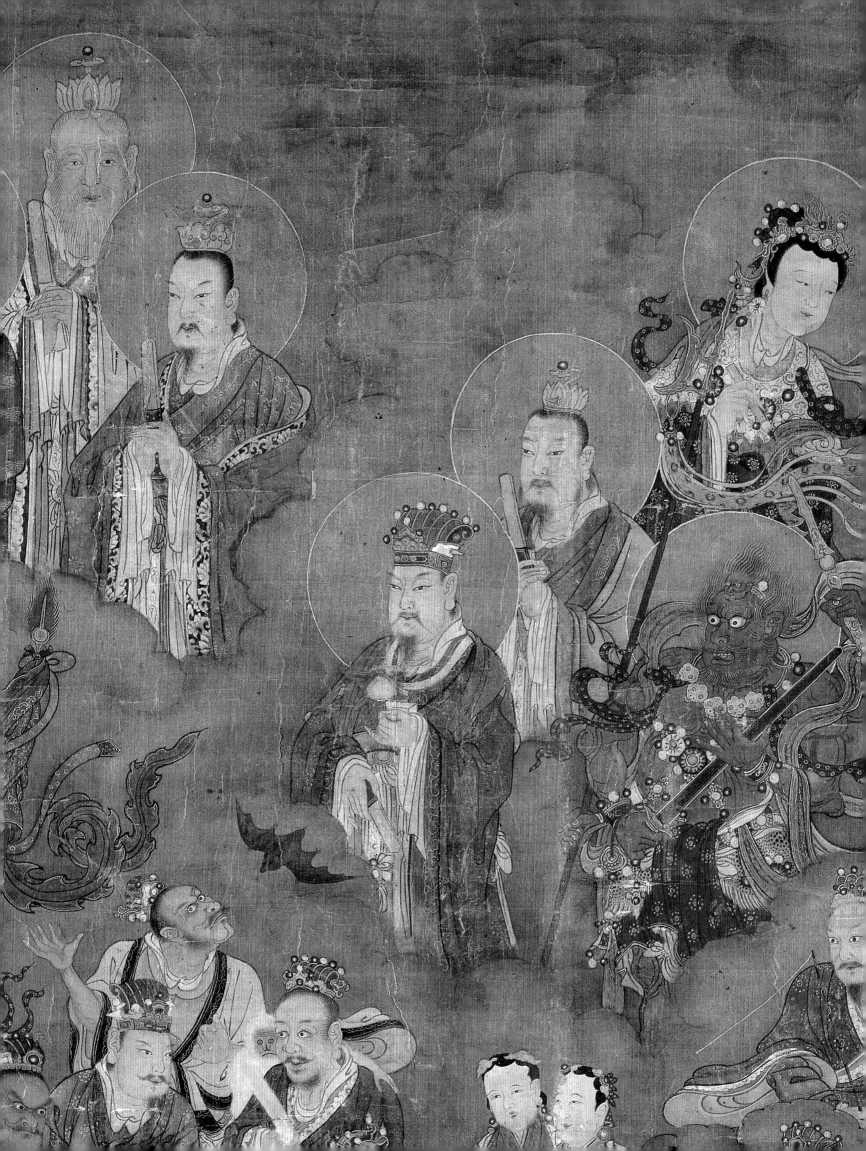

Taoism and the Arts of China

Stephen Little

THE PURPOSE OF THIS EXHIBITION is to examine the role works of art have played in the history of Taoism from the late Han (second century) to Qing (1644–1911) dynasties. Of the Three Teachings *(Sanjiao)* of ancient China—Taoism, Buddhism, and Confucianism—Taoism is the least understood in the West. Our understanding of Confucianism, a largely secular philosophy, and Buddhism, a religion originating in India, is much clearer. Unlike Buddhism, Taoism is indigenous to China. It has a history spanning more than two millennia, and its influence is clear in such diverse realms of Chinese culture as political theory, medicine, painting and calligraphy, and even Chan (Zen) Buddhism. Very little is known, however, about the relationship between Taoism and Chinese art.

The few studies of Taoist art to date stand in sharp contrast to the wealth of scholarly studies and exhibitions of Chinese Buddhist and secular art. Compounding this lack of awareness is the belief still widespread among Western art historians (and sinologists generally) that religious Taoism is nothing more than superstition and folk religion. The goal of this project, therefore, is to introduce China's primary indigenous religion to a Western audience by examining the iconography and function of works of art made in the service of Taoism. An interdisciplinary approach has been taken in the preparation of the exhibition, which draws upon architectural history, religious studies, literature, cultural history, and the history of science to convey a new understanding of how Taoists have defined the structure of the natural and divine worlds and situated humanity in the resulting matrix. The exhibition explores the beginnings of Taoist philosophy in the late Bronze Age (fifth–third centuries B.C.), the transformation of Taoism into an organized religion, the Taoist pantheon of gods who inhabit the stars and heavens, modes of ritual and visualization, the cult of the immortals, and the role of landscape as a symbol of cosmic structure and process.

This exhibition examines the way works of art function in a religious context. Like all major world religions, Taoism has undergone enormous changes in the course of its history. In analyzing the history and art history of Taoism, we must be conscious of both the changing nature of Taoism itself and the social, political, economic, and cultural changes in China that had a direct bearing on Taoism's structure and system of belief. While the focus is on Taoism in traditional China, it is hoped that the visitor will come away with the knowledge that Taoism is a living religion, practiced in Taiwan, Hong Kong, and many overseas Chinese communities, and one that is undergoing a major revival in mainland China today. Taoism answers basic human needs, such as the need to understand the world and one's place in it. In serving these needs, Chinese artists for centuries have created works of art of the highest aesthetic order for use in a Taoist context.

Tao (pronounced "dao") means a road, and is often translated as "the Way." The Tao is conceived as the void out of which all reality emerges, so vast that it cannot be described in words. Beyond time and space, it has been described as "the structure of being that underlies the universe."[1] Significantly, Taoism has no supreme being. Instead there is the Tao itself, underlying and permeating reality. At the same time, paradoxically, religious Taoism evolved many gods. The high gods of Taoism, such as the Celestial Worthy of Primordial Beginning (Yuanshi tianzun) and the Perfected Warrior (Zhenwu), Supreme Emperor of the Dark Heaven, are ultimately mere pneuma who exist to put a recognizable face on the Tao itself.

In the Taoist vision of cosmogenesis, there was first the Tao, empty and still. Then, gradually, primal energy *(yuan qi)* was spontaneously generated out of the Tao. For many cosmic eons this numinous energy swirled in a state of chaos known as

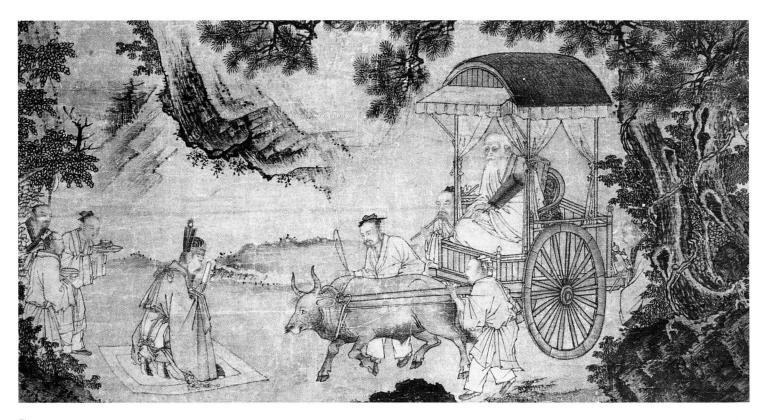

Fig. 1
Shang Xi (active early 15th century). *Laozi Meeting Yin Xi at the Han'gu Pass.*
Hanging scroll; ink and light colors on paper; 83.5 × 111.2 cm. MOA Museum,
Atami, Japan.

hundun. The Tao then generated the complementary forces known as *yin* and *yang*. The creative interaction of these forces directed the primal energy into patterns of movement and transformation, which in turn generated the machinations of the universe. This process is symbolically expressed in the *Daode jing* (*Tao-te-ching;* Classic of the Way [Tao] and its power), traditionally attributed to the sage Laozi:

> The Way (Tao) gave rise to the one,
> The one gave rise to the two,
> The two gave rise to the three,
> The three gave rise to all the ten thousand things.[2]

Inherent in this understanding of the Tao and its workings is a vision of universal order that gave structure to people's daily lives in traditional China. All natural phenomena were understood in terms of *yin* and *yang*. The transformations of the seasons (winter being the season of *yin,* summer the season of *yang*) and the differences between genders (*yin* = female, *yang* = male) were explained by the fluctuations of these two forces. In addition, the shifting patterns of energy that characterize such phenomena as the cycles of the Five Phases (or Five Elements: wood, metal, fire, water, and earth)

were also believed to be governed by the shifting balance between *yin* and *yang.*

From the Taoist point of view, all things are made up of *qi.* Matter and energy are thus interchangeable (a basic assumption of modern nuclear physics). Taoism teaches that to be content as a human being, one must accept that change (transformation) is the absolute reality, and that all things and transformations are unified in the Tao. The concept of *qi* (vital energy or breath), for example, lies at the heart of traditional Chinese medicine, which views illness as caused by imbalances of *yin* and *yang,* resulting in blockages of the free movement of *qi* through the body. Acupuncture and other traditional remedies are designed to restore the proper movement of vital energy, thus restoring health.

A fundamental cosmological principle of ancient Chinese thought, and one adopted by religious Taoism, is that all things correspond to each other. In particular, microcosm reflects macrocosm, and vice versa. The structure of the human body, for example, was believed to reflect both the structure of the natural landscape and the structure of the universe. In religious Taoism, the human body is visualized as a landscape, its different parts populated by deities who correspond to gods that dwell in the

heavens above. This concept of divine correspondence appears throughout religious Taoism, and is one of many ideas that have remained constant over the course of its development. The Five Elements correspond to the Five Directions (the four cardinal directions and the center), the Five Sacred Peaks, and the Five Planets. The correspondences between the parts of the human body and the structures of the natural world provide the intellectual underpinnings of traditional Chinese physiognomy.[3] Another principle that emerged out of early Taoist philosophy was the importance of the cultivation of virtue (de), and of living in balance with the natural world. Harold Roth has translated de as "inner power": "This inner power can be thought of as a psychological condition of focused and balanced awareness from which the adept is able to respond spontaneously and harmoniously to whatever arises."[4]

These ideas, along with the importance of always being attuned to the Tao, are first articulated in the *Daode jing* (also known as the *Laozi*), the classic text attributed to the sage Laozi (Lao-tzu).[5] Laozi is believed to have lived in the sixth century B.C., and the *Daode jing* is thought to have achieved its final form in the fourth or third century B.C. According to Taoist tradition, this text was first revealed to the frontier guardian Yin Xi as Laozi left China for the western regions (see fig. 1). In 1993 archaeologists excavating a late-fourth-century-B.C. tomb at Guodian, Hubei province, made a remarkable discovery: the earliest known manuscript of the *Laozi* (see fig. 2).[6] Comprising three bundles of inscribed bamboo slips, this Warring States period manuscript is roughly one hundred and fifty years older than the versions of the *Laozi* excavated in 1973 among the silk manuscripts at Mawangdui in Changsha, Hunan province (dating to c. 168 B.C.).[7] Like the Mawangdui manuscripts, the Guodian *Laozi* has no chapter titles. The Guodian manuscript may represent an earlier form of the text, or may consist of transcriptions from a larger book. Fifteen other texts were also discovered in the tomb at Guodian, including Confucian works and the cosmogonic text entitled *Supreme Unity Generates Water (Taiyi shengshui)*.

The following two sections, included among the Guodian slips, are characteristic of the paradoxical language for which the *Laozi* is famous. One passage, found in bundle A, corresponds closely to the thirty-second chapter *(zhang)* of the received *Daode jing*:

> The Tao is constant, but has no name (= fame);
> Although the Uncarved Block is subtle (= small, minute),
> In Heaven and Earth, all submit to it.[8]

Fig. 2

Laozi manuscript (detail). Warring States period, Chu kingdom, c. 350/300 B.C. Ink on bamboo slips. Jingmen City Museum, Hubei.

If barons and kings would but possess themselves of it,

The ten thousand creatures would flock to do them homage;

Heaven and Earth would conspire to send Sweet Dew.

Without commands (laws), men would live in peace.

Once (the Block) is carved, there will be names,

And so soon as there are names

Know that it is time to stop.

Only by knowing when it is time to stop can danger be avoided.

To Tao all under heaven will come,

As streams and torrents flow into a river or sea.[9]

Here the Tao represents the empty yet infinitely pregnant void out of which the world emerges. The following passage, also from bundle A, corresponds closely to part of the second chapter of the received *Daode jing*:

It is because every one under Heaven recognizes beauty as beauty,
 that the idea of ugliness exists.

And equally if every one recognized virtue as virtue, this would
 merely create fresh conceptions of wickedness.

For truly being *(you)* and non-being *(wu)* are born of each other,

Difficult and easy complete each other;

Long and short test one another;

High and low determine one another.

Pitch and mode give harmony to one another.

Front and back give sequence to one another.

Therefore the Sage relies on actionless activity *(wuwei zhi shi)*,

Carries on wordless teaching. . . .[10]

The Guodian *Laozi* contains twenty-four sections that correspond to sections of the eighty-one chapter *Daode jing*.[11]

One of the most complicated aspects of Taoism is its transformation from a philosophy to a religion. The West is just beginning to become aware of the long history of religious Taoism. Even scholars who are familiar with Laozi and the *Daode jing* are generally unaware of the later history of religious Taoism from the Eastern Jin (317–420) and Six Dynasties (420–589) periods onward, or of the role of this religion in Chinese political history. That our increasingly sophisticated knowledge of Taoism is so recent a phenomenon is due in large measure to a tendency among Chinese intellectuals in the early and mid-twentieth century to equate Taoism with folk religion and superstition, both seen as obstacles to modernization and social reform. It was not until the 1920s that the Taoist Canon *(Daozang),* a rich repository of philosophical and ritual texts, became available for study through a photo-lithographic reprint of a fifteenth-century

Ming woodblock-printed edition. In contrast, the East Asian Buddhist Canon has been accessible to scholars for centuries in the form of multiple woodblock-printed versions in China, Korea, and Japan. The fact that there is still no comprehensive history of Taoism available in any Western language has only contributed to this lack of awareness. Nonetheless, Taoist studies are proliferating in the West, and the practice of religious Taoism is rebounding in mainland China.

Religious Taoism is the principal focus of this exhibition. Despite the seemingly elusive nature of Taoist art, such arts as painting, sculpture, calligraphy, and textiles have served religious Taoism from its inception. Between the late Zhou (fifth–third century B.C.) and Tang (618–906) dynasties, Taoism underwent a profound change from the relatively straightforward philosophy expressed in the *Daode jing* to a complex religion with a vast pantheon of deities and immortals (adepts), a highly structured church, and an enormous compendium of sacred texts known as the *Daozang,* consisting since the Ming dynasty (1368–1644) of some fifteen hundred scriptures. In the course of this transformation, Taoism absorbed several currents that played important roles in the intellectual and religious life of the late Bronze Age, including the belief in *yin* and *yang;* the symbolism of the Eight Trigrams from the *Yi jing,* or *Book of Changes;* the cyclical activities of the Five Phases (Elements); the worship of sacred peaks; the belief in a vast realm of star gods; and concepts of afterworlds and heavenly paradises. By the end of the Han dynasty, the sage Laozi had been deified, and from this time onward was worshipped as a god by both the emperor and common people.[12]

Scholars have traditionally seen the beginning of religious Taoism as having occurred in the late Han dynasty (second century), with the formation of the Way of the Celestial Masters (Tianshi Dao) in Sichuan province. The first Celestial Master, Zhang Daoling, had a vision of the deified Laozi in A.D. 142, in which a new conception of mankind was transmitted to the world. Two of the central aspects of Celestial Master Taoism were its codes of moral behavior and its rituals of petition, in which priests would submit formal requests to the gods (and by extension the Tao) to act benevolently for the benefit of their parish or diocese.

The term "Daojiao" ("Taoist teaching" or "Taoist religion"), however, was not used by Taoists to describe their tradition until the fifth century. Although many scholars would argue that religious Taoism began with Zhang Daoling's vision of the deified Laozi, the actual point at which the Taoist religion began is still a controversial issue. Other scholars see a continuous

lineage within religious Taoism extending back to the Bronze Age traditions of the *Daode jing* and the *Zhuangzi,* the earliest texts of the Taoist tradition. Some scholars, among them Anna Seidel, have used the term "proto-Taoist" to describe the Han dynasty religion(s) that provided the immediate antecedent to religious Taoism, and such works of sacred art as talismans that were used in the service of the Han religion.[13]

The difficulty in characterizing religious Taoism before the Six Dynasties period (420–589) is illustrated by the example of the cult of Xiwangmu, the Queen Mother of the West. Many scholars consider Xiwangmu an early Taoist goddess, but it is by no means clear that early images of Xiwangmu, such as are found in abundance in northeast and southwest China in late Han (first–second century) funerary contexts, can or should be called Taoist. Xiwangmu is not mentioned in any religious Taoist text until the Six Dynasties period (fourth century), and there is no concrete evidence that she was worshipped by the Celestial Master movement of the late Han dynasty, even though, as Wu Hung has shown in his essay in this catalogue, such images in Sichuan are found in areas in which the Celestial Master sect was active in the second and third centuries. The study of Warring States and Han religion is still in its infancy, and the artistic traditions associated with the religious traditions of China in these periods are so rich and yet still so poorly understood that they would legitimately constitute the subject of a separate exhibition. The astonishing Chinese archaeological discoveries of recent years have only made this situation more complex.

If one were to trace the history of religious Taoism to its origins, one would find that Taoism is a river into which many streams have flowed. Many of these streams of thought can themselves be traced back to the Bronze Age. Among these disparate traditions are practices of self-cultivation leading to "achievement of the Tao" *(cheng Dao),* the veneration of adepts *(xian)* who attained spiritual perfection *(zhen,* literally, "realization"), the worship of such deities as Taiyi (Supreme Unity) and Xiwangmu (the Queen Mother of the West), the philosophical tradition of the *Daode jing,* the worship of local gods and sophisticated traditions of shamanism in the Warring States period (475–221 B.C.), the philosophy of the *Book of Changes,* which can itself be traced to the Western Zhou dynasty (c. 1050–771 B.C.), and the use of talismans as forms of sacred calligraphy that have the power to transform reality.[14] It should be clear from the sheer variety of these traditions out of which religious Taoism emerged that any attempt to generalize about the nature of ancient Chinese religion should be tempered by the need for a

profound awareness of the structure and development of *each* of these streams of belief and practice. Over the long course of its development, however, fundamental aspects of Taoism remained constant.

Sections I.2 and I.3 of this exhibition and catalogue, entitled "Heaven and Earth: Taoist Cosmology" and "Sacred Mountains and Cults of the Immortals," respectively, explore vital concepts that predate the emergence of religious Taoism, but that formed part of the complex world out of which the later religious tradition developed from the Han dynasty onward. Among these concepts was the multivalent image of the mountain.[15] The worship of sacred peaks can be traced as far back as the Shang dynasty (c. 1600–c. 1050 B.C.). Mount Song (Song Shan, the central of the Five Sacred Peaks), for example, was already worshipped as a god during the late Shang.[16] Mountains were venerated in China as numinous pivots connecting the human and celestial realms. Mountains were also seen as places in the terrestrial landscape where the primordial vital energy *(qi)* that created the world was particularly strong and refined. As a consequence, mountains were places where an adept could meditate, experience visions of perfected deities of the celestial realm, and locate the herbs and minerals necessary for the preparation of elixirs that extended one's life. Sacred mountains were also sites where one could find cavern-heavens *(dongtian),* grottoes deep in the earth that functioned as boundaries of the spirit world and gateways to paradise.[17] A system of thirty-six cavern-heavens and seventy-two blessed sites *(fudi)* was formulated during the Tang dynasty, and many of these sites are still venerated in China today. The system of cavern-heavens mirrored the thirty-six heavens in the celestial realm.

The image of the sacred peak coursing with vital energy is conveyed with remarkable beauty in the great incense burner, or *boshanlu,* excavated in 1968 from the tomb of the Han dynasty prince Liu Sheng (cat. no. 20). This extraordinary object points to the deep significance given to mountains during the Han dynasty and earlier, as well as by the fully formed Taoist religion of later times. This imagery also extended to the popular belief in the sacred islands of the immortals sought as early as the third century B.C. by the first emperor, Qin Shihuangdi, and in the succeeding Western Han dynasty by Emperor Wu (Han Wudi; r. 140–87 B.C.).

It is especially significant that in religious Taoism, both the human body and the ritual altar are visualized as a mountain.[18] Furthermore, the inner topography of the human body is perceived as populated by gods who, as shown above, correspond to deities in the heavens. This imagery is fundamental to the

Inner Alchemy (neidan) tradition, and its roots can be seen as early as the *Scripture of the Yellow Court (Huangting jing)*, a text transcribed by the famous calligrapher Wang Xizhi (307–365) in the fourth century (cat. no. 128). The structure of the human body thus mirrors the universal order inherent in the Tao. This system of divine correspondences between human microcosm and celestial macrocosm is a fundamental and continuous element in the entire tradition of religious Taoism.

The earliest art that can properly be called Taoist dates to the Eastern Jin dynasty (317–420) and the Six Dynasties period (420–589). It was in this period that the Taoist religion became fully formed. In the late fourth century, the core texts of the Shangqing (Highest Purity) tradition were revealed by *zhenren* (realized beings) from the Shangqing Heaven to the adept Yang Xi (330–c. 386) in a series of visions. Yang lived at Jurong near Nanjing, and was patronized by the Xu family, one of the leading families of the Eastern Jin dynasty. Less than a century later, the first Taoist canon was compiled by Lu Xiujing (406–477), a scholar active during the Liu-Song dynasty (420–479). Lu divided the canon into three parts, called the Three Caverns *(Sandong)*. These comprised texts of the Shangqing (Highest Purity), Lingbao (Numinous Treasure), and Sanhuang (Three Emperors) traditions, and were called, respectively, the Cavern of Perfection *(Dongzhen)*, Cavern of Mystery *(Dongxuan)*, and Cavern of Divinity *(Dongshen)*.[19] It was in this period that certain elements of Buddhist thought and liturgy were absorbed into Taoism. This is most clearly seen in the Lingbao texts compiled by Lu Xiujing. These scriptures were said to have been originally revealed to the adept Ge Xuan (flourished 238–50) in the third century.[20] Stephen Bokenkamp has written as follows on the Lingbao scriptures:

> First, they were meant to represent the synthesis of all the impor-
> tant religious traditions of the time—most prominently, Celestial
> Master Taoism, Shangqing Taoism, and Buddhism. They are thus
> the first Taoist scriptures to incorporate and redefine Buddhist
> beliefs, practices, and even portions of Buddhist scripture. They
> do this quite openly, positing the temporal priority and spiritual
> superiority of their message against any charge of plagiarism. The
> very name of the scriptures *(ling,* "spirit-endowed," representing
> the heavens, and *yang*, joined to *bao*, "jewel," representing Earth
> and *yin)* refers to the claim that these scriptures are translations of
> spirit-texts that emerged at the origin of all things when the breaths
> of the Tao separated into the two principles of *yin* and *yang*, thus
> giving the Lingbao texts priority over texts composed later.[21]

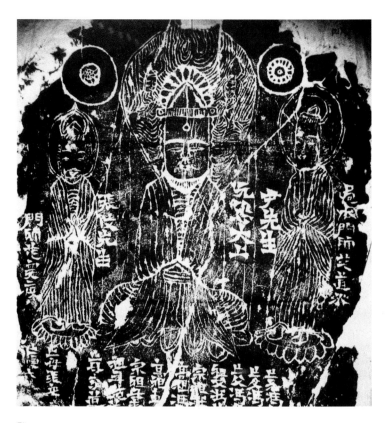

Fig. 3
Ink rubbing of the back of a Taoist stele, depicting the Deified Laozi, Yin Xi, and Zhang [Dao]ling. Northern Wei dynasty, c. 500. Sandstone; h. 79.5 cm. The Field Museum, Chicago.

The Six Dynasties period thus witnessed the mature development of the religious Taoist pantheon, canon, ritual, and art. We know from the writings and recorded actions of the northern Celestial Master Kou Qianzhi (d. 448) and Lu Xiujing that Taoist images (both sculptures and paintings) of the deified Laozi and the Celestial Worthy of Primordial Beginning (Yuanshi tianzun) were being made in the mid-fifth century, even though some spoke out against the use of images to give form to the Tao, considered ultimately formless.[22] It seems clear from an examination of the earliest surviving Taoist sculptures depicting the deified Laozi that there was enormous influence from Buddhist art on early Taoist images. The earliest images that survive date from the Northern Wei dynasty (fifth century) and often depict the deified Laozi surrounded by two flanking figures, following the Buddhist format of a seated Buddha flanked on either side by a bodhisattva. The inscriptional evidence on a Northern Wei stele in the Field Museum, Chicago, collected in the Xi'an area by Berthold Laufer in 1909–10, suggests that the figures that flank the deified Laozi on these early sculptures may depict the frontier guardian (and later immortal) Yin Xi and the first Celestial Master, Zhang Daoling (see fig. 3).[23] This is significant

because Yin Xi was the first human being to receive the *Daode jing* from Laozi, and Zhang Daoling was the first human being to have a vision of the deified Laozi. It is clear from Taoist texts of the Six Dynasties period that by this time the deified Laozi was identified with the Tao itself and credited with the creation of the universe. This conception of Laozi was established by the late Han dynasty, as is documented by a stele inscription of A.D. 153, entitled the *Shengmu bei* (Stele of the Sage Mother), which reads in part:

> Laozi, the Tao:
> Born prior to the Shapeless,
> Grown before the Great Beginning,
> He lives in the prime of the Great Immaculate,
> And floats freely through the Six Voids.[24]

This view is again articulated in the famous stele inscription of A.D. 165, the *Laozi ming*:

> Laozi was created from primordial chaos and lived as long as the three luminants [sun, moon, and stars]. He observed the skies and made prophesies, freely came and went to the stars. Following the course of the sun, he transformed nine times; he waxed and waned with the seasons. He regulated the three luminants and had the four numinous animals by his side.[25] He concentrated his thinking on the Cinnabar Field *[dantian]*,[26] saw Great Unity [Taiyi][27] in his Purple Chamber, became one with the Tao, and transformed into an immortal.[28]

The emergence of a new pantheon of gods, incorporating such deities as Taiyi (Supreme Unity), the Queen Mother of the West (Xiwangmu), and the realized beings *(zhenren)* of the newly revealed Highest Purity Heaven, was a key element in the formation of religious Taoism. An early text that coincides with these developments is the *Xiang'er zhu*, a religious Taoist commentary to the *Daode jing* (cat. no. 34). The text survives in a Northern Wei dynasty (early sixth century) manuscript discovered at Dunhuang, and now part of the Stein Collection in the British Library, London.[29]

The longevity and internal coherence of the Taoist liturgical tradition can be traced to the earliest forms of ritual established in the late Han and early Six Dynasties periods. Such compilations as the *Supreme Secret Essentials (Wushang biyao)* of the Northern Zhou dynasty (557–581) contain the fundamental forms of many Taoist rituals that are still used today.[30] Among other things, the basic structure of the Taoist altar *(daotan)* was established during the Six Dynasties period (see fig. 4).

On another level, the impact of Taoism on the theory and practice of painting and calligraphy, as seen in surviving Six Dynasties period texts, is clear. The idea of the correspondence between the inner vital energy *(qi)* of what is being depicted (be it a person, animal, mountain, god, or other entity), and the spirit-resonance of the artist's response to this visual stimulus, as manifested in the movement of his brush, is articulated in the famous "Six Laws of Painting" by the scholar Xie He (active c. 500–535).[31] There is a close correspondence between Xie He's ideas and earlier concepts of the flow of *qi*-energy through the human body.[32] The first and most famous of the Six Laws reads *qiyun shengdong,* or "engender [a sense] of movement [through] spirit consonance."[33] The great painter Gu Kaizhi (c. 345–c. 406) was a follower of the Celestial Master sect; his depiction of Zhang Daoling, the first Celestial Master, at the Cloud Terrace Mountain is one of the first recorded Taoist paintings.[34]

Similarly, early texts on calligraphy from the third and fourth centuries stress the importance of calligraphy not only as a means of communication, but also as an art that, when properly executed, has the force to transform reality itself.[35] Calligraphy enjoys a special position in religious Taoism. In both the Shangqing and Lingbao schools of Six Dynasties Taoism, for

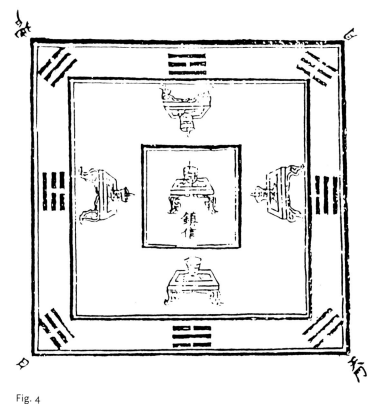

Fig. 4

Diagram of a Taoist altar. From *Wushang biyao* (Supreme secret essentials; HY 1130; woodblock-printed, accordion-mounted book; Ming dynasty, 1444–45; reprint of a lost Northern Zhou dynasty [557–581] compendium). From ZTDZ, vol. 42: 456.

example, sacred scriptures (*jing*) were believed to have existed as cosmic texts even before the creation of the world. Written in "cloud-seal" script, these texts were generated "when sound first issued from the protoplasmic Brahma-ether, itself the earliest emanation of the primordial Tao."[36] As Isabelle Robinet has written,

> They [the Taoist scriptures, or *jing*] are formed by the coagulation and the condensation of this First Breath [*yuan qi*, primordial energy]. . . . Spontaneously born from the Void, they appeared as rays of light that came before the genesis of the world.[37]

The tradition of talismanic writing, which had appeared by at least the Han dynasty, developed into a sacred art that played a fundamental role in Taoist ritual from the Six Dynasties period onward. Several Taoist talismanic texts from Dunhuang, datable to the Tang dynasty, are included in this exhibition; these derive from both the Shangqing and Lingbao ritual traditions. In addition to the importance of their talismans, these works are noteworthy because they highlight the complex blending of Taoism and local religious traditions during the Six Dynasties and Tang periods.[38] It should come as no surprise that the Eastern Jin dynasty calligrapher Wang Xizhi, the greatest master of this art in Chinese history, was himself a practicing Taoist.[39] While his transcriptions of the *Daode jing* no longer survive (these are recorded in the *Dynastic History of the Jin [Jinshu]*),[40] his family's devotion to religious Taoism is well known. Wang Xizhi's transcription of the *Scripture of the Yellow Court*, a text that presages the Inner Alchemy tradition, does survive, in ink rubbings of the Song dynasty (960–1279; see cat. no. 128).

Despite the fact that Buddhism flourished during the Six Dynasties period, enjoying strong imperial patronage in both northern and southern China during the Northern Wei, Northern Zhou, and Liang dynasties, Taoism also flourished in this period, in large measure because from its inception it provided a useful mechanism for establishing political legitimacy. Indeed, throughout its history, Taoism was perceived by many imperial families as representing the highest degree of spiritual and political orthodoxy. Religious Taoism supplied a means by which emperors could extend their control through both the human and divine realms. This is clearly illustrated in the Ming dynasty handscroll of 1493 in the San Diego Museum of Art, the ordination certificate (a combined painting and document) of Empress Zhang, wife of the Hongzhi emperor (r. 1488–1505), made on the occasion of her ordination as a Taoist priestess (cat. no. 57). It is significant in this light, as Anna Seidel has shown, that the Chinese imperial investiture ceremony was based on an ancient

Taoist ritual.[41] The empress is depicted here as a goddess, illustrating the fact that through Taoist ordination, a priest or priestess gained control over the gods. This control was transmitted through registers (*lu*; lists of gods and their attributes) and talismans. Empress Zhang's ordination came in a long tradition of imperial ordinations that extended back to the Northern Wei emperor Tai Wudi, who in the fourth century was ordained by the northern Celestial Master Kou Qianzhi.[42] The Tang dynasty emperor Xuanzong (Minghuang; r. 712–56) also received a Taoist ordination in the form of registers and talismans; these were transmitted to him by the great Taoist master Sima Chengzhen. The *Old Dynastic Records of the Tang (Jiu Tangshu)* contains the following account of Xuanzong's devotion to religious Taoism:

> During his reign of many years, Xuanzong showed a great respect for various techniques for achieving longevity and levitation [*changsheng qingju zhi shu*]. In the Datong [Great Unity] Hall [of the Xingqing Palace], [he] set up the statue of the perfected immortal [*zhenxian*, i.e., the deified Laozi]. [He would] rise at midnight to burn incense and perform the prostration ritual [*dingli*]. In famous mountains, [he] ordered eunuch officers and Taoist recluses to alchemize [cinnabars] and to conduct the rite of *jiao*. The road was teeming [with these people]. The rites to appease the dragon [*toulong*; literally, "casting dragons"] and to make jade offerings [were conducted on his behalf or by himself]. [He] set up Taoist monasteries [*jingshe*], gathered elixirs, [searched for] the formulae of the Perfected [*zhenjue*], and followed the traces of the immortals. [He was involved in these activities] for years.[43]

The Tang dynasty (618–906) was thus a period in which religious Taoism flourished, in large measure owing to imperial patronage.[44] For both political and spiritual reasons, the Tang imperial house sponsored Taoism on a previously unmatched level. Laozi, whose surname (Li) was the same as that of the imperial family, was adopted as the direct ancestor of the emperors. The Tang dynasty thus connected its political fortunes to its relationship with the deified Laozi. For the first time, civil service examination candidates were tested on the *Daode jing*, and Taoist temples were ordered built in every major city in China. That so many Taoist texts have been discovered at Dunhuang, a relatively remote site on the Silk Road, is because a Taoist temple also existed at Dunhuang, a major center of Buddhism during the Tang. Several of these rare manuscripts, from the Pelliot Collection at the Bibliothèque Nationale, Paris, and the Stein Collection at the British Library, are included in this exhibition.

The new role of Laozi as imperial ancestor during the Tang is reflected in the many Taoist sculptures of the deified sage that

survive from this time. Several of these, such as the great marble image now kept in the Forest of Stelae (Beilin) Museum at Xi'an, are well over life-sized, and are clearly metropolitan works that reflect the majesty of the new imperial image. It was also during the Tang that the trinity of high gods known as the Three Purities (Sanqing) first appeared as a group. These gods, conceived as pure emanations of the Tao, were the Celestial Worthy of Primordial Beginning (Yuanshi tianzun), the Celestial Worthy of Numinous Treasure (Lingbao tianzun), and the Celestial Worthy of the Way and Its Power (Daode tianzun). The last of these was none other than the deified Laozi. The earliest dated image of this triad dates to 749, and is found in a Taoist cave at Niujiaozai, Renshou county, Sichuan province.[45]

The Tang dynasty saw the compilation of a new edition of the Taoist Canon, which unfortunately does not survive. This compilation was ordered by Emperor Xuanzong. Despite the simultaneous imperial patronage of Buddhism, Taoist belief and ritual spread throughout China with a previously unmatched consistency. Just as Six Dynasties period emperors sponsored Taoist clerics, so too did the Tang emperors support religious Taoism.

Although it is known from literary evidence that Taoist art proliferated during the Tang, very little art that can be called Taoist survives from this period. Descriptions of imperial Taoist rituals, such as the ordination in 711 of two imperial princesses as Taoist nuns, convey an impression of the richness of the works of art made in the service of religious Taoism that can only be imagined today.[46] The majority of extant Taoist art works from the Tang are stone sculptures and calligraphic manuscripts. Sculptures of the deified Laozi are found in collections in China, and in museums in Japan and the West.[47] The majority of Tang Taoist calligraphic texts that survive come from Dunhuang, and are now kept in London and Paris. The bulk of these texts were conveniently published and annotated by Ōfuchi Ninji in 1978, and provide a remarkable resource for the study of medieval Taoism in China.[48]

While no Taoist paintings survive from the Tang dynasty, literary accounts suggest that great muralists such as Wu Daozi (eighth century) were actively engaged in the decoration of both Taoist and Buddhist temples in this period. Furthermore, the early twelfth-century Northern Song dynasty imperial painting catalogue of Emperor Huizong (the *Xuanhe huapu*) records many Tang Taoist paintings, but none survive. Such works as the *Five Planets and Twenty-eight Lunar Mansions* (Osaka Municipal Museum of Art), attributed to the Six Dynasties period artist Zhang Sengyou, were among the works in Emperor Huizong's collection; this work can only peripherally be desig-

nated as Taoist, reflecting as it does images of planetary and star gods that entered China through the vehicle of Buddhism, and that were absorbed into the Taoist pantheon during the Tang dynasty.

Another important category of Tang Taoist art comprises bronze mirrors, cast with designs that by this time had been thoroughly incorporated into Taoist cosmology. Images of sacred mountains, paradises, and the Eight Trigrams *(Bagua)* of the *Book of Changes* are commonly found on bronze mirrors of this period.[49]

The occasional importance of religious Taoism for even believers in Buddhism was highlighted by the discovery in 1982 on Mount Song (Song Shan, the central of the Five Sacred Peaks; see cat. no. 137) of a gold tablet (fig. 5) commissioned by Empress Wu Zetian (r. 690–705), a devout Buddhist who established the short-lived Zhou dynasty (696–705).[50] The inscription on the tablet is addressed to Mount Song and indicates that it was made for the benefit of the empress herself. The tablet is dated to the seventh day of the seventh lunar month of 700. It is essentially an official communication from Empress Wu's terrestrial representative, the Taoist priest Hu Chao, to the celestial bureaucracy and the netherworldly Nine Departments of the nine hells, which are governed by the Three Officials (Sanguan; see cat. nos. 69–71). Hu requests that the empress's name be removed from the records of those who will be imprisoned in the hells after death, and transferred to the celestial registers of realized beings *(zhenren)*. A very similar practice of "presenting golden tablets" *(toujian)* developed into a Taoist ritual during the Six Dynasties period (420–589), and a description of this ritual is preserved in a scripture from the Highest Purity (Shangqing) corpus contained in the Taoist Canon.[51]

Very few works of Taoist art survive from before the Song dynasty. From this time onward, however, increasing evidence survives of works of art made in the service of religious Taoism. Several of the Song emperors were devout patrons of Taoism; among them the most active were Zhenzong (r. 997–1022) and Huizong (r. 1100–25).[52] The latter, who took for himself the title Daojun huangdi (August Emperor, Lord of the Tao), was the most famous painter among all the emperors of China. In her essay in this volume, Patricia Ebrey explores the ways in which works of art served Huizong's Taoist agenda. Huizong was a patron of the Taoist cleric Lin Lingsu, who founded a new Taoist order, the Divine Empyrean (Shenxiao) movement.[53]

The Song emperors adopted the Yellow Emperor (Huangdi) as their imperial ancestor, just as the Tang emperors had

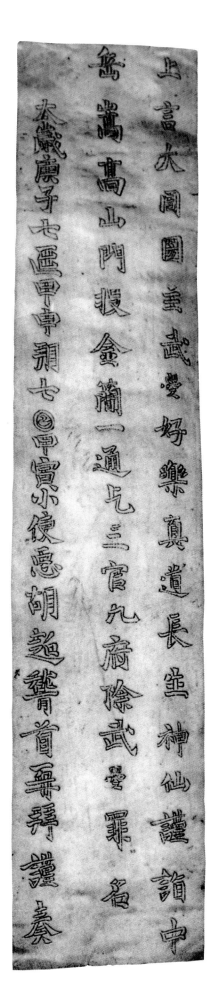

上言大同國玉武變好藥真道長生神仙謹詣中
鳥嵩高山門授金蘭一通乞三官九府除武罷名
大歲庚子七迴軍享翔七●甲寅小使愿胡趙甦首再拜謹奏

Fig. 5
Tablet with inscribed prayer,
commissioned by Empress
Wu. Tang dynasty, 700.
Forged gold; 36.3 × 7.8 cm.
Henan Natural History
Institute.

adopted the deified Laozi as theirs. The high quality of imperially commissioned Taoist paintings during the Song is evidenced by such surviving masterpieces as Wang Liyong's *The Transformations of Lord Lao* in the Nelson-Atkins Museum (cat. no. 35) and Liang Kai's *Liberating the Soul From the Netherworld* (cat. no. 37). It would appear from its extraordinary quality that the twelfth-century triptych of hanging scrolls depicting the Taoist Officials of Heaven, Earth, and Water (the Sanguan) in the Museum of Fine Arts, Boston (cat. nos. 69–71), was also created under imperial auspices. Emperor Huizong's painting *Cranes of Good Omen* (see Patricia Ebrey's essay in this volume, fig. 4) in the Liaoning Provincial Museum, Shenyang, is another image that blends Taoist imagery with an agenda that included political legitimation.[54] That other masterpieces of Song painting, such as Chen Rong's *Nine Dragons* handscroll of 1244 in the Museum of Fine Arts, Boston (fig. 6), were perceived as Taoist images is clear from the content of the artist's inscription on the work, and the attached colophons of the Yuan dynasty, which include inscriptions by Wu Quanjie (1269–1346), Ouyang Xuan (1273–1357), and the thirty-ninth Celestial Master, Zhang Sicheng (1287–1368).

Sadly, none of the Taoist temple murals of this period survive, although echoes of their magnificence can be seen in surviving Buddhist murals of the Northern Song and Jin dynasties, and particularly in the extant fourteenth-century (Yuan dynasty) murals of the Eternal Joy Temple (Yongle Gong) in Shanxi province.[55] We can obtain some sense of how the Taoist pantheon was visualized in the Song dynasty through such works as Wu Zongyuan's *Procession of Immortals* (cat. no. 74), a masterpiece of the eleventh century, and the great twelfth-century album of fifty leaves depicting Taoist gods in the Stephen Junkunc IV Collection.[56]

Significant numbers of paintings of Taoist *xian,* or immortals (adepts), survive from the Song and Jin (1115–1234) dynasties. The earliest image of the popular group known as the Eight Immortals (Baxian) is found among the ceramic sculptures decorating the interior walls and ceilings of Jin dynasty tombs near Pingyang, Shanxi province; these date to the late twelfth or early thirteenth century.[57] The best-known early image of the Eight Immortals, however, is found among the murals of the Hall of Purified Yang (Chunyang Dian) at the Eternal Joy Temple, dating to the fourteenth century.[58] Several Song dynasty paintings of Taoist immortals are included in this exhibition; among them are two fan paintings of Lü Dongbin (Lü the "Cavern-guest"), a patron saint of the Complete Realization (Quanzhen) sect, which rose to prominence in the Jin and Yuan

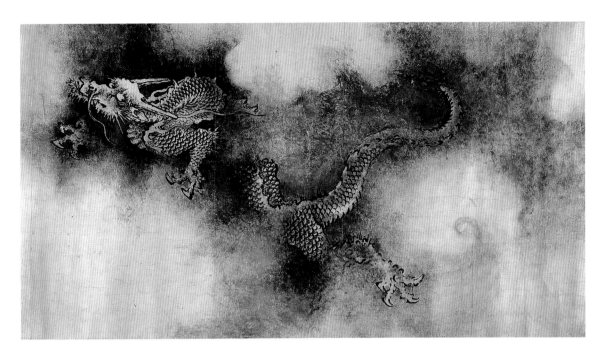

Fig. 6
Chen Rong. *Nine Dragons* (detail). Southern Song dynasty, dated 1244.
Handscroll; ink and light color on paper; 46.3 × 1,096.4 cm. Museum
of Fine Arts, Boston, Francis Gardner Curtis Fund.

(1260–1368) dynasties. As Farzeen Baldrian-Hussein has shown, however, veneration and worship of Lü Dongbin was already widespread during the Northern Song dynasty (960–1126).[59] A more generalized image of an immortal is Ma Yuan's *Immortal Riding a Dragon*, painted at the Southern Song court in the early thirteenth century (cat. no. 28). Some of the most evocative depictions of Taoist mountain paradises also date to the Song dynasty. An excellent example is the monochrome ink handscroll in the Freer Gallery of Art, Washington, D.C., traditionally attributed to Li Gonglin, and probably dating to the late eleventh or early twelfth century (fig. 7).[60]

It seems clear from both historical and artistic evidence that the majority of the Song emperors patronized both Buddhism and religious Taoism, as had the Tang emperors before them (and as did the Ming emperors after them).[61] In addition, the Taoist influence on the Neo-Confucian philosophers of the Song dynasty is clear, as has been pointed out by Sun K'o-k'uan and other scholars.[62] The Song dynasty witnessed the rise of several new Taoist sects, among them the Great Law of Heaven's Heart (Tianxin dafa) sect, and the increasing popularity of Inner Alchemy *(neidan)*. In this discipline, the creation of the alchemical elixir was visualized by the adept within his or her own body. This practice was promulgated by such adepts as Bai Yuchan (flourished 1209–24), and achieved widespread popularity by the end of the Song dynasty.[63] Images of Taoist adepts obtaining the elixir are often found on bronze mirrors dating to the Song, Jin, and Yuan dynasties. These images are most likely allegories of Inner Alchemy (see cat. nos. 135 and 136).

An important development in the Song dynasty was the increasing absorption of local gods and deities of popular religion into the Taoist pantheon. This reflects changing attitudes among Taoists toward the gods of popular religion, since, in the Six Dynasties and Tang periods, a much clearer demarcation was drawn between Taoist deities and popular gods.[64] By petitioning the emperor, a support group (for example, a local society of merchants) could acquire official recognition for a popular god. If the petition was successful, the god would be granted a new title.[65] This pattern continued into the Yuan dynasty. Later, in the Ming dynasty, such decisions were delegated by the emperors to the Celestial Masters of the Orthodox Unity sect. An example of such a petition, dating to the late Ming and comprising a long painted and inscribed handscroll, is in the Metropolitan Museum of Art, New York (cat. no. 82). There was often an economic as well as a spiritual basis for such petitions: recognition of a local god tended to lead to national legitimation of the merchants and devotees who supported the god, leading in turn to increased opportunities for trade and economic development. Among the many popular gods who were absorbed into the religious Taoist pantheon was Guandi (Emperor Guan), originally Guan Yu, a military hero of the Three Kingdoms period in the third century

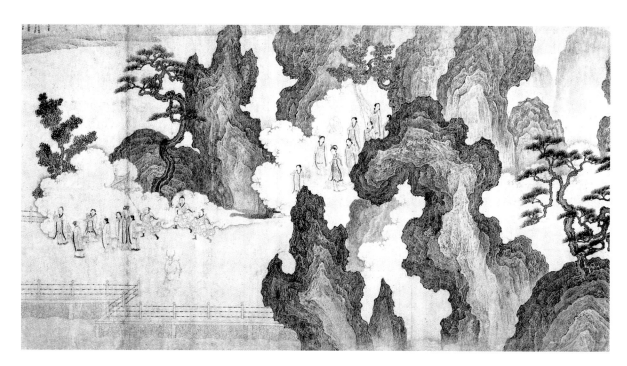

Fig. 7
Traditionally attributed to Li Gonglin. *Taoist Paradise* (detail). Northern Song
dynasty, late 11th/early 12th century. Handscroll; ink on paper; 41.7 × 947.5 cm.
Freer Gallery of Art, Smithsonian Institution, Washington, D.C.

(see cat. no. 83).[66] In the Song dynasty, Guan Yu became a
Taoist marshal *(yuanshuai)*—a celestial guardian who protected
the Taoist faith. Subsequently, in 1615, during the Ming dynasty,
Marshal Guan became Emperor Guan (Guandi). These changes
in title reflect the increasing national importance of a deity who
began as a human hero.[67]

The Jin dynasty (1115–1234), which conquered the Northern
Song dynasty and ruled the north during much of the Southern
Song period, witnessed the founding of the Complete Realiza-
tion (Quanzhen) sect of Taoism by Wang Zhe (1113–1170).[68]
This sect constituted a reform movement within Taoism. Wang
stressed the equality of the Three Teachings *(Sanjiao)*, giving
equal emphasis to such texts as the Confucian *Classic of Filial
Piety (Xiao jing)*, the Buddhist *Heart Sutra (Xin jing)*, and the
Daode jing. He insisted on vegetarianism and the celibacy of
monks, and cultivation of a strict moral code, and also empha-
sized the discipline of Inner Alchemy *(neidan)*, in which the
adept visualized the creation of the elixir. The fourteenth-century
murals of the Hall of Redoubled Yang (Chongyang Dian) at
the Eternal Joy Temple in Shanxi are devoted to depictions of
Wang Zhe's life.[69] The Complete Realization sect has survived to
the present day; its greatest temple is the White Cloud Monas-
tery (Baiyun Guan) in Beijing.[70]

During the succeeding Yuan dynasty (1260–1368), Taoism,

after witnessing a brief period of repression under Khubilai
Khan (Shizu; r. 1260–94), enjoyed a huge resurgence (in 1281,
Khubilai Khan ordered all copies of the Taoist Canon destroyed;
because of this, no copies of the Song dynasty Taoist Canon
have survived). Despite the fact that the Mongol imperial family
chose the Tantric Buddhist deity Mahakala as its dynastic guard-
ian, Taoism was tolerated and even supported. A key element in
this was the rise of the Complete Realization sect, the reform
movement that gradually spread from northern to southern
China.[71] From the thirteenth century onward this sect coexisted
with the earlier Celestial Master sect (also known as the Zhengyi
or Orthodox Unity sect), and they are still the two dominant
Taoist sects in China today. The headquarters of the Complete
Realization sect (the White Cloud Monastery in Beijing) func-
tions today as the headquarters of the Taoist Association of
China (Zhongguo daojiao xiehui), and is a temple where ordina-
tions of Complete Realization Taoist priests are once again
carried out.

In 1287 the Mongol emperors created a new Taoist organi-
zation that superseded the earlier Zhengyi sect, and to which
they delegated control over all Taoist affairs in China. This was
known as the Mysterious Teaching (Xuanjiao) school, and ex-
isted only during the Yuan dynasty. Two of the leading priests
of this school were Zhang Liusun (1248–1322) and Wu Quanjie

(1269–1346), both pupils of the thirty-sixth Celestial Master, Zhang Zongyan (1244–1292) of Dragon and Tiger Mountain (Longhu Shan) in Jiangxi. Among other accomplishments, Zhang Liusun founded the Temple of the Eastern Peak (Dong-yue Miao) in Beijing, the Taoist temple dedicated to the god of Mount Tai (Tai Shan), and Wu Quanjie lived to oversee its completion. During the Cultural Revolution (1966–76), the Dongyue Miao was closed and nearly destroyed, but has recently been renovated and reopened as a museum. The temple still contains an important group of stelae, including the famous *Stele of the Taoist Religion (Daojiao bei)* that tells the story of the temple's founding. The text of this stele was composed and inscribed by the scholar-official Zhao Mengfu (1254–1322).

It is noteworthy that despite Zhao Mengfu's deep interest in Chan (Zen) Buddhism (he was a friend and confidant of the great Buddhist priest Zhongfeng Mingben),[72] he composed several stele inscriptions for Taoist temples.[73] This level of involvement reflects the fact that from the Six Dynasties period onward, many members of the literati class were either directly involved with or deeply knowledgeable about religious Taoism. The prevailing view that, in late imperial China, scholar-officials and literati were primarily Confucian in their philosophical orientation and devoid of interest in or involvement with religion or spirituality is challenged by many historical or literary data. As we have seen, as early as the Eastern Jin dynasty, the scholar-officials Wang Xizhi and Gu Kaizhi were followers of the Celestial Master sect. As a corollary, it is noteworthy that the Liang dynasty Taoist scholar and alchemist Tao Hongjing was renowned as a painter and calligrapher. The letters Tao exchanged with Emperor Liang Wudi are the first texts in Chinese history to discuss the connoisseurship of calligraphy.[74] In the Tang dynasty, the famous poet Li Bo (701–762), for example, was a devout believer in religious Taoism.[75] Like Emperor Xuanzong, Li Bo received a Taoist ordination. As Farzeen Baldrian-Hussein has shown, in the Northern Song dynasty, Su Shi (Su Dongpo; 1036–1101), widely perceived as a paragon of the Confucian scholar-official, while not a practicing Taoist per se, nonetheless had a surprisingly deep knowledge of religious Taoism, and practiced several techniques of Inner Alchemy *(neidan)*. An indication of his knowledge of religious Taoism is seen in a stele inscription he composed in 1091 on the occasion of the rebuilding of a Taoist temple originally built by Tang Taizong (r. 976–97):

> The Taoist school has its origins in the [teachings of the] Yellow Emperor and Laozi. . . . From Qin and Han times on, they began to employ the language of the *fangshi* whence one saw the appear-

ance of techniques such as those of flying immortals who can transform themselves, the methods of Huangting [Yellow Court] and Dadong [Great Cavern] (scriptures), the appelation of (the deities) Taishang [the deified Laozi], Tianzhen [the Heavenly Perfected], Mugong [Dongwanggong] and Jinmu [Metal Mother or Xiwangmu], [the mythical periods] Yankang, Chiming, Longhan, and of the first emperors, the sacrifices to [the stellar deities], the Celestial Emperor [Tianhuang] and the Supreme One [Taiyi] who reside in the palace of Purple Tenuity of the North Pole [Ziwei Beiji] and even to the special techniques of elixir medicines, registers, and talismans, all go back to the Taoist school. . . . The Way of the Yellow Emperor and of Laozi is the root, the sayings of the *fangshi* are the branches. . . .[76]

The evidence for Su Shi's practice of Taoist techniques of Inner Alchemy, visualization, and embryonic breathing is clear from texts surviving among his collected writings. Su wrote, "divine immortals and [the practice of] long life are not merely empty words."[77] In addition to the Song religious texts preserved in the Taoist Canon, our knowledge of the practice of Taoism and the worship of Chinese popular gods in the Song is supplemented by the information contained in such texts as the *Record of the Listener (Yijianzhi)* by the literatus Hong Mai (1123–1202).[78]

During the Yuan, the highly cultured Taoist priest Wu Quanjie played an important role as an intermediary between the Mongol court in Dadu (Beijing) and the world of the literati of south-central China. Wu knew such disaffected literati as the Neo-Confucian philosopher Wu Cheng, and the painters Ni Zan and Huang Gongwang. Ni Zan (1306–1374) came from a wealthy literati family whose members were devout supporters of Taoist temples in the Wuxi-Suzhou area of Jiangsu province; Huang Gongwang (1269–1354) was a master of *fengshui* (geomancy) and a diviner. While few of Ni Zan's paintings give any concrete hint of his Taoist belief, the short handscroll entitled *The Crane Grove (Helin tu)* in the Chinese Art Gallery, Beijing, depicts an outdoor Taoist altar, and was painted for a Taoist practitioner named Zhou Xuanzhen (cat. no. 139). In contrast, several of Huang Gongwang's surviving landscapes are specifically Taoist in theme. These include *Cinnabar Cliffs and Jade Trees (Dan'ai yushu tu)* in the Palace Museum, Beijing, and *Mountains of the Immortals (Xianshan tu)* in the Shanghai Museum.[79] Such scenes of paradise mountains were very popular among Yuan literati painters, and appear as well among the works of Wang Meng, Lu Guang (see cat. no. 142), and Chen Ruyan (see cat. no. 144).[80] Several Taoist priests of the Yuan dynasty were also accomplished painters, including Fang Congyi (active c. 1295–1316;

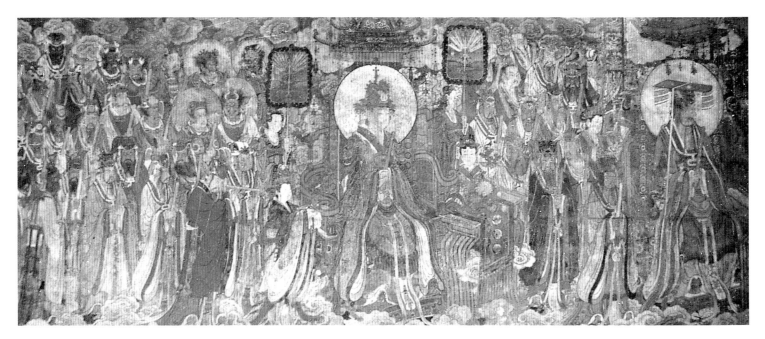

Fig. 8
Murals depicting the Taoist pantheon in the Hall of the Three Purities, Yongle
Gong, Ruicheng, Shanxi province. Yuan dynasty, early 14th century.

see cat. no. 143), Wu Boli (see cat. no. 141), and the Celestial Master Zhang Yucai, all of whom were associated with Longhu Shan in Jiangxi province, the headquarters of the Zhengyi sect of Taoism.[81]

Among the greatest monuments of Yuan dynasty Taoist art are the murals of the Eternal Joy Temple, a Complete Realization sect Taoist temple at Ruicheng in southern Shanxi province. The three main halls of this complex were built in the thirteenth century, and their walls painted with murals in the fourteenth century. The 286 Taoist gods depicted on the walls of the Hall of the Three Purities (Sanqing Dian) provide a magnificent visualization of the Taoist pantheon as it was conceived by the Complete Realization sect in the Yuan dynasty (see fig. 8). The Hall of the Three Purities murals were completed in 1325 by the Luoyang painter Ma Junxiang and his assistants.[82] Chinese scholars have suggested that the textual source for these paintings was the thirteenth-century scripture compiled by Jin Yunzhong (flourished 1224–25) entitled *Great Law of the Highest Purity Numinous Treasure (Shangqing lingbao dafa)*.[83] Originally there were statues of the Three Purities at the center of the hall, but these have disappeared. The murals focus on eight major gods, painted on an enormous scale, each accompanied by a large entourage of deities. The eight principal gods are Nanji dadi (Great Emperor of the South Pole Star), Houtu (Earth Goddess), Yuhuang (Jade Emperor), Ziwei dadi (Purple Tenuity Emperor), Taiyi (Supreme Unity), Jinmu (Metal Mother, or Queen Mother of the West),

Mugong (Wood Sire, or Dongwanggong, Lord Duke of the East), and Gouchen (a celestial emperor representing the constellation surrounding Polaris).[84] While none of these deities is labeled, their identification is now generally agreed upon by scholars.[85] Two other main halls of the Eternal Joy Temple are no less important. The murals of the Hall of Purified Yang depict over fifty scenes from the life of the immortal Lü Dongbin, while those of the Hall of Redoubled Yang depict scenes from the life of Wang Zhe, the founder of the Complete Realization sect. Two Yuan Taoist murals in the Royal Ontario Museum, Toronto, are closely connected in style and date to the murals of the Hall of the Three Purities at the Eternal Joy Temple.[86]

Among the lesser-known works of Yuan Taoist art are the eight cave-temples at Long Shan (Dragon Mountain) in Shanxi province, located southwest of Taiyuan, the provincial capital (not far from the earlier Buddhist cave temple site of Tianlong Shan). These caves, excavated along a sandstone ridge overlooking a deep valley, date to the early fourteenth century (see fig. 9). The carved figures in high relief depict the Three Purities and a variety of early Complete Realization adepts. Several heads of Taoist figures were acquired from this site by the Museum of East Asian Antiquities, Stockholm, in about 1930.[87]

Contrary to the conventional belief that Taoism declined during the Ming dynasty (1368–1644), recent studies have shown that in fact religious Taoism flourished in this period.[88] Although

Zhu Yuanzhang, the first Ming emperor (Taizu; r. 1368–98), has been described as "adamantly anticlerical,"[89] he was actually open-minded toward Buddhism and Taoism, and patronized leaders of both the Orthodox Unity (Zhengyi) and Complete Realization Taoist sects. Pierre-Henry de Bruyn has shown that many of Zhu Yuanzhang's children were in fact deeply involved with religious Taoism.[90]

At the same time that Zhu Yuanzhang was pragmatically attempting to minimize the influence of organized religion, he also actively patronized those elements in organized Taoism that he saw as orthodox. He commissioned, for example, a new official liturgy for Taoist rituals. Zhu mainly supported the Orthodox Unity sect, and also stressed the unity of the Three Teachings (Sanjiao). This concept, namely that Confucianism, Taoism, and Buddhism were different paths to the same goal, attained increasing popularity during the Song and Jin dynasties (see fig. 10), although its roots can be traced to the Six Dynasties period. After 1368 he established the Xuanjiao Yuan, which oversaw the administration of all Taoist affairs in China. This was replaced in 1371 by the Central Taoist Registry (Daolu si). In 1379 Zhu established the Temple of Divine Music (Shenyue Guan), which oversaw the creation of Taoist ritual music.

Similarly, the conventional wisdom is that the Yongle emperor (Zhu Di; r. 1403–24), the fourth son of Zhu Yuanzhang, embraced and supported Tibetan Buddhism. While it is true that he was closely involved with Tibetan and Mongolian lamas of the Kagyu and Sakya orders, on whom he conferred the title Dharma King (Fawang),[91] imperial patronage of religious Taoism proliferated during the Yongle reign. A key event here was the emperor's adoption of the Taoist god Zhenwu (Perfected Warrior) as his personal protector, with political legitimation an overriding concern. The Yongle emperor not only was famous as a warrior and military strategist, but also usurped the throne that rightfully belonged to his older brother. In 1421 Yongle moved the Ming capital from Nanjing to Beijing and rebuilt the Forbidden City. The northernmost building in the imperial palace in Beijing today is still the Hall of Imperial Peace (Qin'an Dian), the imperial temple devoted to Zhenwu.[92] Every subsequent Ming emperor announced his accession by paying homage to Zhenwu. Imperial patronage of the Zhenwu cult included the rebuilding of the god's temples on Mount Wudang (Wudang Shan) in Hubei province, and during the Ming dynasty this god supplanted the deified Laozi as the most important god in the Taoist pantheon. So huge was Zhenwu's cult in the Ming that one section of this exhibition is devoted to him.

Judith Berling has recently suggested that for most Chinese

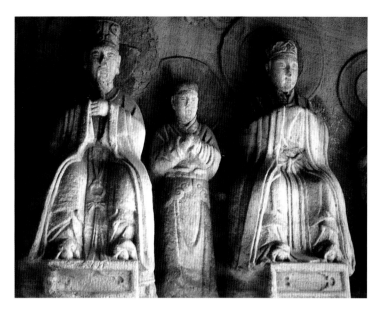

Fig. 9
Interior of a Taoist cave at Dragon Mountain (Long Shan), Shanxi province. Yuan dynasty, early 14th century.

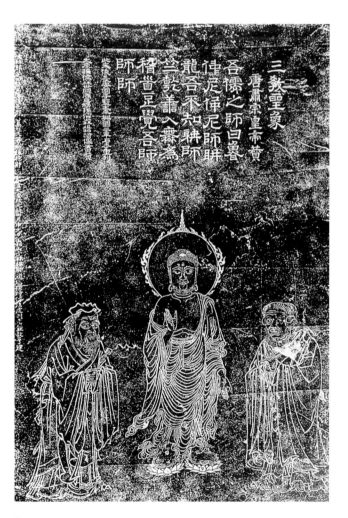

Fig. 10
Ink rubbing of a stele depicting the sages of the Three Teachings (Sanjiao). Jin dynasty, dated 1209. Limestone; 123 × 60 cm. Shaolin Temple, Mount Song, Henan province.

during the Ming, Taoist gods participated more directly than enlightened beings of the Buddhist pantheon in the system of moral retribution, which "encompassed the seamless fabric of the divine and human realms."[93] Despite the machinations of *karma,* the Taoist order of moral retribution and reward worked more quickly, and was seen as being much closer to the principles of justice administered by the imperial government throughout society. From this point of view, Taoism was seen as ultimately supporting Confucian values. This view was articulated by Zhu Yuanzhang, the first Ming emperor. As Berling shows, in his essay on the "Three Teachings" (Taoism, Buddhism, and Confucianism), Zhu Yuanzhang

> argued that those who criticized Buddhism and Taoism on the grounds that they harmed the nation and incited the masses were mistaken. Confucianism, he said, was the Way (Tao) of manifest virtue, while Taoism and Buddhism were the Ways of hidden virtue, secret aids of the imperial mandate to rule.[94]

In fact, it was Zhu Yuanzhang who invited the forty-third Celestial Master, Zhang Yuchu (1361–1410), to the court and paid for the rebuilding of Zhang's residence on Longhu Shan (Dragon and Tiger Mountain) in Jiangxi, the headquarters of the Orthodox Unity sect. In 1391 the Taoist prelate was given authority to authenticate talismans *(fu)* throughout China. In 1406 the Yongle emperor ordered Zhang to compile a new edition of the Taoist Canon. This was not completed until 1444, during the Zhengtong reign, and is a masterpiece of Ming woodblock printing (several volumes, from the Pelliot Collection in the Bibliothèque Nationale, Paris, are included in this exhibition; see cat. nos. 52, 54, 58, 110, 112, 115, and 129). Zhang Yuchu's own writings, such as the *Ten Standards for Taoists (Daomen shigui),* stress the compatibility of Taoism and Confucianism. He further emphasized the proper moral conduct of Taoist priests, and wrote that such individuals would be effective models for the lay public, and "would also devote themselves to prayers and rituals on behalf of the state and community."[95] In his view, it was thus entirely fitting that the imperial government should "support the activities of orthodox Taoist temples." Under the aegis of the Yongle emperor, Zhang Yuchu established the Taoist Affairs Academy in Beijing, and supervised the Central Taoist Registry (Daolu si).

This evidence suggests that a pattern of imperial patronage of the Celestial Master lineage of Taoism at Longhu Shan was established at the beginning of the Ming dynasty. The historical record of imperial Ming patronage of Taoism indicates that instead of being perceived as heterodox, religious Taoism was perceived in the eyes of the emperors as representing the highest degree of orthodoxy, ideally suited to aiding the ruler and the court in administering the state. This is important because it provides a counterpoint to the well-known imperial Ming patronage of Tibetan Buddhism, which was also politically useful for imperial propaganda.[96] Already in the early Ming, such Taoists as Zhang Sanfeng (to whom the discipline known as Taijiquan is credited) were called to court because their moral virtue reflected on the emperor. As Berling has shown, "The pattern of Ming imperial patronage of Taoist temples and rituals was repeated in virtually every reign."[97] This reached an apogee during the Jiajing reign (1522–66), when Taoism was elevated to a state orthodoxy.[98]

A greater number of works of Taoist art in this exhibition date to the Ming dynasty than to any other period, reflecting the widespread devotion to religious Taoism in this period. The court painter Wu Wei (1459–1508) is known to have believed in religious Taoism. Stories about his encounters with adepts and immortals were popular well into the seventeenth century, long after his death.[99] Among his surviving Taoist paintings are *Guangchengzi and the Yellow Emperor* (cat. no. 36), *Female Goddess or Immortal* (cat. no. 94), *The Hermit Xu You and the Oxherd Chao Fu* (an illustration of a story from the *Zhuangzi*) in the Tokugawa Museum, Nagoya, and *The Sage of the Northern Sea* in the National Palace Museum, Taipei.[100] The professional painters of the Zhe School created large numbers of such works in the fifteenth and sixteenth centuries, encouraged by both imperial patronage and public demand. Several very rare examples of Taoist ritual paintings also survive from this period, including the handscroll created for the ordination of Empress Zhang as a Taoist priestess in 1493 (cat. no. 57) and a local god's petition to the Jade Emperor for an official title (cat. no. 82).

A very important resource for our understanding of the ways in which both Taoist and popular gods were visualized during the Ming dynasty are the sets of paintings created for a Buddhist ritual known as the Water and Land Ritual *(Shuilu zhai).* Several impressive sets, or partial sets, of Water and Land Ritual paintings survive from the Ming, among them sets in the Shanxi Provincial Museum, Taiyuan, and the Musée Guimet, Paris.[101] Despite the Buddhist context in which these works were originally created, they often contain the earliest or finest depictions of Taoist gods known. For this reason, several such works are included in this exhibition (see cat. nos. 75, 76, 78–81, 84–86, 91, 97, and 107).

The Ming witnessed the continuing absorption into the Taoist pantheon of gods from Chinese popular religion, a phenomenon

that had already proliferated during the Song dynasty. A new and influential group of gods that emerged during the transition from the Yuan to the Ming were the Three Stars, known in Chinese as Fulushou; these three gods are still widely worshipped today. As a discrete group, the Three Stars—comprising the gods of Good Fortune (Fuxing), Emolument (Luxing), and Longevity (Shouxing, also known as Shoulao)—seem to have first appeared in Chinese culture and art in the early fifteenth century.[102] In addition to their appearance in a Ming painting of 1454 in the exhibition (cat. no. 91), this group appears in another early Ming painting in the Nelson-Atkins Museum of Art, Kansas City (fig. 11). Here the Three Stars are shown with a larger group of celestial deities, including the Nine Luminaries or Sources of Brightness (*jiuyao;* upper right),[103] the Twenty-Eight Lunar Mansions (*Ershiba xiu;* lower left), and the twelve gods of the Chinese zodiac (*shi'er gong;* lower right). The scroll provides one of the few known depictions in Chinese painting of the Three Stars in conjunction with these other stellar gods. Interestingly, the gods of the zodiac are based on the figures of the Near Eastern zodiac, and not on the members of the Chinese zodiac. Edward Schafer has suggested that the Chinese were aware of the Western zodiac by the sixth century, and F. Richard Stephenson has shown that the symbols of the Western zodiac were first introduced into China in the Sui dynasty (581–618), probably via India.[104] Evidence for this is found in a text in the Buddhist canon, the *Scripture of the Great Assembly of Great Doctrinal Universality (Da fangdeng daji jing),* which was translated from Sanskrit into Chinese during the Sui. The forty-second chapter of this text lists the signs of the zodiac that correspond to each of the twelve lunar months: 1, Ram; 2, Bull; 3, Pair of Birds; 4, Crab; 5, Lion; 6, Celestial Woman; 7, Steelyard; 8, Scorpion; 9, Archer; 10, Makara (a mythical sea monster); 11, Water Vessel; 12, Celestial Fish.[105] With the exception of the sixth, seventh, and tenth months, these correspond closely to the signs of the Western zodiac.[106]

Taoist sculpture from the Ming dynasty also survives in relatively large numbers. These include works still found in Taoist temples in China, for example, the White Cloud Monastery, Temple of the Eastern Peak, and Hall of Imperial Peace in Beijing, and others in Kaifeng, Changsha, and many other cities and towns. The majority of such sculptures are made of bronze, wood, ivory, or porcelain. Many Taoist sculptures survive in Western museums as well, where they are often unrecognized as being Taoist, and thus relegated to basement storerooms. As our knowledge of the history of religious Taoism develops and becomes more sophisticated, increasing numbers of such treasures will undoubtedly be excavated from the artistic limbo in

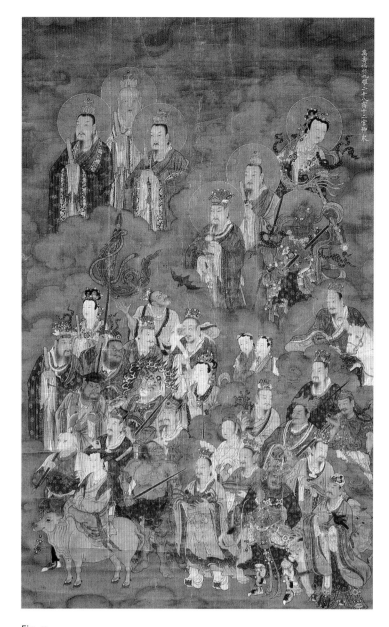

Fig. 11
The Three Stars, Nine Sources of Brightness, Twenty-eight Lunar Mansions, and Twelve Palaces [of the Zodiac]. Ming dynasty, 15th century. Hanging scroll; ink, colors, and gold on silk; 137.2 × 86.7 cm. The Nelson-Atkins Museum of Art, Kansas City, Missouri, Bequest of Laurence Sickman (F88-41/6).

which they now reside. A significant number of works made expressly for use in Taoist ritual also survive from the Ming, some of them works of great beauty. Those included in this exhibition include swords, ivory tablets, and priests' robes.

Taoism continued to flourish during the Qing dynasty (1644–1911), during which the emperors who ruled China were Manchu. While the Manchus openly favored Tibetan Buddhism over Taoism, Taoist ritual continued both inside and outside the court.[107] This is clear from such artistic evidence as the large painting by Jiao Bingzhen in the Arthur M. Sackler Gallery, Washington, D.C., depicting a ritual carried out in the court (cat. no. 44) and the Hall of Imperial Peace, the principal Taoist temple in the Forbidden City, most of the contents of which date to the Qing dynasty (and which demonstrate continuous use by the imperial family during the Qing).

Despite persecution in the twentieth century, particularly between 1949 and 1976, Taoism is rebounding with astonishing speed in contemporary China. The vitality of the artistic traditions associated with Taoism are revealed not only in the reconstructions of temples and Taoist sites, but in the recent attempts to collect and protect historical works of Taoist art, in such temples as the White Cloud Monastery and the Temple of the Eastern Peak in Beijing. Devotion to religious Taoism, widespread throughout most of the late twentieth century in Taiwan, Hong Kong, and many overseas Chinese communities, is enjoying a renaissance in China today. It is hoped that this exhibition will succeed in opening a door onto an ancient and vital tradition in Chinese art history that has all too long remained hidden.

Notes

1. Loewe 1982: 27–28.
2. Stanza 42. See HY 664.
3. One of the most important physiognomic classics, for example, is entitled *Complete Compilation of Divine Correspondences (Shenxiang quanbian)*, compiled in the fourteenth century. Large portions of this book are translated and discussed in Lessa 1968. See Kohn 1986, and Smith 1991: 187–95.
4. Roth 1996: 128.
5. From the Han dynasty onward, the *Laozi* was known as the *Daode jing*.
6. See Jingmen City Museum 1997. The Guodian *Laozi* manuscripts have recently been published in *Guodian Chu mu zhu jian* 1998: 3–10, 111–22. For a translation of the *Daode jing*, see Waley 1958. See also Allen and Williams 2000.
7. The Mawangdui *Laozi* manuscripts, which date to the Western Han dynasty, are published in Chen 1996.
8. The image of the "Uncarved Block" of wood *(pu)* occurs several times in the *Daode jing*, and symbolizes the primal unity of the Tao.
9. Translation adapted from Waley 1958: 183.
10. Translated in Waley 1958: 143.
11. Another six sections are fragmentary, making a total of thirty sections. It is clear from their calligraphy that the texts of Guodian *Laozi* bundles A and B were written by the same hand, but that the text of bundle C was written by a different hand.
12. See Seidel 1969a and Kohn 1998a.
13. Seidel 1987b: 39.
14. On Han dynasty talismans of the first and second centuries, see Wang Yucheng 1993 and 1998.
15. Hahn 1988.
16. Allen 1991: 99.
17. Verellen 1995.
18. Schipper 1993: 91.
19. See Ōfuchi 1979.
20. See Zürcher 1980 and Bokenkamp 1983.
21. Bokenkamp 1996a: 269.
22. Ware 1933: 248, and Bokenkamp 1996–97: 64. On Kou Qianzhi, see Mather 1979.
23. Previously published in Sirén 1925, vol. 2: pls. 130A–B; the rubbing is published in Walravens 1981: no. 356.
24. Kohn 1998a: 39.
25. The spirits of the four cardinal directions; see cat. no. 9.
26. The cinnabar field *(dantian)* is the point in the human body where the elixir is created in the Inner Alchemy *(neidan)* tradition.
27. On the god Taiyi (Supreme Unity), see cat. no. 75.
28. Kohn 1998a: 40, citing Seidel 1969a: 123. The text of the *Laozi ming* is translated into French in Seidel 1969a: 122–28; for the original Chinese text, see 129–30.
29. The Xiang'er Commentary is translated in Bokenkamp 1997: 78–148. The text is traditionally attributed to Zhang Lu (third century), the grandson of Zhang Daoling. Modern scholars are divided on whether the text dates to the third or fifth century (see cat. no. 34).
30. See Lagerwey 1981.
31. Bush and Shih 1985: 10–15, 53–54.
32. I am grateful to Richard Pegg for pointing out this correspondence. See also Hay 1983.
33. Cahill 1961b: 380.
34. Bush and Shih 1985: 34–35.
35. See Chaves 1977. For an excellent study on the relationship between Taoism and calligraphy, see Ledderose 1984.
36. Strickmann 1978: 334.
37. Robinet 1993: 21.
38. See cat. nos. 53, 55, and 56.
39. See cat. no. 128. Rolf A. Stein has pointed out that cinnabar tablets have been excavated from the fourth-century tomb of a woman who was a member of Wang Xizhi's family; see Stein 1979: 55, citing Nanjing shi wenwu baoguan weiyuanhui 1965.
40. See Wong 1982: 72–73. For the *Jinshu*, see JS.
41. Seidel 1983.

42. See Mather 1979: 107.

43. Adapted from Xiong 1996: 316. For the *Jiu Tangshu,* see JTS.

44. See Barrett 1996.

45. Liu Yang 1997a: fig. 9.

46. Benn 1991.

47. A representative group of these is published in Sirén 1925.

48. Ōfuchi 1978–79.

49. Schafer 1978–79. For a discussion of cosmological images current in religious Taoism of the Tang dynasty, see Xiong 1996.

50. Previously published in *Glory of the Court* 1998: 158. The tablet is of particular interest to students of Chinese calligraphy. Empress Wu, like some other dynastic founders, introduced several new versions of characters into the Chinese writing system; these innovations were abandoned after she was deposed. Five examples of such characters can be found in this inscription, and one of them, the name of the empress, is known only from this tablet.

51. This ritual is found in HY 1304, a Highest Purity scripture that has not been precisely dated but is from the Six Dynasties period. It can also be found in the *Wushang biyao* (Supreme secret essentials; HY 1130), *juan* 41, which places the terminus for its development sometime in the early sixth century. A similar ritual, which used golden dragons as "couriers," was also developed in the Lingbao corpus; for example, see HY 352.

52. On Zhenzong's patronage of religious Taoism, see S. Cahill 1980: 23–44.

53. On Huizong's patronage of Taoism, see Strickmann 1978: 335–51. See also the essay by Patricia Ebrey in this volume.

54. See Sturman 1990.

55. *Kaihua si Songdao bihua* 1983, *Yan Shan si Jindai bihua* 1983, Jin 1997.

56. Martin 1913.

57. *Pingyang Jinmu zhuandiao* 1999: 308–19.

58. Jin 1997: pl. 236.

59. Baldrian-Hussein 1986.

60. Partially published in Lawton 1973: no. 34.

61. An exception was Emperor Huizong (r. 1100–25), who initiated a campaign to shut down all the Buddhist temples in the imperial capital, Kaifeng.

62. Sun 1981: 229.

63. On Bai Yuchan, see Berling 1993.

64. Schipper 1985: 831. See also Stein 1979. As Stein points out, citing the fifth-century Taoist text *Santian neijie jing* (HY 1196), even in the Six Dynasties period, exceptions were made by Taoists for worship of the god of the soil and the kitchen god (Stein 1979: 68).

65. Hansen 1990: 23–24, 80–104.

66. Duara 1988.

67. For a concise discussion of some of the issues surrounding the study of Chinese popular religion, see Teiser 1996: 21–25.

68. On Complete Realization Taoism, see Yao 1980 and Yao 1995: 151–58.

69. See Jin 1997: pls. 250–70.

70. For a description of daily life in the White Cloud Monastery in the mid-twentieth century (prior to the Communist takeover of China), see Yoshioka 1979: 229–52.

71. See Waley 1931.

72. Lauer 1999.

73. For example, the handscroll in the Tokyo National Museum entitled *Record of the Restoration of the Three Gates of the Xuanmiao Guan* was designed for a stele; see *Shodō zenshu* 1970–73, vol. 7, pls. 1–5.

74. Ledderose 1979: 42.

75. Schafer 1978b. Another famous Taoist of the Tang dynasty was Du Guangting; see Verellen 1989.

76. Baldrian-Hussein 1996–97: 24–25. Su Shi also transcribed the Inner Alchemical text known as the *Huangting neijing jing* for the Taoist Jian Gongchen; ibid.: 26 n. 43.

77. Ibid.: 31 ff.

78. YJZ. On this text, see Hansen 1990: 17–21.

79. *Yuan sijia huaji* 1994: pl. 7, and *Zhongguo gudai shuhua tumu* 1986–98, vol. 2: 91, no. 1-0181.

80. Wang Meng's handscroll entitled *Cinnabar Mountains, Ying[zhou] Sea* is published in *Yuan sijia huaji* 1994: 109.

81. For a painting of dragons by Zhang Yucai, see Fong 1992: pl. 81a.

82. Katz 1993: 47.

83. Ibid.: 49. For *Shangqing lingbao dafa,* see HY 1213.

84. On Gouchen, see Needham and Wang 1959: 261.

85. These identifications follow those of Jin 1997.

86. Published in White 1940: pls. 47–76.

87. The layout of the site is succinctly described in Wang 1994: 112–14. For the heads acquired by the Museum of East Asian Antiquities in Stockholm, see Sirén 1931: pl. 33.

88. See Berling 1998.

89. Berger 1994: 107.

90. On the Taoist beliefs and activities of the imperial princes Zhu Tan, Zhu Quan, and Zhu Bo (all sons of Zhu Yuanzhang), see Bruyn (forthcoming).

91. See the portrait of the fifth Karmapa, the Mongolian lama Dezhin Shegpa (Helima; 1384–1415), with the Yongle emperor seated in a subservient position next to him, in *Tibetan Sacred Art* 1993: pl. T-9; also published in Berger 1994: 107–10, fig. 31.

92. The current temple dates to the Jiajing reign (1522–66) in the middle Ming.

93. Berling 1998: 975.

94. Ibid.: 985.

95. Ibid.: 956.

96. See Berger 1994.

97. Berling 1998: 966.

98. Chan 1982: 110–12.

99. JLSS: 31a–b.

100. Published in *Changsheng de shijie* 1996, pl. 31.

101. See *Baoning si Mingdai shuilu hua* 1988.

102. Fong 1983: 186–87.

103. On the Nine Luminaries (*Jiu yao*), see *Zhongwen da cidian* 1973, vol. 1: 523, entry 173.684. The Nine Luminaries comprise the sun (*Taiyang,* or Supreme Yang), moon (*Taiyin,* or Supreme Yin), the five visible planets (Mercury [*Chenxing,* or Chronograph Star], Venus [*Taibo,* or Great White], Mars [*Yinghuo,* or Sparkling Deluder], Jupiter [*Suixing,* or Year Star], and Saturn [*Zhenxing,* or Quelling Star]), and the two imaginary (and invisible) planets *Rahu (Luohou)* and *Ketu (Jidu),* borrowed from Indian astronomy and believed to be the celestial bodies responsible for the appearance of eclipses and comets. For anthropomorphic depictions of *Luohou* and *Jidu* in Chinese painting, see *Baoning si Mingdai shuilu hua* 1988: 63.

104. Schafer 1978c: 10; Stephenson 1994: 533.

105. Stephenson 1994: 533.

106. The earliest known Chinese depictions of the Western symbols of the zodiac come from the Tang dynasty (618–906) and were discovered in 1975 in a tomb in Turfan; see ibid.: 539, fig. 13.13. In the Nelson-Atkins Museum scroll are the Western zodiac figures Pisces (a man holding a tray with two fish), Scorpio (a man holding a scorpion), Cancer (a man holding a crab), and Taurus (a man with his hand on a bull).

107. Rawski 1998: 271.

Kristofer Schipper

I. The Taoist Tradition in Ancient China

Taoism is the foremost indigenous religion of China and one of the world's oldest mystical and liturgical traditions. The name Taoism comes from Tao (Dao), a word that means "road" or "way": a way to follow, a way of thought, a method, and a principle.[1] The Tao is seen as the everlasting principle at the origin of the universe. It permeates and transcends all beings; it is at the origin of all transformations. According to Chinese tradition, the Tao existed before the world was born out of the primordial chaos (hundun). The Tao brought forth the world, and all beings naturally belong to the Tao. Therefore, at its most fundamental level, the name Taoism does not refer to a god or a founding figure, but to a universal principle. Nonetheless, the story of Taoism is inextricably linked to the figure called Laozi (Lao-Tzu), the sage who first revealed the Way to us.

Laozi

There have been many discussions about when and where Laozi lived, and even whether he was a historical figure at all. Although what has been transmitted through the ages about Laozi is of a purely legendary nature, these legends are not without historical interest. In fact, they are often more significant than "historical facts," because they show how Taoism and Laozi were already thought of in ancient times. Seen in this way, the traditions that surround him are very significant.

Laozi is said to have been seen in this world at a time corresponding to the sixth century B.C., and the traditional dates given for his life are 604–531 B.C.[2] Laozi is reputed to have hailed from the southern state of Chu (for China was not yet unified into a single empire at this time), and to have been born in Hu, near present-day Luyi, in Anhui province. A later legend of his birth

tells us that Laozi's mother was a virgin who conceived him spontaneously, through the radiance of the Pole Star in the center of the sky. She carried her child in her womb for eighty-one years (a cosmic period of nine times nine) before he was born through her left armpit while she was leaning against a plum tree. At birth, the baby was of course already old, hence the name of "Old Child," which is another way of interpreting his name, in addition to "Master Lao" or "Old Master."[3] After giving birth, Laozi's mother died. In fact this was a phenomenon of transsubstantiation, because mother and child were one and the same person. Alone in the world, the Old Child chose the plum tree, which had lent support to his mother, as his ancestor, and took its name (Li) as his family name.[4]

Laozi is said to have been at one time the scholar in charge of the calendar and archives at the court of the Zhou dynasty (1050–256 B.C.).[5] In that capacity, he received a visit from Kongzi (whom we know by the name Confucius, and whose traditional dates are 551–479 B.C.). Confucius wanted to see the Old Master in order to question him about ritual, because Confucius believed that ritual decorum was the key to good governance. He thought that as long as everyone kept to his status and rank in society and acted according to the established custom, all would be in order. The story of the meeting has many versions,[6] but the main idea is always the same: Laozi did not agree with Confucius's ideas, and told his noble visitor that naturalness, personal freedom, and happiness were more important than trying to conform to traditional standards.

After having lived in this world for a long time, the Old Master decided to leave and retire in the far-off mountains of the western regions. When he crossed, with his ox and his servant boy,[7] the mountain pass that marked the end of the world of men, he was halted by the guardian, who asked him for his teachings.

Laozi then dictated to him the small book, consisting of some five thousand Chinese characters, that we call the *Classic of the Way [Tao] and Its Power (Daode jing)*.

The Background

Through these narratives, we may see that Laozi's lifetime was set at a moment of profound change in China. During the sixth century B.C., the former feudal order of the Zhou dynasty was gradually giving way to a new age of social and human development. Early China, like many other cultures of the Bronze Age, was immersed in ancestor worship and bloody sacrifice, and the memory of that archaic culture survives today in the ritual bronze vessels now on display in many museums which used to adorn the sacrificial altars. Theirs was an aristocratic warrior society, centered around the king and the nobility, their clans, and their ancestors.

The end of this feudal world order was marked by several important innovations. Among these, the development of high-grade iron ore metallurgy during the seventh century B.C. signaled the end of the Bronze Age. Iron tools and other manufactured goods provided trade and economic expansion. Later in antiquity, China also exported silks and lacquerwares as far as the Near East and Rome.

This economic development created a new society of merchants and artisans, which took hold of the city-states, until then dominated by the aristocrats.[8] This in turn caused important institutional changes. The first laws and taxes appeared in China during the second half of the sixth century B.C., to some extent limiting the privileges of the nobility. Most of the great Chinese cities of those times were concentrated in the Central Plain, especially at the crossroads of what are today the provinces of Henan, Shandong, and Anhui, where the ancient states of Song, Wei, Qi, and Chu were situated. It was in this region that Laozi was born.

There were also those who regretted that the ancient religious and social order installed by the kings of the Zhou dynasty was gradually disappearing. One of these conservatives was Confucius. In his efforts to maintain the ritual tradition, he is said to have put down the ritual texts in writing. These became the so-called Chinese Classics.[9] We do not know to what extent these Classics are truly representative of the religion of the aristocracy, but what is certain is that the religion of the common people, with its worship of holy mountains and streams, as well as the great female deities, was systematically left out.

Laozi, on the other hand, is portrayed as a commoner. The legend of his responsibility for the calendar and archives is

intriguing, because such specialists contributed to the worldview in which mutually opposed and complementary forces, *yin* and *yang*, evolve, from the primordial chaos, into the phenomenal world of Heaven and Earth, the "ten-thousand beings." Each of these beings, each part of the creation, is shaped and nurtured by the cosmic energies *(qi)* of Heaven and Earth in endless numbers and continuous transformation. According to this cosmology—fully articulated in the early Han dynasty (second century B.C.)—all beings are related to each other through elaborate systems of correspondence. The creative (and destructive) processes are thus considered to be natural, and not linked to any divine will or destiny. This was a universe that was created and evolved spontaneously through the interplay of cosmic forces according to the universal principle of the Tao.

On the basis of this worldview, the diviners created a system of prognostication, based on a mathematical game (counting numbers of divining sticks), in order to arrive at sixty-four different symbolic combinations noted down as "hexagrams" *(gua)*. This system is documented and elaborated in the classic *Book of Changes (Yi jing)*.[10] The hexagrams ideally represented all the possible, and forever changing, combinations of *yin* and *yang* forces in the universe. Even in later times, when, as we shall see, it developed a pantheon of many transcendent immortals and deities, Taoism always remained a religion without a supreme being. Neither a polytheism nor a monotheism, Taoism lifts us up to a level above particular gods and ancestors, to a heaven above heaven, to the one universal principle that allows the world to find unity in its endless diversity.

It has been observed by several scholars that these developments are in some respects comparable to those of the ancient Mediterranean world. There too the ancient feudal order and the sacrificial religion gradually made place for a new society and culture in the city-states. In ancient Greece, beside the ancient "public cult" there emerged "mystery religions," which were expressions of the search for transcendence and immortality. These movements did not follow traditional class rules, and often recruited members from different levels of society. The mystery religions in turn were the fertile ground on which philosophy developed.

In China as well, a similar, newly emerging conscience marked the divide between the archaic warrior society and the new city civilization, and stood in the very center of the traditional distinction between Laozi and Confucius. Confucius is traditionally seen to have defended the ancient ritual codes by giving them a moral meaning. In reply, the Old Master asked him: But what good does that do to you personally? It is this

awakening of the individual awareness that marked a major turning point in Chinese culture. From it came the questions about individual destiny, the purpose of life, and death and immortality. On the ruins of the old order, a new search emerged that created a religion in which personal transformation occupied a place of increasing prominence, based on the Way of the Old Master.

The Tao of the Old Master

The fourth century B.C. was the golden age in China for the development of the different schools of philosophy. The recent find of fragments of the book of Laozi, the *Daode jing*, in a manuscript preserved in a tomb dating from around 300 B.C., proves that this most fundamental text was already extant in written form when the Inner Chapters of the *Zhuangzi* were composed (see below), and that the worldview it represents had already reached a certain degree of maturity (see Little essay, fig. 2). The study of these fragments in comparison with the now current edition of *Daode jing* shows that the work was written over a long period of time, with some parts being perhaps as old as the fifth century B.C.

The *Daode jing* is a collection of short paradoxical axioms, compiled without any particular order, and following no systematically developed argument. It does, however, display such profundity of insight into the human condition that it has been justly considered by later Taoism as its foremost scripture. It argues that we, as human beings but part of nature, cannot fathom the Way, but can only contemplate its manifestations. Any name we give to it cannot encompass it, because the Tao is beyond any conceivable concept. Only those who know that they do not know can, by uniting with nature and rediscovering spontaneity, through nonaction *(wuwei)*, intuitively grasp the underlying truth of all that is. In grasping and holding on to this truth, they become one with it and thus "obtain the Tao."

The *Daode jing* elevates to the very acme of Taoism the paradox of knowing through not knowing, of acting through not acting, of obtaining though relinquishing. The *Daode jing* is paradoxical because it wants to liberate us from the tyranny of words and names and definitions. It stresses that there is a limit to human life and to our knowledge, and at the same time it shows that, as part of an endless universe, human life and consciousness are limitless. Knowing that we are mortal, we can be immortal in our union with the Way.

The Old Master teaches that the cosmic process of creation out of the primordial chaos is something that each human being has individually experienced through his earlier life in the womb

and his later existence in the fragmented and divided world. Later philosophers would call these two universes the Former Heaven *(Xiantian)* and the Later Heaven *(Houtian)*. Right between these two universes stands the newborn child, who is therefore considered as the embodiment of the Tao at the height of its power (see *Daode jing,* chapter 55). Thus, the whole cosmic process, from the primordial chaos to creation, and the whole universe of heaven and earth are within ourselves, in our very own persons. Finding this underlying truth through nonaction opens the gate to immortality, often discussed in later Taoism in connection with the sixth chapter of the *Daode jing*, which reads:

> The goddess of the valley never dies.
> She is called the mysterious female.
> The gate of the mysterious female,
> Is called the root of heaven and earth.

How this search for the underlying truth *(zhen)* took shape in ancient China can be understood from another work, the *Zhuangzi,* the next great text of ancient Taoism. This book—or, more exactly, this collection of texts—is placed under the name of its supposed author, Master Zhuang. Zhuangzi's personal name was Zhou ("The Complete One"?), and he must have lived sometime between 370 and 280 B.C. He worked as a cleric in a lacquer garden in the land of Song, at a time when these workshops were not yet state agencies. We may note in passing that the earliest instances of artistic Chinese painting are found on lacquer. Zhuangzi certainly knew some of the sayings of the Old Master, because he quotes them. There is, moreover, a certain underlying unity of thought at the basis of the two books. In form and style, however, the two are very different. The *Daode jing* is a small book, whereas the writings placed under the aegis of Master Zhuang are far more elaborate: they consist of a succession of longer and shorter treatises, stories, anecdotes, and even poetry. The *Zhuangzi* is full of strange, amusing, and even humorous passages.

Only the first seven books, the so-called Inner Chapters, of the *Zhuangzi* date from the fourth century B.C. (around 330?), whereas the other twenty-six chapters that make up the Outer and Miscellaneous Chapters were written by the followers of Zhuangzi during the third century B.C. Besides being one of the most wonderful books ever written, the *Zhuangzi* is also a work of great philosophical depth. Zhuangzi brings the critique of knowledge—the dialectics of knowing and not-knowing—to great heights. For him, each person is a world in himself, and all kinds of people who obtain the Tao in their own way—men, women, and children; tradesmen and artisans; kings, nobility,

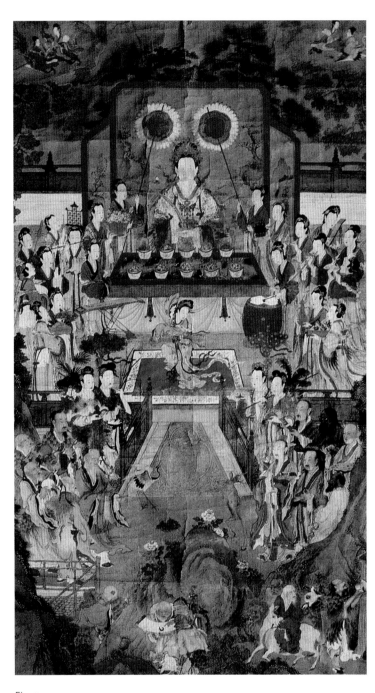

Fig. 1
The Queen Mother of the West (Xiwangmu) and Her Court.
Qing dynasty, 17th century. Hanging scroll; ink and colors
on silk. From *Daojiao shenxian huaji* 1995: 13.

and slaves; criminals and madmen—are described in his book. Zhuangzi does not necessarily recommend that people retire from the world and live in the wilderness, but he proposes that communion with nature can be obtained here and now, in whatever place one happens to be. Such a "wandering on the Way" can be achieved through the opening of the mind and trance meditation, as well as through other ways of discipline in daily life.[11] Those who achieve it are called "true persons" *(zhenren).*

Indeed, Zhuangzi taught that all arts, when brought to perfection, lead to the Tao. Some stories, such as that of Ding the Butcher, who got the Tao by the sheer perfection of his craft, and that of Chi the Robber, who surpassed Confucius in preaching morality, became very famous in later China. While these extraordinary figures may have been born out of Zhuangzi's fertile imagination, many of them were worshipped as holy immortals and saints by those "who loved the Tao."

Immortals

Among the saints and immortals in the *Zhuangzi,* perhaps the most important is Huangdi, the Yellow Emperor, who in ancient China was considered to be a culture hero and the inventor of human civilization. Later, as we shall see, Huangdi is often named along with the Old Master as one of the founders of the Way. Also mentioned by Zhuangzi is Pengzu, who is said to have lived eight hundred years and as such was venerated by those who practiced the arts of long life. Of all the figures presented in Zhuangzi's book, Xiwangmu, the Queen Mother of the West, would rise to greatest prominence in later times. She, as the "Mysterious Mother," would play an immensely important role as the queen of Mount Kunlun, the sacred mountain of immortality (fig. 1).[12] In the book of *Zhuangzi,* these ancient deities are presented as having "obtained the Tao," and they were thus integrated in the new pantheon of immortals *(xian).* The Chinese character for *xian* can be interpreted as "mountain person" (or, with another character, as "dancing person"), and the worship of the immortals centered around mountains where they were believed to dwell. Zhuangzi is the first to tell us about these mountains and about the divine beings who live there.

> In the far-away mountains of Gushe live divine humans. Their skin is cool as frost and snow; they are shy and delicate as virgins. They do not eat grains, but breathe wind and drink dew. They mount on clouds and ride winged dragons to wander beyond the four oceans. By the concentration of their spirit, they can protect people from the plague and make crops ripen.[13]

Han dynasty art forms already show these holy mountains and the immortal beings that inhabit them. Mountain-shaped incense burners, also called "hill-censers" *(boshanlu)*,[14] may very well have been used in the oratories *(jing)* of the adepts and may have served as visual supports for their "far-away wanderings" during meditation, their spiritual journeys to the mountain realm of the immortals. These nature beings, together with wild animals of all kinds, were often depicted on the sides of hill-censers. The fumes of the aromatic herbs that were burned inside the censer were released through the holes in the mountain, as if they were clouds that, according to Chinese imagination, were born from the mountain caves.

Such meditations on sacred mountains were matched by similar visions of an inner landscape. By "reversing the light" *(fanguang)* of the eyes, for example, the adept achieved an introspection of his own body, which was imagined as a mountain inhabited by many deities. The most important of these divine beings inside oneself was the Infant, the embryo of immortality, also called the true person *(zhenren)* of the adept. By nurturing the true person inside himself, the adept cultivated his own immortality. One day, the old child inside him would liberate itself from its mortal coil and join the other immortals in their eternal freedom and happiness.

Apart from the meditation on the outer and inner landscape, the quest for longevity also comprised many physical exercises. Adepts practiced animal dances *(wuqinxi)* as well as different forms of gymnastics.[15] Together with the dance movements, there were all kinds of breathing exercises, massages, herbal drugs, and even sexual practices that stimulated and enhanced the flow of energies in the body and their gradual sublimation.

Initiation

The Tao is universal, and the teachings of the Old Master are ideally meant for all, regardless of their origin, gender, status, or wealth. Yet ancient Taoism was definitely esoteric, and it would be an error to think that the Way was considered to be easy to learn and readily accessible to everyone. The *Daode jing* (chapter 70) says clearly:

> My words are very easy to understand and to put into practice, but in this world nobody is capable of understanding them and nobody does put them into practice. Words have their ancestry and deeds have their author, so those who do not understand [my words] do so because they do not know me. Those who know me are few indeed, and that is why I am so valuable. The sage wears a cloak [on the outside], but inside clasps [precious] jade to his bosom.

Laozi's paradox is that the Tao cannot be taught and transmitted by words. Only a personal, intuitive, and innate knowledge of oneself (I, me) can lead one to it. This form of higher knowledge, however, is accessible only to those apt to receive it. Again, the *Daode jing* (chapter 41) states forcefully:

> When superior persons learn of the Tao, they practice it with ardor.
> When mediocre persons learn of the Tao, it leaves them indifferent.
> When inferior persons learn of the Tao, they laugh loudly.
> If they did not laugh, it would not be worthy of being the Tao.

In other words, when some ignorant people laugh at the Tao, they thereby prove its very value; only superior people can understand it and put it into practice.

This idea is stated even more clearly in the story of the woman Yü that is told in one of the older parts of the *Zhuangzi*. Yü had "learned the Tao" and, though already very old, she still looked like a young girl. When a scholar asked her if he could also learn it, she replied, "No! How could this be! You are not the right person!" When the scholar then asked her how she had obtained her knowledge, she answered, "I learned it from the child of Calligraphy, who had it from the grandchild of Recitation; Recitation had learned it from Vision, and Vision from Secret Instructions, who in turn had received it from Hard Apprenticeship . . ." The text lists in all nine allegorical names that form a fictitious genealogy of the transmission of the Tao. This tale may be seen as fanciful, but it is in fact an echo of a real practice. Already in the fourth century B.C., written texts (hence the allusions to Calligraphy and Recitation) were transmitted from master to disciple, and at each investiture the lineage of the previous masters was an essential element of the transmission. This heritage of transmission would eventually result in the central role of initiation in the religion of Taoism, even until this very day.[16]

The Way of the Yellow Emperor and the Old Master (Huanglao Dao)

In the last two centuries B.C., the above-mentioned elements were gradually consolidated and united in a general framework known as the Way of the Yellow Emperor and the Old Master (Huanglao Dao), since the mythical Yellow Emperor was worshipped alongside Laozi as a patron of the arts of longevity. Recent archaeological finds have greatly advanced our understanding of the Huanglao Dao and its tenets. In 1973 a series of tombs was discovered at a site called Mawangdui, near Changsha in Hunan province. The tombs date from the very beginning of the Han dynasty (second century B.C.). The first

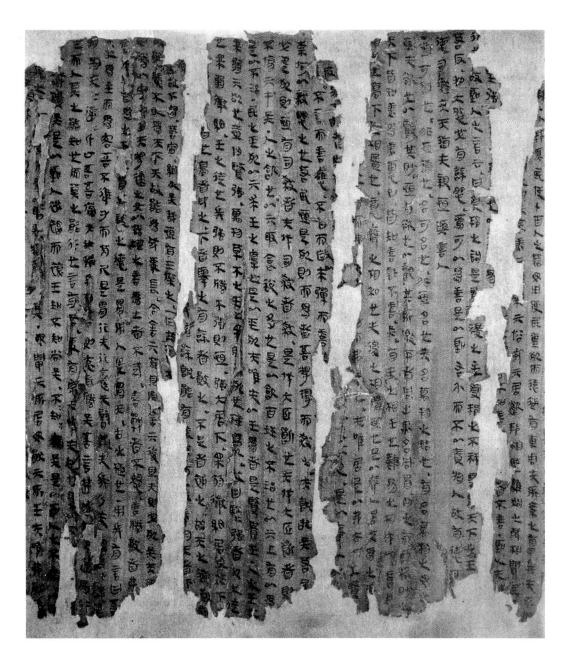

Fig. 2
Laozi manuscript, excavated from a
Western Han dynasty tomb at Mawangdui,
Changsha, Hunan province. 3rd century B.C.
Handscroll; ink on silk. Hunan Provincial
Museum, Changsha.

tomb contained the body of a woman preserved in perfect condition in a watertight wooden coffin filled with a liquid solution of cinnabar, which had preserved the tissues of her body from decay. Many small boxes containing mineral substances used in later alchemy were also found. In addition, the tomb yielded a silk shroud painted with a beautiful representation of the ascent toward immortality.

The third tomb discovered at Mawangdui, dated 168 B.C., contained a collection of eleven silk scrolls *(boshu)*, among which were two copies of Laozi's *Daode jing,* one from before the beginning of the Han dynasty (fig. 2), the other from the reign of its first emperor (who died in 195 B.C.). To each of these versions are appended other, shorter texts, which have been identified by some scholars as the remnants of a hitherto lost "Four Books of the Yellow Emperor."[17] The bulk of the writings relate, however, to tending life and the search for immortality, and concern gymnastics (there is, for example, a beautiful illustrated scroll depicting exercises), deep breathing, sexual practices, drugs, and alchemy. There were other scrolls containing Taoist talismans, though these have not been published.[18] The extraordinary finds at Mawangdui have given us a magnificent testimony of the personal search for the Tao and eternal life that was characteristic of the religious practices of ancient China.

Many pre-imperial philosophers were influenced by the Huanglao Dao, the teachings of which seem to have been dominant in the final decades of the Warring States period (475–221 B.C.). It was certainly prevalent in the most important center of learning of the times, the Qixia Academy of the Ji kingdom.

Our present version of the *Daode jing* is considered to have been edited there, probably around the beginning of the third century B.C. In this version we find traces of a more political thought alongside the many ancient mystical concepts. One of these ideas was that the perfect society was that of the simple rural village: self-sufficient and without many links to the outside world. It was this ideal of local autonomy and freedom from government interference that would be recalled time and again during the peasant movements of the Chinese Middle Ages.

The *Daode jing* in its final and current version advocates a government that rules unseen, through nonaction and natural law, but that aims at keeping the people contented by filling their bellies and emptying their minds (chapter 3). Such a political program seems to run counter to the ideas in the *Zhuangzi,* though it shares similarities with another influential school of thought, that of the so-called Legalists *(fajia)*. This school applied the idea of following nature to the political situation of their times, propagating the idea that people should be governed by steering their natural likes and dislikes to make them into obedient subjects. The Legalists elaborated a system of laws meting out punishments and granting rewards for every conceivable aspect of social and individual life. They are traditionally seen to have created a most efficient Tao of law, but a Tao that hindered personal exploration.

One of the most important thinkers of the Legalist school, Han Feizi, used the *Daode jing* as a guide for the politics of the unification of China, transforming the natural law of Laozi into a *political system*. He became the foremost counselor of the first emperor, Qin Shihuangdi (r. 221–206 B.C.). The result of all this was a very centralized bureaucratic state, governed by an all-compassing system of regulations and laws, which succeeded in creating a unified state, but one in which all forms of personal thought and practice, all independent philosophical schools, were forbidden. In keeping with the philosophy of "filling the bellies and emptying the minds," all books not related to medicine, astronomy, or agriculture were destroyed. At the same time, Emperor Qin Shihuangdi attempted to present himself as a divine immortal. The very title he gave himself bears witness to this: "huangdi" means, literally, "the Supreme Deity of the Pole Star." He also actively sought to enter into contact with the immortals of the sacred mountains. At one time, he sent boats with young boys and girls out on the eastern seas to search for the islands of the immortals. Thus, the religious beliefs of the common people were adopted for the emperor's own personal and political aims.

The Empire and the Confucian Orthodoxy

The experiments of the Emperor Qin Shihuangdi ultimately did not succeed, and after his death the dynasty established by him ended in turmoil and civil war. When the new dynasty of the Han (206 B.C.–A.D. 220) emerged from the feuding factions, it did not follow the previous policy, but signaled a return to a more open, less centralized government. Under the influence of the Huanglao Dao, the emperor shared his authority with many regional governors and local representatives. The different schools of thought that had been repressed during the reign of Qin Shihuangdi were revived. The thought of the Old Master was influential at the imperial court, especially during the reign of Wendi (r. 179–157 B.C.), and the inclination toward the Huanglao Dao was perpetuated by his widow, Empress Dou (d. 135 B.C.), who actively took part in the government.

This philosophical renaissance, to which the Mawangdui manuscripts bear witness, did not last. When Emperor Wu (r. 140–87 B.C.), the sixth sovereign of the Han dynasty, ascended to the throne, he, like Qin Shihuangdi, actively sought to centralize all power in his own hands and to reform the religious and political institutions accordingly. Instead of Legalism, however, he elevated Confucianism as the official ideology. Schooling in the Confucian Classics became mandatory for all officials. These measures meant the end of the many different currents and persuasions that existed until then. Other philosophical schools such as the Mohists, the Logicians, and the Cosmologists, to name but a few among the many, ceased to exist. Nonetheless, some of their books were at least partially preserved in the imperial library, and some of their principal tenets, such as the cosmology of *yin* and *yang*, were taken over by the Confucianism of the state.

The reactionary tendencies of Emperor Wu can be explained in part by his wish to combat the influence of his grandmother Empress Dou and other women in politics. He also persecuted his relative Liu An, the Prince of Huainan, for sedition and forced him to commit suicide. Liu An was a great scholar in the arts of the Tao, and his death spelled the end of the Taoist academy that he had established at his court in South China and where immortal works such as his edition of the *Zhuangzi* and the Summa of Taoist science now known as the *Master of Huainan (Huainanzi)* were edited. At the same time Emperor Wu, like Emperor Qin Shihuangdi, profiled himself as a Taoist adept by practicing alchemy, climbing the sacred Mount Tai, and presenting written petitions to Heaven.[19] This public display of religious piety was unconvincing to later generations, however, and in Taoist lore Emperor Wu has gone down as a hypocrite.[20]

More important here is the fact that, whereas all other schools disappeared or were absorbed by the new Confucianism, the teachings of the Old Master survived, although they were officially condemned. The name of Huanglao Dao was henceforward no longer used. Instead, a new name was given, that of *Daojiao*, the school (literally, the family) of the Dao. This name not only refers to the philosophy of Laozi and Zhuangzi, but to other religious practices, including the pursuit of long life and immortality, as well.

Since the reign of Emperor Wu, throughout Chinese history, and of course within ever-changing circumstances, the traditions of Confucius and Laozi would be seen as the two poles of Chinese civilization. Their interplay took many different forms, and it is perhaps not an exaggeration to say that henceforth Chinese culture was shaped to a large extent by their interaction.

2. THE TAOIST CHURCH IN MEDIEVAL CHINA

Messianism and Apocalypse

The first manifestation of Taoism after the institution of state Confucianism under Emperor Wu came from a popular uprising. In the year 3 B.C., the inhabitants of the peninsula of Shandong left their homesteads and went in large groups to the west, in search of the great mother goddess Xiwangmu, the Queen Mother of the West, who they believed would come and install her reign on earth in order to save it from the present disaster. Carrying insignia of the goddess, they built roads and established hostels so that people could travel toward the capital, where the goddess was expected to establish her diocese *(zhi)*.

The official history of the Han empire devotes but a few sentences to what must have been an important mass event. Some insights as to what kind of new era the believers expected to come can be gleaned, however, from the *Scripture of Great Peace* (or *Great Equality; Taiping jing*), which appeared miraculously, transmitted by an immortal, a few years before this messianic movement. It contained a description of a world where all would be equal, and recommended itself to the government. Other books with the title *Taiping jing* appeared later, one in A.D. 166; another, perhaps yet different, version was transmitted by the ecclesia of the Celestial Masters (see below). There is a work called *Taiping jing* in the Taoist Canon, which, although it certainly contains some ancient material, represents a still later and altered version.[21] There can be no doubt, however, that the ideal of "Great Peace" to be implemented by a just and peace-loving government under the guidance of a sage king, who would respect local customs and autonomy, was common to all these books, and that a similar hope drove the masses in search of the great mother goddess.

This movement was repressed, but during the troubled years that followed, the dynasty itself fell and was replaced by the reign of one Wang Mang (between A.D. 9 and 23), who also assumed the image of a redeemer who received his instructions directly from divine immortals. Among the measures he took towards more equality and justice, we may note the official abolition of slavery. Thus, when the Han dynasty and its Confucian orthodoxy was restored under Emperor Guangwu in A.D. 25, Taoism was by no means vanquished. This can be seen from a number of important texts that appeared in the later Han period, one of which is a collection of stories about immortals *(xian)*, called the *Liexian zhuan* (Biographies of the assorted immortals). These stories confirm that each *xian* had his or her own Tao. Some were shepherds, like Chisongzi, alias Huang Chuping, the young lad who drove his sheep into the mountains and never returned. He is still venerated as the Great Immortal Huang (Wong Tai Sin) at the most popular temple in Hong Kong. Another one was a prince named Wang Ziqiao. He was so good at imitating bird songs that one day a crane came down and took him away to the blessed islands of the immortals. The *Liexian zhuan* also contains evidence that the search for the Tao of immortality brought people together at the sacred places and created groups of adepts and worshippers under the guidance of masters.[22] It also talks of the many shrines that were erected in honor of the immortals, sometimes not only in one place, but in whole regions, and even nationwide. It shows that the worship of those who, by becoming one with nature, had "obtained the Tao" had become a very widespread practice and that festivals in their honor abounded.

New commentaries on the *Daode jing* also appeared. All of them stressed the fact that the political sayings of the Old Master about how to administer the nation should be understood metaphorically and applied, not to the outer, but to the inner country within the body of the practitioner. Other important Taoist works dealt with this vision of the human body as a country and explained how through meditation, one could visit this inner kingdom and establish good relationships with its inhabitants. The oldest known, and also the most famous of these books, is the *Scripture of the Yellow Court (Huangting jing)*, a rhymed description of one's own inner kingdom (see cat. no. 128).

For many, however, the peace and happiness of the inner realm did not suffice. The government and the ruling Confucian orthodoxy had politicized the choice between two kinds of society. Frustrated in its aspirations for freedom and equality, the

country seethed with messianic and apocalyptic expectations. Those who aspired to a better world rallied around leaders who claimed to be appointed by Laozi or by the Yellow Emperor. One of these mass movements rose in A.D. 184 against the dynasty in order to hasten the advent of the new era of Great Peace that had been promised by the *Taiping jing*. Known as the Revolt of the Yellow Turbans, it was defeated, but in the process the Han dynasty exhausted its resources and could no longer maintain its authority. The country's division into different kingdoms marked the beginning of what we call the Chinese Middle Ages.

The Ecclesia of the Celestial Masters

One of the Taoist movements that appeared during the last days of the Han survived the fall of the dynasty. Known as the Way of the Celestial Masters (Tianshi Dao), it became a regular institution and wielded great influence during the entire medieval period (which is considered by historians to have lasted until the tenth century). In the year 142 Laozi appeared to a Taoist hermit named Zhang Ling, or Zhang Daoling, on a holy mountain near Chengdu, the capital of Shu (northern Sichuan). Laozi (or Laojun, "Lord Lao," as he was now often called), identified himself as "the Celestial Master" and said that he reappeared to announce the beginning of an era of Great Peace. Before this was to happen, however, the world would go asunder, but for those who followed him, there was to be another life. They would be part of a new alliance, called the Orthodox One Covenant with the Powers (i.e., of the universe; *Zhengyi mengwei*).

In this "new testament" of Laozi,[23] all animal and food sacrifices were forbidden. "The gods do not eat or drink, the masters do not receive any salary," was one of the rules of the new covenant.[24] This was a clear break with the religious practices of ancient China. Even if formerly Taoism had already opposed the sacrificial cults of the Zhou dynasty, the "feeding" of the gods and ancestors by offering foodstuffs to them, and also the festive banquets during which these offerings were consumed, had remained a universal practice.

The new alliance not only prohibited any form of sacrifice, but also rejected all gods and spirits who received them, and labeled them demons. In ancient China there had been Nine Heavens; the new covenant established that six among them were the abodes of the ancient deities and ancestors, and should therefore be seen as places of corruption and disease, whereas only three, the highest heavens, were filled by the pure energies of the Tao. These had never been incarnated, and therefore had not been polluted by the world. It was these Three Heavens and their deities that were to be worshipped exclusively.[25] The Three

Heavens each contained one cosmic energy *(qi)*, called, respectively, "Mystery," "Principle," and "Origin" *(xuan, yuan, and shi)*. They had three colors—blue, yellow, and white—and constituted the roots of Heaven, Earth, and Water. Each had its own virtue: Heaven (in the sense of the sky) gave forth blessings; Earth forgave sins; and Water averted calamities. Three Officials (Sanguan), pure emanations of the Tao, performed these functions, in which they were assisted by a great number of lesser officials and intermediaries.

Here we find for the first time a true Taoist pantheon, clearly belonging to the Former Heaven and thus distinct from the ephemeral gods, spirits, and ancestors of ancient China. As the name Three Officials already indicates, this pantheon was a bureaucracy. Not only were all the hypostases of the Tao seen as administrators, functionaries, officers, emissaries, etc., but also all the ritual proceedings to be observed to enter into contact with them followed an administrative protocol. Ritual services took the form of solemn audiences at the Chancellery of the Three Officials. The celebrants, dressed as clerics of the Taoist management, approached the divinities through the proper channels, with written memorials and petitions, duly marked with seals and signed with special sacred characters identifying the supplicant as an initiate. Each day of the calendar had its heavenly officers on duty, and for each request there was a corresponding department. All this had to be taken duly into account, and each ritual involved a lot of paperwork.

At the same time, this entire pantheon was also present within the human body, and adepts learned to visualize the three colored energies of the Tao, and their functionaries, and to meditate on them. The names and attributes of all these deities were transmitted on initiation, and consigned in special documents, called registers *(lu)*. The names of the deities were often written in sacred symbolic characters, called talismans *(fu)*. To undertake such a meditation was called "inspecting the legions of the register" *(yuelu)*. Any personal illness or mishap was ascribed to a disorder or a mismanagement of the natural forces of the body, and was seen as a sin against the Tao. Hence the adepts were asked to reflect on their misconduct, confess their sins in writing, and address prayers in the form of written petitions to the Three Officials.

Zhang Daoling is credited with establishing, as the representative on earth of Celestial Master Laozi,[26] regular communities of Taoists. At first the homeland of the new movement, the region of Shu, was divided into twenty-four dioceses *(zhi)*. These were lay communities whose members were recruited from the peasantry of this rich agricultural region.[27] The communities

were governed by chosen officials, twenty-four of each sex. Three times a year, on the fifteenth day of the first, seventh, and tenth moons, the communities held general assemblies *(hui)* at the headquarters of the diocese, normally on the site of a holy mountain. At these assemblies household records were updated—births, marriages, and deaths were reported—and each household contributed five pecks of rice to the common grain reserves, to be used in times of need. This latter practice, in particular, infuriated the government, as it was seen as an illegal collection of taxes. Hence the official annals castigated the Way of the Celestial Masters by calling it "The Way of the Five Pecks of Rice" (Wudoumi Dao) and their leaders were dubbed "rice thieves" *(mizei).*

The Way of the Celestial Masters developed against the background of the rapid decline of the imperial power of the later Han dynasty, and when the dynasty collapsed, the religious organization represented the only authority left in the region of Shu. In fact, in spite of its esoteric aspects, the Way of the Celestial Masters bore many similarities with the traditional organization of local society. For instance, its leaders were called "libationers" *(jijiu),* a title that was used traditionally for the village elder in charge of the sacrifices at the local shrine.

The kingdom of Wei, which succeeded the Han dynasty in Northern China, recognized the Way of the Celestial Masters and ennobled its leaders. Later, during the third century, however, the new dynasty forced the organization to disband and deported the peasant population of Shu to other regions. The result of this brutal measure was the opposite of what was intended: instead of destroying the movement, it helped to disseminate it all over China.

With the Way of the Celestial Masters, Taoism became a church, or an "ecclesia" as we call it, in order to distinguish its community organization, which took the form of political assemblies of free citizens, from the Christian model. The ancient rite of initiation became an ordination, as the transmission of the holy scriptures—among which the *Daode jing* continued to occupy the highest place—now served to consecrate the officials of the ecclesia.

The initiation procedure of the ecclesia of the Celestial Masters did not limit itself to the transmission of scriptures, but comprised also the main rites of passage of a person's life. After the rites for entering the ecclesia at the age of six, boys and girls were taught to read and write and to recite the scriptures. At the age of puberty, they were trained in the arts of *yin* and *yang* and the union of cosmic energies *(heqi)*. This was a very ritualized and highly mystical way of sexual intercourse, during which the

couples, following a prescribed choreography, were united while meditating, so as to participate symbolically in the creation process in a most solemn and controlled way, without committing the sin of lust. The children born from such a union were considered to have been conceived without sin and therefore to belong to a higher form of human being: they were to be spared from the impending apocalypse so that they could become the future citizens of the promised kingdom of Great Peace.

The early Celestial Masters ecclesia assembled its own texts under the title *Statutory Texts of the One and Orthodox Ecclesia (Zhengyi fawen)*. When exactly this was done we do not know, but it is certain that this scriptural canon existed already in the Six Dynasties period, and it is thought at one time to have included no fewer than one hundred different texts. As shown by the status given to it in the later Taoist Canon, where it obtained the most fundamental place, it represents the core liturgical tradition of Taoism.

Taoist Artists

After the Way of the Celestial Masters had spread throughout the northern territory of the Wei dynasty, not only the ordinary citizens entered into the ecclesia, but many aristocratic families as well. Against the background of the disenchantment with the official Confucian ideology of the now defunct Han dynasty, Taoism began to enjoy a renaissance among the higher strata of the society. This involvement of the elite gave rise to a great philosophical, artistic, and literary movement that was once known under the name of "neo-Taoism." On the basis of the texts of the *Daode jing,* the *Zhuangzi,* and the *Yi jing,* a new school of metaphysics known as the School of Mysteries (Xuanxue) arose. It discussed the ontological problems related to the concepts of being and nonbeing as put forward by the philosophers of ancient China and refined them into theories concerning the relationship between thought and language, the nature of music, and the perception of the ultimate truth *(zhen)*.

New commentaries on the *Daode jing* and the *Yi jing* were written by the young genius Wang Bi (226–249). In addition, the *Zhuangzi* was reedited with a commentary by Xiang Xiu (223?–300), which later was further elaborated by Guo Xiang (d. 312). These commentaries were so successful that they have remained the leading exegesis of these great works until the present day.

Well known among the scholars of the times were the so-called Seven Sages of the Bamboo Grove (Zhulin qixian), a group of freethinking and eccentric poets and artists. Among them Xi Kang (223–262) and Ruan Ji (210–263) are most famous; the first one as a musician, the latter as a poet. Not only in their

mystical search for longevity, but also in their veneration of the divine immortals, they showed that they were profoundly Taoist. In a short poem, Ruan Ji once wrote:

> Have you not seen Wang Ziqiao,
> Riding the clouds, sweeping over Dengling?[28]
> He truly possesses those arts of Long Life,
> Which can bring solace to my heart.

There is an undertone of melancholy in this poem, which shows that the desire for long life and the freedom of the immortals *(xian)* was also caused by the uncertainties of the cruel and unstable times. The Wei dynasty had reverted to the kind of "legalist" policies that had been used by Emperor Qin Shihuangdi in unifying China, and that were very inhuman to say the least. Some of the members of the group of the Seven Sages, such as Xi Kang, were condemned for their unconventional behavior and executed.

Other famous artists and poets also adhered to the Way of the Celestial Masters. These were, for instance, the early landscape painter Gu Kaizhi (345–406), the great calligrapher Wang Xizhi (c. 307–365), and the landscape poet Xie Lingyun (385–433). Many of these gentry Taoists were also alchemists. We are well acquainted with the techniques and the lore of medieval Chinese alchemy, thanks to the work of the philosopher Ge Hong (283–343) (fig. 3). Ge set out to prove that the search for immortality should be taken seriously, and that alchemy was the most logical way to obtain it. Indeed, through the manipulation of mineral substances such as cinnabar and mercury, the alchemists did not aim to produce gold, but to find the clue to immortality.[29] Their goal consisted not only in producing a drug, but also in reenacting the cosmic process of mutations from *yin* to *yang* in the laboratory (through the production of cinnabar from mercury and vice versa) and participating ritually in this process, thus traversing eons of time.[30] Ge's book on Taoism, called the *Inner Chapters of the Master Who Embraces Simplicity (Baopuzi neipian)* was written around 310. He discussed not only alchemy, but also many other aspects of Taoism, and quoted many written sources from his own library or from that of his master. As Ge was a southerner, he was apparently not yet well acquainted, at the time he wrote his book, with the Way of the Celestial Masters.

The Revelation of the Shangqing and Lingbao scriptures

In the beginning of the fourth century, northern China was invaded by nomadic peoples from the great plains of Central Asia. After the capital Luoyang fell into the hands of the invaders and

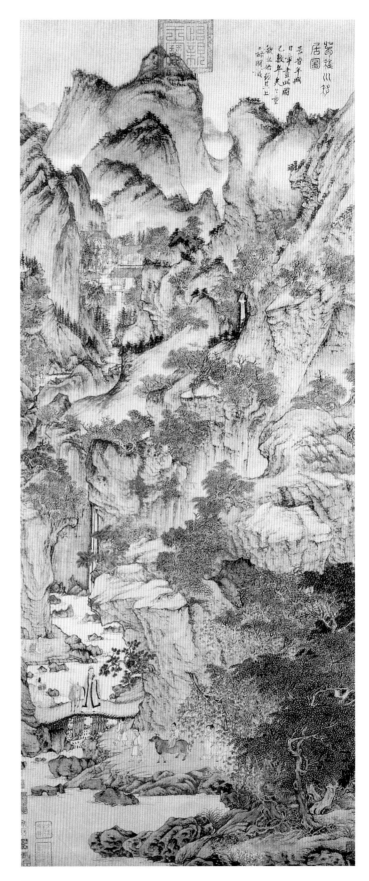

Fig. 3

Wang Meng (c. 1301–1395). *Ge Hong Moving His Residence.* Yuan dynasty, 14th century. Hanging scroll; ink and colors on paper; 139.5 × 58 cm. Palace Museum, Beijing.

was utterly destroyed in 317, the ruling families and many of the underlings fled to the regions south of the Yangzi River, where they installed a new government (the Eastern Jin, 317–420). They brought with them their own Taoism of the Way of the Celestial Masters and of the School of Mysteries. There it was confronted with the ancient southern tradition of which Ge Hong was the great representative.

Soon the aristocracy from the north blended with their southern fellow countrymen, and so did their two forms of Taoism. The northern Tianshi Dao was orthodox and strictly organized. As we have seen, it opposed the worship of local deities and saints, sacrifices of wine and meat, trance techniques, and worship of ancestors. The southern tradition was still very close to the Taoism of ancient China and had continued its cults of the Taoist immortals. It also made ample use of shamans or spirit mediums. The cross-fertilization of the two traditions was to produce some of the greatest literary texts in the history of Taoism.

During the years 364–75, the shaman Yang Xi, attached to the aristocratic southern household of the Xu family in Jiankang (Nanjing), started to receive "visits" from a great number of Taoist immortals and saints. Most of these came from the holy places near the capital, for instance, from the Mao Shan mountain range near Danyang. Others belonged to the Tianshi Dao, such as the female official (jijiu) Wei Huacun. These deities dictated many texts to Yang Xi; some were poems, others messages, but there were also book-length texts. Many of the latter turned out to be new and expanded versions of older texts, such as the *Huangting jing*.[31] The immortals told Yang Xi that these new versions were superior to the old books, and that they came from the highest heaven of all, that of the Highest Purity (Shangqing). Therefore these texts became later known as the Shangqing scriptures. They were written in a beautiful and highly ornate style, much in keeping with the artistic tastes of the times, and they would exert their influence for many centuries. Moreover, Yang Xi noted down the words of the immortals in a special, very beautiful form of calligraphy, which, from an aesthetic point of view, caused these revelations to be held in high esteem.

The Shangqing scriptures were more than a reformulation of older Taoist practices: they also sought to place these on a higher spiritual level. The rites of sexual union as practiced in the ecclesia of the Celestial Masters were replaced by a purely spiritual union of the adept with a divine jade maiden (yunü) or immortal lad (xiantong) from heaven. Descriptions of these

spiritual alliances, with the poems the lovers exchanged during their courtship, have been preserved in the Shangqing literature. Furthermore, the idea that alchemical processes should be spiritual and not material is often alluded to in them. This change heralds the later emergence of so-called Inner Alchemy (neidan), which was to become so vastly popular in modern times (see below).

Some thirty years after the Shangqing revelation, other Taoists, among whom was a descendent of Ge Hong named Ge Chaofu, authored yet another group of new texts, called the Lingbao scriptures (ling originally is a name for "shaman"). These were not works that concerned the individual mystical practice of Taoism like the Shangqing scriptures, but were intended for collective rituals. Most of them were intended to be recited, in the way of Buddhist sutras, for the salvation of all beings, and especially for the benefit of the dead. They contained material from older Taoist works—again many of which had been mentioned by Ge Hong—but in addition to this they showed strong Buddhist influence. The Lingbao rituals moreover contained important elements from the liturgy of the Celestial Masters.

The new revelations of the Shangqing and Lingbao texts therefore did not mark a new beginning in the history of Taoism, because they were very much a continuation and an elaboration of what had been before. The Xu family, which had received the Shangqing revelations, belonged to the ecclesia of the Celestial Masters, and so did, as far as we can tell, those who created, on the basis of mediumistic inspiration, the Lingbao texts. It is therefore completely wrong to speak of a "Shangqing sect" or a "Lingbao sect." At the time, such organizations did not exist. Only much later, as we shall see, did the Shangqing and Lingbao texts become identified with lineages of patriarchs and certain holy mountains. The new revelations were important because they upgraded the literary level of the writings and the cultural level of the practice of medieval Taoism. In Chinese culture, where literature is so highly valued, this had a major impact.

As noted above, the Lingbao texts incorporated many elements from Buddhism. They borrowed from it, for example, the recitation of holy books and the performance of rituals as a means to obtain religious merit (gongfu). They were more easily accessible to the Chinese than the translations of the Buddhist originals and thus played an important role in the absorption of Buddhist faith within Chinese culture. Thus, from the happy confluence of the ancient Taoist traditions preserved in South

China with the liturgy of the Celestial Masters on the one hand, and with Mahayana Buddhism on the other, sprang a new synthesis that developed into one of the highest literary and artistic expressions China has known.

The Impact of Buddhism

During the first and second centuries A.D., Buddhism had slowly but surely conquered China. Like Taoism, Buddhism originated as a movement for personal salvation as a reaction against a sacrificial religion, the ancient Vedic tradition of India. Moreover, Gautama Buddha lived in a time that can roughly be compared to that of the beginning of Taoism. The new Indian faith spread rapidly in Northern India and Central Asia, but although it had reached the regions adjacent to China during the second century B.C., the Confucian orthodoxy of the Han empire did not allow its further diffusion. It was only during the declining years of the dynasty, during the second century A.D., that Buddhism began to establish a foothold.

Historical and textual research has shown that during this period of adaptation, Taoism acted as a kind of receiving structure for Buddhism. Indeed, many early translations of Buddhist scriptures used Taoist terminology in order to render Buddhist terms. Some of these texts did not so much concern Buddhist doctrine as they did techniques related to bodily exercises, apparently in order to cater to the demands of a largely Taoist audience. The relationship between the two must have seemed so close that the Buddha and Laozi were often associated in the worship of the people, and the belief took hold in fact that they were originally two different incarnations of one and the same divine being. The Buddhists may have seen Laozi as an avatar of Shakyamuni, whereas the Taoists saw the Buddha as an Indian form of the Old Master, and Buddhism as some kind of foreign Taoism. Both religions became so much intermingled as to become, in this period, virtually indistinguishable. They also exerted lasting influence on each other. This initial fraternization became the source of much confusion and controversy in later times, when the Buddhists began to dissociate themselves from Taoism and assert the superiority of the Indian faith.

Until the fourth century A.D., Buddhist presence in China was marginal. But when the tribespeople from Central Asia conquered North China, they also began to promote Buddhism in a robust way. With the official backing of the new rulers, many monks came from Central Asia to preach and propagate their faith. Many fundamental texts were translated. Buddhist rites, especially for the salvation of deceased ancestors, became very popular. Taoism believed that salvation was immortality through fusion with nature. It did not have very elaborate ideas about an eventual afterlife and even less about judgments and punishments after death. Buddhism on the other hand preached that sinners went to many hells to be judged and to suffer endless pain, but that the souls of the deceased could be saved through the pious acts of their descendants. This met with great response in China, as can be seen from the many early statues of the Buddha and bodhisattvas that were made "for the salvation of the ancestors of seven generations." Buddhist masses for the dead were also very popular, as can be seen from numerous inscriptions and also from the influence they exerted on Taoist liturgy.

Taoism also adopted from Buddhism its iconography, and during the later part of the period of division between north and south (the Six Dynasties period, 420–589), we find more and more statues and stelae representing Laozi as Laojun (the Old Lord) or as Tianzun (the Celestial Worthy), and looking very much like their Buddhist models.

In the fourth century and the beginning of the fifth, Buddhism held the North and Taoism the South of China. But during the second half of the fifth century and even more so during the sixth century, the situation was inverted: North China gradually reverted to Taoism under the influence of Kou Qianzhi (365–448), patriarch of the ecclesia of the Celestial Masters, whereas the South became profoundly immersed in Buddhism. In the process, the separation between the two religions became unavoidable, and a conflicting situation ensued, something which the Taoists chose to ignore for a long time, but which finally erupted at the end of the sixth century. During the entire Six Dynasties period, imperial favor went sometimes to the one, sometimes to the other. Finally, it was Taoism that was chosen to be the federating national tradition for the reunification of China—a position that, after a short hiatus under the Sui (581–618), it would preserve throughout the Tang dynasty (618–906).

The Taoist Canon

We have seen that the ecclesia of the Celestial Masters had its own collection of texts. When later, in the fourth and fifth centuries, many newly revealed books appeared (not only the Shanqing and Lingbao scriptures, but many others as well), these were invariably presented as superior to the ancient works. Much confusion about their true value, however, ensued. Therefore the emperor of the Southern Liu-Song dynasty (420–479) entrusted the most eminent Taoist of his time, the

patriarch Lu Xiujing (406–477), to select those texts that appeared to be true revelations and present them for inclusion in the imperial library. Lu selected some sixty that he considered the most orthodox. He divided them into three groups: the Shangqing scriptures revealed to Yang Xi, the liturgical Lingbao scriptures, and the texts of the Three Emperors (Sanhuang). The latter consisted mostly of talismans and spells for protection and exorcism.

Lu Xiujing called these three divisions the Three Caverns, meaning that they gave access to the inner strata of the "mountain" of the Tao: 1) the Cavern of Truth, *Dongzhen;* 2) the Cavern of Mystery, *Dongxuan;* 3) the Cavern of Divinity, *Dongshen.* These corresponded to the three traditions, and represented three ways of Taoist practice. The Shangqing Cavern of Truth was related to the individual practice of the Tao through meditation, alchemy, etc.; the Lingbao Cavern of Mystery contained the liturgy of the Taoist communities; and the Sanhuang Cavern of the Divinity had texts that were related to the saints and the holy mountains who could give protection and ward off evil influences. At the same time, there was a hierarchy among the three. The Sanhuang represented the lowest rank, the Lingbao the middle, and the Shangqing the highest. Thus the ancient idea of graduated initiation and ordination through the transmission of texts was maintained.

Lu Xiujing, however, had made a choice only among the newly revealed texts and had left the more ancient books, such as the *Daode jing* and the *Zhengyi fawen* outside of his catalogue of the Three Caverns. Later, under the short-lived Sui dynasty (581–618), his list of canonical texts (to which in the meantime other revealed texts had been added) was enlarged so as to encompass the earlier works. The division into three groups was thereby changed into seven, by creating, in addition to the Three Caverns, the so-called Four Auxiliaries. The latter contained the *Daode jing* and its commentaries, the *Taiping jing,* the ancient manuals for alchemy, and, finally, the *Zhengyi fawen,* which was considered to be fundamental and relevant for the teachings of all the six other groups.

Again, this seven-fold division reflected the hierarchy of the Taoist organization. The first grade was now that of the first ordinations within the ecclesia of the Celestial Masters; the transmission of the *Daode jing* was the next step. Then followed one by one all the other initiations, with, at the very top, the "final register" of the Shangqing scriptures. Thus, the corpus of scriptures was made to reflect the organization of the body of the faithful, the structure of the entire Taoist establishment. Under the Taoist emperor Xuanzong of the Tang dynasty, this

Taoist Canon was for the first time entirely written out in many copies, which were given by the emperor to the great temples of the land. There were a total of 3,477 scrolls.[32] In the seventh year of the Tianbao era (748), Emperor Xuanzong ordered that the texts listed in the catalogue be copied out, in an unknown number of copies, and that the collections of scriptures thus made be distributed to all major Taoist centers. This then was the first true Taoist Canon.[33]

Court Taoism of the High Tang

The Tang dynasty (618–906) was a great religious period. The imperial family claimed to descend from Laozi, and therefore the worship of the Old Master, who was canonized in 666 as Sovereign Ancestor of the Most High Mysterious Origin (Taishang xuanyuan huangdi), became part of the official institutions of the empire. During the preceding Six Dynasties period, many emperors and their spouses had received Taoist initiations. Under the Tang, this became a rule and the solemn ordination rites of the emperor and the ladies of the court became national events. The emperors also founded many Taoist establishments.

Buddhism also prospered, and spread itself further, not only in China, but also in Korea and in Japan. The patronage of the emperors was an important factor in the recognition both religions received. In the beginning of the dynasty, the official policy favored Taoism. Later, the Empress Wu Zetian (r. 690–705) became very powerful, and she very much favored Buddhism. As a reaction against her rule, the following sovereigns again promoted Taoism.

The long reign of Emperor Xuanzong (r. 712–56) marks one of the pinnacles in Chinese culture and is also one of the greatest moments in the history of the Way. Xuanzong, as we have seen, proceeded to publish the Taoist Canon. He moreover founded Taoist temples in honor of his legendary ancestor Laozi in all important cities of the empire. He himself wrote commentaries to the *Daode jing.* He greatly loved Taoist ritual and composed music for it. His favorite consort, the famous Yang Guifei, was herself an ordained Taoist. Xuanzong's love of her and of Taoism in general became the talk of the land and was celebrated in many poems. Not only the members of the imperial family, but also great artists were Taoist. The court painter Wu Daozi is credited with having laid down the ground rules for Taoist liturgical painting, whereas the great poet Li Bai was a "True Person of Highest Purity" *(Shangqing zhenren),* the highest rank in the Tang liturgical organization. His great love of nature left us many magnificent poems:

You ask me why I dwell in mountains green?
I laugh and don't reply; my heart feels just at peace.
Peach blossoms with the stream float far away . . .
This is another world, not that of men.

Science and Technology

It has been said that Taoism stands out among the world religions in that it never opposed science.[34] In addition, concepts like *yin* and *yang* and other tenets of Taoism have been considered by some not to be at variance with many scientific findings, notably in physics. We cannot say that Taoism actively promoted science. It did, however, exert influence on the development of some branches of science, notably on Chinese medicine. The Tang period saw great advances in the study and systematization of Chinese medicine. Some of the greatest scholars in this field, such as Sun Simiao (581–682?) and Wang Bing (active 762), were closely related to Taoism.

Technology also greatly advanced. One of the inventions made by Taoist alchemists was gunpowder. Even if this discovery may have been accidental, the potential of the "fire drug" *(huoyao),* as it was called, was readily recognized and the formula was published in alchemical manuals. Other great inventions include printing and the magnetic compass. In both instances, the influence of Taoism can be demonstrated. As for printing from engraved wooden blocks, there is a long history of Taoist engraving of seals with formulas and spells for reproduction which may have paved the way for the development of this technology. The earliest Chinese printed book on a scientific subject is the Taoist work *Xuanjie lu,* dated 850. As for the compass, it seems to have first been developed for the benefit of the practitioners of geomancy *(fengshui),* before being applied to sea travel.

Inner Alchemy

Alchemical research for the pill of immortality played, as we have seen, an important role in medieval Taoism. Many Tang emperors experimented with alchemical drugs, sometimes with fatal results. This may well have been one of the reasons that during the later Tang period, laboratory alchemy became less popular, and that other approaches were explored. One of these advanced the notion that the alchemical books should be understood, not in a literal, but in a symbolic way. When speaking about the ingredients that went into the making of the pill of immortality, one should see them not as true minerals, but as cosmic energies *(qi)* within the body. The true laboratory, the true crucible, was bodily functions and thus the great cosmological metaphor

of the alchemical process was to be understood as taking place within the microcosm of the body. Instead of manipulating dangerous, poisonous, and also very expensive substances, the adept could, through meditation and concentration, crystallize the true ingredients from his own bodily energies and refine them into spiritual forces.

This Inner Alchemy *(neidan),* as it was called in opposition to the "outer alchemy" *(waidan)* of the laboratory, also reactivated the old Taoist tradition of meditating on the inner landscape or inner country. Many old texts dealing with this technique, such as the *Scripture of the Yellow Court (Huangting jing),*[35] became popular again. But new texts also appeared, claiming to be equally, if not more, ancient than those manuals. One of these proposed a new paradigm for the human body and its cosmic energies. Instead of an inner landscape, this work described the workings of the body in terms of the sixty-four hexagrams of the *Book of Changes (Yi jing).* The work was called the *Concordance of the Three according to the Book of Changes of the Zhou Dynasty (Zhouyi Cantongqi).*

The "three" in question stood for the three transcendent components of Heaven, Earth, and mankind, as well as the three stages of the sublimation of the energies in the body: essence (i.e., sexual energy), breath, and spirit *(jing, qi,* and *shen).* It proposed to regulate the "inner work" in the body according to the cosmic cycle as expressed through the hexagrams. Four hexagrams (Heaven, Earth, Water, and Fire) constituted the foundation, and the cyclical movement of *yin* and *yang* was enacted by the sixty remaining hexagrams. By meditating morning and evening on one hexagram, the complete cycle of these sixty "phases" could be accomplished in thirty days. This method of the *Zhouyi Cantongqi* became immensely influential and many scholars, including Confucians, wrote commentaries to it.

Indeed, during this period, Taoism and Confucianism had grown closer, and their erstwhile conflicts were forgotten. Both felt menaced by the growing impact of Buddhism, which during the Tang period became extremely prosperous and politically influential. Even within Buddhism itself, there were movements that attempted to reform the excesses and to obtain a better integration within Chinese culture and society. The most successful of these reform movements was Chan (Zen) Buddhism, which integrated many Taoist and Confucian ideas in its doctrine. This did not prevent the Confucians from denouncing more and more openly the "foreign" religion, its wealth, its monastic life, and its ways of worship, all of which were considered highly heterodox. At last Buddhism became the victim of a terrible persecution during the years 842–46. Although the

repressive measures were later revoked, Buddhism had received a blow from which it was never entirely to recover.

3. Saints, Temples, and the Union of the Three Teachings

The Rise of Local Traditions

During the ninth and tenth centuries, China underwent great changes. Some of these were due to the technological advances mentioned above. Others were the result of political developments. The Chinese empire, which had greatly increased in size, split into regional entities. During the Five Dynasties period (907–960), the country became once more divided into a number of different kingdoms. Although it is often written about as an obscure time before the advent of the glorious Song dynasty (960–1279), it was in fact an important time of transition between medieval China and what may be called premodern and modern China.

During this period, Confucianism staged a comeback. Having integrated many elements from Taoism, and also some of Chan Buddhism, the new Confucianism developed enduringly to become the nation's foremost ideological and political system. At first, the relationship between Confucianism and Taoism continued to be very close, and some founders of the new Confucian movement, such as Shao Yong (1012–1077), for instance, were perhaps themselves Taoist masters. On the Taoist side, we see that some legendary immortals from the late Tang and Five Dynasties periods, such as Lü Dongbin, are represented as having been originally Confucian scholars.

Even if the new period of division began officially only in 906, the growing regional autonomy had already begun earlier, at the start of the second half of the eighth century. For Taoism, this would have far-reaching consequences. First of all, the division of the country into a number of semiautonomous regions greatly favored the emancipation of local societies, where Taoism had, and still has, its natural habitat. In the middle of the Tang, under Emperor Xuanzong, the organization of the ecclesia of the Celestial Masters was still very much alive, especially in the regions south of the Yangzi River, the so-called Jiangnan area. It was these regions that, in the period of division, grew to be the most prosperous in terms of commerce and industry. The late Tang saw the development of the great merchant cities of Nanchang, Yueyang, Suzhou, Yangzhou, Hangzhou, etc., that were to become the centers of Chinese culture for centuries to come.

Nanchang became an important market town for the grain trade. The neighboring holy mountain of Xi Shan housed the temple of a local Taoist saint, the divine official Xu Jingyang (see cat. no. 115). He became the patron saint of the Nanchang grain traders, who staged magnificent festivals together with large-scale Taoist rituals for the celebration of the immortal saint's birthday. Affiliated communities from as far as Sichuan in the west and Jiangsu in the east would come to participate. Already at the beginning of the Tang dynasty, imperial patronage was obtained for the worship of Xu Jingyang, and this was reinforced in later periods. Other local Taoist saints also were recognized, and even canonized by giving them official titles.

Emperor Xuanzong of the Tang dynasty had canonized Zhang Daoling, the hermit credited with the founding of the ecclesia of the Celestial Masters. This canonization did not benefit the region of Northern Sichuan, where the ecclesia originally came from, but quite another place: the Dragon and Tiger Mountain (Longhu Shan), a Taoist center situated at an important junction of the trade routes that linked the Jiangnan area to the provinces of Jiangxi, Fujian, and Guangdong. There, the local Taoists claimed, was the true place where Zhang Daoling had obtained the Tao, and where his descendants had continued to live. Readily, the emperor also recognized the patriarchs of this lineage as the legitimate holders of the title of Celestial Master, and herewith the Zhengyi (Orthodox Unity) order of Longhu Shan was created. The Zhengyi order prospered along with the commercial development of South China. The new Celestial Masters—one per generation—became more and more influential, so much so that later Western missionaries would call them "Taoist Popes." From the middle of the Tang, beginning with someone who claimed to be the twenty-third successor to Zhang Daoling, the lineage has continued until today: the sixty-fourth Celestial Master lives now in Taiwan. All this of course was fundamentally different from the ancient ecclesia of the Celestial Masters of the Middle Ages.

The Modern Temple Organization

As a result of these developments, the traditional dioceses and local communities of the Taoist ecclesia gradually transformed themselves into modern temple organizations. The new bourgeoisie of the Jiangnan area organized themselves in associations (hui) in honor of their local saints. These associations, which were to dominate the social and economical life of China until modern times, were headed by laymen, but remained intrinsically Taoist in nature. They served many other purposes. Often, the most important associations were vocational groups, such as the grain traders of Nanchang, and hence comparable

to Western guilds. Others were pilgrimage associations, which maintained the networks between different localities. Still others had more precise aims, such as performing deeds of merit: keeping the temple clean, reciting scriptures, caring for the old and the sick, helping the disabled and the mentally unfit, liberating animals, and even collecting old paper (any piece with writing on it was deemed sacred) and training in the martial arts so as to be able to protect the community if need arose. All this was *gongfu*, "religious merit" (a term we now associate with the Chinese martial arts of the temple associations), and because all these activities were performed as a service to the community, we call these associations "liturgical organizations."

The temple-and-market network developed greatly in the Five Dynasties period. Formerly only a few Taoist saints had been officially recognized. Now, in the many and ephemeral kingdoms that emerged, numerous local saints came into the limelight. The worship of the great saints of the Jiangnan area, such as Guangong (see cat. no. 83), the embodiment of martial virtue; Guanyin, the bodhisattva who became the great dispenser of mercy; Mazu, the fisherman's daughter who became the protectress of seafarers; Xu Jingyang, the immortal official, and many, many more became known in these times on a nationwide scale.

In the beginning of the Song period the development of these local and regional organizations was such that it could no longer be ignored by the central government. In a series of bold religious and political actions, Emperor Zhenzong of the Northern Song, after having first been sanctified as the living representative of the Tao on earth by so-called Heavenly Letters, undertook to create a network of officially sponsored Taoist temples (the Tianqing Guan, later Dongyue Miao), which allowed for a partnership between the official and private spheres, for the organization of markets, and for the collection of taxes on trade. The Taoist priests who were appointed as keepers of the sanctuaries were recognized as government officials, a dignity that, in principle, they kept until the end of the imperial period. In the Tianqing Guan, not only Huangdi, the divine ancestor of the dynasty, was worshipped, but also many other deities who belonged either to the Taoist ecclesia, such as the Three Officials and the Earth God (see cat. nos. 69–71, 85), or dynastic deities whose worship was an imperial prerogative, such as the lord of the sacred mountain Tai Shan. Soon, with imperial blessing, next to the Tianqing Guan, individual sanctuaries appeared to all these and many more saints and gods. The modern temple was born, with its lay organization that replaced the ancient dioceses of the ecclesia of the Celestial Masters.

During the Northern Song, the role of the emperor as a Taoist was maintained. Emperor Huizong (r. 1100–1125) even became himself "Lord of the Tao" (Daojun) and attempted to transform his court into a Taoist community. He is famous for his paintings on Taoist subjects, for his immense gardens in the capital of Kaifeng which were modeled after his visions of the paradises of the immortals, and for the many hymns he wrote for the great Taoist rituals. Yet we cannot speak of an "official religion" inasmuch as the temple network of which the emperor was the head existed side by side with the official Confucian bureaucracy and separated from it. This created a kind of dual state: on the one hand, the imperial administration and its Confucian officials, its army, land tax system, examination system, etc., and, on the other, the imperial household, the Taoist priesthood, the canonized local saints, and the corresponding temple network.[36]

This dichotomy is the main theme of the famous Chinese novel *Shuihu zhuan* (translated by Pearl S. Buck as *All Men Are Brothers*).[37] The novel, although written in the Ming period, draws on a long tradition of storytelling. Its setting is the reign of Emperor Huizong, and it gives a striking description of Taoist society as it saw itself in opposition with the Confucian bureaucracy. The *Shuihu zhuan* has remained a bible for the local temple communities until this day.

As to the dual system of Confucianism and Taoism in these times, this is nowhere more aptly expressed than in the institution of the Temples of Tai Shan (Dongyue Miao). The worship of the holiest of holy mountains was in principle reserved for the emperor himself, but now, under his auspices, temples of Tai Shan were founded in all the urban centers. Under the Dongyue Miao came the Chenghuang City God temples, which were present in each township and there represented the Taoist spiritual authority in symmetrical complementarity with the Confucian secular powers. In other words: the City God became the counterpart of the local prefect, one reigning over the spirits, the other over the living humans. Below this level came the Earth Gods and their shrines, which represented the smallest social groups, the villages and neighborhoods. The Earth Gods were the spiritual counterparts of the village community leaders. All this was made perfectly visible through the iconography of the temple statues: the God of Tai Shan was represented as an emperor, the City God as a high official, and the Earth God as a wealthy peasant. As to all these temples, while they were administrated by the officials and the citizens of each place, they always employed Taoist masters, mostly of the Zhengyi order.

So close indeed became the relationship between the imperial establishment and the local temple networks in premodern

China that the reformers at the end of the eighteenth century tended to identify one with the other.

The popularization and secularization of Taoism in premodern and modern China was so thorough that it became virtually indistinguishable from local society. The latter identified itself as the *she,* literally, the local Earth God, and the community or association that maintained the worship of this god, as well as that of all the other local saints and deities, was a *hui,* so this fundamental organization was the *shehui,* a word that nowadays in China is used to translate our concept of "society." There is no better example of the total integration of Taoism within Chinese grassroots culture.[38]

At the beginning of the modern era, the interpenetration among the Three Teachings or Three Religions *(Sanjiao)* had been very strong. Among the Buddhist schools, we have seen how much Chan (Zen) Buddhism was influenced by Taoism. The other great movement, that of Pure Land Buddhism, in turn greatly influenced Song Taoist ritual practice. Confucianism owed an immense debt to both Buddhism and Taoism, which had given it the transcendent dimension it was hitherto lacking. While for many the union of the Three Teachings became more and more a reality, as Taoism grew ever more immersed in local society and popular culture, it became estranged from the other two, or, more precisely, Buddhism and Confucianism gradually distanced themselves from it. The union of the Three Teachings continued, not only during the Song but also during the Ming restoration and even during the last Manchu Qing dynasties, to be one of the cornerstones of the political discourse. In practice, however, only Taoism continued to believe in the dialogue and to promote the common cause, whereas the two other doctrines worked towards a greater differentiation. The unity of the Three Teachings was therefore a typical Taoist cause, and was only actively supported by Confucianism and Buddhism in times when Chinese culture in general was menaced, as happened, for instance, during the Mongol period and again under the influence of the Christian missionary offensive in modern China.

The New Orders: Quanzhen and Xuanjiao

With the demise of the Taoist ecclesia and the rise of the lay associations and their temple networks, the Taoist clergy entered into a long period of decadence. The medieval ordination system, which was so closely linked to the Taoist Canon, became obsolete, first, because the fundamental institution of ecclesia had ceased to exist; and second, because many new scriptures and methods had appeared that no longer fit within the old framework. The Taoist ritual—and therewith the Taoist priest-hood itself—became more and more dependent on temple organizations, whether they were national temples sponsored by the emperor, lineage temples such as the "Celestial Master Residence" *(Tianshi fu)* of the Zhengyi order on Longhu Shan, or similar lineage temples on the other sacred mountains (such as Mao Shan), or again local temples in honor of popular saints operated by a *shehui.*

The main result of all this was that the unity of Taoism, which had prevailed under the general liturgical framework of the Tang dynasty, was lost. Many local schools sprang up, each with its own methods *(fa).* Although different in the details of their methods and rites, they nevertheless continued the basic ritual tradition of the Middle Ages, which they enhanced and expanded with more recent elements, such as Inner Alchemy, or Tantric Buddhist elements. Inevitably, these local schools competed and even quarreled with each other. This breakdown left part of Taoism, especially its higher mystical practices, without true institutional support. Inner Alchemy, which had become its main discipline, was transmitted by many masters, but without any clear lineage and initiation system.

After the fall of the Northern Song (1126) and the flight of the court to South China (the Southern Song period, with its capital at Hangzhou), the North was once again occupied by non-Chinese tribespeople. The twelfth century was a time of incessant war and turmoil. It was there, under these dire circumstances, that a great reaction set in. A former military officer, Wang Zhe, more generally known under his religious name of Wang Chongyang (1113–1170), decided after a failed career in both the military and the civil service under the Jin dynasty, to devote himself to Inner Alchemy. In the year 1159, he had a miraculous encounter with the scholar immortal Lü Dongbin, and the latter's master, the immortal Zhongli Quan. This encounter established Wang's vocation as a preacher, and he carried out his calling in the very eastern part of Shandong province, where he established his first congregation, to which he gave the name of Quanzhen (Total Truth). Indeed, one of the aims of Wang's teachings was to bring the Three Teachings into a single great system once more.

In time, the Quanzhen order became the most important movement of spiritual renewal in premodern China. The order institutionalized Inner Alchemy as the main way to salvation. As the practice of Inner Alchemy is incompatible with heterosexual intercourse, it imposed celibacy on its communities. Although men and women continued to live together, the communities were by and large organized as Buddhist monastic *sangha.* The new movement's success was almost immediate,

and in 1190, only twenty years after the death of the founder, the order was officially recognized by the emperor of the then reigning Jin dynasty (1115–1234). But soon, the Jin dynasty came under heavy pressure from the ever victorious Mongol hordes under Chinggis (Genghis) Khan.

While Chinggis was preparing to invade China, he invited the Quanzhen patriarch Qiu Chuji to come and see him in Central Asia. Qiu, already very aged, undertook the trip with a number of his disciples, and met Chinggis at Samarkand in 1222. He duly impressed the great Khan, and obtained from him assurances that the Chinese people should be spared the all-out slaughter the Mongols perpetrated in most of the countries they conquered. Chinggis also conferred on Qiu large powers over all religious groups in China. His actions established the Quanzhen order as one of the main partners of the Mongols, who completed their conquest and destroyed the Jin in 1234. This patronage allowed the Quanzhen order to expand its activities even more. It did much for the general advancement and enhancement of Taoism, for instance by reprinting, in 1244, the entire Taoist Canon, which had nearly been lost in the incessant wars. It also continued the performance of the traditional Lingbao liturgy.

We may therefore see the Quanzhen as a reaction against the difficulties of the times and against the decadence of other Taoist traditions, but not as a reform movement. It was, first of all, an action of the elite to assert and preserve the Taoist traditions as well as Chinese culture in general. The Quanzhen masters, at the time they were influential at the Mongol court, did much to help and save not only Taoist but also Confucian scholars. Many of these in turn adhered to the Quanzhen order. Among the great painters of the Yuan dynasty, Huang Gongwang (see fig. 4) was a Quanzhen Taoist.

The impact of Quanzhen Taoism was also important on the popular level, as the new theater of the Yuan dynasty was greatly influenced by it. The origins of theater in China are very complex, but in the form it adopted in the Yuan, which was to endure ever after, it was closely linked to Taoist liturgy and temple worship. Until this century, theater has always been performed in conjunction with religious festivals on a stage in front of a local temple, the same stage being also used by the Taoist celebrants for the presentation of memorials to Heaven. The most important part of the theater performance was moreover purely ritual. The actors were for the most part laymen from the temple associations who considered it a work of great merit and honor to perform. Therefore, the use of professional actors was seen as a sinful aberration.

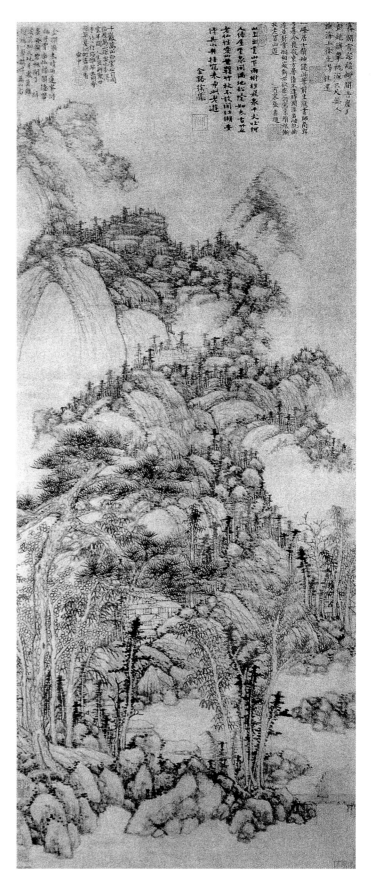

Fig. 4
Huang Gongwang (1269–1354). *Cinnabar Cliffs and Jade Trees.* Yuan dynasty, 14th century. Hanging scroll; ink on paper; 101.3 × 43.8 cm. Palace Museum, Beijing.

But the esteem in which the Quanzhen masters were held at the Yuan court did not endure. Much criticized by the Buddhists, they repeatedly lost in the public debates at court on the eternal controversy of the identity between Laozi and the Buddha, and thus forfeited the patronage of Khubilai Khan (r. 1260–94). In 1281 this great Khan, the builder of Beijing, in a fit of rage, ordered all Taoist books, with the exception of the *Daode jing,* to be destroyed.

The Quanzhen Masters were replaced in the imperial favor by the Celestial Masters of the Zhengyi order. The contemporary Celestial Master had readily espoused the cause of the Mongols, once it became clear that the latter, after having conquered North China, would now also extend their domination over the South (in 1275). Unwilling to submit himself to the life of the court and the cold of the Beijing winters, the southern patriarch soon retired to his holy mountain of Longhu Shan, leaving as hostage one of his disciples, named Zhang Liusun (1247–1322). Zhang was not only a good Zhengyi Taoist, but also an excellent doctor, so that he rapidly gained the confidence of the Mongols. So greatly was he favored that at one time Khubilai proposed to name him "Celestial Master" in replacement of the patriarch of the Longhu Shan. When Zhang Liusun refused, the emperor established a new order, called the "Religion of Mystery" (Xuanjiao), and put Zhang Liusun at its head. The Xuanjiao order lived only as long as the Mongol dynasty, but it was instrumental in advancing the Taoist temple organization and its lay communities. Zhang Liusun founded the great Temple of the Eastern Peak, Dongyue Miao, in Beijing (1223), which was to become the center of most of the guilds and corporations, and thus the unofficial town hall, of the capital. Many other local temples were founded by him, as well as by his equally brilliant successor, Wu Quanjie (see cat. no. 64).

Ming Taoism

When the Ming (1368–1644) dynasty emerged from the ruins of the Mongol period, the new emperor, himself a former monk, squarely placed the dynasty under the aegis of the united Three Teachings. As to Taoism, it was the Zhengyi order and its patriarch of Longhu Shan that took over the role of the Xuanjiao of the former dynasty as the most prominent representative of Taoism. It fulfilled this role with dignity and fairness. The Zhengyi order and its Celestial Masters did not attempt to unify Taoism, but worked for the advancement of all regional and local traditions. This is perfectly borne out by the Taoist Canon they edited, between the years 1408 and 1445, to replace the one destroyed by Khubilai Khan. The editors gathered together all

that legitimately could be considered Taoist without offending either the Confucianists or the Buddhists. The result was a highly eclectic collection of Taoist works, ancient as well as modern, technical as well as poetical, mystical as well as operational. It included all the important commentaries of the *Daode jing* and the *Zhuangzi* available, but also all the modern saints, including the bodhisattva Guanyin, as well as the remnants of the *Statutory Texts* of the medieval ecclesia.

The Quanzhen order was also duly represented in the Canon. After its eclipse from imperial favor, it had continued to prosper in its many monasteries situated all over the country on major holy mountains. The Zhengyi Celestial Masters did what they could to help it, for instance by restoring one of its foremost centers, the famous White Cloud Monastery (Baiyun Guan) in Beijing during the fifteenth century. From Ming times on, Quanzhen and Zhengyi became the most representative Taoist traditions, and they complemented each other perfectly. The Quanzhen, with its strict and Spartan discipline maintained and perfected the higher forms of Taoist mysticism through its practice of Inner Alchemy. The Zhengyi fostered the local communities and temple organizations and provided them with their liturgical framework and ritual specialists.

Taoism under the Ming was everywhere: in the cities as well as in the countryside, in the popular novels of the storytellers as well as in the rituals of the imperial court, in the practices of the sectarian movements as well as in the philosophy of Wang Yangming. It penetrated deeply into the local societies, gradually replacing Buddhism in many of its strongholds in southeastern and northwestern China, as the citizens of the market towns preferred to be their own masters in the local temples, and shook off the tutelage of the Buddhist clergy in favor of the services of the local "Lao Dao" (good old Taoist), who spoke the local language and whose services could be availed of for special occasions.

Not only temples and pilgrimages multiplied, but under Taoist influence, Chinese religion underwent a major transformation: feminization. As we have seen, Taoism had always venerated great goddesses such as Xiwangmu, the Queen Mother of the West. It had also given to women an equal place with men in the priesthood of the medieval ecclesia. In the lay associations of the modern temple networks, as many stele inscriptions show, women played a major role. Now, during the Ming, women's religion became at last truly emancipated. Everywhere, the worship of female saints emerged. For northern China, it was the Sovereign of the Clouds of Dawn, Bixia yuanjun, the daughter of the terrible Lord of the Eastern Peak, who won the

hearts of all women and soon of their sons and husbands as well. The great pilgrimage at the occasion of Bixia yuanjun's birthday became the major social event of the year. In Central China, it was the gentle Guanyin, now entirely Chinese and even outfitted with a Chinese hagiography, who came to offer comfort and guidance. And in South China, the Lady of the Waterfront (Linshui furen), Chen Jinggu, as well as good Mazu, the fisherman's daughter, and many others, provided women with a focus for their faith and a rallying point for their associations.

The acceptance of Taoism in Chinese society increased steadily toward the end of the Ming. Both the Jiajing and Wanli emperors, as well as the other members of the imperial household, were great supporters of the local cults. The latter ordered a Supplement to the *Daozang* of 1445 to be compiled according to his wishes. Aside from incorporating a great many scriptures concerning popular saints and deities, it also contained works by some of the most eminent rebel free thinkers of his times.

Chinese society at last was loosening up. The end of the Ming was one of the most liberal and therefore also the most creative periods in Chinese history. Economic expansion, social mobility, freedom of expression, and even sexual liberation were actively promoted. Liberty brought with it an ever greater diversity of local culture. A trend for the abolishing of the classical written language and the emancipation of the spoken language emerged, propagated by the religious organizations and the many new sectarian movements. Many religious works, such as the Buddhist and Taoist "precious scrolls," which explained the doctrines and the moral tenets to laymen, were written in the spoken language, and so were many novels that also were largely religious in nature.

Reaction and Persecution

The trend toward freedom and diversity did not meet with universal approval. Orthodox Confucian opposition was strong. The Jiajing and Wanli emperors were not just constantly criticized, but regularly abused by orthodox censors. Bixia yuanjun, the Mother *(niangniang)* of Beijing, never received any official recognition in the form of an imperial canonization, not for want of imperial patronage (for the ladies of the palace were members of the associations founded in her honor), but because of Confucian opposition. Worse, the new popular religious movements that had sprung up, and that professed the unity of the Three Teachings, were not only not recognized, but actively persecuted as heterodox and dangerous deviations. Gradually, the situation worsened. The Wanli emperor, sick of listening to the endless recriminations of the Confucian school-

masters, refused to attend the audiences at court. The new religious movements, relentlessly persecuted, rose in revolt. On the other side of the political spectrum, the Confucian literati organized their opposition in political "anti-palace" parties. At the same time, a renewed interest in the ancient Classics made the scholars rediscover the purity of the original Confucian ethics. Like the European reformation before them, critical study of the scriptures made them aware of their original meaning. Soon the critical approach gave way to fanaticism. Scholars ended up by swearing only by the Classics, and wanting to see nothing but the Classics. Thus conservative—or should we say fundamentalist?—Confucianism, which was to have such a dire impact on China's modern fate, came into being.

Many Confucian scholars who opposed the government and the society of the late Ming immigrated to Manchuria, where a new kingdom, that of the Hou Jin, had emerged. It was governed by a tribe of ethnic Tungus who called themselves Manchus, and who had assimilated a great deal of Chinese culture. The Hou Jin had opted for conservative Confucianism as its official ideology. When the monarchs of this small kingdom became by masterful political intrigue in 1644 the rulers of China, they founded the Qing dynasty and continued this policy. Immediately, Taoism became the object of restrictions and interdictions. The Zhengyi patriarch (the Celestial Master of Longhu Shan) was demoted: he was no longer allowed to come to court, and later he could not even visit the capital, as some officials told the emperor that "Taoist are vile; they should not be allowed to pollute the court with their presence." Only the Quanzhen monastic order was condoned. Quanzhen was revived in the capital, the nearly defunct White Cloud Monastery was rebuilt, and a new organization calling itself the Dragon Gate lineage (Longmen pai) took control. With the backing of the government, the Longmen lineage gradually extended itself all over China.

The Manchu government, always afraid of Chinese nationalism, actively repressed the local organizations. The result was strong popular resentment and the rise of secret societies (the Tiandi hui, later known in the West as "Triads") whose aim was to overthrow the Qing and to restore the Ming. In line with its orthodox Confucianist convictions, the government not only discouraged commerce, but also forbade overseas trade, which resulted in a great impoverishment of the state. The history of the "opening up" of China, first by diplomatic efforts—the Macartney embassy to Emperor Qianlong of 1783—and then by the opium trade and the subsequent armed conflicts, is well known. When the Western traders arrived, so did the Christian missionaries. In a nativistic reaction to the Western introduction

of opium and religion, as well as to the oppression of the Manchu state, China's poorest, the Hakka people of Guangxi, rose in revolt, in 1849, under the guidance of a messiah, Hong Xiuquan, who claimed to be Jesus' younger brother. They gave themselves the name of Taiping (Great Peace or Great Equality), which, as we have seen, was also the watchword of the earliest Taoist mass movements. However, the Taiping revolt not only fought against the Manchu rulers, but also destroyed all temples, Buddhist as well as Taoist, wherever its armies passed. This was the first great wave of iconoclasm in modern China. There were many more to come.

After the suppression of the Taiping revolt, and the war with Japan, the young Confucianist scholar Kang Youwei, also from Canton, and equally strongly influenced by a Protestant missionary, proposed in 1898 a series of reforms to the young Manchu emperor Guangxu. His action triggered the so-called Hundred Days Reforms. The first measure, and also virtually the only one that was actually adopted and made into an imperial decree, was to "destroy the temples and build schools" (huimiao banxue). This measure, in the troubled times of the end of the dynasty, immediately provoked the indiscriminate seizure of temple buildings and properties by corrupt officials and military strongmen. The Buddhist establishments were, in the beginning, thanks to the protection of the then still living Empress Cixi, spared, but the Taoist temples of the people, especially in the cities, were an easy prey.

During most of the twentieth century, the drive to annihilate China's own religion increased at each major turning point. The story of this feat, during a century which has seen so much mass destruction in China and elsewhere, has to wait for later historians to be written. It is enough to say that the Taoist Canon of the Ming—for obvious reasons, the Qing never cared to compile one—was almost lost. In 1920, after so many temples had been ruined or confiscated, only two incomplete copies survived. Luckily, a bibliophile association reprinted the invaluable collection in 1926. The reprint was distributed to centers for Chinese studies all over the world. From that date on, research on Taoism began. After a slow start in China, Japan, and France, Taoist studies rapidly developed from the 1960s. Today, they are flourishing everywhere, and especially in China, where the value of Taoism as an intrinsic part of Chinese culture is again recognized. The international scholarly efforts have in no small way contributed towards this recognition of the importance of Taoism as part of the world's spiritual legacy. This is a great victory for science. This catalogue and the exhibition it accompanies would not have been possible without it.

NOTES

1. The term "Tao" was only gradually adopted to designate China's mystical and religious tradition. Zhuangzi speaks of "the arts of the Tao," and later thinkers address the mysteries as "the Way of the Yellow Emperor and the Old Master" (Huanglao zhi dao). In fact the term "Taoism" in its two Chinese counterparts—Daojia (the "school of the Tao") and Daojiao ("the teachings of the Tao")—does not occur before imperial times. The term "school of the Tao" is the older one, and it has been adopted not only for the ancient philosophy, but for the medieval liturgical movements as well. For reasons of commodity, and in keeping with Taoist usage, I use the term "Taoism" freely also for the formative stage, in spite of the evident anachronism.

2. The only "historical" account of Laozi is by Sima Qian, in his *Shiji* (see cat. no. 1).

3. See Schipper 1993: 119–23.

4. Although the above story only appears in later sources, it is obvious that it existed already in ancient times, as Sima Qian calls Laozi "Li."

5. The Chinese term is *zhuxia shi,* "the scribe by the pillar." The pillar was the great sundial of the kingdom, and the scribe appointed to its functioning was in charge of the calendar.

6. The story of the meeting between Laozi and Confucius is told twice in the annals of Sima Qian, and the *Zhuangzi* has no fewer than six accounts. Clearly, it must have been very important for the people in those times. Its general message is the rejection of the conservative feudal order, and the advancement of the individual conscience.

7. The boy was Xu Jia, who finally did not go, but stayed behind and became the ancestor of the shamans.

8. Zhuangzi, in one the early chapters of the work, puts "noblemen and rich merchants" in one and the same category of people (*Zhuangzi,* chap. 4, par. 5).

9. As nowadays the Confucianists insist on considering the Classics as philosophy, it is perhaps not superfluous to point out that they all relate to ritual: the *Book of Songs* contains the ritual hymns (probably a selection of those used at the court of the Lu state), the *Book of Documents* has the ritual prayers, announcements, invocations, calendars and drama texts, the *Book of Rites* (now lost) the scripts of the ritual performances, the *Book of Changes* the oracle texts for the divination in relation to the sacrifice, and the *Chunqiu* annals record the events at which major sacrifices were performed. There is no reason to suppose that Confucius had a hand in the editing of any of them.

10. This is of course not to say that there is any historical relationship between Laozi and the *Yi jing.* It is, however, undeniable that the author(s) of the *Daode jing* knew the *Yi jing.*

11. This is the title of the excellent translation by Victor Mair.

12. This goddess is not mentioned in the Confucian Classics (Laozi and Pengzu are mentioned in the *Analects* of Confucius; Huangdi is mentioned several times in the Classics), which in fact do not mention a single female deity, as they are profoundly misogynist. Confucius considered that "people of low birth and women are difficult to educate." The *Book of Songs (Shi jing),* one of the Classics, contains a sacrificial hymn (no. 264) that is a violent attack on women, especially intelligent ones. It was therefore long thought that Xiwangmu was a creation of the emerging mystery religion (i.e., Taoism) of the Eastern Zhou period. Recent evidence from oracle-bone inscriptions shows, however, that she was venerated as early as the second millennium B.C. What must have happened is that this great mother deity, along with many other gods of early China, was ostracized by the patriarchal Confucian "classics," and survived within the religion of the common people, only to re-emerge with the advent of the Way of the Old Master.

13. *Zhuangzi,* chap. 1, par. 3. Instead of "Gushe" some texts have "Guye." The location of this mountain range has not been established with certainty.

14. *Lu* means incense burner and Boshan is an ancient name for Hua Shan, one of China's famous holy mountains.

15. Among the Mawangdui silk manuscripts, there is a magnificent document that illustrates these techniques.

16. The most important texts, such as the *Daode jing,* have long since entered the public domain and circulate freely. Many Taoist rites and practices, however, are still transmitted only by masters to initiates.

17. This identification, although now widely accepted, remains highly questionable.
18. This important aspect of Taoism is branded as "feudal superstition" in China.
19. See Bokenkamp 1996b.
20. See Schipper 1963.
21. See Kaltenmark 1979.
22. On *Liexian zhuan*, see Kaltenmark 1987; on the ancient adepts known as *fangshi*, see DeWoskin 1983.
23. For this expression, see Seidel 1969a.
24. A quote from the fifth-century Taoist text *Scripture for Initiation into the Doctrine of the Three Heavens* (*Santian neijie jing*; HY 1196).
25. Here we find again the opposition between the universe before creation and that afterwards.
26. Tianshi was first the title of Laozi himself, and Zhang was his vicar. Later his descendants themselves received this title.
27. When the first communal movements appear, we see that their institutions do not fundamentally differ from the local administration per se.
28. The place where Wang Ziqiao had a temple erected in his honor. On the immortal Wang Ziqiao, see Holzman 1998b and Steuber 1996.
29. The recipes that were used were mainly composed of mineral substances, of which very toxic substances like cinnabar and mercury occupied the most important place. There are indications that the practitioners believed that the ingestion of the alchemical substances caused death and that their ingestion corresponded to a kind of suicide. A derivative of the great alchemical drugs, which, apart from being deadly, were also very expensive, was a kind of mineral power, largely made of ground quartz. This drug heated the body, increased sexual power, and could even cause hallucinations. In the long run, however, its use was also fatal. Users were wont to eat and drink great quantities of cold food, so as to counter the heat symptoms—hence the drug went by the name of eat-cold powder *(hanshisan)*.
30. See Sivin 1980.
31. This was the *Huangting neijing jing*. See Schipper 1975.
32. Different numbers have been advanced.
33. While in fact the *Daozang* was divulged in the Tianbao era, Xuanzong's canon is known as that of the Kaiyuan era.
34. See Needham et al. 1974.
35. The original version of this work dates from the later Han dynasty.
36. We may suppose that the income derived from this second, parallel, and, from the official viewpoint, marginal network was at times very important and could surpass the income derived from the traditional tax system.
37. Pearl S. Buck, *All Men Are Brothers* (New York: Grosset and Dunlap, 1937).
38. Nor is there an example that better illustrates the conflicts of contemporary China, inasmuch as the word *shehui* was used to coin the term socialism *(shehui zhuyi)*, although this ideology aimed at destroying the "feudal superstitions" that were the very substance of the ancient "community of the Earth God."

TAOIST ARCHITECTURE

NANCY SHATZMAN STEINHARDT

IF IT IS SOMETIMES DIFFICULT to determine whether a par-
ticular work of art is Taoist, it is a far greater challenge to identify
a Taoist building. Information drawn from Taoist texts or books,
a familiarity with religious lore, and a knowledge of the icono-
graphy of key deities can assist us in our efforts, but structural
signs that a building—or group of buildings—is Taoist may
not be readily apparent, even to someone educated in religious
doctrine or trained in the history and technology of Chinese
construction. This is true for reasons that are peculiar to archi-
tecture among the Chinese arts, for Taoist architecture, first and
foremost, is part of the mainstream of the Chinese building
tradition. The Chinese timber frame is the most adaptable of
construction systems. Fundamentally modular, its large and
small pieces can be added, taken away, or moved to transform
a huge room into small ones; a small, rectangular hall can be
refashioned into a large U-shaped one; or the platform of a
throne can be converted into an altar. Moreover, all of these
changes can occur without altering a building's exterior. In gen-
eral, the wooden members that form the skeletal frame of a
Chinese building and the exterior elements that finish it may
be distinguishable by period-style, by features associated with a
geographic region, or by rank, but almost never by details spe-
cific to its religious affiliation. The invisibility of external signs
of religious affiliation holds true for halls of Taoism, Buddhism,
Confucianism, Judaism, and sometimes Islam in China.[1] In fact,
this invisibility extends beyond religious halls, because, since
ancient times, religious architecture has turned to residential
construction for its first models. When their status is roughly
equivalent, individual Buddhist and Taoist halls replicate not
only each other but also the form of a Chinese palace, and the
arrangement of buildings in a large, well-funded complex—
regardless of the particular religion—imitates that of a multi-
hall Chinese palace. The multifunctionality of the Chinese

timber-frame hall is unique in the universe of building traditions.
On the outside, the Chinese building is, in the purest sense of
the word, a façade, merely a front for what takes place inside or
around it.

There are, of course, exceptions: a pagoda is found only in
a Buddhist context, and a minaret is built only at a mosque. But
not every Buddhist monastery has a pagoda, and it is possible
to confuse a pagoda with a pavilion. The pervasive interchange-
ability of Chinese architecture has even permitted the construc-
tion of pagodas to serve as minarets at mosques. Still, the
situation is not hopeless. Unlike paintings or sculptures that
may rest for centuries in collections or storage, isolated from
clues to their origins and history, it is a rare Chinese building
that stands in isolation from its context. Inscriptions on stelae
at a building site or records of the town, county, prefecture, or
province in which it is located provide the data that inform us
that a building is Taoist and often enough information to recon-
struct more of its history than might ever be possible for many
paintings or statues. In fact, it is unlikely that any extant struc-
ture that is or was Taoist has not been identified as such, unless
it is one located in one of China's most remote regions with
neither interior images nor inscription-bearing stelae.

I. DEFINITIONS

Apart from the consideration of a building's structure, one's
first clue that a building or set of buildings is Taoist is its name.
The most common word designating a Taoist temple-complex is
guan, such as in the name of the most important Taoist temple
in Beijing, the Baiyun Guan (White Cloud Monastery). Some-
times *guan* is translated "abbey" to distinguish it from the stan-
dard translation "monastery" for a Buddhist complex of halls
and temples, known in Chinese as *si*. A Taoist temple-complex

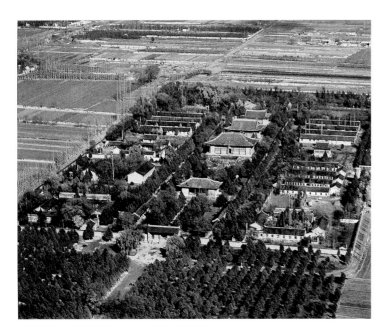

Fig. 1
Aerial view of the Yongle Gong (Eternal Joy Temple), a Yuan dynasty (1260–1368) temple-complex in Ruicheng county, Shanxi province.

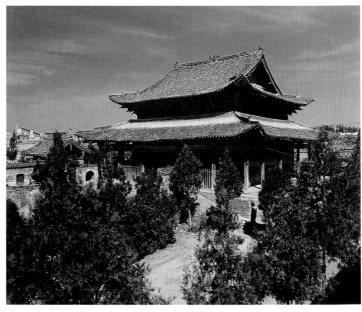

Fig. 2
Shuishen Miao (Water Spirit [or Dragon King] Temple), a Yuan dynasty temple completed by 1319, in Hongdongxian, Shanxi province.

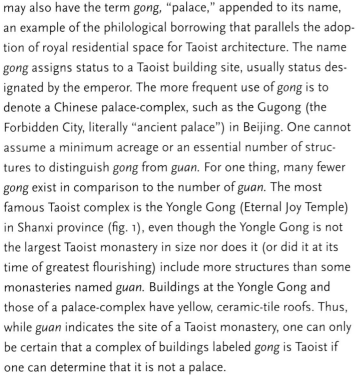

may also have the term *gong,* "palace," appended to its name, an example of the philological borrowing that parallels the adoption of royal residential space for Taoist architecture. The name *gong* assigns status to a Taoist building site, usually status designated by the emperor. The more frequent use of *gong* is to denote a Chinese palace-complex, such as the Gugong (the Forbidden City, literally "ancient palace") in Beijing. One cannot assume a minimum acreage or an essential number of structures to distinguish *gong* from *guan.* For one thing, many fewer *gong* exist in comparison to the number of *guan.* The most famous Taoist complex is the Yongle Gong (Eternal Joy Temple) in Shanxi province (fig. 1), even though the Yongle Gong is not the largest Taoist monastery in size nor does it (or did it at its time of greatest flourishing) include more structures than some monasteries named *guan.* Buildings at the Yongle Gong and those of a palace-complex have yellow, ceramic-tile roofs. Thus, while *guan* indicates the site of a Taoist monastery, one can only be certain that a complex of buildings labeled *gong* is Taoist if one can determine that it is not a palace.

Two other terms are more ambiguous. *Miao,* widely translated as "temple," can refer to a single Taoist building, usually enclosed in its own courtyard: such is the case with Shuishen Miao (Water Spirit [or Dragon King] Temple), located in Hongdongxian in Shanxi province (fig. 2).[2] Yet *miao* refers also to a complex of buildings as vast as any Buddhist monastery *(si)* or Taoist monastery *(guan* or *gong).* Temple-complexes to sacred

Taoist peaks, for instance, are named *miao,* as in Beiyue Miao, the Temple to the Northern Peak (fig. 3). But the same nomenclature also refers to Confucian building groups. In Confucian construction, the range of *miao* spans the most eminent among them, Kong(zi)miao, the Temple to Confucius, including the most splendid one located near the town of the sage's birth in Shandong province, as well as Confucian temple-complexes in provincial towns and single shrines to Mencius or any other Confucian disciple. *Miao,* however, should never refer to a Buddhist complex.

Similarly vague is the suffix *ci.* It, too, can be appended to the name of one building or a group of buildings. Alone, *ci* is a shrine, sometimes called "veneration temple," for the veneration of a mortal, a folk hero, or a semi-legendary figure who has achieved near-deity status. With time, *ci* came to house images worshipped in popular religious practice; but the initial purpose of *ci* was for veneration rather than worship. Thus, like *miao, ci* most often are found in worlds of Confucianism and Taoism. Technically, *ci* should not house Buddhist deities. Yet a *ci* dedicated to a mortal associated with a Buddhist monastery may be present within its outermost enclosure. For groups of buildings, the most famous example of *ci* is Jin Ci, generally known as the Jin Shrines, today a huge complex of structures and landscape architecture in Shanxi province, but originally perhaps a single shrine to venerate the mother of an emperor (fig. 4).

Among groups of Taoist buildings, individual ones are most

often called *dian,* for more important halls, and *tang,* for simpler or less-distinguished halls. In this case, the distinction is apparent by structural features from roof construction to bracketing, to foundation platform and pillar bases. Both *dian* and *tang* are suffixes for names of halls at sites of any religion, at palaces, and at official bureaus. The distinctions between *dian* and *tang* have a history as old as the recorded history of Chinese architecture.[3] Another universal in Chinese architecture—religious and residential—is the term *yuan,* "courtyard" or "cloister," a reference to the fact that Chinese buildings face onto open courtyards and are enclosed inside or as part of covered arcades or walls. For religious buildings, one finds *yuan* translated as "temple," "temple-complex," or "monastery."

Historically, the nomenclature of Chinese halls and building groups has not been applied with the precision one might desire. The multimillennial building history of China is set against an equally old but sometimes more evolving vernacular language. Five hundred years after a shrine was built in a village, we may find it incorporated into a major abbey of what has become a large town, or we may discover a Taoist hall or residence incorporated into or transformed for inclusion in a Buddhist monastery. Old names often persist, and written records do not always precisely reflect the changes a building has endured. Sometimes, a structure of any religious affiliation is called by the locals simply *gusi,* perhaps best translated "old temple."

In this discussion, Taoist buildings are referred to by the Chinese names used for them today. One must keep in mind, of course, that Taoist architecture is living architecture, changing in response to social and political occurrences. Like all religious architecture, the buildings we discuss have received imperial or private patronage, sometimes both. Taoist structures have suffered imperial and Buddhist purges through history, as well as governmental purges also leveled at institutions of other religions during several decades of the twentieth century. Abbots *(fangzhang),* monks *(daoshi),* nuns, and acolytes live in *guan* and *gong* and move from one to another. Primarily and fundamentally, these are not buildings but settings for seeking the Tao (Dao), intensifying one's self-cultivation, defining a relationship with nature, or enhancing or prolonging human life. The life and vitality that may frustrate one's ability to pinpoint a building's name, identify the date of its construction, or determine the extent of its restoration or reconstruction are inherent in religious architecture and are the reasons that these same Taoist buildings exist today.

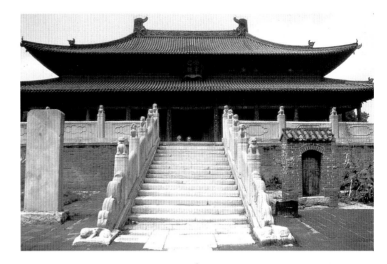

Fig. 3
Dening Dian, a Yuan dynasty hall completed in 1267, part of the Beiyue Miao complex (Temple to the Northern Peak), in Quyang, Hebei province.

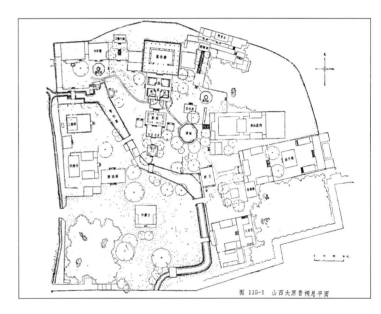

Fig. 4
Plan of Jin Ci (known as the Jin Shrines), a large complex of structures south of Taiyuan, Shanxi province.

II. Taoist Architecture before the Tang Dynasty

The origins of Taoist architecture are believed to have been coincident with the emergence of the religion. The setting for ritual or practice in the early history of Taoism was sometimes outdoors and, notably, in caves.[4] Either location would have served for the veneration of immortals *(xian)*, the practice of ascetics, or the teaching associated with the earliest Taoism. It is also thought that offerings to gods and spirits *(shen)* may have been part of Taoist practice during the first millennium A.D. If so, altars *(tan)* may have been erected for this purpose. Architectural terms found in early writings seem to confirm cave settings and extremely simple shrines or altars for Taoist ritual. The term *guan* ("abbey"), for example, evolved from two usages of the word found in writings that refer to Taoist architecture from the pre-Han dynasty through the period of Northern and Southern dynasties. The first usage, the one common today, had multiple meanings: to look or observe and to ascend or look up (toward the heavens); it also designates a multistory structure. The alternate *guan* has meanings today ranging from inn to guesthouse to public office.[5] It is suggested that the structural *guan* was built of natural materials for such purposes as the observation of heavenly bodies, the worship of those same heavenly bodies or natural phenomena, and the observation of *qi*.[6] During the period of the Warring States, for example, a *louguan*—*lou* meaning "a multistory structure," *guan* meaning "observatory"—stood on Mount Dongnan.

Two other architectural designations that probably refer to Taoist structures are found primarily in writings of the pre-Tang period. *Zhi,* the closest contemporary architectural definition for a place where governing occurs, were constructed in the second and third centuries A.D. as centers of Taoist worship. Their appearance is believed to have been coincident with the rise of the Wudoumi Dao ("Five Pecks of Rice") sect.[7] The use of the term is another example of the borrowing from non-Taoist contexts for the (architectural) terminology of the faith. *Jingshi,* "chambers of quietude," were used by Taoists at the same time as *zhi.*[8] After the appearance of Taoist monasteries, *zhi* and *jingshi* are found less often in Taoist writings. At the same time, caves for Taoist worship or rituals came to be known as *dong,* "grottoes."[9] By the Tang dynasty (618–906), thirty-six were designated *dongtian,* "cavern-heavens." Natural settings designated as Taoist worship spaces were codified into a list at about the same time. They are known as the seventy-two *fudi,* "blessed plots." This kind of codification occurred as Taoism became a more organized reli-gion, following the patterns of Buddhism and practices at the Chinese court.

To the extent that we can discuss Taoist architecture other than caves or natural settings prior to the Tang or Sui–Tang period, it is almost always in the context of great patrons or great masters. Han Wudi (r. 140–87 B.C.), for example, was one of the great patrons of religious architecture. His patronage was tied to his unrelenting pursuit of an elixir of immortality, or at least a means of prolonging his life. Some of the earliest settings associated with Taoism—such as the isles of the King Father of the East, Penglai, Yingzhou, and Fanghu, or Mount Kunlun in the West—are places to which Han Wudi dispatched messengers in search of life-prolonging elixirs. Han Wudi ordered the construction of Feiliangui Guan in his capital city Chang'an and additional *guan* throughout his empire.[10] In the later years of the Han dynasty, the Taoist master Zhang Daoling taught Wudoumi Dao in *jingshi* or *zhi.* In 327 the great alchemist Ge Hong constructed a *guan* for his teachings, but its location was Weimingdong (grotto) on Mount Luofu, suggesting the *guan* still may have been a cave. In 530, during the reign of the Liang emperor Wudi, construction at Mount Mao (Mao Shan) included Chulin Guan and Huayangxia Guan.

The history of Buddhist architecture in the several centuries following the Han dynasty is such that one might have expected to see a surge in Taoist construction of more permanent buildings and larger temple-complexes at this time. The impetus for accelerated Taoist construction should have been the unprecedented building of Buddhist monasteries and the conversion of existing residential architecture into monasteries in Luoyang and the other capitals during the late fifth and sixth centuries. It is a well-known fact that Luoyang, established as the capital of the Northern Wei (386–534) in 493, had 1,367 monasteries, an increase of more than three hundred percent since the first decade of the fourth century when only 42 stood in the Jin capital at Luoyang.[11] Unfortunately, there is very little evidence for contemporary Taoist architecture in the capital.

Taoist subjects common in funerary architecture of the Han (see the essay by Wu Hung in this volume) are still found in subterranean construction during this period. A tomb excavated at Dingjiazha, eight kilometers northwest of Jiuquan in Gansu province, contains among its murals images of the Queen Mother of the West (Xiwangmu), King Father of the East (Dongwangfu), a three-legged crow in the sun, a toad in the moon, a white deer, and a host of winged animals and humans.[12] Knowing nothing of the occupant except that he was an official, and with a date of 386–441 based on which of the Sixteen Kingdoms

controlled this part of Gansu at the time when a tomb with this plan and these murals might have been made, nothing inside the tomb proves its architecture or its occupant to be Taoist. The tomb structure, two chambers of rectangular plan, one with a barrel-vaulted ceiling and the other with walls that curved from all four sides to a small square at the apex, can be found in funerary settings in any part of China or at her borders between the fourth and sixth centuries.[13] Yet lacking scenes more explicitly associated with Confucianism such as stories of filial piety, and lacking Buddhist imagery, there is a good possibility the tomb-builder considered Taoist belief in the choice of themes for the murals. If so, then below the ground as well as above, the funerary architecture of Taoism was indistinguishable from contemporary non-Taoist construction for the same purpose.

III. TAOIST ARCHITECTURE IN THE TANG DYNASTY

Although still not as heavily patronized as Buddhist monasteries, by the Sui–Tang period Taoist architecture had a significant presence in the Chinese capitals and existed in the countryside. As at earlier times in Chinese history, the greatest patrons of large-scale Taoist temple-building were emperors and empresses, beginning with the founder of the Sui, Wendi. His capital city Daxing (Chang'an in the Tang dynasty) had headquarters for both Buddhism and Taoism, the former occupying an entire metropolitan ward on the east side of the city and the latter of smaller size on the west. It is said that at the beginning of his reign, Sui Wendi's capital had 120 Buddhist monasteries and 10 Taoist ones.[14] Probably the number of Taoist abbeys grew proportionate to the number of Buddhist monasteries in the capital in Tang times. The number of Buddhist institutions in Chang'an prior to the persecution of Buddhism during the Huichang reign period (in 845) has been calculated at 156.[15] Although the number of Taoist establishments has been recorded only at 16 during the Kaiyuan reign period,[16] the strong presence of Taoism inside the imperial sectors of Chang'an and the suggestion that a revival of Taoism occurred concurrent with the Huichang persecutions probably means well more than 16 abbeys were in the capital in the seventh to ninth centuries.[17]

At least four Taoist building complexes stood inside the wall-enclosed imperial palaces of Chang'an, two at the first imperial palace site, Taiji Gong, and two at the detached-palace site, Daming Gong, where construction began during the reign of the second Tang emperor, Taizong (r. 627–49) and flourished under the third emperor, Gaozong (r. 650–83). Two of those were halls of the Three Purities (Sanqing Dian), one at each

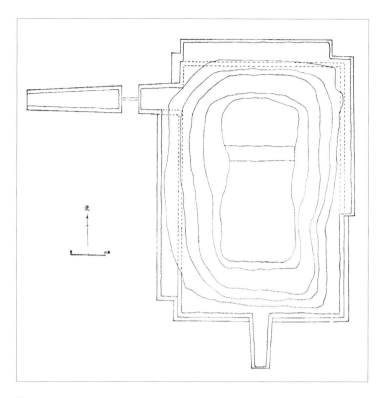

Fig. 5
Plan of Sanqing Dian (Hall of the Three Purities), a Tang dynasty hall within the Daming Gong palace-complex at Chang'an (Xi'an), Shaanxi province.

palace complex. The Hall of the Three Purities at the Daming palace-complex has been excavated.

Located in the northern part of the Daming Gong, just inside and east of the northern gate, Qingxiao Men, the Hall of the Three Purities was elevated on an enormous earthen platform. Measuring 73 meters from south to north and 47 meters east–west, the earthen-foundation platform rose 14 meters in height (fig. 5). Based on excavated remains, archaeologists have suggested that this hall was a multistory structure with a simple, hipped roof, the roof type reserved for the most eminent Chinese structures. Yet beyond this description, few details are certain. The hall could be approached from two sides. One approach, from the south center, measured 14.7 meters in length and was made up of steps. The second, on the northern part of the west side, was 44.3 meters, suggesting comparison with Tang period ramps known as *mandao* or, in spite of its northwesterly position, the magnificent Dragon Tail Way approach to Hanyuan Dian at the same palace-complex.[18] Like Dragon Tail Way of the Hanyuan Dian complex, the approach to the Hall of the Three Purities was made of decorated brick and lined with a stone balustrade.

Tang Xuanzong (Minghuang) (r. 712–56) was a great patron of Taoism. In the first month of 741, he ordered the establishment of a *miao* to Xuanyuan Huangdi (Laozi) in Chang'an, Luoyang,

and each prefectural capital, as well as academies for the study of Taoism (chongxuanxue) in which the Daode jing and the writings of Zhuangzi, Liezi, and Wenzi were taught.[19] Later that year, the emperor had a dream in which Laozi instructed him to search for his portrait west of the capital and upon finding it, to hold a ceremony for him in Xingqing palace-complex. Thereupon, Datong Dian was constructed at his residential palace in the Longqing ward of Chang'an. It was the first time it can be documented that Laozi was worshipped by a Chinese emperor in a hall for that purpose in the capital city.[20] As mentioned above, the same Tang emperor worshipped Laozi at Mao Shan in 751. The next year, officials reported sighting Laozi above or near locations in both Chang'an and Luoyang.

In 743 the miao to Xuanyuan Huangdi at both Tang capitals were renamed Taiqing Gong and Taiwei Gong. The plan of Chang'an's Taiqing Gong is recorded, as is information about its paintings and statuary. The focal point of the interior was a statue of Laozi in imperial garb, flanked by statues of Xuanzong and two high-ranking officials. Upon their fall from imperial favor, the latter two were replaced by statues of Confucius and four realized beings (zhenren): the philosophers Zhuangzi, Liezi, Wenzi, and Gengsangzi.

The name Taiqing has astronomical as well as Taoist connotations. Astronomy had been under the jurisdiction of the Chinese court since earliest times and palaces had been named after astronomical bodies from as long ago as records of names of palace halls exist.[21] Thus, as was the case in the tomb at Dingjiazha, the relationship between a label of "Taoist" and more generally the realm of imperial or high-ranking China was close.

IV. TAOIST ARCHITECTURE IN THE TENTH THROUGH EARLY THIRTEENTH CENTURIES

Beginning in the dynasties that follow Tang, Taoist architecture can be studied through actual buildings. For this period, about a dozen extant buildings, most of them dated, are noteworthy. To understand the full impact of Taoism on architecture at this time, however, one still needs to refer to textual records.

While the Song dynasty ruled from Bianjing (Kaifeng) during the part of the empire's history called Northern Song (960–1126) and then from Lin'an (Hangzhou) during the shrunken Southern Song dynasty (1127–1279), North China and the lands that bordered it were controlled by the Liao (916–1125) and Jin (1115–1234) empires. Although he brought no Chinese religion with him from his birthplace in today's Chifeng county of Inner Mongolia, Abaoji (r. 907–26), the first ruler of the group who

would found the Liao dynasty, built temple-complexes of Confucianism, Buddhism, and Taoism at his capital, Shangjing, today Balinzuoqi, in Inner Mongolia, in the year 918. The text is specific: Kongzimiao (Confucian temples), Fosi (Buddhist monasteries), and Daoguan (Taoist abbeys) were constructed.[22] The following year, Abaoji's wife Yingtian and the crown prince were instructed to worship at si and miao separately.[23] Yet it is not certain that more than one abbey existed in the capital. The dynastic history of the Liao provides only one name, Tianchang Guan, located at this capital during the reign of the second ruler, Deguang (r. 927–47).[24] Compared to the countless Buddhist monasteries named in the Liao history, and a temple to the dynastic ancestors at their ancestral capital Zuzhou, also in Chifeng county, the early establishment of an abbey was probably recognition of, even deference to, the Chinese religious system in general, deemed necessary by the first ruler as part of his symbolic movement toward Chinese-style rule. There is no evidence of extant Taoist architecture in Liao times nor does Taoism seem to have had a significant impact on Liao culture.

The situation in China under Jin rule (1115–1234) was completely different.[25] Tremendous changes occurred in Taoism at this time, three of which have particular relevance to architecture. First is the syncretism of Buddhism, Taoism, and Confucianism known as Sanjiao heyi, a phenomenon that was not new during the Jin period, but was more important than it had been earlier in China. Second was the emergence of new Taoist sects, of which Quanzhen Taoism had the greatest impact on building history. Third, another Tianchang Guan was constructed, this one in the Jin central capital, Zhongdu, today Beijing.

Syncretism of the three creeds and the particular impact of this syncretism on Taoism are explained in the essays by Stephen Little and Kristofer Schipper in this volume.[26] As for Tianchang Guan, it has been called the most important Taoist monastery in Jin China.[27] Rebuilt between 1167 and 1174 by imperial patronage on a monastic site that had existed since the Tang dynasty, Tianchang Guan today is Baiyun Guan (White Cloud Monastery), the major Taoist monastery in Beijing. Images including the Three Purities were housed inside one of its halls and a nearby mountain was designated for monks from Tianchang Guan to refine cinnabar pills. Performance of the jiao offering ceremony there in 1190 was believed to have cured the emperor's mother, whereafter the ties between this abbey and the imperial Jin household were even stronger.[28] Masters of all Taoist sects prevalent in the Jin dynasty who were summoned to the capital by the emperor stayed at Tianchang Guan, including the founders of the Taiyi and Quanzhen sects. Tianchang Guan

seems to have flourished under Jin rule in spite of several imperial bans on construction by the general populace of Buddhist and Taoist monasteries, for it is not certain they were upheld.[29]

The most important existing building associated with Taoism during the centuries between the fall of the Tang and the onset of the Mongol rule, the Yuan dynasty, is the Song period Sage Mother Hall (Shengmu Dian), which stands today as the focus of the Jin Shrines (Jin Ci) about 25 kilometers south of Taiyuan in Shanxi province (figs. 4 and 6). Many exterior and interior features of Sage Mother Hall are unique.

The first of them is the approach to the hall, a cruciform-shaped, white-marble bridge. The hall itself is a seven-by-six-bay structure with an additional, open bay across the front. That bay is marked by gilt dragons that wind around the pillars. In addition to the approach and pillar decoration, other unique features of the hall (among extant Song buildings) are eight-rafter-long beams that span the entire length of the hall. These three features combine with the seven-*puzuo* bracketing, the second most eminent bracket-set type described in the building manual of the Song court, *Yingzao fashi* (Building standards), and the most eminent variety in an existing building, to define the importance of the Sage Mother Hall.[30]

These details suggest that the Sage Mother Hall is an example of Song imperial architecture. In fact, like other buildings whose architectural details represent the highest-ranking structures codified by the Chinese system, the Sage Mother Hall straddles the labels Taoist and Confucian. Its history begins with a revered mortal, the mother of Prince Shuyu of the Zhou dynasty. A structure in which to pay homage to her is precisely the purpose of a shrine, *ci*. With time, the Sage Mother came to be worshipped. In the Song dynasty, when the present hall was constructed, she was enthroned with images of her female attendants, many of which remain in the hall today. The association with Confucianism, or what might better be called the Chinese bureaucratic tradition, thus is traceable to the original purpose of the hall, including the construction by a prince to pay homage to his ancestor, and to the fact that the structure of the hall is the closest known to what buildings in the Song palaces at their capital Bianjing might have looked like. The Taoist associations for this structure and site are due to the fact that the local populace came to believe the Sage Mother could aid those who worshipped her, and to the importance of natural phenomena, most importantly, water.[31] The Taoist context is confirmed by other buildings in the Jin Ci complex. These include "grottoes" to Laozi, the Three Purities, the Three Heavens, and the Yellow Emperor; shrines to the Three Purities, the Eastern Peak,

Fig. 6
Shengmu Dian (Sage Mother Hall), a Song dynasty hall within the Jin Ci complex, south of Taiyuan, Shanxi province.

the Three Sages, and Lu Ban; pavilions to Lü Dongbin, the Three Officials, Zhenwu, and various immortals; temples *(miao)* to Caishen (the god of wealth), the Dragon King, the spirits of the mountains, the Emperor Guan, Taitai, Lingguan, and the god of the earth; and a "palace" dedicated to Wenchang (the god of literature). The site and surrounding area contain about half that number of Buddhist halls and complexes. Few are dated and most have a history long enough to include multiple construction periods. Among all the buildings and as a composite group, nothing architectural offers an obvious clue to the Buddhist, Taoist, or other purposes of any of them.

Although on mostly flat ground, Jin Ci rambles and lacks focus, much in the manner of a Taoist mountain-temple. In fact, it is more lacking in single focus than many of the temple-complexes located in mountain terrain discussed in the last section. Jin Ci developed, like many of the later Taoist monasteries on mountains, in response to local worship needs and patronage. Several building complexes constructed around courtyards at this site can be considered focal points of the whole (see fig. 4).

Another Northern Chinese temple-complex that received imperial patronage but whose focal deity places it between Taoist and Confucian contexts is the Houtu Miao, the Temple to the Earth God. First built in 1006 during the Song dynasty, its site at Fenyang was destroyed by flood in the sixteenth century. The original layout of the temple-complex is preserved on a stele of 1137 from the Jin period which, similar to another Jin period stele

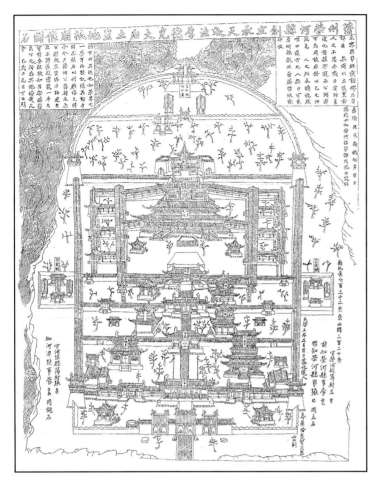

Fig. 7
Line drawing of a carving on a stele of 1137 showing the plan of Houtu Miao (Temple to the Earth God), a Song dynasty temple-complex constructed in 1006, in Fenyang, Shanxi province.

of a different Taoist building complex, the Temple to the Central Peak in Dengfeng county, Henan, shows a structural group almost as large as Jin Ci, but focused along a single axial line (fig. 7).[32] Today the Houtu Miao grounds are used for a kindergarten. Inside the hall are exquisite murals of Taoist divinities dated to the Ming dynasty.

Xuanmiao Guan was built in Putian, Fujian province, a decade after the Temple to the Earth God at Fenyang. Nothing is known about the original layout of the abbey. Today the Hall of the Three Purities survives with much of its early-eleventh-century appearance intact, and halls to a god named Tiandi and the Eastern and Western Peaks remain from later times.[33] The most noteworthy features of the Hall of the Three Purities (fig. 8) in Putian are its gracefully sloping exterior roof eaves and similarly exaggerated curved beams, both typical of southern Chinese architecture; and the bracket sets that project perpendicularly to the building plane along five steps. The last feature is characteristic of architecture in south China during the Northern Song dynasty. The building most similar in structure to the Hall of the Three Purities of Xuanmiao Guan is Daxiongbao Hall of the Buddhist monastery Baoguo Si, constructed three years earlier in 1013 in Yuyao county, close to Ningbo, in Zhejiang province. Both represent a style of southern Chinese architecture transmitted to Japan at the beginning of the Kamakura period (1185–1334).[34] Today devoid of images and used as a building for the local middle school, this structure—apart from its name—bears no signs of the Taoist associations of the hall or its monastery.

The fate of five Taoist halls in Jincheng county of Shanxi prov-

Fig. 8
Sanqing Dian (Hall of the Three Purities), the main hall at the Northern Song dynasty Xuanmiao Guan, constructed in 1016, in Putian, Fujian province.

ince is similar. The Middle Hall and the Hall of the Jade Emperor at Yuhuang Miao, both dated 1076, stand in a ruined state, their interiors used for storage.[35] The Main Hall of the Erxian Guan, the Two Immortals Abbey, dated c. 1107, is likewise closed from public view, but a few pictures of its altar and the Song period Taoist sculpture in it exist (see fig. 9).[36] Two buildings constructed between 1161 and 1189 remain at the Temple to the Eastern Peak in Jincheng, together with Buddhist structures at the same site. A destroyed building studied in the 1930s by the Society for Research in Chinese Architecture, may, as its name suggests, have had Taoist imagery inside of it: the Yuhua Gong at Yong-shou Monastery in Yuci, Shanxi, had a date of 1008.[37]

It is probably not coincidence that all but one of the buildings discussed so far are or were in Shanxi province. It has been recognized since the initial modern investigations of traditional Chinese architecture that more old buildings remain in Shanxi than in any other Chinese province.[38] This is true for both Buddhist and Taoist architecture. It is not certain that Shanxi was a more "religious" province than others, but the amount of architecture may have to do with the fervor of Taoists, including the rise of the Quanzhen sect in Shanxi during the Jin period, and an overall religious atmosphere that contributed to that rise. Another factor in the importance of religious architecture in Shanxi must be the presence of the sacred Buddhist mountain Wutai in the north center of the province. That mountain necessitated places for pilgrims to stay en route from every direction. At the end of the twentieth century, however, each of the buildings mentioned here and indeed almost every religious complex in the province, Buddhist or Taoist, except those on Wutai Shan, in the major cities of Datong and Taiyuan, and the Yongle Gong, all of which generate tourist revenue, have long since ceased to be religious sites. Instead, Shanxi's architecture has been locked up to prevent theft and desecration and each building, including those on the grounds of schools, bears serious signs of weathering and other damage resulting from neglect through the centuries.[39] Only occasionally has a temple-complex of Taoist associations beyond the main tourist route through Shanxi been maintained. One example is Zetian Shengmu Miao, the Temple to the Sage Mother Empress Wu (Zetian) in Wenshui county. One hall, dated to 1145, remains, but the images in this living temple are new.

One building, the Hall of the Three Purities at Xuanmiao Guan in Suzhou, dated 1176, represents Taoist architecture of the Southern Song (fig. 10). Like the main hall from Xuanmiao Guan built in Putian in the early eleventh century, the Hall of the Three Purities in Suzhou is an excellent example of southern

Fig. 9
Interior view of the main hall at Erxian Guan (Two Immortals Abbey), dated c. 1107, in Jincheng county, Shanxi province, showing a portion of an altar with Song period Taoist sculptures.

Fig. 10
Sanqing Dian (Hall of the Three Purities), the main hall at the Southern Song dynasty complex Xuanmiao Guan, dated 1176, in Suzhou, Jiangsu province.

Chinese structure of the period, boasting gracefully sloping roof eaves but a somewhat rigid interior structure. Today the focus of a shopping arcade, it too bears nothing but its name to suggest that it is a Taoist building.[40]

Beyond these structures, the rest of the picture of Taoist architecture on the Chinese landscape during this period must be filled in through literary sources. They record at least two Song emperors to have been serious patrons of Taoist monasteries. The third Song emperor, Zhenzong (r. 998–1023), enacted a ceremony in which he received the "heavenly teachings" and ordered the construction of Abbeys to Celebrate the Heavens (Tianqing Guan) throughout the empire.[41] The involvement with Taoism of Song Huizong, who styled himself a Taoist master (daojun), is the subject of the essay by Patricia Ebrey in this volume. Among his building projects was Yingzhen Guan, a Hall for Welcoming the Perfected.[42] During the rule of the Southern Song, more than thirty Taoist monasteries were constructed in the capital Lin'an (Hangzhou).[43]

Taoist construction was spread between urban and mountainous settings in Song China. Two of the most famous Song Taoist temple-complexes were Chongfu Gong on Mount Song (the central of the Five Sacred Peaks) in Henan province and Zongyang Gong (also known as Dongxiao Gong) on Mount Dadi outside the city of Lin'an. The latter is said to have been so expansive that its approach wound nine kilometers from the front gate to the main hall. The Song is also the period during which the first Bixia Ci on Mount Tai (Tai Shan), to be discussed below, was erected.

Six structures should have been present in the majority of Taoist monasteries of the Song period. First was the *shen dian*, a "spirit hall," for sacrificial rites. Second was the *zhai guan*, a hall for vegetarian or *maigre* feasting in preparation for *xiuzhen* (cultivating perfection). In addition there would have been a scripture repository, often two-storied, for housing sacred texts; a hall for teaching or preaching the Taoist law; guest halls; and garden architecture.[44] Each had an equivalent space in contemporary Buddhist construction.

V. Taoist Architecture in the Thirteenth and Fourteenth Centuries

Probably dozens of Taoist buildings survive in China from the thirteenth and fourteenth centuries, the period of the surge of Quanzhen (Complete Realization) Taoism in the north, and sects at Mount Mao (Mao Shan) and Dragon and Tiger Mountain (Longhu Shan) in the south. As buildings are studied and

as heretofore unknown inscriptions or records emerge, the list of architecture from this period grows. So far, a large percentage of halls that survive from the thirteenth and fourteenth centuries are in Shanxi, as is the case for survivals from earlier centuries.[45] Again, the history of Taoist construction and patronage of Taoist monasteries is tied to the government. Yet, unlike in the past, the rulers of all of China during the century from 1271 to 1368 were Mongols. Their interest in Taoism is as easy to document as that of early rulers including Han Wudi or the Song emperor Huizong, but the nomadic origins of this group have roused more interest in court patronage of Taoism than has been the case for most other periods of Chinese history. Imperial Mongol interest in Taoism has been viewed both as a means of imperial legitimation, serving the purpose Chinese religions had for every ruler on a Chinese throne since at least the Northern Wei dynasty, and as an aspect of the uniquely Mongol attitude toward religion. Beginning with Chinggis Khan's famous interview of the Quanzhen master Qiu Chuji at the Mongol's camp, one interpretation of the Mongol attitude toward Taoism has been that it is an example of the openness to any philosophical system that might enhance or prolong life or whose masters might be able to influence Mongol designs at universal domination. Attitudes at the Yuan court occasionally gave way to a kind of ecumenicism whereby institutions of all faiths were patronized, especially by Mongol imperial wives. Yet the same openness to religion gave way to court-sponsored debates between Buddhism and Taoism, some intense strife between the religions, and occasional warfare.[46]

Buildings of superlative quality at three sites represent not only the heights of Taoist construction during the centuries of Mongol rule in China, but also the most eminent architecture to survive from these centuries in China. Each of them should be considered against the backdrop of Mongol and religious politics during the period from the rise of new sects under Jin rule through the collapse of the Chinese portion of the Mongol empire to the Ming dynasty.

Four examples of Yuan period (1260–1368) Taoist architecture in China are seen at the Yongle Gong, the Eternal Joy Temple, located in Ruicheng county at the southern tip of Shanxi province. The uniqueness of their survival was such that in 1959 these four structures were moved upriver from their original location in Yongji in order to preserve them while making way for a reservoir.[47] Yongle Gong is intimately connected to a patriarch of Quanzhen Taoism, Lü Dongbin. One of the Eight Immortals, some legends of Lü Dongbin trace his birth to the Tang dynasty in the vicinity of the original town of Yongle, where a

veneration shrine to him was erected after his death.[48] A shrine to Lü Dongbin probably stood at the future site of Yongle Gong in the Tang dynasty. By the Northern Song dynasty, it had become a temple-complex. Whatever buildings were at the site in Jin times were destroyed by fire in 1244. Just three years later, even before the Mongols established their supremacy in all of China, reconstruction began under their sponsorship. It is probably this association with the rulers that gave way to the designation of *gong*.

Yongle Gong's three main halls were rebuilt between 1247 and 1262. The gate known as Wuji Men was completed shortly afterward. The four stood on a line, the gate farthest south and halls to the Three Purities (Sanqing), Lü Dongbin (Chunyang), and the historical founder of Quanzhen Taoism, Wang Zhe (Chongyang; 1112–1170), behind it. In subsequent dynasties a gate was added farther south and halls were built on either side of the long axial line (see fig. 1).

The Hall of the Three Purities (Sanqing Dian) is the crown of the Yongle Gong. Elevated on a white marble platform, 28.44 meters across the front and 15.28 meters in depth (seven by four bays), a huge *yuetai* ("moon terrace"), 15.6 by 12.15 meters, projects in front of it. The size of a hall itself, this large front platform is a common feature in Taoist halls of the Yuan period, and it may have provided space for ceremonies. Approach to the *yuetai* is from the sides: stepped ramps known as *tadao* lead to "ear platforms" on either side. Besides the high platform, a feature that defines the Hall of the Three Purities as a structure of high rank in the Chinese building system codified in Song times is the use of six-*puzuo* bracket sets. The *puzuo* number is an important factor associated with a building's eminence or lack of it. The Song system stipulates fundamental bracketing configurations, or *puzuo*, of which no. 8 is the highest and no. 3 is the lowest. The highest *puzuo* number extant in Yuan structures is six, the formation employed at the Hall of the Three Purities.[49] In addition to the platform and bracket sets, the simple, hipped roof and the three lanterns, or cupolas *(zaojing)*, of its ceiling are marks of a distinguished structure. Features that define this hall as a Yuan structure are the presence of two struts in the form of bracket sets between the pillar-top bracketing across the front façade and the suggestion of three cantilevers, which are in fact decorative ends of bracket-arms and thus "false" cantilevers, on the corner bracket sets of the front façade and hall interior.[50]

The structures of the halls to Lü Dongbin (Chunyang Dian) and Wang Zhe (Chongyang Dian) at the Yongle Gong provide equally good evidence of architecture of the Yuan period but

of slightly less eminence than the Hall of the Three Purities. Possessing the two intercolumnar bracket sets and the suggestion of three cantilevers that define Yuan period architecture, the bracket clusters of Chunyang Dian are six-*puzuo* and those of Chongyang Dian are five-*puzuo*. The numbers are in accordance with the placement of the halls in the monastery and the importance of the subject of the hall's dedication. Second after the Three Purities in the scheme was Lü Dongbin, and, after him, Wang Zhe. Befitting buildings slightly less prestigious than the main hall, but at a major monastery, are the hip-gable combination roofs that top both Chunyang Dian and Chongyang Dian and the presence of one *zaojing* in each of their ceilings. As for a feature that may define these as Taoist halls, the oversized *yuetai* approached from the sides also is present at both.

One cannot help but notice the lack of doors or windows on all sides but the front of the three Yuan period halls and the gate at the Yongle Gong. Although rare in Chinese architecture, in general, such construction is usually a sign that all possible interior wall space was needed to accomplish a painting program. Certainly that was the case at the Yongle Gong. Equal to its importance as a site of Taoist architecture is the fact that the Yongle Gong is a repository for 842 square meters of Yuan period Taoist wall painting. The names of the halls relate to the central figures of worship within.[51] The Hall of the Three Purities, for example, contains murals of over two hundred members of the Taoist pantheon paying homage to statues of the Three Purities (now lost). Similarly, legends of Lü Dongbin and Wang Zhe are the subjects of the images in Chunyang Dian and Chongyang Dian, respectively (fig. 11). The legends are set against architectural backgrounds, providing the most extensive source of paintings of architecture from the period. Although like most Chinese painting of architecture, exaggeration and idealization are evident in the murals, a few details are specific to the period. These include two sets of intercolumnar bracket sets, corner bracket sets with three diagonal projections, and large *yuetai* with detailed, carved decoration.

The structure of Dening Dian, focus of the Temple to the Northern Peak complex (Beiyue Miao) in Quyang, Hebei, is as extraordinary as that of Sanqing Dian (fig. 3). Dening Dian was constructed in 1267, probably within fifteen years of Sanqing Dian and within about a decade of the initial construction of Khubilai Khan's imperial city at Dadu.[52] Not only do the two Yuan halls share architectural components that designate structural eminence during the Yuan period including elevation on a high marble platform, six-*puzuo* bracketing, two sets of intercolumnar bracket sets, and the hipped roof, but additional features not

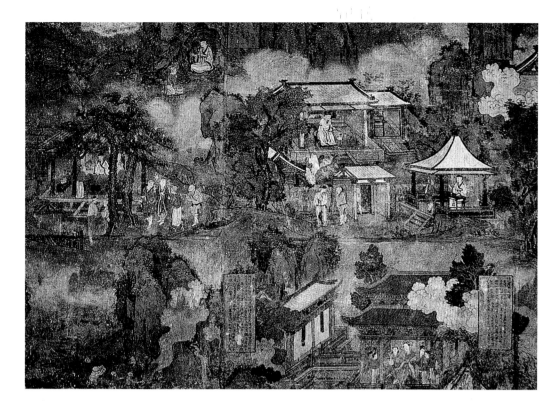

Fig. 11
Detail of a wall painting from Chunyang
Dian, the hall to Lü Dongbin, 1262, at
the Yongle Gong, Ruicheng county,
Shanxi province.

present at Sanqing Dian mark Dening Dian as the closest surviv-
ing structure to descriptions of buildings in the Mongol capital.
Those include the double set of roof eaves, the marble balus-
trade and animals that cap its posts, and the heads of animals
on which those posts rest.[53] As at three Yongle Gong halls, an
oversized *yuetai* is positioned at Dening Dian's front. Also as in
the three halls of the Yongle Gong, the interior walls of Dening
Dian were originally covered with murals. Only a few images
survive from the Yuan period, among them those of deities who
bring forth rain. Nine statues, all made centuries after the Yuan
dynasty, are on an altar inside the hall.

Like the Sage Mother Hall of the Jin Shrines, Dening Dian of
Beiyue Miao is a Taoist structure whose architecture exemplifies
the Chinese imperial tradition. The presence of spirits to whom
one prays for rain among the wall paintings and, of course, the
dedication of the site to the Northern Peak, are clear evidence
that the label "Taoist" is appropriate. Besides ambitions of the
Taoist church in the Yuan period, imperial and political motives
led to the construction and placement of the Temple to the
Northern Peak in Hebei. The Liao sought confirmation by the
Lord of the Northern Peak at this site before launching an attack
against Song China. The new Mongol rulers of China decreed
the construction of Dening Dian even before the official found-
ing of the Yuan dynasty and before the completion of the city
walls of their great capital Dadu (Beijing). In Yuan times, Beiyue
Miao was the one Taoist stronghold in a part of northern Shanxi

and Hebei heavily populated by major Buddhist monasteries.[54]

Shuishen Miao, the Temple to the Water Spirit, or Dragon
King (also known as Mingyingwang), the deity to whom interior
paintings at Dening Dian were dedicated, was completed by
the year 1319 (fig. 2). A standard structure with two sets of roof
eaves, one of them hip-gable in form, and five-*puzuo* bracket
sets, the Shuishen Miao has one exterior feature that may indi-
cate its Taoist affiliation: a *yuetai* with two approaches from the
side. Inside, the subjects of its exquisite wall paintings represent
the heights of southern Shanxi, or Pingyang regional style, com-
parable to those at the Yongle Gong, including illustrations of
the world of the Chinese scholar, a painting of a Tang emperor,
and one of the Dragon King himself. The Dragon King Temple,
although in its own enclosed courtyard, is on the grounds of
the Buddhist monastery Guangsheng Si, where repairs of its
Buddhist halls occurred at the same time as those of the
Dragon King Temple.

Among the other extant Yuan period Taoist buildings, both
the Hall of the Five Peaks (Wuyue Dian) at Wuyue Miao in
Fenyang county and the Hall of the Three Purities at Wanshou
Gong in Gaoping preserve Yuan period wall paintings on their
interiors.[55] An isolated hall dedicated to a god named Tangdi in
Bo'ai prefecture, Henan, is an excellent example of the kind of
humble structure that at one time probably stood in every
Chinese town and village.[56] Finally, the Yuan period offers a bit
of information about Taoist tombs and perhaps about a city plan

inspired by Taoist ideals. Northwest of the original Yongle Gong in Yongji prefecture, behind the three main halls, were a shrine *(ci)* to Lü Dongbin and temples *(miao)* to two Quanzhen Taoists who had been involved in the construction of the Taoist palace, Song Defang (1183–1247) and Pan Dechong. In addition, tombs excavated at the site are believed to belong to the three of them. None of the tombs boasts remarkable structure.[57] The presence of the shrines and tombs, however, is yet another indication that the Buddhist practice of veneration and burial of monks and laymen deeply involved in a monastery's founding, expansion, or history had its counterpart in Taoist monastery construction.

As for cities, throughout Chinese history no city can be described as Taoist, certainly not to the extent that one thinks of Northern Wei Luoyang as a Buddhist city. However, unique evidence about Shangdu (Xanadu), the capital founded by Khubilai Khan at Kaipingfu (today Duolun [Dolonnur], Inner Mongolia) in 1256, suggests that Taoist practice may have been a basis for its design. Eight great monasteries were positioned roughly at the four cardinal directions and the four corners of the Shangdu palace-city. One can interpret this plan as the realization of a mandala, such as the configuration at the focus of the Womb World Mandala, in which each monastery would represent an esoteric deity. However, a second interpretation is possible. Designed by a Chinese official in Khubilai's service, the construction program may also be a reference to the eight fundamental trigrams of the *Book of Changes (Yi jing),* whereby the Huayan Monastery and Qianyuan Monastery, in the northeast and northwest parts of the palace-city, would have been associated with the trigrams *gen* and *qian,* respectively.[58]

VI. TAOIST ARCHITECTURE AFTER 1368

The majority of Taoist architecture we see today was constructed after the return to native Chinese rule by the Ming dynasty in 1368. Post-fourteenth-century Taoist buildings survive in every province, in their cities and towns and in the countryside. Almost every active Taoist monastery has a building history that can be documented from the Ming dynasty onward and a history that is much older.

For those outside of China, the best-known of China's active Taoist monasteries are on sacred peaks, in major cities, or in extraordinary natural settings. The architecture of Tai Shan, Wudang Shan, and Baiyun Guan are examples of this group. These or others like them such as the Temple of the Eastern Peak in Beijing have come to the attention of the non-Chinese public also because information about them is available in West-

ern languages.[59] Yet there are abbeys that remain remote whose architecture and interior wall painting are of equal or superior quality. In this final historical section, Taoist sites that represent the range of construction in living monasteries are discussed.

Tai Shan, or Mount Tai, would be on almost any list of the most significant sites of Taoist architecture in China. Located in central Shandong province, since the beginnings of Chinese imperial history Tai Shan has been Dongyue, the Eastern Peak. Burnt offerings are said to have been made at Mount Tai even earlier, since the age of the legendary emperors.[60] Legendary emperor Shun is said to have initiated the practice that came to be called inspection tours *(xunshou)* of his realm, beginning at Mount Tai in the east, the direction of the rising sun. Both Qin Shihuangdi and Han Wudi made sacrifices there. Tang Gaozong performed the *feng* and *shan* sacrifices at Tai Shan on the same tour as he made sacrifices to Confucius at a temple near the sage's birthplace in Qufu, Shandong, and to Laozi in Anhui, during 665–66.[61] Besides enactment of the imperial sacrifices of *feng* and *shan,* performed by these three emperors and perhaps only three others, the last in 1008,[62] its associations with the sacred privileges of the Chinese emperor were so strong that a Hall of Light (Mingtang) was constructed on Tai Shan.[63] Yet again one observes the unique blending of Taoism and Confucianism at a Taoist site that received imperial attention.

Contrasting Tai Shan's fundamental place in imperial ideology is the reason that probably brought emperors there in the first place: the mountain itself is a deity.[64] Tai Shan's eminence even among the sacred peaks is due to its proximity to the Eastern Sea, where the isles of Taoist immortals Penglai, Yingzhou, and Fanghu were believed to be. Furthermore, the Lord of Tai Shan is believed to control the fate of the Chinese emperor. Like most of the Taoist ceremonial sites discussed thus far, Tai Shan bridges the world of the emperor's Confucian responsibility to his state and the Taoist quest for immortality and belief that natural phonomena are sacred. Yet when one turns to architecture, little about the buildings that stand or are said to have stood on Tai Shan presents itself as identifiably Taoist. The two building-complexes most central to Tai Shan's purposes, Dai Miao and Bixia Ci, can serve as examples.

Dai Miao, or Dai Temple, is dedicated to the god of the mountain himself. Among the multitude of spirits gathered at the Eastern Park, he is the ultimate one and thus it is fitting that his temple should exhibit the most splendid architecture at the site. The building history of Dai Miao can be traced to the Eastern Han. Later construction occurred under three emperors famous as Taoist patrons, Tang Xuanzong and Song Zhenzong and Hui-

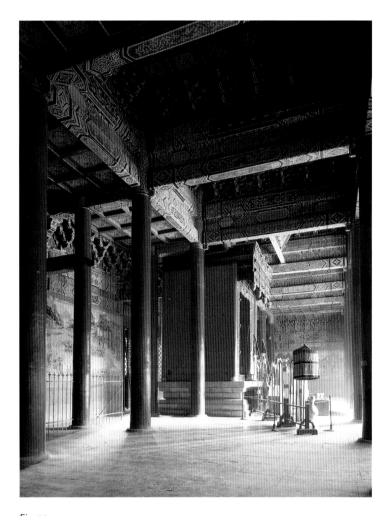

Fig. 12
Dai Miao (Dai Temple), a Qing dynasty structure on Tai Shan (Mount Tai, the Eastern Peak; also called Dongyue), Shandong province.

zong. The main temple does not survive from those times, but probably it was a Tang or Song equivalent of the Qing structure we see today (fig. 12). A Qing imperial building in every respect, the main temple has more in common with the Hall of Supreme Harmony in Beijing and Dacheng Dian of the Confucian Temple in Qufu than with any other structure in China.

Bixia Ci, or Bixia Shrine, dedicated to the Sovereign of the Clouds of Dawn (Bixia yuanjun), is in a more mountainous setting. Still, it consists of four main halls enclosing the four sides of a courtyard—an excellent example of the fundamentally Chinese principle of spatial enclosure called *siheyuan*—as well as a pavilion inside that courtyard, and additional, symmetrically placed towers or pavilions. The halls and arrangement are indistinguishable from those of a Buddhist or residential courtyard. One needs to enter a hall and see an image of Bixia yuanjun to know it is a Taoist site. Like the architectural complexes, pictures of them reveal little of their Taoist affiliations. *Clearing Sky after Snow on the Purple Empyrean Palace at Mount Wudang* (cat. no.

109) is an example. The actual Purple Empyrean Palace (Zixiao Gong) at Wudang Shan dates to the fifteenth century. Nestled in a beautiful landscape is a rigidly presented architectural group. The triple-entry gate and the main hall behind are impressively similar to the actual hall, including the long approach to it and extremely high double-layer platform on which it is elevated (fig. 13). The height of the hall is noteworthy, recalling the elevation and approach to Dening Dian at the Temple to the Northern Peak in Quyang (fig. 3) and to Dai Miao. Xie Shichen wrote in his inscription that he painted from memory. Perhaps he did, but if the painter wanted to refresh his memory he could have entered any religious complex of his day. Nothing at the actual hall, except perhaps the elevation and approach, and nothing in the painting, marks the main hall of Zixiao Gong as the place where Zhenwu overcame the forces of the dark northern quadrant.[65]

Guan Huai's *Taoist Temples at Dragon and Tiger Mountain* (cat. no. 151) exemplifies the generic aspect of paintings of Taoist architecture such that the plans could as easily be those of Buddhist monasteries, on the one hand, and a kind of specificity whereby this hanging scroll provides detailed information about a monastery now lost, on the other. Nothing survives of the eighteenth-century monastery in Guixi, Jiangxi, that Guan might have seen, nor do structures from the nineteenth-century renovations at the Zhengyi sect headquarters. Guan Huai's painting is the only record. In it, the painter has labeled the buildings and natural features of the plans of two eighteenth-century temple-complexes at Dragon and Tiger Mountain (Longhu Shan). The similarities between those two plans, each with a triple entry gate, second gate behind it, one or several principal halls and the back gate, to Zixiao Gong on Wudang Shan or the Bixia Ci on Tai Shan or the Yongle Gong on flat ground, are obvious. Even if the halls and gates were not so precisely set along axial lines, it is likely the roofs of specific halls in the two temple-complexes were hip-gable combination and possessed one as opposed to two sets of roof eaves. Guan Huai's image of a Taoist monastery is accurate. Finally, the high elevation and long approach to the main hall in each complex are features we continue to observe in Taoist architecture.

Taifu Guan is a Taoist monastery on less mountainous terrain, but one that retains Ming structures. Located in Shangmiao village of Fenyang county, Shanxi, the region of the Houtu Miao mentioned above and numerous other Taoist temple sites that originated in Jin times or earlier, one building at Taifu Guan survives from the Jin period. The entrance to the monastery is a three-bay ceremonial gate with glazed ceramic rooftiles and ceramic-tile dragons in roundels on either side of the doorway.

Directly behind it is the three-bay-square, Jin period main hall, dedicated to Haotian. Inside, the principal image is the Jade Emperor. He is attended by three images on each side, females next to him and a pair of males beyond each of them. The garments of each sculpture are painted in extraordinary detail and the altar on which they stand is a superior example of *xiaomuzuo*, "lesser carpentry," the woodworking technique described in the twelfth-century architectural manual *Yingzao fashi*, which was taken to its greatest heights in ceilings and decoration such as this altar in Jin times.[66]

The courtyard of Taifu Guan is framed according to the *siheyuan* principle of structures on four sides. Five-bay halls form the sides between the front gate and Hall of the Jade Emperor (fig. 14). The hall on the right as one enters the courtyard is dedicated to the Sage Mother (Shengmu). All the images in this hall are female, again with garments painted in great detail and with wall paintings of the daily activities of women behind them. Among the sculptures is one of a nursing mother, suggesting the function of the monastery for folk worship in the village. Also stored in the hall are palanquins that no doubt were used to carry the images in processions.

The hall on the left, by contrast, contains more formal imagery of the Taoist pantheon. Across the front altar are deities of the Five Sacred Peaks: Tai Shan in the center, with Hua Shan (west) and Heng Shan (north) to his right and Song Shan (east) and Heng Shan (south) to his left. On altars on the two side walls are deities of the four rivers, two on each.

All four structures of Taifu Guan have hip-gable combination roofs. All roofs except that of the front gate of Da Shangqing Gong appear to be hip-gable also. In Xie Shichen's painting, the roofs also seem to be of the hip-gable combination. As for the layout of each monastery, in Xie's painting the scheme is *siheyuan*, such as it is at Taifu Guan, whereas in both the Longhu Shan monasteries depicted in Guan Huai's painting only gates that break the continuous covered corridor around the monasteries are perpendicular to the main axial line. The significant conclusion to be drawn from these comparisons is that Taoist monasteries in paintings and extant Taoist monasteries from the same time period conform to the same general rules of Chinese spatial planning. This statement can be extended to painted, engraved, and described plans of Buddhist and Confucian temple-complex space.

Thus it seems likely that the plans of temple-complexes of China's other famous peaks and those in the cities that do not survive could be reconstructed from extant paintings or stele inscriptions. Mao Shan, located southwest of Nanjing in Jiangsu

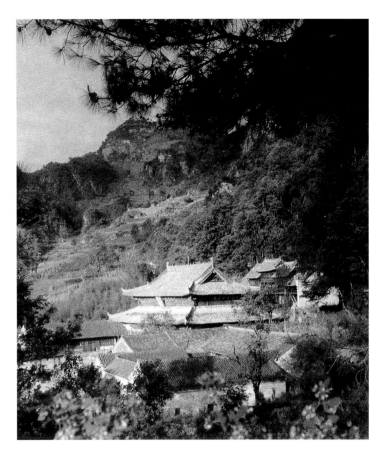

Fig. 13
Purple Empyrean Palace on Wudang Shan (Mount Wudang).

Fig. 14
Entry to Taifu Guan, a Ming dynasty monastery in the village of Shangmiao, Fenyang county, Shanxi province.

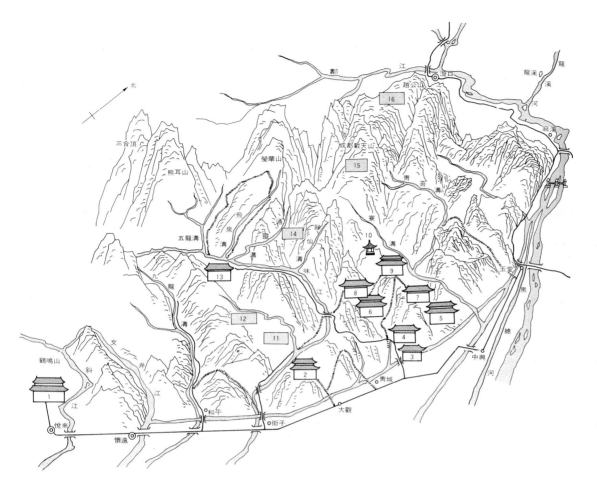

Fig. 15
Location of Taoist and Buddhist palaces and monasteries (or observatories) on Azure Wall Mountain (Qingcheng Shan), Sichuan province: 1. Crane-call Monastery (or Observatory) (Heming Guan); 2. Temple of Universal Illumination (Puzhao Si); 3. Palace of Eternal Life (Changsheng Gong); 4. Palace of Establishing Good Fortune (Jianfu Gong); 5. Palace of Encircling Brilliance (Yuanming Gong); 6. Celestial Master Cavern (Tianshi Dong); 7. Palace of Jade Purity (Yuqing Gong); 8. Palace of the Perfected Warrior (Zhenwu Gong); 9. Palace of Highest Purity (Shangqing Gong); 10. Pavilion of Calling Response (Huying Ting); 11. Temple of Encircling Penetration (Yuantong Si); 12. Arranged Immortals Monastery (or Observatory) (Luoxian Guan); 13. Temple of Great Stability (Tai'an Si); 14. Temple of the Celestial Platform (Tiantai Si); 15. Eight Trigrams Platform (Bagua Tai); 16. Temple of Duke Zhao (Zhaogong Miao).

province, is one place where such reconstruction should be possible. Named for three brothers who practiced alchemy there during the reign of Han Jingdi (r. 156–141 B.C.) and associated with Ge Hong in the third century and Tao Hongjing in the Liang dynasty (502–557), no pre-twentieth-century building survives on the three-peak mountain.[67] Probably, the various temple-complexes resembled those of Qingcheng Shan.

Indeed, more impressive than the architecture of a flat Taoist monastery like Taifu Guan or the Yongle Gong are monasteries in mountainous settings in which the spatial arrangement nevertheless conforms to the layout on flat ground. At present the mountain Qingcheng Shan houses sixteen Taoist and Buddhist monasteries.[68] Their placement is shown in figure 15. In spite of the topography, the main structures of each individual monastery are focused on a straight line. The only feature that might be considered a deviation from the rigid axis is that the building line can run north–south, east–west, or a direction between a cardinal one.[69]

The Qingyang Gong in Chengdu, Sichuan province, is said to be where Laozi attained immortality (huasheng). Tang Xuanzong stopped there in 751 and worshipped Laozi when he fled the Tang capital for Sichuan. Upon his return to the capital, Chang'an, Emperor Xuanzong elevated the status of the monastery to gong and gave tremendous sums for construction. Qingyang Gong was destroyed at the end of the Tang dynasty, rebuilt in Song times, destroyed and rebuilt in Yuan and Ming times, eventually leading to repairs under the Kangxi emperor and a visit by the Yongzheng emperor who came to worship Laozi.[70]

The dedications of Taoist halls and temple-complexes at Qingyang Gong are standard: they are for service of deities worshipped since the initial construction of Taoist architecture. Lingzu Dian is a five-bay, two-story structure in which Guansheng and Wenchang are worshipped in the first story and Wangling is worshipped in the upper story. The hall dedicated to Laozi, Hunyuan Dian, is also five bays across but only one story. On either side of Laozi on the interior are images of civil and military officials. The Hall of the Eight Immortals is actually a pavilion, octagonal in plan, elevated on a square foundation

surrounded by a stone balustrade painted red-brown. Rising twenty meters, its roof is decorated with yellow, green, and purple ceramic tiles. The Hall of the Three Purities, also known as Wuji Dian, is the main hall of the monastery. Five bays across, with a single-eaved, hip-gable roof, its interior houses images of Lü Dongbin and Zhongli Quan as well as the Three Purities. Like the first hall, Doumu Dian is two-storied. The last hall, dedicated to Tang rulers, is one of three structures in a back garden. In addition, a hall for printing Taoist scriptures stands to the east of the main line of halls, and a hall for worship of Taoist sages through history stands to the west. The deities to which the halls are dedicated define the Qingyang Gong as a Quanzhen-sect monastery. Other evidence of this association is found in inscriptions in the adjacent Erxian Convent to the east. Nothing structural identifies the monastery halls as Taoist or its sect as Quanzhen.

Baiyun Guan, built along seven courtyards, is a Quanzhen-sect site too (fig. 16). Emperor Xuanzong worshipped Laozi there in the Tang dynasty, the abbey suffered destruction thereafter, and was built in 1203 during the Jin dynasty as the Taiji Gong, signifying imperial patronage. When the Quanzhen master Qiu Chuji took up residence at the Taiji Gong in the thirteenth century, repairs and new building commenced. In 1227 Khubilai Khan named it Changchun Gong. Today the headquarters of the Chinese Taoist Society, Baiyun Guan has been one of the most active urban Taoist monasteries in recent decades. Its counterpart in the Taipei suburbs—one of the largest, most popular, and most active Quanzhen monasteries in Taiwan—is Zhinan Gong (fig. 17), a towering twentieth-century megalith whose architectural details, in particular the colorful tile decoration on its roofs, are characteristic of contemporary architecture of Buddhism, Taoism, and Confucianism on Taiwan more than of anything specifically Taoist.

Are there, finally, general statements to be made about Taoist architecture? Except for their elevation on high platforms, their long approaches, and their sometimes oversized platforms in front, no exterior or interior component of a structure is identifiably Taoist. Rather, an examination of representative halls through the history of Taoism in China shows extraordinary similarity to imperial, Confucian, or Buddhist architecture of comparable status. The sectarian designation of a Taoist hall or its building complex cannot be determined by exterior signs either. Taoist architecture does not identify itself as a place for the attainment of immortality or the mixing of elixirs for that purpose. Upon entering a Taoist structure, the message of its

Fig. 16
A courtyard of the Baiyun Guan (White Cloud Monastery) in Beijing.

Fig. 17
Zhinan Gong, one of the largest Quanzhen-sect monasteries, located in the village of Mucha, near Taipei, Taiwan.

murals might be an enhancement to a practitioner's transformation, or a devotee might purchase an elixir mixed by a resident priest, but the same two occurrences could happen as easily and efficiently in a grotto. Certainly images offer an opportunity for personal prayer, and objects on an altar afford the possibility of ceremony, and both identify a structure as Taoist once inside.

One might be inclined to attribute the lack of visible signs of Taoism in its architecture to some kind of mysticism associated with the faith. In fact, that is not the case. Nor is it true that knowledge of associations of a site with a Taoist sage, immortal, or emperor-patron or memory of an event in Taoist history that occurred there offer greater understanding of the architecture than can be observed by a non-Taoist. Knowledge, devotion, and belief enhance the experience of a Taoist site, but not in ways unique to Taoist architecture among Chinese religious structures. Once Taoism turned to the Chinese building system of wooden pillars and lintels to replace grottoes and altars in natural settings, its buildings were and were to remain first and foremost Chinese timber-frame buildings in complexes of buildings arranged along Chinese-inspired axial lines and around Chinese-style courtyards. Whether Taoist wooden architecture learned from Buddhist, or both learned from Confucian building patterns is impossible to say. Rather, one can conclude that architecture for all purposes served by the Chinese building tradition evolved together, and one of the only ways to determine if a building complex might be Taoist is the lack of a pagoda. Even without the pagoda, the range of possibilities for that group of buildings includes some Buddhist monasteries and imperial architecture and Confucian architecture, as well as Taoist.

NOTES

1. Christianity is not on this list because a church is identified on the outside by a cross. However, churches appear in China much later than architecture of the other religions in this list. Probably the buildings of religions practiced in China during the first millennium A.D. but that died out thereafter such as Manichaeism and Zoroastrianism were no easier to distinguish on the exterior than synagogues or Confucian temples. On the shared architectural forms of the latter two, see Steinhardt 1997.

2. The word *miao* commonly refers to a place for worshipping local deities associated with popular religion. These deities are sometimes, but not always, incorporated into the Taoist pantheon, and Taoist priests will sometimes perform rites in *miao*. Consequently, *miao* are often places where Taoist and popular practices come together, rather than being exclusively Taoist places of worship.

3. The most extensive record of Chinese building practices is *Yingzao fashi* (Building standards), presented to Song Huizong's court by official Li Jie in 1103 and reissued in 1145 during the Southern Song. The distinctions between *dian*, a high-ranking hall, and *tang*, a hall, are articulated in it. To understand the differences fully, one needs to read all sections of the 34-*juan* work relevant to the Chinese timber-frame and its decoration. The terms *dian* and *tang* are first discussed in *juan* 1, one of two *juan* that comprise the section known as *zongshi*, or general terminology.

 The first word listed in *juan* 1 is *gong* (see YZFS 1974, vol. 1: 2–4). Nowhere in the discussion of *gong* is a Taoist context suggested. The same is true in the definition of *gong* in the classical dictionary *Erya*. None of the other names for Taoist temple-complexes is discussed in *Yingzao fashi*. Research confirms the implementation of what is written in the text in extant Buddhist buildings of the Tang through Yuan periods, even though the purpose of the text was to promulgate the official building standards. Several examples of the distinction between high and low rank are presented in the discussion of bracket sets of Taoist buildings that follow. In that discussion it will be shown, for example, that details of the architecture of the main hall of Yongle Gong follow the standards for eminent architecture such as palace buildings explained in *Yingzao fashi*. In other words, the structures of buildings of *gong* can be linked to imperial architecture even if the name *gong* cannot be proved to be a sign of imperial patronage. The bibliography on *Yingzao fashi* is long. For an introduction in English, see Glahn 1975.

4. Although Chinese Buddhists built caves and cave-temples for meditation and worship, the Buddhist employment of caves is based on the Indian model, not native Chinese building practices. The great importance of grottoes for meditation, transformation, and ritual practices in Taoism, on the other hand, seems to have developed from an indigenous tradition.

5. Morohashi 1966–68, vol. 10: 346. See also *Zongjiao jianzhu* 1991: 27.

6. *Zongjiao jianzhu* 1991: 27.

7. Qiao 1993: 124.

8. Ibid.

9. For more on caves and their classification, see Robinet 1997: 132.

10. *Zongjiao jianzhu* 1991: 27.

11. See Jenner 1981: 141.

12. On this tomb, see *Jiuquan Shiliuguo mu bihua* 1989.

13. For examples of this plan, see An 1996: 565–600.

14. Wright 1978: 89–90. His source is *juan* 7 of Song Minqiu's *Chang'an zhi* of 1075.

15. Ono 1989: 453–70.

16. Wei 1973, section 8 of reprinted text. Song Minqiu's figure of ten abbeys is also quoted here.

17. Schafer 1963: 151.

18. On excavation of Sanqing Dian of the Daming Gong, see Ma 1987, esp. 329–31. The bibliography on the Daming Gong is long. On Hanyuan Dian, specifically, see, for example, Fu 1973 or "Hanyuan Hall," in Steinhardt 1984: 92–99.

19. Xiong 1996: 263.

20. Ibid.: 264. The events discussed in this paragraph and the following one are related in Xiong's article.

21. Taiji Gong (palace-complex of the North Pole Star) were constructed in the palace-cities of Wei-Jin and Northern Wei Luoyang, Eastern Jin Jiankang, and both Tang capitals, for example. On the role of astronomy at the Han

court, see Eberhard 1957. For more general discussion that includes the role of astronomy in the Chinese state, see Needham and Wang 1959: 171–461 passim.

22. Liao S, *juan* 1: 13.
23. Ibid., *juan* 2: 15.
24. Ibid., *juan* 37: 441.
25. For more on the subject, see Yao 1995.
26. On both syncretism and Quanzhen, see Noritada 1968a and Sun 1965.
27. Yao 1995, p. 157. Information in this paragraph is taken from Yao's article, the source of which is Oyanagi 1928.
28. For studies of the *jiao* ceremony in English, see Saso 1972 and Lagerwey 1987b.
29. Yao 1995: 157.
30. So far, no serious monograph on the Jin Shrines has been written. A good introduction to the early buildings and their architecture is in Lin and Liang 1935 or Chai 1989: 27–30. Many aspects of this monument will be explained in Miller (forthcoming).
31. This subject is dealt with at length in Miller (forthcoming).
32. On these two stelae, see Cao 1990: 5–6, 22–23 and pls. 67–69, 76–78.
33. The only study of Xuanmiao Guan of which I am aware is Lin 1957: 52–53.
34. On this subject, see Fu 1981.
35. For pictures of these two halls and their sculpture and brief descriptions, see Li et al. 1986: 209–13.
36. Ibid.: 209.
37. The only information on this structure is a hand-written report, see Mo 1945.
38. Chai 1986 writes that 106 of the 140 pre-thirteenth-century buildings, in other words, more than seventy percent of China's total, are in Shanxi. Unfortunately, Chai does not provide a complete list of extant buildings.
39. Personal experiences of this author.
40. Like so many buildings of this period, no monographic study exists for Sanqing Dian of the Suzhou Xuanmiao Guan. On this building, see Liu Dunzhen 1935. Liu calls the abbey Yuanmiao Guan.
41. Qiao et al.: 81.
42. Ibid.: 82.
43. Ibid.
44. Ibid.
45. Many, but not all, of them are discussed in Zhang 1979.
46. On the debates and struggles between Buddhists and Taoists during the Yuan period, see Thiel 1961 and Noritada 1968b.
47. The bibliography on Yongle Gong is long. The discovery of the Taoist monastery was first announced in Qi et al. 1954: 69–72. The entire issue no. 8 of *Wenwu* 1963 is devoted to Yongle Gong. Among the publications on the Yongle Gong wall paintings are *Yongle Gong bihua xuanji* 1958; *Yongle Gong* 1964; *Eiraku-kyu hekiga* 1981; *Lü Dongbin de gushi* 1981; *The Yongle Palace Murals* 1985; and Jin 1997.
48. On Lü Dongbin, his cult, and the legends, see Katz 1996a: 70–104; Katz 1996b; Katz 1999; and Baldrian-Hussein 1986.
49. For more on architectural features of Yuan halls, see Steinhardt 1988.
50. Ibid.
51. On the murals, see Jing 1994.
52. On this building, see Steinhardt 1998.
53. Ibid.
54. Ibid.
55. For information and illustrations of the halls and their murals, see Chai 1997: 74–79, 232–34.
56. On Tangdi Hall, see Liu 1980.
57. On the tombs, see Li 1960.
58. On the design of Shangdu and the role of Chinese official Liu Bingzhong in it, see Hok-lam 1967 and Steinhardt 1989.
59. On the Temple to the Eastern Peak, see Goodrich 1964.
60. Wechsler 1985: 162.
61. On the *feng* and *shan* sacrifices, see Wechsler 1985: 170–94.
62. Ibid.: 167.
63. Ibid.: 199–205.
64. Chavannes 1910: 3. On Tai Shan, see also Baker 1925 and *Taishan* 1981.
65. Lagerwey 1992: 296, 318.
66. "Lesser carpentry" is discussed in *juan* 6–11. Other outstanding examples of *xiaomuzuo* from the Jin period in Shanxi province are the ceiling of the main hall of Jingtu (Buddhist) Monastery in Ying county and the altar of the main hall of Erxian Guan (see fig. 9).
67. On the history of Mao Shan and the Taoist sects associated with it, see Robinet 1993.
68. For brief descriptions of the architecture of Qingcheng Shan, see *Zhongguo mingsheng cidian* 1986: 886–87.
69. For three different plans of temple-complexes on Qingcheng Shan, see Qiao 1993: 149–51.
70. On Qingyang Gong, see Qiao 1993: 137.

WU HUNG

IN RECENT YEARS TAOIST ART has attracted considerable attention from scholars whose published work has begun to constitute the basis for a new field of art historical inquiry.[1] At the present stage of research, however, we can talk about this art confidently only when dealing with such Taoist icons as statues of the deified Laozi (later known as the Supreme Lord Lao, or Taishang laojun) and the Celestial Worthy of Primordial Beginning (Yuanshi tianzun), which appeared no earlier than the fifth century.[2] It is true that some scholars, including myself, have referred to certain images in Han dynasty art, such as those of the Queen Mother of the West (Xiwangmu) or the god Taiyi, as Taoist. But such identifications remain hypothetical. We all know that the cult of both the Queen Mother and Taiyi long predated organized Taoist religion. Although these deities were later absorbed into the Taoist pantheon, it would be *ben mo dao zhi*—"putting the cart before the horse"—if one were to identify an earlier image based on a later appropriation. Thus, although the existence of Taoist art during the Han dynasty seems beyond doubt, we still need to examine the evidence for this assertion systematically—we must trace its various regional traditions and map its intrinsic and extrinsic properties, including its visual forms, production, patronage, and function.[3]

In undertaking such an investigation, it is crucial to remember that the meaning and content of Taoism have undergone many changes over the course of its long history, and that images of early Taoist art must have differed markedly from later ones. Generally speaking, any definition of Taoist art must be a historical and dynamic one, taking into account the continuity of this art as well as its specific manifestations in different places and times. While it is necessary to take later Taoist conventions into consideration, such conventions do not automatically yield a historical definition of early Taoist art. To this end, it is especially important to avoid assuming an "orthodox," retrospective Taoist position, for to do so would negate the complex history of Taoism and condemn earlier traditions as unorthodox or even un-Taoist.[4]

Let us then undertake the task of reconstructing a Taoist art tradition at its earliest developmental stage and recognize that "art," in a broad sense, includes not only individual pictorial images and objects but also symbolic or narrative "programs" of images and objects, their architectural contexts and ritual functions, their makers and patrons, production and consumption, geographical distribution and period style, and so on. Thus, the term "art," as used here, means "visual culture": the different kinds of visual forms produced by a group of people who were linked together by a shared language, shared ideas and behavior, and a common sense of identity. The visual culture I investigate in this essay belonged to a branch of early religious Taoism that developed in the present-day provinces of Sichuan and southern Shaanxi during the second and early third centuries. Referred to in historical texts as Wudoumi Dao ("Five Pecks of Rice" Taoism), Tianshi Dao (Way of the Celestial Masters), Zhengyi Dao ("Orthodox One" Taoism), or Gui Dao (Ghost Taoism), this religious tradition was identified by the later orthodox Taoist church as its origin, and the initiator of this tradition, Zhang Ling, was claimed as the founder or the first Celestial Master of this church. This identification—whose historical reliability is a complex question that lies beyond the scope of this essay—has nevertheless prompted much effort by historians of Taoism to discover textual evidence for this tradition (hereafter referred to as Wudoumi Dao).

The main goal of this essay, however, is to discover visual evidence for the same religious entity. Since textual records of Wudoumi Dao contain little description of ritual paraphernalia or pictorial images, we cannot identify certain objects and images as the visual products of this Taoist tradition simply by

matching their physical forms with texts. On the other hand, these texts do allow us to connect Wudoumi Dao with certain visual forms on other levels. One such level is geography: we can investigate the geographic distribution of certain images, objects, and architectural types, and we can relate their distribution patterns to the regional development of Wudoumi Dao as recorded in texts. By pursuing such a research project, we may literally be able to put Taoist art on a second-to-third-century map.

The basis for this study is the "regional" characteristic of early religious Taoism. The two earliest Taoist sects to appear during the late Eastern Han dynasty were both regional organizations. Zhang Jiao's Taiping Dao was active in the east. According to historical records, its several hundred thousand followers were organized into thirty-six *fang*—units distributed in Shandong, Hebei, northern Jiangsu, and eastern Henan provinces.[5] Zhang Ling, on the other hand, established Wudoumi Dao in the southwest. His grandson Zhang Lu further became a local ruler of Shu for some thirty years, during which Taoism became the dominant religion in this southwest region and attracted believers from both Chinese and non-Chinese populations *(min yi xin xiang)*. New immigrants to Shu adopted this religion under local pressure, as the *History of the Latter Han (Hou Han shu)* records: "Even those who came from other parts of the country were afraid not to adopt it."[6]

Interestingly, these two regions of early religious Taoism, one in the east and one in the southwest, were also during exactly the same period the two main centers of Han funerary pictorial art. In both regions tombs with carved or painted scenes were built for people of different social classes and occupations. Abundant evidence demonstrates that in many of these tombs art served to realize the attainment of postmortem immortality.[7] The developments of religious Taoism and funerary art thus show general parallels in terms of time, place, content, and function. This does not mean of course that funerary art in these two regions can simply be identified as a Taoist art. But these parallels do establish that we can, with additional evidence, define certain burials, mortuary objects, and carvings as Taoist products. In fact, if we believe even half of what has been recorded in historical texts about the popularity of Taiping Dao and Wudoumi Dao, we can assume that their numerous followers must have left material traces of their religious beliefs and practices—that the many excavated Han tombs in these two areas must include those of Taoist believers, whose religious identity may well be reflected in the design, decoration, and furnishing of their own tombs.

Of the two regions, Sichuan provides the better opportunity for a regional study of Taoist art, because after Taoism was introduced to Shu prior to the mid-second century, it developed steadily in this region for close to a century. Such stability provided a likely condition for the invention and production of religious symbols and structures, which can in turn be recovered through archaeology. In addition, we have better knowledge about the local organization of Wudoumi Dao and the chronology of Sichuan pictorial art—two factors crucial for a study of Taoist art in this area.

A common misconception among some modern scholars is that members of early Taoist sects, including those of Wudoumi Dao, were "poor peasants" or ordinary people.[8] Yet both textual and archaeological evidence demonstrates that followers of early Taoism were not restricted to lower social strata. This is especially true of the Sichuan region, where Wudoumi Dao maintained a close relationship with the region's elite and officialdom. Furthermore, we know from historical texts that many members of the local elite were believers of early Taoism, including at least two governors of the whole region in different periods.[9] Zhang Ling, the founder of Wudoumi Dao, served as the magistrate of Jiangzhou before he went to Sichuan. His son Zhang Heng, the next Celestial Master of the sect, was offered the title *Langzhong* (gentleman of the interior) by the government.[10] But it was Zhang Lu, the third Celestial Master, who fully integrated the organization of Wudoumi Dao with the region's civil administration.

According to the *Record of the Three Kingdoms (Sanguo zhi)*, Zhang Lu replaced local officials with Taoist priests called *jijiu*, and this reform was welcomed by local people.[11] From the late second to the early third century, Zhang Lu became the supreme ruler in this region and expanded his power to the Hanzhong area in present-day southern Shaanxi.[12] After taking over Hanzhong, according to his biography in *Record of the Three Kingdoms*, he "assumed the title *Shi jun* [Master-ruler] and taught people Ghost Dao [i.e., Wudoumi Dao]. For some thirty years he ruled the region of Ba[jun] and Han[zhong] majestically. This was at the end of the Han. Unable to subjugate him, the central government was forced to offer him titles such as General of Subjugating Barbarians and Grand Magistrate of Hanning."[13] After the fall of the Han, Zhang Lu's subordinates proposed to honor him with the title of King of Han[zhong]; but he declined after weighing the political advantage. He was finally defeated by Cao Cao in 215, but was still left with a fief and a noble title.[14] It is clear that Zhang Lu and his ministers/priests were far from being poor peasants or ordinary people, and that their culture simply cannot be identified as a "popular" one. In fact, using the

best available textual evidence, it can be said that Zhang Lu established the first Taoist regime in Chinese history. Thus, it is unthinkable that with such stability and power Wudoumi Dao did not develop its cultural and artistic production in this region. Indeed, many archaeological remains from this region, including large tombs and ritual objects, may be related to this early Taoist sect. The question that remains is how to prove this assumption by connecting archaeological materials with Wudoumi Dao.

First of all, it is possible to establish such connections because we are left with important records about the locations of the administrative centers of Wudoumi Dao. According to several texts, Zhang Ling established a series of Taoist centers called "the twenty-four *zhi*." Zhang Ling and his successors may have also elaborated on this system with additional "secondary centers" called *pei zhi* and *you zhi*. Most of the twenty-four *zhi* were distributed in a broad belt from Xichang in the south to Hanzhong in the north (fig. 1).[15] The core area within this region was the Chuanxi Plain at the upper reaches of the Min and Tuo rivers, with the Wudoumi Dao headquarters, Yangping Zhi, at present-day Pengxian, northwest of Chengdu.[16] It is possible that Yangping Zhi acquired this prominent position under the second Celestial Master, Zhang Heng, who practiced there and "ascended to immortality" *(sheng xian)* on Mount Yangping in 179.[17]

Another basis for a study of early Taoist art in this region is archaeology. A number of large-scale surveys, mainly carried out by Sichuan archaeologists over the past thirty years, have yielded important information about the geographical distribution and temporal development of three categories of regional cultural and artistic products during the Eastern Han. These include: 1) architectural forms—predominantly cliff tombs and stone sarcophagi with pictorial carvings; 2) objects—principally "money trees" and bronze mirrors; and 3) pictorial carvings, including images of divinities and others possibly related to Taoist sexual arts. These three categories of archaeological evidence provide us with the basic materials and the analytical structure of further discussion.

CLIFF TOMBS AND STONE SARCOPHAGI WITH PICTORIAL CARVINGS

During the Eastern Han and post-Han period, cliff tombs *(ya mu)* were a burial form unique to Ba and Shu (including present-day Sichuan, the Zhaotong area in Yunnan, and the Zunyi area in Guizhou). According to the Sichuan archaeologist Luo Erhu, thousands of such tombs are known; the earliest dated one bears an inscription from A.D. 65.[18] Although cliff tombs are found throughout Sichuan, they are most densely distributed in the Chuanxi Plain; today the Leshan area alone preserves about ten thousand such tombs. Moreover, only the cliff tombs in the Chuanxi Plain, especially in Leshan and Pengshan, have rich pictorial carvings (see the shaded area in fig. 2).[19] But even in this area, pictorial carvings appear only in a limited number of tombs. According to a survey conducted by Tang Changshou, of the ten thousand cliff tombs in Leshan only about one hundred are carved with pictorial decoration.[20] He further divided these hundred tombs and those in the adjacent Pengshan area into three periods: 1) the period of emergence, during the first half of the second century; 2) the period of development, from the mid-second century to the 180s; and 3) the period of flourishing, from the 180s to the early third century.[21] Stone sarcophagi with pictorial carvings are sometimes found in tombs of the second and third periods. According to Gao Wen, all known examples of such sarcophagi are from areas along the Min, Tuo, and Fu rivers (see fig. 3). The most elaborate ones have again been found in the Chuanxi Plain.[22] Summarizing the research available thus far, we reach the general observation that although cliff tombs and sarcophagi were distributed over a large region, the richly decorated examples were limited to the core area of Wudoumi Dao and to the period in which Wudoumi Dao reached its greatest prosperity in this area.

Additional archaeological evidence further links specific cliff tombs and sarcophagi in this area with practices of Wudoumi Dao. One type of evidence consists of engravings, including both images and inscriptions. A considerable number of cliff tombs in Pengshan and Leshan, for example, are carved with a *sheng* pattern above the entrance (among them, Pengshan tombs 45, 166, 169, and 530; see fig. 5). The *sheng* is the headdress of the Queen Mother of the West and the most important symbol of this goddess. It could not be a casual act to mark a tomb with this symbol in such a way that anyone could see it before even entering the tomb. In some other cliff tombs, a composite dragon-and-tiger motif occupies the same position above the entrance (in, for example, Leshan tomb 99 and Pengshan tomb 355; see fig. 7). The relationship between *longhu* (dragon and tiger) and early Taoism is well known. It is recorded in various texts, for example, that at the moment when Zhang Ling attained immortality in Shu he saw a multitude of heavenly beings arriving with dragons and tigers.[23] The headquarters of the later Celestial Masters Taoism, possibly founded by Zhang Ling's great-grandson Zhang Sheng, was at the Dragon and Tiger Mountain (Longhu Shan) in Jiangxi.[24] A passage from the

Fig. 1
Map of Sichuan province showing the
locations of the twenty-four *zhi* of
Celestial Master Taoism.

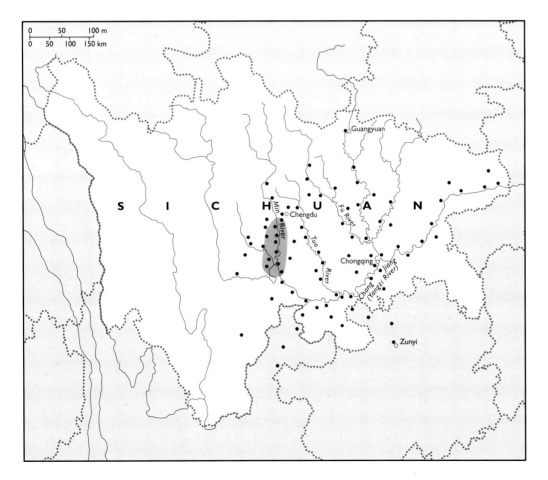

Fig. 2
Map of Sichuan province showing the distri-
bution of cliff tombs. The shaded area indi-
cates the region where tombs decorated with
pictorial carvings are most densely located.

Fig. 3
Map of Sichuan province showing the
distribution of stone sarcophagi with
pictorial carvings.

Fig. 4
Map of Sichuan province showing the
distribution of excavated "money trees."

Fig. 5
The front gate of a cliff tomb at Pengshan, Sichuan, with a *sheng,* the headdress of the Queen Mother of the West, carved above the entrance.

Fig. 6
Line drawing of an image carved in a tomb (Mahao M1) in Leshan, Sichuan.

"Genealogy of the Celestial Master Zhang" *(Zhang Tianshi shijia)* explains that the mountain was so named because a dragon and a tiger emerged when Zhang Ling succeeded in making the Divine Elixir of Nine Heavens *(Jiutian shendan)* in this place. Indeed, "dragon" and "tiger" are chief metaphors used in Taoist writings on both internal and external alchemy; they refer specifically to lead and mercury, the two most important ingredients used in making elixirs.[25] In addition, Taoist deities are often described and portrayed as riding dragons and tigers or accompanied by them. All this literary and artistic evidence suggests that the *sheng* and dragon-and-tiger images carved above the entrance to a Sichuan cliff tomb may signify the religious identity of the tomb occupant. Similar symbols are abundant on stone sarcophagi from the same region and should have served the same role.

Among numerous pictorial motifs and scenes found in cliff tombs and on sarcophagi, one particular figural image may depict a Wudoumi Dao priest. Discovered in a Leshan tomb (Mahao M1), he appears as a standing figure wearing a tall hat (fig. 6). According to Tang Changshou, who found this image, "The figure wears a long robe and a tall hat of an unusual type. He holds a ceremonial staff *(jie zhang)* in his left hand and a medicine bag in his right hand. . . . This image is carved next to the door to the rear chamber—a position which indicates an intimate relationship between this image and the deceased [buried in the rear chamber]."[26] Tang has identified this image as a *fangshi*-necromancer, who is recorded in *Records of the Historian (Shiji)* and other texts as holding a *jie zhang.*[27] While Tang's proposal is well taken, it is possible to identify this image more specifically as a Wudoumi Dao priest called a *shi,* described in texts as a religious professional who held a special ceremonial staff *(jiu jie chang)* while praying and reciting incantations for believers.[28] Similar images also appear on sarcophagi, *que*-pillars in front of tombs, and mirrors from this region. On a sarcophagus from Nanxi, for example, a half-open gate represents the "heavenly gate" *(tian men)* or "the gate of the soul" *(hun men).* Outside the door is a man who kneels while holding a long staff. The subject of his veneration is inside the gate—a deity on a dragon-and-tiger throne (fig. 8). On another sarcophagus, from Changning, this figure reappears, again holding his staff. But this time he is following a deer on the way to an immortal mountain (fig. 9).[29] We also find this figure on the stone tower Gao Yi Que in Ya'an, again depicted outside a half-opened gate, and it appears twice on an inscribed bronze mirror likely produced in the Sichuan region, once before an "ancestor" *(xianren)* figure and once before a "divine lady" *(shen nü).*[30] In

Fig. 7
Rubbing of the dragon-and-tiger pattern carved above the entrance to a stone chamber tomb at Hejiang, Sichuan.

Fig. 8
Rubbing of the long side of a stone sarcophagus (no. 3) from Nanxi, Sichuan.

Fig. 9
Rubbing of the long side of a stone sarcophagus (no. 1) from Changning, Sichuan.

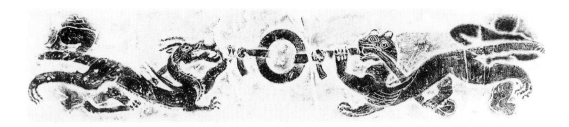

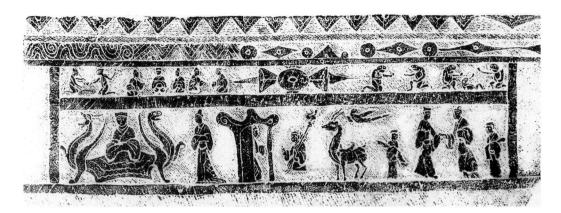

all these cases, therefore, this image is represented as an intermediary between the human world and the immortal realm.

In addition to symbols and pictorial images, inscriptions also provide important evidence for the relationship between certain cliff tombs and Wudoumi Dao. Some of these inscriptions disclose the Taoist ideal of immortality. For example, an inscription in a cliff tomb near Chongqing, dated to the third month of 135, identifies the tomb as a "stone chamber which prolongs life" (yannian shishi) (fig. 10).[31] Another inscription in a cliff tomb at Jianyang reads: "On the eighteenth day, the fourth month, the first year of Han'an [i.e., A.D. 142], [I come here to] meet immortal friends" (fig. 11).[32] The tomb chamber was thus a meeting place with immortal friends (xian you), a term that may designate either supernatural figures or fellow believers in a religious sect such as Wudoumi Dao. A third and much longer inscription from Sichuan, traditionally known as the "Jijiu Zhang Pu Inscrip-

tion," was first recorded by the Song antiquarian Hong Kuo. Zhang Pu was a Wudoumi Dao priest with the title jijiu. In this inscription he recorded that he and some fellow believers gathered together to transmit "subtle scriptures" (wei jing). Hong Kuo noted that the carving of this inscription is rough and irregular, unlike that of formal stele inscriptions.[33] Perhaps it too was a "cliff inscription" (moya keci) like the two previous ones.

Another possible relationship between some Sichuan cliff tombs and Wudoumi Dao is suggested by objects found in these tombs. Sichuan archaeologists have discovered, for example, a clay jar buried in the front chamber in Mahao tomb 99 at Leshan. Inside the jar were pieces of mica and other minerals.[34] This is not the first time such a finding has been reported: the Song poet and traveler Lu You recorded a similar discovery and identified the minerals as materials for "making golden elixirs."[35] Because the front chamber of a cliff tomb functioned

Fig. 10 *(left)*
Rubbing of an inscription in a cliff tomb at Longwang Dong, Yubei district, Chongqing, Sichuan, dated 135.

Fig. 11 *(right)*
Rubbing of an inscription in a cliff tomb at Xiaoyao Shan, Jianyang, Sichuan, dated 142.

as an offering shrine, and because these minerals were related to Taoist alchemical practices, using such minerals as offerings seems to indicate the religious identity of the deceased.[36] In addition, Luo Erhu believes that a kind of "stove" found in many cliff tombs was used, either symbolically or practically, to make elixirs—a suggestion that again connects these tombs with Taoist practices.[37]

In 1973 a bronze seal was found in a cliff tomb in Ziyang county. Some scholars have found that the style of its characters is neither *zhuan* nor *li*, but resembles certain Taoist talismanic writings.[38] So far six seals with such characters are known, all from Sichuan (fig. 12). The seal from Ziyang is the first example found through an archaeological excavation, and its placement in a cliff tomb seems again to point to the religion of the deceased.

"MONEY TREES" AND "MIRRORS WITH IMAGES OF IMMORTALS ON THREE LEVELS"

In addition to the evidence of Taoist practices offered by the cliff tombs and sarcophagi presented thus far, archaeological examination of a cliff tomb at Hejiashan in Mianyang has produced two "money trees" and a bronze mirror with "images of immortals on three registers" *(sanduan shenxian jing)*.[39] Both types of object have been identified as local products of Shu, and both bear direct connections with Wudoumi Dao. The term "money tree" *(qian shu* or *yao qian shu)* is actually a later designation and a somewhat misleading one because the main decorative motifs on both the bronze tree and its clay or stone base are not coins, but deities on dragon-and-tiger thrones, immortals playing the *liu bo* game, heavenly horses, the drug-pounding hare, and musicians and dancers. Coins appear only as leaves hanging down from each branch (see fig. 13). In view of the fact that some trees are decorated with large, iconlike, divine images (see fig. 14), if we must give this object a name, a "divine tree" *(shen shu)* probably better reflects its nature.[40]

According to Susan Erickson, more than eighty such objects have been reported, mostly from tombs dated to the late Eastern Han (see fig. 4).[41] The Chinese scholar Xian Ming has further outlined the region in which "money trees" have most frequently been found: "Most of them are from a belt-like region, which extends north to Hanzhong in southern Shaanxi and south to Xichang and Zhaotong, passing the areas of Guangyuan, Mianyang, Santai, Guanghan, Pengxian, Chengdu, Xijin, Pengshan, and Lushan. This region therefore basically overlaps with [Wudoumi Dao's] twenty-four *zhi*."[42] Xian Ming also reported that a

Fig. 12
Line drawing of seals with unidentified characters from Sichuan.

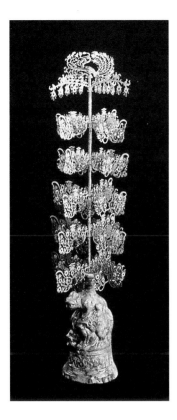

Fig. 13 *(above left)*
Bronze "money tree" with pottery base, from Guanghan, Sichuan.

Fig. 14 *(above right)*
Line drawing of a fragment of a bronze "money tree," with an image of a divine figure.

Fig. 15
Pottery "money tree" base from the vicinity of Chengdu, Sichuan.

considerable number of "money trees" and "money tree" bases have been unearthed at the locations of some of the twenty-four *zhi* of Wudoumi Dao, including three examples from Pengxian, the location of Wudoumi Dao's headquarters, Yangping Zhi.[43] These studies confirm, therefore, that this type of ritual object enjoyed a definite popularity in the central area of Wudoumi Dao during the flourishing period of this religion.

Images on "money trees" and "money tree" bases are largely identical with those found in cliff tombs and on sarcophagi from the same region, and they are clearly products of the same religious and artistic tradition. But the three-dimensional form of a "money tree" base gave the artist greater freedom to create original and complex sculptural images. One of the most impressive "money tree" bases, excavated from the suburbs of Chengdu, vividly represents a journey in search of immortality (fig. 15). The clay base is shaped like a columnar mountain. Men and women are climbing the mountain and appear on three levels. Those on the first level still have a long way to go; those on the third level are about to reach the top of the mountain where they will join the deity on the summit. The design of this

base thus translates into a visual form a passage from the Taoist text the *Master of Huainan (Huainanzi)*: "He who climbs onto the Chilly Wind peak of Kunlun will achieve deathlessness; he who climbs twice as high onto the Hanging Garden will become a spirit . . . ; he who climbs twice as high again will reach Heaven and will become god."[44] An interesting feature of this sculpture is the caves on the three levels. Punctuating the journey, each of them marks a particular stage in the search for immortality. This is the earliest example I know that represents the concept of *dongtian* (literally a "cavern-heaven"). It is also possible that the three levels of the mountain represent metaphorically the three stages of a Taoist spiritual cultivation toward immortality.

A tale cited in the Taoist encyclopedia *Seven Slips of the*

16a

16b

Figs. 16a–b
Rubbings of two examples of "mirrors with images of immortals on three registers":
a) Seattle Art Museum (drawing by Hayashi Minao); b) Palace Museum, Beijing.

Cloudy Satchel (Yunji qiqian) also helps identify the religious associations of a "money tree." It is said that a man living at Yangping Zhi adopted an orphaned boy, who was then married to an orphaned girl. One day a flood came and there was a great shortage of food. The couple then used their magic to obtain anything people needed from a tree. When asked where they learned this magic the young man answered: "I am actually an immortal in the Yangping Cave, descending to this world because I had made a small mistake. I will leave soon."[45] Ten days later the couple disappeared. What this story implies is an intimate relationship between a divine tree and a Taoist immortal in the Yangping Cave.

In addition to "money trees," a particular type of bronze mirror may also be identified as a product of Wudoumi Dao. This type is conventionally known as a "Mirror with Images of Immortals on Three Registers"—a designation based on the composition of the mirror's central circular area, which is divided into three registers of equal height by two horizontal bars. The top and bottom registers are each centered on a nonfigurative image. As exemplified by one such mirror in the Seattle Art Museum (fig. 16a), the central image on the top register is a broad umbrella standing on the back of a turtle. Sev-

eral figures, including a "jade maiden" *(yunü),* stand beneath the umbrella and pay homage to it, while a much larger figure with wings on the shoulders is seated to one side. Images on the middle level always constitute a symmetrical pair. On most "three register" mirrors, including the one found in a cliff tomb at Hejiashe, Mianyang, this pair is formed by the Queen Mother of the West and the King Father of the East. In other cases this pair consists of a dragon and a tiger, as exemplified by a mirror in the collection of Beijing's Palace Museum (fig. 16b). Figures on the lower register are centered on a loop motif in the shape of a figure 8, possibly a tree with two intertwining trunks.

Based on archaeological and stylistic evidence, Professor Huo Wei of Sichuan University has made a convincing argument for the Sichuan (Shu) origin of this type of mirror. More specifically, he has identified the Chuanxi Plain as its production center, and has associated this type of mirror with the so-called Ghost Dao, an alternative name for Wudoumi Dao.[46] His opinion can be supported by additional archaeological finds as well as by the images on a "three register" mirror. In terms of archaeological evidence, at least three mirrors of this type have been found in various locations in southern Shaanxi.[47] That Shu mirrors appeared in this region around the end of Han is logical because,

as discussed earlier, during this period Zhang Lu established his seat in Hanzhong and expanded his territory to include southern Shaanxi. In terms of decoration, images on a "three register" mirror reflect Taoist ideas and may have been designed to facilitate Taoist meditative practices.

Among the various images on a "three register" mirror, the identifications of those on the middle level—the Queen Mother of the West and the King Father of the East—are most certain. Hayashi Minao has further identified the loop motif on the lower level as *Jian mu*, described in ancient texts as a divine tree at "the center of Heaven and Earth," along which heavenly lords *(di)* moved back and forth between these two realms.[48] This identification seems to be supported by similar tree images found on other objects from Sichuan. For example, on a stone sarcophagus mentioned earlier, a tree with loop-shaped, intertwining trunks is juxtaposed with other images related to the idea of immortality (see fig. 9). A male figure under this tree seems to be bidding farewell to a female figure; in fact, he may be about to ascend to Heaven along this divine tree. Another similar tree image is found on a pottery "money tree" base from Guanghan; its intertwining branches reach Heaven and embrace the fantastic world of the Queen Mother of the West.[49] This last example leads us to speculate on a possible relationship between the mythological *Jian mu* and the "money tree." Based on the decoration of a "money tree," I suggested above that a more precise designation for this object would be a "divine tree," which provides a path to the world of immortals. Just as this "divine tree" is a unique subject of Sichuan Han art, *Jian mu* is believed to be located in this particular area in China.

Several texts specify the location of *Jian mu* as Duguang in the Southwest.[50] Huo Wei has suggested, again very convincingly, that Duguang is also known as Guangdu, a place located thirty *li* west of Chengdu according to some post-Han texts.[51] I would add that this place was very close to the location of Yangping Zhi, the headquarters of Wudoumi Dao. It is possible that to strengthen its authority and mystique, Wudoumi Dao appropriated an ancient myth for its own use, and identified Yangping Zhi as "the center of Heaven and Earth." This, in turn, implies a close relationship between Wudoumi Dao and mirrors decorated with the *Jian mu* tree.

The most controversial image on a "three register" mirror is the umbrella image and the accompanying figures on the top level. Hayashi Minao believes that the winged figure next to the umbrella represents the Great Heavenly Emperor (Tianhuang dadi) at the North Pole in Heaven, and that the umbrella symbolizes the Huagai xing ("Elaborate Canopy" constellation),

which consists of a series of nine stars next to the North Pole.[52] Hayashi's opinion has been challenged by Higuchi Takayasu and Huo Wei. In particular, Higuchi argues that it would be illogical to depict the "canopy" stars in the center and to place the Heavenly Emperor to one side.[53] I agree with this criticism, and I want to propose a new identification for the umbrella image. In my view, any interpretation of this image must take these three features into consideration: 1) its placement in the most honorable position in the decorative program of a "three register" mirror; 2) its composite form as an umbrella standing on a turtle (in some cases on a Xuanwu—a combination of a turtle and a snake); and 3) its role as the subject of reverence and worship by surrounding figures. Relating these features to textual references, I propose that this image actually represents the deified Laozi in a symbolic form.

The transformation of Laozi from an individual historical figure to a cosmic deity has been the subject of much scholarly discussion.[54] A turning point in this transformation was marked by a series of events taking place in 165 and 166, when Emperor Huan built a shrine to honor Laozi in his birthplace and offered sacrifices to Laozi both in this shrine and in the imperial palace.[55] These events have been discussed in every book on early Taoism as a definite indication of Laozi's deification. The form of the imperial sacrifice in 166, however, has drawn less attention from scholars. Here is how this ritual is described in the "Chapter on Sacrifices" ("Jisi zhi") in the *History of the Latter Han:*

> [The emperor] personally offered sacrifices to Laozi in the Zhuo-long Palace. An altar covered with patterned woolen fabric was prepared, and vessels decorated with gold rims [were used]. *A seat was set up [for Laozi] under an elaborate canopy (she huagai zhi zuo).* The music played during the sacrifice was adopted from the semi-annual sacrifice to Heaven.[56] (Italics added.)

Significantly, no image or statue of Laozi is mentioned. The reason is simple: as the personification of the Dao, Laozi was considered to have neither matter nor form; he could therefore only be symbolized by an empty "seat" *(zuo),* not represented by a figurative likeness. This early Taoist convention persisted until at least the fifth century. A passage from Falin's *In Defense of What Is Right (Bianzheng lun)* relates that the Taoist master Tao Hongjing "set up both Buddhist and Taoist institutions on Maoshan and paid homage in both every day. In the Buddhist halls there were sacred statues, which the Taoist temples did not have."[57]

In the context of the present discussion on an early Taoist artistic tradition in Sichuan, it is important to note that the

Xiang'er Commentary on Laozi (Laozi Xiang'er zhu), a Taoist text attributed to Zhang Lu, especially stresses this aniconic approach. This text identifies Laozi with the Tao and insists that the latter is formless: "The Dao is infinitely superior. It is subtle and hidden, without shape, resemblance, or image. People can only follow its teaching, but cannot comprehend it through appearance."[58] From this position, the text criticizes any figurative representation of Laozi or the Tao as a "false method" *(wei ji):* "Now there is this false method in the world, which represents the Dao with concrete forms, giving it clothes and names as well as facial and bodily forms. This is all wrong, all evil and false!"[59] This strong conviction probably represents an orthodox approach within Wudoumi Dao, according to which a proper representation of Laozi should only emphasize the hidden nature of the Tao.

With this in mind, we return to the umbrella image on a "three register" mirror. As mentioned earlier, this is the most honored image in the entire decorative program, and it is also a subject of worship and reverence. This image, in fact, can be called *huagai zhi zuo*—"the seat under an elaborate canopy"—for this is the phrase used in the *History of the Latter Han* for the place of Laozi in the imperial sacrifice. This image can thus be identified as Laozi's seat, which in turn symbolizes the existence of this Taoist patriarch. Additional evidence for this interpretation is found in the *Baopuzi* of Ge Hong (283–343). Instructing how to use a mirror to visualize the "true form" *(zhenxing)* of Laozi, this Taoist text identifies Laozi's throne as a "divine turtle" *(shen gui).*[60] It cannot be a coincidence that the "elaborate canopy" illustrated on a "three register" mirror is supported by a turtle.

IMAGES OF DIVINITY

As mentioned earlier, the *Xiang'er Commentary on Laozi* attacks figurative representations of the Tao or Laozi. It is unclear from this text whether such prohibition also extended to other gods and immortals worshipped by Wudoumi Dao followers. Archaeological evidence, however, reveals that the practice of depicting images of many deities existed in the area of Wudoumi Dao. I say "many deities" because these images, though sharing a lot of features, are distinguished from one another by some important iconographic markers. Their differences, however, have largely been ignored. As a result, divine figures sitting on dragon-and-tiger thrones in a frontal posture—a popular composition in Sichuan Han art—have been uniformly identified as the Queen Mother of the West. The question remains: Is this identification reliable?

A number of reasons prompt me to raise this question. Most importantly, examining the ever-increasing supply of archaeological materials, we begin to notice some subtle but significant differences among these so-called Queen Mother images. Scholars agree that one of the most important iconographic features of the Queen Mother is her *sheng* headdress. Images of figures wearing this headdress indeed existed in Sichuan, but a large number of deities depicted on the dragon-and-tiger throne are not wearing *sheng.* Instead they wear various caps including a *mian* (see fig. 17), a three-pointed *wang guan* (see fig. 18; also see fig. 7), a flat military cap decorated with bird features above the ears (see fig. 19), or a small vertical cap similar to those worn by later Taoists (see fig. 20). While in real life a *sheng* was worn by women, all these other caps were for men or male deities.[61] It is unthinkable that a Sichuan artist could have freely altered the cap or headdress of a deity represented as the central icon in a composition. It is more likely that these images with different caps and headdresses actually represent different deities. As commonly seen in other traditions of religious art, different deities are often distinguished not by their overall shapes but by some minor features, often their headdresses. Thus, what these Sichuan images demonstrate is probably not a religion centered on the worship of the Queen Mother of the West, but a religion that began to fashion a pantheon consisting of a multitude of male and female deities. Based on textual evidence, some Taoist scholars have noted a similar effort made by Wudoumi Dao.[62] For example, *Zhengyi fawen jingzhang guanpin* lists 120 deities including both civil and military types, "each with his or her own administrative duties."[63] It is possible that the image of the Queen Mother of the West, which had become widespread in various parts of China since the first century, provided a basic compositional formula for depicting these new deities, while minor iconographic features were invented to differentiate them.

Furthermore, archaeological evidence reveals that within this growing pantheon of gods and goddesses in Sichuan, the Queen Mother of the West seems to have acquired a specific significance. In a number of cases, images of this goddess are combined with sexual symbols and scenes. One such example is found on a stone sarcophagus from Yingjing (fig. 21). Here, the Queen Mother, wearing a typical *sheng* headdress, is juxtaposed with a couple at an intimate moment. A similar but more explicit love scene was originally carved above the main gate of a cliff tomb at Pengshan (fig. 22). The third example is a clay "altar" found recently in a tomb at Guanghan, in a place very close to the Wudoumi Dao's headquarters, Yangping Zhi. On the front

Figs. 17–20
Rubbings from stone sarcophagi.

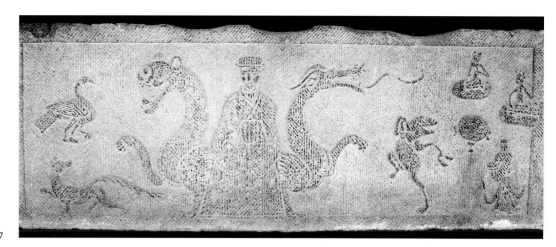

17

18

19

20

Fig. 21
Rubbing of the long side of a stone
sarcophagus from Yingjing, Sichuan.

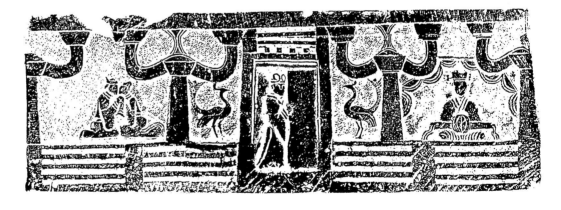

side of the altar is an image of the Queen Mother of the West, wearing a *sheng* and seated on a dragon-and-tiger throne. Two figures, half human and half beast, kneel on top of the altar, both showing erect male organs. Between them, in the center of the altar, is a sculpted phallus (fig. 23).[64] In all these cases, the Queen Mother of the West seems to have been associated with a fertility cult or Taoist sexual arts, indicating the changing symbolism of this goddess toward the post-Han period. Decorating tombs, sarcophagi, and funerary objects, these divine and erotic images seem to indicate a particular path toward eternal happiness.

It is appropriate to discuss the Buddha's image in Sichuan in this section on Taoist deities, because the adoption and appropriation of these images, if viewed in its cultural and religious context, actually took place within the domain of Taoist art. As I have discussed elsewhere, most existing images of the Buddha and Buddhist symbols in Han art are located either inside tombs or within the territory of a Taoist temple. These images were used to strengthen the pursuit of immortality or to enrich the emerging pantheon of early religious Taoism.[65] The present study provides a more precise regional context for this argument.

Fig. 22
Stone relief of an "embracing couple," originally above
tomb 550 at Pengshan, Sichuan.

Fig. 23
Clay altar from Guanghan, Sichuan.

Figs. 24a–b
A cliff tomb at Mahao, Leshan, with an image of the Buddha carved on the lintel
above the entrance to the burial chamber and b) detail showing the image of
the Buddha.

Based on an increasing body of archaeological evidence, we can reach the basic understanding that, in Sichuan, images of the Buddha were used by Taoist followers for their own sake.

Although Buddha-like figures have been found in different parts of Han China, Buddha images appeared in Sichuan in much greater number and in more authentic form.[66] Yet there is no text recording the practice of Buddhism in this region during the period when these images were created. The answer to this dilemma is found in the new cultural and religious contexts of these images. No longer decorating Buddhist temples, these images were combined with Taoist symbols and used to embellish cliff tombs, bronze "money trees," and clay "money tree" bases. As discussed earlier, all these architectural forms and objects were related to the practice of Wudoumi Dao in the area. Moreover, these Buddha images have only been found in the core area of Wudoumi Dao in the Chuanxi Plain.

Two Buddha images of similar form have been found in cliff tombs at Mahao and Siziwang in Leshan. In each tomb the image appears on the back wall of the front chamber above the entrance to the burial chambers, and defines the focus of visual perception and ritual homage. The one at Mahao is better

preserved (fig. 24). The figure is seated, with the left hand holding a portion of the gown. The right hand is raised in the gesture known as the *abhaya mudra*. The face is unfortunately damaged, but an extra protuberance or *usnisa* on top of the head—one of the Buddha's holy marks—is still visible and is ringed by a halo. All these features, as well as the heavy folds of the robe, can be traced to Indian images of the Buddha created in Mathura and Gandhara in the second century.[67] But in the Mahao tomb, this "Buddha" is juxtaposed with a sculpted dragon on the lintel.

The basic iconography of this image is shared by another Buddha figure—a three-dimensional image on a "money tree" base found in a cliff tomb at Pengshan (fig. 25).[68] The Chinese scholar Wu Zhuo has noticed that the *usnisa* on the head of the Buddha is unusually tall and is shaped almost like a small cap. He has also identified the two standing figures on either side of the Buddha as two attendants of different ethnic origins, one Chinese and one non-Chinese, and the animal motifs on the Buddha's circular base as a tiger and a dragon.[69] His observation reveals that this sculpture, rather than being a pure Buddhist image, synthesizes various Buddhist and Taoist motifs into an iconic presentation. Such religious fusion is demonstrated by additional Buddha images found recently in a cliff tomb at Hejiashan in Mianyang. Decorating fragments of a bronze "money tree," each image shows the Buddha grasping the end of his gown with his left hand and raising his right hand in the *abhaya mudra*.[70] An interesting feature of these images is the figures' moustaches, which indicate a possible Gandharan origin; but other motifs on the "money tree" are traditional Chinese symbols of immortality. It is also significant that this tomb yielded a "three register" mirror, which, as discussed earlier, was closely related to the practice of Wudoumi Dao in this area.

It is not difficult to explain how images of the Buddha could facilitate Taoist beliefs and practices. This artistic borrowing was actually part of a larger religious phenomenon that characterized the development of religious Taoism during the second and third centuries. In the Taoist scripture *Taiping jing,* for example, the story of the miraculous birth of Laozi is an outright copy of that of the Buddha. The same text twice relates that Heaven sent evil gods and Jade Beauties to test the religious conviction of Taoist believers. Both accounts are clearly based on the temptation of the Buddha by Mara and his daughters.[71] Also around this time, the story of "Laozi converting the barbarians" *(Laozi huahu)* circulated widely in Taoist circles. An early version of this story relates that "Laozi went to barbarian lands and became the Buddha."[72] It is quite certain that in the second and third centu-

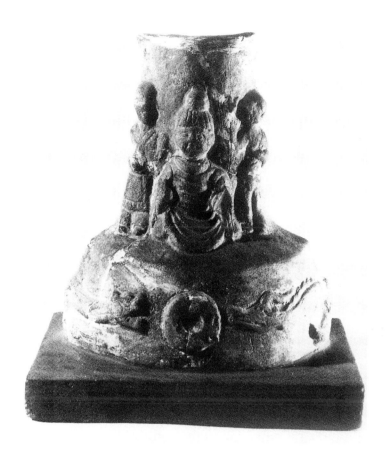

Fig. 25
Clay "money tree" base from Pengshan, Sichuan.

ries, many Taoist followers believed that the Buddha was none other than Laozi or his manifestation.[73] It is thus not surprising that stories of the Buddha were used to create a biography for the legendary founder of religious Taoism. For the same reason, an image of the Buddha could have been thought of as an image of Laozi; the Taoist prohibition of representing Laozi may have encouraged this deliberate misunderstanding. This complex situation explains a strange Taoist argument, which identifies Laozi as the inventer of the image of the Buddha: "The barbarians do not believe in emptiness and non-being, therefore when Laozi emigrated [to the West] he had them make statues of his form, and with the help of these images he converted these barbarians."[74]

Conclusion

To map early Taoist art means to integrate the studies of Han art and early religious Taoism in a coherent historical framework. Taking the geography of an early Taoist sect as its cue, I have tried in this essay to compare the locations of major centers of Wudoumi Dao with the distribution patterns of certain

images and objects in Sichuan art. This comparison shows that two "maps"—one of a regional religious tradition and the other of a regional art tradition—clearly overlap. A closer examination of the content, function, and context of these images and objects has further substantiated the strong Taoist characteristics of this regional art tradition.

It should be emphasized, however, that early Taoist art was an extremely complex phenomenon and consisted of many different traditions and levels of representation; this essay deals with only one of these traditions. My purpose is therefore to prompt, not to conclude, an important, but much neglected, line of inquiry in the field of Chinese art history. It is not possible for me to explain here why the study of Taoist art has largely been ignored in this field until recent years; but I hope that this essay has demonstrated the potential contribution of this study to a renewed understanding of Han art.

Many architectural structures, objects, and pictorial images discussed in this essay are familiar to students of Han art, but they have only been studied as general properties of a unified "funerary art" from the third century B.C. to the third century A.D. By contextualizing these visual forms in a local religious tradition, it is now possible for us to identify their specific meaning and to reconstruct their specific historical development. A "Taoist" study of these forms also allows us to explore the identity and intention of their makers and owners, and provides a new perspective from which to understand certain cultural interactions. A study of early Taoist art, therefore, will, I hope, not only rediscover a forgotten tradition, but also contribute to the general body of research in the field of Chinese art history. Together with a growing scholarship on the Confucian influences in Han art, this study will bring our understanding of Chinese art during this period to a new level.[75]

NOTES

I have presented different versions of this paper in a number of conferences, including the "Daoism in East Asia" conference (Center for Japanese Studies, Kyoto, March 1999), the "Religion and Power in Ancient China" conference (Harvard University, May 1999), and the "Between Han and Tang: Religious Art and Archaeology in a Transformative Period" conference (University of Chicago, November 1999). I want to thank the organizers of these conferences and all the scholars whose comments have helped me in revising this paper.

1. Two general studies of the history of Taoist art include Wang 1994 and Little 1988.

2. The earliest examples of such Taoist icons or combinations of Taoist and Buddhist icons are found on the Wei Wenlang stele dated to 424 and on the Yao Bodo stele dated to 496. Studies of early Taoist art have often focused on these and other examples; see Ding 1984; Han and Yin 1987; Li 1991; Kamitsuka 1998 and Kamitsuka 1993; Pontynen 1980 and Pontynen 1983; Ishimatsu 1998; James 1989; Bokenkamp 1996–97; Abe 1996–97; and Seidel 1969a.

3. For a discussion of intrinsic and extrinsic analyses of works of art, see the introduction to Kleinbauer 1971.

4. It is noteworthy that the development of Taoism is often characterized by a tendency to negate a previous developmental stage. This tendency became noticeable even during the Han: Zhang Lu's *Laozi Xianger zhu* attacked "those who followed the teachings of the Yellow Emperor, the Divine Lady, Gongzi, and Rong Cheng" as "sham Taoists"; see Rao 1991: 11. In all likelihood, this text represents a position within early Taoism, which claimed orthodoxy by separating itself from other, more "primitive" Taoist traditions. Later, when Kou Qianzhi tried to reinvent Tianshi Dao in the early fifth century, he again accused the teaching of Three Zhangs (i.e., an earlier Tianshi Dao tradition represented by Zhang Ling, Zhang Heng, and Zhang Lu) as "false Taoism."

5. It is recorded that after Zhang Jiao founded Taiping Dao, "all people in Qin, Xu, You, Ji, Jing, Yang, Qiu, and Yu responded to his call. [In order to follow him] some sold or abandoned their properties. Traveling to join him they filled the roads; more than ten thousand fell ill and died before reaching their destinations"; ZZTJ 50, 5: 1864.

6. HHS, *Liu Yan zhuan:* 2436.

7. On the concept of immortality in funerary art, see Wu 1994. For the concept of "postmortem immortality," see Loewe 1982: 114–26; Seidel 1987a: 223–37.

8. This approach is especially prevalent in mainland Chinese scholarship on early religious Taoism. See, for example, Qing 1992: 65–66; Lou 1992: 69.

9. One of the two, Wang Fu, was the Magistrate of Chongquan from 57 to 75 and the Governor of Yizhou from 84 to 86. He established a stele and personally wrote the inscription to honor Laozi and the Sage Mother. See *Quan Hou Han wen* (A complete collection of writings from the latter Han), *juan* 32, in QHW. The other person was Liu Yan, the Governor of Yizhou at the end of Han, who took Zhang Xiu and Zhang Lu, two main leaders of Wudoumi Dao of his time, into confidence. See HHS, *Liu Yan zhuan:* 2435–36; SGZ, *Zhang Lu zhuan:* 263–64.

10. *Zhang Tianshi ershi zhi tu* (A diagram of Celestial Master Zhang's twenty administrative centers), cited in Zhang Junfang's *Yunji qiqian, juan* 28, *Ershiba zhi bu;* see Jiang 1996: 158–62, esp. 158.

11. SGZ, *Zhang Lu zhuan:* 263.

12. During the Eastern Han, Hanzhong was part of Yizhou. Zhang Lu changed the name of Hanzhong to Hanning after he occupied this place. For the history of Hanzhong, see Li 1999: 166.

13. SGZ, *Zhang Lu zhuan:* 263–64.

14. Ibid.

15. Based on HY 1130, *juan* 28, *Zhengyi qizhitu* and *Ershisi zhi bu* in Jiang 1996: 158–62.

16. *Ershiba zhi bu* in Jiang 1996: 158–62. For a general discussion of the twenty-four *zhi* of Wudoumi Dao, see Wang 1996: 87–100.

17. *Ershiba zhi bu* in Jiang 1996: 158.

18. Luo 1988: 142.

19. Gao 1987: 5.

20. Tang 1993: 3.

21. Ibid.: 57–58.

22. Gao 1997. The most comprehensive publication of Sichuan sarcophagi is Gao and Gao 1996: nos. 1–78.
23. *Zhang Tianshi ershi zhi tu* in Jiang 1996: 158; SXZ, *juan* 4. For a collated version, see Qing 1996, vol. 1: 159–60.
24. For a discussion of Zhang Sheng's relationship with Longhu Shan, see Fu 1998: 82–83.
25. See Meng 1993: 12, 51–52.
26. Tang 1993: 123.
27. Ibid.
28. HHS, *Liu Yan zhuan*: 2435–36; SGZ, *Zhang Lu zhuan*: 263–64.
29. This image is reproduced in Gao and Gao 1996: nos. 9, 27.
30. Liu Tizhi 1935: 16.48. This mirror belongs to the type called a "mirror with images of immortals on three registers." The provenance of this type will be discussed later in this paper.
31. A rubbing of this inscription is recently reproduced in an excellent collection of Han dynasty images and inscriptions from Sichuan: see Gong et al. 1998: no. 479. For other records and discussion of this inscription, see Feng and Feng 1934, vol. 6; Chen 1988: 1; Liu 1997a.
32. Deng 1949.
33. See LX.
34. Tang 1993: 122.
35. Lu You, *Cangdandong Ji* (Record on the Cave of Storing Dan), cited in Tang 1993: 122.
36. A whole *juan* in *Yunji qiqian* records different recipes of "immortal elixirs" which use mica as the base. See Jiang 1996: 464–70.
37. Luo 1988: 162. These archaeological finds seem to challenge a previous belief based on textual evidence, that "there was no alchemy in early Celestial Master Taoism." Proposed by Rudolph Wagner in 1973; summarized in Seidel 1989–90.
38. This is the opinion of Feng and Wang 1996.
39. Mianyang Museum 1991. For the Taoist identification of the mirror, see Huo 1999.
40. See Chen 1997.
41. Erickson 1994.
42. Xian 1995: 10.
43. Ibid.
44. HNZ.
45. Cited in Xian 1995: 12.
46. Huo 1999.
47. These three mirrors were excavated, respectively, from tomb 457 at Baqiao near Xi'an, tomb 1 at Hansengzhai in Xi'an, and a tomb at Chaoxian. See *Shaanxi chutu tongjing* 1958: nos. 75–77.
48. Hayashi 1973. The main textual references to *Jian mu* are found in SHJ, *Hainei jing* and HNZ, *Dixing xun*.
49. For an illustration of this object, see Chen 1997: fig. 6.
50. These texts include HNZ, Gao Yiu's commentary to *Lushi chunqiu,* and *Shanhai jing.*
51. Huo 1999: 47.
52. Hayashi 1973.
53. Higuchi 1979, vol. 1: 226.
54. For example, Kohn 1998b.
55. This event is recorded in several places in the *History of the Latter Han,* including *Huandi benji* (Biography of Emperor Huan), *Xiyu zhuan* (Records of the Western Distrinct), *Jisi zhi* (Records of Sacrifices), and *Xiang Kai zhuan* (Biography of Xiang Kai). See HHS: 313, 316–17, 320, 1092, 2922, 3188.
56. HHS, *Jisi zhi, zhong:* 3188.
57. T 2110, 52.535a; translation from Kamitsuka 1998: 65, with minor modification.
58. Rao 1991: 17.
59. Ibid.: 17, 19.
60. Wang Ming 1996: 273.
61. See Sun 1991: 246–47.
62. See, for example, Qing 1988–95, vol. 1: 162–64.
63. See ibid.: 162–64.
64. This object is first introduced in Chen Xiandan 1997. It is possible that it is related to a local fertility cult. Other Sichuan carvings reflecting this cult include a figure with an animal head in a cliff tomb at Shuangjiang, Pengshan, and a "bear" image in Pengshan tomb 951. Both creatures show pronounced male organs. About the possibility that these images served as fertility symbols, see Tang 1993: 70.
65. Wu 1986.
66. Ibid.: 266–67.
67. For such Indian examples, see ibid., pls. 3, 4.
68. Nanjing Museum 1991: 36–37.
69. Wu 1992: 40–51, 67.
70. Mianyang Museum 1991; He 1991.
71. Wang 1960: 2
72. HHS: 1082. The same story was reiterated in the *Xirong zhuan* (Records of western barbarians) in GSZ.
73. For a detailed discussion of the different versions of the "Laozi huahu" story, see "The Conversion of the Barbarians" in Zürcher 1972: 288–320.
74. This Taoist argument is cited in the Buddhist work *Shi sanpu lun* (Examining the essay on threefold destruction), collected in T 2102; 52.52b.
75. For discussions on Confucian elements in Han art, see Powers 1991; Wu 1989, esp. 228–30.

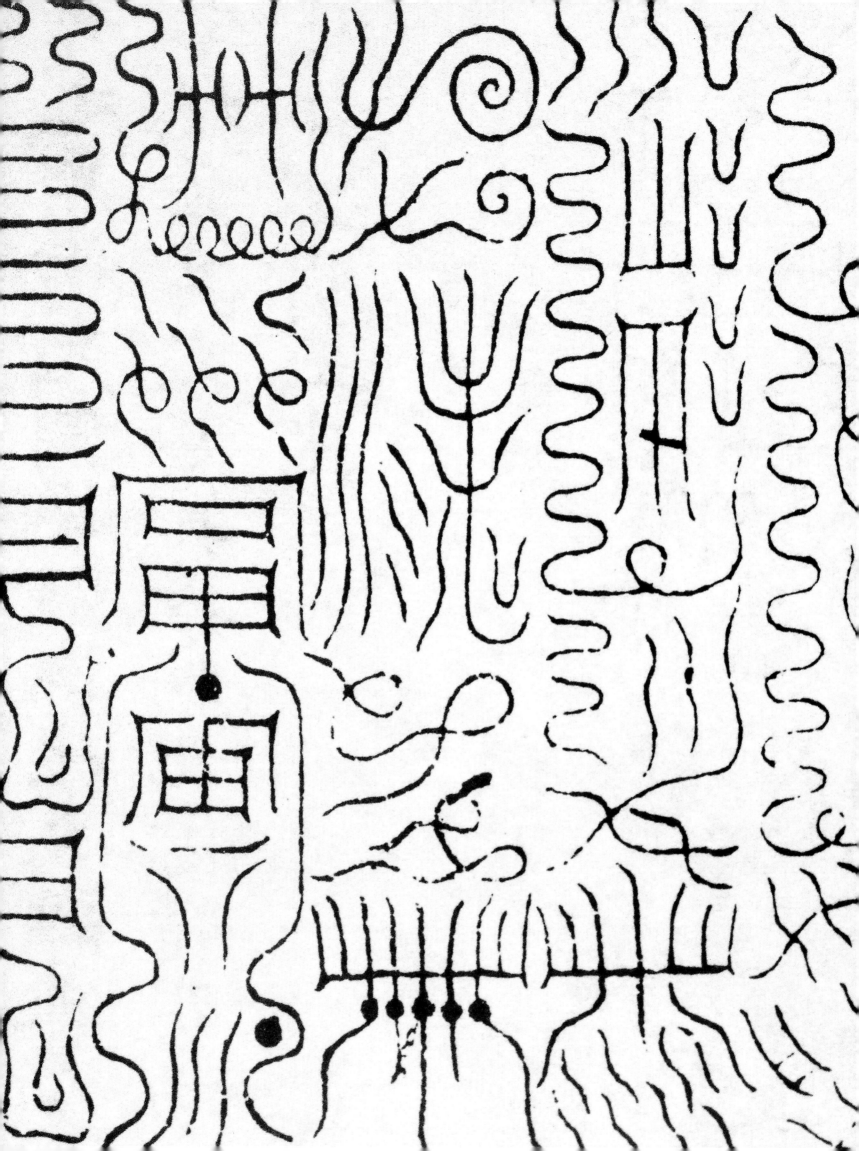

PATRICIA EBREY

THE WEST WALL OF the Hall of Purified Yang (Chunyang Dian) in the Eternal Joy Temple (Yongle Gong), Shanxi province, painted in 1358, depicts a set of palace buildings amidst clouds. By the gate and on the terraces, officials mix with Taoist priests. From the caption, we know that the scene depicts the Assembly of the Thousand Taoists summoned by Emperor Huizong (1082–1135, r. 1100–25) during the Song dynasty (960–1279) (fig. 1).

Further evidence of the presence of Huizong in the Taoist tradition is found in liturgical practice. In Taoist temples in Taiwan today, as the introit to a *jiao* offering ritual, the officiants, standing before the altar table, sing in unison one or two of the ten verses of the hymns composed by Huizong to accompany the "Pacing the Void" *(buxu)* ritual dance (see cat. no. 52), such as the following:

> The Precious Registers show how to cultivate perfection.
> The cinnabar pledges ascend to the blue heavens.
> The streams and fountains bring one near the good-omened.
> Arising before dawn, it is calm and peaceful.
> Disaster is dispelled from the myriad things.
> The third constellation is an auspicious sign.
> When pacing the void, the sounds are fully comprehended.
> Once again we sing the verses of the grotto mysteries.[1]

In the Taoist tradition, as these two examples attest, Huizong is a celebrated figure. He is one of the three or four emperors who did the most to promote Taoism, putting him in the same class with Xuanzong (r. 712–56) in the Tang dynasty and Zhenzong (r. 998–1022) in the early Song.[2] Huizong's pro-Taoist actions included sponsoring the first printing of the Taoist canon, heaping honors on charismatic Taoist teachers, setting up a Taoist school curriculum, sponsoring Taoist temples throughout the country, and favoring Taoists over their long-term rivals, the Buddhists.

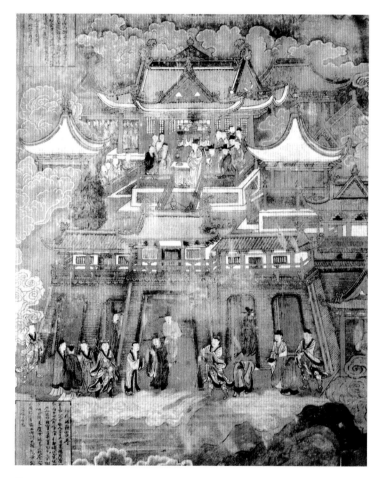

Fig. 1
The west wall of the Hall of Purified Yang in the Eternal Joy Temple, Shanxi province, depicting the Assembly of the Thousand Taoists (detail). Yuan dynasty, 1358. Ink and colors on plaster.

Fig. 2
Emperor Huizong. *Two Poems* (detail), in Slender Gold script. Northern Song dynasty, c. 1120. Handscroll; ink on silk; 27.2 × 265.9 cm. National Palace Museum, Taipei.

Taoists were not the only learned and talented men Huizong brought to his court. Joseph Needham has compared Huizong's court to that of Rudolf II at Prague, where, five centuries later, alchemists, astrologers, prophets, artists, and Rosicrucians enjoyed the patronage of a learned and curious sovereign.[3] But even more than Rudolf II, Huizong was a practitioner himself. He was not satisfied to gather around him individuals with exceptional talents and powers, but tried his hand at a very large range of the arts and sciences of his day. He developed a distinctive style of calligraphy, still easily recognizable (the Slender Gold style; see fig. 2), and he mastered both the running and cursive scripts as well. He wrote hundreds of poems, over four hundred of which survive. He also wrote on music, tea, medicine, and Taoist subjects. Most amazingly, perhaps, he painted in several styles, from the sketchy, "amateur" style of the literati to the highly exacting style of court bird-and-flower painting traditions (see fig. 3).[4]

Traditional Chinese historiography has been decidedly ambivalent about Huizong, undoubtedly because his reign came to a tragic end when his armies could not fend off the invasion of the non-Chinese Jurchen from the north, and he and three thousand members of his family and court were taken captive, to end out their lives in the far north. Although some historians reveal admiration for Huizong's talents, the moral framework of Chinese historiography makes explaining what went wrong the main task for historians. Huizong's many passions then become his vices, not his virtues. His love of art is seen as self-indulgence and his faith in Taoism as self-delusion. His passions, in this view, not only indicate a dangerous indifference to the serious business of governing, but also led him to waste so many resources that the country was in no condition to put up an adequate defense against the Jurchen, making the debacle that ended his reign all but inevitable. This view of Huizong was found in late Song sources and is still commonly repeated today.[5]

Art historians rarely object to this portrayal, but some historians of Taoism have tried to counter it by presenting Huizong as a deeply religious man who was convinced that he would benefit everyone through his promotion of the true religion.[6]

In this essay my goal is not to judge whether Huizong's Taoist faith or art mania had deleterious effects on his ability to govern, but rather to use them as a vantage point for considering the complexities of the relations among Taoism, art, and emperorship in imperial China. Emperors in China were the grandest of all patrons. They could and did order the construction and decoration of temples in the far reaches of the empire. They commissioned and collected art on a scale no private individual could match. A ruler like Huizong, moved by both art and Taoist teachings and willing to devote vast resources to promoting them, had the potential to make a great impact on the development of religion, art, and religious art.

The links between Taoism and imperial rule date far back in China's history. Many of the gods of Taoism were conceived of as emperors. They had titles redolent of imperial majesty and, wearing imperial garments, sat on thrones in temples called palaces. Those who wished to communicate with them used the ritual forms (prostrations, written petitions) employed by those addressing emperors. Emperors, for their part, found much to value in Taoist philosophy, cosmology, and ritual, ranging from the early Taoist notions of the emperor who achieves everything by doing nothing, to grand Taoist rituals of cosmic renewal, to projects to establish Taoist temples throughout the realm. But emperors did not have an exclusive relationship with Taoism—they had to preside over the state cult, for which Confucian ritualists presented themselves as the experts, and they were expected to support the Buddhist establishment as well. In fact, emperors more committed to Taoism than to Confucianism or Buddhism were the exception rather than the rule.

The links between Taoism and art in China are no less complex. Taoist ideas were pervasive in art theory and practice, especially in calligraphy, painting, and garden design, even if in somewhat diluted secular form. Taoist religious art, however, such as images of deities, developed in a context in which Buddhism was an overwhelming presence. There were many times more Buddhist than Taoist temples in the land, and the artists called on to decorate Taoist temples usually did most of their work for Buddhist temples. As a result, distinctively Taoist styles of painting or sculpting deities were slow to emerge.

Court patronage of both religion and art is also a complex subject. Until relatively modern times, royal courts the world over have been major sites of cultural production, sponsoring much of the finest architecture, metalwork, music, painting, poetry, religion, philosophy, science, furniture, textiles, and so on. There is no mystery to this: it is only to be expected in periods when wealth, power, books, treasures, talent, and other resources are concentrated in the capital and court. In China, at least, there was also a strong cultural validation for the preeminence of the court. In Confucian theory, in the best of all possible worlds, the Son of Heaven (the emperor) would be a perfect exemplar of all the virtues, and his court would be a center for music, poetry, art, ritual, and everything refined and beautiful. Nevertheless, over the course of time, in China as elsewhere, royal patronage became a less dominant element in higher culture. The eventual decline in the cultural preeminence of the court is a complex phenomenon connected to such developments as changes in the technology of transmitting culture, new forms of wealth, the emergence of great cities far from the capital, and more. In the Chinese case, the Six Dynasties period (the Southern Dynasties; 420–589) and Tang are viewed as high points of court culture, and a subsequent decline is vaguely associated with the rise of the literati. We have long known that Song literati such as Su Shi (1036–1101) challenged court taste in painting with their promotion of the "amateur ideal," the idea that painting done by artists outside the court and outside the art market was superior to painting done by professional or court artists.[7] Recently Amy McNair has shown how during the early Song the court as the arbiter of taste in calligraphy came to be challenged in a similar way by scholars such as Ouyang Xiu (1007–1072), who extolled the bold and direct style of Yan Zhenqing over the highly polished Wang Xizhi style associated with the court since early Tang times.[8] But what about other domains of art, such as temple and garden design, illustrated books, porcelains, or textiles? Or other domains of culture, including religion, scholarship, and science? Was the court better

able to leverage its vast resources toward shaping cultural developments in these fields?

Other scholars have looked at some of the artistic activities I deal with in this essay without playing up their connections to Taoism on the grounds that there was nothing exclusively Taoist about them. Peter Sturman has argued that one does not have to consider Huizong's Taoist activities to understand his paintings of auspicious subjects such as Cranes of Good Omen, since auspiciousness was a matter of concern to Confucians as well as Taoists.[9] Similarly, James Hargett has downplayed Taoist connections to Huizong's huge garden, the Genyue, preferring to put it in the context of prior imperial pleasure parks.[10] In this essay, however, I approach the Taoist aspects of these ventures from a different perspective. Taoists were not obligated to make art totally unlike the art non-Taoists made. Once we recognize that Huizong had a strong interest in Taoism from early in his reign, many of the art-related projects he undertook can be seen as precisely the ones an emperor with such Taoist interests would undertake. Our understanding of them can only be deepened by seeing how they fit into a Taoist agenda.

In this essay I am not concerned with the unanswerable question of how much of what was produced under Huizong's name at his court was done by him acting alone, without any assistance from the thousands who served him in one capacity or another.[11] Just as we assume that court officials regularly drafted most of the edicts that were issued in Huizong's name, it is reasonable to assume that he turned to other sorts of specialists either to draft or complete other works (and evidence of just that practice will be given below). Huizong was the CEO, impresario, general editor—the one who decided what was to be done, how it should be approached, and whether the finished product met his standards. We do not have to believe that Huizong moved each rock to credit him with the Genyue garden, nor do we have to think he came up with each allusion in the poems that circulated under his name or made each stroke in every painting that he signed. An emperor with grand goals had every reason to draw on the talents of those serving him.

Still, it is worth noting in the story that follows the emphasis Huizong placed on his personal participation, especially his personal brush. A major way an emperor showed the level of his interest and support was by getting personally involved and by symbolically giving a piece of himself—usually something he had personally written. Other themes that run through Huizong's involvement with both the arts and Taoism are concerns with potency and efficacy. In the spheres we label Taoist and those we label art the techniques of gaining power by naming or

embodying seem to have played rather similar roles, and skills Huizong learned in one arena he could carry over to the other.

A chronological survey of Huizong's engagement with art and Taoism must start with his youth. Born the third son of the reigning emperor, Shenzong (r. 1067–85), Huizong was still a toddler when his father died and his eldest brother, then eight years old (ten *sui*), succeeded to the throne as Zhezong.[12] Huizong continued to live in the palace, where he was prepared for the life of the wealthy prince.

In the world of Huizong's youth, the resources of art and religion were available in abundance, but individuals were free to choose which resources to draw on. Shenzong had taken considerable interest in the work of court painters, and artists like Guo Xi and Cui Bo thrived under his patronage. Shenzong's mother, the Empress Dowager Gao, who took over the court after his death, had less interest in painting, and Zhezong, once he took personal charge of the government after her death in 1093, does not seem to have had any special interest in painting either. Several of Huizong's aunts and uncles, however, had strong interest in the arts, some excelling in calligraphy or painting, others taking more of an interest in connoisseurship and collecting. For a few of them, Taoism was one of many interests, like medicine, music, and antiques.

Huizong and the four brothers he grew up with in the palace were given literary educations in the classics and histories. A set of linked mansions was built for them, designed by the famous architect Li Jie, so that by the time they were in their mid teens they could move out of the palace. Huizong's interests in painting and calligraphy began in this period. He studied with good teachers and modeled himself on major masters. He also began to collect old works, and found that his high rank and kinship connections gave him entrée to key circles of connoisseurs and collectors, including relatives such as Wang Shen (widowed husband of Shenzong's sister) and imperial clansmen such as Zhao Lingrang.

Politics in this period were decidedly unpleasant. Empress Dowager Gao, who had never approved of Shenzong's support for the reformer Wang Anshi, brought in the most vocal of Wang's opponents once she had the chance. After she died, in 1093, Zhezong returned the favor, expelling the conservatives and returning the reformers to power. Princes were expected to stay distant from all of this political maneuvering—nothing would be viewed as more threatening to the throne than a possible heir becoming friendly with men who had a stake in succession at court. It was astute of Huizong as a prince to act more interested in art than politics.

Huizong was seventeen (nineteen *sui*) when Zhezong died without an heir at age twenty-five, early in 1100. Shenzong's two eldest surviving sons were only three months apart in age, and Shenzong's widow, who was the mother of neither of them, selected Huizong over his elder brother on the grounds that his brother had problems with his eyes (emperors were expected to do a great deal of reading). During Huizong's first year as emperor, he was somewhat tentative, deferring to his stepmother and attempting a reconciliation of the two main political factions by inviting representatives of each to join the small circle of leading officials. But by 1103 he had decided to favor the faction identified with his father and Wang Anshi (the reformers). He appointed Cai Jing (1046–1126) as chief councillor and in 1104 approved a plan to bar from office all of the "Yuanyou partisans" who had been brought to office by his grandmother after Shenzong died.

From his earliest years on the throne, Huizong acted on his interests in art. When he had the Taoist Temple of the Five Peaks (Wuyue Guan) built, he recruited several hundred painters from all over the realm to paint its walls. According to Deng Chun, Huizong's dissatisfaction with the quality of their work gave him the idea of setting up a painting school to raise standards.[13] Thus, in 1104, when he implemented an ambitious expansion of the school system, he set up schools within the palace for both painting and calligraphy. The eminent connoisseur Mi Fu was brought to court as an erudite of painting and calligraphy.[14] Rigorous training programs were instituted, with calligraphy students studying different scripts, and painting students studying both texts and different genres of painting. The students in these schools were promoted on the basis of examinations, putting them on more of a par with those who studied the classics in order to become civil servants.

Huizong quickly showed he had a collector's passion for acquiring fine things. In 1105 he set up a bureau in Suzhou to forward rocks, flowers, and trees from the southeast for the imperial gardens.[15] Huizong also began collecting art objects on a large scale. He acquired many items from Mi Fu and Wang Shen, including both calligraphy and paintings. His collection of antique bronzes grew so fast that already in 1107 the first edition of his illustrated catalogue was published.[16] Two years later he published a set of calligraphy reproductions, the *Specimens of the Daguan Period (Daguan tie)*.

Huizong's well-developed interest in the exceptional drew him to both learned Taoist masters and *fangshi*, men capable of tapping into mysterious powers to work wonders.[17] Early in his reign, in 1104, he put into practice some of the proposals of the

seer, wonder-worker, and musical theorist Wei Hanjin, who advocated not merely the codification of new musical scales, but also the casting of nine bronze tripods using water and soil from the nine regions of the realm. The tripods were installed in a special temple where they were used in sacrifices to the Yellow Emperor, the Duke of Zhou, and others, using a complex scheme of color and direction correlations. In response, an especially auspicious sign appeared: several thousand cranes circled above the palace surrounded by colored clouds.[18]

The Taoist master who had the most frequent contact with Huizong in his early years was Liu Hunkang (1035–1108), twenty-fifth patriarch of the Highest Purity (Shangqing) lineage at Mount Mao (Mao Shan) in Jiangsu province. Mao Shan had been a Taoist center since the fourth century, the form of Taoism associated with it distinguished above all for its focus on the stars. During the Tang, Mao Shan Taoism was close to the official religion.[19]

Liu Hunkang had already been favored at court under Shenzong and Zhezong.[20] Huizong summoned him to court soon after taking the throne, but in 1103 Liu asked to return to Mao Shan. Between then and Liu's death in 1108, Huizong kept up an active correspondence with him; several dozen of Huizong's letters to him have been preserved in the history of Mao Shan.[21] These letters deal both with ordinary matters and with issues of religious ideas and practice. Huizong repeatedly urged Liu to come to the capital. The two discussed the construction of buildings Huizong was providing at Mao Shan. Liu encouraged Huizong to support Taoism in its competition with Buddhism, and they carried on a correspondence concerning the problem of Buddhist temples incorporating shrines to Taoist deities.[22] Cai Tao (d. 1147), son of Cai Jing, thought it was Liu's slanders of the Buddhists that turned Huizong away from Buddhism.[23]

From the letters Huizong sent Liu, we see the range of topics Huizong considered within the purview of a Taoist master. Huizong inquired about methods for curing illness, the names to be given newly constructed temples, and how to deal with misfortunes such as the continuous rains that were harming farmers. He repeatedly asked for detailed analyses of disasters and anomalies. He once noted that "the matter I prayed for previously still has not had a response."[24] Huizong made reference to his own religious practices, particularly the use of talismans. We do not have Liu's responses, but sometimes Huizong cited a statement Liu had made in previous letters, such as the statement that gentlemen cannot become *fangshi* by force.[25]

Art occasionally entered into the relationship between these two men. In 1106 Huizong sent several items for the new temple,

including a plaque with the title of the temple in his own calligraphy and an essay written by the high official Cai Bian (1058–1117; Cai Jing's brother). He also sent ten fans with his own painting and calligraphy on them, telling Liu to use them to summon a breeze on a hot day.[26] These fans seem to have been personal gifts, much like the fans Huizong gave to leading officials on other occasions.[27] For the temple, Huizong gave art that was more distinctly religious. Cai Bian's essay mentions that Huizong sent as gifts for the new temple several chapters of Taoist scripture that he wrote out himself as well as a painting of Laozi that he painted himself.[28] The next year, when Huizong was sending another group of presents, he included two more paintings he had done himself, of two of the most important Taoist deities, the Celestial Worthy of Primordial Beginning (Yuanshi tianzun) and the Supreme Lord of the Way (Taishang daojun). Huizong wrote that if these were put together with the painting he had done the year before of Laozi, they would make a complete set of the Three Purities (Sanqing), the highest gods of Taoism (see cat. nos. 65–67).[29] In another letter Huizong mentioned the completion of an image of the Third Mao Lord (San Mao jun), one of the principal deities of the Highest Purity movement, which would be given to Liu when he returned to the capital.[30]

Huizong's calligraphy seems to have been valued even more than his paintings. At one point Liu asked permission to have some of the calligraphy Huizong had done for him carved on stone at the temple. Huizong responded that the commemorative essay he had written for the temple and the seeing-off poem he had recently sent could be engraved, but not the letters that were in his hand.[31] Apparently Huizong would not have been so open in his letters to Liu if he had expected them to be carved on stone for all to read.

From these early years on, Huizong took an interest in Taoist liturgy. In 1108 he ordered that liturgies for the Rite of the Golden Register be collected in order to send them to each county and prefecture with a Taoist temple where the prefect or magistrate would select a Taoist priest to perform them.[32] According to Michel Strickmann, "The purpose of the Rite of the Golden Register ever since its inception in the fifth century had been to guarantee the welfare of the imperial house. Thus the distribution of a newly codified redaction of the Golden Register Rites was intended to ensure that a vast chorus of supplication of the interests of the Song would rise from every corner of the empire."[33] Preparing this compendium took time, and two years later Huizong handed over to his chief councillor, Zhang Shangying (1043–1121), what had been assembled. He told

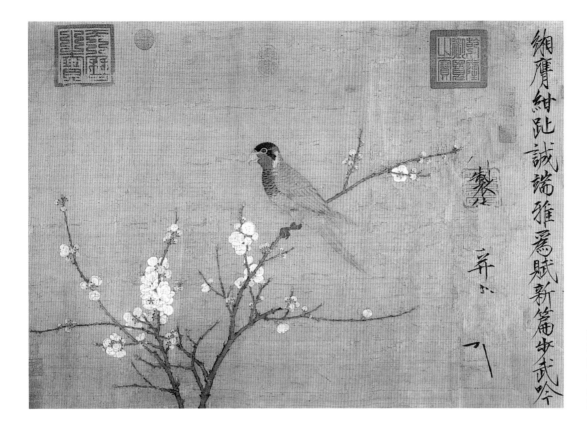

Fig. 3
Emperor Huizong. *Five-Colored Para-keet* (detail). Northern Song dynasty, early 12th century. Handscroll; ink and colors on silk; 53.3 × 125.1 cm. Museum of Fine Arts, Boston.

Zhang that the Taoist masters to whom he had entrusted the job disagreed on many points and that he wanted Zhang to correct, complete, and polish what they had submitted.[34]

From about the beginning of the Zhenghe period (1111–17), Huizong began taking on more ambitious projects, many with Taoist connections. By this time he was in his early thirties, full of confidence and energy. He began building on a large scale, had paintings of auspicious signs done by the hundreds if not thousands, and started collecting rare Taoist texts, to mention only some of the most ambitious projects.

Building projects certainly must have consumed a lot of energy and resources. In the fourth month of 1113, the building in which Huizong had been born was converted into a Taoist shrine. In that same month, a new palace complex was begun, called Precious Harmony Hall (Baohe Dian). Decorated in an understated style with unpainted wooden beams and rafters, it had pavilions for the storage of books, antiques, paintings, calligraphy, and musical instruments.[35] But the largest palace-related project was the huge extension of the palace to the north, creating the parklike Extended Blessings Palace (Yanfu Gong). Writing half a century later, Hong Mai (1123–1202) described Extended Blessings as the most extravagant palace project done in Song times. It had seven halls, thirty pavilions, and a 110-foot artificial mountain with a pavilion on top. A pond measuring 400 by 267 feet was dug, and the cranes, deer, and peacocks kept

there numbered in the thousands.[36] In 1115 Huizong also restarted a long-set-aside plan to build a Hall of Enlightenment, which the architect Li Jie had planned for him in 1104.[37]

Given the scale of these construction projects, it is perhaps not surprising that Huizong set court painters on an ambitious project as well: making visual records of all the auspicious phenomena of his reign. A couple of Huizong's poems refer to summoning painters to make visual records of auspicious objects and events:

> Fine crops are a sign that this is a special time.
> There are even numinous mushrooms at the base of the Halcyon Arch.
> Passing through, one sees their brilliance and knows they are an exceptional thing.
> A painter is summoned to create a new picture.[38]

> No day passes without auspicious items brought for submission.
> With bows they present grains and grasses, each different in some way.
> Sometimes I call for an expert in red and green pigments.
> In each case I give him the plan and have him make the painting.[39]

If we are to take at face value the accounts of art chroniclers such as Deng Chun and Tang Hou, Huizong must have called on painters to record auspicious occurrences rather frequently,

not to mention taking up the brush himself from time to time. Deng Chun, in his *Painting Continued (Huaji)* of 1167, mentioned that paintings were made of unusual phenomena deemed to be of good omen, such as a red crow, white magpie, and double-stemmed bamboo, as well as rare objects sent from distant lands. These pictures were made up into a series of albums of fifteen leaves each.[40] Tang Hou, writing over a century later, claimed that hundreds of albums of thirty pictures each were made in this way and concluded that court painters must have done much of the work.[41]

Of the dozen or more surviving paintings believed to be by Huizong's hand, three are thought to have originated in this project: *Five-Colored Parakeet* (fig. 3), *Cranes of Good Omen* (fig. 4), and *Auspicious Dragon Rock* (fig. 5). The size of these short handscrolls (perhaps originally large album leaves) varies from 51 to 54 centimeters in height and 125 to 138 centimeters in width. The coupling of lengthy inscriptions and exacting painting means the auspicious phenomenon is documented in both word and image. On the two that have fully legible inscriptions, Huizong claimed not merely to have "designed" the painting but also to have painted it and done the calligraphy ("Imperially designed, imperially painted, and inscribed" [*yu zhi yu hua bing shu*]).

Taoist associations are strongest in *Cranes of Good Omen*. The painting depicts eighteen cranes flying above the southern front gate to the palace, with two more cranes perched on the roof ornaments. Clouds surround the gate. Above the clouds the sky is painted an azure blue, something quite unusual in a Chinese painting. The roof is drawn in the standard style for rendering architectural subjects, with the lines of the tiles and the brackets of the eaves all drawn with a ruler. The cranes, although small, are carefully depicted, the black and red feathers of their heads, necks, and tails scrupulously indicated. Their heads are all seen in profile, but the wings of those in flight are seen from above. They are flying in several directions, suggesting that they were circling around above the roof. This impression of action is countered by an equally strong impression of elegant patterning. The cranes are distributed fairly evenly over the sky in a two-dimensional pattern, with none blocking the view of another, creating the sort of pattern one might find on a textile or lacquer box.

The inscription on *Cranes of Good Omen* instructs us to view it as a visual record of an extraordinary event witnessed by thousands of residents of the capital:

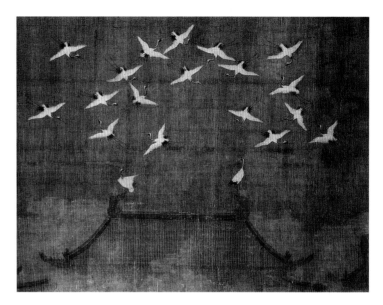

Fig. 4
Emperor Huizong. *Cranes of Good Omen*. Northern Song dynasty, early 12th century. Handscroll; ink and colors on silk; 51 × 138.2 cm. Liaoning Provincial Museum, Shenyang.

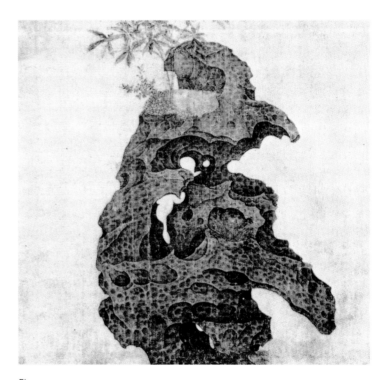

Fig. 5
Emperor Huizong. *Auspicious Dragon Rock* (detail). Northern Song dynasty. Handscroll; ink and light colors on silk; 53.8 × 127.5 cm. Palace Museum, Beijing.

On the evening of the day after the *shangyuan* festival in 1112, auspicious clouds suddenly formed in masses and descended about the main gate of the palace, illuminating it. Everyone raised their heads to gaze at them. Suddenly a group of cranes appeared flying and calling in the sky. Two came to perch atop the "owl-tail" ridge-ornaments of the gate, completely at ease and self-composed. The others all wheeled about in the sky, as if responding to some rhythm. Residents of the capital walking about all bowed in reverence, gazing from afar. They sighed at length over the unusual sight. For some time the cranes did not disperse. Then they circled about and flew off, separating at the northwest quarter of the city. Moved by this auspicious event, I wrote the following poem to record the facts:

Brilliant multi-hued rainbows caress the roof's ridge.
The immortal birds, proclaiming good auspices, suddenly arrive
　in favorable response.
Wafting about, originally denizens of the Three Immortal Isles,
Pair after pair, they go on presenting their thousand-year-old
　forms.
They seem to be imitating the blue *luan* phoenix that roosted atop
　the jeweled halls.
Could they possibly be the same as the red geese that congregated
　at Heaven's Pond?
Lingering they call and cry at the Cinnabar Tower,
Thus causing the ever-busy common folk to know of their
　presence.[42]

The vocabulary employed in this poem is similar to that in the large body of poetry by Huizong, which has many references to auspicious or multicolored clouds, rainbows, phoenixes, cranes, flying, the auspicious, the numinous, and places such as Cinnabar Tower and the Three Immortal Islands.

It is the painting, however, that makes *Cranes of Good Omen* so powerful. Peter Sturman, in his study of this painting, draws attention to how the meticulous fashion in which the cranes and building are painted makes the auspicious event somehow more real.[43] There seems a ritual dimension here: not only does representation call powers into being, but getting every detail right is essential to success.

Cranes appear in other paintings and poems by Huizong. An album of six depictions of cranes in various poses signed by Huizong was published in the 1930s, though its current whereabouts is unknown (fig. 6). Years ago Benjamin Rowland proposed that this album was a copy of a well-known but no longer

extant wall painting by Huang Quan, a painter Huizong admired.[44] Huizong also wrote a set of ten poems on cranes. The following two show something of the range of themes:

The halls of the Five Clouds Palace allow one to pace the void at
　length.
The Dipper revolves and turns the empyrean before the night is
　done.
The white crane flies here carrying an auspicious missive.
The pure sounds one after the other—the fragrance of returning
　spirits.[45]

They assemble at Penglai, then scatter—the immortals returning.
Feathered riders breeze by—the white cranes flying.
In brilliant ages people are used to seeing such auspicious sights.
Why must we wait for folk ballads to sing of the golden-clothed?[46]

Huizong's interest in the visual depiction of auspicious signs was also manifested in other ways. Several times between 1114 and 1117 he had special flags commissioned so that representations of these phenomena could be carried in the grand processions that accompanied the imperial carriage when the emperor left the palace to perform rituals.[47]

The early and middle Zhenghe period also marked an intensified interest in Taoism on Huizong's part. Cai Tao, who, as the son of Cai Jing, had as good an opportunity to know what went on at court as anyone, thought a dream marked the turning point:

Early in the Zhenghe period the emperor was ill. After a hundred days he was on the mend, then one night he had a dream that someone summoned him. In the dream it was like the time when he lived in his princely mansion and attended Zhezong's court. In response to the summons he entered a Taoist temple where two Taoist masters acted as ushers. They arrived at an altar where the exalted one told Huizong: "It is your destiny to promote my religion." Huizong bowed twice and accepted the command. As he left, the two ushers led him away. When he woke up he made a record of the dream and sent it to Cai Jing, who at the time was living in Hangzhou.[48]

It was after this dream, Cai Tao claimed, that Huizong stepped up the construction of Taoist temples in the palace and brought in more Taoists to perform ceremonies. It was then, too, that he personally composed the "Pacing the Void" hymns still extant.

The two Taoist masters who attracted the most notice at court in this period were both surnamed Wang. Wang Laozhi was an ascetic who ate only one meal a day and wore only a single

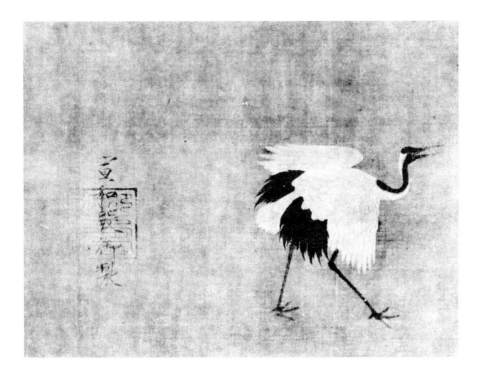

Fig. 6
Emperor Huizong. *Crane*, leaf 6 from an album of 6 leaves entitled *Six Cranes*. Northern Song dynasty. Ink and colors on silk. Location unknown.

garment winter or summer. In the ninth month of 1113, he was summoned to the palace and given the title Master of the Cavern Tenuity (Dongwei xiansheng). Huizong had Cai Jing house him in the southern garden of the house he had given Cai Jing. Once, according to Cai Tao, Huizong asked Wang about his consort Liu, who had recently died.[49] Wang told him she was the Sovereign of Exalted True Purple Emptiness (Shangzhen zixu yuanjun). For some time Wang served as a medium and carried messages between Huizong and Consort Liu. One of the other consorts, who also missed Consort Liu, asked Wang Laozhi whether Liu still remembered her, and the next day Wang brought a letter from Liu discussing things the two consorts had talked about the previous autumn. Many literati treated Wang Laozhi as a seer and visited him to have him write characters for them, which were interpreted as cryptic prognostications. Huizong did a piece of his calligraphy for him, which read "Illuminated Perfected who Observes the Marvelous" (*Guanmiao mingzhen*).[50]

After Wang Laozhi died, in 1114, another clairvoyant, Wang Zixi, took his place, both at Cai Jing's house and at court. At the time there was a drought. When the emperor prayed for rain, he would send a messenger to Wang to get him to write a prayer for rain on a plain piece of paper. Once when this occurred, Wang Zixi suddenly wrote a small talisman with a note to the left: "Burn this talisman, put the ashes in hot water, and wash with it." The palace messenger was afraid to take it, but Wang insisted. This talisman water turned out to be an effective cure for the pink-eye then afflicting a favored consort.[51] Through his uncanny prescience of this sort, Wang developed a reputation for being able to foresee events. Cai Jing, however, grew tired of him and complained to Huizong about being asked to support *fangshi*, whereupon Huizong had Wang sent instead to a Taoist temple he had just built.[52]

Huizong's fascination with these extraordinary individuals did not lead him to neglect the more text-oriented side of Taoism. Late in 1113 Huizong issued a general call for the collection of Taoist texts, ordering prefects and circuit intendants to conduct wide searches and priests, laymen, gentlemen, and commoners all to submit their Taoist books promptly.[53] Moreover, in the third month of 1114 he ordered every circuit to send ten Taoists to the capital for advanced training.[54]

Some of the learned Taoists who arrived in the capital were brought into the project of editing a new Taoist canon. This editorial project did not just look for the best editions of old classics, but incorporated the key texts of relatively recent teachings, such as the Celestial Heart, Thunder Rites, and Divine Empyrean schools.[55] As the work on the canon was completed, other editorial jobs were found for the assembled Taoists, including a *History of the Tao (Daoshi)* and an *Institutes of the Tao (Daodian)*. The *History* was to cover the period through the Five Dynasties, with chronicles of the rulers who had attained transcendence, twelve monographs on Taoist subjects, and biographies of male and female immortals. The *Institutes* would cover the Song period.[56]

Although these text-oriented projects were taking Huizong's

interest in Taoism away from dreams, auspicious signs, and communications with the dead, they also led to his meeting Lin Lingsu, the Taoist master who Huizong came to feel had powers greater than any of the others he had met over the years.[57] Lin came to the capital in 1113 or 1114, probably in response to Huizong's call for unusual texts and adepts. Originally from Wenzhou (Zhejiang), Lin was a master of Thunder Rites and an exponent of a new sect of Taoism, Divine Empyrean (Shenxiao) Taoism, which he had learned from a Taoist master in Sichuan.[58] The Divine Empyrean, they proclaimed, was a celestial region far superior to those that governed the other Taoist orders. In Isabelle Robinet's words, "The style of this movement was essentially liturgical. A complete cycle of recitations ensures the salvation of humankind, equivalent to a Return to the Origin. It breaks the circle of life and death and permits rebirth in the Taiping heaven. An important place is reserved for the cosmic and apotropaic power of thunder and lightning, which the master must interiorize in order to make use of its power."[59]

One of the earliest and fullest accounts of Lin Lingsu again draws attention to Huizong's belief that dreams reveal truths. One night Huizong dreamt that in response to a summons from the Eastern Flowery Sovereign he traveled to a Divine Empyrean Palace. When he awoke, he asked the Taoist official Xu Zhichang to find out what the terms referred to. After asking around, Xu learned of a Taoist from Wenzhou named Lin who talked of the Divine Empyrean and had written poems about it. Xu reported this to Huizong, who summoned Lin. At his audience, Huizong asked Lin what techniques he possessed, and Lin rather immodestly claimed to comprehend the Heavens, the world of men, and the subterranean regions. Huizong granted Lin titles and built the Penetrating Truth Temple for him to live in.[60] Lin's first job was to work on the *History of the Tao,* but soon he was giving monthly lectures in the palace for court officials and imperial relatives.

What makes Lin Lingsu notorious in Chinese historiography is his revelation in 1116 or 1117 that Huizong was an incarnation of the elder son of the Jade Emperor, named the Great Lord of Long Life (Changsheng dadi).[61] Huizong was so pleased with learning this from Lin that he had the palatial Supreme Purity Precious Treasure Temple built for him. He also ordered Divine Empyrean temples established in every prefecture to house images of the Great Lord of Long Life and his brother, the Sovereign of Qinghua. Existing Taoist temples could be used for this purpose. In places without any Taoist temples, Buddhist ones could be converted, and there is evidence that Buddhist temples were in fact taken over by Taoists in this period.[62] The construc-

tion or conversion of these temples must have created a lot of work for painters and sculptors, since they typically had twenty-two immortals depicted on their eastern and western walls, in addition to images of the main deities at their altars.[63]

Twice in 1117 Lin Lingsu was involved in the descent of heavenly spirits. The first occurred in the second month when Lin Lingsu announced that the Sovereign of Qinghua had descended to earth. Huizong assembled huge numbers of Taoist priests at Precious Treasure Temple to hear Lin tell of this great event.[64] This is the Assembly of the Thousand Taoists commemorated on the wall of the Eternal Joy Temple.[65] From then on Huizong made frequent trips to this temple and would always distribute large quantities of cash. Wanting his subjects to know of the strength of his commitment to Taoism, in the fourth month of 1117 Huizong issued an edict stating that he believed he had been given the mission of saving China from the foreign religion (i.e., Buddhism) and returning it to the correct way.[66]

The second visitation of heavenly spirits occurred in the twelfth month. The *Dynastic History of the Song (Song shi)* merely records that heavenly spirits came down to Earthly Tranquility Hall (Kunning Dian) and that a stone was carved to record the event.[67] One stele in Huizong's calligraphy with the full account of the event survived in a temple in Shaanxi, showing that rubbings of the stele in the capital must have been distributed for copying around the country (fig. 7). This four-foot-tall stele is perhaps the most unambiguously Taoist work among the surviving examples of Huizong's art. It is visually striking because of the "dragon-emblem cloud-seal" script used for the poem by Lin Lingsu at the top.[68] The lower part, in Huizong's slender gold calligraphy, records that on the evening of the full moon in the twelfth month of 1117, heavenly spirits again descended to Earthly Tranquility Hall, creating a scene even more numinous and extraordinary than the time before. Amidst thunder, lightning, and colored clouds, a procession appeared, and marvelous music and unusual fragrances were perceptible.

> Suddenly among the tables there was a twenty-eight character poem in dragon-emblem, cloud-seal script. The vocabulary was as marvelous as spirits and immortals, unlike that of the human world. Before the ink was dry, I looked at it closely. Chu Hui, the Senior Officer of the Western Terrace, had signed the end of it. Chu Hui is none other than the Feathered Guest, Lin Lingsu, who is the Senior Officer of the Western Terrace of the Royal Headquarters of the Exalted Supreme Divine Empyrean Jade Purity Right Extreme, the first among the regions of Heaven's administrations of the immortals. At this time he was far away in Penetrating

Truth Temple sleeping soundly, yet he was able in the night to communicate with the spirits like this. The next day when questioned about this incident, he smiled but did not answer, so I knew one cannot communicate in words how the great Way shows its vast powers, which is to be found specifically in the conjunction of ideas. Accordingly I have engraved this on stone to record the facts. Written in Proclaiming Harmony Hall (Xuanhe Dian) on a day in the middle of the month.[69]

Huizong's confidence in the potency of his own calligraphy—both its inherent power when judged by the aesthetic standards of the time and its added power as a manifestation of the Son of Heaven—undoubtedly encouraged him to agree to let his calligraphy be widely displayed. As seen above, he had earlier allowed Liu Hunkang to erect stelae with his compositions in his handwriting. Later, in the eighth month of 1119, Huizong composed and wrote in his own hand a record of the Shenxiao Jade Purity Longevity temples that was carved on a stele, and copies were distributed throughout the realm so that stones could be erected at Shenxiao temples everywhere.[70]

Huizong did not confine his compositions to commemorative pieces. Like Xuanzong in the Tang, he wrote a commentary on the *Laozi*. This text, which has been preserved in the Taoist canon, cites a range of authorities, including Confucius and Mencius, but draws most heavily on the philosopher Zhuangzi and the *Book of Changes (Yi jing)*.[71] Liu Ts'un-yan, who studied the commentary in depth, finds in it evidence that Huizong looked on the *Laozi* as a guidebook for rulers on how to govern.[72] Huizong's commentary was engraved in stone at the Shenxiao temple in the ninth month of 1118 and printed in 1123.[73] Scholars were encouraged to read and comment on it. The Taoist Canon contains commentaries on Huizong's commentary written by two contemporaries, one a low-ranking official, the other a student at the imperial academy.[74]

Huizong's enthusiasm for Lin Lingsu's teachings occasionally intersected with his interest in painting. The late Song hagiography of Lin Lingsu records that after Lin had redecorated a hall at a temple, Huizong asked to see Zhenwu, the martial god of the north. Lin Lingsu spent the night at the temple fasting. At noon the next day dark clouds obscured the sun and there was thunder and lightning. Huizong burned incense, bowed, and prayed to see Zhenwu, who eventually appeared to him wearing a long black robe, gold shield, and jade belt. Huizong sketched his likeness, then summoned a court painter to finish the painting for him. Almost immediately Zhenwu disappeared. The next day Cai Jing suggested comparing the painting just made of Zhenwu

Fig. 7
Emperor Huizong. Ink rubbing of a Taoist stele from Yao county, Shaanxi province. Northern Song dynasty. Ink on paper.

to the one that had been made under similar circumstances during Taizong's reign (r. 976–97) and kept sealed up ever since. The two, we are told, turned out to be identical.[75]

Huizong's interests in the visual found an outlet also in the Taoist Canon project. He wrote a preface to a set of illustrations in the *Lingbao wuliang durenjing futu* (Talismans and diagrams of the wondrous scripture of supreme rank on the infinite salvation of numinous treasure). In Judith Boltz's words, "Designed to introduce the rudiments of the Shenxiao reenactment of the Lingbao revelation, the treatise supplies the essential diagrams, talismanic inscriptions, sacred recitations, and lengthy registers of the celestial bureaucracy."[76] The talismans have obvious visual interest, especially to someone so devoted to calligraphy as

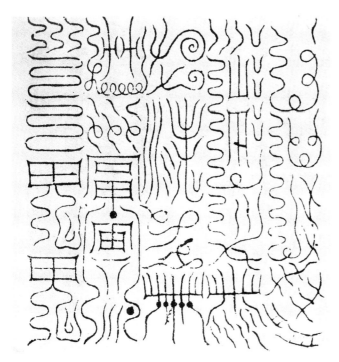

Fig. 8
Zhao daming jiuhua zhi fu (The talisman of summoning the nine transformations of great obscurity). From *Lingbao wuliang duren [shangpin miaojing] futu* (Talismans and diagrams of the wondrous scripture of supreme rank on the infinite salvation of numinous treasure; woodblock-printed, accordion-mounted book; Ming dynasty, 1444–45; reprint of a lost Northern Song dynasty book, early 12th century). From ZTDZ, vol. 4: 588.

Fig. 9
Yuandong yuli zhang (Stanza of the jade eon of the primordial cavern; detail). From *Lingbao wuliang duren [shangpin miaojing] futu* (Talismans and diagrams of the wondrous scripture of supreme rank on the infinite salvation of numinous treasure; woodblock-printed, accordion-mounted book; Ming dynasty, 1444–45; reprint of a lost Northern Song dynasty book, early 12th century). From ZTDZ, vol. 4: 581.

Fig. 10
Seal inscribed "The mandate was received from Heaven; long life and everlasting glory." Believed to have been Huizong's. From Ecke 1972: 246, pl. 18.

Huizong (see figs. 8 and 9). One of the seals used by Huizong (fig. 10) seems to draw inspiration from these sorts of talismans.

After promoting the Shenxiao teachings for a couple of years, Huizong began placing curbs on Buddhist establishments. In 1118 the Taoist Bureau reviewed over six thousand volumes of Buddhist texts to discover ones that slandered Taoists or Confucians. Nine volumes were singled out to be destroyed, though a copy of each was to be preserved as evidence. Lin Lingsu wrote a treatise detailing the slanders in these texts, which was printed and circulated.[77] Anti-Buddhist measures went a step further in the first month of 1119 when Buddhist temples and monasteries were forbidden to increase their land or buildings. Then the foreignness of Buddhism was to be erased through a process of renaming. Buddhist monks were renamed "scholars of virtue" (*deshi,* to correspond to *daoshi,* Taoist priests). They were to wear Taoist-style robes, use their original surnames, and salute with raised fists, not joined palms—in other words, they were to make themselves visually indistinguishable from Taoist clergy. Buddhas, bodhisattvas, and arhats were all given new names— Shakyamuni, the historical Buddha, was to be called the Golden Immortal of Great Enlightenment. Temples could retain the old

statues of these newly renamed deities, but had to clothe them in the robes and caps of Taoist divinities.[78]

Not surprisingly, Huizong's support of Lin Lingsu and Divine Empyrean Taoism provoked resistance and protest. Huizong's eldest son, the heir apparent, a young man in his mid teens, was the most direct, calling Lin a fraud who used tricks such as paper cranes to create the illusions with which he dazzled Huizong.[79] Cai Jing went along with most of Huizong's projects, dutifully offering praise whenever called for, but he too began complaining. Supporters of Buddhism circulated texts ridiculing the Divine Empyrean, and even Huizong's former chief councillor, Zhang Shangying, wrote a text defending Buddhism.[80]

Lin Lingsu had become a political liability, and Huizong may have lost faith in his powers as well. In the eleventh month of 1119 Lin Lingsu was sent back to Wenzhou and the following year most of the restrictions on Buddhism were removed.

Even at the height of his enthusiasm for the Divine Empyrean, Huizong's interest in Taoism was never exclusive, and he continued to find pleasure in many other sorts of wonderful things, from rare books to fine calligraphy and ancient bronzes. This can be seen from the entertainment Huizong offered his guests at a banquet held in the ninth month of 1119, a couple of months before Lin was sent away. His guests, including a son and two brothers as well as eminent officials such as Cai Jing and Wang Fu, were brought to Preserving Harmony Palace, the compound built in 1113. The treasures Huizong had laid out to show them included not only "Taoist books of the golden casket and jade book box, along with the various secret Heavenly texts of the Divine Empyrean sect" but also Confucian works, the stone drums of the Zhou, ancient bronzes, and many scrolls of painting and calligraphy from the Tang and earlier.[81]

Not only did Huizong show off his collections, but in this period he put many scholars to work on the catalogues of them. The *Xuanhe Painting Catalogue (Xuanhe huapu)* has a preface dated 1120, and the *Xuanhe Calligraphy Catalogue (Xuanhe shupu)* must date to a couple of years later, probably 1123.[82] Huizong's commitments to Taoism are reflected throughout the *Xuanhe Painting Catalogue.* As Xiao Baifang has shown in a detailed study, this catalogue of the imperial painting collection was compiled and edited in a way that gave Taoism a more elevated position than it occupied in any earlier work on painters or painting.[83] First, and perhaps most important, it listed over 350 paintings on Taoist subjects, the majority in the Taoist-Buddhist section, but a large number also were listed under artists classified as figure, landscape, or architecture specialists. Typical of the Taoist paintings listed in the *Painting Catalogue* are paintings

of the star and constellation gods, paintings of major deities such as the Three Purities, the Celestial Worthy of Primordial Beginning (Yuanshi tianzun; see cat. nos. 65, 68), Laozi, astral deities, immortals *(xian),* and realized beings *(zhenren).* Most of these were undoubtedly originally made to be hung at altars in temples, so it is of note that they had been removed from their religious settings and turned into art objects to be kept in the palace, where they were probably kept rolled up most of the time.[84]

Another way the catalogue elevates Taoism is by giving it priority. Taoist and Buddhist paintings were made the first category in the catalogue, something no earlier work had done.[85] Then, in the lists of paintings by individual artists, Taoist paintings are generally listed first.[86] Taoist language and Taoist ideas are found throughout the work. The death of the painter Guo Zhongshu, for instance, is referred to as his "becoming an immortal."[87] Moreover, the *Painting Catalogue* gives more attention to paintings by Taoist masters and more attention to their status as Taoist masters than any earlier works on painters did. The Tang master Zhang Suqing, for instance, had been described by Guo Ruoxu, author of *Experiences in Painting (Tuhua jianwen zhi),* as a Taoist adept attached to a temple, but nothing more is said of his Taoist status. In the *Painting Catalogue,* however, his status as a priest is highlighted by a recounting of the imperial honors he received.[88]

Two Taoist priests still active when the catalogue was compiled were given listings in the *Painting Catalogue.* Xu Zhichang, the Taoist priest who introduced Lin Lingsu to court, was said to have the "style of a literati gentleman." He was described as a skilled musician who had a reputation for techniques of curing illnesses without the use of drugs. Knowledgeable in both the Taoist and Confucian texts, he was employed on the canon editing project. His paintings of gods and immortals were said to be right in every detail, but the imperial collection had only one of them.[89] Xu's contemporary Li Derou was also employed on the canon project. He was said to have had a natural talent for painting and to have been especially good at capturing likenesses. The twenty-six paintings by him in the palace collection included one of each of the Mao Lords, Zhuangzi, Lü Dongbin, Tao Hongjing, Sun Simo, Wang Ziqiao, Liezi, and many other key figures in Taoist traditions.[90] Cai Tao, in his account of Li Derou, adds something not in the catalogue: Li was sent away from the capital for having made fun of the Divine Empyrean affair.[91]

In the last five years of Huizong's reign (1120–25), he did not initiate any new pro-Taoist projects, but he does not seem

to have lost faith in Taoism or even in the revelation that he was an incarnation of the Great Lord of Long Life. He found new Taoist adepts to talk to, such as Wang Wenqing, another follower of Divine Empyrean Taoism.[92]

Another interest that Huizong continued to pursue after the departure of Lin Lingsu was the magnificent garden Genyue (Northeast Peak). Genyue has generally been interpreted as the supreme example of Huizong's megalomania. Begun in late 1117 or early 1118, this garden surpassed even Extended Blessings Garden.[93] Genyue was built away from the palace, in the northeast quarter of the Old City, and had a circumference of "more than ten *li*" (i.e., it was over three miles around, which if square would mean it was less than a mile on each side, making it considerably smaller than the Summer Palace in Beijing, the last of the imperial pleasure parks). A forty-six-foot-tall stone, named Divine Conveyance Rock, was just one of many named rocks in the park, all admired for their unusual shape and the way they represented the forces of nature. Behind this rock was an artificial mountain about one hundred feet tall. There were also streams, pools, waterfalls, and grottos, all given names, many of which carried Taoist overtones, such as "Propitiating the Perfected Ones Ledge" or "Eight Immortals Lodge." The park was stocked with rare plants and a great variety of birds and animals, including gibbons from Sichuan and hundreds of deer.

The artificial mountain and streams, the collection of specimens from across the country, and the labeling of sites to correspond to famous places in distant regions make Genyue rather like a small version of the huge cosmic park (400 *li* in circumference) created by Emperor Wu of the Han and celebrated in many Han literary pieces. Emperor Wu's Shanglin Park was said to have three thousand species of plants and valuable exotic stones, including a coral tree with 462 branches. As Lothar Ledderose has written, gardens like this drew on "the magical belief that by artificially making a replica of something one wields power over the real object."[94]

Huizong wrote an account of Genyue that was inscribed on a stele placed near the entrance of the park, much as he wrote accounts to be inscribed on stone at Taoist temples (and on paintings of auspicious signs). Huizong began on a very general level with a discussion of the geographical locations of the capitals since the Zhou, and the connections between the security of dynasties, the military vulnerability of their capitals, and their virtue. He then discussed earlier royal parks, including the 70-*li*-square one of King Wen (celebrated in Confucian texts because the people shared its joys). Huizong added that "in the sea there are the three islands of Penglai, which the sovereigns make their

capital and where the immortals and sages dwell. They do not stay there unless the configuration is right."[95] His own park, he seemed to imply, would be a similar paradise that would attract immortals and sages. Huizong next discussed how the garden re-created the great sights of the realm—specific bodies of water and mountains are named, as well as the plants from all over, such as loquat, orange, tangerine, lichee, magnolia, and jasmine. But much more space is devoted to the naming and description of the man-made structures, such as the Documents Lodge, shaped like a half moon, the round Eight Immortals Lodge, and the massive Longevity Mountain.

In creating Genyue, Huizong strove to match the extent of the realm and the diversity of phenomena found in it, and to gain mastery over them through naming them. I suspect that Huizong spent enormous resources on this project because he saw it as efficacious, not just sensually satisfying.

What was the impact of Huizong's active patronage of both artists and Taoists? Court patronage is never a simple phenomenon and certainly was not simple in twelfth-century China. Huizong had vast resources at his disposal to give material and institutional support to doctrines, styles, and trends he favored. For instance, he changed the curricula used to train court artists and introduced government schools for Taoists. He subsidized temples that honored particular deities. He organized huge text-editing and publishing programs, which enabled him to see to it that his views received wide circulation. But resources are not everything. Huizong, like other emperors, could not ensure that everyone approved of his choices. Sometimes influential circles turn against what the court favors, precisely because they distrust court patronage. The long-term impact of Huizong's support for Taoism, the arts, and Taoist art is not all that he would have desired.

Huizong's initiatives in the training of court artists are usually viewed positively. He insisted that court artists learn to join poetry and painting and to observe nature closely. Through the Southern Song, the court maintained a successful painting academy that built on traditions Huizong had introduced. Major artists such as Ma Yuan, Xia Gui, Li Song, and Li Di thrived in this environment.[96] One could also argue that Huizong's collecting had positive, if unintended, consequences. The huge collection of art and antiques Huizong amassed made possible the preparation of catalogues that helped advance knowledge for centuries to come. The art and antique market was already well developed when Huizong took the throne, but the huge purchases made by the court could only have stimulated this market further.[97] One might have feared that by taking so many

paintings and calligraphies out of circulation, imperial collecting would hurt art, but, as happened in Europe, not everything that entered a palace collection stayed there forever.[98] Even though the Jurchen seized the collections, pieces gradually reentered circulation.

We often cannot know for sure what Huizong expected to accomplish from his larger projects. He commissioned Taoist art for all the temples he had built and promoted recognition of Taoist paintings in his *Painting Catalogue*. Probably it is fair to assume that he wanted to see Taoist art gain stature. If so, he seems to have been unsuccessful. None of the Taoist paintings in the *Xuanhe Painting Catalogue* are extant today, and the Southern Song imperial collections were not strong in this field.

Historians of Taoism are divided on the long-term impact of Huizong's massive support. Twenty years ago Michel Strickmann called the early twelfth century a period of renaissance for Taoism. He saw Huizong's reign as the "beginning of another great wave of Taoist revelation, comparable in some sense to the fourth-century movements," and argued that "in the same way that fourth-century scriptures provided the substance of Taoist practice throughout China's Middle Ages, the re-establishment and revivification of the religion during Huizong's reign is responsible for much in the shape and complexion of Taoism in modern times."[99] One reason Strickmann placed so much importance on Huizong's patronage is the weight he gave to the textual traditions of Taoism. Huizong's collection of Taoist texts and expansion of the Taoist Canon, and, above all, his printing of it, had an undeniable impact on the survival of Taoist texts. On the other hand, Shenxiao Taoism by no means became a dominant strand of Taoist teachings. To the contrary, it probably was tainted by its failure to save Huizong and his empire from the Jurchen. The contemporary historian of Taoism Ren Jiyu sees a reaction against Huizong's emphasis on ritual-oriented Taoism in the decades after his reign. This allowed more ethically oriented strands of Taoism, such as Quanzhen (Complete Realization) Taoism, to gain strength in the mid-twelfth century.[100]

Huizong himself seems to have been aware of the danger that imperial support for one among many competing styles, doctrines, or traditions could do more harm than good. For a year and a half he experimented with subordinating Buddhism to Taoism. But through most of his reign he sought less confrontational forms of merging or fusing traditions. Several times he tried to diminish or mitigate rivalry between Taoism and Confucianism. There were many arenas in which there was at best a blurry line between Confucian and Taoist ideas and rituals, rang-

ing from the state cults to heaven and other deities, to studies of the *Yi jing*, prognostications, and numerology, to shrines to local heroes. Huizong seems to have wanted to make this line even blurrier. In the fourth month of 1118 he issued a memorial on the reform of the school system that began by asserting the common origins of Confucianism and Taoism. The Tao, he asserted, is everywhere, in the way Confucians (*ru*) rule the state and the way scholars (*shi*) cultivate themselves. The separation of the way of Laozi and the mythical Yellow Emperor from that of Confucius and the ideal rulers Yao, Shun, and Zhou Gong did not occur until the Han dynasty. His personal mission, Huizong asserted, was to bring the two traditions into harmony. Toward this end, those pursuing the traditional curriculum should also study two Taoist texts and those in the Taoist curriculum should study two Confucian texts.[101]

Huizong's patronage of court painting and calligraphy involved much less in the way of resources than did the construction of temples, palaces, and parks, and therefore evoked less protest. Nevertheless, I interpret many of the editorial choices that went into the *Xuanhe Painting Catalogue* as attempts to create a "big tent" for art lovers, a tent large enough to accommodate those who loved the bird-and-flower paintings of Huang Quan and Cui Bo as well as those who considered them vulgar and preferred sketchy monochrome paintings of symbolically rich materials such as bamboo or plum. It gave Taoist subjects a place of honor, but in a universe that contained much that was far from the centers of Taoist interest. Huizong never subordinated art to Taoism. He did not convert the painting academy to a Taoist art academy, or make painters study Taoist scriptures. In fact, much of Huizong's own art work fits the literati model of work made for one's own enjoyment. Of the surviving calligraphy by him, besides a couple of government documents, most of the rest consists in poems or exercise texts of the sort Northern Song literati commonly did. He painted in a range of styles, including ones categorized as literati. There is no sign that at any time he switched entirely to Taoist subjects or approaches. His aim always seems to have been a synthesis in which the arts of the literati, the arts and techniques of the Taoist masters, and the arts and techniques of those with all sorts of other skills, from court painters to clock makers, could be pursued side by side.

NOTES

I would like to thank Chris Dakin for help with the poetry used in this paper and Maggie Bickford for helpful suggestions.

1. QSS, *juan* 1494: 17066; Schipper 1989: 119. Schipper (1989: 119–20) gives the music for this hymn as it is currently performed in Taiwan.
2. On Xuanzong's commitment to Taoism, see Xiong 1996 and Benn 1987. On Zhenzong and Taoism, see S. Cahill 1980.
3. Needham et al. 1965: 498–502. On Rudolf II, see Fucikova et al. 1997.
4. The only comprehensive study of Huizong I know of is Ren 1998, which is strongest on politics. There is, however, a large literature on Huizong as a painter. Scholars now largely concur that the paintings attributed to Huizong are a mixed bag; among them are ones by his hand alone, ones he did in collaboration with court artists, ones done by court artists acting under Huizong's instruction, later copies of paintings from his court, and later imitations and forgeries. See Rowland 1951, Sirén 1956–58, Xie 1989, Ecke 1972, Xu 1979, J. Cahill 1980, Li 1984, Deng 1985, Chen 1993, and Bo 1998.
5. For a late Song view, see the historical romance *Xuanhe yishi*, translated in Hennessey 1981, especially 13–14. One reason this view has not undergone much revision in the twentieth century is probably its resonances with Qing history. Huizong, it seems to me, is often interpreted in Chinese scholarship as a combination of Qianlong and Cixi—all of the grandiosity of Qianlong combined with the militarily disastrous self-delusion that Cixi displayed when she built a marble boat and tried to use the Boxers against the Western powers.
6. E.g., Xiao 1990a, 1990b. Some other historians of Taoism give a more conventional, judgmental view. See, for instance, Ren 1990: 481–82.
7. See J. Cahill 1960, Bush and Shih 1985: 191–240, *Eight Dynasties of Chinese Painting* 1980, and Bickford 1996.
8. McNair 1998.
9. Sturman 1990: 34.
10. Hargett 1988–89; see especially 31 n. 118.
11. This question has preoccupied many art historians, who focus on the issue of distinguishing which paintings are by his own hand, which he commissioned, which are by court artists acting more independently, and which are later forgeries. See, for instance, Xu 1979 and Xie 1989.
12. Most historical sources say he was the eleventh son, but this counts all the sons who died in infancy. When he was born he had only two elder brothers, one only three months old.
13. Since this school was set up in 1104, presumably the temple was decorated earlier. See HJ, *juan* 1: 3.
14. See Sturman 1997: 182–93.
15. This "flower-rock network" came to be greatly resented. See Hargett 1988–89.
16. The catalogue, *Xuanhe bogu tu* (Illustrated encyclopedic antiquities of the Xuanhe reign), has survived. There are several Ming editions. There is also a fairly good version in the *Siku quanshu* (Complete books of the four storehouses).
17. Overviews of Huizong's relations with Taoist masters are provided by Sun 1965: 93–122; Jin 1966, 1967; Miyakawa 1975b; Yang 1985; and Xiao 1990a.
18. WXTK, *juan* 90: 842a–b. TWSCT, *juan* 1: 11–12; *juan* 5: 87.
19. On Highest Purity teachings, see Robinet 1997: 114–48.
20. CB, *juan* 498: 6a; *juan* 491: 1a; *juan* 500: 1b. HZL, *hou* (part 2), *juan* 2: 72. HY 296 (*Lishi zhenxian tidao tongjian*), *juan* 52: 1b. TJCBJSBM, *juan* 127: 12a–b. HY 304 (*Mao Shan zhi*), *juan* 11: 12a–13a.
21. HY 304, *juan* 3, 4.
22. HY 304, *juan* 3: 19a–b. See also HY 769, *juan* 9.
23. TJCBJSBM, *juan* 127: 12b.
24. HY 304, *juan* 3: 6a.
25. HY 304, *juan* 3: 7b.
26. HY 304, *juan* 3: 12a–b.
27. HJ, *juan* 1: 2–3.
28. HY 304, *juan* 26: 10b. When Liu Hunkang died, Huizong also had Cai Bian write an epitaph for him that was carved in stone at Mao Shan. See HY 304, *juan* 26: 12a–16a.
29. HY 304, *juan* 4: 1b.
30. HY 304, *juan* 4: 4b. The Third Mao Lord was the youngest of three Mao brothers during the Han dynasty who were later deified.
31. HY 304, *juan* 3: 15a–17a.
32. SS, *juan* 20: 380; TJCBJSBM, *juan* 127: 1a.
33. Strickmann 1978: 341–42, altered to pinyin.
34. Loon 1984: 39.
35. XZZTJ, *juan* 91: 2349.
36. RZSB, *sanbian* (third edition), *juan* 13: 568–69.
37. SHY, *Li* (Ritual), *juan* 24: 68a, 70b–72a.
38. QSS, *juan* 1491: 17044.
39. QSS, *juan* 1492: 17051.
40. HJ, *juan* 1: 2.
41. HuaJ: 419–20.
42. Sturman 1990: 33, slightly modified. Sturman explains all the allusions in the poem. The original text can be found in ZHWQN, *Songhua bian* (Song [dynasty] painting volume), *juan* 2: 137.
43. Sturman 1990.
44. Rowland 1954.
45. QSS, *juan* 1494: 17067.
46. QSS, *juan* 1494: 17068.
47. SHY, *Yufu* (Carriages and clothing), *juan* 3: 2a–b. On these processions and the paraphernalia involved, see Ebrey 1999 (forthcoming).
48. TJCBJSBM, *juan* 127: 1a–b.
49. She died in 1113; see SS, *juan* 243: 8644.
50. TWSCT, *juan* 5: 87–88; XZZTJ, *juan* 91: 2353.
51. TJCBJSBM, *juan* 127: 14a–15a.
52. TWSCT, *juan* 5: 87–89.
53. TJCBJSBM, *juan* 127: 1b.
54. TJCBJSBM, *juan* 127: 2a.
55. On this canon, see Strickmann 1978.
56. Strickmann 1978: 336. TJCBJSBM, *juan* 127: 9b, and HY 769 (*Hunyuan shengji*), *juan* 9, describe these projects under the year 1121, perhaps when the work was nearing completion. Neither work survives.
57. The main primary sources on Lin Lingsu are TJCBJSBM, *juan* 127; HY 296, *juan* 53; SS, *juan* 462: 13528–30; and BTL, *juan* 1: 4–6. There are many contradictions among these sources, even on basic matters such as dates. Besides the scholarly works mentioned in n. 17, see Miyakawa 1975a and Tang 1992.
58. On thunder rites, see Boltz 1993, especially 272–86.
59. Robinet 1997: 180. Robinet sees Shenxiao Taoism as an offshoot of Lingbao Taoism, giving it a genealogy distinct from that of the Mao Shan Taoism Huizong had learned from Liu Hunkang.
60. BTL, *juan* 1: 4. There is no way to be sure whether this dream is different from the one reported by Cai Tao that also involved a summons, since neither gives a firm date and they give different details.
61. The revelation is recorded in a surviving text in the Taoist Canon, *Gaoshang shenxiao zongshi shoujing shi* (Formulary for the transmission of scriptures according to the patriarchs of the most exalted Divine Empyrean; HY 1272). On Shenxiao texts, see Boltz 1987a: 26–30. On confusion about the date of the revelation, see Tang 1992: 25.
62. See SHY, *Li* (Ritual), *juan* 5: 4a–b; TJCBJSBM, *juan* 127: 4a, 10a for decree. See also Tang 1994 on Shenxiao temples. For evidence that Buddhist temples were taken over, see LXABJ, *juan* 9: 115. See also YJZ, 3 *si*, *juan* 7: 1352–54; and YJZ, *Zhiding*, *juan* 1: 972.
63. LXABJ, *juan* 9: 115.
64. An official of the Taoist bureau made an record of this event. See TJCBJSBM, *juan* 127: 3a–4a.
65. Some sources say two thousand attended (XZZTJ, *juan* 92: 2385, and SS, *juan* 21: 397), others eight hundred (TJCBJSBM, *juan* 127: 3a–4a).
66. TJCBJSBM, *juan* 127: 4a.
67. SS, *juan* 21: 399.
68. On "magical" scripts of this sort, see Tseng 1993: 79–83, 103–06.
69. Yao 1965: 147; SXJSZ, *buyi* (supplement), *juan* 1: 37a–b.
70. XZZTJ, *juan* 93: 2412. TJCBJSBM, *juan* 127: 11b–12a, gives a summary of the text. One of these stelae survives in Putian in Fujian. The text is transcribed in Ding and Zheng 1995: 9–10.

71. *Song Huizong yujie daode zhenjing* (Imperial explanation of the realized scripture on the way and its virtue, by Emperor Huizong of the Song dynasty; HY680, in four *juan*.

72. Liu 1974; see also the much longer Liu 1991.

73. TJCBJSBM, *juan* 127: 9b–11a.

74. HY 681 and HY 694. See Boltz 1987a: 214–15.

75. HY 296, *juan* 53: 8a–9a.

76. Boltz 1987a: 27, altered to pinyin.

77. TJCBJSBM, *juan* 127: 4b–5a.

78. TJCBJSBM, *juan* 127: 7b–8b.

79. BTL, *juan* 1: 4; HY 296, *juan* 53: 4–5.

80. BTL, *juan* 1: 5; Schmidt-Glintzer 1989.

81. The source for this story is HZL, *Yuhua* (Excess words), *juan* 1: 276–79, but see also CB, *Shibu* (Found fragments), *juan* 40: 4b–6a.

82. See Nakata 1970: 8–10, which points out the internal evidence that the *Xuanhe Calligraphy Catalogue* was done after the *Xuanhe Painting Catalogue* and that it was done after Cai Jing had retired in 1120 and before he returned in 1124. To this could be added the fact that among the calligraphies listed for Cai Jing are several pieces composed to commemorate occasions at the Genyue garden, not finished until 1122.

83. Xiao Baifang 1991.

84. The imperial collection also contained Buddhist paintings, in even greater numbers than Taoist ones, so presumably the collection of religious paint-ings by the Song court had a history long predating Huizong.

85. Liu Daochun's *Songchao minghua ping* (Evaluations of Song dynasty painters of renown) started with figures, but did not make religious paintings a separate category (see Lachman 1989). Guo Ruoxu divided his record of painting (*Tuhua jianwen zhi* [Record (of things) seen and heard in (connec-tion with) paintings]) first by dynasty, then by the artist's status, then by genre: figure, narrative, landscape, bird-and-flower, then miscellaneous (see Soper 1981). Moreover, when he grouped together Buddhist and Taoist, Guo put Buddhist first (using the term "Fodao," not "Daoshi," the term used in the *Xuanhe Painting Catalogue*).

86. Xiao Baifang 1991: 164–85.

87. XHHP, *juan* 8: 84.

88. Soper 1951: 25; XHHP, *juan* 2: 23.

89. XHHP, *juan* 4: 47.

90. XHHP, *juan* 4: 47–48.

91. TWSCT, *juan* 5: 91.

92. HY 296, *juan* 53: 16a–21b.

93. On Genyue, see Hargett 1988–89.

94. Ledderose 1983: 166. See also Stein 1990 on the ideas that underlay minia-turization and cosmic gardens.

95. HZL, *Houlu* (Supplementary record), *juan* 2: 72–73.

96. See J. Cahill 1996 for a positive assessment of the Academy. For a more negative evaluation of Huizong's impact on Song painting, see Barnhart 1977.

97. See H. Liu 1997.

98. On this point see Brown 1995: 249–53 and passim.

99. Strickmann 1979b: 3–4. See also Strickmann 1978, which is less explicit but more accessible.

100. Ren 1990: 482–83.

101. TJCBJSBM, *juan* 127: 5a–b.

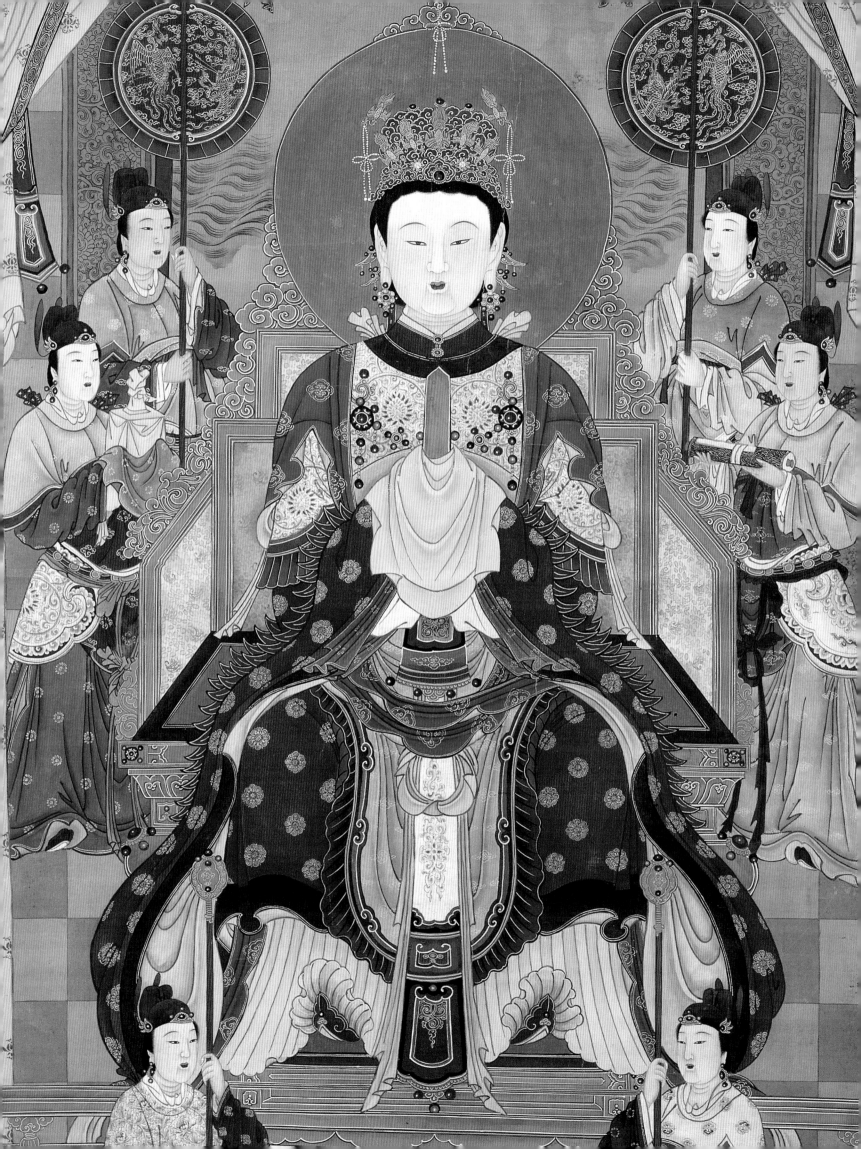

CATALOGUE OF THE EXHIBITION

IN CHINESE, TAO (PRONOUNCED "DAO") means a road, and is often translated into English as "the Way." The Way of all things, the Tao is described as an empty void that spontaneously generates the cosmos. Beyond time and space, beyond the ability of words to describe, the Tao is the source of reality. In the Tao, all opposites are unified. Taoism teaches that in the pure emptiness of the Tao there is an infinitely powerful force that those with sufficient moral virtue can use to transform the world.

Taoism traces its origins to the sage Laozi (Lao-tzu), a royal archivist believed to have lived in the sixth century B.C. The book attributed to Laozi, the *Classic of the Way [Tao] and Its Power (Daode jing,* or *Tao-te-ching),* introduces the concept of the Tao and serves as a guide for human behavior and experience. The *Daode jing* teaches the importance of cultivating simplicity, detachment, and virtue, and of living in harmony with the natural world. The *Daode jing* achieved the form in which it is known today in the third century B.C.

Significantly, Taoism teaches that there is no supreme being, but instead the Tao that underlies and permeates reality. Despite its later transformation into a religion with a vast pantheon of gods, conceived as divine emanations of the Tao, Taoism would always hold true to this belief.

1

1

Fachang Muqi (active 13th century)
Portrait of Laozi

> Southern Song dynasty, early 13th century
> Hanging scroll; ink on paper
> 88.9 × 33.5 cm
> Okayama Prefectural Museum of Art

2

Zhang Lu (c. 1490–c. 1563)
Laozi on an Ox

> Ming dynasty, early/mid-16th century
> Hanging scroll; ink on paper
> 101.5 × 55.3 cm
> National Palace Museum, Taipei

Taoists trace the origins of their philosophy and religion to Laozi, the ancient sage traditionally believed to have transmitted the *Classic of the Way [Tao] and Its Power (Daode jing)* to the frontier official Yin Xi in the sixth century B.C., during the Eastern Zhou dynasty. Laozi was seen as perfectly embodying the Tao, and was deified in the late Han dynasty (second century; see cat. no. 29). While it cannot be proven that Laozi ever existed as a historical figure, he has been credited with being the first person to articulate the concept of the Tao. Since his deification, he has been seen as both a sage and a god. By the Tang dynasty (618–906), he had become one of the Three Purities (Sanqing), the highest gods of religious Taoism and pure emanations of the Tao. These images of the sage, by the Southern Song dynasty (1127–1279) Buddhist monk-painter Fachang Muqi and the Ming dynasty (1368–1644) Zhe School painter Zhang Lu, depict Laozi as a human being, in contrast with other images of Laozi enthroned as a god. Both paintings reflect the image of Laozi recorded in Sima Qian's *Records of the Historian (Shiji;* 104 B.C.):

> Laozi was a native of the hamlet of Quren in the village of Li in Hu County of [the state of] Chu. . . . Laozi cultivated the Way [Tao] and its virtue. His teachings emphasized hiding oneself and avoiding fame. After living in Zhou for a long time, he saw Zhou's decline, and left. When he reached the pass [at the western border of China], the Prefect of the Pass Yin Xi said, "Since you are going to retire from the world, I beg you to endeavor to write a book for us." Laozi thus wrote a book in two sections which spoke of the meaning of the Way [Tao] and its virtue *[de]* in five thousand and some characters and then departed. No one knows where he finally ended. . . .

Supposedly, Laozi lived to be 160 years old, some say over 200; his great longevity came through cultivating the Way [Tao].[1]

In Muqi's painting, a haggard Laozi clutches his hands and robe in front of him, and stares into space with a world-weary expression. Here Laozi the philosopher is depicted as an unkempt, wise old man, his mouth hanging open, hairs sprouting from his nose, and a long, curved fingernail extending from his thumb. While his robes are painted with dragged lines of dark ink, the head is outlined with finer translucent lines. This is one of the earliest and most powerful painted portraits of Laozi known. Zhang Lu's painting in the National Palace Museum is also in ink on paper, and depicts Laozi as he is more often shown, riding an ox as he departs China for the Western Regions. A bat, a symbol of good fortune, flies overhead.[2]

Fachang Muqi was one of the outstanding Buddhist monk-painters of the Southern Song dynasty.[3] He was born in Sichuan, but moved to the capital of Lin'an (Hangzhou), where he worked at the Liutong Temple. According to the fourteenth-century writer Wu Taisu, Muqi died in the early Yuan dynasty, during the reign of Khubilai Khan (r. 1260–94).[4] His works enjoyed much greater renown in Japan than in China, and most of his surviving works are found in Japanese collections. The famous triptych by Muqi depicting the bodhisattva Guanyin (Kannon), monkeys, and a crane in the Daitoku-ji, Kyoto, for example, entered the collection of the Muromachi period (1392–1568) Shōgun Ashikaga Yoshimitsu (r. 1368–94) about one hundred years after the artist's death.[5] In the upper left corner of the painting is a seal of the artist, reading *Muqi*. In the lower left corner of this scroll is a seal of Ashikaga Yoshimitsu, reading *Dōyū*, indicating that the painting has been in Japan since at least the late fourteenth century.[6] During the Edo period (1615–1868), the painting was owned by a branch of the Tokugawa family.[7]

Zhang Lu, the artist of the National Palace Museum scroll, was a professional painter of the middle Ming dynasty.[8] Active in Kaifeng, Henan province, he married into the imperial family, and was the leading Zhe School master of the sixteenth century. Many of his surviving works depict Taoist themes.[9]

—S. L.

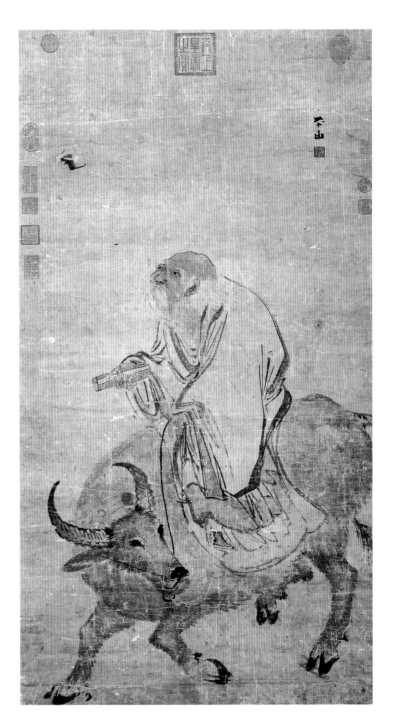

2

（detail）

太玄隱訣

先燒香長服礼十拜心存玄中大法師老子

河上真人尹先生曰開經蘊呪曰

玄玄至道宗上德體洪无天真雖遠妙近緣

泹九君宮室皆七寶窓牖目有分清淨常致

真駕景兼紫雲日月左右照外仙長年全七

祖上生天世為道德門畢叩齒卅六通咽啞

卅六過先心存左青龍右白席前朱雀後玄

武足下八卦神龜卅六師子伏在前頭巾七

呈五藏生五炁羅文霞身上三一侍經各

從千乘万騎天地各有万八千玉童玉女衛之

口訣讀經五百言輒叩齒三咽液三也

道經上

道可道非常道名可名非常名无名天地始

有名萬物母常无欲觀其妙常有欲觀所曒

此兩者同出而異名同謂之玄玄之又玄衆

妙之門

天下皆知美之為美斯惡已皆知善之為善

斯不善已有无相生難易相成長短相形高

下相傾音聲相和先後相隨是以聖人治處

无為之事行不言之教萬物作而不為始為

而不恃成功不處夫唯不處是以不去

不上賢使民不爭不貴得貨使民不盜不

見可欲使心不亂聖人治虛其心實其腹弱

其志彊其骨常使民无知无欲使知者不敢

不為則无不治

道冲而用之又不盈淵似萬物之宗挫其銳

解其忿和其光同其塵湛似常存吾不知誰

子象帝之先

3

Laozi's Scripture of the Way, Upper Roll

From Dunhuang, Gansu province
Tang dynasty, 8th century
Handscroll; ink on paper
26 × 380 cm
Bibliothèque Nationale de France, Paris (Pelliot Chinois 2584)

THE *DAODE JING*, also known as the *Laozi*, is the oldest and most revered text of the Taoist tradition. It is traditionally attributed to the sage Laozi (sixth century B.C.). The earliest known manuscript of the text, dating to the late fourth century B.C., was discovered in 1993 in a tomb at Guodian, Hubei province.[1] Despite its great age, the *Daode jing* has remained the fundamental text of Taoism. One has to appreciate the irony of its opening passage:

> The Way (Tao) that can be spoken of is not the constant Way (Tao);
> The name that can be named is not the constant name.

Despite this warning, a substantial commentarial tradition developed around Laozi and the *Daode jing* in later times.

By the Han dynasty (206 B.C.–A.D. 220), the *Daode jing* and Laozi (see cat. no. 1) were already revered at the imperial court. During the Six Dynasties period (420–589), the ritual recitation of the *Daode jing* was standardized, several commentaries based on Taoist doctrines were written (see cat. no. 34), and a preface was added to the beginning of the scripture.[2] The present manuscript *(Laozi Dao jing, shang)*[3] reflects many of these developments, and is representative of the way in which the *Daode jing* would have been transmitted to new disciples in the late Six Dynasties and Tang periods. In its present state, it is incomplete, since it consists only of the first half of the *Daode jing,* together with the preface mentioned above; the second half of the *Daode jing* is represented elsewhere in this catalogue (cat. no. 4).

The Pelliot Collection text is written on nine joined pieces of yellow paper. The characters of the text are inscribed in a pale grid of ruled columns. At the end is written "A Daoist seeking the Cavern Mystery scriptures"; similar inscriptions are found on other Tang dynasty Taoist manuscripts from Dunhuang.[4]

The preface to this manuscript is a valuable resource for understanding the medieval context of the *Daode jing*. It singles out two events in the history of this scripture to illustrate the significance of Laozi and his writings. The first is the initial revelation of the scripture to the Guardian of the Pass, Yin Xi, in the sixth century B.C. The second comes in the time of the Han dynasty emperor Wen (Wendi; 179–157 B.C.). Emperor Wen was fond of the *Daode jing*, but neither he nor his ministers could fully understand its meaning. Consequently, the Way (Tao) sent a realized being *(zhenren)* known as the Lord on the River to descend to the Yellow River, where he met with the emperor and transmitted a commentary on the *Daode jing* to him. This commentary was the *Stanzas of the Lord on the River (Heshang gong zhangju)*, one of the standard commentaries on the *Daode jing,* and the first to divide it into sections; these sections are still used today.

The preface emphasizes two aspects of the *Daode jing*. The first is its political significance. Laozi left China because of the Zhou dynasty's failure to support the Way; as a consequence, this dynasty faltered. On the other hand, when Emperor Wen venerated the *Daode jing,* then the Way enabled him to secure the rule of his family. This aspect of the preface resulted from the time when it was written, as the fortunes of Taoism became increasingly dependent on the patronage of the ruling house.

The second aspect is the use of this scripture as a tool for personal cultivation. The preface ends with a standardized ritual for the recitation of the *Daode jing,* which shows the way this scripture was actually practiced during the Six Dynasties and Tang periods. Before initiates began to recite the scripture, they would first visualize Laozi, Yin Xi, and the Lord on the River. Yin Xi was often depicted as a companion to Laozi in sculptures from the Six Dynasties period, as in a stele in the Field Museum (see the essay by Stephen Little in this volume, fig. 4); together with the Lord on the River, these three figures were the highest deities of the *Daode jing* in medieval Taoism. Then the meditator would visualize the animals that correlate to the Five Elements or Phases (see cat. no. 17) surrounding him, a tortoise with the Eight Trigrams (symbols of *yin* and *yang* from the *Book of Changes [Yi jing]*; see cat. no. 14) on its back beneath his feet, and thirty-six lions kneeling before him. The seven stars of the Northern Dipper (Ursa Major; see cat. nos. 18 and 78) were wrapped around his head, and his five vital organs emitted ethers that represented the energies of the Five Phases. This meditation, which represents a culmination of centuries of visualization techniques, would have been one of the very first taught to new initiates, and as such it is one of the most important practices to come out of the Six Dynasties period.

—S. E.

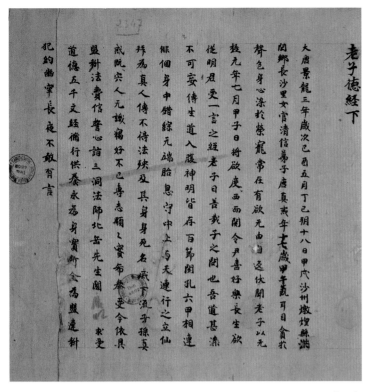

(detail)

4

Laozi's Scripture of Power, Lower Roll

From Dunhuang, Gansu province
Tang dynasty, Jinglong reign, dated 709
Handscroll; ink on paper
28 × 323.5 cm
Bibliothèque Nationale de France, Paris (Pelliot Chinois 2347)

THIS HANDSCROLL (*LAOZI DE JING, XIA*) consists of the second part of the *Daode jing*, the "Scripture of Power" *(Dejing)*, and a short scripture known as the "Scripture of Ten Precepts" *(Shijie jing)*, as well as "oath texts" *(mengwen)* accompanying each of these scriptures.[1] In its present form, it is incomplete; however, taken together with the manuscript described in the previous catalogue entry, it gives a fairly complete picture of the *Daode jing* as it would have been transmitted to Taoist disciples in the Tang dynasty (618–906).

As the number of Taoist scriptures increased during the medieval period, protocols were established for their transmission. Eventually, the transmission of scriptures became one of the primary means for distinguishing different ranks in the church hierarchy. Despite the large number of scriptures written in this period, the *Daode jing* remained the most fundamental scripture of Taoism, and the ordination rite surrounding its transmission was of particular importance to both the disciple and the church. For the former, it represented formal recognition as a full lay member of the Taoist community. For the latter it represented an affirmation of the supremacy of the church hierarchy, since disciples were required to accept the authority of the church and its teachings as part of their ordination.

The oath texts found after both scriptures are remnants of the ritual in which they were transmitted to a new initiate into the Taoist community, a ritual that was codified over a century before this particular manuscript was written.[2] Most remarkably, these oath texts contain biographical information about the recipient of the scriptures, a seventeen-year-old girl from the town of Changsha in Dunhuang county (modern Gansu province). The oath text shown here summarizes the first transmission of the *Daode jing* by Laozi to the Guardian of the Pass, Yin Xi, of which this young woman's ordination would have been a symbolic reenactment; indicates the lineage into which she is being initiated; and ends with her recognition of the Taoist church as the sole authority to transmit scriptures. The signature of the priest who supervised the ordination is visible towards the end of the text. Finally, there is a single stroke resembling the character for "one" in red ink over the entire oath text. This stroke is not described in ordination rites for the *Daode jing* in the Taoist Canon, but is described in ordination rites for other scriptures from the medieval period.[3] It would have been drawn together by disciple and master, each of whom would have held the brush, and would have served as an additional oath with the same significance as the oath text. The choice of the color red for the stroke may have derived from the early use of blood smeared over the mouth when an oath was taken.

—S. E.

5

Confucius Visiting Laozi

Ink rubbing of a stone panel from the Wu Liang Shrine, Jiaxiang
county, Shandong province
Eastern Han dynasty, 2nd century
Ink on paper
42 × 212 cm
The Field Museum, Chicago (244697)

THIS INK RUBBING is taken from a stone discovered at the Eastern Han funerary shrine of Wu Liang (78–151) in 1786.[1] The two central figures are labeled on the stone as Laozi (to the right) and Confucius (to the left). To either side of these figures are their chariots and attendants. This is one of the earliest known depictions of Confucius visiting Laozi, a famous event.[2] Early texts of the Taoist tradition such as the *Zhuangzi* made a point of belittling Confucius, who, like Laozi, lived in the sixth century B.C. Confucius taught a philosophy that provided a basis for achieving a harmonious society.[3] In his teachings, he focused on proper human behavior and rituals that reinforced social hierarchies. According to the Confucian *Analects,* "The Master [Confucius] took four subjects for his teaching: culture, conduct of affairs, loyalty to superiors and the keeping of promises."[4]

Confucianism was elevated to a state philosophy in the early Han dynasty (second century B.C.), and maintained this position until very recently.[5] From the Taoist point of view, Confucius's preoccupation with the human realm neglected larger, more fundamental issues, such as the place of man in the universe.

The story of Confucius's visit to Laozi is recorded in the *Zhuangzi* and in Sima Qian's *Records of the Historian (Shiji;* 104 B.C.). In each case, Confucius goes to Laozi to seek advice on ritual, and each time Laozi mocks Confucius's preoccupation with social order. Laozi's answers to Confucius's questions mystify the latter, who later compares Laozi to a dragon (a symbol of the Tao).[6] In the description of the two sages' meeting in the *Records of the Historian,* Laozi says to Confucius,

> Cast off your arrogant airs and many desires, sir, your contrived posturing and your overweening ambition. All of these are of no benefit to your person. What I have to tell you is this, and nothing more.

Later, Confucius tells his disciples, "Today I have seen Laozi; is he perhaps like the dragon?"[7]

—S. L.

6

Lu Zhi (1496–1576)
Zhuangzi Dreaming of a Butterfly

Ming dynasty, mid-16th century
Leaf 1 from an album of 10 leaves; ink on silk
29.4 × 51.4 cm
Palace Museum, Beijing

ZHUANGZI IS CONSIDERED the most important Taoist philosopher after Laozi, and the *Zhuangzi* is one of the great classics of world literature. Sardonic in tone, Zhuangzi is perhaps best known for his insistence on the relativity of all things. He openly mocked Confucius and his followers for being preoccupied with achieving social harmony at the expense of a greater ontological equilibrium. While Zhuangzi is believed to have lived in the fourth century B.C. (Warring States period), the book attributed to him was probably compiled in the second century B.C., during the Western Han dynasty.[1] In the text that has come down to us today, only the first seven chapters (the "Inner Chapters," or *neipian*) are traditionally believed to be by Zhuangzi himself. In the year 742, during the reign of Tang Xuanzong (Minghuang), an imperial edict was issued to honor Zhuangzi, and from that time onward the *Zhuangzi* was also known as the *Nanhua zhenjing,* after one of Zhuangzi's alternate names.

In traditional Chinese painting, Zhuangzi is often depicted asleep. Such images illustrate the story of the philosopher's dream of the butterfly, found in the second of the "Inner Chapters." This tale illustrates Zhuangzi's belief that all things are relative:

> Once Zhuang Zhou (Zhuangzi) dreamt he was a butterfly, a butterfly flitting and fluttering around, happy with himself and doing as he pleased. He didn't know he was Zhuang Zhou. Suddenly he woke up and there he was, solid and unmistakable Zhuang Zhou. But he didn't know if he was Zhuang Zhou who had dreamt he was a butterfly, or a butterfly dreaming he was Zhuang Zhou. Between Zhuang Zhou and a butterfly there must be *some* distinction! This is called the Transformation of Things.[2]

Lu Zhi, the painter of this album leaf, was one of the finest Wu School artists of the sixteenth century.[3] A student of Wen Zhengming (1470–1559; see cat. no. 147), Lu lived on Mount Zhixing near Suzhou, in Jiangsu province. Lu Zhi's painting of Zhuangzi is one of ten leaves in an album on miscellaneous themes.

—S. L.

(detail)

7

Zhou Dongqing (active late 13th century)
The Pleasures of Fishes

Yuan dynasty, Zhiyuan reign, dated 1291
Handscroll; ink and light colors on paper
30.8 × 593.7 cm
The Metropolitan Museum of Art, New York, Purchase, Fletcher Fund
(47.18.10)

One of the best-known stories in the *Zhuangzi* is a tale of two men walking by a river. Seeing fish swimming in the water, Zhuangzi remarks on their freedom and happiness. The Confucian Huizi challenges Zhuangzi: "How do you know what fish enjoy?"[1] After a moment of verbal sparring, Zhuangzi states that the answer is obvious to anyone standing by the river and seeing the fish. This story, contained in the chapter entitled "Autumn Floods," has been long perceived as one of the clearest articulations of a Taoist worldview. According to Zhuangzi, true understanding should be acquired intuitively, without the need for explication. Huizi, a man obsessed with logical explanations, is unable to grasp this point.

Zhou Dongqing, the artist who painted this scroll, was a native of Linjiang, Jiangxi province. Very little is known about his life. Nonetheless, he was recognized by the last Southern Song dynasty prime minister, Wen Tianxiang, who wrote poems on his paintings.[2] Described by Wen Fong as a Song loyalist, he is best remembered for his paintings of fish.[3] This handscroll is his only known surviving work. The aquatic creatures and water plants are painted in carefully controlled washes of pale ink,

with occasional touches of blue and red color in the fish. The subtle gradations of ink and color successfully convey the illusion of an underwater realm in which the fish move freely and happily about.

That Zhou Dongqing's scroll alludes to Zhuangzi's tale of fish is clear from the artist's inscription at the end of the scroll:

> Not being fish, how do we know their happiness?
> We can only take an idea and make it into a painting.
> To probe the subtleties of the ordinary,
> We must describe the indescribable.[4]

The scroll bears three seals of the Qianlong emperor (r. 1736–95), and two seals of the nineteenth-century collector Wu Yuanhui.[5] Mounted after the painting is a colophon by Wu Rongguang (1773–1843), dated 1836.

—S. L.

NOTES

Cat. nos. 1–2

1. Nienhauser 1994b: 21–22. For another translation, see Graham 1998: 23–24. For a recent book devoted to the history of Laozi, see Kohn 1998a.
2. The word for bat *(fu)* is a homonym for the word for good fortune *(fu),* and is written with a different character.
3. Wey 1974: 11–45.
4. Ibid.: 39–40.
5. See *Mokkei* 1996, pl. 1.
6. Shimizu and Wheelwright 1976: 18.
7. *Gen jidai no kaiga* 1998: 157.
8. On Zhang Lu, see Barnhart 1993: 305–20, and Fong et al. 1996: 365–66.
9. See, for example, the album of Taoist figures in the Shanghai Museum, published in *Zhongguo gudai shuhua tumu* 1986–98, vol. 2: 296–98, no. 1-0537.

Cat. no. 3

1. For the initial excavation report, see Jingmen City Museum 1997; see also *Guodian Chu mu zhu jian* 1998, and Allen and Williams 2000.
2. See Kobayashi 1990: 269–95, for a detailed discussion of this preface.
3. Previously published in Ōfuchi 1978–79, vol. 2: 401–05.
4. See, for example, *Laozi huahu jing* (Scripture of Laozi's conversion of the barbarians; The British Library, London [Stein 1857]), in Ōfuchi 1978–79, vol. 1: 322; and *Taixuan zhenyi benji jing* (Scripture of great mystery realized one root margin scripture; Bibliothèque Nationale, Paris [Pelliot Chinois 2475]), in Ōfuchi 1978–79, vol. 1: 137–38.

Cat. no. 4

1. The oath to the *Dejing* is illustrated in Ōfuchi 1978–79, vol. 2: 411.
2. See HY 1130, *juan* 37, and Ōfuchi 1997: 327–343.
3. In particular, see HY 802 and the discussion of this practice in Ōfuchi 1991: 154.

Cat. no. 5

1. Wu 1989: fig. 25. See also Chavannes 1909/1913, vol. 2: pl. 71, no. 137.
2. Another Eastern Han depiction of this meeting is a carved stone panel from Jinan in Shandong; a rubbing exists in the Rietberg Museum, Zurich (RCH 4039).
3. The basic teachings of Confucius are contained in the *Analects;* see Waley 1938. The *Zhuangzi* was compiled in the second century B.C.; see Loewe 1993: 56–57.
4. Waley 1938: 128.
5. In Taiwan, Hong Kong, Singapore, and many overseas Chinese communities, Confucius and his teachings are still venerated today. With the recent rebuilding of old shrines to Confucius in mainland China, veneration of the sage has also been revived in the land of his birth.
6. Watson 1968: 162–63.
7. Nienhauser 1994, vol. 7: 21–22.

Cat. no. 6

1. On the date of the *Zhuangzi,* see Roth 1993: 56–57. A brief biography of Zhuangzi appears in Sima Qian's *Records of the Historian (Shiji;* second century B.C.); see Nienhauser 1994, vol. 7: 23–24.
2. Watson 1968: 49.
3. On Lu Zhi, see Yuhas 1979 and Cahill 1978: 239–44. The Palace Museum album leaf is previously published in Beijing Palace Museum 1990: no. 57a.

Cat. no. 7

1. Watson 1968: 188–89.
2. Yu 1980: 483.
3. Fong 1992: 380.
4. Translated in ibid.
5. Despite the presence of the Qianlong seals on the scroll, the painting is not recorded in the imperial Qing painting catalogue, *The Precious Satchel of the Stone Channel (Shiqu baoji),* or its successors. The painting may have been given away by the emperor as a gift before being recorded in the imperial catalogue.

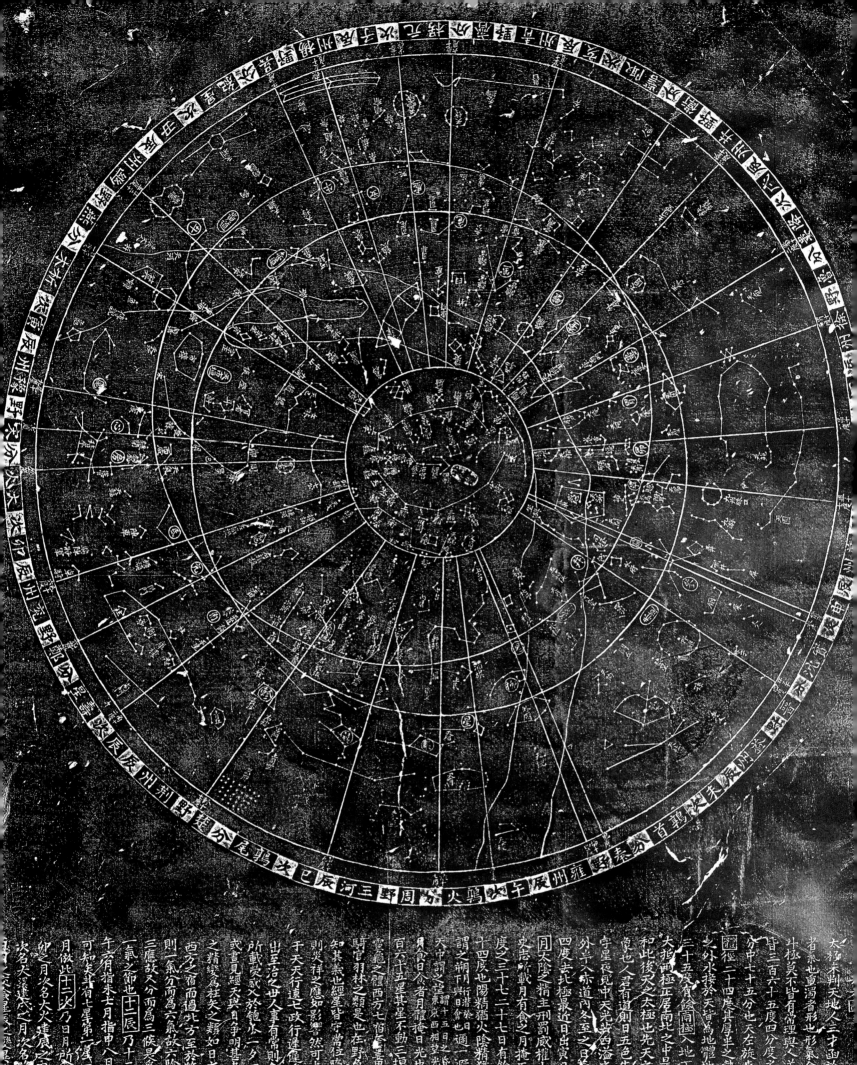

IN ANCIENT CHINA, the term "Heaven and Earth" meant "the universe." According to Taoist cosmology (the study of the origin and structure of the universe), in the beginning was the Tao (pronounced "dao"), conceived of as an empty void of infinite potential. Then, over a period of many eons, out of the Tao emerged *qi* (vital energy or breath; pronounced "chee"). Taoists believe that all things are made of *qi,* which is in a constant state of movement and flux. Originally the universe was in a state of chaos, but eventually the light *qi* rose and formed the heavens, while the heavy *qi* sank and formed the earth. Taoists believe that physical matter cannot be distinguished from its basic substance, *qi,* and that thus matter and energy are interchangeable. Taoism also teaches that, in order to be content, human beings must accept the reality that the only constant in the universe is change. The shifting patterns of *qi* are governed by the shifting balance of *yin* and *yang,* two complementary forces that emerged from the primordial Tao, and whose interaction defines and regulates the mechanisms of the universe. The concept of *qi* lies at the heart of traditional Chinese medicine, for example, which views illness as caused by imbalances of *yin* and *yang,* resulting in blockages of the free movement of *qi* through the human body. Acupuncture and other remedies are designed to restore the proper movement of *qi* through the body, thus restoring health. In ancient China, *yin* and *yang* were respectively symbolized by the tiger and the dragon, and in later times by the *taiji* diagram (commonly known as the *yin-yang* diagram), which represents *yin* and *yang* unified by the Tao from which they emerge.

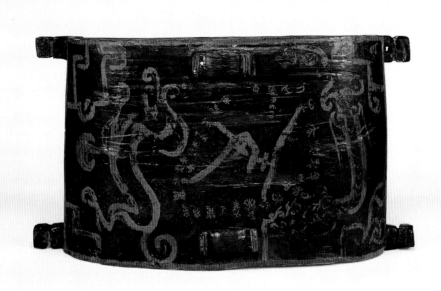

8

*Clothing Chest with Celestial Diagram of a Tiger and Dragon,
the Northern Dipper, and the Twenty-eight Lunar Mansions*

Excavated in 1978 from the tomb of Marquis Yi of the state of Zeng,
 Hubei province
Eastern Zhou dynasty, Warring States period, c. 433 B.C.
Painted lacquer
40.5 × 82.8 × 47 cm
Hubei Provincial Museum, Wuhan

AMONG THE MANY LACQUER OBJECTS discovered in 1978 in the Warring States period (475–221 B.C.) tomb of Marquis Yi of Zeng (buried c. 433 B.C.) near Suizhou, Hubei province, was this extraordinary chest.[1] The designs painted in red on black lacquer on the top include the earliest known arrangement of the characters representing the constellations known as the Twenty-eight Lunar Mansions *(Ershiba xiu).*[2] The Lunar Mansions are situated along the moon's path of rotation around the earth and are significant as divisions of the heavens and of time. This archaeological evidence proves that the concept of the lunar lodges known today was fully evolved by the fifth century B.C. By the Han dynasty (206 B.C.–A.D. 220), the Lunar Mansions were used to mark the movement of the planets. The earliest known complete depiction of the Twenty-eight Lunar Mansions, in which the asterisms are shown as dots connected with lines, was found in 1987 in a late Western Han tomb (first century B.C.) near Xi'an.[3] By the Six Dynasties period (420–589), these asterisms had been deified and absorbed into the Taoist pantheon.[4]

The central design on the top of the chest is an archaic form of the character *dou* (dipper), representing the Northern Dipper. This is surrounded by the names of the Twenty-eight Lunar Mansions in a ring, flanked on either side by a tiger and a dragon, symbols of *yin* and *yang,* respectively. A cyclical date, "third day of [the month] *jiayin,*" appears under one of the constellation's names. The designs on either end of the box depict a mushroom-shaped cloud, stars, circles, and a toad, while one of the long sides depicts two confronting animals.[5]

The Northern Dipper was venerated as a deity as early as the late Shang dynasty (thirteenth/eleventh century B.C.).[6] According to Han dynasty beliefs, the Northern Dipper was the conduit for the primal energy *(qi)* dispensed by the god Taiyi (Supreme Unity; see cat. no. 75), who lived in the circumpolar region. The Dipper's significance can be explained in part by its proximity to the Pole Star, and by the fact that the annual sweep of its handle around the sky acts as a celestial clock.[7]

—S. L.

9

Roof Tiles with Symbols of the Four Cardinal Directions

Han dynasty (206 B.C.–A.D. 220)
Molded earthenware
Dragon: 18.7 × 2.2 cm; bird: 15.5 × 1.65 cm; tiger: 19 × 2.75 cm;
 Dark Warrior: 19.3 × 2 cm
Shaanxi History Museum, Xi'an

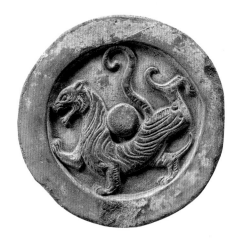

BY THE HAN DYNASTY (206 B.C.–A.D. 220), if not earlier, the animal symbolism of the four cardinal directions had been codified. The ancient Chinese in fact conceived of five directions: east, south, west, north, and center; these were directly correlated to the Five Phases or Elements and to their animal symbols as follows:

East	Wood	Dragon	*yang*
South	Fire	Bird	*yang*
West	Metal	Tiger	*yin*
North	Water	Dark Warrior	*yin*
Center	Earth	(no symbol)	neutral

The east was represented by the Azure Dragon (Qinglong *or* Canglong), the south by the Vermilion Bird (Zhuque), the west by the White Tiger (Baihu), and the north by the Dark Warrior (Xuanwu), comprising an entwined turtle and snake.[1] These four animals were known as the Four Divinities (Sishen or Siling), and were often depicted as a directionally oriented group on the backs of Han dynasty bronze mirrors. The 1978 discovery in the tomb of Marquis Yi of Zeng (c. 433 B.C.) of a lacquer chest decorated with the dragon and tiger on either side of the Northern Dipper and the Twenty-eight Lunar Mansions (cat. no. 8) indicates that the symbolism of the tiger and dragon, corresponding respectively to *yin* (west) and *yang* (east), was well established by the Warring States period (475–221 B.C.).

As John Major has shown, however, the Four Divinities, representing all four cardinal directions, became widespread only in the Han dynasty.[2] Nonetheless, rituals to the gods of the four directions are known from as early as the Qin dynasty (221–207 B.C.).[3] During the Han dynasty, the roofs of many official buildings were decorated with stamped tiles adorned with the animal symbols of the four directions.

—S. L.

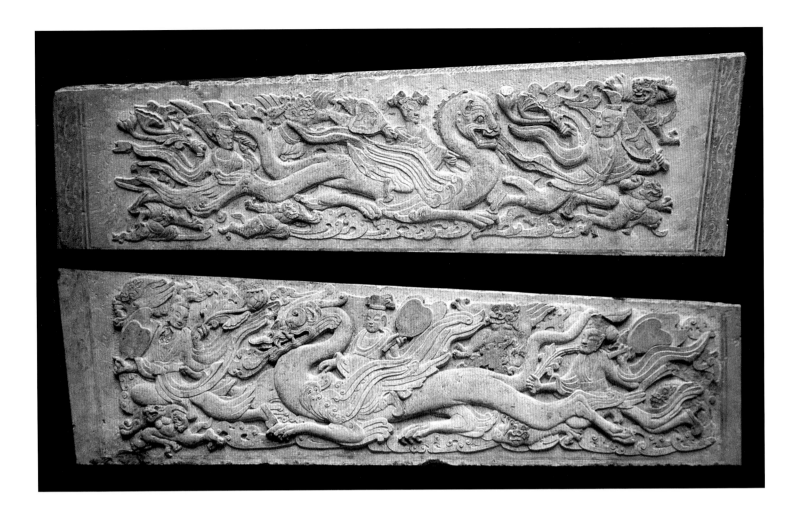

10

Two Panels from a Sarcophagus: Tiger and Dragon

> Northern Wei dynasty, c. 500/534
> Limestone with traces of pigment and gilding
> Tiger panel: 71.2 × 228.6 cm; dragon panel: 68.6 × 228.6 cm
> Private collection

SINCE AT LEAST THE ZHOU DYNASTY (c. 1050–256 B.C.), the tiger and dragon have been the primary symbols of *yin* and *yang*, respectively, in China. These two cosmic forces direct the movement and transformations of *qi*, the vital energy that makes up all things. Evidence that the paired tiger–dragon symbolism extends back to the Neolithic period (c. 3000 B.C.) was found in the 1988 excavation of a funerary shell sculpture depicting these animals, flanking a corpse in the Neolithic burial at Puyang, Henan province.[1]

In the context of religious Taoism from the Six Dynasties period (420–589) onward, paired tigers and dragons symbolized *yin* and *yang*. It was not until the Song dynasty that the now-ubiquitous *taiji* diagram (the so-called *yin–yang* symbol) came into being (see cat. no. 11). In addition to symbolizing *yin* and

yang, the tiger and dragon also symbolize west and east, and the elements (or phases) fire and metal. In Taoist chemical alchemy (*waidan*, or "outer" alchemy), the tiger and dragon also represent two of the most powerful elixir ingredients known, lead and mercury, while in the Inner Alchemy *(neidan)* tradition, the two animals symbolize *yin* and *yang* as they are brought together in the inner (human) body through visualization and transformed to create a divine embryonic form of the practitioner.

These two sarcophagus panels are carved in relief and intaglio with designs of the tiger and dragon flying among scudding clouds. Appropriately, the tiger is ridden by a female *(yin)* figure, and the dragon by a male *(yang)* figure. Other celestial figures holding lotus flowers and fans fly among bear-headed monsters in front of and behind the tiger and dragon. While it may be impossible to know whether the person for whom the sarcophagus was made was a Taoist believer, in a funerary context it is almost certain that the paired image of the tiger and dragon symbolized *yin* and *yang*, and that these animals may have been intended to protect the deceased.[2]

—S. L.

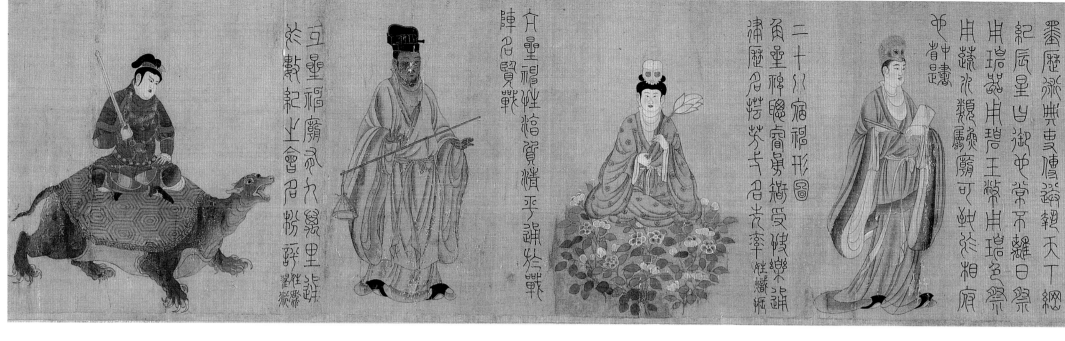

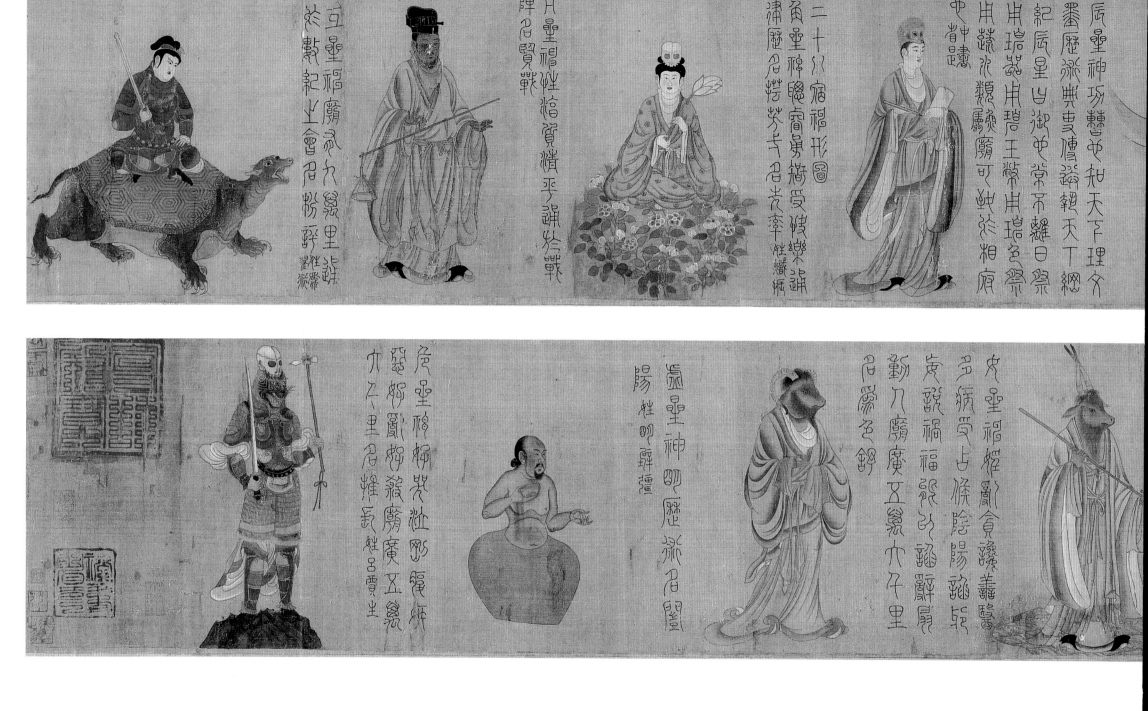

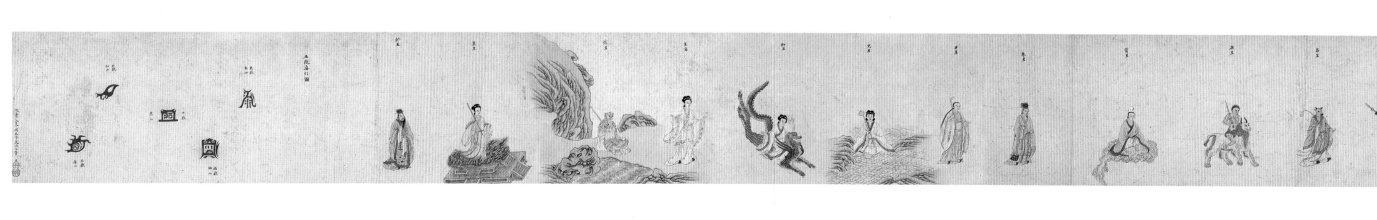

Zhang Huang (1527–1608)
Diagram of the Supreme Ultimate, from the Compendium of Diagrams

Ming dynasty, Tianqi reign, dated 1623
Woodblock-printed book; ink on paper
26.3 × 15.5 cm (each page)
The University of Chicago Library, East Asian Collection

The *taiji* diagram *(taiji tu)* first appeared in a Taoist con-
text at the beginning of the Song dynasty (960–1279). Several
Song sources state that it originated with the Taoist Chen Tuan
(c. 906–989), although Isabelle Robinet has shown that an
antecedent for the diagram appeared in the work of the Tang
dynasty Buddhist monk Zongmi (780–841).[1] Prior to this, *yin*
and *yang* were symbolized by the tiger and dragon, and this
symbolism has continued through the history of later Taoism.

The diagram symbolizes the unity of the forces of *yin* and
yang within the Tao. *Taiji* means "supreme ultimate," and as
such the diagram symbolizes the fundamental Taoist view of the
structure of reality, namely that beyond the duality of phenom-
enal existence, created through the interaction of *yin* and *yang*,
is the unity of the Tao, which exists beyond time and space.[2]

The term *taiji* also appeared in the apocrypha *(weishu)*—
cosmological and philosophical texts that flourished in the Han
dynasty (206 b.c.–a.d. 220)—where it was associated with the
concept of "primal chaos"; in other texts of the late Han and
Six Dynasties (420–589) periods, *taiji* was also associated with
the "primordial breath" *(yuanqi)*, and ultimate truth as embod-
ied in the Tao.[3] In Taoist texts of the later Six Dynasties and Tang
periods, *taiji* refers as well to a heaven and one of the stars of
the Northern Dipper *(Beidou)*.[4] In a further elaboration, in the
Six Dynasties Taoist text known as *Scripture of the Cavern of Mys-
tery Numinous Treasure Essence of the Tao (Dongxuan lingbao
daoyao jing)*, a series of steps in the creation of the world are
envisaged, starting with the Tao and leading sequentially to the
primordial breath *(yuanqi)*, then to a state called *taiji*, then to
Heaven and Earth.[5]

The *Compendium of Diagrams (Tushubian)* is a 127-chapter
encyclopedia on cosmology, geography, and human life com-
piled in the early Wanli reign (1573–1620) by the scholar Zhang
Huang.[6] Because of its length, it was not published until 1613,
when the printing blocks were carved under the supervision of
Zhang's pupil Wan Shanglie. Significantly, the *Diagram of the
Supreme Ultimate* is the first image that appears in the book.

—S. L.

古太極圖

乾 巽 兌 離 艮 震 坎 坤

正南純陽方也故畫
為乾正北純陰方也離於東
故畫為坤離畫於東
象陽中有陰也畫坎
於西象陰中有陽也
乎畫震西南陰生陽
東北陽生陰下於是
下於是乎畫巽兌於
長陰消是以東
東南觀陰盛陽微是
以畫艮於西北也

traditionally attributed to Zhang Sengyou
(active early 6th century)
The Five Planets and the Twenty-eight Lunar Mansions

Northern Song dynasty (960–1126) or earlier
Handscroll; ink and colors on silk
27.5 × 489.7 cm
Osaka Municipal Museum of Art, Abe Collection

Shown in Chicago only

Qiu Ying (c. 1495–1551/2)
*The Divine Forms of the Five Planets, Twenty-eight Lunar
Mansions, and Five Sacred Peaks*

Ming dynasty, c. 1520/30
Handscroll; ink and colors on paper
19 × 396.2 cm
The Metropolitan Museum of Art, New York, Gift of Douglas Dillon
(1989.235.4)

Catalogue no. 12 is attributed to Zhang Sengyou, a painter
of Buddhist images during the Liang dynasty (502–557). There
are reasons for doubting this attribution (see below), but there
are two seals of Emperor Huizong (r. 1100–25) of the Song dy-
nasty (960–1279) at the end of the scroll, and the scroll was re-
corded in the catalogue of Huizong's collection, the *Xuanhe
Painting Catalogue (Xuanhe huapu)*,[1] so it dates to no later than
the Northern Song (960–1126). Catalogue no. 13 is an early-
sixteenth-century copy of the first scroll by Qiu Ying (c. 1495–
1551/2). Catalogue no. 12 is incomplete, with images of the Five
Planets and only twelve of the Twenty-eight Lunar Mansions,
but the painting by Qiu Ying depicts the Five Planets, all twenty-
eight of these constellations, and the Taoist talismans (the True
Forms, or *zhenxing*) of the Five Sacred Peaks. The Osaka scroll
has colophons by Dong Qichang (1555–1636) and Chen Jiru
(1558–1639), respectively attributing the scroll to Wu Daozi (ac-
tive c. 710–c. 760) and Yan Liben (d. 673), while the Qiu Ying
scroll has inscriptions written by Wen Boren (1502–1575), and a
frontispiece by Zhao Fu dated 1837.[2]

The stellar deities depicted in these two scrolls were absorbed
into the later Taoist pantheon. They appear, for example, in the
entourage of the Emperor of Purple Tenuity *(Ziwei)* in the early-
fourteenth-century murals of the Hall of the Three Purities (San-
qing Dian) of the Eternal Joy Temple (Yongle Gong) in southern
Shanxi province, a Taoist temple of the Complete Realization
(Quanzhen) sect.[3] Dong Qichang's colophon at the end of the
Osaka handscroll gives the painting the Taoist-sounding title of
Illustrations of the True Forms of the Twenty-eight Lunar Mansions,[4]
and identifies its author as Wu Daoshi, a reference to the great
Tang painter Wu Daozi, a painter of Taoist themes active at the
court of Emperor Xuanzong (r. 712–56). Dong further states that
this painting was owned by Emperor Huizong due to his interest
in religious Taoism (Daojiao) as much as his interest in paint-
ing. In addition, the copy of this painting by Qiu Ying incorpo-
rates Taoist talismans, all of which indicate that later viewers
understood the subject of the Osaka handscroll to be Taoist.

However, the images depicted in this handscroll are neither
Taoist, nor, strictly speaking, Buddhist in origin. They represent
a combination of Chinese cosmological beliefs and western
astrology that was brought to China together with Buddhism.
The Osaka handscroll begins with depictions of the Five Planets,
together with a description of the attributes of each planet writ-
ten in elegant seal script. These attributes seem to suggest the
influence of western astrology. For example, Jupiter, ruler of
the gods in ancient Rome, is described as "righteous with great
authority," a "lordly prince" whose shrine was placed at the

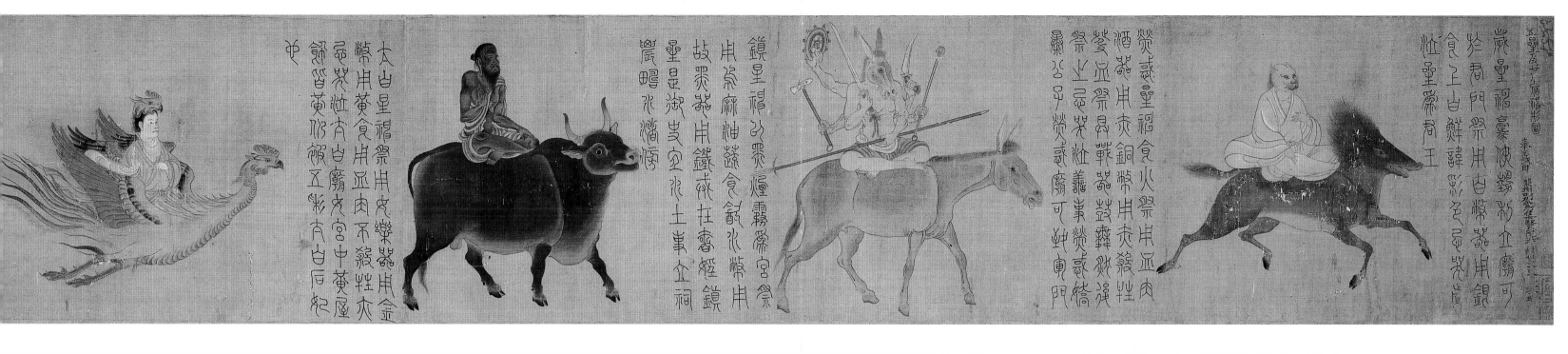

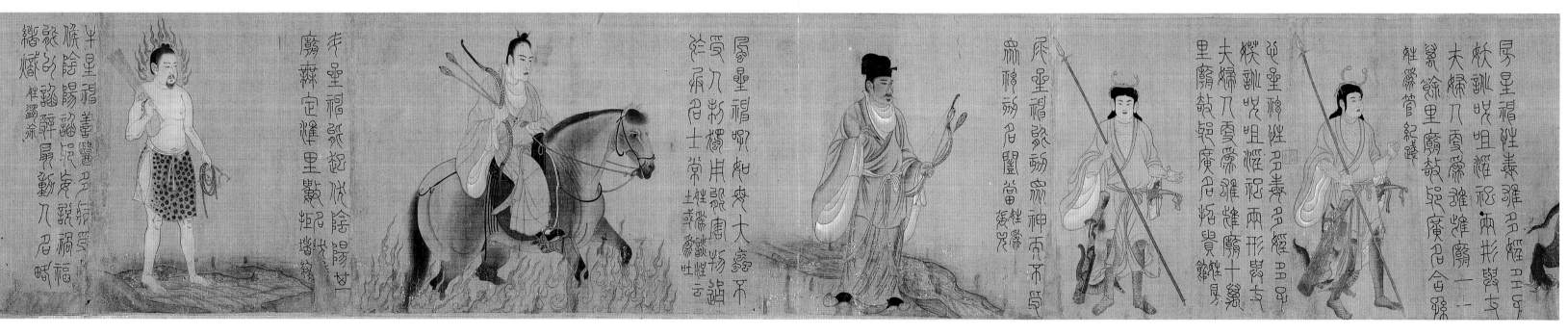

12

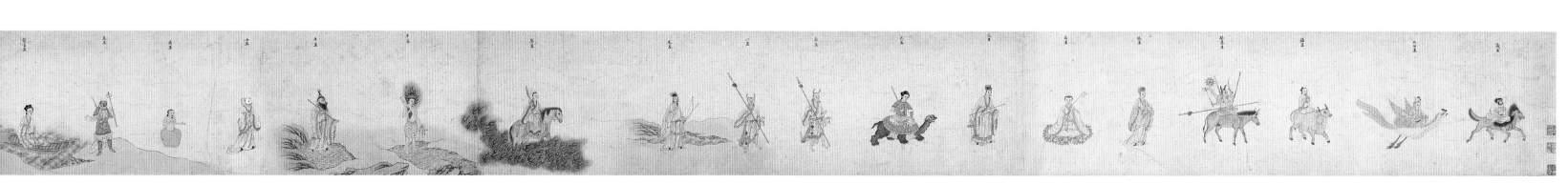

13

"Lord's Gate." Mars, the most martial of Roman gods, is a "willful and violent noble" whose shrine was placed at the "Soldier's Gate." Saturn, who had strong agrarian connotations in ancient Rome, is described as "appropriate for matters concerning water and earth," and his shrine was placed "next to a field or a small river islet." Venus, the most feminine of Roman deities, is an "imperial consort" whose worship required female musicians and whose shrine was placed in the "Women's Palace." Finally, Mercury, messenger and scribe for the gods of ancient Rome, is an "official" whose shrine was placed in the "Minister's Residence."

While these attributions closely follow western traditions, they have little precedence in traditional Chinese astrology; in addition, the color attributions of each planet do not follow the Chinese Five Phase system (see cat. no. 17). The similarities between the Osaka handscroll and Sogdian-inspired Buddhist sources suggest that the images of the five planets in this scroll were inspired by a Central Asian source, perhaps from Sogdiana.[5] This Central Asian iconography of the Five Planets was probably first introduced into China during the Tang dynasty (618–906).

The second part of the scroll contains images of the Twenty-eight Lunar Mansions, the constellations through which the moon passes on its circuit through the sky. These images also show the influence of western astrology, linking the twelve western zodiac figures with the Twenty-eight Lunar Mansions. The first image of the mansion Horn (Jiao), which corresponds to Virgo, is depicted as a woman, while the second, Neck (Kang), which corresponds to Libra, holds the scales of Libra in his hand. The mansions Chamber (Fang) and Heart (Xin), the fourth and fifth images, which both correspond to Scorpio, bear scorpions on their heads. Tail (Wei) and Winnower (Ji), the sixth and seventh images, both correspond to Sagittarius, and they each carry a bow, the device of this Graeco-Roman figure. Ox (Niu) and Woman (Nü), the ninth and tenth images, correspond to Capricorn, and they are each depicted with goats' heads. Finally, the eleventh image, of the Emptiness (Xu) mansion, which corresponds to Aquarius, is shown inside of a water jar, an attribution of this zodiac figure. The interpretations of the twelve solar houses seen here are sometimes rather clumsily incorporated, particularly in the figure of the Emptiness mansion; however, the task of incorporating such alien images into the Chinese astrological system must have been very difficult indeed.

The western zodiac seems to have been introduced into China around the end of the sixth century, and can be found in the *Scripture of the Great Assembly of Great Doctrinal Universality (Da fangdeng daji jing).*[6] It became well known in the Tang dynasty, an age when the Chinese were noted for their interest in exoticism and foreign ideas. Consequently, when taken together, the iconography of the Five Planets and the Twenty-eight Lunar Mansions shown here suggests that this handscroll was inspired by ideas introduced in the Sui–Tang period (531–906), implying a later date for the scroll than would be possible if it had been painted by Zhang Sengyou.

Central Asian–inspired sources in the Buddhist Canon similar to this handscroll[7] tell us that when the Five Planets entered into the lunar mansion under which a person was born, known as the "destiny mansion," then that person was to recite certain scriptures and *mantra* (sacred syllables that embody the divine energy of a god), wear colors appropriate to the planet, and make offerings to its deity. In addition, one method instructs the practitioner to paint an image of the planet, which was hung around the neck until the planet had left the lunar mansion and then burned;[8] the images shown in these handscrolls may originally have served as models for paintings used in similar practices. The information provided for worshipping the Five Planets in the Osaka painting does not correspond exactly to these astrological treatises; instead, it goes into details concerning the vessels and types of food used for sacrifices to each planet. However, the intentions of these works are essentially the same. Like Tang dynasty Buddhist astrological works, the text inscribed on the Osaka scroll instructs the practitioner on the proper method for making sacrifices to the deities of the Five Planets, which help counteract the negative influences of these planets when they travel through a person's "destiny mansion." In the same manner, the written descriptions that accompany each of the lunar mansions describe the personalities of people born under their influences, together with the names of the deities who govern these mansions.

—S. E./S. L.

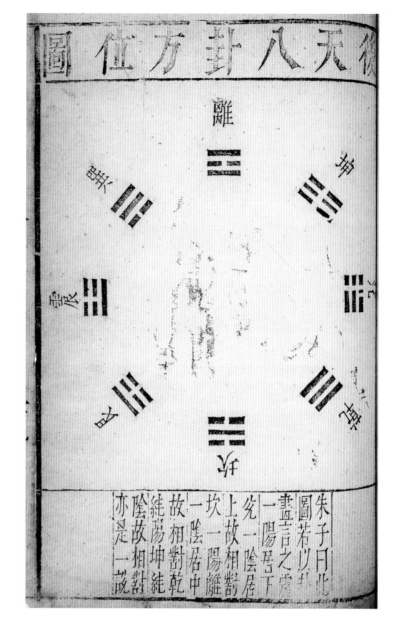
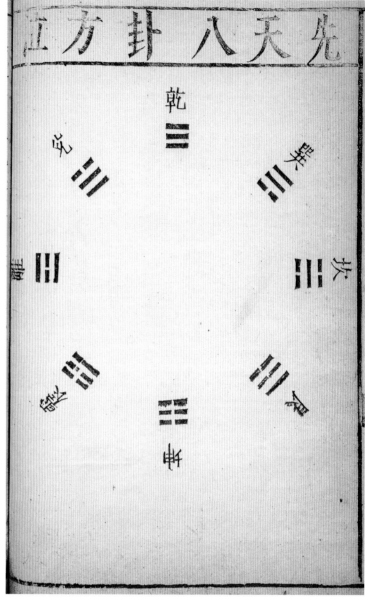

14

ZHANG HUANG (1527–1608)
The Eight Trigrams: The Prior Heaven and Later Heaven Arrangements, from the Compendium of Diagrams

Ming dynasty, Tianqi reign, dated 1623
Woodblock-printed book; ink on paper
26 × 17.3 cm (each page)
C. V. Starr East Asian Library, Columbia University, New York

THE EIGHT TRIGRAMS (Bagua) are among the best-known images associated with Taoism, and yet their origin is altogether independent of Taoism. These visual symbols are the basis for the sixty-four hexagrams of the *Changes of the Zhou (Zhou yi)*, the earliest form of the text now known as the *Book of Changes (Yi jing)*.[1] The *Changes of the Zhou* is an ancient divination text whose origins can be traced to the Western Zhou dynasty (c. 1050–771 B.C.), even though it probably did not assume its final form until the end of this period.[2] The Eight Trigrams are made up of combinations of broken and unbroken lines, taken to symbolize *yin, yang,* and the intermediary stages in the cycle from *yin* to *yang* and back. The *Changes of the Zhou* and the *Book of Changes* are texts that provide a means of assessing the present state of the world and a basis for decision-making. The most important of the Eight Trigrams are *qian* and *kun*, representing *yang* and *yin*, with three unbroken and three broken lines, respectively.

The earliest surviving visual evidence for the Eight Trigrams dates to the Western Han dynasty (206 B.C.–A.D. 8). One of the most important archaeological discoveries of recent years in China was the discovery in 1973 of the earliest known text of the *Changes of the Zhou* found in Han tomb no. 3 at Mawangdui, Changsha, Hunan province, a burial dated to 168 B.C.[3] This complete text includes the sixty-four hexagrams and text with the *Xici* commentary, described by Edward L. Shaughnessy as "a synthetic explanation of the text, its composition, function and meaning."[4]

The Anterior or Prior Heaven *(Xiantian)* arrangement of the Eight Trigrams is traditionally derived from the sage Fu Xi (third millenium B.C.), one of the Five Emperors of high antiquity, and represents the relationship of the trigrams in the state of primordial chaos *(hundun)*, before the emergence of *yin* and *yang* as active agents in the world.[5] The Later Heaven *(Houtian)* arrangement of the Eight Trigrams is traditionally derived from the early Western Zhou dynasty king Wen (Wenwang), and represents the relationship of the trigrams in phenomenal reality, after the emergence of *yin* and *yang*. The Fu Xi arrangement of the trigrams is further associated with the numerological and talismanic diagram known as the River Diagram *(Hetu)*; the Wenwang arrangement is similarly associated with the Luo Writing *(Luoshu)*. The *Hetu* and the *Luoshu* are two cosmic diagrams that emerged out of the Yellow and Luo Rivers on the backs of a dragon-horse and tortoise, and were revealed to Fu Xi and Emperor Yu, respectively.[6] Such spontaneous revelations of cosmic structures through sacred texts and diagrams is characteristic of the Taoist tradition.

Evidence for the early use of the Eight Trigrams in a religious Taoist context can be found in several Six Dynasties period (420–589) literary sources. One of these is the preface to the *Daode jing* attributed to Ge Xuan, probably written during the Liu-Song dynasty (420–479), in which the initiate to whom the scripture was being transmitted visualized a turtle with the Eight Trigrams on its back beneath his or her feet (for a discussion of this preface, see cat. no. 3). The imagery of the sixty-four hexagrams, which are made up of the Eight Trigrams from the *Book of Changes,* also plays a role in the *Declarations of the Perfected (Zhen'gao),* a visionary text of Highest Purity (Shangqing) Taoism compiled by Tao Hongjing (456–536) during the Liang dynasty (502–557).[7]

The Eight Trigrams played a vital role in the Taoist alchemical tradition. This was because chemical alchemy entailed manipulating the forces of *yin* and *yang* toward understanding and immortality. The trigrams and their associated hexagrams were subtle visual symbols of cosmic flux, and were easily adopted by Taoists to help explain cosmological principles of transformation.[8] As Isabelle Robinet has written,

> *Qian* and *kun* are, in cosmological terms, Heaven and Earth, south and north; in alchemical terms, the Furnace and the Cauldron; and in human terms, the Spirit and the Body. *Li* and *kan* are, in cosmological terms, the Sun and the Moon, east and west; in alchemical terms, the "ingredients" Mercury and Lead, Dragon and Tiger. *Qian* and *kun* are the constants in the system (the "completed procedures," *chengwu*), and *Li* and *kan* are the principles of resonance *(ganying)* and growth and exchanges *(jiaoji)*.[9]

The Eight Trigrams and their symbolism are one of several Bronze Age traditions that flowed together in the Han dynasty (206 B.C.–A.D. 220) to form the basis of religious Taoism.

—S. L.

15

Mirror with Animals of the Four Directions and the Zodiac

> Sui dynasty, c. 600
> Bronze
> Diam. 24.8 cm
> Museum Rietberg, Zurich

16

Mirror with Cosmological Designs

> Tang dynasty (618–906)
> Bronze
> Diam. 26.4 cm; h. 1.3 cm
> American Museum of Natural History, New York, Berthold Laufer
> Collection (70/11671)

17

Mirror with the Five Phases (Elements),
Eight Trigrams, and Twelve Branches

> Tang dynasty (618–906)
> Bronze
> Diam. 14.5 cm
> Palace Museum, Beijing

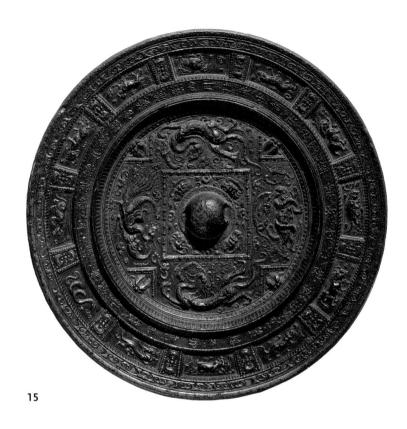

15

THE EARLIEST CHINESE BRONZE MIRRORS date to the late Shang dynasty (thirteenth–eleventh century B.C.).[1] As early as the Warring States period (475–221 B.C.), cosmological designs were cast into the backs of mirrors. This was in part linked to the symbolism of mirrors, which were objects used by the living to reflect the real world and by the dead as symbolic sources of light and as maps of the underworld and the cosmos.[2] The most complex of these designs date to the Sui (581–618) and Tang (618–906) dynasties; three examples are included here. A key aspect of these designs is that they illustrate the correlations between *yin* and *yang* and various directional, seasonal, and chronological systems of ordering natural phenomena. While the mirrors are not Taoist per se, they are significant in a Taoist context because they give visual form to the basic principles underlying the structure of the cosmos in ancient China. These principles of cosmic order and systems of correspondence were codified in the Warring States and Han (206 B.C.–A.D. 220) periods, and were among the intellectual underpinnings of the Taoist religion.

The Sui dynasty mirror from the Museum Rietberg, Zurich (cat. no. 15), depicts the animal symbols of the Four Directions around the central knob.[3] These animals, known collectively as the Four Divinities (Siling or Sishen); are the Azure Dragon

(Qinglong or Canglong) of the east; the Vermilion Bird (Zhuque) of the south; the White Tiger (Baihu) of the west; and the Dark Warrior (Xuanwu) of the north, consisting of an entwined turtle and snake. In a wide band around the mirror's perimeter are the twelve animals of the Chinese zodiac, arranged in a clockwise sequence: rat, ox, tiger, hare, dragon, snake, horse, ram, monkey, cock, dog, and boar. In Chinese cosmology, these symbols correspond to the twelve divisions of the celestial equator known as the earthly branches *(dizhi),* each of which also corresponds to a direction (rat = north, ox = north-northeast, and so on). An inscription in standard script is cast into a narrow band between the inner and outer zones. As Helmut Brinker has pointed out, its content is related only loosely to the symbolic designs on the mirror.[4] The generic name for this type of mirror *(renshou)* comes from a phrase in this inscription meaning "benevolence and longevity."[5] The *renshou* mirror type appears to have been made in southern China, although similar examples have been excavated from sites as disparate as Xi'an in Shaanxi and Xing'an in Guangxi.[6]

The Tang dynasty (618–906) mirror in the collection of the American Museum of Natural History (cat. no. 16) is one of the largest and finest surviving examples of its type.[7] The mirror has a dark green surface. Like the Museum Rietberg mirror, the

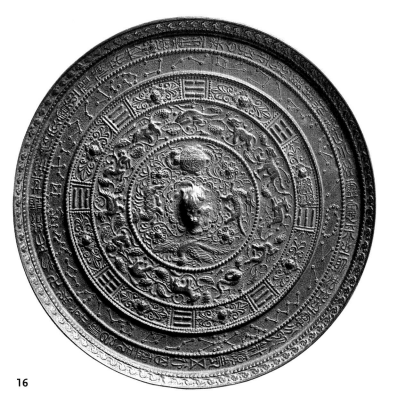

16

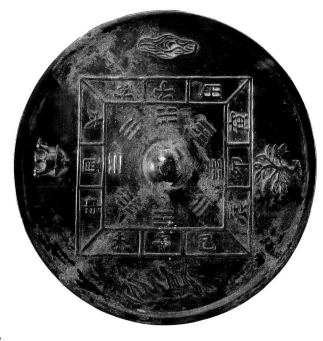

17

designs cast into the back represent several corresponding levels of order in the structure of the universe. The entire system illustrated here was absorbed into religious Taoism by the end of the Six Dynasties period. The designs are arranged in five concentric bands. Around a central frog-shaped knob are the animal symbols of the four directions, separated by floral designs. In the next band are the twelve animals of the Chinese zodiac, also arranged in a clockwise sequence. The next band depicts the Eight Trigrams, representing the cosmic flux of *yin* and *yang*. These appear in the Later Heaven *(Houtian)* arrangement (see cat. no. 14). The trigrams are interspersed with floral bosses and leaves; among these is a cast design of a boy holding two cartouches with the characters *cao* and *pu,* the latter of which may be a name. The next band of decoration depicts the stylized forms of the Twenty-eight Lunar Mansions in a manner that existed as early as the Han dynasty.[8] This is one of the earliest surviving examples showing the Lunar Mansions as a coherent group. The next band, just inside the outer band of *ruyi* mushroom-shaped clouds, contains a poetic inscription in standard script, which mentions the correlations of *yin* and *yang,* the Eight Trigrams, and the Five Phases or Elements.[9]

The Tang cosmological mirror in the collection of the Palace Museum, Beijing (cat. no. 17), is unusual in its inclusion of the Five Elements in the decorative scheme. At the center of the mirror, around the raised boss, are the Eight Trigrams, in the Later Heaven arrangement. Then, in a square arranged around the center, are the Chinese characters for the twelve earthly branches that correspond to the twelve celestial stations of Jupiter and to the Chinese zodiac. Finally, around the perimeter, are symbols representing four of the Five Elements: an incense burner (metal), flames (fire), a tree (wood), and a lotus leaf (water). The element earth, which is not represented, is symbolically present at the center. The mirror thus symbolizes the coherent relationship between the Five Elements, the twelve phases of the zodiac, and the Eight Trigrams.

—S. L.

(detail)

(detail)

18

Star Maps

> From Dunhuang, Gansu province
> Tang dynasty (618–906)
> Handscroll; ink and colors on paper
> 24.5 × 340 cm
> The British Library, London, Oriental and India Office Collections
> (Stein 3326)

THE BRITISH LIBRARY SCROLL of star maps is one of two surviving astronomical diagrams from Dunhuang and was one of the many manuscripts acquired by Sir Aurel Stein at the great Buddhist cave-temple site in Central Asia in 1907.[1] The handscroll, painted and inscribed in ink and color on pale beige paper, is truncated at both ends. It begins with a divination chart depicting forms of *qi* (vaporous energy), with notes indicating the significance of the different cloudlike shapes. This is followed by depictions of twelve sections of the sky, corresponding to the twelve stations *(ci)* of the planet Jupiter, in addition to a depiction of the circumpolar area known as the Court of Purple Tenuity *(Ziwei yuan)*. The Jupiter stations are twelve equal divisions of the sky, based on the full circuit of the heavens made by Jupiter in its twelve-year rotation around the sun. Because the twelve Jupiter stations are positioned along the celestial equator, they are unrelated to the twelve stations of the Western zodiac, which are situated along the ecliptic (the annual path of the sun through the sky).[2] The Jupiter stations do, however, correspond to the twelve "earthly branches" *(dizhi)* and the corresponding animal symbols of the Chinese zodiac.[3] In addition, the Jupiter stations correspond to the Twenty-eight Lunar Mansions (see cat. no. 12), with two or three mansions occupying each station, depending on the angular extension of the mansions along the celestial equator.[4] Within each Jupiter station, the key constellations (including the Lunar Mansions) that fill the corresponding section of the sky are depicted.

The star maps begin with the Jupiter station Murky Hollow *(Xuanxiao)*, which contains three Lunar Mansions: Woman *(Nü)*, Emptiness *(Xu)*, and Roof *(Wei)*. The fourth map, the Jupiter station Great Plank-Bridge *(Daliang),* includes as one of its asterisms the star cluster known in the West as the Pleiades and known to ancient Chinese astronomers as the Lunar Mansion Mane *(Mao)*. The fifth map illustrates the Jupiter station *Shichen* (the name of a deity), containing the Lunar Mansions Beak *(Zui)* and Triaster *(Shen),* corresponding to the Western constellation Orion. The scroll ends with an anthropomorphic figure holding a bow, labeled "God of Lightning" (Leishen). In its inclusion of explanations of different forms of *qi,* this scroll resembles the other Tang dynasty star map that survives from Dunhuang, entitled *Book on the Prognostication of Clouds and Vapors (Zhan yunqi shu)*.

The significance of the Stein scroll lies primarily in its methodical arrangement of star maps that together comprise the earliest known depiction from any ancient civilization of the entire night sky as seen from the northern hemisphere.[5] Its importance in a Taoist context lies in its emphasis on the circumpolar region as the most important part of the heavens, with the concentration in this zone of such pivotal asterisms as the Celestial Pole *(Beiji)*, the Northern Dipper *(Beidou)*, Purple Tenuity *(Ziwei)*, and Wenchang (also the name of the later God of Literature), each of which plays a key role in religious Taoism (see, for example, cat. nos. 76, 78, and 89), and in the fact that, from early times, all stars were believed to have an impact on human fate.[6] In addition, as shown elsewhere (see cat. no. 12), by the Tang dynasty, if not earlier, almost all of the constellations shown here represented gods in the pantheon of religious Taoism (the Lunar Mansions, for example, appear as anthropomorphic gods in the Yuan dynasty [mid-fourteenth century] murals at the Eternal Joy Temple in Shanxi province). Of the circumpolar asterisms, the most important by far was the Northern Dipper, perceived from at least the late Shang dynasty (thirteenth/eleventh century B.C.) as an enormous celestial chronogram. In the *Records of the Historian (Shiji)* by Sima Qian (145–87 B.C.), the Dipper is described as follows:

> *Beidou* serves as the chariot of the emperor and effectuates its control over the four cardinal points by revolving around the center; it separates the *yin* and the *yang* and regulates the four seasons; it maintains balance between the Five Elements *(Wuxing);* it regulates the moving of the celestial objects; it determines the epoch of the calendar.[7]

The custom of depicting constellations as series of dots joined by straight lines appears to have begun in the second century B.C.[8] In the Stein scroll, constellations are not only shown in this manner, but are also distinguished by their different colors (red, black, and white), corresponding to star groups catalogued by the Warring States period astronomers Shi Shen, Gan De, and Wu Xian.[9] The original star catalogues by these scholars were lost after the Liang dynasty (502–557), but their systems of categorization were passed down by others, having been codified into a single unified system by Qian Lezhi during the Liu-Song dynasty (420–479).[10]

—S. L.

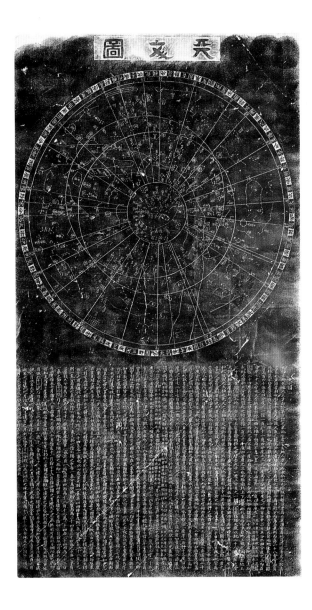

19

Star Chart

> Ink rubbing of a stele at the Confucian Temple, Suzhou,
> Jiangsu province
> Southern Song dynasty, Chunyou reign, dated 1247
> Hanging scroll; ink on paper
> 183 × 100 cm
> Stone Carving Museum, Suzhou

AT THE TIME THE STONE from which this Southern Song ink rubbing showing a star chart was engraved, in 1247, it was the most advanced celestial map anywhere in the world. It is labeled at the top "Chart of the Celestial Patterns" *(Tianwen tu)*.[1] The chart is significant in a Taoist context because it depicts the home of a vast number of gods in the Taoist pantheon, centering on the circumpolar region with the Northern Dipper and the Pole Star, the most important stars in the Taoist heavens. In

addition to a large number of constellations, the celestial equator and the ecliptic (the apparent path of the sun in the sky during the course of the earth's annual rotation) are shown. The chart includes a total of 1,436 stars. The entire northern celestial hemisphere is shown, in addition to part of the southern sky, up to fifty degrees south of the celestial equator. The lines radiating from the northern celestial pole to the celestial equator mark the location in the heavens of the Twenty-eight Lunar Mansions *(Ershiba xiu)*.

The star chart was completed in 1193 by Huang Shang (1147–1195), a tutor to Prince Jia, the future Southern Song emperor Ningzong (r. 1195–1224). In 1247, over twenty years after Ningzong's death, it was carved onto a stone stele by Wang Zhiyuan.[2] The accompanying text has been described by Joseph Needham as "one of the shortest (and most authentic) expositions of the Chinese astronomical system."[3] The text states that there are 1,565 named stars (roughly ninety percent of these are shown on the chart), and mentions the ancient theory correlating cities and provinces to specific heavenly bodies. The ancient state of Zhou, for example, was tied to the Jupiter station Quail Fire, comprising the Lunar Mansions Willow *(Liu)*, Star *(Xing)*, and Spread or Extended Net *(Zhang)*.[4] The Northern Dipper is presented as a celestial clock and seasonal indicator as it rotates through the Lunar Mansions (as it had been perceived since at least the Han dynasty [206 B.C.–A.D. 220]).

The circumpolar region appears at the center of the chart. Here the Northern Dipper (Ursa Major) is clearly visible. It is one of the few constellations in which each component star is named on the chart (see cat. no. 78 for an anthropomorphic depiction of these stars). The ring around the perimeter is marked with the names of the Jupiter stations, the Lunar Mansions, the terrestrial branches *(dizhi)* corresponding to the Chinese zodiac, the names of the ancient states to which the asterisms corresponded, and the widths of the Lunar Mansions along the celestial equator that are accurate up to half a degree.[5] The boundaries of the Twenty-eight Lunar Mansions are indicated by the lines radiating out from the center to the perimeter. The large circle concentric with the inner boundary of the Central Palace (the circumpolar area) is the Celestial Equator; this runs through the Lunar Mansions (for example, the constellation Orion, the belt of which was the mansion known as Triaster [Shen], is clearly visible along the Celestial Equator). The offset circle is the ecliptic, mistakenly shown here as a circle instead of an ellipse. The Milky Way is also clearly shown, meandering from one side of the chart to the other.

—s. l.

NOTES

Cat. no. 8

1. The complete excavation report on the Marquis of Zeng tomb can be found in Hubei Provincial Museum 1989. For a brief English summary of the tomb and its significance, see MacKenzie 1999: cat. nos. 92–109.
2. As F. Richard Stephenson has pointed out, the next complete list of the Lunar Mansions dates from roughly two centuries later; see Stephenson 1994: 519. Prior to this, the earliest known references to Lunar Mansions were found in the *Book of Songs (Shi jing),* and in the inscriptions of certain ritual bronze vessels of the Western Zhou dynasty; see Stephenson 1994: 516–17.
3. Stephenson 1994: 523. For the original report, see Shaanxi Archaeological Institute and Jiaotong University 1990. The precise angular (equatorial) extensions of the lunar mansions are given in the *Master of Huainan (Huainanzi;* 139 B.C.); see Major 1993: 127–28.
4. See the anthropomorphic depictions of the Lunar Mansions in the fourteenth-century murals at the Eternal Joy Temple in Shanxi, illustrated in Jin 1997: pls. 50–52, 59–61.
5. See *Lacquerware from the Warring States to the Han Periods* 1994: no. 15.
6. Stephenson 1994: 514.
7. This despite the fact that the actual pole star has changed several times in the past several millennia owing to the precession of the equinoxes; see ibid.: 531.

Cat. no. 9

1. Major 1985–86: 65.
2. Ibid.: 68.
3. Cheng 1957: 167–68.

Cat. no. 10

1. See Sun and Kistemaker 1997: 116, fig. 6.2.
2. Similar Northern Wei sarcophagi have been excavated in Henan and Shandong provinces. Another example, carved in intaglio, is in the collection of the Temple of Guandi near Luoyang, Henan province.

Cat. no. 11

1. Robinet 1990: 374–76; see also Robinet 1997: 221, 271 n. 2.
2. Major 1993: 108–09, 64–65.
3. Robinet 1990: 382–83.
4. Ibid.: 383.
5. Ibid.: 384.
6. Goodrich and Fang 1976: 83–85.

Cat. nos. 12–13

1. See XHHP: *juan* 1, chap. 1: 379–380.
2. There is also a copy of the Osaka scroll by the Qing dynasty court painter Ding Guanpeng (active 1737–68) in the National Palace Museum, Taipei; see *Changsheng de shijie* 1996: 6–7.
3. Jin 1997: pls. 19, 63–66, 69 (the Five Planets), and pls. 50–52, 59–61 (the Twenty-eight Lunar Mansions).
4. This imitates the names of such Taoist magical diagrams as the *Diagram of the True Forms of the Five Sacred Peaks (Wuyue zhenxing tu;* see cat. no. 137).
5. For example, see T 1311, attributed to the Chinese monk Yixing (673–727), and T 1308, attributed to a "brahmin" monk named Jinjuzha from a "western country," both of which use Sogdian names for the planets and days of the week. These names are identified by Amoghavajra in T 1299 as being Sogdian *(hu);* see Needham and Wang 1959: 258. The iconography of the Five Planets described in these two texts is nearly identical to that of the Osaka handscroll. This opens the interesting possibility that the Central Asian imagery in this painting comes originally from Sogdiana, and that the Graeco-Roman elements were introduced through a Sogdian or Persian source. In this case, the astrological treatise by Jinjuzha, which dates to around 806, is probably the most direct source for the Osaka handscroll still preserved.
6. See T 397.
7. See note 5.
8. See T 1308.

Cat. no. 14

1. For an excellent discussion of the textual history of the *Yi jing* or *Zhou yi,* see Shaughnessy 1993. For a translation of the *Yi jing,* see Wilhelm 1967.
2. Shaughnessy 1993: 219.
3. The various silk manuscripts found in this tomb are published in Chen 1996.
4. Shaughnessy 1993: 220.
5. On different meanings and contexts of the term *Xiantian,* see Robinet 1990: 385.
6. Seidel 1983: 302.
7. Kroll 1996b: 183.
8. Robinet 1997: 234 ff.
9. Ibid.: 236.

Cat. nos. 15–17

1. Examples were excavated from the tomb of the Shang dynasty queen Fu Hao at Anyang, Henan province, in 1976; see *Yinxu Fu Hao mu* 1980: pl. 68.4–5.
2. See Loewe 1979: 60–85.
3. For a detailed discussion of the Rietberg Museum mirror, see Brinker and Fischer 1980: 91–94, no. 32.
4. Ibid. Brinker's translation is adapted from Wenley 1962: 141, cited in Brinker and Fischer 1980: 92.
5. On this term see Soper 1967: 55–66.
6. Brinker and Fischer 1980: 92 n. 3.
7. The design of this mirror (or a nearly identical example) is reproduced in the catalogue of the imperial Qing dynasty bronze collection, the *Mirror of Antiquity of the Western Qing (Xiqing gujian)* of 1751, and also in *On Bronzes and Jades (Jinshi suo)* of 1821; see XQGJ, *juan* 40: 45, and JSS, *Jin* (bronze) section. A slightly smaller mirror with a nearly identical design was published in Beijing in 1935; see Rupert and Todd 1935: no. 352.
8. As F. Richard Stephenson has shown, however, surviving Han examples are only fragmentary. For another Tang depiction of the stylized constellations of the Lunar Mansions, from a tomb near Turfan, Xinjiang province, see Stephenson 1994: 537, fig. 13.12.
9. The inscription is translated in Needham and Wang 1959: fig. 53.

Cat. no. 18

1. The other is kept at Dunhuang; it is published in Ho 1987: 58, and Stephenson 1994: fig. 13.11.
2. The first mention of Jupiter stations is found in the *Spring and Autumn Annals (Lushi chunqiu);* see Stephenson 1994: 515. Ritual offerings were made to the planet Jupiter as early as the late Shang dynasty (thirteenth/eleventh century B.C.), and are mentioned in oracle bone inscriptions found at Anyang, the last Shang capital; see Stephenson 1994: 514. Both the celestial equator and the ecliptic are shown on the Southern Song dynasty star chart of A.D. 1247 (cat. no. 19).
3. For a chart of these correspondences, see Schafer 1978c: 76, table 2.
4. Ibid. For a chart indicating the location of the Twenty-eight Lunar Mansions, see Needham and Wang 1959: 235–37, table 24.
5. For a list of references to Han dynasty star maps, see Needham and Wang 1959: 276 n. d.
6. See the remarks of the Eastern Han dynasty scholar Zhang Heng to this effect, quoted in ibid.: 265.
7. Sun and Kistemaker 1997: 23, quoting from the "Treatise on Celestial Officials [Constellations]" *(Tianguan shu)* in Sima Qian's *Shiji.*
8. Harper 1978–79: 1, 6 n. 1.
9. Needham and Wang 1959: 263.
10. Ibid.: 263–64.

Cat. no. 19

1. For detailed studies, see Rufus and Tien 1945 and Pan 1976, no. 1: 47–61.
2. Sun and Kistemaker 1997: 31.
3. Needham and Wang 1959: 278.
4. Schafer 1978c: 76, table 2. The translations of the names of the Lunar Mansions used here are from Schafer 1978c, and Needham and Wang 1959: 235, table 24.
5. Stephenson 1994: 549.

立屋……（碑刻殘文，隸書）

旅消有道……遣使者以萬禮讓……君君忠肅上翔然

樹上消庭有持抱束賜錢千萬間君不君覓諂得以十衛中送

拜祓上之……詔人遣造使者……君讓娉君君諂忠肅上月翔

申郡之頃庭道……束賜錢千……君禮讓娉君君不君諂忠得以十

郡徹魏上項持抱諮人遣使……十千萬間君讓不君覓諂得以十衛

護魏玄妙秋雨詔束十一……上萬問君禮娉不君君諂忠得肅一上

師大夫玄張以白……十出萬間君……十一上月翔然蜀來

玄郡張妙抱白兩……八十菜錢使……君禮讓娉如集

名去多夫雄妙秋……出白兩束賜使者萬以來集常時有赤東

去四日字男建陽呉出白……束賜道造人暈土南銀而末

區時丙所建空東齋窗以束錢使遣造道人……士南銀陰

四時日丙卜男仙退孝孝郷晏入十菜錢使者以……未集

述休帝時丙男建仙退孝孝郷計子宜月上萬問君……來集常

赫顧休所字故勸神亶建空東齋窗……十……禮讓……

理顧休坎列故神勸君重仙退泉孝莣莣計穆為心慈……

又理坊故暦佛賜其嘉祉祠橋柶升遊見紀子孫企墓

FUNDAMENTAL TO RELIGIOUS TAOISM is the concept of the sacred peak as a numinous pivot connecting heaven and earth. Central to the cosmological beliefs of the Han dynasty (206 B.C.– A.D. 220) was the worship of the Five Sacred Peaks (symbolizing and defining the four cardinal directions and the center) and other holy mountains. The earliest and most visually compelling images of such peaks are the mountain-shaped bronze incense burners *(boshanlu)* of the Han dynasty, the most spectacular of which was excavated in 1968 from the tomb of the Han prince Liu Sheng (second century B.C.; cat. no. 20). The image of a Taoist mountain paradise, populated by transcendent beings, is illustrated in the "Sacred Landscape" section (III.6) of this exhibition and catalogue by Chen Ruyan's fourteenth-century handscroll *Mountains of the Immortals* (cat. no. 144), which ties together the concepts of mountains as sites where the cosmic vital energy *(qi)* is most refined, where the natural ingredients (herbs and minerals) for Taoist elixirs of longevity and immortality are found, and where one can encounter immortal adepts.

The *xian* (adepts or immortals) were conceived of as perfected beings who had transcended *yin* and *yang* and achieved union with the Tao through self-cultivation. Han dynasty images of such figures were known as *yuren,* literally, "winged beings." The bronze example excavated from a Han tomb in Luoyang in 1987 (cat. no. 21) reflects the way in which such figures were conceived. Later images of immortals, including the thirteenth-century painting by Ma Yuan *Immortal Riding a Dragon* (cat. no. 28), are ultimately based on Bronze Age traditions, such as the descriptions of the "divine beings" *(shenren)* found in the *Zhuangzi* (c. 300 B.C.).

The most famous of the ancient immortals, the Queen Mother of the West (Xiwangmu), was one of the most powerful goddesses of early Taoism (see cat. nos. 24–27). Even before the emergence of religious Taoism, she was already worshipped at the imperial Han court. The most illustrious human encounter with the Queen Mother of the West was that of the Zhou dynasty king Mu, a meeting that, according to Chinese mythology, took place in the eighth century B.C. Other immortals whose cults continue to the present day in China, Taiwan, and Hong Kong are Master Red Pine (Chisongzi) and Wang Ziqiao.

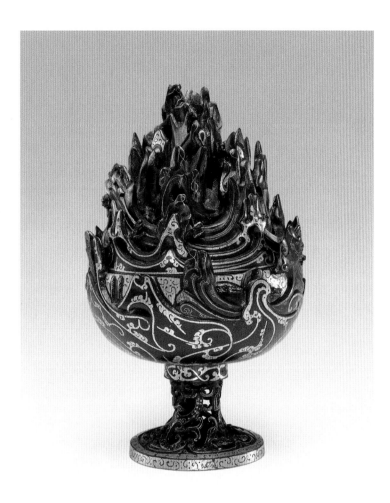

20

Mountain-shaped Censer

> From the tomb of Liu Sheng at Lingshan, Mancheng, Hebei province
> Western Han dynasty, second half 2nd century B.C.
> Bronze with gold inlay
> H. 26 cm; diam. 15.5 cm
> Hebei Provincial Museum, Shijiazhuang

MOUNTAINS HAVE PLAYED a key role in the history of Chinese religions. The image of the sacred peak as an axis joining heaven and earth has been prevalent for centuries in Chinese philosophical and religious thought. Mountains were sites where an adept could encounter perfected beings and gods, or the minerals and herbs that were the ingredients for elixirs of long life. One meditated and purified oneself on mountains and found caverns that were gates to paradise. Mountains were where the *qi*-energy that formed the world was particularly refined. In Taoist ritual the altar is visualized as a mountain that is symbolically (and sometimes actually) climbed by the officiating priest; in Taoist meditation the inner human body is visualized as a mountainous landscape, its forms simultaneously reflecting the structure of the natural landscape and the cosmos.[1]

Over time a cult of the Five Sacred Peaks developed, comprising mountains that defined the cardinal directions and the center: Mount Tai (Tai Shan) in the east, Mount Heng (Heng Shan) in the south, Mount Hua (Hua Shan) in the west, Mount Heng (Heng Shan) in the north, and Mount Song (Song Shan) in the middle. This group was codified by the Warring States period (475–221 B.C.), and worship of the Five Peaks was widespread from the Han dynasty (206 B.C.–A.D. 220) onward.[2]

The perception of mountains as numinous pivots joining heaven and earth was given visual form during the Han dynasty in the remarkable bronze and ceramic incense burners known as *boshanlu* ("universal mountain censer").[3] This example was excavated in 1968 from the tomb of the early Han dynasty prince Liu Sheng, at Mancheng, Hebei province. It depicts a sacred peak inhabited by animals and transcendent beings. The flowing lines of gold inlay around the base suggest the clouds that were seen as the mountain's "breath," and the movement of *qi* that pulsates through the earth.

A huge variety of mountain-shaped incense burners have been excavated from Han dynasty tombs in China, reflecting the widespread popularity of this type, which appeared in its mature form during the reign of Han Wudi (r. 140–87 B.C.).[4] This example was cast in three parts: the conical top, the bowl, and the stemmed, openwork foot. Inlaid with gold wires, the censer depicts a fantastic mountain covered with figures and animals. The flamelike peaks that jut up around the mountain's surface are perforated to allow the release of incense smoke.[5]

—S. L.

21

Winged Figure

Eastern Han dynasty, 2nd century
Bronze with gold inlay
15.5 × 9.5 cm
Luoyang Museum, Henan

EXCAVATED FROM AN EASTERN HAN dynasty (25–220) tomb on the eastern outskirts of Luoyang, Henan province, in 1987, this winged figure *(yuren)* is one of the earliest three-dimensional sculptures to depict a realized being. Similar figures are often found as part of the decoration on Han dynasty bronze mirrors cast with cosmological diagrams, and on ceramic tomb sculptures. These figures, usually depicted with winglike appendages, were perceived as having transcended the bonds of *yin* and *yang* and as existing beyond time and space. They lived among sacred mountains, in a numinous realm removed from the world of humankind. Such figures are described in early texts of the Taoist tradition, such as the *Zhuangzi* and the *Liezi*. The former book, for example, includes the following passage:

> Jian Wu said to Lian Shu, "I was listening to Jie Yu's talk—big and nothing to back it up, going on and on without turning around. I was completely dumbfounded at his words—no more end than the Milky Way, wild and wide of the mark, never coming near human affairs!"
>
> "What were his words like?" asked Lian Shu.
>
> "He said that there is a Holy Man *(shenren)* living on faraway Gushe Mountain, with skin like ice or snow, and gentle and shy like a young girl. He doesn't eat the five grains, but sucks the wind, drinks the dew, climbs up on the clouds and mist, rides a flying dragon, and wanders beyond the four seas. By concentrating his spirit, he can protect creatures from sickness and plague and make the harvest plentiful. I thought this was all insane and refused to believe it."
>
> "You would!" said Lian Shu. "We can't expect a blind man to appreciate beautiful patterns or a deaf man to listen to bells and drums. And blindness and deafness are not confined to the body alone—the understanding has them too, as your words just now have shown. This man, with this virtue of his, is about to embrace the ten thousand things and roll them into one. Though the age calls for reform, why should he wear himself out over the affairs of the world? There is nothing that can harm this man. Though flood waters pile up to the sky, he will not drown. Though a great drought melts metal and stone and scorches the earth and hills, he will not be burned.[1]

The *Liezi* includes a similar description, expanding on these miraculous beings:

> The Guye mountains stand on a chain of islands where the Yellow River enters the sea. Upon the mountains there lives a Divine Man *(shenren)*, who inhales the wind and drinks the dew, and does not eat the five grains. His mind is like a bottomless spring, his body is like a virgin's. He knows neither intimacy nor love, yet immortals *(xian)* and sages serve him as ministers. He inspires no awe, he is never angry, yet the eager and diligent act as his messengers. He is without kindness and bounty, but others have enough by themselves; he does not store and save, but he himself never lacks.[2]

Both the *Zhuangzi* and the *Liezi* describe such beings as *shenren,* literally, "divine men," using the character *shen* that usually denotes a spirit or god. Their characteristics are similar to early descriptions of *xian*—adepts or immortals—beings that have broken the quotidian bonds of phenomenal reality through their transcendence of *yin* and *yang* and their union with the Tao.

Several similar bronze figures are known; among them are examples in the Osaka Municipal Museum of Arts and a private collection in Paris.[3]

—S. L.

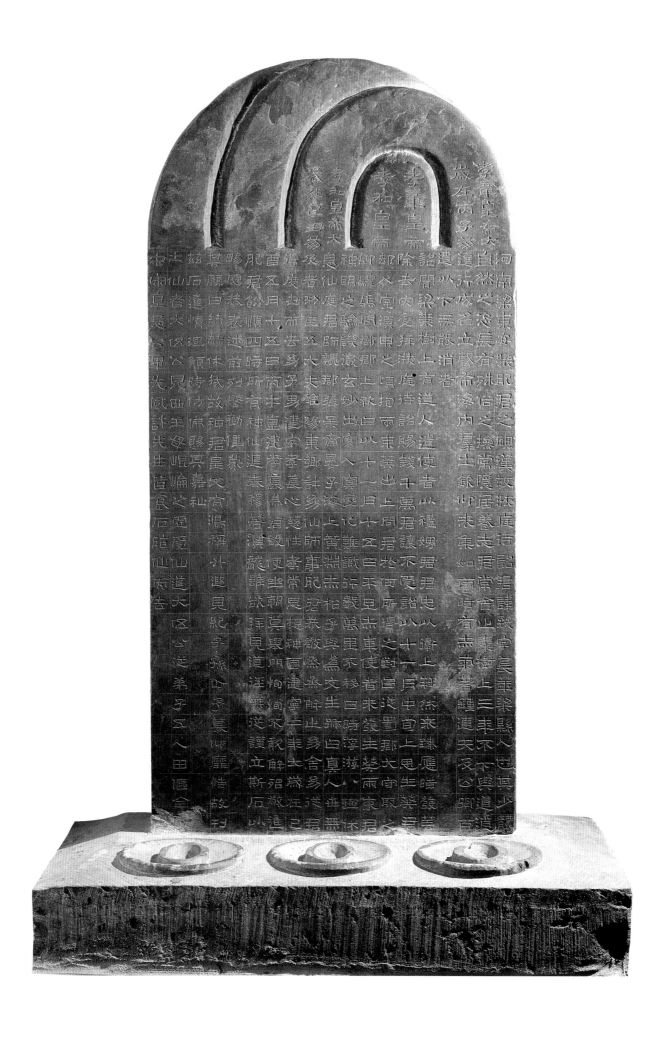

22

Stele in Memory of Fei Zhi

Eastern Han dynasty, 2nd century
Limestone
98 × 48 × 9.5 cm
Administrative Committee of Cultural Relics, Yanshi, Henan

THIS STELE IS THE ONLY REMNANT of a Han dynasty cult devoted to the realized being *(zhenren)* Fei Zhi.[1] It was found during the excavation of an Eastern Han dynasty (25–220) tomb to the east of Luoyang, Henan province, a few kilometers away from the boundaries of this city when it was the capital of the Eastern Han. The tomb in which this stele was found is unusual in that several bodies were found buried in it. The stele was placed on a pedestal with three cavities, which may have been used to hold offerings. Kristofer Schipper has described the stele as "not just a monument dedicated to the memory of the Taoist saint Fei Zhi, but also his altar and the seat of his spirit."[2]

The stele is as enigmatic as the tomb in which it was found, since neither Fei Zhi nor his disciples named in the stele are recorded in historical sources. According to the inscription, Fei Zhi first became famous for climbing up into a jujube tree and perching there for three years without coming down. Fei's eccentricities eventually brought him to the attention of the imperial court, and the stele indicates that he was summoned to the court twice, in 76 and 89, at the beginnings of the reigns of emperors Zhang (r. 75–88) and He (r. 88–105). Thanks to his aid in making "calculations" that helped the court to avoid inauspicious omens, he was awarded an official title. Fei is further identified with prominent figures from ancient China, including the "Confucian" *(ru)* scholar Yanzi, a contemporary of Confucius, and the magician Master Red Pine (Chisongzi).

Eventually, Fei acquired disciples, of whom the official Xu You (also unknown from historical records) is most prominently mentioned. Fei's cult seems to have been established by Xu You's son Xu Jian, who began making offerings to Fei in 169. The stele also attributes divine status to Xu You, who is claimed to have met with the Queen Mother of the West (Xiwangmu; see cat. no. 24) on Mount Kunlun. Finally, the stele indicates that five disciples of Xu You, including a certain Master Xu (which

may refer to Xu Jian), consumed an alchemical drug known as "stone marrow," which allowed them to leave the world as adepts.

Since the date of 169 mentioned on the stele precludes the possibility that it was made as a funerary memorial for Fei Zhi, who lived over half a century earlier, or that the grave mound was his, Schipper has suggested that the remains in the tomb may belong to the five disciples mentioned at the end of the inscription, to Xu Jian and his family, or to other members of the cult dedicated to Fei Zhi.

The inscription on this stele is not the only one of its kind to be preserved. There are similar stele inscriptions from the same period recorded in historical documents, including one devoted to the cult of Wang Ziqiao around Mount Song (also in Henan) dated to 165, and another to the cult of Tang Gongfang in the Hanzhong region, Shaanxi province, the same region where the Celestial Master movement first came to prominence under Zhang Lu at the end of the Han dynasty.[3] Unlike Fei Zhi, both of these figures have a long, well-documented history, and have played an important role in Chinese religion right up to the modern era.

This newly discovered stele increases our understanding of the late Han dynasty and serves as an important link between late Warring States politico-philosophical writings such as the *Zhuangzi* and the *Daode jing* and later religious Taoism. It bridges the historical gap between early myths and terms such as "realized being" in Warring States texts and their prominent use in later writings of the Taoist religion. As archaeological research in mainland China advances, new insights continue to be gained into the precedents that formed the foundations of religious Taoism and into the transition from the "classical" age of the Warring States to the flourishing of religion in medieval China.

—S. E.

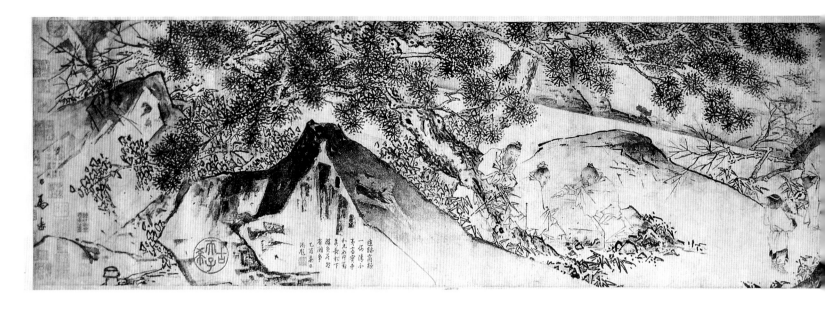

23

MA YUAN (ACTIVE C. 1190–C. 1225)
The Four Sages of Mount Shang

Southern Song dynasty, c. 1225
Handscroll; ink and light colors on paper
33.6 × 307.3 cm
Cincinnati Art Museum, Anonymous gift (1950.77)

MA YUAN'S HANDSCROLL depicts the Four Sages of Mount Shang, who fled into the mountains during the reign of the early Han dynasty emperor Gaozu (r. 206–195 B.C.).[1] These worthies' retreat into Mount Shang was motivated by their disagreements with the actions of the emperor and their desire to maintain their moral integrity.[2] The Four Sages' names were Dongyuan, Luli, Qi Liji, and Xiahuang. While often held up as paragons of Confucian virtue, by the fourth century, the Four Sages were also viewed as adepts *(xian)* renowned for their techniques of self-cultivation and alchemy. The *Baopuzi (The Master Who Embraces Simplicity)* by Ge Hong (283–343), for example, refers to all four figures as *xian* (adepts or immortals) and mentions that they taught alchemy to the famous strategist Zhang Liang.[3] In later tradition, the Four Sages continued to be seen as paragons by both Confucians and Taoists. They appear, for example, in the Song dynasty handscroll in the Freer Gallery of Art entitled *An Assembly of Immortals (Qunxian gaohui tu),* traditionally attributed to Li Gonglin (c. 1049–1106), which depicts a Taoist paradise populated with such diverse figures as the Yellow Emperor and Guangchengzi, the Queen Mother of the West, and the female immortal Magu.[4]

The Four Sages of Mount Shang lived solely on mushrooms, and one of the four, Luli, composed the "Song of the Purple Mushroom":

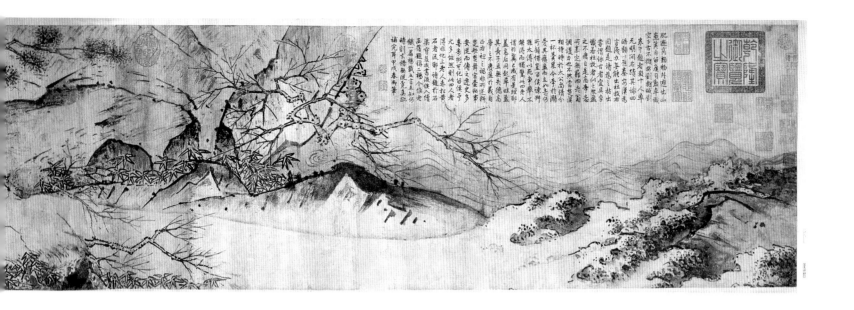

Silent is the lofty mountain;

Long is the deep valley.

Bright are [the] purple mushrooms;

They can still my hunger.

The ages of [the emperors] Yao and Shun are gone forever;

Whither shall I go?

A carriage and four, and lofty roofs,

All bring great worries [to the inmates].

If riches and honors entail submission to others,

I would rather be poor and lowly in order to live happily.[5]

Ma Yuan was a painter active at the imperial Southern Song court in Lin'an, Hangzhou province, during the reigns of Emperors Guangzong (r. 1189–94) and Ningzong (r. 1195–1224), and into the early part of Lizong's reign (r. 1225–64). The Cincinnati *Four Sages of Mount Shang* is one of his surviving works on paper, and has been dated to c. 1225. It is painted primarily in ink with occasional touches of light color, and depicts the Four Sages in a mountainous landscape. A stream flows from left to right through the background of the composition, emptying into a river or lake with crashing waves near the beginning of the scroll. The remote setting is accentuated by the quickly flowing water, the cliffs and grotto-like formations among the rocks, the gnarled pine trees, spiky plum trees, and lush bamboo. Two of

the sages are seated on rocks and playing the board game known as *weiqi,* while a third leans on the trunk of a pine tree and watches. The fourth sage walks with an attendant along a mountain path and searches for mushrooms. The scroll is signed at the end, *Chen Ma Yuan* ("Your servant, Ma Yuan"), indicating that it was painted at the imperial court. The scroll has thirty-seven colophons by scholars of the Yuan and Ming dynasties, including inscriptions by Yang Weizhen (1296–1307) and Ni Zan (1301–1374).[6] The painting was owned by the great Ming dynasty collector Xiang Yuanbian (1525–1590), and in the Qing dynasty entered the collection of the Qianlong emperor (r. 1736–95), remaining in the Forbidden City until the early twentieth century.[7] The scroll bears two inscriptions by the Qianlong emperor, and still has its imperial Qing silk wrapper and inscribed jade pin.

Ma Yuan's handscroll emphasizes the close connection between hermits, immortals, and mountains in traditional China. Even before the emergence of religious Taoism in the late Han dynasty (second century), mountains were considered pure and remote places where one could encounter immortals. The rocks, water, pines, and plum trees of Mount Shang are symbols of the values the Four Sages stood for, including strength and moral integrity.

—S. L.

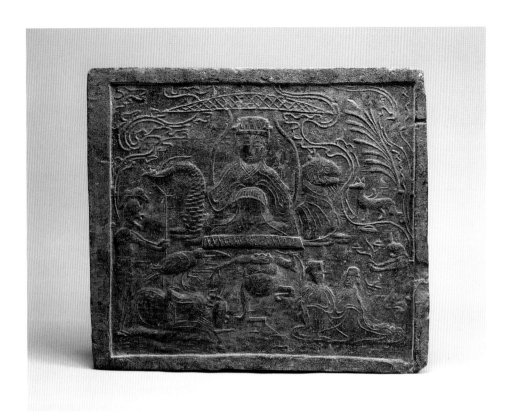

24

24

Tomb Tile with the Queen Mother of the West

> From Sichuan province
> Eastern Han dynasty, 2nd century
> Stamped earthenware tile
> 41 × 47 cm
> Sichuan Provincial Museum, Chengdu

25

*Money Tree with the Queen Mother of the West and
a Seated Buddha*

> From Sichuan province
> Eastern Han dynasty, 2nd century
> Lead-glazed earthenware and bronze
> H. 177 cm
> Asian Art Museum of San Francisco, Gift of the Connoisseurs'
> Council (1995.79)

ONE OF THE MOST POPULAR DEITIES of the Han dynasty (206 B.C.–A.D. 220) was the Queen Mother of the West (Xiwangmu), depicted in these two archaeological objects from Sichuan province. While the origins of this goddess in the early Bronze Age are murky, Xiwangmu emerged by the third century B.C. as a formidable deity in the Chinese pantheon. The "Inner Chapters" of the *Zhuangzi* list the Queen Mother of the West as

a deity who "obtained the Tao."[1] According to the *Scripture of Great Peace (Taiping jing),* a text that first appeared in the late Han dynasty, Xiwangmu was an immortal *(xian).* During the Han, the Queen Mother of the West was worshipped by the imperial family, the aristocracy, and the literati, as well as by the common people.[2]

In legend, ancient kings and emperors sought out the Queen Mother of the West, and asked for her advice on the arts of rulership and self-cultivation (see cat. no. 26). Although originally not a Taoist deity, she was adopted into the pantheon of religious Highest Purity (Shangqing) Taoism in the Six Dynasties period (420–589) and is the principle female deity in the *Supreme Secret Essentials (Wushang biyao),* a Taoist encyclopedia completed in 577, during the Northern Zhou dynasty.[3]

Above all, Xiwangmu was associated with the *yin* force of the *yin–yang* polarity, and with the phase (or element) metal in the Five Phase *(Wuxing)* system. *Yin* correlated with the west, the direction most strongly associated with death and rebirth. Nonetheless, in the funerary tile from Sichuan (cat. no. 24), in which the Queen Mother sits on a mat at a feast, she is flanked by a tiger *and* a dragon (see cat. no. 10), symbolizing her ultimate transcendence of *yin* and *yang.*

By the early Eastern Han dynasty (first century), the Queen Mother was associated with Mount Kunlun, a mythical paradise

located to the far west of China.[4] Kunlun was perceived as an enormous mountain, or mountain range, that functioned as a cosmic pivot connecting Heaven and Earth.

In the earthenware tomb tile, excavated in 1965 from a tomb at Qingbaixiang in Xinfan near Chengdu, Sichuan province, Xiwangmu is entertained at a feast. Regally posed under a canopy, she faces the viewer while a group of figures and animals occupy the foreground. To the left, a hare holds a candelabra; behind the hare is a fox. In front of the hare two figures, either human or celestial courtiers, sit next to a low table. Directly in front of the Queen Mother a frog dances, while a bird and two other human or immortal figures look on at the left.[5]

A much stranger object is the so-called money tree (qian shu) from the Asian Art Museum of San Francisco (cat. no. 25). This is one of many examples that have been found in Eastern Han (second century) tombs in Sichuan, one of the areas in which Xiwangmu had the greatest following in this period.[6] These objects are typically made of a bronze trunk and branches set into a ceramic or stone base. The term "money tree" derives from the fact that the bronze branches are decorated with coin-shaped designs that imitate coins of the Han period.[7] The function of such money trees in late Han dynasty Sichuan was to provide a symbol of rebirth and eternal life for the occupant of the tomb.

In this example, the base is made of earthenware covered with an amber-colored lead glaze. The surface of the base is covered with molded designs depicting animals, culminating at the top with a figure riding on the back of a deer. From here the bronze tree ascends, with six levels of branches growing off the trunk; these are attached with tenons. Each branch consists of a horizontal stem, with images of coins growing above and below. Near the top is an image of the Queen Mother of the West, seated between two dragons under a canopy; above her, an immortal rides on the back of a dragon. A noteworthy feature of the decoration is the small figure of a meditating Buddha, situated below the figure of Xiwangmu. Buddhism entered China during the late first century, and as Wu Hung has shown, by the second century the Buddha was often seen as an immortal.[8] Similar images are found in other materials in the Eastern Han period, including stone carvings, ceramics, and bronze mirrors.[9] Such images would proliferate during the Three Kingdoms period (220–280) and after. The presence of the Buddha under Xiwangmu's image on the San Francisco money tree clearly conveys the superiority of the latter, and yet signals the openness among the Queen Mother's followers toward other systems of belief.

—S. L.

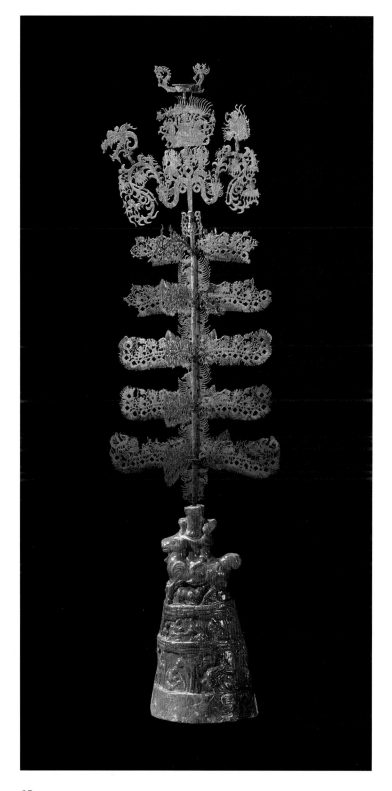

25

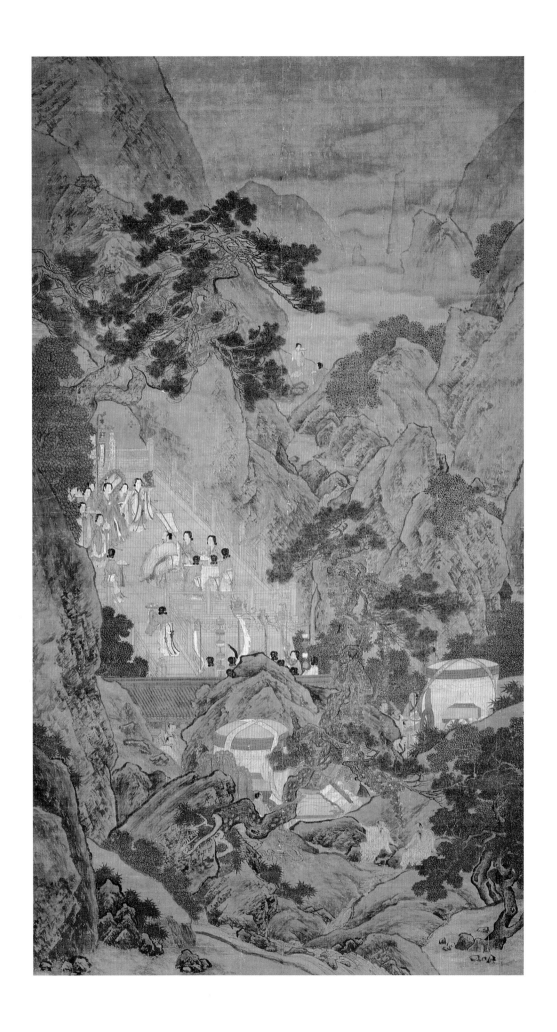

26

TRADITIONALLY ATTRIBUTED TO LIU SONGNIAN
(ACTIVE LATE 12TH–EARLY 13TH CENTURY)
Offerings for Long Life at the Turquoise Pond

Ming dynasty, early 16th century
Hanging scroll; ink and colors on silk
198.7 × 109.1 cm
National Palace Museum, Taipei

THIS PAINTING DEPICTS the Zhou dynasty king Mu's visit to the Queen Mother of the West (Xiwangmu), a story that is ultimately about self-understanding and transcendence. Ancient texts describe King Mu (Muwang; r. 1001–946 B.C.) as the only human ruler to have arrived at the Queen Mother of the West's paradise on Mount Kunlun, located far to the west of China. Their meeting was brief and tinged with melancholy. The king, perhaps aware that he could never rise to the level of the goddess, bemoaned his unworthiness, and then returned home. The story is first found in the *Bamboo Annals,* said to have been excavated from a third-century-B.C. tomb in the third century A.D., and appears as well in the early Taoist text *Liezi.*[1] Its most elaborate version, however, is in the Tang dynasty text *Primordial Ruler, Metal Mother (Jinmu yuanjun),* by the Taoist Du Guangting (850–933):

> King Mu gave the command to harness his eight fine steeds in two teams of four. . . . Riding full speed ahead for a thousand *li,* they reached the nation of the Great Sou Clan. The Great Sou Clan head then offered as tribute the blood of white swans for the king to drink; he set out ox and horse milk to be used for washing the king's feet. After the men . . . drank, they proceeded along the road.
>
> They spent the night in a fold of Kunlun on the sunny side of the Red Water River. On another day, they ascended Kunlun Hill, in order to inspect the palace of the Yellow Thearch [Yellow Emperor]. . . .
>
> Subsequently he was a guest of the Queen Mother of the West. As they toasted each other with drinks at the side of the Turquoise Pond [Yao Chi], the Queen Mother of the West composed poems for the king. The king matched them. Their lyrics were sad. Then he observed where the sun set. In a single day, it had gone ten thousand *li.* The king sighed and said, "I, the Unique Person [as Son of Heaven], am not overabounding with virtue. Later generations will certainly trace back and count up my excesses!" It is also said that the king grasped a white jade tablet and heavy multi-colored damask, offering them in order to acquire the secrets of the Queen

Mother's longevity. She sang the "Poem of the White Clouds." On top of Cover Mountain, he carved a stone to record his traces, then returned home.[2]

In the painting, King Mu and the Queen Mother of the West sit facing each other on a terrace, surrounded by jade maidens *(yunü).* The setting is a mountainous landscape, representing the paradise on Mount Kunlun. In the foreground, just outside a roofed enclosure, the king's chariots and attendants await him among boulders and trees. Despite the scroll's traditional attribution to the Southern Song dynasty court painter Liu Songnian, the style is closer to that of the Ming dynasty Wu School master Qiu Ying (c. 1495–1551/2).[3] A similar painting in the Walters Art Gallery, Baltimore, bears a spurious Qiu Ying signature, and may be by a close follower.[4]

—S. L.

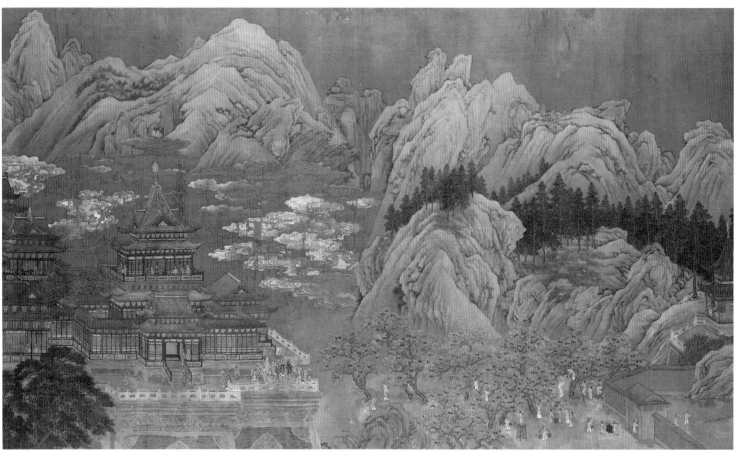

(detail)

27

Festival of the Peaches of Longevity

Ming dynasty, 15th century
Handscroll; ink, colors, and gold on silk
52 × 476 cm
The Nelson-Atkins Museum of Art, Kansas City, Gift of the Herman R.
 and Helen Sutherland Foundation Fund (F72-39)

NOTES

Cat. no. 20

1. Schipper 1993: 91 ff.
2. See Kleeman 1994b.
3. The term *boshanlu* appears to date to the late Six Dynasties period (sixth century); see Erickson 1992: 14. During the Han, such vessels appear to have been called *xunlu* or merely *lu*, both meaning censer.
4. Ibid.: 6.
5. Soot on the interior of the top indicates that the censer was actually used during Liu Sheng's lifetime; see Fong 1980: no. 95.

Cat. no. 21

1. Watson 1968: 33. For the Chinese text, see XYZDB: 53.
2. Graham 1960: 35. For the Chinese text, see XYLDB: 74.
3. See *Masterpieces from the Osaka Municipal Museum of Art* 1986: no. 306, and Desroches 1994: 126–27, no. 47.

Cat. no. 22

1. This entry is based on the study of the stele by Kristofer Schipper; see Schipper 1997.
2. Ibid.: 239; translated from French.
3. See, respectively, Chen 1988: 2, and Schipper 1991.

Cat. no. 23

1. For a comprehensive study of this scroll, see Avril 1997: 54–59, no. 27.
2. Among other things, the Four Sages disagreed with Gaozu's choice of his heir; see ibid.: 54, 58 n. 1.
3. Ware 1981: 104, 273.
4. Selected details of this scroll are published in Lawton 1973: no. 34.
5. Translated by Achilles Fang in Avril 1997: 54.
6. These are discussed at length in ibid.
7. The painting is recorded in the imperial Qing catalogue compiled by Zhang Zhao, et al.; see SQBJ: 571–77.

Cat. nos. 24–25

1. See Watson 1968: 82. For the Chinese text, see XYZDB: 107. As Suzanne Cahill has shown, this is one of the earliest references to Xiwangmu, although references to a deity called the "Western Mother" (Xi mu) occur in the oracle bones of the Shang dynasty; see Cahill 1993: 12–14.
2. Cahill 1993: 21–24.
3. Ibid.: 34. Xiwangmu is also mentioned as an immortal *(xian)* in the *Declarations of the Perfected (Zhen'gao;* HY 1010), compiled by Tao Hongjing (456–536); for example, see *juan* 2: 10b–11a, where Xiwangmu is identified as the mother of one of the female deities who figures in the *Zhen'gao.*
4. Textual references that connect Xiwangmu to Mount Kunlun are found in both the *Classic of Mountains and Seas (Shanhai jing),* and in the *Record of the Ten Continents (Shizhou ji);* see Cahill 1993: 19, 36–38, and Smith 1990: 110. The *Classic of Mountains and Seas,* traditionally attributed to Yu the Great and his assistant Yi (late third millenium B.C.), is variously dated to the Warring States (fifth–third century B.C.) or Han periods; see Fracasso 1993: 359–61. According to Suzanne Cahill, the *Record of the Ten Continents* is traditionally attributed to the immortal Dongfang Shuo (154–93 B.C.), active at the court of Han Wudi; see Cahill 1993: 36.
5. Two of these animals, the hare and the frog, were associated with immortality, procreation, and the *yin* force. Both animals were also associated with the moon, an ancient symbol of *yin* (just as the sun symbolized *yang*). As Wu Hung has shown, this funerary tile was originally placed on a wall between tiles depicting symbols of the sun and moon, further emphasizing Xiwangmu's position as a being "beyond opposing or conditional forces, thus representing eternity." See Wu 1987: 26, fig. 6.
6. For another example, see Rawson 1996: cat. no. 87.
7. As Chen Xiandan has shown, the money tree did not produce money, but instead symbolized the riches of a divine paradise, and was thus seen as a "tree of life"; see Chen 1997.
8. Wu 1987: 33. On other Buddhist images of the late Han, see Wu 1986.
9. Wu 1987: figs. 11–12.

Cat. no. 26

1. Cahill 1993: 46.
2. Ibid.: 123–24.
3. The fact that the painting is not by Liu Songnian, but resembles works by the early-sixteenth-century painters Zhou Chen, Tang Yin, and Qiu Ying, is pointed out in *Changsheng de shijie* 1996: 80.
4. Walters Art Gallery, acc. no. 35.42.

Cat. no. 27

1. Sources differ on the periodicity of the peach trees' blossoming; they range from one thousand to three thousand years. See Cahill 1993: 178.
2. Ibid.: 54–55.
3. Ibid.
4. Freer Gallery of Art, acc. no. 08.170.

Cat. no. 28

1. Previously published in *Changsheng de shijie* 1996: pl. 2.
2. Watson 1968: 33; see also cat. no. 21.
3. See Cheng 1957: pl. 3, fig. 6 (depicting a pair of Han ceramic dragons ridden by winged figures, now in the collection of The Art Institute of Chicago, 1978.1029–30), and Nakano 1994: cat. no. 55.
4. Translated in Watson 1961, vol. 2: 52; cited in Dragan 1991: 148. This story also appears in the short biographical account of the Yellow Emperor in the *Biographies of the Assorted Immortals (Liexian zhuan)* (77–6 B.C.) of the Han dynasty; see Kaltenmark 1987: 50–53.
5. *Changsheng de shijie* 1996: pl. 1.

萬物將自化王者法道為政吏民廢薩子悉

化為道化如欲作吾將鎮之以无名之樸失

正慶得耶之政得怠之為耶美觀貝將慶道

齋正而以不可復豪之為耶美觀貝將慶道

便鎮制之檢以无名之樸教誡見也王者亦

當法道鎮制之而不能制者世俗卷慶為耶

美下古世是也无名之樸罪將不欲道性於

倡闕都无所欲王者亦當法之无欲以靜天

地自此道常无欲樂清靜故令天地常正美

地道臣也王者法道行誡臣下悉皆自正美

THIS SECTION OF THE CATALOGUE introduces religious Taoism and focuses on two key moments in its early development: the deification of the sage Laozi and the emergence of the first Taoist church. One of the most complicated aspects of Taoism is its transformation from a philosophy to a religion. One catalyst for this transformation was the political disintegration of the Han dynasty in the second century A.D.; another was the impact on Taoism of Buddhism, a foreign religion that arrived in China from India over the Silk Road in the late Han dynasty. At about the same time, in the second century A.D., the sage Laozi was deified by imperial decree.

The origins of religious Taoism can be traced to Sichuan province in the second century, when the spiritual leader Zhang Daoling had a vision of the deified Laozi. In this vision Laozi commanded Zhang to organize his followers into a movement, which came to be known as the Way of the Celestial Masters (Tianshi Dao). Zhang Daoling became the patriarch of the Celestial Master lineage. Central to this movement was the cultivation of a strict moral code and the belief in gods who, through rituals, could be invoked to aid humanity to achieve both its spiritual and material needs. These gods were perceived as beings composed of the most refined spirit, personifying and giving a recognizable face to the Tao.

The deification of Laozi was given early visual expression in stone sculptures that depict the ancient sage as a god. These works, dating to the Northern and Southern Dynasties period (386–589), illustrate the tremendous impact of Buddhism on Taoism. The two aspects of this influence explored here are the borrowings from Buddhist conventions in the early Taoist depictions of the deified Laozi, and the adaptation from Buddhism of the idea of reincarnation (originally a Hindu concept), reflected in images of the earlier manifestations of Laozi, for

example, his incarnation as Guangchengzi during the reign of the Yellow Emperor (third millennium B.C.).

The remarkable stone sculptures shown here range in date from the Northern Wei to Tang dynasties (sixth to eighth centuries). Among these is a stele dating to 517, from the Forest of Stelae in Xi'an, China, which on one side depicts the deified Laozi (holding his usual attribute, a fan), and on the other the historical Buddha Shakyamuni. Syncretic works such as this, which make room for both religions, demonstrate the pragmatic approach to religion characteristic of traditional Chinese culture. (This phenomenon is explored further in section III.1, "Taoism and Popular Religion.") The sculptures of the deified Laozi from the Tang dynasty (618–906) illustrate the sage as the divine ancestor of the Tang emperors, and are early illustrations of the usefulness of Taoism in establishing political legitimacy.

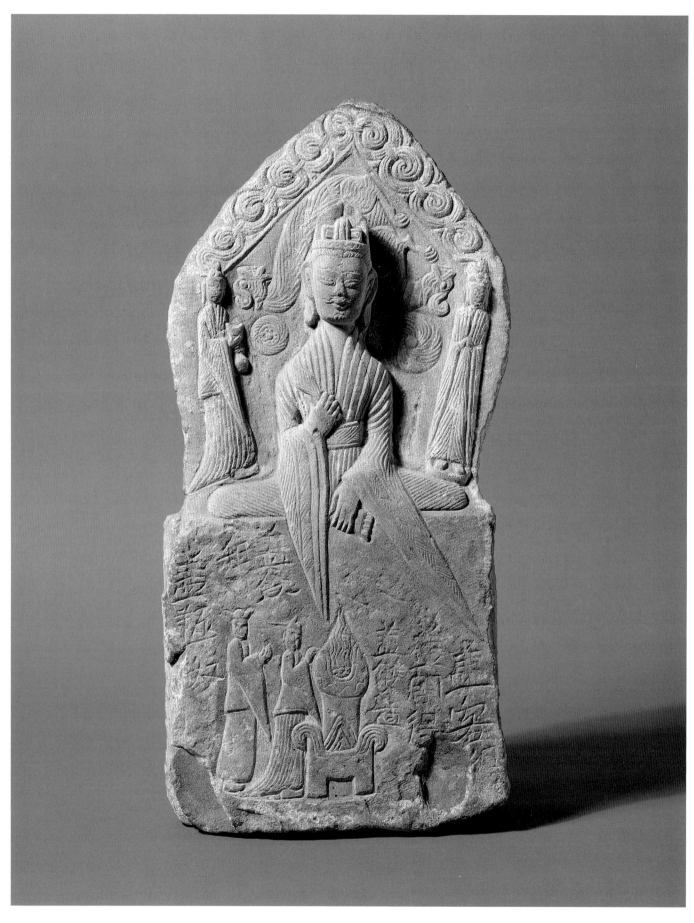

29

29

Stele with the Deified Laozi and Two Attendants

Northern Wei dynasty, Yanchang reign, dated 515
Sandstone
H. 43.5 cm
Osaka Municipal Museum of Art, Yamaguchi Collection

30

Stele with the Deified Laozi and Shakyamuni Buddha

Northern Wei dynasty, Xiping reign, dated 517
Limestone
203 × 87 cm
Forest of Stelae (Beilin) Museum, Xi'an

31

Four-sided Taoist Stele

Northern Qi dynasty, dated 554
Limestone
H. 70.6 cm
Osaka Municipal Museum of Art, Yamaguchi Collection

32

Votive Stele with the Deified Laozi

Sui dynasty, Kaihuang reign dated 587
Limestone
24 × 15 cm
Museum of Fine Arts, Boston, Special Chinese and Japanese Fund
(07.732)

THE SAGE LAOZI is known to have been worshipped as a god by the second century A.D., in the late Han dynasty. Two recorded stele inscriptions of the Eastern Han—the *Stele of the Sage Mother (Shengmu bei)*, dated 153, and the *Inscription for Laozi (Laozi ming)*, dated 165—both reveal a new view of Laozi as a god. The former text was the first to describe Laozi as equivalent to the Tao; the second records an imperial sacrifice to the deified sage enacted by Emperor Huan (r. 147–67) at Laozi's birthplace.[1] The *Stele of the Sage Mother* inscription includes the following lines:

> Laozi, the Tao:
> Born prior to the Shapeless,
> Grown before the Great Beginning,
> He lives in the prime of the Great Immaculate,
> And floats freely through the Six Voids.[2]

The *Inscription for Laozi* proves that by the middle of the second century Laozi was worshipped as a god by the Han elite. As

Livia Kohn has shown, the sage was now seen as "the central deity of the cosmos, who was born from primordial energy, came down to earth, and eventually ascended back to the heavenly realm as an immortal."[3] This stele inscription reads in part:

> Laozi was created from primordial chaos and lived as long as the three luminants [sun, moon, and stars]. He observed the skies and made prophesies, freely came and went to the stars. Following the course of the sun, he transformed nine times; he waxed and waned with the seasons. He regulated the three luminants and had the four numinous animals by his side.[4] He concentrated his thinking on the cinnabar field [*dantian*],[5] saw Great Unity [Taiyi][6] in his purple chamber, became one with the Tao, and transformed into an immortal.[7]

In the late Han and Six Dynasties periods, the deified Laozi became the central god in the pantheon of religious Taoism. The earliest images of the deified Laozi date to the fifth century, and are only known in significant numbers from the early sixth century onward (late Northern Wei dynasty). Several references to Taoist image-making survive in fifth-century texts.[8] As Stephen Bokenkamp has pointed out, Lu Xiujing (406–477), the compiler of the Taoist Lingbao scriptures, spoke out against the creation of ornate images for Taoist worship, indicating that such works were being made in southern China in the mid-fifth century.[9] The Northern Wei Celestial Master Kou Qianzhi (365–448) is also recorded in the *History of the Sui Dynasty (Sui shu)* as having commissioned Taoist images of Celestial Worthies *(tianzun)* for a temple near the imperial capital.[10] The majority of Taoist sculptures that survive from the Six Dynasties period come from the area around Xi'an in Shaanxi province. The four sixth-century examples included here range in date from 515 to 587 (late Northern Wei to Sui dynasties).

Images of the deified Laozi (now known as Taishang Laojun, or Supreme Lord Lao) are most often found on stone stelae, usually carved from sandstone or limestone.[11] The first stele, from the Osaka Municipal Museum of Art, bears an inscription dated to 515, corresponding to the fourth year of the Yanchang reign of the Northern Wei dynasty (cat. no. 29). At this time China was divided between north and south, with the Turkic Toba ruling the Northern Wei (386–534), and Chinese emperors ruling the Liang dynasty (502–557). The Osaka stele is stylistically characteristic of many Taoist and Buddhist sculptures that have been found in the vicinity of Xi'an, an area that was part of the Northern Wei state in the early sixth century. This area played an important role in religious Taoism from the fifth century onward. One of the most sacred Taoist sites is the Observation Platform

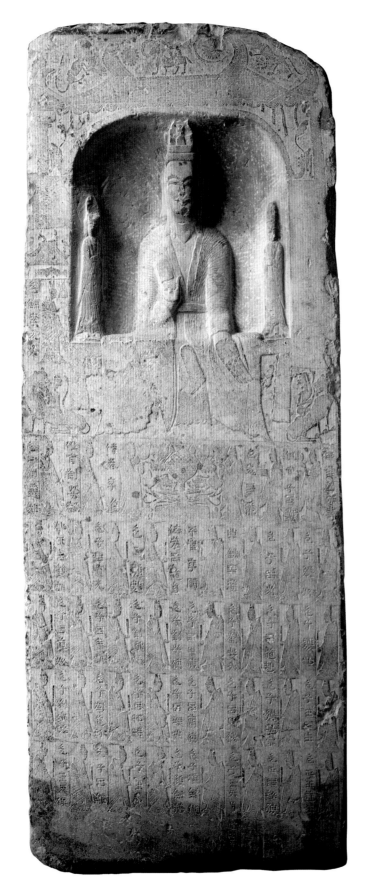
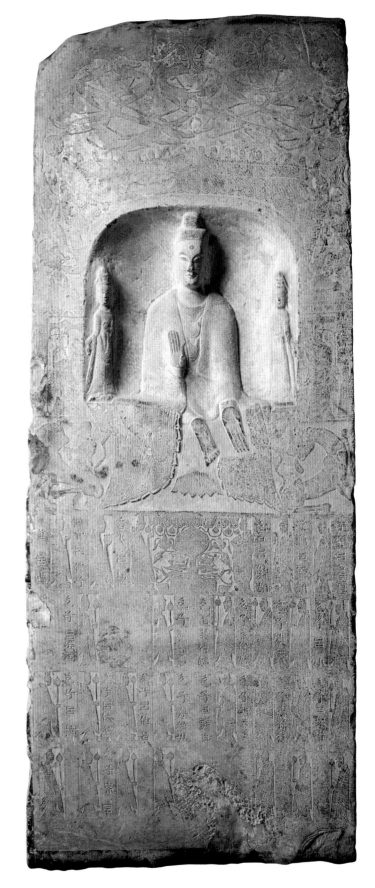

(Louguan Tai), located at the base of the Zhongnan Mountains, about sixty kilometers southwest of Xi'an. This is where Yin Xi watched for the purple aura that filled the sky as Laozi approached on his ox as he left for the Western Regions, and where Laozi transmitted the *Daode jing* to Yin Xi.[12]

In its focus on a large central image of the deified sage, the Osaka stele is typical of a format commonly encountered among many Taoist sculptures from the Six Dynasties period. This figure sits in meditation and holds a fan in his right hand; this would become a standard attribute of the deified Laozi in Chinese art. He has a mustache, and on his head is a Taoist priest's cap. Carved in low relief behind Laozi are two intertwined dragons and circular images of the sun and moon. A border of coiled motifs, perhaps clouds, appears at the very top of the stele. The deified Laozi is flanked by smaller standing attendants, one of whom clasps his hands together, while the other holds a vase and a cup. Below the figure of Laozi is a scene depicting two standing worshippers making obeisance before an incense burner; as Kristofer Schipper has pointed out, in Taoism, "the offering of incense in the burner is the essential element of worship."[13] The stele's inscription is short, beginning on the right side with the date ("On the fifth day of the fourth month of the fourth year of the Yanping reign" [i.e., 515]), and concluding on the lower front with a list of donors; the latter section has suffered from damage.[14] The back and left sides are unadorned.

Scholars have long assumed that the basic format seen here—the large figure of the deified Laozi flanked by two attendants—was borrowed from the prevailing style of Buddhist sculpture, in which a central Buddha was flanked by smaller figures of bodhisattvas; this observation appears entirely correct. In addition, as Jean James has shown, the formula for many of the dedicatory inscriptions on early Taoist stelae were also borrowed from contemporary Buddhist practice.[15] While we know nothing of the precise mechanics of such borrowing, it appears to have been analogous to the well-documented borrowing of textual and ritual elements from Buddhism by early Taoists in the fourth and fifth centuries.[16]

Until recently the identity of the figures flanking the deified Laozi on such stelae has been a mystery. An inscription on the back of a Northern Wei stele in the Field Museum, undated but close in style and date to the Osaka stele, identifies the two flanking figures as Yin Xi (Yin xiansheng) and Zhang Ling (Zhang Ling xiansheng).[17] The figures are significant because these were the first human beings to receive revelations from Laozi. It was to Yin Xi that Laozi first transmitted the *Daode jing* (see cat. no. 1), while Zhang Ling (Zhang Daoling) was the first

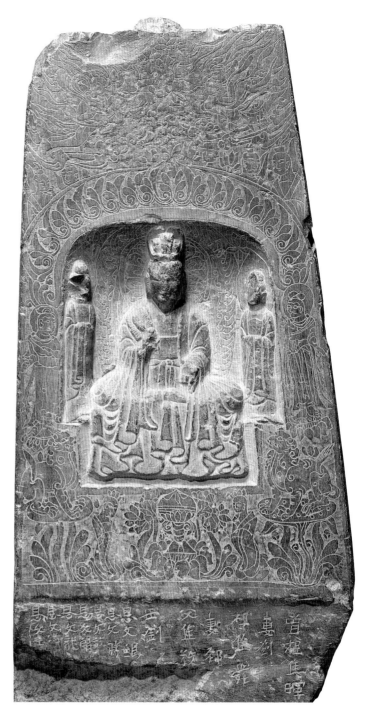

31

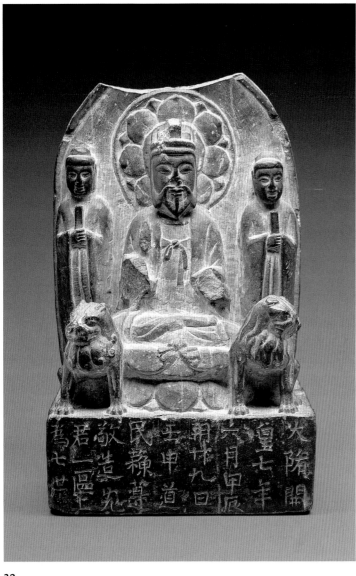

32

human being to experience a vision of the deified Laozi (later known as the Supreme Lord Lao [Taishang Laojun], or Celestial Worthy of the Tao and its Power [Daode tianzun], or merely Celestial Worthy [*tianzun*]). One result of Zhang Daoling's vision was his reception of the title "Celestial Master" *(tianshi)* from Laozi.[18] It is possible that the figures flanking the deified Laozi on many Six Dynasties and Tang (618–906) period Taoist sculptures also depict Yin Xi and Zhang Daoling. In later Taoist tradition, both Yin and Zhang became immortals.[19]

The large Northern Wei stele in the Forest of Stelae (Beilin) Museum, Xi'an, bears an inscription dated 517 (cat. no. 30).[20] Carved two years after the Osaka stele, it is over six feet tall and is four-sided, with niches carved into each side. The stele is extraordinary in that the primary image on the front is the deified Laozi, while the primary image on the back is the Buddha Shakyamuni.[21] Laozi is identified by his Taoist cap, the fan he holds in his right hand, and his mustache; the Buddha is identified by his *urna* (the raised bump at the top of his cranium), his *usnisa* (the tuft of hair at the center of his forehead), and the sacred gesture of his right hand, which is raised in *abhaya mudra,* signifying the absence of fear. The two figures are flanked by attending immortals and bodhisattvas, respectively. Laozi sits under a pavilion with *weichi* (owl's tail) finials at the ends of the ridge-beam.

The ecumenical nature of this work is emphasized by the careful attention to detail in the depiction of the Buddha and bodhisattvas and by the presence among the donors of two Buddhist monks *(bhikshu)* with shaved heads, their monastic names inscribed, flanking the bodhisattvas. This part of the stele could easily be mistaken for a Buddhist sculpture. The syncretic appearance, however, may be illusory. The stele lists over sixty donors, more than half of whom are members of the Lü family, and two of these are listed as Taoist priests *(daoshi)*. The overwhelmingly Taoist spirit of the stele is suggested by the many Taoist given names among the lay donors: Daoguang (Radiance of the Tao), Daonu (Servant of the Tao), Daoqi (Ascendance of the Tao), and Daozhen (Prize the Tao). There are different interpretations of the mixed Taoist and Buddhist images on such works.[22]

To either side of Laozi's throne are immortals riding on mythical beasts; both the figures and their mounts turn to look at each other. Immediately below the figure of Laozi is a large incense burner entwined by two dragons, with three donors facing the censer on each side. In all there are five registers of donors below the niche containing the deified Laozi. On the back, a canopy with stylized flames appears above the Buddha's niche, above which are many heads of celestial beings. A celestial angel

appears at the left, and what may be a reborn soul emerging from a lotus flower appears at the right. Mythical beasts crouch to either side of the Buddha's throne, one of which has an elfin rider. Below is an incense burner entwined by dragons, just as on the front of the stele. The fact that several of the donors on this side of the stone are unnamed and the existence of blank spaces among the donors suggest that the front side was filled up with names first, with others then added on the back.

The stele's left side has a niche showing a priest or immortal seated with his hands folded in his lap. This figure wears the same cap as Laozi and his attendants, and is clearly Taoist. The three donors named as Taoist priests appear directly below this figure. While this figure is unidentified, he, like Laozi, sits under a pavilion with owl's tail roof finials. Four celestial angels resembling Buddhist *apsaras* soar through the air above. The stele's right side has a niche that appears to have contained a single figure of the bodhisattva Maitreya; the figure's head is missing, however, so its identity is not clear. The stele's dedication appears below this niche and comprises nine vertical columns of standard script, ending with the date, "The second year of the Xiping reign, the cyclical year *dingyou*" (i.e., 517).

The significance of the Beilin stele lies in the way in which it demonstrates the fluid boundary between early Taoism and Buddhism, giving equal place to the deified Laozi and the Buddha. While the precise mechanisms that determined the iconographic structure of such stelae remain unclear, works of this type clearly reflect the openness of the Chinese people to other religions and other gods. This fluid boundary allowed Taoism to accommodate other traditions and beliefs, among which were cults to local gods and immortals (see section III.1, "Taoism and Popular Religion"). In other inscribed examples from the sixth and early seventh centuries, Buddhist and Taoist titles of both deities and donors are often seemingly mixed up, as in the case when the central deity is Taoist, but the donors list themselves as Buddhist disciples, and vice versa.[23] The large numbers of Buddhist sculptures from the same area of Shaanxi province suggest that Taoism and Buddhism flourished side-by-side in this area during the late Northern Wei dynasty and were not necessarily seen as mutually exclusive systems of belief. Stephen Bokenkamp has suggested that by this time Taoists in Shaanxi had absorbed certain doctrines from the new Lingbao scriptures from southern China (see cat. nos. 53, 56).[24]

By the mid-sixth century, the arrangement of figures seen on the Northern Wei sculptures had become even more formalized. The Northern Qi dynasty (550–577) Taoist stele in the Osaka Municipal Museum of Arts (cat. no. 31), dated 554, is a good

example. This stele is carved from limestone and has niches with the deified Laozi on all four sides. The front and back present the seated Laozi with two standing attendants. On the front, the figure of Laozi holds his usual attribute, a fan. These niches appear against a background of low-relief carvings, executed with great vitality; these include flying celestial figures among scudding clouds, an ornate arch above the niche, standing attendants to either side, and a censer, kneeling attendants, and lions below. Following the dedication and the cyclical date *jiaxu* (554) is a long list of donors.[25] A similar though undated Taoist stele is in the Arthur M. Sackler Gallery, Washington, D.C.

Many Taoist images survive from the Sui dynasty (581–618), during which China was reunited after over three centuries of disunion. The small stele in the Museum of Fine Arts, Boston, presents a niche with the triad of the deified Laozi with two standing attendants who hold tablets (cat. no. 32). Behind Laozi's head is a lotus-shaped halo. On either side of this central group are two seated lions. The inscription, carved below, reads:

> On the twenty-ninth day, [the cyclical day] *renshen* of the sixth month (*jiachen*) of the seventh year of the Kaihuang reign of the Great Sui [dynasty], the Taoist [*daomin*] Su Zun respectfully had commissioned a sculpture of Lord Lao [Laojun], above for seven generations of fathers and mothers, for the father and mother who gave him birth, and all his dependents and relatives. May they all achieve the Tao [*cheng Dao*] at one time.

This group of sixth-century Taoist stelae reflect the development and proliferation of images of Laozi during the Six Dynasties and Sui periods. These sculptures set the stage for images of the succeeding Tang dynasty, when the deified sage was appropriated as the divine ancestor of the imperial house.

—S. L.

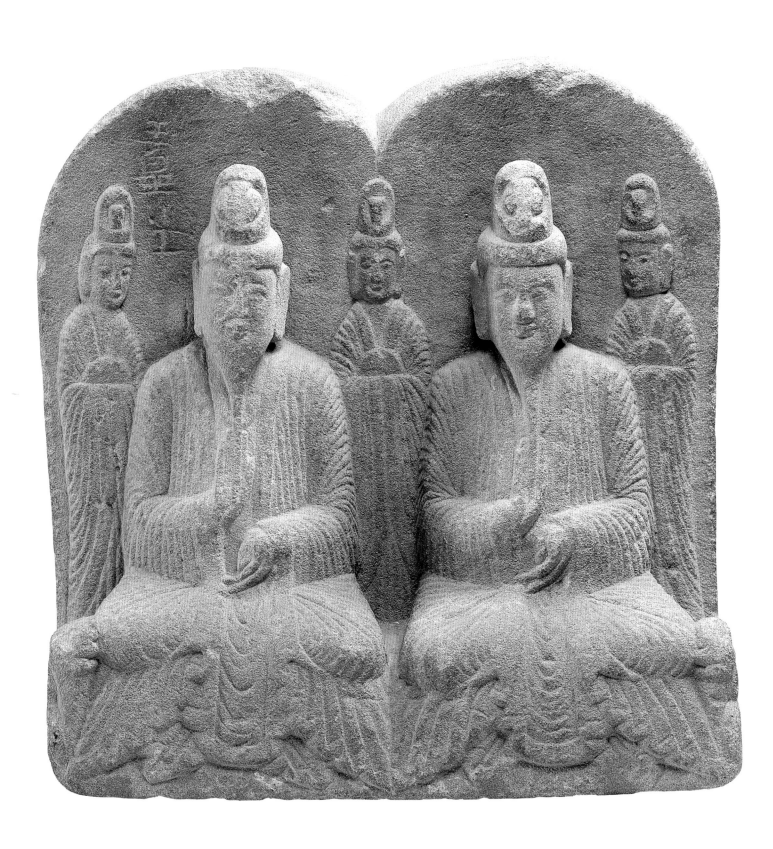

33

Stele with the Deified Laozi and the Jade Emperor

Northern Wei dynasty, Longxu reign, dated 527
Sandstone
27.8 × 27.5 cm
National Museum of Chinese History, Beijing

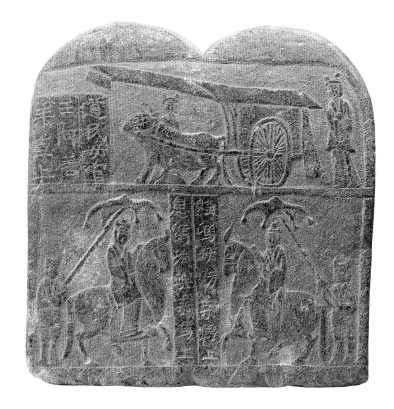

THIS FINELY CARVED STELE appears to depict the deified Laozi with the Jade Emperor or Jade Thearch (Yuhuang).[1] The two primary figures are seated side-by-side in identical postures.[2] Both figures are bearded and wear the caps of Taoist priests. Their beards extend down over their hands, which are turned outward; their faces radiate expressions of calm detachment, with meditative, half-closed eyes. Behind them stand three smaller figures. Seated lions are carved in low relief on either side of the two primary figures. An inscription at the upper left identifies the larger figure on the left as Yuhuang shi (Master Jade Emperor).[3] This may be the earliest surviving depiction of the Jade Emperor in Chinese art.

The back of the stele is divided into two horizontal registers, carved with scenes depicting the stele's donors in low relief. At the top is an ox cart, with a female attendant next to the ox, and a female figure walking behind. Judging from the inscription to the immediate left of this scene, the standing female figure is probably Wang Ashan, the primarily donor of the stele. The lower register is divided into two scenes, both of which depict riders on horseback, attended by servants holding parasols.

The left side of the stele is inscribed, "On the twenty-fifth day of the eleventh month of the first year of the Longxu reign [527], the female officer [nüguan] Wang Ashan commissioned two sculptures. May my mother and son long have virtuous households." The inscription continues on the back, in three sections: 1) "The Taoist female officer Wang Ashan [who] rides in a cart"; 2) "The niece Feng Wufang [who] rides on a horse"; 3) "The son Feng Faxing [who] rides on a horse." A similar sculpture in the collection of the Museum of Fine Arts, Boston, bears an inscription dated to 515, and may have come from the same workshop.[4]

One of the earliest scriptural sources for the Jade Emperor is the *Supreme Secret Essentials (Wushang biyao)*, a Taoist compendium dating to the Northern Zhou dynasty (557–581).[5] By the Tang dynasty (618–906), awareness of the Jade Emperor was widespread among literati.[6] During the reign of the Northern Song dynasty emperor Zhenzong (r. 997–1022), worship of the Jade Emperor was made part of the imperial cult.

The earliest recorded painting of the Jade Emperor was created in the tenth century by Shike in Shu (modern Sichuan). The painting was significant for its depiction of the Jade Emperor holding court, as the head of a vast pantheon:

> Assembled in the sovereign's presence are the celestial immortals *[tianxian]* and numinous officials *[lingguan]*, the golden boys *[jintong]* and jade maidens *[yunü]*, the Three Officials [Sanguan, the gods of Heaven, Earth, and Water; see cat. nos. 69–71], the Supreme Unity [Taiyi], the Seven Primes [Qiyuan, the gods of the seven stars of the Northern Dipper], the Four Saints [Sisheng; see cat. no. 107], the constellations everywhere, the deities of wind, rain, thunder, and lightning, the lords of hills and streams, all rulers of the regions above or below the Earth.[7]

The Jade Emperor, perceived as the head of the popular pantheon, played an increasingly vital role in Chinese religion from the Song dynasty (960–1279) onward. The Jade Emperor occupies a key position that bridges the Taoist and popular pantheons. Several Taoist gods, such as Zhenwu and Yisheng (see cat. no. 107), were called to serve as gods by the Jade Emperor,[8] and images of the Jade Emperor are often seen in Taoist temples today.

—S. L.

(detail)

34

The Xiang'er Commentary to Laozi's Scripture of the Way, Upper Roll

From Dunhuang, Gansu province
Northern Wei dynasty, early 6th century
Handscroll; ink on paper
26.7 × 900 cm
The British Library, London, Oriental and India Office Collections
 (Stein 6825)

THE *XIANG'ER COMMENTARY* is a highly polemic Taoist work that is universally critical of other traditions, including the Five Classics of Confucianism. The commentary is truncated at the beginning, starting with chapter 3 of the modern edition of the *Daode jing* and continuing only to chapter 37. As in contemporaneous Buddhist texts, there are seventeen characters per column of text. The calligraphy has a balanced, architectonic appearance. Based on similarities with dated Buddhist scrolls from Dunhuang, this work most likely dates to the early sixth century.[1] An unrelated text appears on the back of the scroll, written in a much more informal script.

For a number of reasons, the *Xiang'er Commentary* to the *Daode jing* is one of the most important, most fascinating, and most perplexing of all early Taoist writings. First, its calligraphic style suggests that it was written two centuries before most of the other Taoist manuscripts found at Dunhuang, making it one of the earliest original sources on the Taoist religion.[2] Second, it is one of the earliest commentaries on the *Daode jing* to be influenced by religious Taoism. Together with the *Stanzas of the Lord on the River (Heshang gong zhangju)* commentary,[3] it is our earliest source for understanding how the *Daode jing* was seen within the religion that revered it above all other scriptures. Moreover, the *Xiang'er* and *Heshang gong* commentaries often stand in direct opposition to each other. When placed together, these two commentaries seem to suggest the earliest controversy on how to interpret the *Daode jing* within religious Taoism.

Finally, the *Xiang'er* is important for the role it has played in modern scholarship. Because of the difficulties involved in dating the composition of the scripture, and the significance that this dating holds for our understanding of the early development of Taoism, this brief, incomplete commentary is one of the most controversial of all early Taoist texts. Some Six Dynasties (420–589) sources attribute this commentary to Zhang Lu, the third patriarch of the Celestial Master tradition, the earliest and most fundamental of all the traditions that formed Taoism. Lu successfully established an independent theocracy when the Han dynasty collapsed, ruling for decades before he finally submitted to the kingdom of Wei in 215; he was enfeoffed by the Wei court, and his teachings gradually spread throughout China. He is believed to have been responsible for much of the early codification of the Celestial Master church. There are, however, virtu-ally no writings that can be confidently attributed to Lu. Thus, if he did produce the *Xiang'er,* this commentary would be an extremely significant primary source for understanding early Celestial Master doctrines.[4]

At the same time, though, it was common in the Six Dynasties period to attribute writings to Lu or his grandfather Zhang Ling (Zhang Daoling), the first patriarch of the movement, since these two men were the most highly respected figures in the history of the church. The very attribution of a text to one of them makes it immediately suspect. Consequently, some scholars have suggested that the *Xiang'er* was not written until the Six Dynasties period, probably during the Liu-Song dynasty (420–479).[5] There is substantial evidence on both sides of this controversy, but the argument for a later date finds support in the fact that many of the terms and ideas appearing in this text have no outside precedents until the Six Dynasties period. For example, the *Xiang'er* uses the term "Taoism" *(daojiao)* as a reference to its religious competitors; the first texts other than the *Xiang'er* to use this term as a reference to the religion of Taoism date to the fifth century, two centuries after the supposed creation of the *Xiang'er.*[6] Consequently, if the *Xiang'er* was written by Zhang Lu, it would substantially change our understanding of many of the key doctrines and terms of Taoism, including even the name of the religion. On the other hand, if this text was written in the Six Dynasties and only attributed to Lu, which would seem to be more in accordance with the ideas it expresses, then the *Xiang'er* could be understood as a reactionary movement against the innovations of the fifth century, when Taoism as we know it today was first codified. This gives the *Xiang'er* a very different context, but does not diminish its importance, since according to this interpretation it would represent one of the earliest, if not the first, internal challenges to the newly formed religion of Taoism in the early Six Dynasties period.

—S. E.

35

WANG LIYONG (ACTIVE 1120–AFTER 1145)
The Transformations of Lord Lao

Southern Song dynasty, early 12th century
Handscroll; ink and colors on silk
44.7 × 188.4 cm
The Nelson-Atkins Museum of Art, Kansas City, Purchase, Nelson
　Trust (48-17)

Shown in Chicago only

As the legends around Laozi developed, he gradually changed from a figure limited by time and space to a deity with the power to appear in different places at different times, repeatedly taking human form as an imperial instructor to guide the development of Chinese civilization. The deification of Laozi was already under way in the Han dynasty (206 B.C.–A.D. 220).[1] During the medieval period, the names taken by Laozi during these early manifestations were standardized,[2] and a list of scriptures revealed to each ancient ruler was developed.[3] In addition, by this time Laozi was given credit for transmitting to each of these emperors the fundamental developments of Chinese civilization, from fire and farming to the Eight Trigrams (see cat. no. 14).

In this handscroll Wang Liyong depicts ten manifestations of Laozi, and he indicates the names the deified sage took during each appearance, the cultural advances he taught to each ruler, and the scriptures he revealed to them. These can be summarized as follows:

1. In the beginning of the *Chiming* world age (*jie* or *kalpa*), he transmitted the "Numinous Treasure" (Lingbao) scriptures;[4] in the beginning of the following *Kaihuang* world age, he transmitted the "Cavern of Divinity" (Dongshen) scriptures.[5] These revelations were accompanied by his manifestation to the most ancient Chinese rulers, the "Three Emperors" (Sanhuang), under the name of Master Gu.

2. In the time of Suiren, the legendary ruler credited with the discovery of fire,[6] Laozi appeared as the Imperial Lord of the Golden Tower (Jinque dijun).

3. In the time of Fuxi, the inventor of the Eight Trigrams, Laozi appeared as Yuhuazi and transmitted the *Scripture of Primordial Yang (Yuanyang jing)*.

4. In the time of Shennong, the inventor of crop cultivation, Laozi appeared as Dachengzi and revealed the *Scripture of Primordial Essence (Yuanjing jing)*.

5. In the time of Jurong, the inventor of metal casting, Laozi appeared as Guangshouzi and revealed the *Scripture of Massage Which Circulates Essence (Anmo tongjing jing)*.

6. In the time of the Yellow Emperor (Huangdi; see cat. no. 36), China's first great martial ruler and caster of nine magical tripods, Laozi appeared as Guangchengzi and revealed the *Scripture of the Utmost Way and Great Life (Zhidao taisheng jing)*.

7. In the time of Emperor Yao, Laozi appeared as Zhenxingzi and revealed the *Scripture of the Numinous Treasure (Lingbao jing)*.

8. In the time of Emperor Shun, Laozi appeared as Xueyizi and revealed the *Scripture of Great Clarity (Taiqing jing)*.

9. In the time of Yu, who undertook massive land reclamation projects throughout China, Laozi appeared as Wuchengzi and revealed the *Scripture of Opening the Heavens (Kaitian jing)*.[7]

10. In the time of Tang of the Yin (Shang) dynasty, Laozi appeared as Chuanyuzi and (again) revealed the *Scripture of the Numinous Treasure*.

For the most part, the first six of these manifestations agree with the Northern Song biography of Laozi entitled *Biography of the One Who Seems like a Dragon (Youlong zhuan*; HY 773), compiled by Jia Shanxiang during the reign of Emperor Zhezong (r. 1085–1100), a few decades before this painting was made. Manifestations 7 through 10, however, do not correspond to the standard biographies of Laozi in the Taoist Canon. Wang may have been working with a source corrupted by scribal errors, since the names for manifestations 7 and 9 have been reversed; but other details of these manifestations do not agree with the standard sources.

The idea of Laozi's transformations had a significant impact on the development of the Taoist religion. Laozi came to be understood as instructor and special patron of the imperial family, an idea that gained strength as Taoism began to vie with Buddhism for imperial support. This doctrine culminated in the identification of the members of the Tang ruling house as the descendants of the Elder Lord himself, although it defined the relationship between the Taoist church and imperial court and served as a tool for political legitimation both before and after the Tang dynasty.

The signature by Wang Liyong at the end of this handscroll is preceded by the character *chen* ("servant" or "official"), indicating that this was an imperially commissioned painting. In addition, seals of Emperor Gaozong of the Song dynasty (r. 1127–62) suggest that the painting was commissioned by him and painted between 1134 and 1162.[8] Wang Liyong was a native of Tongzhou, Sichuan, and obtained the *jinshi* degree in 1120, during the reign of Emperor Huizong. After the Song capital was moved to Lin'an (Hangzhou), he served under Emperor Gaozong as a secretary in the imperial library. He was known for his talent as a calligrapher and figure painter, as well as for his knowledge of the *Book of Changes (Yi jing)*. The scroll also bears two colophons by the great Ming dynasty collector Xiang Yuanbian (1525–1590).

—S. E.

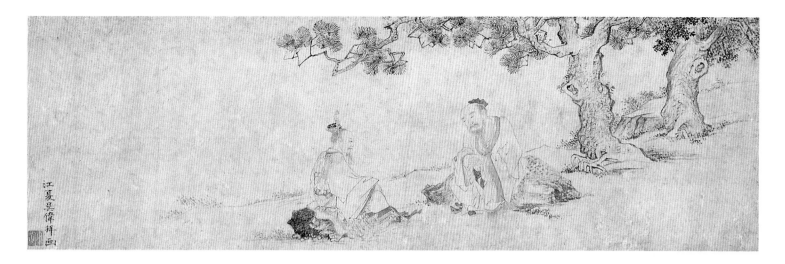

36

WU WEI (1459–1508)
Discussing the Tao (Guangchengzi and the Yellow Emperor)

Ming dynasty, c. 1500
Handscroll; ink on paper
30 × 97.5 cm
Tianjin Municipal Art Museum

OF THE EARLY MANIFESTATIONS of the deified Laozi, none was as frequently depicted in art as Master of Vast Attainment (Guangchengzi), the spiritual advisor of the Yellow Emperor (Huangdi), traditionally believed to have lived in the third millennium B.C. The Yellow Emperor was seen as an ancestor of the Chinese people and a master of esoteric wisdom.[1] During the Warring States period (475–221 B.C.), a blending of ideas attributed to two different schools of thought, traced to Laozi and the Yellow Emperor, gave rise to the so-called Huang-Lao school.[2]

The earliest text to describe the meeting between Huangdi and Guangchengzi, said to have occurred on Emptiness and Identity Mountain (Kongtong Shan—traditionally believed to be in Gansu province), is the eleventh chapter of the *Zhuangzi*, thought to have been compiled by the early second century B.C.[3] According to this narrative, the Yellow Emperor visited Guangchengzi and asked him about the Tao, saying that he would like to use this knowledge to nourish the people, and to "control *yin* and *yang* in order to insure the growth of all living things."[4] Guangchengzi responded by pointing out that instead of concerning himself with the world, the Yellow Emperor should focus on perfecting himself. The Yellow Emperor then gave up his throne and retired to a simple hut, where he lived alone for three months. He later asked Guangchengzi what he should do to master his own being and live a long life. Master Guangcheng then revealed that in order to pursue the Perfect Way, the Yellow Emperor had to cultivate emptiness and tranquility and distance himself from what was outside of himself.[5]

Wu Wei (1459–1508) was one of the great court painters of the Ming dynasty.[6] In this handscroll, Guangchengzi appears on the right, under a pine tree, while the Yellow Emperor sits facing him, sitting slightly lower than his teacher on a gently sloping hill. This theme is often encountered in Ming (1368–1644) and Qing (1644–1911) dynasty painting, and owed its popularity in part to the perceived need for any ruler to be in harmony with the Tao in order to lead the people.[7] The Tianjin Museum scroll has a colophon by the Manchu calligrapher Tiebao (1752–1824), consisting of a transcription in standard script of the *Scripture of the Yellow Court* (*Huangting jing;* see cat. no. 128), dated 1817.

—S. L.

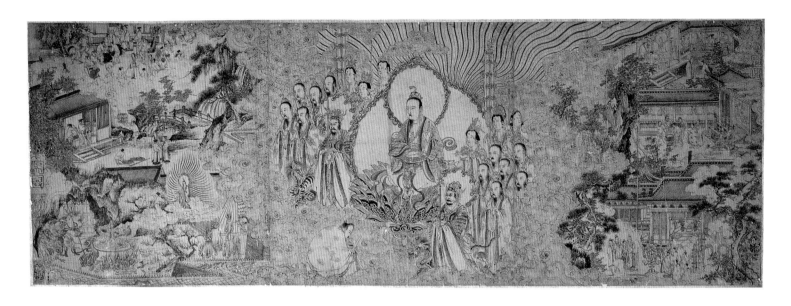

37

Liang Kai (active early 13th century)
Liberating the Soul from the Netherworld

Southern Song dynasty, early 13th century
Handscroll; ink on paper
26 × 73.9 cm
Mr. and Mrs. Wan-go H. C. Weng Collection

One of the finest surviving examples of Taoist painting from the Southern Song dynasty (1127–1279), this handscroll is also a rare early work by the painter Liang Kai. Painted in the refined *baimiao* (uncolored line drawing) technique, the scroll presents a visionary scene in which a Taoist god and his celestial entourage appear to a Taoist priest. On either side are smaller scenes relating to the primary theme of the scroll: liberation of the soul from the underworld.

Taken as a whole, this painting describes the magical operation whereby the souls of the Taoist faithful were liberated from the netherworld through a combination of religious and secular actions that assured the practitioner a place in the ranks of the celestial offices. The balanced composition of the painting highlights this combination. Each scene within a Taoist temple on the right corresponds to a scene in the secular world on the left: the ritual for the liberation of the patron's ancestors in the lower right, for example, is paired with the liberation of the patron's own soul in the lower left; the vegetarian feast in the middle right is paired with the freeing of captive animals in the middle left; and the commissioning of religious images in the upper right is paired with the giving of alms in the upper left. The central image of the Taoist priest in audience with a celestial deity joins the sacred and secular worlds, and shows the power of the Taoist priest to transform the secular into the sacred through the

medium of Taoist ritual, which infuses the secular world with the sacred energy *(qi)* of the divine.

One particularly effective compositional element of the painting is the fact that the netherworld in the lower left lies just on the borders of the secular world. There is actually a gateway between the two, and the walls of the netherworld extend beyond the borders of the lower left-hand scene into the secular scene in the middle left. This conjunction gives the netherworld a presence not seen in many other paintings with similar themes and demonstrates Liang Kai's mastery of composition.

The theme of this painting received its principal exposition in the Numinous Treasure scriptures, especially the *Scripture of Conveyance (Duren jing),* which by Liang Kai's time was becoming the most important of all Taoist scriptures; this scripture is still put in the most honored place in the present Taoist Canon from the Ming dynasty.[1] In particular, the "refinement and conveyance" *(liandu)* funerary rituals that developed around this scripture were especially popular during Liang's lifetime, and may have been a direct influence on the painting.[2]

The artist's signature, reading "[Your] servant *[chen],* Liang Kai," can be found in the bottom left-hand corner of the painting. The presence of the character *chen* indicates that the painting was imperially commissioned at the Southern Song court in Lin'an (Hangzhou). During the Jiatai reign (1201–04) of Emperor Ningzong, Liang served as a painter-in-attendance *(daizhao)* at the imperial court. He is best known for his monochrome ink paintings of Chan (Zen) themes, many of which are preserved in Japan. This handscroll serves as important evidence that this great Buddhist artist painted Taoist themes as well, and titles of several other paintings by Liang with Taoist themes are also recorded, though none have been preserved.[3] Another surviving work that Liang painted for the imperial court is *The Buddha Shakyamuni Descending from the Mountain,* now owned by the Agency for Cultural Affairs, Tokyo.[4]

The painting is followed by a copy of Wang Xizhi's *Scripture of the Yellow Court* (cat. no. 128) attributed to the great Yuan dynasty calligrapher Zhao Mengfu (1254–1322); Zhao's signature, however, is a forgery, and the writing was actually done by a later calligrapher in his style. The contents of the *Scripture of the Yellow Court* are unrelated to the theme of Liang's painting, and this text was probably added solely because the *Scripture of the Yellow Court* was a popular calligraphic text and contained Taoist themes. Following the transcription are colophons by the scholars Wang Zhideng (1535–1612) and Da Zhongguang (1623–1692). Liang Kai's handscroll is erroneously recorded in Wu Qizhen's *Record of Calligraphy and Painting (Shuhua ji;* c. 1677) as *Deities of the Scripture of the Yellow Court.*[5]

—S. E./S. L.

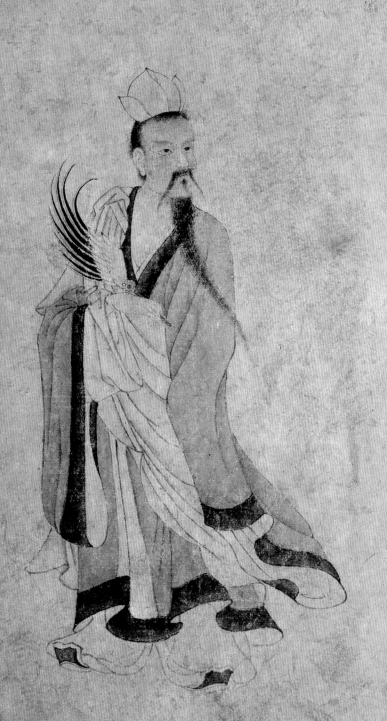

貞白先生小象

38

Portrait of Tao Hongjing

Yuan dynasty, 14th century
Album leaf; ink and light color on paper
36.7 × 30.4 cm
National Palace Museum, Taipei

THIS ALBUM LEAF depicts the Six Dynasties period Taoist master Tao Hongjing (456–536). It is accompanied by a colophon, dated 1344, comprising a short biography of Tao, written by the Yuan dynasty Taoist Zhang Tianyu (1283–1350). Originally from Qiantang (modern Zhejiang), Zhang Tianyu lived on Mount Mao, the site of Tao Hongjing's residence during his retirement, and he was, therefore, an especially appropriate person to comment on this portrait.

Tao Hongjing was one of the most prominent political figures of the Southern Qi (479–502) and Liang (502–557) dynasties.[1] He served as a high-ranking minister during the Southern Qi, and instructed the imperial princes in the Confucian classics. Although he retired from office in 492, he remained influential well into the next dynasty, and was known as the "hermit Grand Councillor" during the reign of Liang Wudi (r. 502–49). Tao had many other accomplishments as well: he was one of the most distinguished literati of the Southern Qi–Liang period, associated with figures such as the great poet Shen Yue (441–513), and he was a gifted painter and calligrapher. His correspondence with Emperor Liang Wudi is preserved in the first major compilation of treatises on calligraphy, the *Essential Record of Calligraphy (Fashu yaolu)*, compiled in the Tang dynasty. As Lothar Ledderose has shown, it is in Tao Hongjing's writings that the first mention of tracing copies of calligraphy appears.[2] A stone inscription attributed by many scholars to Tao, the "Inscription on the Burial of a Crane" *(Yihe ming)*, influenced the calligraphic styles of Ouyang Xiu (1007–1072) and Huang Tingjian (1045–1105), two of the greatest calligraphers of the Northern Song dynasty (960–1126). Ironically, Huang Tingjian claimed that the inscription was by Wang Xizhi (see cat. no. 128); it was Huang Bosi (1079–1118) who first identified it as the work of Tao Hongjing.[3] Tao was also prominent for his scientific endeavors: in addition to alchemical experiments, he was famous for his astronomical charts (see cat. no. 18) and his design of a water-clock.[4] He experimented with techniques for forging swords and is said to have presented to Liang Wudi swords of exceptional quality,

intended for the practice of "corpse liberation" (see cat. nos. 58–59).[5]

For later generations, however, Tao's greatest achievement was probably the work he did collecting, editing, and annotating the fragmentary manuscripts of the original Highest Purity revelations (cat. no. 55). This work resulted in two major compilations, *Hidden Explanations for Ascending to the Perfected (Dengzhen yinjue;* HY 421) and *Declarations of the Perfected (Zhen'gao;* HY 1010). The Highest Purity revelations formed the basis for the first of the Three Caverns, the "Cavern of Perfection" section, and yet virtually everything we know about the earliest formulation of this scriptural tradition comes from Tao's writings. In addition, Tao described in some detail the later development of this tradition during the Six Dynasties period, so that his work is the foremost source for understanding the entire first century of development for the Cavern of Perfection scriptures.

Tao's studies of the Highest Purity manuscripts led him to become critical of the mainstream tradition of Taoism. He claimed, for example, that the Numinous Treasure (Lingbao) scriptures—which formed the second of the Three Caverns, the "Cavern of Mystery" section—were nothing more than "fabrications" in imitation of earlier Highest Purity writings. In addition, he criticized many of his predecessors, including Lu Xiujing (406–477), who he claimed had intentionally suppressed genuine manuscripts in favor of later corrupted editions. As a result, Tao did not support many of the Taoist doctrines that were already becoming standard by the middle of the Six Dynasties period. Before the end of the Six Dynasties period, however, Tao's own work was reincorporated into Taoist orthodoxy and became a part of the mainstream tradition.

—S. E.

39

Deified Laozi

> Tang dynasty, late 7th/early 8th century
> Limestone
> H. 56 cm
> Museum für Ostasiatische Kunst, Cologne; acquisition made possible by the Ministry of Cultural Affairs of the Land of Northrhine-Westphalia, the Association of the Friends of the Museum of East Asian Art, Cologne, and an anonymous private donor (Bc92,2)

40

Deified Laozi

> Tang dynasty (618–906)
> Limestone
> 145 × 64 cm
> Shanghai Museum

41

Head of the Deified Laozi

> Tang dynasty, 8th century
> Marble
> H. 43.2 cm
> The Field Museum, Chicago, Mrs. T. B. Blackstone Expedition, Berthold Laufer Collection (121488)

42

Stele with the Deified Laozi and Donors

> Tang dynasty, Kaiyuan reign, dated 726
> Sandstone
> H. 45.7 cm
> The Field Museum, Chicago, Gift of Duan Fang (32362)

THE WORSHIP OF the deified Laozi in religious Taoism reached a new level of significance during the Tang dynasty (618–906). In this period, Laozi was appropriated as the divine ancestor of the Tang imperial family, for both political and spiritual legitimacy. The fact that the ancient sage (now a god) and the Tang emperors shared the same surname (Li) helped make this possible. In 625 Emperor Gaozu announced that Taoism should be ranked ahead of Confucianism and Buddhism (in that order), and in 626 the direct connection between Taoism and the Tang ruling house was clearly articulated.[1] The increasingly important role of Laozi came about in part through the activities at the court of a Taoist priest of the Louguan (Observation Platform) Temple near Xi'an, Yin Wencao (622–688), who claimed to be a descendant of Yin Xi (to whom Laozi had first transmitted the *Daode jing*).[2] In 666, during the reign of Emperor Gaozong, the deified Laozi was given a new title, Supreme Emperor of Mystery Prime (Taishang xuanyuan huangdi).[3] In 675 a new edition of the Taoist Canon was compiled, and in 678 the *Daode jing* became a required text in the civil service examination system.[4] In 730, during the reign of Emperor Xuanzong (Minghuang), imperially sponsored lectures on the *Daode jing* were held at the court in Chang'an (Xi'an), and two years later copies of the text were inscribed onto stone tablets, along with a commentary by the emperor.[5] An imperial order was promulgated in 733 to the effect that every household in China should own a copy of the *Daode jing*. Subsequently, in 743, during the Tianbao reign, Laozi began to be worshipped in the imperial ancestral temple. As Livia Kohn has written,

> These numerous manifestations and visions of the deity [Laozi] recorded in official inscriptions under the Tang were not only placed in various, often newly emerging, places of sacred impact but also show a completely different Lord Lao. No longer the far-distant cosmic creator and abstract symbol of cosmic harmony and state perfection, he has become the concerned ancestor of the ruler of the new dynasty, a deity who is close to humanity both as the third god of the trinity [the Sanqing; see cat. nos. 65–67] (and thus the teaching aspect of the Tao) and because he has active family ties on earth and is a responsible and caring ancestor to his descendants.[6]

Under Emperor Xuanzong (r. 712–55), who was ordained as a Taoist priest, Taoism increasingly became a vehicle for con-

39

40

solidating political legitimacy.[7] In 741 Xuanzong decreed that Taoist temples should be established throughout China, in the two imperial capitals (Chang'an and Luoyang) and in every prefectural capital; these were to be called Temples for the Sovereign Emperor of Mystery Prime (Xuanyuan Huangdi Miao).[8]

Four Tang sculptures of the deified Laozi are included in this exhibition. While only one is dated by inscription, all four can be stylistically dated to the seventh or early eighth century. The limestone images from the Museum für Ostasiatische Kunst, Cologne, and the Shanghai Museum are typical of the new, Tang period image of Laozi, who is often presented as a single seated figure without the standing attending figures seen in sixth-century images. Furthermore, both textual and artistic evidence indicates that in the early Tang a new grouping emerged, namely the Three Purities, of which the deified Laozi was one, the Celestial Worthy of the Way and Its Power (Daode

tianzun). The others in this new triad of the highest gods of religious Taoism were the Celestial Worthy of Primordial Beginning (Yuanshi tianzun) and the Celestial Worthy of Numinous Treasure (Lingbao tianzun). It is conceivable that the sculptures from Cologne and Shanghai were originally parts of such triads. In addition, while identified as the deified Laozi (Laojun, or Lord Lao), neither image holds a fan, the attribute by which Laozi is usually identified from the Northern Wei dynasty (386–534) onward. Because of damage, the Shanghai image holds no attribute, while the Cologne image holds a *ruyi* scepter, an emblem of good fortune that was originally a symbol of debate.[9] Both figures were originally shown resting their arms on a curved support called a *ji*, only traces of which remain. In addition, both figures sit on thrones whose form is derived from the "Sumeru throne," so-called because in a Buddhist context it represented the Indian *axis mundi*, Mount Sumeru. The stylized

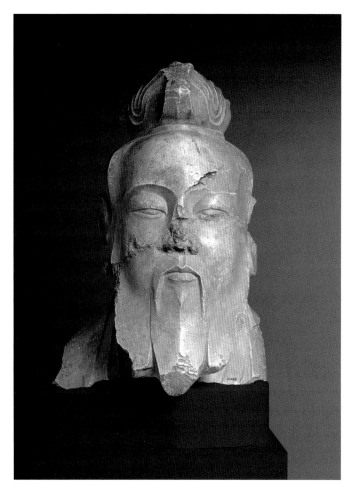

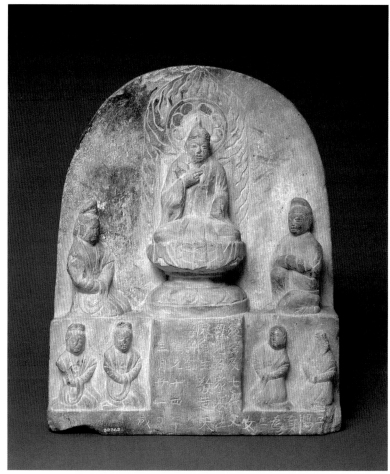

41

42

lotus petals (images of purity) at the base of the throne in
the Cologne sculpture are another element borrowed from
Buddhist usage.

While broken and fragmentary, the large head of the deified
Laozi in the Field Museum, Chicago (cat. no. 41), like the Shang-
hai image, conveys a brooding, mysterious presence seen in
many Tang dynasty images of the god. Carved in marble, this
image once belonged to a larger-than-life-size sculpture. The
remains of a tripartite beard and the Taoist cap identify the fig-
ure as the deified Laozi, now a Celestial Worthy *(tianzun)*. Very
few large-scale sculptural images of Lord Lao survive from the
Tang dynasty; one of the largest known is now in the Forest of
Stelae (Beilin) Museum, Xi'an (unpublished).

Another image in the Field Museum is a small sandstone
stele dated 726. A 1907 gift to the museum from the Manchu
viceroy Duan Fang (1861–1911), who visited Chicago in 1906,
this stele is unusual in depicting the deified sage with the
donor and his family. The god is seated on a throne at the upper
center, against a mandorla of flames. The donor and his wife

kneel to either side, their hands joined in veneration. Below,
the donor's four daughters also kneel on either side of a flat,
inscribed surface that reveals the date of this stele ("Fourteenth
year of the Kaiyuan era" [726]). While rare, similar images are
known: a small limestone stele in the Museum of Fine Arts,
Boston, depicts Laozi, two attendants, and the kneeling donor
with his wife; this sculpture is dated 754, at the end of the
Tianbao reign.

The dedication on the Field Museum stele reads:

> The son Yang Zhen respectfully made this image of the Celestial
> Worthy *(tianzun)* for his deceased daughter Ling Kong, seven
> generations of his fathers and mothers, his living family, and all
> the beings of the world. Completed on the twenty-first day of the
> third month of the fourteenth year of the Kaiyuan reign [726].

On the back of the stele are inscriptions in Chinese (inscribed
into the stone) and English (written in ink) documenting the gift
of the stele to the Field Museum.

—S. L.

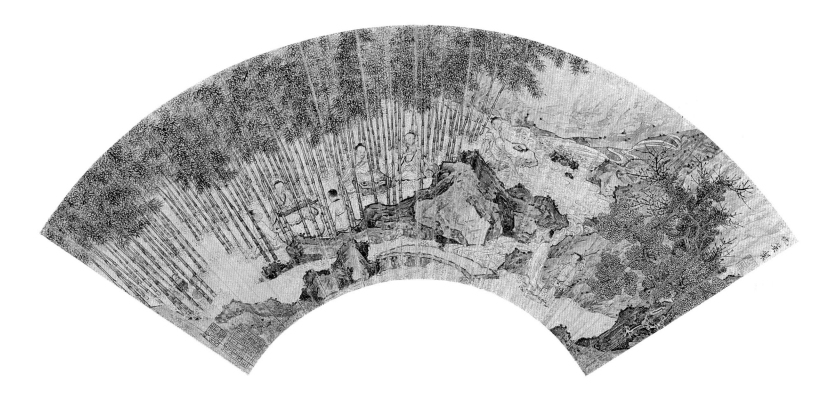

43

Qiu Ying (c. 1495–1551/52)
The Seven Sages of the Bamboo Grove

> Ming dynasty, c. 1540–50
> Fan painting; ink and colors on gold-flecked paper
> 18.1 × 54.6 cm
> Asian Art Museum of San Francisco, The Asian Art Museum
> Foundation (B79 D5i)

The Seven Sages of the Bamboo Grove (Zhulin qixian) were a group of poets, musicians, and scholar-officials active in the third century, in the vicinity of Jiankang (Nanjing), in south-central China.[1] The group included the musicians Xi Kang (223–262) and Ruan Ji (210–263), famous for their mastery of the *qin* zither and the *ruan* (a banjo-like instrument), respectively.[2] The other members of the group were Shan Tao (205–283), Wang Rong (234–305), Ruan Xian (234–305), Xiang Xiu, and Liu Ling.

The theme of the Seven Sages is often cited as a Taoist or "Neo-Taoist" subject.[3] The group's connection to the early religious Taoism of the Three Kingdoms period (220–280) was, however, tenuous. Instead, the Seven Sages were exemplars of Mystery Learning or Dark Learning (Xuanxue), a philosophical movement that sought understanding of the supreme reality (Tao) and questioned social conventions. The Xuanxue movement was ultimately derived from such texts as the *Daode jing* and the *Zhuangzi*. As Erik Zürcher has shown, "it is useful to remember that Dark Learning was both created by and intended for *literati,* i.e., politicians and state officials, and definitely not by Taoist masters, hermits, or cave-dwelling mystics."[4] The Seven Sages lived at precisely the same moment that religious Taoism was beginning to spread beyond Sichuan province, the area of its first emergence. They sought the spiritual freedom taught in the *Daode jing* and the *Zhuangzi*. Many anecdotes about the Seven Sages are recorded in *A New Account of Tales of the World (Shishuo xinyu),* compiled by Liu Yiqing (403–444).[5]

In Qiu Ying's fan painting, six of the sages are shown seated in a dense bamboo grove, situated next to a rushing stream. A seventh figure, accompanied by a servant, approaches the grove across a bridge at the lower right. Within the grove the zither player Xi Kang is clearly identifiable. He faces Ruan Ji, who plays the *ruan.*

This fan painting is a late work by Qiu Ying and is one of his finest surviving paintings. It is one of an album of ten Qiu Ying fans put together by the late Qing collector Pan Zhengwei (1791–1850).[6]

—S. L.

Cat. nos. 29–32

1. Kohn 1998a: 39–40. The classic study of the *Laozi ming* is Seidel 1969a.
2. Kohn 1998a: 39.
3. Ibid.: 40.
4. The spirits of the four cardinal directions; see cat. no. 9.
5. On the cinnabar field *(dantian)*, see cat. no. 128.
6. On the god Taiyi (Supreme Unity), see cat. no. 75.
7. Kohn 1998a: 40, citing Seidel 1969a: 123. The entire text of the *Laozi ming* is translated into French in Seidel 1969a: 122–28; the original Chinese text is on 129–30.
8. See Kamitsuka 1998: 64–66.
9. See Bokenkamp 1996–97: 64.
10. Ibid.: 64 n. 25, and Ware 1933: 248. On the activities of Kou Qianzhi, see Mather 1979.
11. For recent studies of Six Dynasties period Taoist sculpture, see Bokenkamp 1996–97; Abe 1996–97; Ishimatsu 1998; and Kamitsuka 1998.
12. The Louguan Tai is an active Quanzhen (Complete Realization) sect Taoist temple today; for a discussion of its history, see Chen 1985: 261–64. An alternate site (the Han'gu Pass, located to the east of Mount Hua, and south of the confluence of the Wei and Yellow rivers) was originally said to be the actual location of Laozi's transmission of the *Daode jing;* see Kohn 1998a: 20, 257–58. The shift of the site to the Louguan Temple occurred during the fifth and sixth centuries.
13. Schipper 1993: 22. It should be noted that incense burners are also frequently found in the decoration of sixth-century Buddhist stelae.
14. For a transcription of the inscription, see *Chūgoku no seki-butsu* 1995: 147, no. 89.
15. James 1989: 72.
16. See, for example, Zürcher 1980; and Bokenkamp 1996a: 269, in which Bokenkamp discusses the Taoist Lingbao texts (composed c. 400) as "the first Taoist scriptures to incorporate and redefine Buddhist beliefs, practices, and even portions of Buddhist scripture."
17. See the essay by Stephen Little in this volume, fig. 4.
18. On Zhang Daoling's visions of the deified Laozi in Sichuan in A.D. 142, 144, and 155, see Schipper 1993: 9–10, 57; Robinet 1997: 55; Kohn 1998a: 98, 300–302.
19. See the biographies of Yin Xi and Zhang Daoling in LXQZ.
20. Rubbings of the surface of this stele are published in *Seian hirin* 1966: pls. 29–31 (rubbings), text p. 10, and Zhang 1993: no. 12.
21. The earliest example of a work in which Buddhist and Taoist images are shown together is the Wei Wenlang stele of 424 (Northern Wei) in the Yaowang Shan Museum in Yaoxian, Shaanxi province; see Xiao Gaoshe 1991: pls. 1–8. Two similar examples to the stele of 517 exhibited here are in the Lintong City Museum, Shaanxi, and are dated 518–20 and 523; see Xiao Gaoshe 1991: pls. 63–68, 86–91.
22. Compare the approaches taken in Bokenkamp 1996–97 and Abe 1996–97.
23. See James 1989: 72–73.
24. Bokenkamp 1996–97: 63–66.
25. The inscription is transcribed in *Chūgoku no seki-butsu* 1995: 152.

Cat. no. 33

1. Previously published in *Zhongguo meishu quanji* 1988: pl. 73. For an alternative identification of the two primary figures, see Abe 1996–97: 70.
2. The pairing of the two central figures resembles similar pairs in Buddhist art of the late Northern Wei dynasty (late fifth–early sixth century); these almost always depict the historical Buddha, Shakyamuni, and the primordial Buddha, Prabhutaratna, sitting side-by-side in a stupa hovering in mid-air, a scene from the *Lotus Sutra;* see Davidson 1954: 1–6; fig. 1.
3. While Stanley Abe has suggested that the inscription reading *Yu Huang shi* is a later addition, I have examined the original sculpture carefully, and believe that the calligraphy is technically and stylistically coeval with that of the longer inscription on the back and side of the same stele; see Abe 1996–97: 70, n. 3.
4. Published in Sirén 1925, vol. 2: pl. 126B; and Abe 1996–97: fig. 1.
5. Lagerwey 1981: 126. In this text, the god is entitled Supreme Boundless Great Tao Vast Heavens Jade Emperor (Taishang wuji dadao haotian yuhuang shangdi).

6. The Jade Emperor is mentioned, for example, in poems by Han Yu (768–824), Liu Zongyuan (773–819), and Yuan Zhen (779–831); see Feng 1936: 245.
7. The painting is recorded in the *Deyuzhai huapin* by the Northern Song dynasty scholar Li Zhi; the translation is adapted from Soper 1949: 26–27.
8. See the account of Zhenwu's audience with the Jade Emperor in Seaman 1987: 112.

Cat. no. 34

1. See Ōfuchi 1991: 294–96. The entire text is translated in Bokenkamp 1997.
2. Most of what we know about Taoism comes from Ming dynasty (1368–1644) editions of Taoist scriptures contained in the Taoist Canon.
3. The *Heshang gong* commentary began during the Han dynasty, but seems to have been modified to include Taoist doctrines in the early Six Dynasties. See Kobayashi 1990: 241–68.
4. See Bokenkamp 1997: 29–77.
5. See Kobayashi 1990: 241–68, 328–56.
6. Prior to this, the term *daojiao* was understood more generally as the "teachings of the Way" and could be used as a reference to everything from Confucian texts to Buddhism. For the importance of formally establishing Taoism as a "teaching" *(jiao),* see Kobayashi 1991: 511–38.

Cat. no. 35

1. See Seidel 1969a for a study and translation of the earliest known writing to describe the many transformations of the Laozi, the Han dynasty *Scripture of the Transformations of Laozi (Laozi bianhua jing).*
2. The names given in the *Laozi bianhua jing* often differ from those of later times; the earliest list that accords with the later standard doctrine is found in HY 1196, which dates to the very beginning of the Liu-Song dynasty.
3. See HY 1425. This scripture apparently figured in the imperial debate of 626 which was sparked by the anti-Buddhist memorial by Fu Yi (554–639) presented to the court in 621. In a Buddhist polemic by the monk Minggai that resulted from this debate, the author of this scripture is identified as a certain Zhang Pan (dates unknown). The appearance of HY 1425 in this early-seventh-century debate suggests that it was already in existence by the end of the sixth century; see the *Guang hongming ji* (T 2103), *juan* 12.
4. These scriptures formed the basis for the second of the Three Caverns around which the present Ming dynasty Taoist Canon is arranged.
5. These scriptures form the third of the Three Caverns.
6. Laozi is here credited with the discoveries of each of these rulers.
7. HY 1425.
8. See *Eight Dynasties of Chinese Painting* 1980: no. 18, for a discussion the various seals on this painting. The seals of Emperor Huizong of the Northern Song dynasty are spurious.

Cat. no. 36

1. The Yellow Emperor is associated with the development of writing, sericulture, the calendar, music, mathematics, the arts of healing, and sexual techniques. See Yates 1997: 17, and Le Blanc 1985–86.
2. Among the texts attributed to this school are a series of Western Han dynasty (second century B.C.) manuscripts excavated in 1973 from tomb no. 3 at Mawangdui, Changsha, Hunan province; these are translated in Yates 1997: 103–53. There is some evidence that the Huang-Lao school originated in the state of Qi during the mid-Warring States period; see Yates 1997: 17–19.
3. A version of this story also appears in the *Master of Huainan (Huainanzi),* dating to the second century B.C.; see Roth 1997: 57–58. Roth's article presents an extensive analysis of the story of the Yellow Emperor's meeting with Guangchengzi as recorded in the *Zhuangzi.* For yet another version of the story, found in the Tang dynasty Taoist text HY 1425, see Kohn 1993: 41. On Emptiness and Identity Mountain, see Min et al. 1994: 871.
4. Watson 1968: 119; for the Chinese text, see XYZDB: 144–45.
5. Watson 1968: 120.
6. Barnhart 1993: 223–41; see also Little 1991–92: 202–03. The Tianjin Municipal Art Museum scroll was previously published in *Zhongguo gudai shuhua tumu* 1986–98, vol. 9: no. 7-0078.

7. For another Ming example, see Christie's 1995: lot 35 (now in the Yale University Art Gallery); for a Qing example, see *Zhongguo gudai shuhua tumu* 1986–98, vol. 1: 113, no. 7–025, and *New Interpretations of Ming and Qing Paintings* 1994: no. 35.

Cat. no. 37
1. HY 1.
2. See Boltz 1983 and Boltz 1987a for a discussion of the *liandu* ritual in the Song dynasty (960–1279).
3. See Ferguson 1982 and NSYH, vol. 3: 1713.
4. Published in Loehr 1980.
5. SHJ, vol. 8: 59. This record is copied in NSYH, vol. 3: 1715. See the discussion of this painting in Lin 2000.

Cat. no. 38
1. See Strickmann 1979a for a detailed account of Tao Hongjing's life.
2. Ledderose 1979: 35.
3. See *Shodō zenshu* 1970–73, vol. 5, for a more detailed discussion of the *Yihe ming*. Strickmann 1979a: 155 provides further evidence from Tao's biography to support the attribution of the *Yihe ming* to him.
4. HY 300.
5. Tao's sword-making is discussed in Strickmann 1979a.

Cat. nos. 39–42
1. Barrett 1996: 27.
2. Kohn 1998a: 22–23.
3. Ibid.: 23; see also Barrett 1996: 32.
4. Barrett 1996: 37–38.
5. Ibid.: 56. See also Xiong 1996, which presents an excellent overview of Taoism during the reign of Emperor Xuanzong.
6. Kohn 1998a: 51.
7. Ibid.: 59.
8. See Xiong 1996: 263. On even earlier (seventh century) attempts to establish Taoist temples throughout the realm, see Barrett 1996: 31, 35.
9. See Davidson 1950: 242; as he shows, the original name of the *ruyi* was *tanbing*, or "discussion stick." The Cologne sculpture has been in Germany since 1929 and was previously published in Schlombs 1995. The presence of the *ruyi* scepter instead of a fan suggests that the Cologne image may actually represent the Celestial Worthy of Numinous Treasure (Lingbao tianzun), who is often identified by a *ruyi* scepter (see cat. no. 66).

Cat. no. 43
1. The earliest known depiction of this theme dates to the fourth century, and comprises a group of impressed tiles excavated in 1960 from a tomb near Nanjing, Jiangsu province; see Soper 1980: fig. 1.
2. On Xi Kang, see Gulik 1941a.
3. See, for example, Laing 1974.
4. Zürcher 1972: 87. It is noteworthy that Ge Hong (283–343), author of the *Baopuzi (Master Who Embraces Simplicity)*, criticized followers of the Xuanxue movement as "high-class idlers who disregard the rules of decorum and moral behavior and who waste their time in noisy gatherings 'falsely quoting *Laozi* and *Zhuangzi*'"; see Zürcher 1972: 348 n. 11.
5. Mather 1976: 371 ff.
6. The album is recorded in TFLSHJ, *juan* 3: 235. The album bears a colophon by Wu Rongguang (1773–1843), dated 1841.

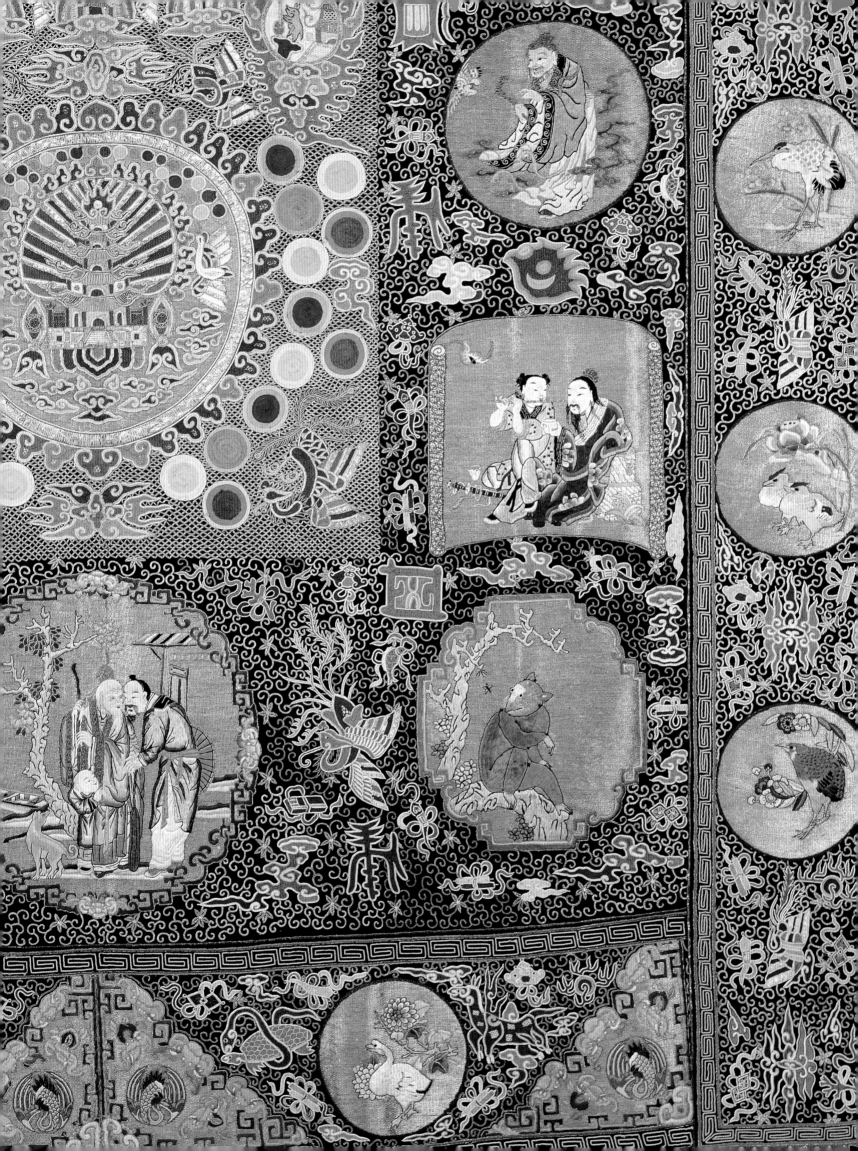

RITUAL IS THE PRIMARY WAY in which human beings communicate with the gods who personify the Tao. Taoist ritual is a public event, designed to serve the needs of a community. The central figure in any Taoist ritual is the priest *(daoshi)*, who petitions the gods on behalf of the community he serves. Incorporating words, music, and dance, Taoist ritual is a performance closely linked to theater and may last from several hours to several days. In the course of a ritual, the priest visualizes his own return to the Tao, the source of all things. Among the sacred dance forms in Taoist ritual is the symbolic pacing of the stars of the Northern Dipper (the Big Dipper), the seat of the celestial bureaucracy of the gods.

The Taoist ritual space, or altar *(daochang* or *daotan)*, reflects the structure of the cosmos, and is visualized as a sacred mountain connecting the human and divine realms. The altar may be installed anywhere, and is taken apart when the ritual is complete. At the center of this sacred space is an incense burner, the most important of all ritual implements.

Taoist ritual can be broadly divided into two types: rituals for the living and the dead. In modern Taoism, the *jiao* is a rite of offering designed for the living, while the *zhai* is a rite of fasting for the spiritual well-being of the dead. The ultimate goal of both rituals is to reaffirm humanity's origins in the Tao and to celebrate the human covenant with the divine powers of the world.

44

JIAO BINGZHEN (ACTIVE C. 1689–1726)
Taoist Ritual at the Imperial Court

Qing dynasty, c. 1723–1726
Hanging scroll; ink and colors on silk
358 × 157 cm
Arthur M. Sackler Gallery, Smithsonian Institution, Washington, D.C.;
 Purchase—Smithsonian Collections Acquisitions Program, and
 Partial Gift of Richard G. Pritzlaff (S1991.99)

THIS HANGING SCROLL shows a Taoist ritual being performed in a courtyard, on a three-tiered altar made of stacked tables. On top of the altar a young man, the patron of the ceremony, kneels in front of a table, while the Taoist priest officiating stands to his right under a parasol. An uninscribed plaque, perhaps a symbol of the principal deity to whom the ritual is directed, stands on the table, and the table is covered by a canopy, a traditional symbol of the heavens. On the ground to either side of the altar, musicians play wind and percussion instruments to accompany the ceremony.

When acquired by the Arthur M. Sackler Gallery, this painting was listed as representing "the Yongzheng emperor's nephew at a Taoist ceremony for the recovery of his father."[1] If this title is correct, then the painting would have been done sometime early in the Yongzheng reign (1723–35). The setting of the painting indicates that the ritual may have taken place in a private imperial residence rather than a Taoist temple, as is suggested by such details as the tiled courtyard and the potted plants and trees in the background. The theme suggests that this ceremony was a "fast" *(zhai)* ritual, one of the most important kinds of Taoist ceremonies. The fast ritual has an ancient history, first identified with the earliest Celestial Master movement at the end of the Han dynasty (second century); many descriptions of fast rituals, including personal accounts of participation in these rituals, survive from the medieval period.[2] Fast rituals were used for a wide variety of purposes, and well before the Qing dynasty (1644–1911) several types of fast rituals had developed, from ones intended for an individual to others celebrated for the entire country, with certain types of fast only being performed for the benefit of the imperial family or the emperor himself.

While there were many different kinds of fast rituals, they were most commonly commissioned for the benefit of a family member who was either ill, in which case the participants would pray for his or her quick recovery, or deceased, in which case the ritual would be performed to liberate the individual from the netherworld and enable him or her to ascend to the celestial paradises. The participants would subject themselves to ritualized penitence and self-denial as they confessed their and their families' wrongdoings, hoping thereby to gain merit and have their petitions heard by representatives of the celestial hierarchy. The merit they gained would then be transferred to the person for whom the ritual was being performed, in order to compensate for the accumulation of negative *karma* that had caused the illness or death. In this case, the emperor's nephew (if the subject has been correctly identified) would have performed ritual penitence in the hope that the merit he gained could be used to cure his father's illness, through the intercession of the Taoist priest who stands next to the uppermost altar table.

The most striking feature of this painting is the altar made from stacked tables. Three-tiered altars were already the most common type of Taoist altar by the Tang dynasty,[3] but early sources indicate that they were usually made from tamped earth. The use of tables in this ritual was probably a simplification necessitated by the setting, since a tamped-earth altar would have been difficult to build in the middle of a tiled courtyard in a private imperial residence. Although such simplifications are rarely mentioned in standard sources from the Taoist Canon, they are likely to have been common, given the circumstances of a particular ritual. They may often have been dictated by economic or practical concerns not taken into account by the theoretical works included in the Taoist Canon. Paintings such as this one therefore provide an important counterbalance to the image of Taoism gleaned solely from literary sources.

This painting is also of interest because it depicts a ritual commissioned by the Qing imperial family. The Qing dynasty rulers were active supporters of Esoteric Buddhism, but this painting serves as evidence that they patronized Taoism as well, and commissioned Taoist rituals for the benefit of members of the ruling house.[4]

—S. E.

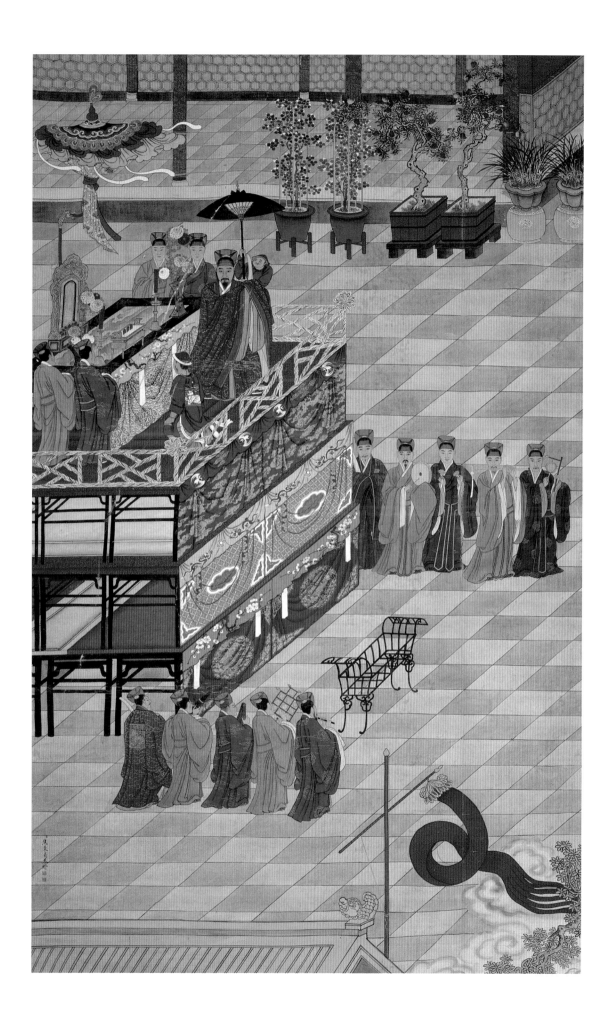

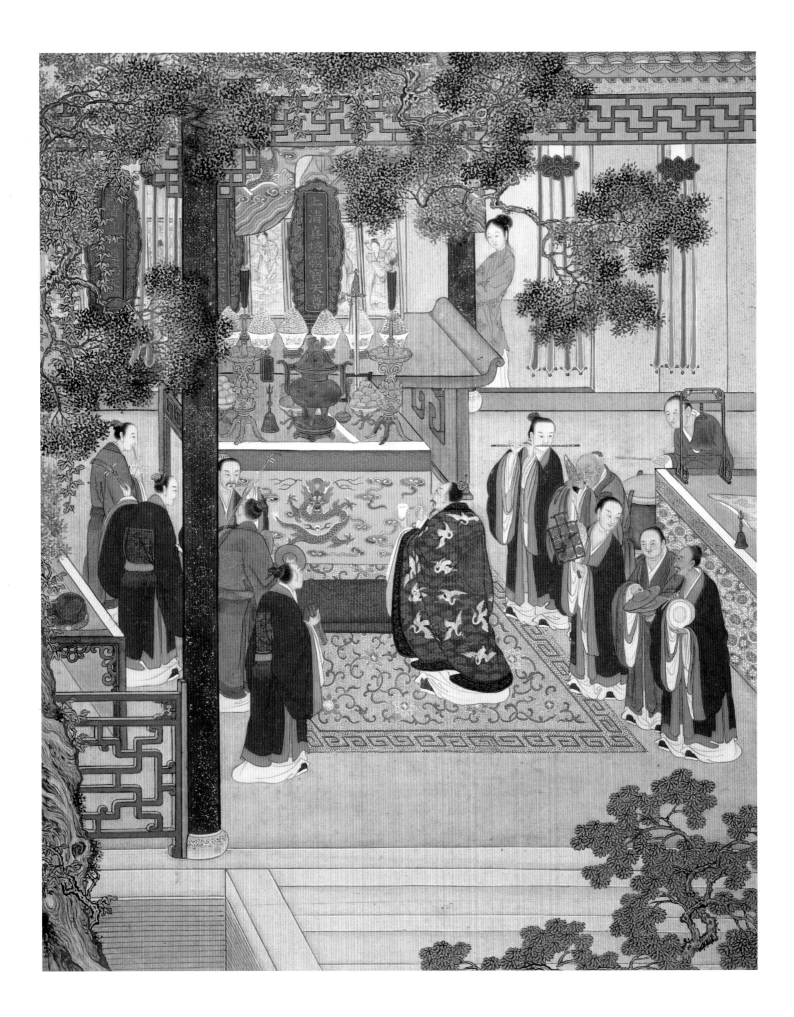

45

Taoist Ritual from The Plum in the Golden Vase

Qing dynasty, Kangxi reign, c. 1700
Album leaf; ink and colors on silk
39 × 31.2 cm
The Nelson-Atkins Museum of Art, Kansas City, Uhlmann Family
Fund, 1983 (F83–4/1)

THIS ALBUM LEAF illustrates chapter 66 of the sixteenth-century novel *The Plum in the Golden Vase (Jinping mei),*[1] a Ming dynasty work that has been called by one translator "a landmark in the development of narrative art," compared to which "there is no earlier work of prose fiction of equal sophistication in world literature."[2] The painting depicts a Taoist funerary ritual commissioned by the principal character of the novel, Ximen Qing, for Li Ping'er, with whom he had had an illicit affair, and for whose death he was partly responsible by having forced her to take a dangerous aphrodisiac during her menstrual period.[3] The ritual was supervised by Huang Yuanbai, a high-ranking Taoist priest from the imperial court, and the caption next to the painting gives the title *Perfected Man Huang Sends Forth an Official Document Recommending the Deceased.* This painting is part of an album of over two hundred leaves, created at the Kangxi court and now dispersed, depicting the different chapters of *The Plum in the Golden Vase.*

The scene shown here was part of a complicated "fast" ritual (*zhai*; cat. no. 44) that went on for many days, and was designed to "refine and convey" *(liandu)* the soul of the deceased,[4] that is, to purify it of the negative *karma* that had accrued through one's bad actions while alive, and thereby convey (or "liberate") the soul from the tortures of the hells to the celestial paradises of Taoist adepts. The liturgical text of the ritual includes the following lines:

> His Benevolent Reverence Taiyi [cat. no. 75] descends on
> his mount,
> The dark passes of the ravines of endless night open one after
> another;
> Pairs of youths lead the way,
> As the soul of the dead is refined and climbs the cloudy steps.

The series of rites described in the novel include, among other things, making food offerings, burning incense and symbolic goods for the use of the dead in the afterlife *(huacai)*, reciting scriptures,[5] and dancing the "Pace of Yu" (cat. no. 52) over a diagram of the stars of the Northern Dipper (cat. no. 18). Following the caption, the present scene shows Huang Yuanbai

presenting official memorials to the Three Officials (cat. nos. 69–71) and the celestial bureaucracy requesting that the soul of the deceased be liberated from the underworld and given passage to the celestial realms. Huang stands before the altar, holding a "*dharma* cup of cleansing water" in his left hand and making a benedictional *mudra* gesture with his right hand. Although it is not depicted in the painting, the text indicates that the rite also called for a "seven star precious sword," a sword engraved with the stars of the Northern Dipper. Huang is dressed in a robe decorated with cranes, as described in the novel:

> Jade leaves are gathered in his star cap,
> Golden clouds are embroidered in his crane robes.

According to the novel, Huang's performance of the rite was so magnificent that he appeared to be "a living god" whose "spiritual purity was like the bright moon over the Long River."

The altar before which Huang stands basically accords with details in the novel, although the literary text describes an even more sumptuous setting for the ritual than is shown here. An incense burner and various ritual implements, some showing Buddhist influence, rest on the altar, together with candles, symbolic of illuminating the darkness of the netherworld, and food offerings, for the "hungry ghosts" who were its captives. On the highest level of the altar stand plaques inscribed with the names of the Three Purities (cat. nos. 65–67). Behind the altar hang paintings that appear to depict the Eight Immortals (cat. nos. 117–18); this detail is missing from the novel. To either side of Huang stand musicians who accompany him during the rite, playing various wind, string, and percussion instruments, including a *sheng* mouth-organ, vertical *xiao* and horizontal *dizi* flutes, lutes, drums, bells, cymbals, and gongs; a similar orchestra can be seen in the nearly contemporary painting by Jiao Bingzhen (cat. no. 44).

The Plum in the Golden Vase has been understood as a criticism of perceived corruptions and excesses of the late Ming dynasty, and the ritual shown here is a prime example of this social critique. The lavish offerings, rich clothes, rugs, and decorations in both the novel and this painting create an image of excess that turns the ritual into "overly elaborate funeral observances that are prime examples of conspicuous consumption."[6] In addition, the performance of a funerary ritual for the morally questionable Li Ping'er by an imperial representative such as Huang Yuanbai has been interpreted by some scholars as a violation of social mores, and it has been suggested that the use of certain specific Taoist scriptures in the ritual was a usurpation by Ximen Qing of imperial prerogatives.[7]

—S. E.

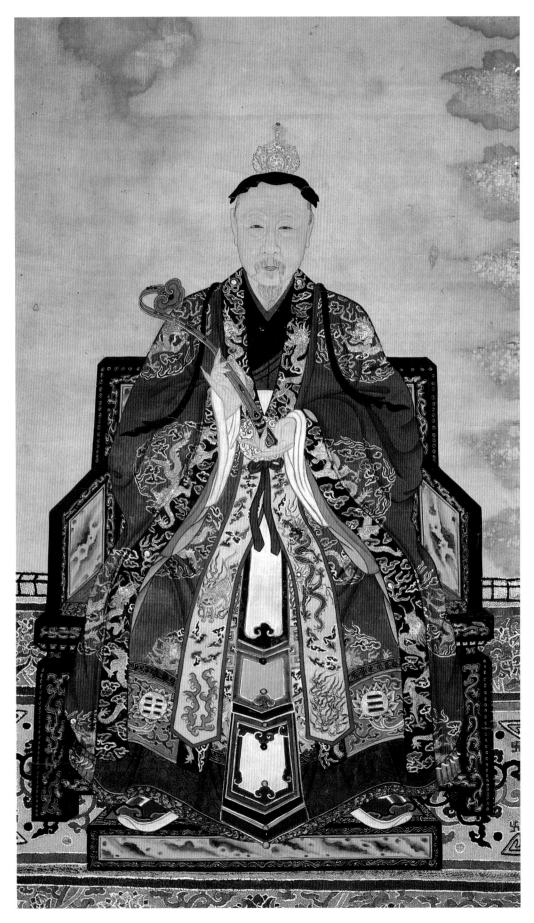

46

Portrait of a Taoist Priest

> Qing dynasty, 18th century
> Hanging scroll; ink, colors, and gold on silk
> 156 × 87.7 cm
> Royal Ontario Museum, Toronto, The George Crofts Collection,
> Gift of Mrs. H. D. Warren (921.32.85)

> Shown in Chicago only

47

Taoist Priest's Robe

> Qing dynasty, 1650/1700
> Embroidered satin
> 127 × 208.7 cm
> Victoria and Albert Museum, London, Chester Beatty Gift
> (T.91–1928)

48

Taoist Priest's Robe

> Qing dynasty, mid-19th century
> Embroidered satin
> 139.6 × 156.2 cm
> The Art Institute of Chicago, Samuel M. Nickerson Fund,
> 1947.514

49

Taoist Priest's Robe

> Qing dynasty, mid-19th century
> Embroidered satin
> 129.5 × 176 cm
> The Minneapolis Institute of Arts, The John R. Van Derlip Fund
> (42.8.296)

50

Taoist Priest's Robe

> Qing dynasty, early 19th century
> Painted silk gauze
> 147 × 170 cm
> The Minneapolis Institute of Arts, The John R. Van Derlip Fund
> (42.8.293)

51

Taoist Priest's Robe

> Qing dynasty, mid-19th century
> Embroidered silk tapestry
> 126 × 186.3 cm
> The Minneapolis Institute of Arts, The John R. Van Derlip Fund
> (42.8.118)

AMONG THE MOST visually spectacular works of Taoist ritual art are the robes worn by officiating priests. The decoration of these robes presents images of the structures of the cosmos, which are unified in the Tao and in the person of the priest himself. A Taoist text from as early as the Six Dynasties period (420–589) describes regulations concerning Taoist priests' robes.[1] Actual Taoist robes survive from as early as the Jin dynasty (1115–1234),[2] excavated from the late-twelfth-century tomb of a Taoist named Yan Deyuan, near Datong, Shanxi province. This tomb contained two types of priests' robes: the more commonly encountered *jiangyi,* or Robe of Descent, and the less common *daopao* (Taoist robe).[3] The primary image in these robes is the crane, a bird associated with transcendence since at least the Han dynasty (206 B.C.–A.D. 220), and probably much earlier. The Taoist adept Wang Ziqiao, said to have lived during the Zhou dynasty (c. 1050–256 B.C.), ascended to heaven on a crane.[4] The principal priest depicted in the Taoist ritual from the *Plum in the Golden Vase (Jinping mei)* has a robe decorated with flying cranes (cat. no. 45). References to the close connection between cranes and Taoist priests and their vestments are common in early literature. In the "Second Prose-poem on the Red Cliff" by Su Dongpo (1037–1101), for example, the poet encounters a Taoist priest in a dream, dressed in a feathered robe; it is clear from the context that these are crane feathers.[5]

The majority of surviving Taoist priests' robes date to the Ming (1368–1644) and Qing (1644–1911) dynasties and the modern era, and are typically decorated with designs reflecting traditional Taoist cosmology. Characteristic designs on Ming and Qing examples include depictions of the Taoist pantheon, the Eight Immortals, the Eight Trigrams, the Twenty-eight Lunar Mansions, and the twelve animal symbols of the Chinese zodiac. The primary Taoist priest's robe is the Robe of Descent; three of the robes included in this exhibition are of this type, square in shape, with a round hole for the neck.[6] Such robes are normally yellow or red in color, although green, black, and other colors are known as well.

The portrait in the Royal Ontario Museum, Toronto, is one of the few such images of a Taoist priest known (cat. no. 46). He wears a Robe of Descent decorated with dragons and the Eight Trigrams, and holds a *ruyi* scepter in his hands. The elaborate throne on which he sits is inlaid with "dream-stone" panels. He wears a blue cloth on his head, over which is a Taoist cap in gold, with the Eight Trigrams displayed on its leaves. Judging from the style of painting and the furniture, it appears likely that this work dates to the eighteenth century, possibly to the reign of Qianlong (1736–1795).

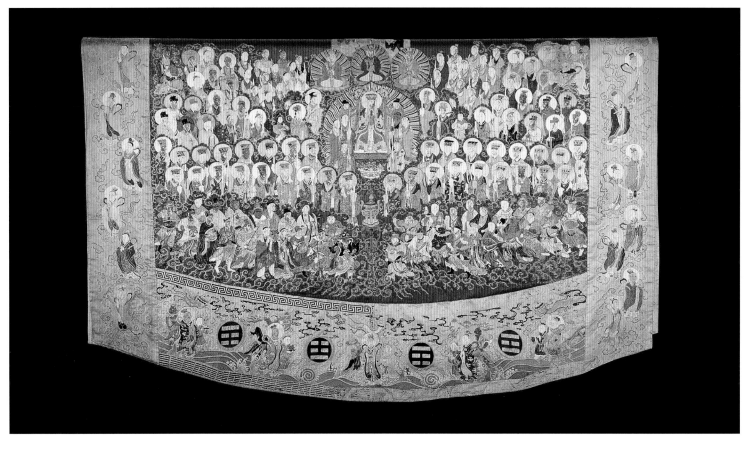

47

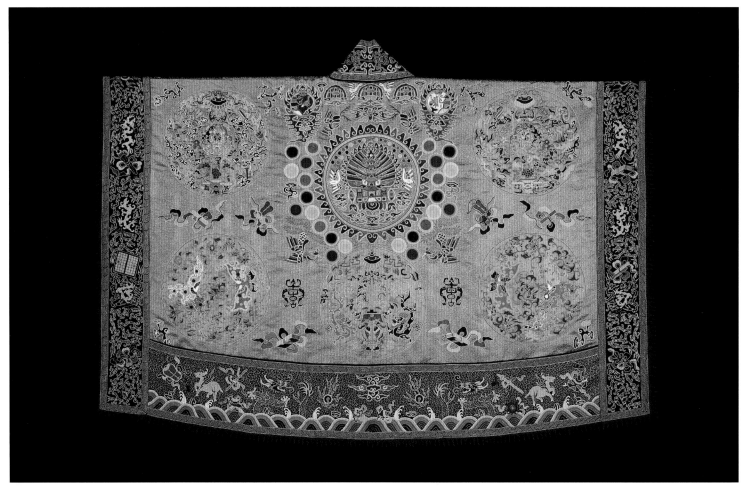

48

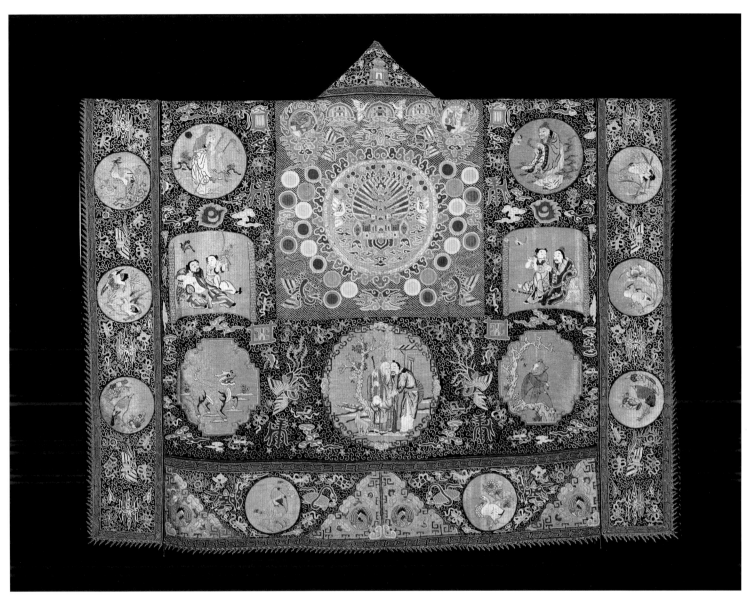

49

The earliest robe in this group is in the Victoria and Albert Museum, London, and dates to 1650/1700 (cat. no. 47).[7] It depicts gods of the pantheon, beginning at the top with the Three Purities (Sanqing): the Celestial Worthy of Primordial Beginning (Yuanshi tianzun), the Celestial Worthy of Numinous Treasure (Lingbao tianzun), and the Celestial Worthy of the Way and Its Power (Daode tianzun, the deified Laozi). Below these figures the Jade Emperor appears in a circle, with an entourage. Many of the gods have their names embroidered next to their images. A similar robe, lacking its original border, is in the Metropolitan Museum of Art, New York.[8]

The back of the Robe of Descent in the collection of The Art Institute of Chicago (cat. no. 48) is embroidered on a turquoise-green silk ground with roundels containing auspicious symbols including dragons, butterflies, and bats, surrounding a central roundel with a tower. Above this central roundel are three palaces representing the Taoist heavens of Jade Purity, Highest Purity, and Supreme Purity, with symbols of the sun and moon to either side and large multicolored dots representing constellations below. Other designs on the back include *lingzhi* mushrooms, phoenixes, and stylized forms of the character *shou* (longevity). The front of the robe is decorated with two towers. The hem is decorated with auspicious emblems, dragons, and other mythical beasts among waves.

The spectacular black-ground Robe of Descent in the Minneapolis Institute of Arts also dates to the nineteenth century (cat. no. 49). It is heavily embroidered with decorative panels containing immortals, auspicious and mythical animals (including

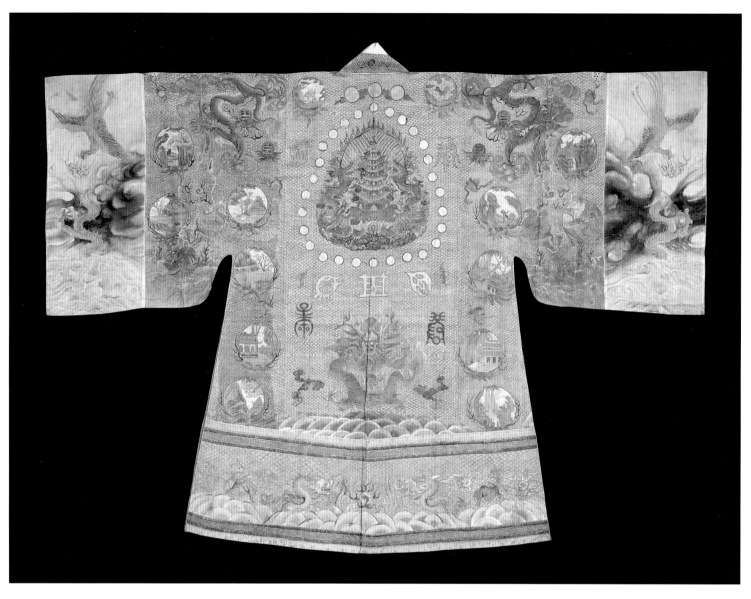

50

the *qilin* and bear), birds, and flowers. The designs center on a large roundel depicting a tower, surrounded by discs representing constellations, and the talismanic "True Forms" *(zhenxing)* of the Five Sacred Peaks (see cat. no. 137).

The next example, also from the Minneapolis Institute of Arts, is unusual in being made of gray silk gauze, with painted decoration (cat. no. 50). This early-nineteenth-century *daopao* is enlivened with dragons among clouds, talismans, and roundels containing the animals of the Chinese zodiac, in pale green, red, lavender, and gold.

The other *daopao* in the Minneapolis Institute of Arts, dating to the mid-nineteenth century, is embroidered on a red ground (cat. no. 51). Its decoration includes the tiger and dragon (symbolizing *yin* and *yang*), the Eight Trigrams, the Twenty-eight Lu-

nar Mansions, the True Forms of the Five Sacred Peaks, discs symbolizing the sun and moon, a tower surrounded by dragons, the taiji *(yin–yang)* symbol, and large roundels containing cranes with mushrooms and sprigs of bamboo in their beaks.

—S. L.

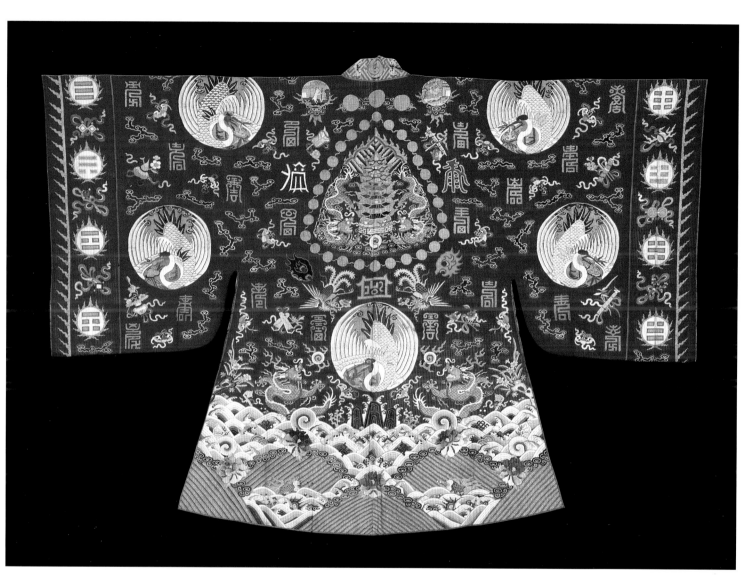

51

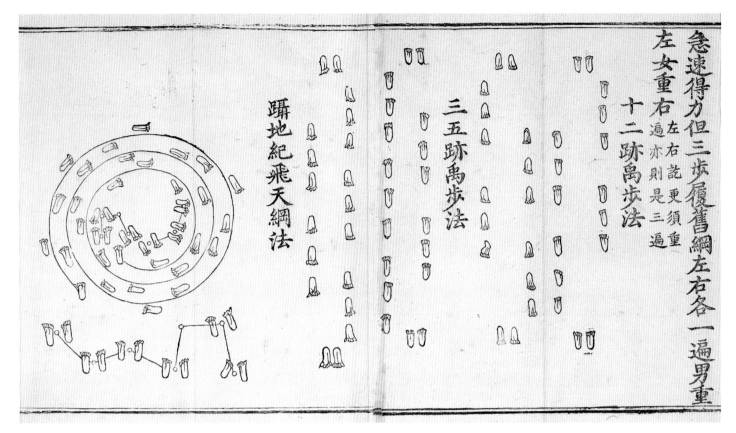

(detail)

52

YUAN MIAOZONG (ACTIVE EARLY TWELFTH CENTURY)
*The Pace of Yu from Secret Essentials on Assembling the
Perfected of the Most High for the Relief of the State and
Deliverance of the People, from the Taoist Canon of the
Zhengtong Reign*

Ming dynasty, Zhengtong reign, 1444
Woodblock-printed book; ink on paper
35.4 × 12.7 cm (each page)
Bibliothèque Nationale de France, Paris, Chinois 9546 (1210/8)

The Pace of Yu is a Taoist ritual dance, named for the mythic
Emperor Yu, founder of the Xia dynasty (traditionally late third–
early second millennium B.C.). In this dance, the priest imper-
sonates both Yu, who paced the boundaries of the terrestrial
world, and the celestial god Taiyi (Supreme Unity), who paced
the heavens.[1] The priest visualizes walking through the Dipper
stars, dragging one foot behind him in imitation of the limp of
Emperor Yu. The dance serves many functions, including exor-
cism and purification.

The Pace of Yu is a form of the ancient ritual dance known
as "pacing the guideline" *(bugang)*, the origins of which can be
traced to pre-Taoist rituals of the Warring States period (475–
221 B.C.) and the Han dynasty (206 B.C.–A.D. 220).[2] As Poul
Andersen has written, "It was from the Han dynasty milieu of

ritual and divinatory speculation, commonly associated with the
fangshi (magicians), that the Taoist practice of *bugang* (Pacing
the [Celestial] Guideline) derived its theories."[3]

The earliest mention of pacing the Dipper in a Taoist context
occurs in the Highest Purity (Shangqing) teachings, revealed
to the fourth-century visionary Yang Xi.[4] Again, Andersen has
explained the sacred dance:

> Each step is accompanied by an incantation which is pronounced
> by the adept standing in the star and which evokes the image of
> the deity of the star in question. References to the effects of the
> practice are scattered throughout the incantations, and they center
> on the notions of entrance into nothingness, obtainment of invis-
> ibility, and ascent to the Purple Court, Ziting (i.e., the palace of
> Taiyi, surrounding the celestial north pole), by way of the Barrier
> of Heaven, Tianguan, the seventh star of the Dipper.[5]

Yuan Miaozong's *Secret Essentials on Assembling the Perfected
of the Most High for the Relief of the State and Deliverance of the
People (Taishang zhuguo jiumin zongzhen biyao)* of 1116, shown
here in a Ming edition, contains several diagrams illustrating
the Pace of Yu.[6] The author was active during the Zhenghe reign
of Song Huizong (r. 1100–25), and was a Taoist priest of the
Great Law of Heaven's Heart (Tianxin dafa) sect.[7]

—S. L.

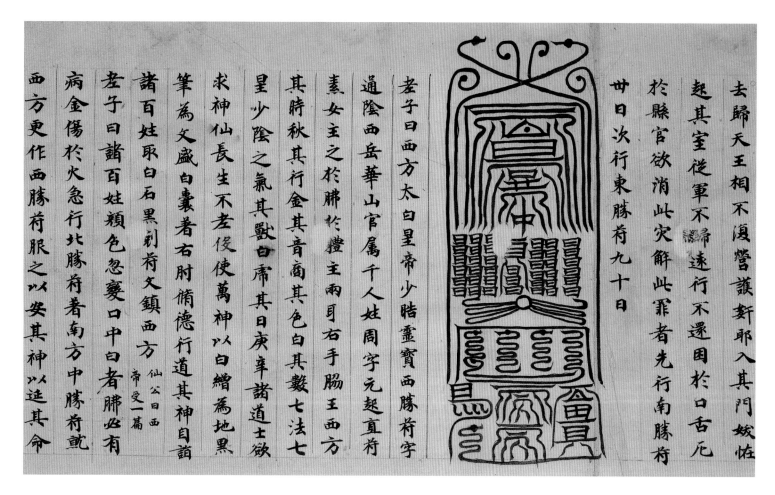

53

53 (detail)

Scripture of the Numinous Treasure Realized One Five Correspondences

> From Dunhuang, Gansu province
> Tang dynasty, 7th/8th century
> Handscroll; ink on paper
> 26.2 × 1,173.6 cm
> Bibliothèque Nationale de France, Paris (Pelliot Chinois 2440)

54

Supreme Highest Scripture of the So of Themselves Realized One Talismans of the Five Correspondences of the Limitless Great Way, from the Taoist Canon of the Zhengtong Reign

> Ming dynasty, Zhengtong reign, dated 1445
> Woodblock-printed book; ink on paper
> 35 × 11.3 cm (each page)
> Bibliothèque Nationale de France, Paris (Chinois 9546 [666/1])

THE TANG DYNASTY MANUSCRIPT from Dunhuang *(Lingbao zhenyi wucheng jing)* is truncated at the beginning, but its ending identifies it with HY 671 from the present Taoist Canon. The fragment consists of nineteen pieces of joined yellowish brown paper. The text is inscribed within a lined grid, with seventeen characters per line. This scripture belongs to the Numinous Treasure (Lingbao) category of scriptures, which form the "Cavern of Mystery," the second of the "Three Caverns" into which all Taoist scriptures are classified. It contains five talismans *(fu),* magical diagrams that correspond to the Five Phase system; these talismans extend well beyond the predrawn borders. Talismans were believed to be sacred images that mirrored the forms of the primordial energies at the inception of the world. Consequently, the scripture describes these talismans as follows:

> The "Numinous Treasure So of Themselves Talismans of the Five Correspondences of the Great Highest" came into being in the prior heaven, transforming together with the energy of the Way; they are the realization of the Way. From them came forth heaven and earth; the ten thousand spirits of heaven and earth all find

their source in the Numinous Treasure. . . . If you wish to serve the gate of profundity to the Grand Way of the Numinous Treasure, [then] wear these five talismans and the ten thousand spirits will all find their source in you.

Each talisman corresponds to one of the Five Phases, and the scripture associates them with the various elements that accord with this system: the stars, deities, mountains, parts of the body, seasons, sounds, colors, numbers, animals, days, and so on.[1] Since these talismans were believed to contain the fundamental energies of the Five Phases, they were ingested on special days throughout the year, when the practitioner would perform a meditation to absorb their essences.

In addition, these talismans were written in colored ink on silk and worn on the person of the meditator, or engraved on stones placed around the house in order to subdue the negative forces of the five directions. They were believed to have a number of magical powers, which ranged from curing illnesses and gaining popularity to reversing curses directed toward their wearer.

Because of the magical power believed to be inherent in each of these talismans, they were copied very carefully, so that the same talismans from the Ming dynasty edition of the Taoist Canon (cat. no. 54) are still very close to their Tang dynasty predecessors (cat. no. 53).[2] On the other hand, the Tang manuscript contains a number of interesting textual variants, the most noticeable of which is the use of the term "Buddha" where the Ming edition of the canon uses "teaching" (jiao), and the term "bodhisattva" where the Ming uses "realized being" (zhenren). These differences show the considerable influence of Buddhism on the early development of the Lingbao scriptures, while supplying evidence of later attempts to hide such influence.

Parts of this scripture have a distinctly popular character, and many of its practices differ from later orthodox Taoist rituals. These practices probably developed out of local traditions that were in vogue in the Jiangsu region when the scripture was written. For example, while the theoretical basis of the talismans described in the first section of the manuscript accords very well with orthodox Taoist doctrines from the later Six Dynasties period, the second section contains a number of unusual practices that seem to have little place in the orthodox tradition.

These practices are primarily concerned with the use of figurines carved from poke root (phytolacca acinosa) which were placed around the household as guardian spirits. These figurines were used in conjunction with images of the Eight Trigrams and the Talismans of the Five Correspondences. Thus, this scripture is a very important document for our understanding of the popular religious practices of southern China during the early fifth century, and of the interaction between locally prominent family traditions and Taoism during its early development.

—S. E.

咀呼天稱怨或自恚恨或容相猒蠱神衞散
去歸天王相不復營護姦邪入其門妖怪起
其室從軍不歸遠行不還困於口舌厄於縣
官欲消此災解此罪者先行南稱符三十日
次行東稱符九十日

老君曰西方太白星白帝少昊靈寶西稱符
字通陰西嶽華山官屬千人姓周字元起直
符白素王女主之於肺於體主兩耳右手脇
王西方其時秋其行金其音商其色白其數
七法七星少陰之氣其獸白虎其目庚辛諸
道士欲求神仙長生不老役使萬神以白繒
爲地黑筆爲文盛以白囊著右肘修德行道
其神自詣諸百姓取白石黑刻符文鎮西方
也受一篇也 仙公曰西帝

54 (detail)

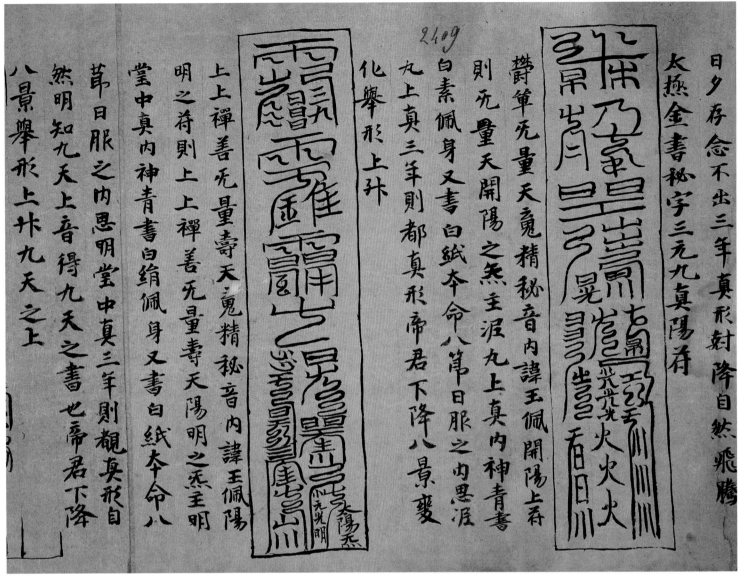

日夕存念不出三年真形對降自然飛騰

太燕金書秘字三元九真陽符

化舉形上升

九上真三年則都真形帝君下降八景變

白素佩身又書白紙本命八第曰服之內思涯

則炁量天開陽之炁主涯九上真內神青書

鬱單炁量天竟精秘音內諱玉佩開陽上昇

堂中真內神青書白絹佩身又書白紙本命八

明之符則上上禪善炁量壽天陽明之炁主明

上上禪善炁量壽天竟精秘音內諱玉佩陽

節曰服之內思明堂中真三年則觀真形自

然明知九天上音得九天之書也帝君下降

八景舉形上卅九天之上

(detail)

55

Highest Purity Jade Girdle and Golden Crown, Golden Script Book of the Great Ultimate

From Dunhuang, Gansu province
Tang dynasty, 7th/8th century
Handscroll; ink on paper
25.4 × 277.8 cm
Bibliothèque Nationale de France, Paris (Pelliot Chinois 2409)

THE BEGINNING AND END of this manuscript are truncated, but it corresponds to the work identified as HY 56 in the present Taoist Canon. Only about one-third of the complete text is preserved in this fragment. It is written on six joined pieces of yellowish brown paper, in relatively informal calligraphy. As in the other texts of this type discovered in Dunhuang, this manuscript is written within a lined grid, seventeen characters per line. It consists primarily of nine talismans *(fu)*, magical diagrams that derive from the most fundamental energies forming all existence. These talismans are associated with the "Jade Girdle" *(yupei)* from the title of the scripture *(Shangqing yupei jindang taiji jinshu)*, which is defined as the *hun*-soul or *yang*-essence of the Nine Heavens. Since this scripture is primarily concerned with meditation and visualization techniques, it uses a highly symbolic language with many different layers of meaning. Consequently, this essence manifests itself in several different ways, as the recitation that forms the scripture proper, as the deity that protects the scripture, as the nine deities that embody the Nine Heavens, and as the nine talismans possessed by these deities—the nine talismans illustrated in this manuscript.

At midnight on particular days throughout the year, the practitioner would enter into his or her "quiet room," a room reserved for worship and meditation, and recite the scripture. Then he or she would visualize the energy of the Jade Girdle descend from the Nine Heavens and encircle his or her body. After this, the practitioner visualized the nine deities representing the Nine Heavens, wrote the talismans associated with each of these deities, and ingested them, thereby absorbing the energies of these deities and the heavens they embodied. In order to facilitate the visualization of the different deities, a detailed description of each deity is provided, including alternate forms that the deity may take when it manifests in the world. Some of these deities could take rather unusual forms, appearing, for example, with multiple heads, or as animals, or as a human body with a bird's head, or as a bird with a human head. These images are very evocative, suggesting, on the one hand, ancient depictions such as those of nature spirits from the southern kingdom of Chu during the Warring States period, and, on the other, similar images that entered China with Tantric Buddhism; the images here, however, may have developed independently of either of these traditions.

Each of the concepts in this scripture has both a microcosmic and a macrocosmic significance, symbolizing celestial regions and energies as well as the corresponding regions and energies in the human body. For example, the meditations described are based on one of the most fundamental of all Taoist meditations, the "Three Ones." According to this meditation, there were three "palaces" *(gong)* or "cinnabar fields" *(dantian)* located inside the body: in the head, the heart, and the abdomen. Each of these palaces, known here as the "Three Primes," was occupied by a deity, and these three deities were manifestations of a more primordial "one" based on ideas implicit in the *Daode jing.* According to this scripture, after the "one" manifested into the "Three Primes," each of these in turn manifested itself threefold, resulting in the Nine Heavens, the nine deities, and the nine talismans of the Jade Girdle.

The Jade Girdle is paired with the "Golden Crown," which represents the *po*-soul or *yin*-essence of the Nine Heavens. Only the beginning of the section describing the Golden Crown is preserved in this manuscript. The symbolism of the Golden Crown is very similar to that of the Jade Girdle, and there is a single talisman for the Golden Crown in HY 56 that corresponds to the nine talismans for the Jade Girdle. In addition, there are two final sections preserved only in HY 56 that associate the Jade Girdle and the Golden Crown with the sun and moon, respectively.

This scripture belongs to the "Cavern of Perfection" category, the first of the "Three Caverns" into which all Taoist scriptures are arranged. This group of scriptures is commonly known as the Highest Purity (Shangqing) scriptures, since they were believed to provide one with access to the heaven of the same name. They grew out of the religious tradition of the Xu family from the Jurong area (modern Jiangsu) in the fourth century. Many of the first sacred writings of this tradition were revealed to Yang Xi (330–386), a medium employed by the Xus, who received his first revelations in 364. The writings of Yang, his patron Xu Mi (305–373/6) and Xu's son Hui (341–370), were collected, edited, and annotated by Tao Hongjing (456–536; cat. no. 38), one of the greatest Taoist scholars of the Six Dynasties period (420–589) and a close confidant to the imperial house during the Southern Qi (479–502) and Liang (502–557) dynasties.

—S. E.

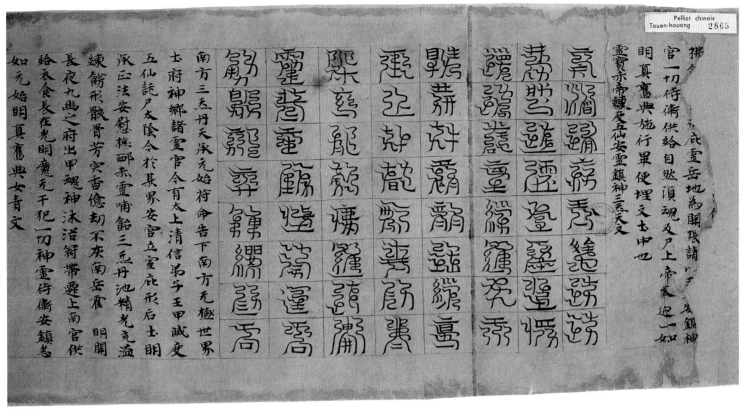

(detail)

56

Great Highest Cavern Mystery Numinous Treasure Subtle Scripture on Extinguishing and Conveying the Five Refinements and Reviving the Corpse

From Dunhuang, Gansu province
Tang dynasty, 7th/8th century
Handscroll; ink on paper
26 × 560 cm
Bibliothèque Nationale de France, Paris (Pelliot Chinois 2865)

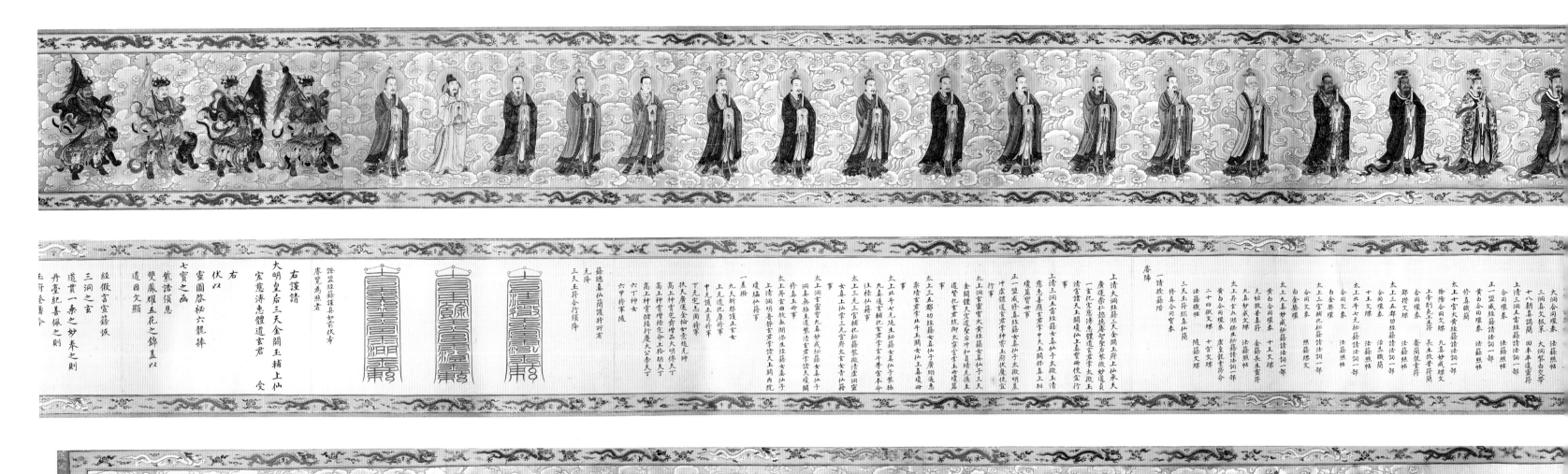

THIS SCRIPTURE *(Taishang lingbao dongxuan miedu wulian shengshi miaojing)* is truncated at the beginning and end, but its contents correspond to HY 369 from the Taoist Canon, and also to another manuscript discovered in Dunhuang, known as Stein 298. The text, written on yellow paper, contains five stylized inscriptions written within a ruled grid.[1] These inscriptions are derived from the most famous of all Taoist scriptures, the *Scripture of Conveyance* (HY 1),[2] and they are based on a magical invocation contained at the end of the *Scripture,* which in turn is an imitation of similar incantations at the ends of Buddhist scriptures, called *dharani.*

This scripture contains one of the earliest descriptions of a Taoist funerary ritual. The celestial script version of the incantation was meant to be recited during this ritual and inscribed on five stones placed in the grave. Each part of the invocation was accompanied by an order directed toward the netherworld bureaucracy to aid the soul of the deceased. The Taoist priest conducting this ceremony would perform the Pace of Yu (see cat. no. 52) a number of times appropriate to each direction, read each part of the invocation and its accompanying order, and then bury the stone with the same inscription in the appropriate part of the grave. This ritual allowed the soul of the deceased to forego the tortures of the hells and ascend to the Southern Palace where new adepts were processed, or else to reenter the wheel of reincarnation.

The invocation upon which the inscriptions in this manuscript are based first appeared spontaneously in the sky during one of the sermons of the Celestial Worthy of Primordial Beginning (see cat. no. 65). The characters that made up the invocation were formed of primordial energy, and consequently the written forms of these characters in the present manuscript are stylized to reflect this first manifestation. In this sense, the magical writing seen in this manuscript is different from the talismans *(fu)* seen elsewhere in this catalogue, since it reflects actual words, rather than an "abstract" diagram. In fact, Chinese characters were believed to derive from celestial equivalents that were harnessed by the Celestial Worthy and other deities from self-formed characters of pure energy, so that the magical writing seen here was actually thought to be a purer form of writing than common script.

Both the present manuscript and Stein 298 contain an additional section that is not preserved in HY 369, but that forms an integral part of the funerary ritual described therein. This section consists of a long memorial summoning the spirits of the five directions to order the netherworld bureaucracy to release the soul of the deceased and guide it back to life. At midnight on the night before the burial, the priest burned incense in the five directions, and then left this memorial exposed overnight beside the corpse.

This additional section, which comes at the end of the manuscript, also contains a number of stories about practitioners who benefited from this scripture. Some of these stories, particularly those about souls that return to re-animate their deceased corpses, are quite colorful. For example, a certain Zheng Renan reanimated his corpse, only to be set on fire by a terrified onlooker; unperturbed, his skeletal form continued to rise quietly, ascending to a post in the celestial bureaucracy. Other stories tell of reanimated corpses bursting out of coffins unearthed during public works projects. The initiates who figure in these stories were guaranteed positions in the celestial bureaucracy, but died before they were able to accumulate the merit necessary to ascend directly to the celestial realms "in broad daylight"; consequently, they had to undergo a period of further refinement in the netherworld before their souls could rejoin with their bodies and rise to the heavens. This idea was probably based on the doctrine of "corpse liberation" *(shijie),* which was very popular at the time this scripture was first composed.

Like cat. no. 53, this scripture belongs to the Lingbao scriptures of the "Cavern of Mystery" category of Taoist scriptures, and probably dates to the early Liu-Song dynasty (420–479), during the formative phase of the Taoist religion. The funerary ritual described in this scripture dates to a period before the full standardization of Taoism, and is a very rare example of the early funerary practices that formed one of the foundations of later Taoist rituals. At the same time, since the present manuscript provides a more complete account of this ritual than is given in HY 369, this important document provides an invaluable resource for understanding the way in which early Taoism helped the living (and the deceased) pass through one of life's principal transitions.

—S. E.

57

Ordination Scroll of Empress Zhang

Ming dynasty, Hongzhi reign, dated 1493
Handscroll; ink, colors, and gold on paper
54.6 × 2,743.2 cm
San Diego Museum of Art, Gift of Mr. and Mrs. John Jeffers
(1961.094)

EMPRESS ZHANG (1470–1541) was the sole consort of the Hongzhi emperor, Zhu Youtang (r. 1488–1505), who was widely admired as a model Confucian ruler, yet was also known for his belief in religious Taoism.[1] Between the first and seventh lunar months of 1493, the empress was ordained as a Taoist priestess. This handscroll is her ordination certificate. Both painting and document, it depicts fifty-two gods and immortals, and bears a long inscription by Zhang Xuanqing (d. 1509), the Celestial Master of the Zhengyi (Orthodox Unity) sect of Taoism. The inscription outlines a ritual or series of rituals in which an important group of scriptures, talismans, and registers (lists of gods' names) were transmitted to the empress. The acquisition of the registers indicated she was a member of the same spiritual hierarchy as the gods.[2] In spiritual terms, Empress Zhang was elevated to the status of a realized being *(zhenren).* For the empress, Taoism represented the highest degree of orthodoxy, ideally suited to aiding her husband in ruling the nation.[3] The pattern of imperial ordination seen here was established as early as the Northern Wei dynasty, when Emperor Tai Wudi (r. 424–51) was ordained in 442 as a Taoist priest by the northern Celestial Master Kou Qianzhi (d. 448).[4]

In the painting, the empress is depicted floating on a cloud in the heavens, accompanied by an entourage and a large group of deities and adepts. The empress's portrait is painted on a separate piece of paper which has been pasted over a section of the scroll that was intentionally left blank to receive it. It seems clear that the same painter who executed the remainder of the scroll painted this portrait. To the right of the empress is a portrait of Zhang Xuanqing. Among the other figures are the first Celestial Master, Zhang Daoling; the Supreme Lord of Fate; Wenchang, the God of Literature; guardians of the four cardinal directions; celestial generals; the gods of the zodiac; jade maidens *(yunü);* and the immortals Ge Xuan, Xu Xun (see cat. no. 115), and Fuqiu.[5] These figures are identified by small standard script labels inscribed in gold. At the beginning of the scroll is the title, inscribed in large "cloud-seal" *(yunzhuan)* characters: "Tablet of the Transcendent Who Superintends Reality, Red Writ of the Three Caverns" *(Sandong chiwen zong zhen xian jian).* A repaired

tear in the scroll that follows indicates that the first section of painted gods has been truncated. This missing section may have illustrated the highest Taoist gods, the Three Purities (see cat. nos. 65–67), which often appear at the beginning of scriptures in the Taoist Canon. The scroll terminates with its original Ming dynasty *kesi* silk wrapper, woven with dragons in blue, green, red, and gold threads.[6] The painting's upper, lower, and side borders are decorated with alternating black, white, green, red, and blue dragons.

The main inscription, at the middle of the scroll, is by Zhang Xuanqing, who became the forty-seventh Celestial Master of the Orthodox Unity sect in 1477.[7] It begins with four large characters, reading "Executive Bureau of Supreme Mystery" *(Taixuan dusheng).* The text that follows is divided into seven sections:

1. The Celestial Master Zhang Xuanqing recounts the lineage of his scriptural tradition, going back to the Taoist god Celestial Worthy of Primordial Beginning (Yuanshi tianzun).[8]

2. On the fifth day of the first lunar month of the sixth year of Hongzhi (1493), the Celestial Master requests permission from the celestial hierarchy to transmit certain scriptures to the Ming empress of the Central Palace (Da Ming zhonggong huanghou). The time of day (the *chen* hour, corresponding to the period from 7:00 to 9:00 a.m.), the place (the Blessed Plot *[fudi]* of Dragon and Tiger Mountain [Longhu Shan] in Jiangxi), and the name of the altar (the Ancestral Altar of Ten Thousand Methods *[Wanfa zongtan]* are listed.[9] Then permission is asked to transmit ten sacred scriptures that are descended from the first Celestial Master, Zhang Daoling. These are listed as follows:

1. *Register of the Scripture of the Great Cavern of Supreme Purity (Shangqing dadong jinglu)*
2. *Register of the Five Thunder Scripture of the Three Caverns of Supreme Purity (Shangqing sandong wulei jinglu)*
3. *Register of the Scripture of Cultivating Perfection of the Majestic Oath of Orthodox Unity (Zhengyi mengwei xiuzhen jinglu)*
4. *Register of the Great Yellow Scripture of the Ten Palaces of the Most High (Taishang shigong dahuang jinglu)*
5. *Register of the Scripture on the Highest Accumulated Merit of the Three Fives (Taishang sanwu dugong jinglu)*
6. *Secret Register of the Seven Primes (Stars) of the Highest Northern Dipper (Taishang beidou qiyuan bilu)*
7. *Secret Register of the Highest Three Officials Who Assist in Transformation (Taishang Sanguan fuhua bilu)*
8. *Secret Register of the Subtle Precepts of the Highest Nine Perfections (Taishang jiuzhen miaojie bilu)*

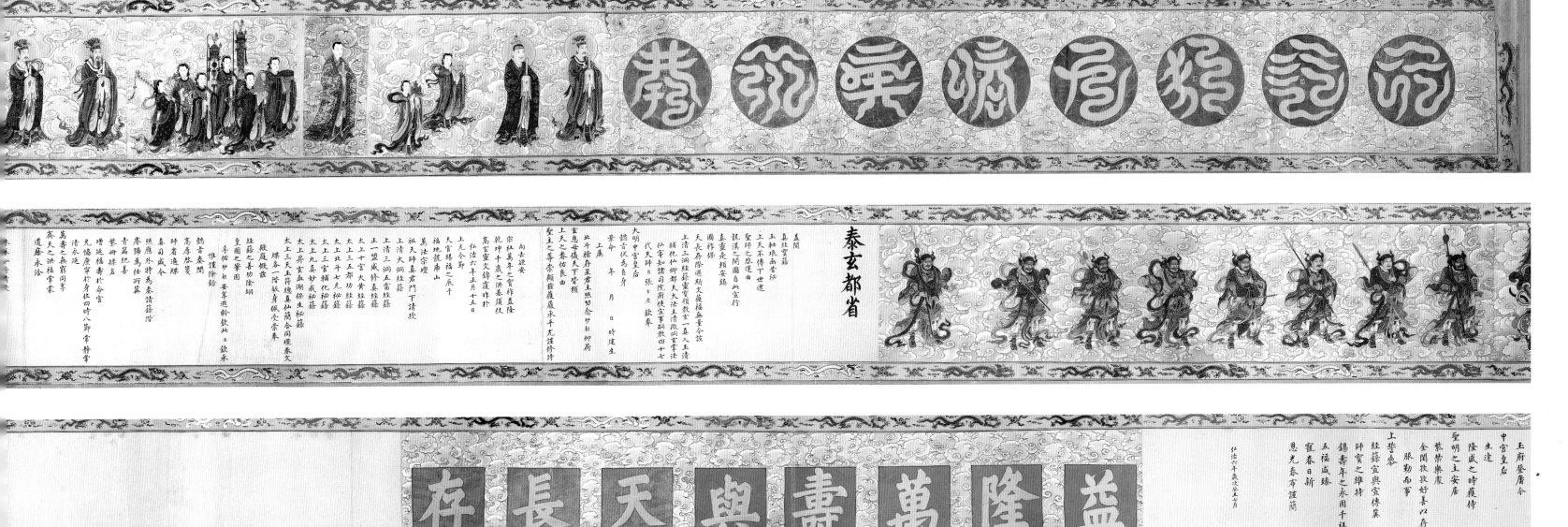

9. *Secret Register of the Highest Ascending Mystery Blood Lake Protection of Life (Taishang shengxuan xuehu baosheng bilu)*
10. *Tablet of the Transcendent who Superintends Reality of the Highest Three Heavens Jade Talisman and Contractual Writ of the Unifying Circlet (Taishang santian yufu zongzhen xianjian he tonghuan quanwen)* (referring to this handscroll).

This is followed by a request for a title and rank in the celestial bureaucracy to be conferred on the empress, and a prayer that the empress will enjoy long life and good fortune.

3. A list of accompanying documents, objects, and talismans that will enable the empress to use the scriptures and registers that have been conferred on her.

4. Licenses to perform the rituals and practices of each of the conferred scriptures.

5. The register (list of the deities) under the control of the ordained empress. This includes celestial Mystery Maidens *(xuannü)*; Celestial Generals *(jiangjun)* Tang, Ge, and Zhou; Marshal *(yuanshuai)* Zhao; Celestial Guards *(tianding)*; six *ding* Spirit Maidens *(liu ding shennü)*; and six *jia* Generals *(liu jia jiangjun)*, the last two groups corresponding to gods of the zodiac. Most of these gods are depicted in the painting.

6. Three large talismans ("Jade Talismans of the Three Heavens" [*Santian yufu*], written in red ink, to be used by the empress for summoning the gods of her register. The three heavens refer to the Three Purities, and the names of these heavens (*qingwei* for Jade Purity, *yuyun* for Highest Purity, and *dachi* for Great Purity) are included in a stylized form in their respective talismans.

7. A final proclamation, beginning with a verification of the empress's oath, followed by the empress's new Taoist name: Empress of the Great Ming, Sovereign of the Three Heavens Golden-Gate Jade-Assistance High-Immortal Vast-Compassion Universal-Kindness Embodying the Tao *(Da Ming huanghou santian jinque yufu shangxian hongci puhui tidao xuanjun)*. Mention is then made of the "Seven-treasures" box and "Twin-phoenixes Brilliant Five-flowers" embroidered cloth in which the handscroll will be stored, along with a statement that the empress will serve the emperor ("the lord of the sagely Ming"). At the end is the final date (the seventh lunar month of the sixth year of Hongzhi, the cyclical year *guichou* [1493]), with the day itself left blank.[10]

Following this are eight enormous characters, reading "Increasing Prosperity and Ten Thousand Longevities, to Exist as Long as the Heavens" *(Yi long wan shou yu tian chang cun)*. Finally, after a length of blank paper, are depictions of nineteen more gods, including the Celestial Generals Tang, Ge, Zhou,

and Zhao; twelve gods of the zodiac, comprising six female *ding* and six male *jia* gods; and three Celestial Guards *(tianding)*.[11]

Empress Zhang was a native of Xingji, located on the Grand Canal, about one hundred miles south of Beijing.[12] Her father attended the Imperial University. The Ming dynastic history *(Ming shi)* states that the future empress was conceived after her mother dreamt that light from the moon (a symbol of *yin*) entered her womb. She married Zhu Youtang in 1487, at the age of seventeen, one year before his accession to the throne. In 1491 she gave birth to Zhu Houzhao, the future Zhengde emperor. In 1495 the empress gave birth to a second son, who died a year later. At the beginning of the Zhengde reign (1506), Empress Zhang became Empress Dowager. She outlived her son and died in 1541, during the Jiajing reign (1522–66). No mention is made in the empress's official biography of her ordination as a Taoist priestess. Nor is any mention made of this event in the *Veritable Records of the Ming Court (Ming shilu)* or in the biography of the officiating Celestial Master, Zhang Xuanqing.[13]

Zhang Xuanqing was highly educated and recognized for his talents in poetry and painting. He was first ordained during the Chenghua reign, in the 1470s, and rose to the rank of Celestial Master in 1477. In that year he married a daughter of Zhu Yi (1427–1496), Duke of Chengguo, a member of the imperial family.[14] Zhang's activities at the court in Beijing also began before the Hongzhi reign. In 1486, at the end of the Chenghua reign, he was called to the palace in Beijing, where he performed a *jiao* offering ritual in the Hall of Imperial Peace (Qin'an Dian), the most important Taoist temple in the Forbidden City. In 1488 Zhang Xuanqing had an audience with the Hongzhi emperor, and subsequently became one of the latter's favorites. Zhang performed a *jiao* in 1490, on the occasion of the conception of the emperor's first child. When a son was born, the emperor bestowed on Zhang a jade belt, a gold cap, a silk robe, and silver. In 1498 Zhang was asked to pray for snow in the Temple of Worshipping Heaven (Chaotian Gong), with the result that a heavy snow fell the next day.

In 1501 Zhang Xuanqing introduced his successor to the emperor and requested permission to retire, which he did the following year. In 1504 Zhang presented the emperor with a self-portrait and an ancient sword that the emperor had requested. In return, Zhang was given gold coins and a portrait of Zhang Daoling, the first of the Celestial Masters. Zhang Xuanqing died in 1509.

—S. L.

58 (detail)

58

Highest Purity Illustration of the Sword and Mirrors That Hold Images, from the Taoist Canon of the Zhengtong reign

Ming dynasty, Zhengtong reign, dated 1444
Original text by Sima Chengzhen, Tang dynasty, 8th century
Woodblock-printed book; ink on paper
35 × 11.3 cm (each page)
Bibliothèque Nationale de France, Paris (Chinois 9546 [428])

59

Taoist Ritual Sword

Qing dynasty, 18th century
Steel, brass, ray skin
L. 77 cm
The Art Institute of Chicago, lent by Mrs. E. F. Jeffery (846.30)

THE INSCRIPTION ON cat. no. 59 copies part of the inscription from a sword possessed by Emperor Xuanzong (r. 712–56) of the Tang dynasty (618–906; cat. no. 58), whose reign marked the "golden age" of imperial China.[1] This sword was presented to the emperor by Sima Chengzhen (647–735), an eminent Taoist priest active at his court. The original sword is lost, but an illustration of it is preserved in the Ming dynasty Taoist Canon (HY 431; *Shangqing hanxiang jianjian tu*), shown here as cat. no. 58.

The original sword was known as the *Sword of Phosphorescence and Thunder (Jingzhen jian)*. It bore a number of symbols that developed upon the ideas of *yin* and *yang*, including the phosphorescence and thunder of its name, which are described as concrete manifestations of the primordial energies of *yin* and *yang*. The respective characters for these two concepts *(jing and zhen)* were inscribed on opposite sides of the sword's pommel. Under the character for "phosphorescence" was the following inscription:

Qian descends essence,
Kun responds to the numinous;
The sun and moon are imaged,
The sacred peaks and rivers are formed.

This forms the first part of the inscription on the Art Institute's sword. *Qian* and *kun* refer to the first two trigrams and hexagrams of the *Book of Changes (Yi jing)*, which represent *yang* and *yin* energy, respectively. These two trigrams were shown in two talismans etched on opposite sides of Xuanzong's sword. Stylized representations of the sun, moon, Northern Dipper (Ursa Major), and the Five Planets of traditional Chinese astronomy were also etched on the "phosphorescence" side of the sword, while the names of the Five Sacred Peaks and Four Rivers of China were etched on the "thunder" side of the sword, followed by the words "wind and clouds, thunder and lightning" *(fengyun leidian)*. The second half of the inscription on the Art Institute sword copies that found under the character "thunder" on Xuanzong's sword:

Spreading thunder and lightning,
Moving the mysterious stars;
Harmful wickedness is destroyed,
Beneficial purity is received.

The "mysterious stars" refers to the stars on the "phosphorescence" side of the sword, just as the previous passage described the peaks and rivers depicted on the "thunder" side; this implies the idea of *yin* within *yang* and *yang* within *yin*.

Taken as a whole, these images delineate the various combinations of *yin* and *yang* that form the world. Beginning with the unbroken lines of *qian* and the broken lines of *kun*, the most primordial representations of *yin* and *yang*, these two principles

are combined to form the elemental manifestations of phosphorescence and thunder, which favor one idea but imply its opposite as well. These combinations continue to form the stellar bodies on the "phosphorescence" side, which represent the heavens, and the sacred peaks and rivers on the "thunder" side, which represent the earth. The sword is therefore seen as a microcosm of the entire cosmos.

Unlike the original sword, there is no inscription on either the pommel or grip of the sword in the Art Institute; the two separate inscriptions from the grip of Xuanzong's sword are combined into a single inscription on the blade of this later sword. In place of the stellar and earthly bodies on Xuanzong's sword, depictions of the Twenty-eight Lunar Mansions are inscribed on the opposite side of the blade, accompanied by the Northern Dipper. As a result, the balance between the heavens and the earth created by the placement of the sun, moon, stars, and geographical features on Xuanzong's sword is not preserved in this example.

The ancient Chinese considered swords to be powerful magical implements with many different uses. Xuanzong's sword supposedly had exorcistic powers, "gathering up ghosts and destroying wickedness." These powers came from the fact that swords were understood as a sacred microcosm that embodied primordial energy. In this sense, swords were closely connected with another sacred microcosm, the human body. This association of the human form with a sword is reflected in the idea of "corpse liberation" *(shijie)*, the belief that the body could be refined in the same way that a cicada or snake sheds its old skin as it develops a new one. Following this practice, some adepts *(xian)* would undergo a process similar to physical death in order to refine their bodies. When they "died," they would sometimes use a sword to take the place of their corpse in the coffin; this sword was like the skin left behind by a snake, taking the shape of the deceased but reverting to its original form after burial. In this way, the adept could hide the real significance of his death from the eyes of the profane. Among the prominent Taoist figures who used corpse liberation was Tao Hongjing (456–536; cat. no. 38), who supposedly left behind only a sword and his "empty clothing."[2]

—S. E.

59

60

Taoist Ritual Sword

> Sword: Ming dynasty, Yongle reign, dated 1403
> Scabbard: possibly Qing dynasty, Qianlong reign (1736–95)
> Steel, gold, and jade
> L. 73.5 cm
> Staatliches Museum für Völkerkunde, Munich (19-5-2)

61

Taoist Ritual Sword

> Sword: Ming dynasty, Hongzhi reign, 1500
> Scabbard: Qing dynasty, 19th century
> Steel and brass
> L. 64 cm
> Staatliches Museum für Völkerkunde, Munich (19-5-3)

THE FIRST TAOIST RITUAL SWORD shown here (cat. no. 60) is noteworthy for having been given to a leading Taoist master of the Ming dynasty by the Yongle emperor (r. 1403–24). Both sides of the steel blade are inlaid with gold designs depicting stylized constellations, one of which is the Northern Dipper *(Beidou)*, the most powerful asterism in the Taoist heavens. A short gold-inlaid inscription on one side of the blade, just below the hilt, reads: "On the first month of the first year of the Yongle reign [1403], imperially bestowed on Gaodao Liu Yuanran." The sword's grip is made of jade; it bears a short inscription in seal script that reproduces part of the inscription on the grip of the sword given to the Tang emperor Xuanzong by the Taoist master Sima Chengzhen in the eighth century (cat. no. 58).

Liu Yuanran (1351–1432), a famous Taoist priest of the early Ming dynasty, was a native of Gongxian in Jiangxi province, and the son of a Yuan dynasty official. His official biography states that in 1393 he attracted the attention of the Hongwu emperor (r. 1368–98) with his abilities at rainmaking.[1] The emperor granted him the title Gaodao (Noble Tao), and Liu subsequently officiated in the Paying Homage to Heaven Palace [Chaotian Gong]. In 1421 the Yongle emperor moved the capital from Nanjing to Beijing, and Liu accompanied him to the north. During the reign of Xuande (r. 1426–35), Liu advanced to the rank of Great Realized Being *(da zhenren)*. When he retired in 1433, the Xuande emperor painted a landscape painting with a poem, and

presented it to him.[2] The Ming history states that as a Taoist master, Liu Yuanran contributed to the ritual correctness of the imperial court through his "pure, calm, and self-controlled" personality.

As one of the leading Taoist priests in the imperial service, Liu Yuanran was a well-established and highly respected figure by the beginning of the Yongle reign in 1403, when this ritual sword was imperially bestowed on him. Liu was a priest of the Pure Illumination (Jingming) sect of Taoism, a school that grew to prominence in the Song and Yuan dynasties and stressed the fusion of Taoist and Confucian ideas (see cat. no. 115).[3]

The blade of the second sword (cat. no. 61) is inlaid with talismans in fine lines of gold. The handle has fittings of gilded brass, with a wheel *(chakra)*-shaped pommel. According to an inscription of 1849, written in gold on the leather scabbard, the sword was made in 1500, during the reign of Hongzhi (r. 1488–1505). In 1849 the sword was presented to a temple known as the Shrine of Numinous Response (Linggan Ci).

—S. L.

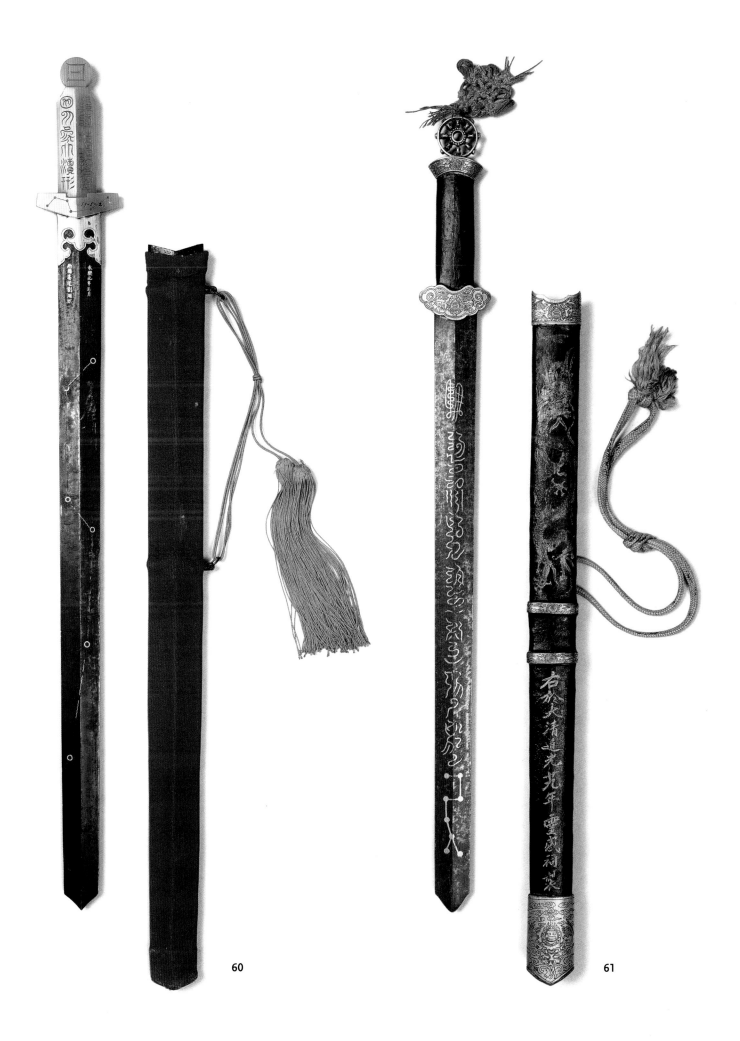

60 61

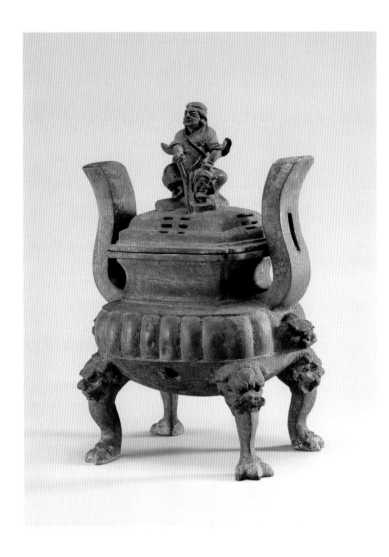

62

Incense Burner with Li Tieguai

Ming dynasty, 15th/16th century
Bronze
31 × 23 cm
Sichuan Provincial Museum, Chengdu

IN ANY TAOIST RITUAL, the incense burner is the single most important implement. As the Southern Song dynasty Taoist adept Bai Yuchan said, "You have only to set up the incense burner for the divine empyrean to be present."[1] The censer symbolizes the gate between the human world and the realm of the gods (and, by extension, the Tao). The presence of the incense burner sanctifies the space in which any ritual is enacted. The importance of incense in religious Taoism cannot be overstated. As John Lagerwey has shown,

> Incense . . . is not just a fragrant offering to the gods, making the altar a pleasant place for them to spend some time. It is what literally draws them to the altar, as to a magnet, and especially to the altar-body of the high priest, for the incense is in the first place a symbol of the Three Energies of his body, billowing up into the bizarre configurations of all primordial energy—"celestial seals"—and thus attracting its divine counterpart, its "other half" into the cave [of the altar].[2]

The incense burner sits on the altar table, known as the *dong'an* ("cave table"), symbolizing the numinous grotto in the mountain through which the priest communicates with the heavens.[3]

Very few incense burners that can specifically be said to be Taoist survive from earlier than the Ming dynasty (1368–1644). This bronze example was excavated in Qingsu village near Chengdu, the capital of Sichuan province. The four legs descend from lion masks at the corners of the rectangular bowl. The lid is pierced with holes in the shapes of four of the Eight Trigrams. At the top of the lid is a handle in the shape of the Taoist adept Li Tieguai ("Iron-crutch Li"; see cat. no. 125), suggesting that this incense burner was designed for use in a temple of the Quanzhen (Complete Realization) sect.

—S. L.

63

Taoist Ritual Tablet

Ming dynasty, 15th/16th century
Ivory
49 × 8.5 cm
Staatliches Museum für Völkerkunde, Munich (11.125)

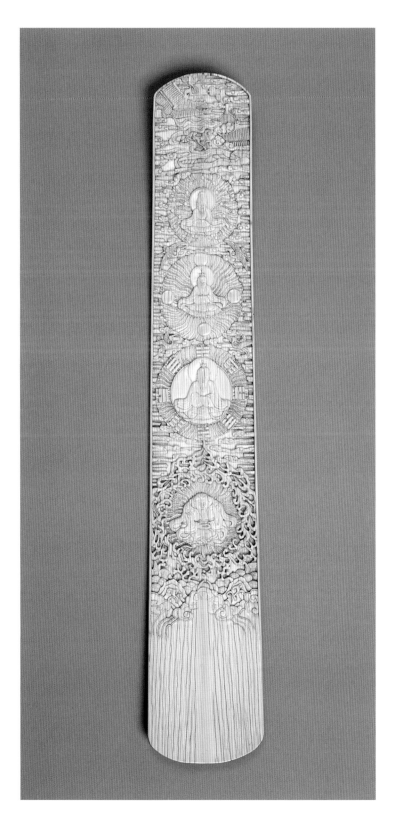

TABLETS *(HU)* LIKE THIS ONE, used during ritual audiences with deities from the Taoist pantheon, were modeled after the tablets carried by officials during imperial audiences. Depictions of the actual use of similar tablets during a Taoist ritual can be seen elsewhere in this catalogue (for example, see cat. no. 44).

The tablet is carved with four figures hovering in clouds above sacred mountains, on which grow magical fungi *(lingzhi;* see cat. no. 129). Above the figures is another mountain partially veiled by a coiling cloud, and above this celestial palaces supported by more clouds. Between the figures are four cranes, traditional symbols of longevity. The significance of the figures is not entirely clear, but they may have been inspired by Inner Alchemy *(neidan).* The lowest figure probably represents the meditator, surrounded by a ring of energy *(qi)* directed upward.[1] The upper three figures suggest the microcosmic three cinnabar fields *(dantian),* centers of energy in the head and upper and lower torso of the body, and the macrocosmic Three Purities (see cat. nos. 65–67). The attributes of the figures suggest an inner alchemical numerical progression that reduces the phenomenal world to its primordial energies. The lowest of these three figures is surrounded by the Eight Trigrams in the Later Heaven *(Houtian;* see cat. no. 14) arrangement, symbolizing *yin* and *yang* energy manifested in the world.[2] The next figure is surrounded by four circles, which may represent the inner alchemical refinement of the Eight Trigrams into the more fundamental trigrams of *qian* and *kun,* pure *yang* and *yin* energy, and *li* and *kan,* the first intermingling of these energies.[3] The final figure is surrounded by constellations, in particular the Southern Dipper (a group of stars in Sagittarius) and Northern Dipper (Ursa Major) to the left and right.[4] The Southern and Northern Dippers were traditionally believed to control (respectively) the records of life and death, and in this context they probably represent the further purification of energy into its most basic manifestation as *yang* and *yin.* As a result, the images on the tablet represent the refinement of energy from its limitless manifestations in the world to its eightfold manifestation in the trigrams, the further refinement of the trigrams into their constituent energies, and the eventual purification of these energies into pure *yin* and *yang.* The final stage of primordial oneness is represented by the heaven that resides even above the Three Purities, the ultimate goal of the inner alchemical process.[5]

—S. E.

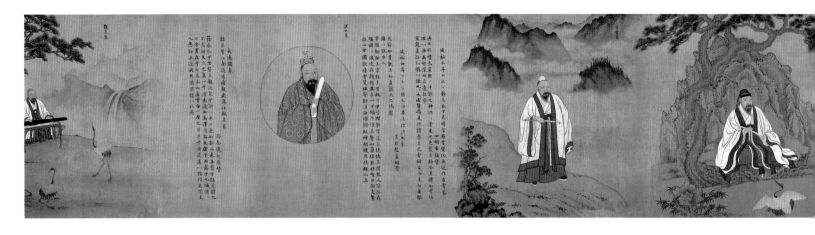

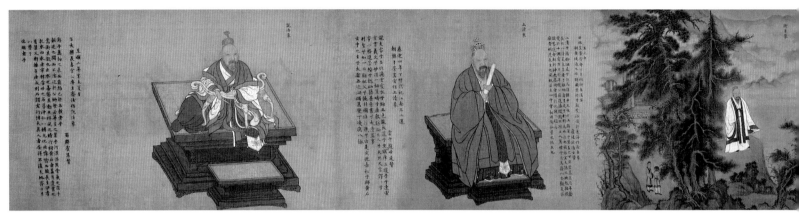

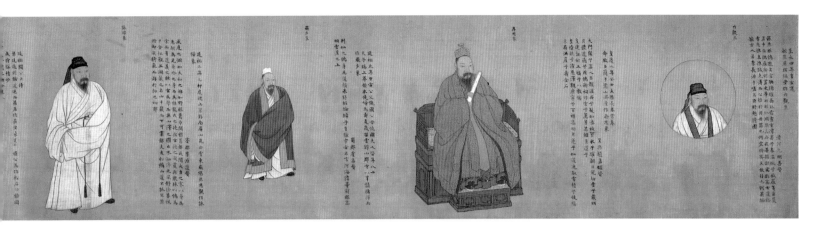

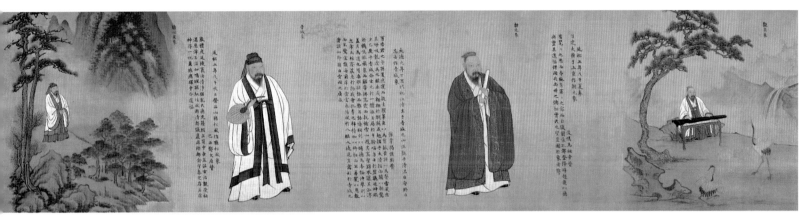

64

TRADITIONALLY ATTRIBUTED TO CHEN ZHITIAN
Fourteen Portraits of Wu Quanjie

Yuan/Ming dynasty, second half 14th century
Handscroll; ink, colors, and gold on silk
51.8 × 834.8 cm
Museum of Fine Arts, Boston, Gift of Mrs. Richard E. Danielson
(46.252)

THIS SERIES OF PORTRAITS depicts Wu Quanjie (1269–1346), one of the most famous Taoist priests of the Yuan dynasty (1260–1368).[1] Wu was a pupil of Zhang Liusun (1248–1322), himself a pupil of the thirty-sixth Celestial Master, Zhang Zong-yan (1244–1292). During his lifetime, Wu Quanjie gained fame as a widely respected priest who was as comfortable in the Mongol court as he was among the literati of south-central China. He became a patriarch of the Mysterious Teaching (Xuanjiao) school of Taoism. The first patriarch of this school was Zhang Liusun, who had been summoned to Beijing in 1276 by the first Mongol emperor, Khubilai Khan (r. 1260–94).[2] The Xuanjiao school existed only during the Yuan, having been founded in 1287.[3]

Wu Quanjie began studying Taoism when he was twelve, and became a Taoist priest (*daoshi*) at the age of sixteen.[4] His teacher summoned him to the capital of Dadu (Beijing) in 1287, and subsequently Wu spent most of his time in the north. When the Yuan emperor Chengzong (r. 1295–1307) came to the throne, Wu Quanjie officiated at the *jiao* ritual of thanksgiving to celebrate the accession. In 1307 Wu was given the title "Heir to the Xuanjiao Patriarchy."[5] After his teacher's death in 1322, Wu Quanjie became head of this sect. He was put in charge of all Taoist affairs in the country, under the aegis of the Academy of

Worthies (Jixian yuan), which also oversaw all Confucian activities, such as the Imperial University.[6] Wu was respected for his Confucian learning, and often recommended literati to positions at court. As Sun K'o-k'uan has shown, it was through such individuals as Wu Quanjie that the literati elite of the lower Yangzi valley obtained a voice, and thus a measure of influence, at the Mongol court:

> Xuanjiao, "the sublime teaching," was in effect a branch of the southern Tianshi Taoism that had been created by the edict of the Mongol rulers. Xuanjiao was purely a Yuan religious phenomenon, for the Xuanjiao patriarchy was obliterated by the founder of the Ming dynasty, Ming Taizu. What is more important, from the standpoint of the history of Yuan literati, is that Xuanjiao, a Taoist religious movement replete with beliefs in magic, divination, and immortality, was the product, not of Taoists acting on their own, but of Taoists working with the active cooperation of prominent Confucian literati and under the endorsement and sponsorship of the ruling Mongols. Xuanjiao was a distinctive form of Daojiao [religious Taoism], and from the standpoint of traditional elite Han Chinese culture it was highly refined and literary. It was also highly political. In effect, Xuanjiao Taoist culture and the culture of the Han Chinese literati were overlapping phenomena, and in some cases they were one.[7]

Among his many accomplishments, Wu Quanjie is credited with the building of the Temple of the Eastern Peak (Dongyue Miao) in Beijing. While the idea to build the temple was Zhang Liusun's, Zhang died before construction could actually begin. In 1322, under the direction of Wu Quanjie, the main hall was completed.[8] Aside from his skillful managing of Taoist affairs, Wu Quanjie was widely respected by contemporary Chinese literati for his upright character. He is described as follows in the Yuan dynastic history:

> [Wu] Quanjie elegantly favored making friends with literati [shidafu], and there were no favors he would not perform [for them]. In his relations with his elders, he was especially considerate and respectful, and in promoting [the careers of] talented persons, he feared only that he did not exert all his strength. As for helping those in poverty or in dire straits, he never let his mind be altered by personal debts or grudges. In his day he was highly regarded for his endowment of chivalric spirit [xia qi].[9]

The handscroll in the Museum of Fine Arts, Boston, is a rare document of Wu Quanjie's life. It includes fourteen portraits, depicting Wu between the ages of forty-three and sixty-three.

According to a record of this composition in the early Ming catalogue *Coral and Munan Gems (Shanhu munan)* by Zhu Cunli (1444–1513), the scroll originally included seventeen portraits.[10] The Boston scroll has traditionally been attributed to Chen Zhitian, but its individual portraits were based on paintings by several artists, including Zhao Mengfu (1254–1322). While the sequence of portraits generally follows a chronological progression, several are out of sequence.[11] Each portrait has a note indicating the date and circumstances surrounding the image, and an accompanying poem:

1. The first portrait depicts Wu in 1311. The note reads: "In the fourth year of the Zhida reign [1311], [Wu] returned to court. In Yan [Beijing] he lived in the Hall of Encircling the Pivot [Huanshu Tang].[12] [Thus was] made [this] *Portrait of Inner Observation [Neiguan xiang]*. Eulogized by Yuan Mingshan of Qinghe." The image is a bust portrait, depicting Wu within a circle. Wu wears a white robe with a blue lapel; a Taoist priest's jade cap is visible under his translucent horse-hair hat. The term *neiguan* (inner observation) refers to a Taoist practice of meditation, "a conscious introspection of one's own body and mind."[13]

2. The second portrait depicts Wu in formal ritual attire, holding an ivory tablet and seated on an elaborate wooden throne. The note reads: "In the second year of the Huangqing reign, the cyclical year *guiyou* [1313], [Wu] celebrated a great *jiao* ritual in the Palace of Eternal Spring [Changchun Gong, a Taoist temple].[14] He was honored and directed to take jade tablets to Mount Song [Henan] and the Ji River [Shandong].[15] [Thus was] made [this] *Portrait of Calming the Mind [Cunsi xiang]*. Eulogized by Zhao Mengfu of Wuxing." The presence here of Zhao Mengfu's inscription and poem is significant because it confirms the close relationships Wu Quanjie maintained with leading literati during his lifetime. Zhao Mengfu wrote many formal inscriptions for Taoist temples in Beijing and elsewhere.[16]

3. The third portrait depicts Wu in 1314, performing a Taoist ritual dance (*feibu*, or "flying pace"), most likely the "Pace of Yu" (see cat. no. 52). The accompanying note, by Yu Ji, states that in that year Wu's mother and father were granted official titles, and that the emperor gave Wu gifts of a *zun* beaker and clothing.

4. The fourth portrait depicts Wu in an informal white robe. Despite the informal pose, his status is indicated by the jade *bi* disc tied to his belt. The note describes Wu's return to Beijing after a trip to Jiangxi in 1315.

5. The fifth portrait depicts Wu Quanjie holding a *ruyi* (mushroom-shaped) scepter and seated under a pine tree

among rocks and bamboo. A crane dances in the foreground. Yu Ji's note states that Wu was greatly honored by the Yuan emperor Renzong (r. 1312–20), and that the original depiction of this scene was painted by Zhao Mengfu during this emperor's Yuanyou period (1312–20).

6. The sixth image depicts Wu in 1316, standing on a mountainous bluff and watching clouds. The note is by Yuan Jue of Siming (Ningbo, Zhejiang province).

7. The seventh image is a bust portrait from 1317. The note reads: "In the fourth year of Yuanyou, the cyclical year *dingsi* [1317], the Master concluded the cultivation of the Method of the Great Cavern [*Dadong fa*]. [Thus was] made [this] '*Niwan* Portrait' (*Niwan xiang*). Eulogized by Zhao Mengfu of Wuxing." *Niwan* refers to the upper of the three Cinnabar Fields of Inner Alchemy (*neidan*). One of the key energy centers of the human body, it is visualized at the center of the head. *Niwan* can refer to a space, a palace, and a god.[17] The term first appears in the *Inner Scripture of the Yellow Court (Huangting neijing jing)*, a text dating to the fourth or fifth century.

8. The eighth portrait depicts Wu Quanjie during the Dade reign (1297–1307). He is shown near a waterfall on Mount Lu in Jiangxi, playing a *qin* zither under a pine tree while two cranes dance.

9. In the ninth portrait, Wu is shown in 1318, carrying out a *jiao* offering ritual at the court.

10. In the tenth portrait, Wu is shown in 1297, visiting the sacred Taoist mountain of Qingcheng Shan near Chengdu in Sichuan. On this trip from Beijing to Sichuan, Wu was asked to substitute for the emperor in worshipping the god of the Yangzi River.

11. The eleventh portrait shows Wu in 1318, in the Western Hills outside Beijing, listening to the wind in the pines.

12. The twelfth portrait depicts Wu during the Zhiyuan reign (1264–94), standing at the summit of Mount Heng, the great sacred peak in Hunan. The note states that Wu was instructed by Yuan Shizu (Khubilai Khan) to offer sacrifice to Mount Heng.

13. The thirteenth portrait depicts Wu in 1327, as a high-ranking Taoist priest at the Yuan court. He wears a blue robe and holds a tablet, and is shown conducting a *jiao* ritual in the Venerating Perfection Palace (Chongzhen Gong).

14. The final portrait depicts Wu in 1331, at age sixty-three, on the occasion of a *jiao* ritual he conducted at court. Here he leans on a three-footed arm-rest (*ji*) and discusses ritual techniques (*fa*).

This handscroll is one of the few surviving portraits of a Taoist priest from the Yuan dynasty. A memorial portrait sculp-

ture of Wu Quanjie was once installed in its own hall at the Dongyue Miao in Beijing, where it was worshipped as an icon to the temple's builder.[18] An original example of Wu Quanjie's calligraphy can be seen in his colophon to Chen Rong's famous *Nine Dragons* handscroll of 1244, in the Museum of Fine Arts, Boston.[19]

—S. L.

NOTES

Cat. no. 44

1. This title does not appear on the painting itself or on its mounting.
2. For example, see the account by Lu Xiujing (406–477) in HY 1268.
3. See Benn 1991 for a detailed study of early Taoist altars.
4. See Rawski 1998: 271.

Cat. no. 45

1. The *Jinping mei* was written during the second half of the sixteenth century and first published around 1618. For the history and importance of this novel, see the introduction in Roy 1993.
2. Roy 1993: xviii.
3. The principal characters of the novel are all described in Roy 1993.
4. For more on *liandu* rites, see Boltz 1983.
5. In particular, the *Jiutian shengshen zhangjing*; the significance of this particular scripture in the *Jinping mei* has been studied in an unpublished paper; see R. Wang 1999.
6. Roy 1993: lxxiv.
7. See R. Wang 1999.

Cat. nos. 46–51

1. The text survives as a Tang dynasty (618–906) Taoist manuscript from Dunhuang in Central Asia, and corresponds to HY 1117 in the Taoist Canon (*Dongxuan lingbao sandong fengdao kejie yingshi*; *juan* 5 includes regulations on robes for Taoist priests; see Ōfuchi 1978–79: vol. 1, 223–42). The Dunhuang scroll is now in the Bibliothèque Nationale, Paris (Pelliot 2337).
2. Datong shi bowu guan 1978: pl. 2.
3. See Wilson 1995: fig. 6a–b.
4. The story of Wang Ziqiao was recorded on a late Han dynasty stele dated A.D. 165; see Chen 1988: 2; see also Ebrey 1981: 38–39. I am grateful to Joseph Steuber of the Nelson-Atkins Museum, Kansas City, who kindly sent me a copy of his master's thesis; see Steuber 1996.
5. Watson 1965: 91–93.
6. Lagerwey 1987b: 291.
7. Previously published in Kerr 1991: pl. 28, and Wilson 1995: 44, fig. 3.
8. Acc. no. 46.188; published in Mailey 1978: no. 10.

Cat. no. 52

1. The division of China into nine ancient provinces (*jiuzhou*) was one of the many achievements credited to Emperor Yu; another was the quelling of annual floods and the harnessing of great rivers. Yu's earthworks and feats of hydraulic engineering symbolized the bringing of order to chaos.
2. Andersen 1989–90: 15–16. As Andersen shows, the Pace of Yu is mentioned in both the *Ri Shu (Day Book)*, a bamboo-slip manuscript excavated in 1975 from a tomb dated 217 B.C. (Qin dynasty) at Shuihudi, Hubei province, and the *Wushi'er bingfang (Fifty-two Healing Methods)*, a medical treatise written on silk discovered in 1974 in an early Han tomb at Mawangdui, Changsha, Hunan province.
3. Ibid.: 21. On early conceptions of the Northern Dipper, see also Harper 1978–79.
4. Andersen 1989–90: 18, 37.
5. Ibid.: 38. Proper enactment of the Pace of Yu could result in transformation into a "terrestrial immortal," acquisition of the mushroom of immortality, and realization as a perfected being (*zhenren*). As Andersen has shown, in the original Shangqing teachings of the Six Dynasties period, the Pace of Yu appears to have been an individual practice, unlike its later manifestation at the center of communal ritual. This change appears to have occurred during the Tang dynasty (618–906).
6. Boltz 1987a: 34.
7. Ibid.: 33. Boltz notes that "From the *Yijianzhi* stories [compiled by Hong Mai, 1123–1202], it appears that the Tianxin practitioners were recognized above all else for their expertise in the exorcism of possessing spirits that were thought to have caused various forms of mental disturbances" (ibid.: 37–38).

Cat. nos. 53–54

1. See the chart in Bokenkamp 1983: 451.
2. The Ming woodblock-printed version of this text has a superb illustrated frontispiece depicting the Three Purities (Sanqing), the highest gods of the Taoist pantheon.

Cat. no. 56

1. The accompanying commentary is not written in a grid.
2. The complete title is *Lingbao wuliang duren shangpin miaojing*.

Cat. no. 57

1. See the biography of Zhu Youtang in Goodrich and Fang 1976, vol. 1: 375–80; see also Twitchett and Fairbank 1988: 353.
2. See Seidel 1983: 323. Seidel has shown that the imperial investiture ceremony was based on an ancient Taoist ritual.
3. Berling 1998: 956, 966. The imperial patronage of religious Taoism reached an apogee during the Jiajing reign (1522–66). Berling has shown that "the pattern of Ming imperial patronage of Taoist temples and rituals was repeated in virtually every reign." This provides a counterpoint to the better-known Ming imperial patronage of Tibetan Buddhism; see Berger 1994: 107–10.
4. Mather 1979: 118.
5. Fuqiu was the teacher of the Zhou dynasty immortal Wang Ziqiao.
6. Despite the fact that the *kesi* wrapper appears at the end of the painting, it is clear that the scroll was meant to be read from right to left (see Sung 1999: 136).
7. Zhang's biography is recorded in *Han Tianshi shijia* (1607), a text in the Wanli period (1573–1620) supplement to the Taoist Canon; see HY 1452, and ZTDZ, vol. 58: 442–43 (*juan* 4: 8–10). The *Han Tianshi shijia* documents the lives of the Ming Celestial Masters up to 1565.
8. Zhang Xuanqing here prefaced his signature with the character *chen* ("servitor"), denoting that he is a servant of the court.
9. Dragon and Tiger Mountain was Zhang Xuanqing's home.
10. This is the case in many imperial inscriptions, such as tomb epitaphs or contractual agreements with the spirit world.
11. The zodiac gods have the heads of their corresponding animal symbols on their headdresses.
12. For Empress Zhang's biography, see MS, vol. 12: 3528.
13. For information on events in the life of the Ming Celestial Master, see Seidel 1983 and *Huang Ming enming shilu*, a text in the Taoist Canon (HY 1450) documenting events in the lives of the Celestial Masters from 1360 to 1605.
14. On Zhu Yi, see GCXZL, *juan* 5: 51a–55a. Bruyn 2000 points out that during the Ming, many of the Celestial Masters from Longhu Shan married into the imperial family. Through this marriage the Celestial Master obtained a brother-in-law in Li Dongyang (1447–1516), a highly influential Grand Secretary in the reigns of Hongzhi and Zhengde, and one of the finest poets of the Ming dynasty.

Cat. nos. 58–59

1. On Sima Chengzhen and Emperor Xuanzong, see Schafer 1978–79: 58. The Tang dynasty sword is also illustrated in Schafer 1978c: fig. 4. See also Kroll 1978.
2. On Tao Hongjing, see Strickmann 1979a.

Cat. nos. 60–61

1. MS, *juan* 299: 7656.
2. The Xuande emperor was well known as a painter; see Barnhart 1993: 53–57.
3. Berling 1998: 957–58.

Cat. no. 62

1. Schipper 1993: 85.
2. Lagerwey 1987b: 80. For examples of "celestial-seal" or "cloud-seal" script, see cat. no. 57.
3. Ibid.: 39.

Cat. no. 63

1. The ring of energy around this figure is similar to inner alchemical depictions of the union of fire (*yang* energy) and water (*yin* energy) in the energy centers of the body; for example, see cat. no. 133.
2. There is apparently a mistake in this arrangement, since the trigram *kun* is shown in the place of *li* as well as in its own position, while *li* is missing altogether.
3. See the introduction to section III.5 and the entries in that section for more detail on the significance of these trigrams in Inner Alchemy.
4. Both dippers are shown with seven stars, although in fact the Southern Dipper has only six stars. The number of stars in the dippers were sometimes altered for aesthetic balance; see cat. no. 78.
5. It was sometimes believed that there was a final highest heaven above the Three Purities called the *Daluo* heaven; the single peak and the palaces at the top of this tablet may refer to this ultimate celestial realm (see also cat. nos. 65–67).

Cat. no. 64

1. Wu Quanjie's biography is found in YS: 1160–61. Valuable information on Wu Quanjie can also be found in Yu Ji's long inscription on the *River Chart Immortal's Altar (Hetu xiantan bei)* in DYXGL, *juan* 25: 5b ff. (see Sun 1981: 238–39).
2. Zhang Liusun was the most powerful Taoist at the Yuan court in the late thirteenth century. A sign of his influence was his success in seeing that the ban on Taoist scriptures that had been promulgated by Khubilai Khan in 1271 was no longer enforced.
3. As Sun K'o-k'uan has shown, the Xuanjiao school was formed by the Mongol emperors as a means of co-opting the authority of the Celestial Masters of the Orthodox Unity sect at Dragon and Tiger Mountain (Longhu Shan) in Jiangxi province. As part of this program, in 1304 the Celestial Master Zhang Zongyan was summoned to court from Longhu Shan and given the title "Head of the Zhengyi School" (Zhengyi jiaozhu); see Sun 1981: 229, and Swann 1964: 17.
4. YS: 1160.
5. Sun 1981: 224.
6. Ibid.; see also Broeck and Tung 1951: 102.
7. Sun 1981: 212–13.
8. Wu Quanjie also played a role in the choice of the forty-third Celestial Master, Zhang Yuchu (1359–1410), a pivotal Taoist of the early Ming who began a new compilation of the Taoist Canon (eventually published in 1444–45); see Broeck and Tung 1951: 77. For a painting by Wu Boli inscribed by Zhang Yuchu, see cat. no. 141.
9. Translated in Sun 1981: 225. Of all the Yuan literati, Wu Quanjie was probably closest to Wu Cheng, the greatest Neo-Confucian scholar of his day and a court official under the Mongols. Wu Quanjie and Wu Cheng came from the same home town. See Gedalecia 1981: 186–211.
10. SHMN: 372–75.
11. The same is true of the sequence of portraits recorded in the *Shanhu munan*.
12. The "pivot" *(shu)* refers to the axis determined by the relative position of the Pole Star and the earth. The Pole Star was called *Beiji* (Northern Extremity) or *Tian shu* (Pivot of Heaven). Both the terrestrial and celestial realms circumscribed this axis.
13. Kohn 1989a: 196.
14. The present White Cloud Monastery (Baiyun Guan) in Beijing is located just west of its predecessor, the Changchun Guan.
15. The jade tablets were offerings directed to the gods of Mount Song and the Ji River.
16. See, for example, Zhao's stele inscription at the Dongyue Miao, Beijing, entitled *Daojiao bei (Stele on the Taoist Religion)*, and the handscroll in the Tokyo National Museum entitled *Record of the Restoration of the Three Gates of the Xuanmiao Guan;* see Broeck and Tung 1951, and *Shodō zenshū* 1970–73, vol. 17: pls. 1–5.
17. In the body, the god Taiyi (Supreme Unity; see cat. no. 75) dwells above the *niwan;* see Robinet 1993: 100. The *niwan* itself consists of nine cavities that correspond to nine celestial palaces; see Despeux 1994: 67.

18. Broeck and Tung: pl. 2. A copy made in 1999 stands in the same hall today.
19. Wu 1997: pl. 92. The *Nine Dragons* scroll also bears colophons by Ouyang Xuan and the thirty-ninth Celestial Master, Zhang Sicheng (dated 1331; see cat. no. 73), among others.

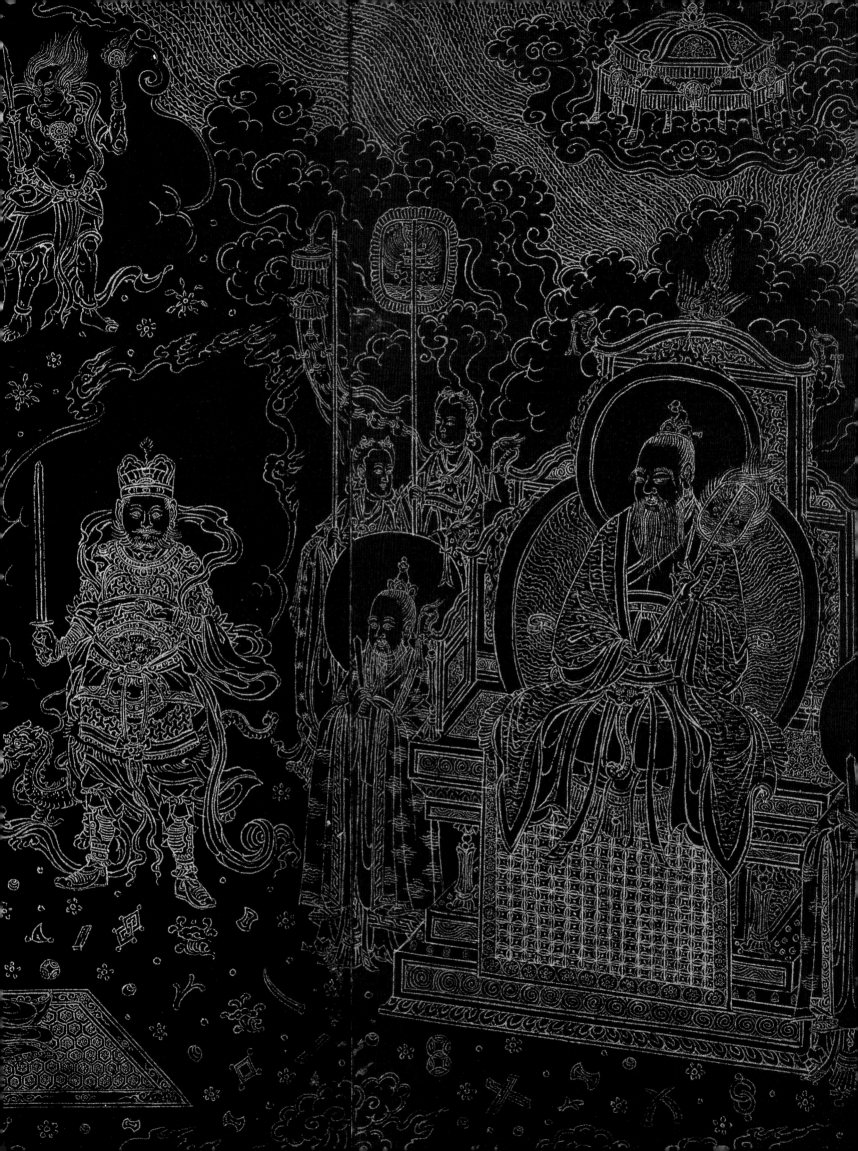

THE TAOIST PANTHEON developed with the growth of the Taoist religion in the late Han and Six Dynasties periods (second–sixth centuries). By the Tang dynasty (618–906), the Three Purities (Sanqing), one of whom was the deified Laozi, were established as the highest gods of the Taoist pantheon. In religious Taoism, the gods are conceived of as pure emanations of the Tao. An important corollary is that the gods are ultimately less important than the Tao itself. Taoism has no supreme being, but teaches that there is only the Tao that spontaneously generates the cosmos.

Taoist gods can further be defined as those deities who are represented by revealed scriptures in the Taoist Canon (Dao-zang). This characterizes the majority of Taoist gods, as opposed to the gods of popular religion, who more often begin their existence as human heroes or even animal or terrestrial spirits and who are eventually transformed into gods of the popular pantheon. Of the Three Purities, only the deified Laozi has his own mythology. Among the high gods of Taoism are the Three Officials (Sanguan): the gods of Heaven, Earth, and Water, who function as judges of human fate.

This section of the exhibition includes an eleventh-century handscroll by Wu Zongyuan in ink on silk, depicting deities of the Taoist pantheon, entitled *Procession of Immortals Paying Homage to the Primordial* (cat. no. 74). Paintings such as this may have served as models for murals in Taoist temples, and are iconographically significant because they allow us to reconstruct the Taoist pantheon at different moments in its historical development. The most spectacular surviving depictions of the Taoist pantheon are the fourteenth-century murals painted on the walls of the Hall of the Three Purities at the Eternal Joy Temple (Yongle Gong), a Yuan dynasty Taoist temple in southern Shanxi province. These murals focus on eight major gods, painted on an enormous scale, each accompanied by a large entourage of deities. The eight principal gods are the Great Emperor of the South Pole Star, the Earth Goddess (Houtu), the Jade Emperor (Yuhuang), the Purple Tenuity Emperor (Ziwei dadi), Supreme Unity (Taiyi), Metal Mother (Jinmu, the Queen Mother of the West), Wood Sire (Mugong, the ancient Dong-wanggong, Lord King of the East), and Gouchen (a celestial emperor representing the constellation surrounding the Pole Star). Among the lesser gods included are the deities of the Sun, Moon, and Five Planets, the gods of the Eight Trigrams, and the gods of the Chinese zodiac.

The images in this and other sections of the exhibition include paintings from several important sets of hanging scrolls made for use in the Water and Land Ritual (Shuilu zhai), a Buddhist rite developed in China for the universal salvation of all sentient beings from hell. Like other "fast" rituals common to both Buddhism and Taoism, the ritual was intended to establish merit (gong) for both the living and the souls of the dead in the netherworld, so that they might be released from the tortures of these hells and re-enter the wheel of reincarnation, or, better yet, ascend to the celestial realms. Until the Northern Song dynasty (960–1126), sets of Water and Land Ritual paintings included depictions of the highest gods of religious Taoism, the Three Purities (Sanqing), but from the time of Emperor Huizong (r. 1100–25) onward, the inclusion of these images was forbidden in such sets. In many cases the images of Taoist gods that appear in surviving Ming dynasty sets of Water and Land Ritual paintings provide the earliest or finest known images of particular Taoist gods, and it is for this reason that they are included in the exhibition.

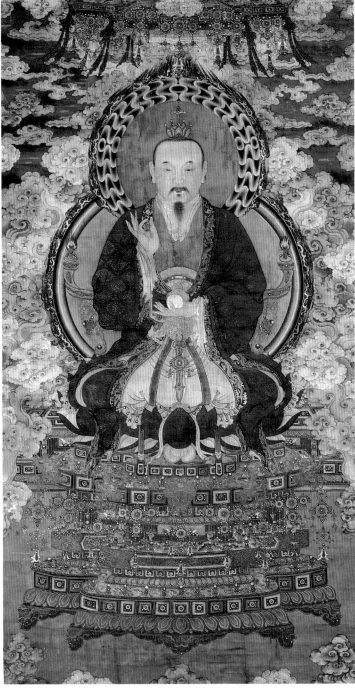

65

Celestial Worthy of Primordial Beginning

> Ming dynasty, 16th century
> Hanging scroll; ink and colors on silk
> 140 × 80 cm
> White Cloud Monastery (Baiyun Guan), Beijing

66

Celestial Worthy of Numinous Treasure

> Early Qing dynasty, 17th/18th century
> Hanging scroll; ink and colors on silk
> 160 × 80 cm
> White Cloud Monastery (Baiyun Guan), Beijing

67

Celestial Worthy of the Way and Its Power

> Early Qing dynasty, 17th/18th century
> Hanging scroll; ink and colors on silk
> 160 × 80 cm
> White Cloud Monastery (Baiyun Guan), Beijing

THESE THREE HANGING SCROLLS, from two different triptychs, depict the three highest deities of the later Taoist pantheon, the Three Purities (Sanqing). The Three Purities rule over the highest three celestial realms of Jade Purity *(Yuqing)*, Highest Purity *(Shangqing)*, and Great Purity *(Taiqing)*, also called the Three Purities; these realms are often identified with the Three Heavens *(Santian)*.[1] Each of these three fundamental embodiments of the Way in turn transforms itself threefold, resulting in nine heavens, which then manifest in the four directions, for a total of thirty-six heavens. According to the Northern Song dynasty Taoist master Zhang Junfang (active early eleventh century),

> Originally, Taoism *(daojia)* arose from what has no beginning; it left traces and responded to impulses, giving birth to the Wondrous One (Miaoyi). The Wondrous One divided into the Three Primes (Sanyuan), the Three Primes transformed into the Three Energies *(Sanqi)* and the Three Energies transformed into the Three Materials *(Sancai)*.[2] When the Three Materials grew, then all the ten thousand things were prepared for.[3]

This vision of the inception of world is derived from chapter 42 of the *Daode jing:*

> The Way gave rise to the one,
>
> The one gave rise to the two,
>
> The two gave rise to the three,
>
> The three gave rise to all the ten thousand things.

Although the deities of the Three Purities seen in these hanging scrolls were a fairly late development, the ideas that formed their basis began to appear as early as the fourth or fifth century. The threefold division of the world reflected in the "Three Energies" and the "Three Materials" described by Zhang Junfang was a fundamental part of the first attempts of the Celestial Master movement to organize the Taoist religion on a large scale in the fifth century. For example, an early Liu-Song dynasty (420–479) scripture[4] from this movement claims that Laozi (see cat. no. 1) first took shape from the Mysterious, Primordial, and Beginning energies (the Three Energies) that manifested from Great Nothingness *(Taiwu)*, and that he further spread these energies to form the heavens, the earth, and all things in between (in other words, the Three Materials). In addition, this scripture states that the teachings that Laozi transmitted to Zhang Ling, the founder of the Celestial Master movement in the Eastern Han dynasty (25–220),[5] were manifestations of the energies of the Three Heavens, and that part of Zhang's title was "Master of the Three Heavens" (Santian zhi shi).

This threefold division of the celestial realms and the energies that formed the world would eventually be associated with another three-part system, the Three Caverns *(Sandong)*. This system, first codified by the Liu-Song dynasty Taoist scholar Lu Xiujing (406–477), was a means for the Celestial Master tradition to incorporate scriptural writings from outside the movement, in particular those that included new teachings that had developed out of prominent family traditions in the area near the southern capital.[6] The Highest Purity scriptures, which centered around the Xu family from the Jurong area (southeast of modern Nanjing), were organized into the Cavern of Perfection *(Dongzhen)* category; the Numinous Treasure (Lingbao) scriptures (see cat. no. 53), which centered around the Ge family from the same area, were arranged into the Cavern of Mystery *(Dongxuan)* category; and a group of writings centered around the *Scripture of the Three Emperors (Sanhuang jing)*, which was connected with both the Xu and Ge family traditions through its supposed author, Bao Jing, were arranged into the Cavern of Divinity *(Dongshen)* category. While Taoist scriptures quickly expanded beyond the limits of these three scriptural traditions, the Three Caverns were maintained as the basis for organizing Taoist scriptures, and the Ming dynasty (1368–1644) Taoist Canon is still nominally arranged according to the Three Caverns.

Gradually, attempts were made to incorporate these different three-part doctrines into a single, coherent system, which was then applied to the Taoist pantheon; the eventual result of these attempts was the Three Purities. Early versions of the Three

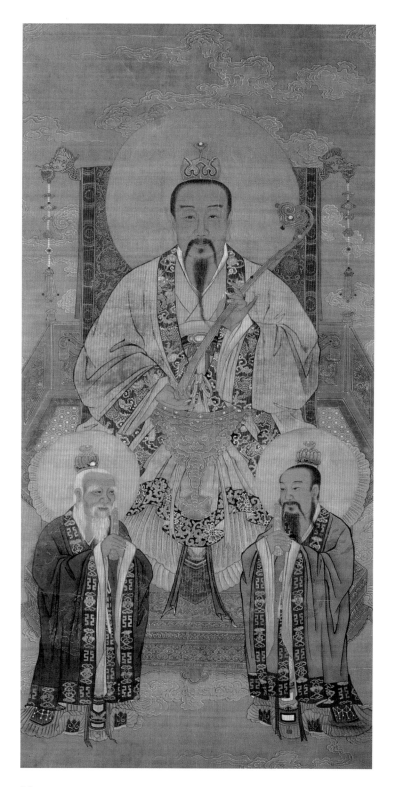

66

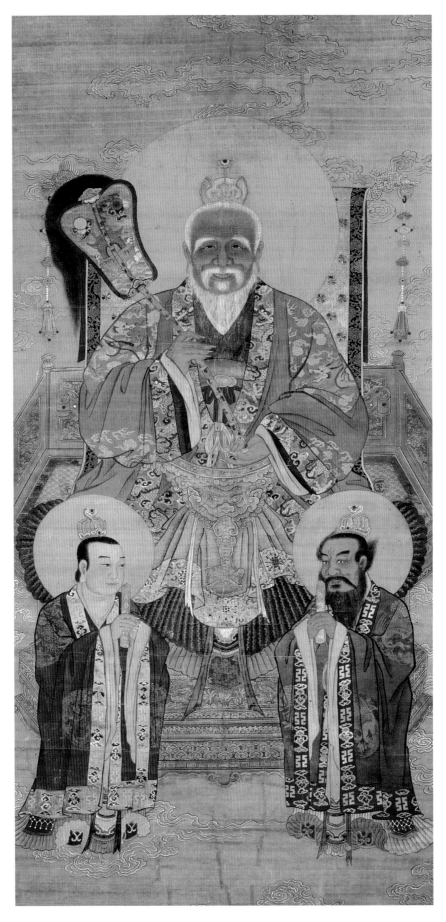

67

Purities appeared in the Tang dynasty (618–906). For example, Wang Xuanhe, a Taoist encyclopedist active during the reigns of Emperor Gaozong of the Tang (r. 649–83) and China's only empress, Wu Zetian (r. 684–705), identified Jade Purity as the realm of the Celestial Worthy of Primordial Beginning (Yuanshi tianzun), Highest Purity as the realm of the Great Highest Lord of the Grand Way (Taishang dadao jun), and Great Purity as the realm of the Great Highest Elder Lord (Taishang laojun, or Laozi).[7] The Three Purities theory continued to mature through the Tang and Song (960–1279) dynasties, and variants were developed on the basic threefold division of the highest heavens and the deities associated with them. Zhang Junfang, who was the most prominent Taoist figure of his time, stated that Jade Purity is ruled by the Celestial Treasure Lord (Tianbao jun), Highest Purity is ruled by the Numinous Treasure Lord (Lingbao jun), and Great Purity is ruled by the Spirit Treasure Lord (Shenbao jun).[8] Above these three realms is one more heaven, the highest of the highest, which is the residence of the Celestial Worthy of Primordial Beginning. Zhang's theory is fully matured, and associates these three deities with the Three Heavens, the Three Energies, and the Three Caverns.[9] At the same time, though, this theory differs from both the Tang dynasty system set forth by Wang Xuanhe and the later system evident in these three paintings. Consequently, it seems that the idea of the Three Purities, while well developed and widely supported, was still not entirely standardized by the Northern Song period.

In addition, there is evidence that the Three Purities were incorporated into Buddhist ritual during the Northern Song, which indicates that the doctrine had already expanded beyond the boundaries of Taoism by this time.[10]

These three paintings represent the Three Purities as understood by the Complete Realization (Quanzhen) sect of Taoism (see below). The first deity, who rules over the realm of Jade Purity and is the patriarch of the Cavern of Perfection scriptures, is the Celestial Worthy of Primordial Beginning. The second deity, who rules over the realm of Highest Purity and is the patriarch of the Cavern of Mystery scriptures, is the Celestial Worthy of Numinous Treasure (Lingbao tianzun). The third deity, who rules over the realm of Great Purity and is the patriarch of the Cavern of Divinity scriptures, is the Celestial Worthy of the Way and Its Power (Daode tianzun); the iconography of this last deity indicates to us that he is none other than Laozi (see cat. no. 1). These names and attributes are the end result of the various accretions that developed around the threefold division of both the celestial realms and the Taoist scriptures, beginning in the medieval period. They are at once the highest of all Taoist deities,

the rulers of the most refined celestial realms, and the patrons of the three major sections of the Taoist Canon as it still exists today. As manifestations of the Three Energies, they are the source of all life, and as the patriarchs of the Three Caverns, they are the source of all knowledge.

These paintings differ from many of the other works in this catalogue in that they come from an active Taoist temple, the White Cloud Monastery (Baiyun Guan) in Beijing, rather than from a museum. Thus, they not only are relics of past beliefs, but represent a tradition that is still alive, despite the hostile political climate of the recent past. The Three Purities are still revered in this temple, and their images hold a place of special honor in their own pavilion along the central axis of the temple grounds.[11] The White Cloud Monastery is the principal seat of the Complete Realization sect, one of the two major movements of Taoism in modern China.[12] This movement, which is best known for its doctrine of the "unity of the Three Teachings" (Sanjiao yizhi), joining together the ideals of Taoism, Buddhism, and Confucianism, grew out of the chaos of the twelfth century after the fall of the Northern Song. It gained considerable political influence through the figure of Qiu Chuji (1148–1227), also known as Qiu Changchun ("Endless Spring"), a disciple of the founder of the movement, Wang Chongyang (1112–1170).[13] Qiu was first patronized by the Jin dynasty (1115–1234) ruling house, but his support was also sought by the Southern Song (1127–1279) imperial house and the Mongols under Chinggis (Ghengis) Khan (r. 1206–27). Qiu began to court the Mongol rulers, and, in 1222, at over seventy years of age, he traveled into Central Asia to meet with Chinggis Khan, thereby linking his movement with the rising Yuan dynasty (1260–1368), which would later gain control over all of China. The White Cloud Monastery was originally named after Qiu,[14] whose remains are said to be buried under the hall devoted to him, which is in front of the Pavilion of the Three Purities. The White Cloud Monastery also originally housed the Ming dynasty woodblock edition of the Taoist Canon, which formed the basis for all modern reprints of this compilation; this Ming edition of the Taoist Canon was kept in the second floor of the Pavilion of the Three Purities.[15] In this sense, the Pavilion of the Three Purities in the White Cloud Monastery can rightly be said to be the source for all contemporary research on the religion of Taoism, and the deities worshipped there remain the patriarchs of the modern scholarly tradition.

—S. E.

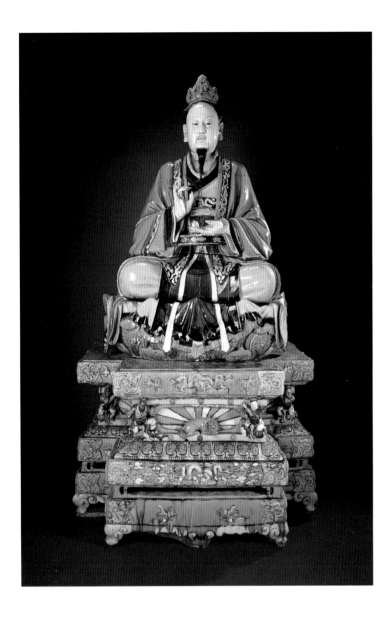

68

Celestial Worthy of Primordial Beginning

> Ming dynasty, late 15th/early 16th century
> Glazed stoneware
> H. 203 cm
> Tsui Art Foundation, Hong Kong

THE INTRODUCTION OF MAHAYANA ("Greater Vehicle") Buddhism into China through trade routes in Central Asia had a tremendous impact on Chinese religion, including Taoism. Taoist writers began to reproduce the narrative style of Buddhist writings, and to develop deities in imitation of the many Buddhas and bodhisattvas of the Mahayana pantheon. This trend is clearest in the figure of the Celestial Worthy of Primordial Beginning, an imitation of the supreme Buddhas of the Mahayana tradition.

After his initial appearance in the early fifth century, this deity quickly became the most important of all Taoist gods. By the Tang dynasty, the Celestial Worthy of Primordial Beginning was seen as the source of all Taoist teachings. Supposedly, Taoist scriptures first existed only as patterns that appeared in the pure energies of the unformed world, potent but unintelligible. The Celestial Worthy of Primordial Beginning took these patterns and refined them, casting them into gold and jade tablets with readable characters similar to talismanic script (see cat. no. 56). When the Celestial Worthy of Primordial Beginning first revealed his teachings, the blind regained their sight, the deaf were able to hear, and withered bones even sprang from their graves, filled with new life.[1] Each time a Taoist priest recited the scriptures revealed by the Celestial Worthy of Primordial Beginning, he re-enacted these miracles, freeing the souls of all living things from suffering and transforming his own body through the sacred energies contained in the scripture.

The Celestial Worthy of Primordial Beginning was eventually incorporated into the Three Purities (see cat. no. 65) as the highest of these three deities, and this assured him an unsurpassed position in the later Taoist pantheon. This large sculpture was most likely made as one of a set of three images depicting these Three Purities. The sculpture is made of separately fired and glazed parts that have been put together; this example is unusual in being largely intact.[2] The green, yellow, aubergine, blue, and transparent enamel glazes found here were widely used during the Ming dynasty for both Buddhist and Taoist ceramic sculpture, and are closely related to the glazes used in Fahua ware.

—S. E.

69

TRADITIONALLY ATTRIBUTED TO WU DAOZI
Taoist Official of Heaven

> Southern Song dynasty, first half 12th century
> Hanging scroll; ink, colors, and gold on silk
> 125.5 × 55.9 cm
> Museum of Fine Arts, Boston, Chinese and Japanese Special Fund
> (12.881)

70

TRADITIONALLY ATTRIBUTED TO WU DAOZI
Taoist Official of Earth

> Southern Song dynasty, first half 12th century
> Hanging scroll; ink, colors, and gold on silk
> 125.5 × 55.9 cm
> Museum of Fine Arts, Boston, Chinese and Japanese Special Fund
> (12.880)

71

TRADITIONALLY ATTRIBUTED TO WU DAOZI
Taoist Official of Water

> Southern Song dynasty, first half 12th century
> Hanging scroll; ink, colors, and gold on silk
> 125.5 × 55.9 cm
> Museum of Fine Arts, Boston, Chinese and Japanese Special Fund
> (12.882)

72

*Illuminated Manuscript of the Marvelous Scripture of the Most
High Three Principles Who Protect and Prolong Life, Eliminate
Disaster, Abolish Danger, Forgive Sins, and Confer Blessings*

> Ming dynasty, Chenghua reign, dated 1470
> Accordion-mounted album; gold on indigo paper
> 30.5 × 21.3 cm (each page)
> Museum of Fine Arts, Boston, Asiatic Curator's Fund and
> Frederick L. Jack Fund (1996.58)

THE TRIAD OF GODS known as the Three Officials (Sanguan)
emerged in the religious Taoist pantheon as early as the late
Han dynasty (second century). These gods function as judges of
human fate. According to a Taoist scripture of the fifth century
(the *Taishang santian neijie jing,* or *Supreme Scripture on the Inner
Elucidation of the Three Heavens*), the Three Officials played a
role in the deified Laozi's initial revelation in A.D. 142 to the first
Celestial Master of religious Taoism, Zhang Daoling. As a conse-
quence of this revelation, Zhang Daoling "made a contract with
the Three Officials of Heaven, Earth, and Water respectively, as
well as with the generals of the star of the Great Year [*Taisui,* or

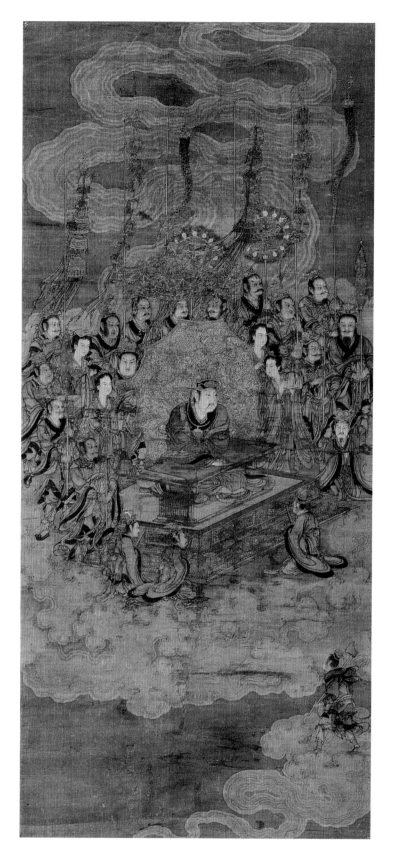

69

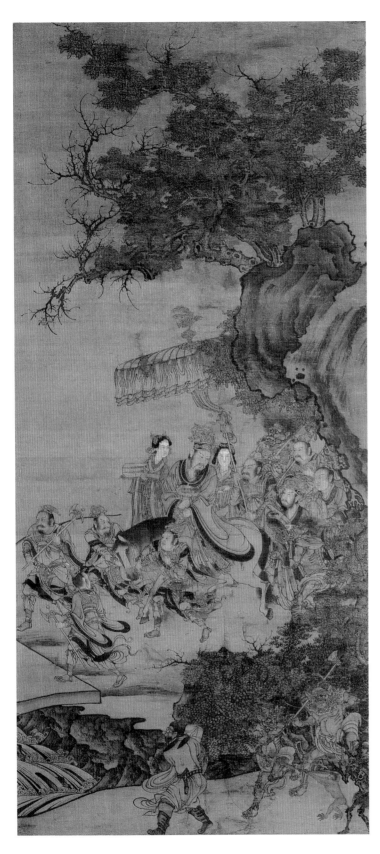

70

Jupiter], so that they then entered the orthodox system of the Three Heavens and no longer opposed the faithful."[1] It is noteworthy that the origin of the Three Officials is older than that of the Three Purities (Sanqing), the highest gods of the religious Taoist pantheon (see cat. nos. 65–67).

The Three Officials also appear in such fifth-century Lingbao scriptures as the *Precepts of the Three Primes (Sanyuan pin)*, and the *Supreme Secret Essentials (Wushang biyao)*, a Taoist encyclopedia compiled during the Northern Zhou dynasty in the late sixth century.[2] Thereafter the Three Officials played a key role as intermediaries between human beings and the bureaucracy of the netherworld of the dead. Certain days of the ritual calendar were reserved for the offering of petitions to the Three Officials, when these gods would review an individual's merits and demerits: the seventh days of the first and seventh months, and the fifth day of the tenth month.[3] On these occasions, petitions to the Official of Heaven (Tian guan) were burned (and thus carried via smoke to the heavens), petitions to the Official of Earth (Di guan) were buried, and those to the Official of Water (Shui guan) were submerged.[4]

The theme of the Three Officials is recorded as having been painted as early as the Tang dynasty (618–906).[5] The earliest surviving depiction of these gods, however, may be that in the well-known Junkunc album, datable to the early Southern Song dynasty (twelfth century).[6] There the gods are shown with the official titles they were granted in the Northern Song dynasty (960–1126), and are accompanied by Emissaries of the Five Directions. The most elaborate depiction of the Three Officials from the Song dynasty (960–1279), however, is found in the triptych of twelfth-century hanging scrolls in the Museum of Fine Arts, Boston (cat. nos. 69–71).[7] Painted in ink, colors, and gold on finely woven silk, with great visual coherence and meticulous attention to detail, these are among the finest surviving Taoist paintings of the Song dynasty.[8] Each painting depicts one of the Three Officials in his realm, surrounded by an entourage of lesser gods and attendants.

The Official of Heaven (cat. no. 69) is shown seated on a platform, surrounded by a large entourage of male and female attendants; the entire group floats on a pale reddish cloud against a void painted in green wash. The Official leans on a low table. Facing him is a kneeling acolyte holding a tablet. An elaborate mandorla appears behind the god, and a canopy is held over his head. This mandorla is decorated in ink and gold with twin dragons against a dense ground of floral scrolls. Fourteen attendants hold a variety of banners, standards, fans, and offerings. In the lower right corner, a single figure holding an axe ascends on a cloud.

In the central painting of the Boston triptych (cat. no. 70), the Official of Earth is shown traveling on horseback through a landscape, accompanied by an entourage of attending gods, immortals, and demons. A parasol surmounted by a phoenix is held over the official's head. The god is dressed in the guise of an emperor of high antiquity *(shanggu),* and holds a switch in his right hand. The figures accompanying the Official of Earth are both male and female. A demonic attendant walking behind the horse holds a falcon in his hand. At the bottom of the painting is Zhong Kui, the Demon Queller, accompanied by three demons and a monkey. The rocks and trees of the landscape are painted in a style derived from that of the Northern Song (eleventh century) master Guo Xi.[9] Like the earthforms, the foliage is painted primarily in ink, with occasional additions of pale green pigment; here the "crab-claw" brushwork in tree branches is also derived from Guo Xi. The painting of the figures is exceedingly fine, with sensitively rendered facial expressions.

The third painting depicts the Official of Water crossing the roiling waves of an ocean on the back of a dragon (cat. no. 71). The character *wang* (king) appears on the front of his crown. An ornate canopy is held over the official's head. He is accompanied by a host of attendants, including five demons at the bottom of the scroll; two of the attendants ride on the backs of sea turtles. The painting is executed primarily in monochrome ink, with occasional additions of orange-red pigment in the figures' robes. Gold highlights appear throughout the scroll, for example in the attendants' armor, staffs, and hats. The eyes of the dragon are painted red, with gold pupils. The roofs of an underwater palace emerge from the waves at the lower right corner. Above, in the clouds, the god of thunder (Leigong) pounds on a set of drums, while a red-robed scholar and a female figure appear in the upper right corner. The painting of the background waves, rendered in monochrome ink, stands among the finest depictions of water in Chinese painting, despite the fact that the lower edge of the painting is completely repaired.

As Wu Tung has shown, in Chinese paintings of the Ming (1368–1644) and Qing (1644–1911) dynasties, the Three Officials are more often depicted in one scroll.[10] The grouping of all three gods together does occur at least as early as the Song dynasty, however, as can be seen in a leaf in the Junkunc album. The Three Officials are also shown as a group in the fourteenth-century Taoist murals at the Eternal Joy Temple (Yongle Gong) in southern Shanxi province, where they form part of the entourage of the star-god Gouchen.[11] A Ming painting in the National Palace Museum, Taipei, entitled *The Three Officials Conducting an Inspection Tour,* has traditionally been attributed to the Southern Song court painter Ma Lin (active early to mid-thirteenth

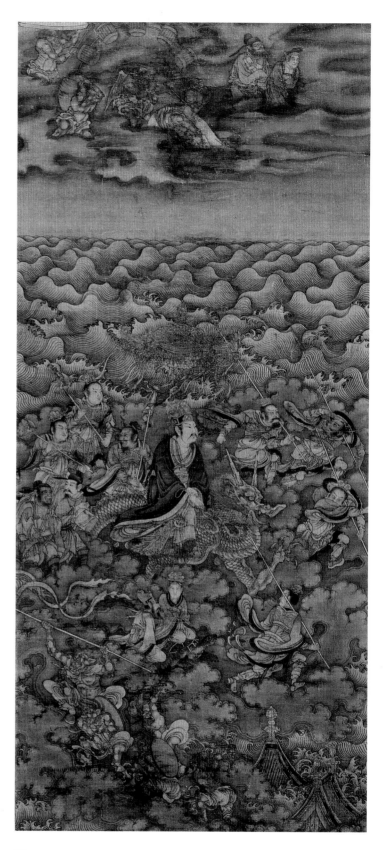

71

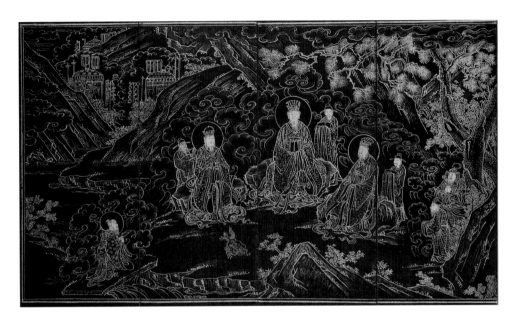

72 (detail)

century).[12] Painted in ink and colors on silk, this work depicts all three officials and their respective entourages in one composition. At the bottom, riding a dragon through waves, is the Official of Water; in the middle ground, riding on a white mythical beast, is the Official of Earth; and at the top, riding in a cart pulled by another mythical beast, is the Official of Heaven. Despite the attribution to Ma Lin, it appears that this work should be attributed to an artist of the Ming dynasty, most likely working in the sixteenth century.[13] A slightly earlier image of all three gods together is found among the fifteenth-century Water and Land Ritual *(Shuilu zhai)* paintings from the Treasured Tranquility Temple (Baoning Si), now in the Shanxi Provincial Museum, Taiyuan.[14]

The early Ming illuminated Taoist scripture in the Museum of Fine Arts, Boston (cat. no. 72), is a transcription of a text in the Taoist Canon that describes the efficacy of the Three Officials. Composed in the Southern Song (1127–1279) or Yuan (1260–1368) dynasties, the full title of the text is *Marvelous Scripture of the Most High Three Principles Who Protect and Prolong Life, Eliminate Disaster, Abolish Danger, Forgive Sins, and Confer Blessings (Taishang sanyuan cifu shezui jie'e xiaozai yansheng baoming miao jing)*, also known as the *Scripture of the Three Officials (Sanguan jing)*.[15] The Boston manuscript is a handwritten, accordion-mounted album. The frontispiece, painted in gold and pale blue pigment on indigo paper, depicts the Three Officials seated in a landscape. Each official is attended by a civil official or attendant. To the left a worshipper holding a tablet kneels on a rock slab, while a guardian and scholar stand in attendance at the right. In the left background are three carriages prepared for an inspection tour by the Three Officials of their respective realms.

On the ground at the center, in front of the three gods, is a tortoise. The landscape includes rocks and pines with scrolling clouds above, all painted in gold. The text is written with seventeen characters per vertical column, a format imitating Buddhist *sutras*. The full title of the scripture appears following a short preface. A dedication at the end is dated to the second lunar month of the sixth year of Chenghua (1470), but states that the scroll was actually finished in the first lunar month of the preceding year:

> Made in the first month of the fifth year of Chenghua (1469). Within I devote my heart and grant funds (to make this) gold book, the *Marvelous Scripture of the Most High Three Principles Who Protect and Prolong Life, Eliminate Disaster, Abolish Danger, Forgive Sins, and Confer Blessings,* in order, through this action, to (accumulate) merit and (cultivate) virtue. I pray for my household, that it enjoy what is pure and auspicious, and that (the Three Officials) protect my family. This preface (is written) in order to unite and pacify fires and robbers, and to remove all *karma;* consequently I think of this. Inscribed on an auspicious day of the twelfth month, in the sixth year of Chenghua (1470).

While the majority of surviving images of the Three Officials from traditional China are paintings, sculptural images of these gods were also made. Among the finest of these are the set of enormous Ming dynasty wood sculptures now located in the main hall of the recently renovated Temple of the Eastern Peak (Dongyue Miao) in Beijing; these colossal figures also date to the Chenghua reign (1465–87).[16]

—S. L.

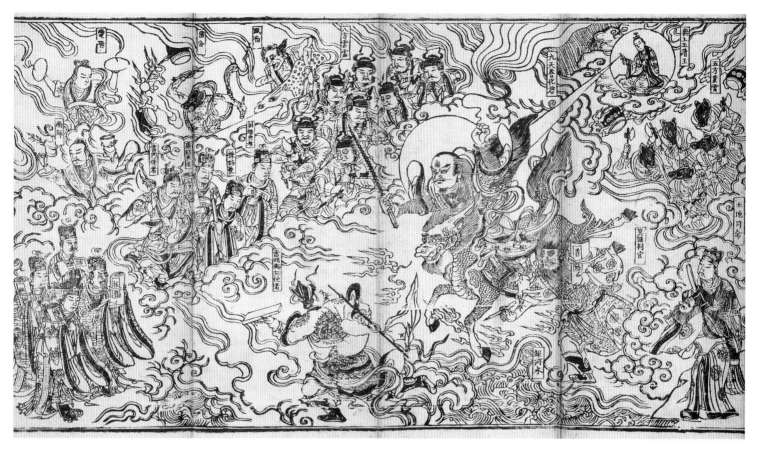

73

Uppermost Highest Spirit Thunder Jade Pivot Thunderous Peal Precious Scripture with Talismanic Seals

> Yuan dynasty, Zhishun reign, colophon dated 1333
> Woodblock-printed book, ink on paper
> 33.2 × 12.5 cm (each page)
> The British Library, London (15103.aa.2)

THIS RICHLY ILLUSTRATED woodblock-printed book is an annotated edition of the Southern Song dynasty *Precious Scripture of the Jade Pivot (Yushu baojing).*[1] This scripture developed from the Divine Empyrean (Shenxiao) movement, which began as an imperial cult sponsored by the late Northern Song emperor Huizong (r. 1100–25); Huizong believed himself to be an incarnation of the supreme deity of this movement.[2] There are three commentaries included in this version, attributed to the Taoist master Bai Yuchan (1194–1228); the first patriarch of the Celestial Master movement, Zhang Daoling (second century); and a certain "Celestial Lord Zhang, Emissary of the Five Thunders." These commentaries are accompanied by a set of eulogistic poems attributed to Lü Dongbin (see cat. no. 120). The name of the scripture is explained by one of these commentaries as follows:

Jade is the essence of the heavens and the earth, the sun and moon; it is the congealed flower of *yin* and *yang,* water and fire. . . . It does not decay, even after ten thousand years. Pivot means trigger, axis. It is the origin of life and death.

This scripture is said to have been revealed to the Thunder Master Luminous Elder (Haoweng) by a deity called the Celestial Worthy of the Nine Heavens Who Responds to the Primordial, with a Voice of Thunder, Transforming All. According to the commentary, "Thunder is the command of the heavens. . . . The heavens do not speak—thunder speaks for them." It was believed that this deity supervised a group of officers who controlled life and death, prosperity and failure, and that he was surrounded by an orchestra of thirty-six spirits (for the manifestations of the highest nine heavens in the four directions) who beat the drums that made the thirty-six different kinds of thunder. In this scripture, he is said to have taken a vow to save all beings who recite his name, probably in imitation of Buddhist deities such as Amitabha or Avalokiteshvara (Guanyin). Moreover, the scripture claims to aid all those who recite it during times of illness or difficulty and who employ the protective talismans included at the end of the scripture.

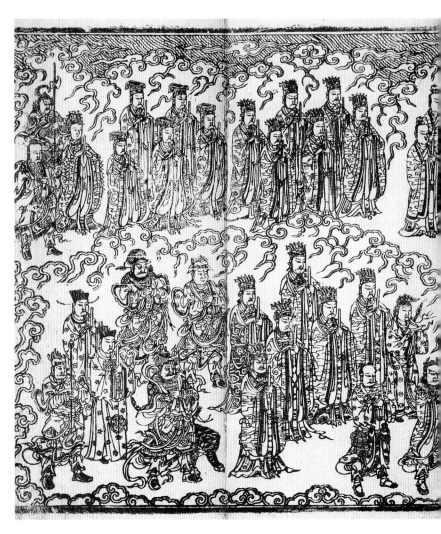

(detail)

This edition contains over two dozen illustrations corresponding to the narrative of the scripture, in addition to a magnificent frontispiece, a depiction of a procession of deities, and other supplementary illustrations; these are not preserved in the corresponding text in the Taoist Canon. In addition, this edition is one of the few (if not the only) printed versions of any Taoist scripture that predate the present, Ming dynasty Taoist Canon. As such, it is of unparalleled importance for our understanding of printed Taoist scriptures before the Ming, at the same time that it preserves a more complete edition of the *Precious Scripture of the Jade Pivot* than those found in the Ming Taoist Canon.

The first illustration shown here, which comes toward the end of the scripture, accompanies a *gatha* metrical hymn, a feature adopted from Buddhist scriptures:

> The Highest Prince of Jade Purity
> Unites the thirty-six heavens;
> The Lord of the Nine Heavens Who Transforms All

Changes his form for the worlds of all ten directions.
With loose hair, he rides a magical beast *(qilin)*,
With bare feet, he treads over layered ice.

The commentaries read the titles in the first and third lines as both referring to the Celestial Worthy who transmitted the scripture, although the illustration shows the Lord of the Nine Heavens (the central figure) in line three as a manifestation of the Highest Prince of Jade Purity (shown in the upper right, with a beam of energy directed from his upraised hand to the central figure), whose relationship with the Celestial Worthy is unclear owing to a lack of defining attributes. The Lord of the Nine Heavens is accompanied by a fierce figure who carries the records of good and bad actions, and four figures in charge of punishing wrongdoers are shown in the lower left corner. The other figures are all officials under the control of the Lord of the Nine Heavens, including many thunder gods. Of particular interest are the popular gods in the upper left corner: the Earl of Wind (Fengbo), shown with an animal skin that holds the winds; the Duke of

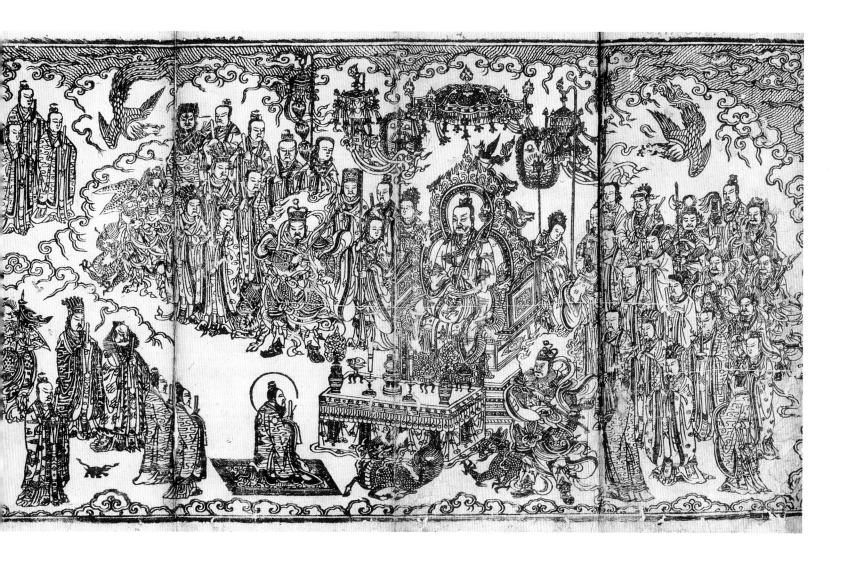

Thunder with his circle of flaming drums; the Mother of Lightning, holding mirrors that emit lightning bolts; and the Rain Master, holding a cup full of rain and a branch with which to scatter it over the earth.

The second illustration shown here is the frontispiece. This frontispiece shows the initial revelation of the scripture in Jade Purity, the highest of the Three Purities (see cat. no. 65). The Celestial Worthy sits in a throne aflame with magical energy, flanked by two celestial guardians and a host of other civil and martial officials. In his hands he holds his principal attribute, a mushroom-shaped scepter *(ruyi)* of golden light. Phoenixes hover above him, while other magical animals sport before his throne. The Luminous Elder kneels before an altar in front of the Celestial Worthy as he receives teachings, followed by a host of other deities in the lower register of the image. Hovering above these deities in the upper register is a second line of deities, at least some of whom appear to be star gods.[3] The frontispiece is followed by an illustration of a procession (not shown here)

of Taoist patriarchs *(jiaozhu)*, realized beings *(zhenren)*, celestial lords *(tianjun)*, and marshals *(yuanshuai)*, led by the Perfected Warrior (Zhenwu; see cat. no. 103). The procession includes many figures who are illustrated elsewhere in this catalogue, such as Lü Dongbin (see cat. no. 120), Emperor Guan (see cat. no. 83), and Marshal Wen (see cat. no. 87).

After the scripture come a commentary and two colophons. One of the colophons, written by the thirty-ninth Celestial Master, Zhang Sicheng, and dated to 1333, is printed in imitation of the Celestial Master's own script, which suggests that it was originally written to commemorate this edition. These three additions all identify this annotated version of the scripture with the Yuan dynasty figure Xu Daoling.[4] Little is known of Xu, but another scripture annotated by him in the Taoist Canon includes a commentary dated to 1334, indicating that he was still alive when this edition was published.[5]

—S. E.

WU ZONGYUAN (ACTIVE EARLY 11TH CENTURY)
Procession of Immortals Paying Homage to the Primordial

Northern Song dynasty, early 11th century
Handscroll; ink on silk
58 × 777.5 cm
Private collection

WU ZONGYUAN was one of the greatest painters of Taoist images of the early Northern Song dynasty (960–1126). Working in the style of the Tang dynasty muralist Wu Daozi (active c. 710– c. 760), Wu received many commissions to decorate the walls of Taoist temples in Kaifeng, the Northern Song capital.[1] An official as well, he attained the rank of Vice President of the Bureau of Parks, Lakes, and Mountains.[2] It is significant that the first half of his career, during which he was most productive, corresponded to the reign of Emperor Zhenzong (r. 998–1022), one of the most devoted of all Northern Song rulers to religious Taoism.[3] Wu Zongyuan was recorded as having made handscroll copies of two Wu Daozi murals in Kaifeng.

Painted in ink on two pieces of pale brown silk, this long scroll (over seven meters) depicts a magnificent procession of Taoist gods, moving from right to left over a series of bridges that span a lotus pond. The composition resembles surviving murals depicting gods of the Taoist pantheon from temples of the Yuan dynasty (1260–1368), and Xu Bangda and others have suggested that it is a sketch for such a mural painting.[4] It is possible that it transmits the composition of either such a Tang mural by Wu Daozi, or one of Wu Zongyuan's own murals in a Northern Song Taoist temple. The scroll is truncated at the beginning. It presents an extraordinary vision of a celestial realm of the type described in the early visions of the Highest Purity (Shangqing) movement—a heaven populated by elegant gods and goddesses. Each of the deities is labeled, with names written in standard-script characters in cartouches adjacent to each figure. The painting is remarkable for the strength and fluidity of its brushwork, and is the earliest surviving Taoist work of its type. Despite its astonishing quality, the painting is clearly an unfinished sketch; this is evident from such details as the partially finished trees and lotus plants and the informal rendering of many of the figures' hair, painted in pale wash only with no further detail.

The Taoist deities in this handscroll are painted in different sizes, a reflection of their respective rank in the celestial bureaucracy. The primary deities, shown larger than their attendants, are the Great Emperor of Fusang (Fusang dadi), the Celestial Emperor of the Southern Pole [Star] (Nanji tian dijun), and the Eastern Floriate Celestial Emperor (Donghua tian dadi). The first represents the mythical realm from which the sun rises, the second the god who determines the length of human life, and the third Dongwanggong (Lord King of the East), the ancient consort of the Queen Mother of the West (Xiwangmu), in his later manifestation as Mugong (Wood Sire). In the fourteenth-century murals in the Hall of the Three Purities (Sanqing Dian) at the Taoist Eternal Joy Temple (Yongle Gong) in Shanxi, both the Emperor of the Southern Pole Star and the Eastern Floriate Celestial Emperor are depicted in much the same guise, although seated.[5] In the Yongle Gong murals, which are nearly three hundred years later in date than the Wu Zongyuan handscroll, the gods are also surrounded by many other Taoist gods and realized beings.

Among the many attending gods in this handscroll are male and female figures with such names as Supreme Ultimate Immortal Marquis (Taiji xianhou), Nine Doubts Immortal Marquis (Jiuyi xianhou),[6] Primordial *Yang* Youth (Yuanyang tongzi), Supreme Clarity Immortal Earl (Taiqing xianbo), Supreme Cinnabar Jade Maiden (Taidan yunü), Opening Brightness Youth (Kaiming tongzi), Opening Radiance Youth (Kaiguang tongzi), Brahma Ether Maitreya Jade Maiden (Fanqi Mile yunü), and Brahma Treasure Cinnabar Glory Jade Maiden (Fanbao danchang yunü). Aside from the presence of names borrowed from the Buddhist world, it is noteworthy that in this painting, the attendant deities called "youths" (tongzi; literally, "lads") are all female. The precise scriptural source (if one exists) of this pantheon has yet to be identified.

The earliest reliable colophon on the scroll is by the Yuan scholar-artist Zhao Mengfu (1254–1322).[7] It is dated to 1304, and in it Zhao attributes the scroll to Wu Zongyuan. The scroll's current title was written by the epigrapher Luo Zhenyu (1866– 1940), and has been translated as *Procession of Immortals Paying Homage to the Primordial (Chaoyuan xianzhangtu)*. In this context, the word *yuan* (prime or primordial) refers to the Tao. There is a reduced-scale copy of this scroll in the Xu Beihong Memorial Museum, Beijing.[8] It is slightly later in date, painted on paper, and lacks the identifying inscriptions of the Wu Zongyuan scroll.

—S. L.

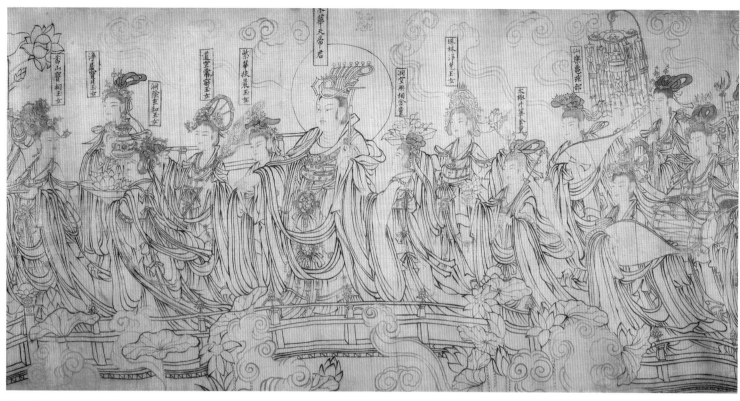

(detail)

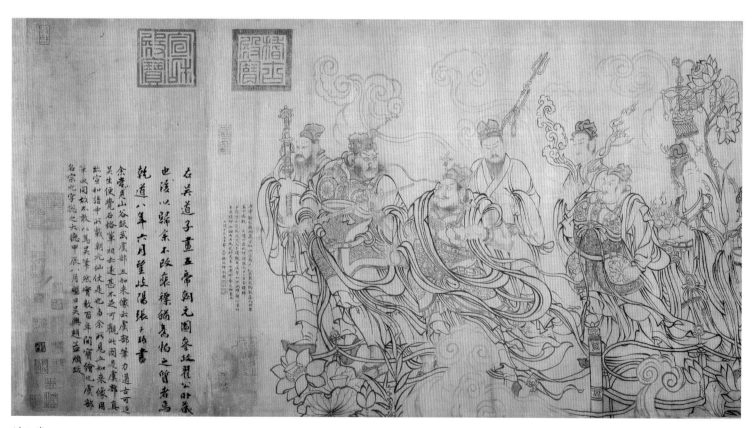

(detail)

The God Taiyi and Attending Deities

From the Treasured Tranquility Temple (Baoning Si), Youyu county,
 Shanxi province
Ming dynasty, c. 1460
Hanging scroll; ink and colors on silk
116 × 61 cm
Shanxi Provincial Museum, Taiyuan

TAIYI (SUPREME UNITY) is one of the oldest gods of the Taoist
pantheon. His worship can be traced to the Warring States pe-
riod (475–221 B.C.), well before the emergence of Taoism as an
organized religion, and continues to the present day.[1] The early
importance of this god has been confirmed by the recent discov-
ery of a text known as *Taiyi Generates Water (Taiyi sheng shui)*
from a fourth-century-B.C. tomb at Guodian, Hubei province.
Based on his research on this text, Donald Harper has shown
that Taiyi was a cosmogonic god, a creator of the universe whose
actions mirror those of the Tao, who was already worshipped by
the social elite in the Warring States period. Taiyi (or Donghuang
Taiyi, the Eastern August Supreme Unity) is also the first god
described in the "Nine Songs," a series of shamanistic hymns
found in the ancient anthology the *Songs of Chu (Chuci)*.[2]

The early Han text *The Master of Huainan (Huainanzi)* states
that Taiyi resides in the celestial palace known as Taiwei (Su-
preme Tenuity), later known as Ziwei Gong (Purple Tenuity Pal-
ace).[3] During the Han dynasty (206 B.C.–A.D. 220), sacrifices
to the astral god Taiyi were part of the imperial cult.[4] The *Inscrip-
tion for Laozi (Laozi ming),* the late Han stele documenting
Laozi's divination, states that Laozi "concentrated his thinking
on the cinnabar field, saw Great Unity (Taiyi) in his purple cham-
ber, became one with the Tao, and transformed into an im-
mortal."[5] In the Han dynasty apocryphal texts known as *weishu,*
the Northern Dipper was perceived as the instrument of Taiyi:
"It is described variously as the ladle by means of which he pours
out the primordial breath *(yuanqi)* and as the chariot in which
he moves through the heavens."[6] A celestial god, Taiyi was
sometimes known as the "supreme emperor of heaven."[7] He
was associated with the star Kochab, known in Chinese as
Thearch *(Di),* part of the Little Dipper (Ursa Minor). A passage
from the *Records of the Historian (Shiji)* of Sima Qian (second
century B.C.) reads:

> The Dipper is the Thearch's carriage. It revolves around the
> central point and majestically regulates the four realms. The
> distribution of *Yin* and *Yang,* the fixing of the Four Seasons, the

coordination of the Five Phases, the progression of rotational
measurements, and the determining of all celestial markers—
all of these are linked to the Dipper.[8]

Schuyler Cammann, citing the *Records of the Historian* and the
History of the Former Han Dynasty (Qian Hanshu), writes,

> The Han records state that after Wudi [r. 140–87 B.C.] came to the
> throne in 140 B.C., he regularly conducted the usual sacrifices to
> Heaven and to Earth, to the Five Emperors (legendary rulers repre-
> senting the Five Elements), and to the Sun and the Moon (for Yang
> and Yin), in order to insure the orderly regularity of the universal
> process; but in 124 B.C. he was persuaded to adopt, in addition, the
> cult of Taiyi. At first this was merely an additional form of worship,
> using a separate shrine, but in 113 B.C., having been told that the
> Five Emperors were only this god's aides, Emperor Wu displaced
> from the central location in the imperial rites the Yellow Emperor
> (Huangdi), who represented the Center among the Five Directions,
> in order to give Taiyi the focal position in the state worship.[9]

According to recent research by Li Ling, images of Taiyi can
be traced back to as early as the Warring States period.[10] During
the Tang dynasty reign of Xuanzong (712–56), sacrifices to Taiyi
were fully incorporated into imperial Taoist rituals.[11] By the time
of the fourteenth-century Taoist murals of the Eternal Joy Temple
(Yongle Gong), a Complete Realization (Quanzhen) sect temple
in southern Shanxi province, Taiyi is shown in the guise of an
emperor, with a mortarboard-type hat with tassels, and holding
a tablet.[12]

In the Water and Land Ritual *(Shuilu zhai)* painting from
the Treasured Tranquility Temple (Baoning Si), Taiyi is shown at
the center, surrounded by five attending gods.[13] He clenches his
hands together in front of his chest, as do the two attending
gods in front. Of the remaining attendants, two hold lances, and
one holds a pole with a white banner. Here Taiyi takes on the
appearance of Zhenwu (Perfected Warrior), Supreme Emperor
of the Dark Heaven, reflecting the enormous popularity and
influence of Zhenwu during the Ming dynasty (see section III.3,
"Zhenwu, the Perfected Warrior"). At the time the Treasured
Tranquility Temple Water and Land Ritual paintings were cre-
ated, Zhenwu was the most important Taoist god in China. The
resemblance of Taiyi to Zhenwu is unmistakable: both figures
wear robes covering armor, and have long hair combed straight
back from their foreheads (see cat. no. 103). Unlike Zhenwu,
however, Taiyi wears boots (Zhenwu is usually shown barefoot).

—S. L.

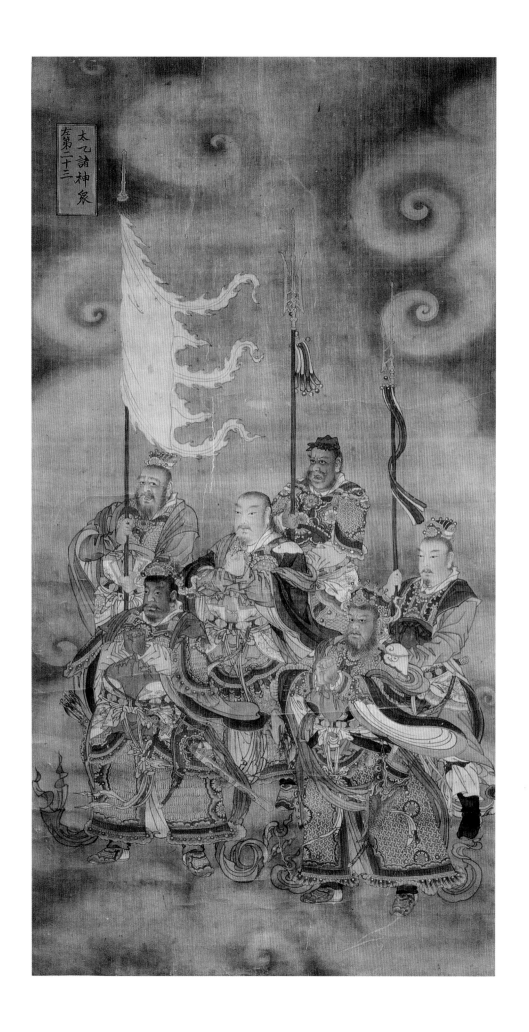

76

The Purple Tenuity Emperor of the North Pole [Star] and Attendants

From the Treasured Tranquility Temple (Baoning Si), Youyu county, Shanxi province
Ming dynasty, c. 1460
Hanging scroll; ink and colors on silk
117 × 60.5 cm
Shanxi Provincial Museum, Taiyuan

THIS SCROLL IS FROM a set of Water and Land Ritual *(Shuilu zhai)* paintings; the surviving set comprises one hundred and thirty-nine hanging scrolls depicting a variety of Buddhist and Taoist gods and other beings.[1] These paintings were designed for use in a Buddhist ritual, but include some of the finest known depictions of Taoist gods. The goal of the Water and Land Ritual was the universal salvation of all beings, generic depictions of which are shown in the scrolls of this and other, similar sets that survive from the Ming (1368–1644) and Qing (1644–1911) dynasties. The paintings include depictions of gods of the animal and plant worlds, human beings, and gods of the Buddhist, Taoist, and popular pantheons.

In the Treasured Tranquility Temple (Baoning Si) painting, the Purple Tenuity Emperor (Ziwei dadi) appears in the central foreground, accompanied by six attendant deities. The background is taken up by swirling clouds. The Ziwei emperor is shown in the guise of a ruler of high antiquity *(shanggu),* holding a tablet in his hands, and wearing a crown in the shape of a long horizontal board with tassles hanging from either end. He wears a blue outer robe decorated with dragons; his inner robes are red and green, with white hem and collar. The gods to either side also carry tablets of rank in their hands, while the other four attending gods respectively hold a canopy, banners, and a basket of flowers.

Like many Taoist gods, the Purple Tenuity Emperor and his attending deities were conceived of as celestial counterparts to the emperor and his court on earth.[2] One of the most powerful gods in the Taoist pantheon, the Ziwei emperor was viewed since at least the Han dynasty as a god controlling one of the most influential constellations in the northern sky. The emperor of the Ziwei court is still widely worshipped in Taoist temples today, and often depicted in painting and sculpture.

The first known mention of the Ziwei Palace is found in the *History of the Han Dynasty (Han shu),* in a description of a comet that appeared in 138 B.C.[3] The early Han dynasty Taoist classic

The Master of Huainan (Huainanzi), presented to Emperor Wudi by Liu An (d. 122 B.C.), prince of Huainan, mentions the Purple Palace *(Zi Gong),* the asterism ruled by the emperor depicted in the Baoning Si painting: "The Purple Palace is the dwelling place of the Grand Monad (Taiyi)."[4] The multiplicity of celestial gods that occupy the Purple Palace asterism is attributable to the simultaneous conceptualization of constellations as gods and as homes of gods. This correlative thinking is articulated in Han dynasty (206 B.C.–A.D. 220) texts, but appears to have originated earlier. It is significant that as the dwelling place of the older god Taiyi (conceptualized since the Warring States period as equivalent to the Tao), the Purple Tenuity *(Ziwei)* Court occupies a position in the heavens in immediate conjunction to the Northern Dipper and the Pole Star *(Beiji).*[5] The Purple Tenuity court was one of three celestial courts *(yuan)* that enclosed large groups of constellations; the others were known as Supreme Tenuity *(Taiwei)* and Heavenly City *(Tianshi).*[6] The individual star groups that comprised the Purple Tenuity court were first listed in the second century B.C., in the "Treatise on Celestial Officials [Constellations]" *(Tianguan shu)* chapter of Sima Qian's *Records of the Historian (Shiji).*[7]

In the fourteenth century, the Ziwei emperor was still counted as one of the most important Taoist gods of the Complete Realization (Quanzhen) pantheon, as depicted in the Yuan dynasty murals at the Eternal Joy Temple (Yongle Gong) in Shanxi province.[8]

—S. L.

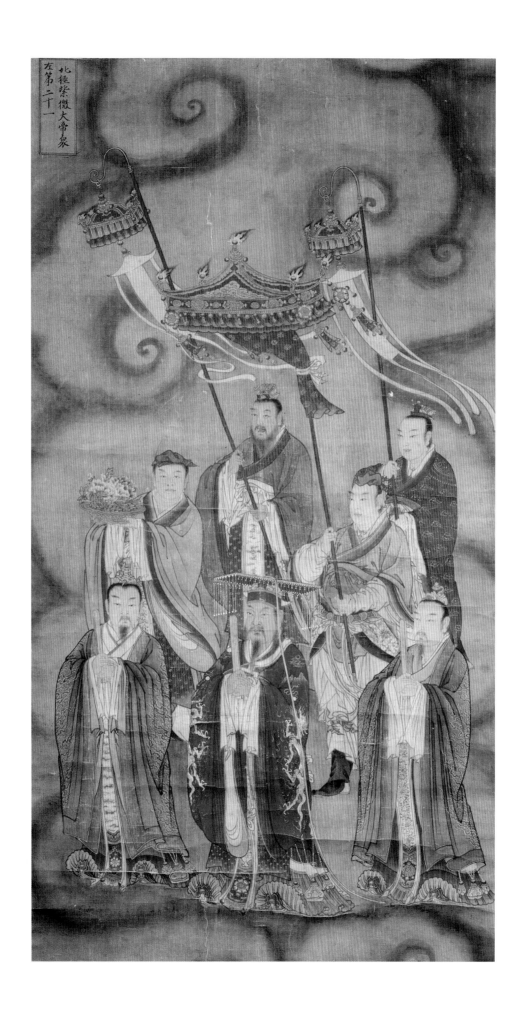

77

Marvelous Scripture of Salvation that Prolongs Life

Ming dynasty, Longqing reign, dated 1568
Accordion-mounted album; gold on indigo paper
25.9 × 11.9 cm (each page)
Arthur M. Sackler Museum, Harvard University,
 Philip Hofer Bequest (85.1971.518)

ALTHOUGH THE OUTER COVER of this Ming dynasty Taoist
manuscript in the Sackler Museum bears the title *Marvelous
Scripture of the Mysterious Numinous Northern Dipper That Pro-
longs Life, Revealed by the Most High [Laozi] (Taishang xuanling
beidou yansheng miaojing)*, the text actually consists of several
related scriptures. These were traditionally said to have been
revealed in A.D. 155 by the deified Laozi to Zhang Daoling, the
first Celestial Master, in Sichuan.[1] The texts were most likely
composed, however, during the Five Dynasties (907–960) or
early Northern Song (late tenth century) periods.[2] The complete
group of texts to which these scriptures belong contains peti-
tions for summoning key stellar gods, including the deities of
the Seven Stars of the Northern Dipper and the gods of the
Southern, Eastern, Western, and Central Dippers.

The texts included in this manuscript are inscribed in gold
ink on indigo paper, in the manner of Buddhist scriptures. Ac-
cording to a note in a cartouche at the end, the scriptures were
transcribed with the well-being of the emperor and the nation in
mind. The text is bound as an accordion-mounted album. The
first text is entitled *Marvelous Scripture of Salvation of the South-
ern Dipper That Prolongs Life in the Six Bureaus, Spoken by the
Most High [Laozi] (Taishang shuo nandou liusi yanshou duren miao
jing)*. Following this are scriptures entitled *Marvelous Scripture
of the Eastern Dipper That Rules over Destiny and Protects Life,
Spoken by the Most High [Laozi] (Taishang shuo dongdou zhusuan
huming miao jing), Marvelous Scripture of the Western Dipper That
Records Names and Protects the Body, Spoken by the Most High
[Laozi] (Taishang shuo xidou jiming hushen miao jing)*, and *Gold
Mysterious Feathered [Immortal] Petitions of the Seven Primes
[Stars] of the Northern Dipper (Beidou qiyuan jinxuan yuzhang)*.
These texts are also found in the Taoist Canon *(Daozang)*,
printed in 1444–45.[3] A final text, entitled *Mysterious Petitions

(detail)

on the Star Lords of the Sun, Moon, Five Phases [Five Planets],
and Four Luminants, [Spoken by the] Most High [Laozi] (Shang-
qing riyue wuxing siyao xingjun xuanzhang)* includes petitions to
the gods of the sun (Taiyang), moon (Taiyin), the Five Planets
(in the following sequence: Jupiter, Mars, Venus, Mercury, and
Saturn), and the invisible (and imaginary) planets Luohou (Rahu)
and Jidu (Ketu). This text is not included in the fifteenth-century
edition of the Taoist Canon.

A cartouche at the end of the manuscript depicts a celestial
guardian holding a sword and a tiger on a chain. An inscription
within the cartouche, unsigned, reads:

> Respectfully manifesting a sincere heart, [I] have inscribed in gold
> characters [these] various categories of Dipper Scriptures. [I] look
> up and pray that the great perfected on high bless [this] august
> nation, and guard the path of the emperor so that it is enduring

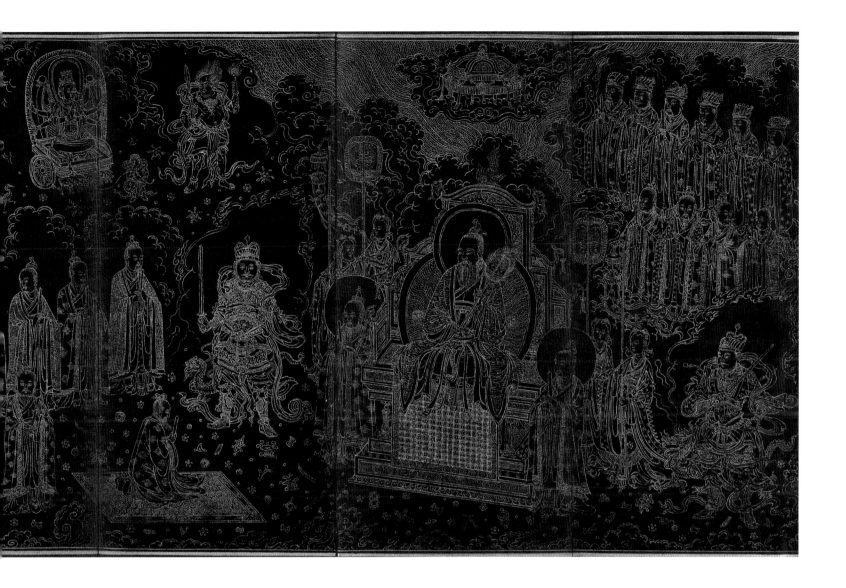

and prosperous, so that [all] households and the nation enjoy prosperity, that the people be at peace, that all things be abundant, and that all dwellings be in order, forever abiding in good fortune and extended years. In the second year of the Longqing reign, the cyclical year *wuchen* [1568], on the first day of the first month of spring.

The scriptures are preceded by a superb illuminated frontispiece, also in gold on indigo paper, depicting the deified Laozi on an enormous throne, holding a fan. Over Laozi's head is a canopy, with beams of light emerging from clouds. He is flanked by celestial guardians, one of whom holds onto a dragon, while the others are armed with swords. A Taoist priest, perhaps representing the first Celestial Master, Zhang Daoling, holds a tablet and kneels on a carpet in front of the deified Laozi. Auspicious emblems are scattered on the ground around this scene of

revelation. To the left are eight gods, and in the upper right corner are six more gods, and four celestial figures with Taoist priests' caps; all of these figures hold tablets. In the upper left corner is a depiction of the goddess Marichi, a Buddhist deity, or possibly the Taoist goddess Doumu, the Dipper Mother, who some scholars believe was derived from Marichi (see cat. no. 98). The goddess has three heads (one a boar's head) and eight arms. She is seated on a throne-chariot pulled by seven pigs. In addition, the scene includes two Taoist marshals *(yuanshuai)*.

—S. L.

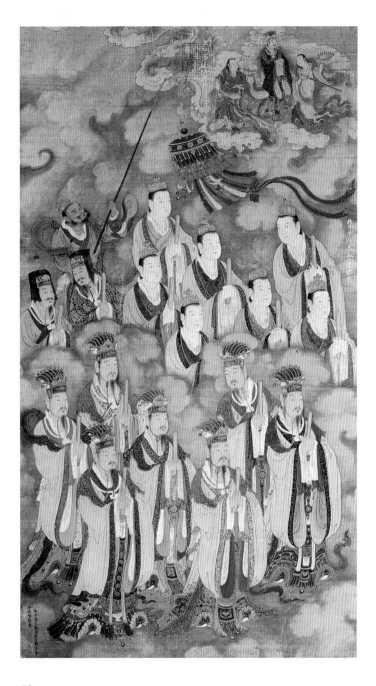

78

Lords of the Root Destiny Stars of the Northern and Central Dippers

Ming dynasty, Jingtai reign, dated 1454
Hanging scroll; ink, colors, and gold on silk
141 × 79 cm
The Metropolitan Museum of Art, New York, lent by Oscar L. Tang

THIS HANGING SCROLL belongs to a set of paintings imperially commissioned for the Buddhist Water and Land Ritual *(Shuilu zhai)*. It depicts the deities of the Northern and Central Dippers, with one additional deity in the upper right corner.

Although the Northern Dipper (Ursa Major), and, to a lesser

extent, the Southern Dipper,[1] appear most frequently in Taoist scriptures, there are actually five dipper constellations in Taoist astronomy, in accordance with the Five Phase system (see cat. no. 17):

> The Eastern Dipper governs the count of years, the Western Dipper records the names [of those who will ascend to the heavens], the Northern Dipper removes names from the records of death, the Southern Dipper enters them into the records of life, and the Central Dipper, the Great Leader, is the loftiest and most eminent.[2]

The lower register of the painting depicts the seven star-gods of the Central Dipper.[3] These gods are dressed in elaborately embroidered and decorated robes, with outer garments of yellow to indicate their centrality (yellow is the color of the center in the Five Phase system). They wear hats that distinguish their place in the celestial hierarchy, and bear the ivory tablets (see cat. no. 63) of high-ranking officials.

The gods of the Northern Dipper stand in the middle register of the painting, distinguished from the gods of the Central Dipper and partially obscured by the clouds upon which these latter deities float. The primary group of gods of the Northern Dipper consists of seven deities dressed in simple robes with lotus-shaped caps; unlike the gods of the Central Dipper, these figures do not have beards, and almost seem to be androgynous.[4] The iconography of these figures corresponds to other depictions in the Ming dynasty Water and Land Ritual paintings from Treasured Tranquility Temple (Baoning Si) and from the Yuan dynasty Taoist murals in the Eternal Joy Temple (Yongle Gong) in Shanxi province.[5] This primary group of seven stars is accompanied by the gods of the two hidden stars of the Northern Dipper,[6] whose dress and appearance are distinct from the rest of the group. The gods of the Northern Dipper are also followed by an attendant who raises a parasol above them.

The term "root destiny" *(benming)* in the title of the painting alludes to the belief that the life of each person was governed by one of the stars of the Northern Dipper, depending on when they were born according to the traditional cyclical calendar. Six times each year,[7] on the cyclical day of one's "root destiny," the "Root Destiny Realized Officer" of that cyclical day would descend to the human world, at which time people born under the influence of that officer were to fast and make offerings.[8] While the identity of the deity in the upper right corner is not indicated in the title of the painting, he may be a variant of these Root Destiny Realized Officers, since his attendants bear offerings of peaches (symbolic of long life) and a sheep's head.

—S. E.

79

Gods of the Twenty-eight Lunar Mansions

Ming dynasty, Jingtai reign, dated 1454
Hanging scroll; ink, colors, and gold on silk
141 × 79.5 cm
Musée National des Arts Asiatiques Guimet, Paris (EO 668)

Shown in Chicago only

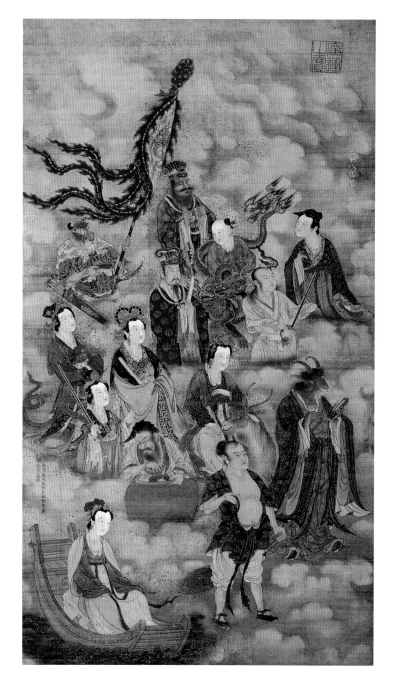

THIS HANGING SCROLL from the Musée Guimet depicts seven of the Twenty-eight Lunar Mansions *(Ershiba xiu)*. The history of these gods extends to the Warring States period (475–221 B.C.), and they have been depicted in Chinese art since that time (see cat. no. 8). The Guimet scroll is one of two scrolls from an early Ming imperial Water and Land Ritual *(Shuilu zhai)* set that depict the Twenty-eight Lunar Mansions.[1] The figures include a woman in a small boat, a bearded man in a jar, a ram-headed god, and a tiger-headed god holding a banner. These correspond to the Lunar Mansions *Shi* (House), *Xu* (Emptiness), possibly *Nü* (Woman), and *Zhang* (Spread). The gods emerge from a murky background of clouds and water. An imperial cinnabar seal at the top reads "Treasure of the Guangyun [Palace]." This palace was built in the Forbidden City in the fifteenth century, when the capital was moved from Nanjing to Beijing. An inscription in gold in the top right corner reads "On the third day of the eighth month, in the fifth year of the Jingtai reign of the Great Ming." The painting's title is inscribed along the right border in gold, and reads "Gods of the Twenty-eight Lunar Mansions" *(Ershiba xiu xing jun)*. An ink inscription in the lower left corner reads "By imperial order, directed and supervised by the Senior Eunuchs of the Directorate of the Imperial Household Service, Shang Yi and Wang Qin."[2]

The gods depicted here are significant because they are a vital part of the Taoist pantheon (see cat. no. 12). Appropriated into religious Taoism in the Six Dynasties period (420–589), they are frequently found in the entourage of higher circumpolar gods. In the Yuan dynasty (fourteenth century) murals at the Eternal Joy Temple (Yongle Gong) in Shanxi province, for example, the Twenty-eight Lunar Mansions form part of the entourage of the Purple Tenuity Emperor (Ziwei dadi; see cat. no. 76).[3] Several of these figures appear in the Osaka Museum of Art handscroll entitled *The Five Planets and the Twenty-eight Lunar Mansions*, attributed to Zhang Sengyou of the Liang dynasty, including Emptiness *(Xu)*, the man emerging from a jar, who corresponds to the Western zodiac figure Aquarius.

—S. L.

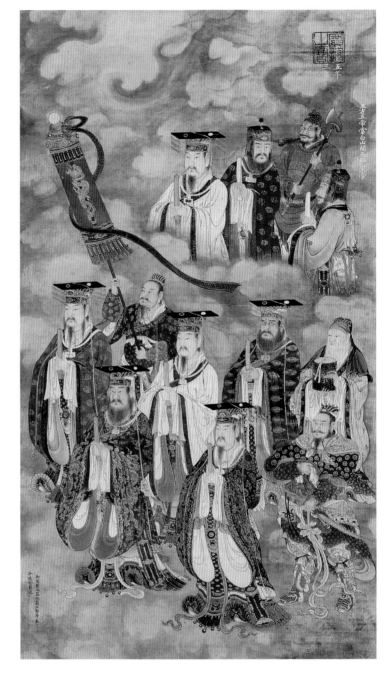

80

Emperors of the Five Directions and the Opening Heaven Great Sage Emperor of Mount Changbo

Ming dynasty, Jingtai period, dated 1454
Hanging scroll; ink, colors, and gold on silk
140.5 × 79 cm
Musée National des Arts Asiatiques Guimet, Paris (EO 686)

Shown in San Francisco only

THIS PAINTING IS ONE of the mid-fifteenth-century Water and Land Ritual *(Shuilu zhai)* set brought to France from China by the great Sinologist Paul Pelliot. Acquired in Beijing, these scrolls were originally created for use by the imperial court in the Forbidden City. Several other examples from this set are included in this exhibition (for example, cat. nos. 78, 79, and 81). In the foreground are the gods of the Five Directions, dressed as emperors of high antiquity, holding tablets of rank in front of them. They wear mortarboard-style crowns with hanging tassels. They are accompanied by three attendants, two of whom are martial guardians (one holds a banner), the other an old scholar holding a scroll. In the upper half of the painting is the Opening Heaven Great Sage Emperor of Mount Changbo, with attendants.

As early as the apocryphal texts *(weishu)* of the Han dynasty (206 B.C.–A.D. 220), the Gods of the Five Directions were believed to inhabit the circumpolar constellation Supreme Tenuity *(Taiwei),* located next to the Northern Dipper *(Beidou).* These gods are also known in Taoist literature from the Six Dynasties period (420–589) onward. That they formed part of the pantheon of later religious Taoism is corroborated by their appearance among the gods in the Eternal Joy Temple (Yongle Gong) murals of the mid-fourteenth century. These gods are significant because they reflect the cosmic structure of the world, in which *yin, yang,* and the Five Phases (Elements) are in balance. They predate religious Taoism, and may have originated as chthonic gods of the Neolithic period. Governing all directions (east, south, west, north, and center), they correspond not only to the Five Elements, but to the seasons, the Five Sacred Peaks, the Five Planets, and the zodiac symbols as well.

The Emperors of the Five Directions can be identified by the colors of their robes. Center wears yellow, East wears green, South wears red, West wears blue,[1] and North wears purple (normally black). The Changbo Mountain Emperor at the top of the scroll wears the same regalia as the Emperors of the Five Directions. The identity of this god is still unclear. He has three

attendants, two of them ancient scholar-officials holding tablets, the other a guard holding an axe.

An inscription in gold along the right border bears the title, "Emperors of the Five Directions and the Opening Heaven Great Sage Emperor of Mount Changbo" *(Wufang wudi Changbo Shan kaitian hongsheng di).* The same dated inscription and imperial seal found on the other 1454 Water and Land Ritual paintings in the exhibition are seen here.

—S. L.

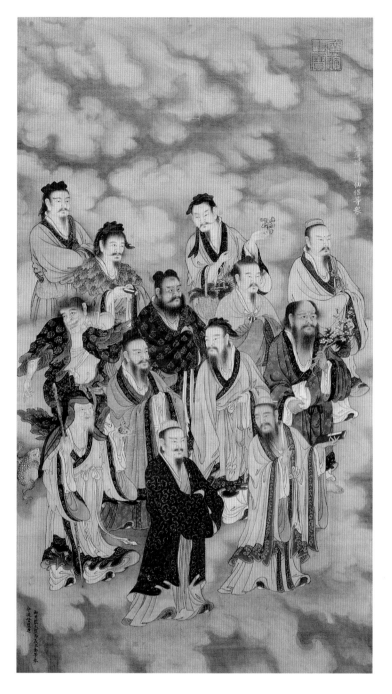

81

Divine Immortals of the Five Paths and Transcendents Who Have Obtained the Tao

Ming dynasty, dated 1454
Hanging scroll; ink, colors, and gold on silk
140.5 × 79 cm
Musée National des Arts Asiatiques Guimet, Paris (EO 693)

Shown in San Francisco only

PART OF AN EARLY Ming imperial set of Water and Land Ritual paintings, this hanging scroll depicts a group of Taoist adepts, realized beings, and immortals. The Five Paths represent five realms of existence, comparable to the Six Paths (originally Five Paths) of Mahayana Buddhism. One of the figures is shown as hermit, dressed in a robe made of leaves; others are shown as Taoist priests, wearing the cap that distinguishes members of the clergy; and still others are shown as scholars and adepts. The one recognizable figure is the immortal Liu Haichan, shown at the left with his three-legged toad (see cat. no. 124). One figure holds a basket of *lingzhi* mushrooms, one holds a flowering branch of a plum tree, one holds a book, one holds a scroll, and one holds a staff and a double gourd.

This scroll presents a generic depiction of Taoist worthies, visualized as part of the Taoist pantheon. Unlike the higher gods, these figures are distinguished by having started out as ordinary human beings. After cultivating the Tao and undergoing a spiritual and physical transformation, they achieved realization *(zhen)* and a state of being beyond *yin* and *yang,* and yet exist in the phenomenal world.[1] As models of virtuous human behavior, they also exist outside the normal confines of quotidian society. Such beings play a unique role in Chinese culture, having rejected conformity to Confucian norms, and yet functioning as saints who are capable of healing illness, of transforming themselves into myriad shapes and states of being, and of helping others attain the Tao.

One of the earliest texts to describe such beings is the *Biographies of the Assorted Immortals (Liexian zhuan),* attributed to Liu Xiang (77–6 B.C.) of the Han dynasty.[2] This work includes biographies of such figures as the Yellow Emperor, Wang Ziqiao, Chisongzi (Master Red Pine), and the female adept Magu. During the Six Dynasties (420–589) and Tang (618–906) periods, such biographical accounts proliferated, and today the literature on Taoist adepts and immortals is voluminous.[3]

—S. L.

NOTES

Cat. nos. 65–67

1. The concept of the Three Heavens actually predates the Three Purities, and the association of the two is a later development (see below).
2. These are the heavens, the earth, and humanity.
3. *Yunji qiqian* (HY 1026), *juan* 3.
4. *Taishang santian neijie jing*, HY 1196.
5. Zhang Ling, otherwise known as Zhang Daoling, is often recognized as the first patriarch of the Taoist religion. For more on this figure, see Ōfuchi 1991: 39–46.
6. This theory on the development of the Three Caverns is set forth in Kobayashi 1990: 222–29. For an alternate theory, see Ōfuchi 1997, ch. 1.
7. *Sandong zhunang*, HY 1131, *juan* 7.
8. Zhang adapted these names from the fifth-century Numinous Treasure scripture *Jiutian shengshen zhang jing* (full title: *Dongxuan lingbao ziran jiutian shengshen yuzhang jing*; HY 318), where they are also associated with the terms Jade Purity, Highest Purity, and Great Purity. This scripture in turn developed from the *Scripture of the Three August*, as can be seen from a quotation of the *Scripture of the Three August* contained in *juan* 6 of the *Wushang biyao* (HY 1130). See Kobayashi 1990: 217–40.
9. *Yunji qiqian* (HY 1026), *juan* 3.
10. *Fozu tongji* (T 2035), *juan* 46.
11. See the map of the White Cloud Temple in Yoshioka 1979: 250–52.
12. The other movement is the Celestial Master, or Orthodox Unity (Zhengyi) sect.
13. On Qiu Chuji, see Waley 1931.
14. Previously, there was a temple first established in the Tang dynasty on this site, which was given to Qiu and renamed "Palace of Endless Spring" in his honor.
15. This is probably because the Three Purities were considered the patriarchs of all Taoist scriptures, as noted above.

Cat. no. 68

1. HY 1, *juan* 1. Similar miracles can be found in other Numinous Treasure scriptures from the same time. One might ask how there could have been any corpses to be revived at the beginning of time, but such inconsistencies were clearly irrelevant to the authors of the early Numinous Treasure scriptures.
2. Previously published in Mingze 1930: 555, pl. 1, and Christie's 1998: lot 108.

Cat. nos. 69–72

1. Schipper 1993: 61. On the role of Jupiter as a god in early Taoism, see Hou 1979: 200–209.
2. Kohn 1993: 102; Lagerwey 1981: 42–43.
3. Maspero 1981: 34, 82, 158–59.
4. Robinet 1997: 59–60.
5. Wu 1997: 150.
6. Martin 1913: pl. 20.
7. Previously published in Wu 1997: pls. 21–23.
8. Ibid.: 149.
9. See, for example, Guo Xi's masterpiece, *Early Spring*, in Fong et al. 1996: pl. 60.
10. Wu 1997: 150.
11. Jin 1997: pls. 20, 71.
12. *Changsheng de shijie* 1996: pl. 5.
13. Ibid.: 67.
14. Published in *Baoning si Mingdai shuilu hua* 1988: pl. 77.
15. Schipper 1993: 253. For the original text, see ZTDZ, vol. 58: 274–79 (HY 1430).
16. See *Beijing Dongyue Temple* 1999: 19–20.

Cat. no. 73

1. The cover of the present book bears the title *Gaoshang yushu leiting baojing fuzhuan*; the title at the head of the text is *Jintian yingyuan leisheng puhua tianzun shuo yushu baojing*, which corresponds to HY 99.

2. See the essay by Patricia Ebrey in this volume and Boltz 1987a: 26–30.
3. For example, the group of seven deities in the front of the line probably comprises the gods of the Northern Dipper, while the next group of six probably represents the Southern Dipper; see cat. no. 78 for a comparative image.
4. The afterword says that the scripture was unannotated before Xu, suggesting that the commentaries may in fact have been written by him. On the other hand, this statement may refer only to a group of notes found after the colophons. In any case, this printed edition seems likely to have been based on an edition of the scripture possessed by, and to an unknown extent annotated by, this Yuan writer.
5. See HY 750.

Cat. no. 74

1. Wu Zongyuan was known during his lifetime as a reincarnation of Wu Daozi; see Yu 1980: 537.
2. Bush and Shih 1985: 346.
3. See S. Cahill 1980: 23–44.
4. Xu 1984a, vol. 1: 95.
5. Jin 1997: pls. 12, 138.
6. Jiuyi (Nine Doubts) is a sacred mountain in Hunan province.
7. See Barnhart 1983: 52–53, 180.
8. Xu 1984a: pl. 33.

Cat. no. 75

1. On the relationship between Taiyi (Supreme Unity) and Taiji (Supreme Ultimate), see Robinet 1990: 381–82.
2. The "Nine Songs" are traditionally believed to have been compiled by the late Warring States period poet Qu Yuan (fourth century B.C.); see Hawkes 1959: 36–37.
3. Major 1993: 80; for the Chinese text, see HNZ: 70.
4. Kohn 1998a: 134. See also Li 1995–96: 2–3.
5. Li 1995–96: 40; for an alternate translation (in French), see Seidel 1969a: 123. Note that the original text has "underwent a bodily transformation" *(shen hua)* for "transformed into an immortal" *(xian hua)*, the reading of a later commentary; see Seidel 1969a: 123 n. 9, 129.
6. Anderson 1989–90: 24–25. Based on such textual sources of the early Han, it is conceivable that the figure riding the Northern Dipper like a chariot at the Wuliang Shrine in Shandong province (second century) represents Taiyi; see Chavannes 1909/1913, vol. 2: pl. 133; and Harper 1978–79: 2.
7. Anderson 1989–90: 29.
8. Harper 1978–79: 2.
9. Cammann 1961: 60–61.
10. Li 1995–96: 12–13. Li also discusses several images of Taiyi that survive from the Han dynasty.
11. Xiong 1996: 293, 314.
12. Jin 1997: pl. 13.
13. Wu 1988: 217.

Cat. no. 76

1. Based on a colophon of 1705 that records a remounting of the scrolls, it has been surmised that the set was an imperial gift to the temple at the time of its construction in 1460, during the Tianshun reign; see Wu 1988: 217. The scroll depicting the Purple Tenuity Emperor is labeled as "number 21, left" in the set.
2. Sun and Kistemaker 1997: 133–35.
3. Stephenson 1994: 527.
4. Major 1993: 80.
5. See cat. no. 18, the Tang dynasty star diagram from Dunhuang that includes a depiction of the Ziwei Enclosure.
6. Sun and Kistemaker 1997: 27–28.
7. Ibid.: 23.
8. See Jin 1997: pl. 46.

Cat. no. 77

1. Kohn 1998a: 97–98, and 92, table 5.
2. Ibid.: 99.
3. HY 624 (Southern Dipper), HY 625 (Eastern Dipper), HY 626 (Western Dipper), HY 973 (Northern Dipper); see also ZTDZ, vol. 19: 12–16, 17–18, and 19–20.

Cat. no. 78

1. This constellation is formed of six stars in Sagittarius resembling Ursa Major.
2. HY 627. This scripture probably dates to the tenth century (see also cat. no. 77).
3. Sources from the Taoist Canon such as HY 627 indicate that there were only three stars in the Central Dipper; the reason for this discrepancy is unclear, but it is possible that the Central Dipper is here depicted as seven gods in order to correlate with the seven gods of the Northern Dipper shown in the middle register.
4. This may result from the Taoist belief already prevalent in the medieval period that the Northern Dipper actually consisted of two sets of stars, one visible group that was manifested by male deities, and another, invisible group manifested by female deities who were the "souls" and the source of illumination for the visible group; for example, see HY 428.
5. See *Baoning si mingdai shuilu hua* 1988 and Jin 1997. On the other hand, these gods are depicted with beards in the Ming dynasty Water and Land Ritual murals of the Pilu Temple; see Kang 1998.
6. It was traditionally believed that the Northern Dipper consisted of nine stars, two of which were hidden from the sight of normal people.
7. The traditional Chinese calendar is divided into a cycle of sixty days, so that each cyclical day occurs approximately six times (6 × 60 = 360) each year.
8. HY 622.

Cat. no. 79

1. The pendant, EO 692, is published in Weidner 1994: cat. no. 29, color pl. 15.
2. Translated by Wai-kam Ho in *Eight Dynasties of Chinese Painting* 1980: no. 131.
3. Jin 1997: pl. 19.

Cat. no. 80

1. The ancient symbolic color of West is white, which is also associated with death, and in painting is usually chosen to depict ghosts. It is perhaps because of this that the Emperor of the West wears a blue robe.

Cat. no. 81

1. For introductory studies of Taoist adepts and immortals, see Robinet 1985–86, Kohn 1990c: 1–22, and Penny (forthcoming).
2. Translated in Kaltenmark 1987.
3. One of the most extensive such works is HY 296, *Lishi zhenxian tidao tongjian,* compiled by Zhao Daoyi (fl. 1294–1307) during the Yuan dynasty; see Boltz 1987a: 56–58.

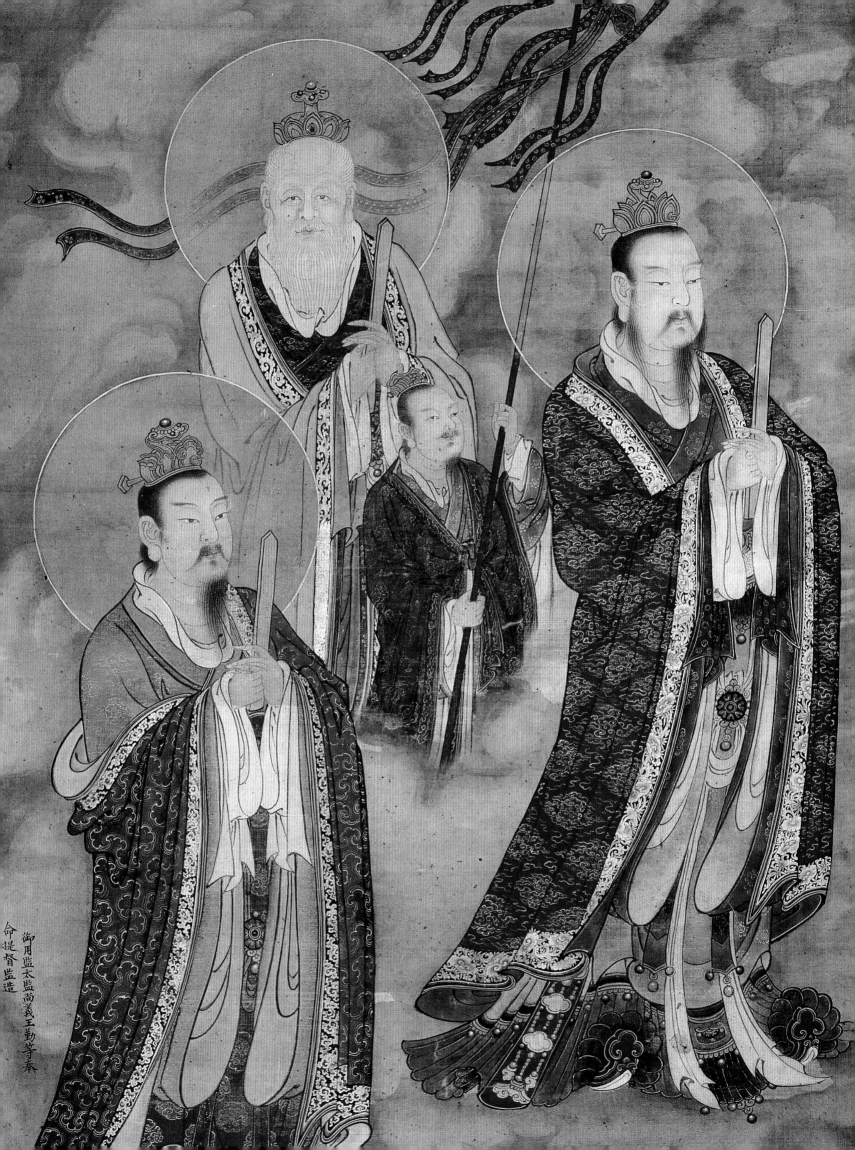

TAOISM IS A FLEXIBLE SYSTEM of thought, and it allows the worship of many gods who are not, strictly speaking, Taoist. This section of the catalogue explores the fluid boundary between orthodox Taoism and Chinese popular religion, and between Taoist gods and popular gods. Local and popular deities began to be brought into the Taoist pantheon with increasing regularity from the Song dynasty (960–1279) onward. The majority of popular gods can be defined as deities who are associated with specific locales in China (e.g., mountains and cities), nature spirits (e.g., gods of sacred springs and trees), human heroes who through their virtuous deeds have been transformed into gods, or animal spirits who have undergone a similar apotheosis.

The boundary between Taoism and other religious beliefs in China is so fluid that even images of the Buddhist deity Guanyin, the Bodhisattva of Compassion, are often found in Taoist temples. In the Song dynasty this syncretic approach led to the popular belief that the Three Teachings (Taoism, Confucianism, and Buddhism) were merely different paths to the same spiritual goal.

Among the popular gods examined here are City Gods (Chenghuang), gods of sacred mountains, nature deities, Wenchang (the national god of learning and scholarship who began his existence as a local snake god in Sichuan province), Guandi (the God of War, hero of the *Romance of the Three Kingdoms*), and Zhong Kui (the Demon Queller).

82

Investiture of a Local God

Ming dynasty, Chongzhen reign, colophon dated 1641
Handscroll; ink, colors, and gold on silk
48.2 × 908 cm
The Metropolitan Museum of Art, New York, Purchase, Fletcher Fund
(1938.31.1)

PAINTED ON yellowish brown silk in the final years of the Ming dynasty, this extraordinary painting depicts the investiture of a local god into the Taoist pantheon.[1] The scroll consists of a long painted section depicting gods, followed by several attached pieces of silk with various colophons. The entire scroll is bordered by painted dragons, whose bodies alternate in different colors, interspersed with flaming pearls. The handscroll is significant because it documents a process that was increasingly widespread in China from the Song dynasty (960–1279) onward, namely the petitioning of the throne or (from the Ming dynasty onward) the Taoist establishment of the Orthodox Unity sect for recognition of the spiritual legitimacy of local gods. The result of such imperially sanctioned recognition was that local gods and their human supporters enjoyed increasing prestige in both the spiritual and material worlds.[2] The entire process was often driven by economic concerns, for the conferring of legitimacy frequently led to increased opportunities for trade.

The painted section of the scroll, consisting of six pieces of joined silk, opens with a depiction of the court of the Jade Emperor, head of the popular pantheon. Among multicolored clouds, painted in red, blue, white, and pale yellow pigments, this god sits on a high throne under a parasol. He is dressed as an ancient emperor and wears a crown in the shape of a mortarboard with hanging tassels; he holds an official tablet in his hands. The god is surrounded on either side by attending gods and celestial guardians. These attending gods are both male and female. One holds a dragon while another holds a tiger—symbols of *yin* and *yang*. The female attendants hold banners with images of the sun and moon, also symbols of *yin* and *yang*. One of the male attendants is clearly recognizable as Zhenwu (the Perfected Warrior). Barefoot, he wears a black robe decorated with gold clouds and holds a tablet in his hands. Behind his head is a red halo. His identity is confirmed by the presence of the tortoise and snake, the ancient symbol of Xuanwu, the Dark Warrior. Significantly, Zhenwu stands in a subservient position to the Jade Emperor, who enfeoffed him at Mount Wudang (Wudang Shan) in Hubei province.

Beyond the court scene stands a red lacquer table, covered with offerings, including two blue vases holding lotus flowers and a tripod incense burner. A long line of seventeen officials follows, emerging from a red gate in the sky. Two guardians, one with a brown face and one with blue, attend this gate. On the other side the procession continues, with an envoy in a green robe and black hat, eight guardians holding halberds, standards, and parasols, a white horse with a groom, and eight bearers carrying a palanquin, with a tiger skin hanging out the door. This entourage is followed by a group of four tall guardians holding swords, with flames above their heads. Beyond this group are two youthful attendants holding lamps, other attendants holding a sword and a wrapped box, officials with green robes and red halos, and another youthful attendant holding another box. Above the head of this last figure, a flying messenger carries the mandate from the Jade Emperor to the local god, officially recognizing the latter as a legitimate deity.[3] Finally, the local god himself appears, standing large in a red robe, wearing a high black and gold crown, and holding an official tablet. The god looks straight out at the viewer, and is accompanied by two young attendants holding boxes.

Following the painting are several inscriptions. The first, written by a Taoist priest named Li Daoqing, consists of a record of the petition made to the Celestial Master Zhang at Dragon and Tiger Mountain (Longhu Shan), Jiangxi, asking that the local deity, named Li Zhong, be recognized as a legitimate god. This text mentions the worthiness of the god and cites a ritual first used in the Southern Song dynasty in 1157 (during the Shaoxing reign). The inscription states that three Taoist registers were conferred on the god, namely registers corresponding to the three heavens of Jade Purity, Highest Purity, and Supreme Purity (these correspond to the realms of the Celestial Worthies of Primordial Beginning, Numinous Treasure, and the Way and Its Power [Laozi]). That the inscription was written by a Taoist priest is clear from the presence of an elaborate talisman, written in red ink over the Shaoxing reign date. The second inscription is signed by one Zhu Zhongsu, and is dated 1641, in the Chongzhen reign. It cites the virtue of the local god, and documents the protection he renders his followers. Zhu also specifically mentions the attached painting, describing it as a work that gives visual form to the transmission of Taoist registers to the deity. The final inscription comprises a list of names of patrons of the local god; this too is dated to 1641.

—S. L.

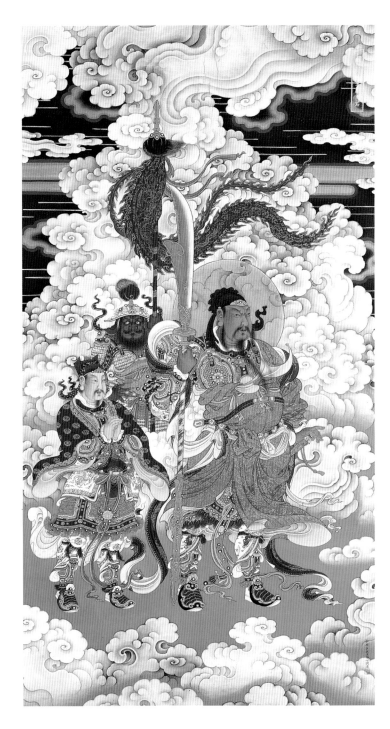

83

Emperor Guan

Qing dynasty, Kangxi reign (1662–1722)
Ink, colors, and gold on silk
173 × 120 cm.
Plum Blossoms (International) Ltd., Hong Kong

GUANDI (EMPEROR GUAN) or Guan Gong (Duke Guan) is a god of the Chinese popular pantheon, a human hero who was absorbed into the Taoist pantheon in the Song dynasty (960–1279). He is the deified form of Guan Yu, a hero of the early third century. He was famous as a warrior and for his alliance with Liu Bei, founder of the Shu kingdom (221–263) in Sichuan, and Zhang Fei. Guan Yu is also one of the heroes of the Ming dynasty novel *Romance of the Three Kingdoms (Sanguo zhi yanyi)*, a fictionalized account of events of the Three Kingdoms period (220–280).[1] After he was killed, Guan Yu began to be worshipped as a god. Often called the God of War, Guan Yu became a deity of popular religion by the early Tang dynasty (618–906). Being a martial figure, he was worshipped as a celestial protector against all threats to the individual and the state. A special patron of the military, he was associated with loyalty and bravery, and he was also a killer of demons and queller of ghosts. He is still one of the most widely worshipped gods in China today.

By the twelfth century, if not earlier, Guan Yu was absorbed into the Taoist pantheon with the title Marshal *(yuanshuai)*.[2] In 1615, during the Wanli (1573–1620) reign of the Ming dynasty, Marshal Guan was imperially granted the title Emperor *(di)*.[3] As Henri Maspero has shown, Guandi was also a god summoned by spirit-mediums in planchette-writing seances.[4]

The menacing figure of Guandi dominates this scroll. Dressed in armor, boots, and swirling robe, he is accompanied by his two assistants, Zhou Cang (holding a banner) and Guan Ping (clasping his hands together).[5] The figures stand on a green ground, surrounded by swirling green, pink, and gold clouds against a brilliant blue sky. A gold cartouche at the upper right contains the god's name and title: "The Overseer of the Gate, Sage-Emperor Lord Guan." An inscription in ink along the bottom right border reads, "Sincerely Commissioned by the Imperial Prince of Qin, Zhuang" *(Heshi Zhuang Qinwang faxin cheng zao)*.[6]

—S. L.

84

Great Generals of the Deserts and the Spirits of Grasses and Trees Who Dwell in the Void of Water and Land

Ming dynasty, Jingtai reign, dated 1454
Hanging scroll; ink, colors, and gold on silk
140.5 × 78.5 cm
Musée National des Arts Asiatiques Guimet, Paris (EO 684)

Shown in Chicago only

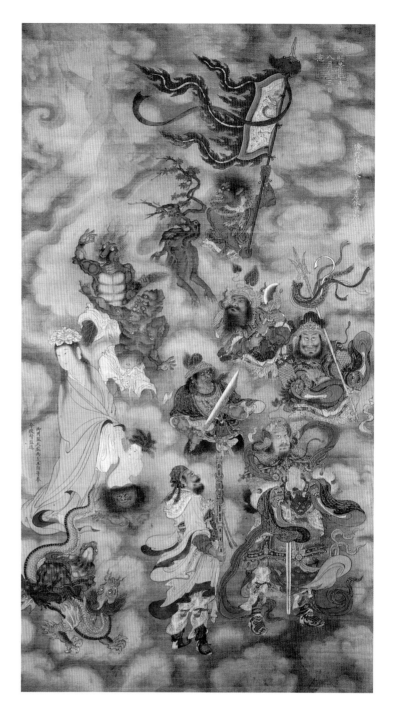

AMONG THE GODS of Chinese popular religion are thousands of deities of the natural world—gods of stones, trees, springs, hills, rivers, and lakes. This hanging scroll, part of the early Ming imperial set of 1454 depicting the Water and Land Ritual in the Musée Guimet, Paris, is devoted to the generic category of these spirits of nature.[1] Their presence in the world of Chinese religion is significant, for they are part of the divine matrix in which humanity is situated.

In the lower right corner of the scroll are a group of military generals; these depict the Great Generals of the Deserts (Kuangye dajiang) mentioned in the painting's title. At the lower left a robed tortoise rides on the back of a dragon; these represent the realm of animals, both real and mythical. Near the left border of the scroll is a young woman wearing a peony blossom in her hair; she is accompanied by a hairy gnome and a toddler with leaves sprouting from his head. The significance of this group is not clear. As Caroline Gyss-Vermande has shown, however, a similarly dressed female figure appears in the fifteenth-century Treasured Tranquility Temple (Baoning Si) set of Water and Land Ritual paintings in the Shanxi Provincial Museum, in the painting depicting the realm of animals and tree-spirits.[2] Finally, the most fascinating and bizarre deities are those shown at the upper left. These comprise spirits of the vegetable and mineral realms, and include beings in the shapes of trees, rocks, and air (a figure barely visible among the background clouds). This personification of living beings of the natural world clearly reflects the traditional Chinese belief that not only plants, but also rocks and minerals, are animated by the vital force *(qi)* created by the Tao, and, like gods and people, they have their own cycles of life and death.[3]

—S. L.

City Gods of All Municipalities and Earth Gods of All Districts

Ming dynasty, c. 1600
Hanging scroll; ink, colors, and gold on silk
214 × 103 cm
Musée National des Arts Asiatiques Guimet, Paris (EO 734)

Shown in Chicago only

PART OF A late Ming dynasty set depicting the Water and Land Ritual acquired in China by Paul Pelliot, this painting depicts City Gods (Chenghuang) and Earth Gods (Tudi). The title of the scroll is inscribed in a cartouche in the upper left corner. Both City Gods and Earth Gods are deities of Chinese popular religion, and they are not, strictly speaking, considered Taoist gods. Of the two types, the oldest are the Earth Gods, shown at the top of this scroll. Their origins can be traced to early gods of the soil *(she)*, worshipped in the Han dynasty (206 B.C.–A.D. 220) and earlier. As David Johnson has written,

> When the Zhou feudal order was replaced by the Qin–Han bureaucratic system, cities, towns, and villages continued to have *she*. These sacrifices were mandated by statute as part of the official religion. In county and prefectural capitals, the expenses of the cult were evidently borne by the government; in villages and hamlets, the inhabitants had to meet the costs themselves. In Han times formal worship of the god of the soil in the county and prefectural cities thus was in the hands of the officials. The cult was thoroughly rationalized: the earth-god had long since been depersonalized and universalized, and was as featureless and abstract as the deities of the hills, rivers, thunder, rain, and other features of the natural world that received official sacrifice. The open altar was made of earth and was extremely plain, with only a stone pillar, representing the god, and a tree to mark it. Sacrifices there were offered only twice a year, on days in the second and eighth months fixed by statute.[1]

The emergence of the cults of both City Gods and Earth Gods out of the traditional worship of the ancient god of the soil appears to have begun during the Six Dynasties period (420–589) and to have accelerated during the Tang dynasty (618–906).

The gods in the foreground of the Guimet painting are City Gods; the existence of this category, literally known as "Wall and Moat Gods" *(chenghuang shen),* can be traced to the early sixth century, in the Six Dynasties period.[2] The increasing worship of City Gods from the eighth century onward reflects the proliferating urbanization that characterized south and south-central

China during the mid-Tang period.[3] Like many gods of the popular pantheon, City Gods often began as human heroes (frequently military generals) who were later deified on the local level. By the end of the Song dynasty, the cult of City Gods was supported by the state at the level of the municipality. When a newly appointed magistrate arrived at his post, he first paid his respects to the City God in the latter's shrine, and maintained a fixed schedule of sacrifice thereafter.[4] As Paul Katz has pointed out

> The cult of the City God gained increasing popularity during late imperial times because he was seen as the arbiter of a region's fate, the spiritual equivalent of the district magistrate. As the magistrate could punish evil-doers or intercede with the emperor on behalf of the people, so could the City God inflict calamities or act as a go-between between the people and the Jade Emperor during times of crisis.[5]

These observations have been echoed by Angelo Zito: "Every major locality had a City God temple inhabited by a god who held a heavenly bureaucratic rank equivalent to his earthly counterpart."[6] While Johnson has suggested that the rise of the City God cults was linked to the rise of the mercantile class from the Tang dynasty onward, other scholars, in particular Valerie Hansen and Barend ter Haar, have suggested that itinerant figures such as priests, doctors, and migrant workers could also have been responsible for the spread of these cults.[7]

There is evidence from as early as the tenth century that City God temples contained images (either sculptures or paintings) of their gods and attendants, and during the Song dynasty there is clear evidence of imperial recognition of the City God cult.[8] Occasionally a City God temple would be built in proximity to a Taoist temple. There was, for example, originally a sub-temple to the City God at the Yongle Gong (Eternal Joy Temple), the great Yuan dynasty (1260–1368) Taoist temple of the Complete Realization (Quanzhen) sect at Ruicheng, Shanxi province.[9] Worship of City Gods continued through the Ming (1368–1644) and Qing (1644–1911) dynasties, and is still found today in Taiwan, Hong Kong, and many overseas Chinese communities.[10] The importance of the City God cults is reflected in stele inscriptions composed by the Qing dynasty Yongzheng (r. 1723–35) and Qianlong (r. 1736–95) emperors, in which these Manchu rulers made public declarations of their respect for the City God of Beijing.[11]

—S. L.

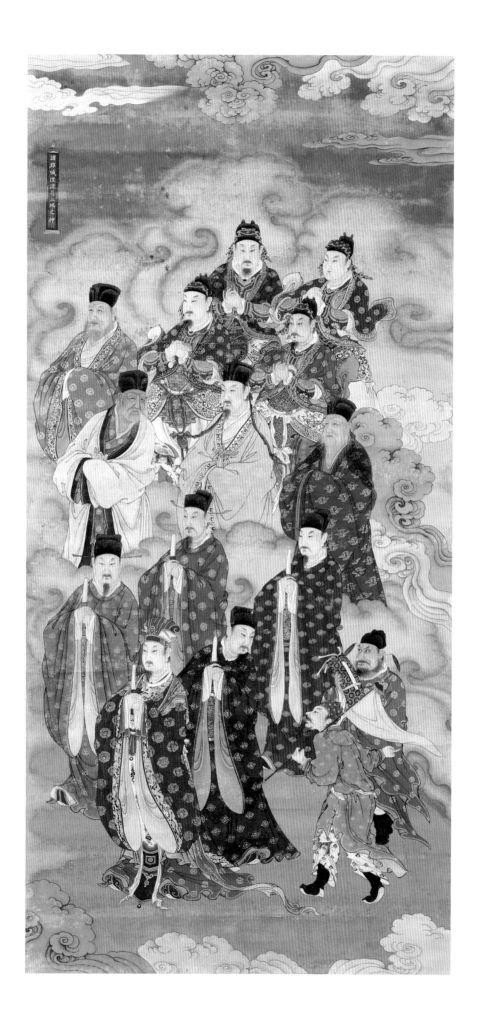

86

The Realm of All Mountain Kings and the Six Spirits of the Household

Ming dynasty, c. 1600
Hanging scroll; ink, colors, and gold on silk
214 × 103 cm
Musée National des Arts Asiatiques Guimet, Paris (EO 742)

Shown in San Francisco only

THIS LATE MING DYNASTY hanging scroll belongs to the same set as cat. no. 85, depicting the Water and Land Ritual. It depicts the generic categories of mountain gods and spirits of households. While the Household Spirits have remained gods of Chinese popular religion, some mountain deities (the gods of the Five Sacred Peaks, for example) were absorbed into the pantheon of Taoism by the late Six Dynasties period (sixth century). The mountain gods shown here represent lesser peaks, and their depictions are generalized. Five of the six Household Spirits (Jiazhai liushen) are shown at the top of the scroll: they are the Stove God (Zao wang), the Door God (Menshen), the God of the Kitchen Door (Hushen), the God of the Well (Jingquan tongzi), and the Earth God (Tudi).[1] The sixth, the Goddess of the Latrine (Sangu furen), is missing. One of the earliest known references to the Stove God is in the third-century text *In Search of the Supernatural (Soushen ji)*:

> During the times of Emperor Xuan of the Han (dynasty), Yin Zifang of Nanyang, who was by nature a filial man, had accumulated many blessings by alms and good acts. He took most pleasure in sacrifices to the Stove God, and one winter solstice morning during the ceremonial lighting of the stove, the god himself appeared. Zifang thanked it for his numerous blessings, and since there was a light-tan ram in the house, he sacrificed it to the Stove God.[2]

There is a great deal of information regarding the cults of mountains in the Han dynasty (206 B.C.–A.D. 220). Since this period, a standard group of Five Sacred Peaks has been worshipped as gods in China. The origins of the veneration of individual sacred mountains *(yue)* can be traced back to the late Shang dynasty (thirteenth–eleventh century B.C.); such peaks are mentioned in the oracle bone inscriptions excavated at the last Shang capital, Anyang.[3] Mountains were seen as powerful forces in the Han and Six Dynasties periods. In Ge Hong's *The Master Who Embraces Simplicity (Baopuzi)* of the fourth century, there are famous passages that discuss ways of moving through mountains, and the herbs and minerals found on sacred peaks that aid self-cultivation and alchemy:

> All mountains, whether large or small, have gods and spirits *(shenling)*. If the mountain is large, the god is great; if the mountain is small, the god is minor. If someone enters the mountain possessed of no magical arts, he will certainly suffer harm. Some will fall victim to acute diseases or be wounded by weapons. When frightened and uneasy, some will see lights and shadows, others will hear strange sounds. Sometimes a huge tree will topple, though there is no wind, or a cliff will collapse for no reason, striking and killing people. Sometimes the man will flee in confusion, tumbling down a cavern or into a gorge; other times he will encounter tigers, wolves and poisonous insects that attack men. One cannot enter a mountain lightly![4]

Ge Hong's *Baopuzi* is also the first text to mention the sacred talismans or "true forms" *(zhenxing)* of the Five Sacred Peaks (see cat. no. 137). With the greater institutionalization of Taoism in the Tang dynasty, the gods of the Five Sacred Peaks came increasingly under the control of higher Taoist gods. In the early eighth century, the guidelines for imperial worship of these mountains were determined by the Taoist church.[5] Mount Tai (Tai Shan), in the east, has been perceived as the most important of the Five Sacred Peaks since the third century B.C., and by the end of the Song dynasty (960–1279) there was a temple to the god of Tai Shan in almost every major city in China.[6] The close connections between Taoism and mountains cults are illustrated by the fact that in 1349 a temple to the Emperor of the Eastern Peak (Dongyue dadi) was built at the Yongle Gong in Ruicheng, Shanxi province, the birthplace of the immortal Lü Dongbin (see cat. nos. 120–22).[7]

—S. L.

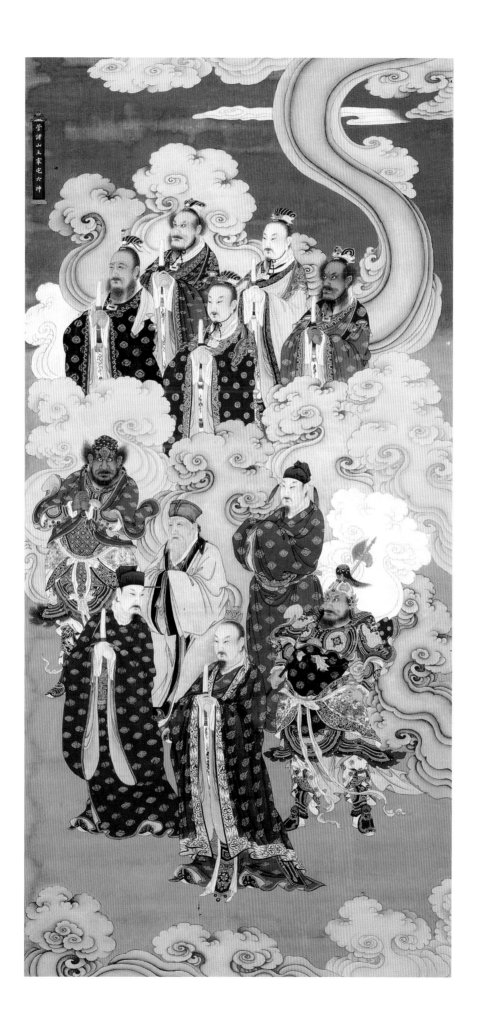

TRADITIONALLY ATTRIBUTED TO JIANG ZICHENG
Marshal Wen

Ming Dynasty, late 14th/early 15th century
Hanging scroll; ink and colors on silk
124 × 66.1 cm
Museum of Fine Arts, Boston, Fenollosa-Weld Collection (11.4008)

THIS PAINTING DEPICTS Marshal Wen, an exorcistic god of the popular pantheon who rose to prominence during the Southern Song (1126–1279) and Yuan (1260–1368) dynasties.[1] Marshal Wen, or Wen Yuanshuai, was best known as a deity who eradicated plague demons. It is significant that his cult arose along the coast of Zhejiang province, where plagues and epidemics were common events.[2] At the same time, Marshal Wen was also seen as a protector of the Tao who eradicated heterodox (xie) and licentious (yin) local deities, and a god that worked in the service of the god of the Eastern Peak (Tai Shan) to uphold traditional Confucian values such as filial piety.[3] Wen's biography in the *Daozang* makes clear that he served not only the god of Tai Shan, but also the Taoist god Zhenwu, Supreme Emperor of the Dark Heaven.[4]

Like many gods whose worship spans the fluid boundary between Taoism and popular religion, Marshal Wen began as a local god who was absorbed into the Taoist pantheon (another example is the God of Literature, Wenchang; see cat. no. 89). Unlike Wenchang, however, the cult of Marshal Wen did not spread throughout China, but was limited to the south-central coastal provinces of Zhejiang and Jiangsu, and Sichuan in the southwest. He is still worshipped today in Taiwan.

Marshal Wen's cult originated in Pingyang, Wenzhou prefecture, located along the southern coast of Zhejiang province. By the mid-thirteenth century (1264), a temple honoring Marshal Wen had been built in Hangzhou, the Southern Song capital; this was known as the Temple of Boundless Numinosity.[5] Paul Katz has demonstrated that local merchants played a prominent role in spreading Marshal Wen's cult throughout Zhejiang, and that Taoist priests and scholar-officials also played key roles in supporting worship of this popular god. One of the primary literary sources on Marshal Wen, for example, is the Yuan dynasty stele inscription composed by the scholar-official Song Lian (1310–1381) in 1355 for a temple in Wenzhou prefecture.[6]

The earliest hagiographic source on Marshal Wen is a text in the Taoist Canon (Daozang) composed in 1247 by Huang Gongjin, a priest of the Divine Empyrean (Shenxiao) sect.[7]

According to this text, *Biography of Grand Guardian Wen, Supreme Commander of Earth Spirits (Diqi shangjiang Wen taibao zhuan),* the deity originated as a man named Wen Qiong who was born in Pingyang in the Tang dynasty (618–906).[8] Known for his martial prowess, he was ultimately transformed into a plague-fighting god who worked in the court of the Emperor of the Eastern Peak (Dongyue dadi). Among his responsibilities was the administration of the registers of life and death. Song Lian's stele inscription of 1355, in contrast, depicts Marshal Wen as a traditional scholar of the Tang dynasty who could perform the Pace of Yu *(Yubu)* by the age of seven (see cat. no. 52), and had memorized the Confucian Classics by the age of fourteen.[9]

In the Museum of Fine Arts painting, Marshal Wen is shown as a warrior dressed in red and gold armor and holding a sword with a gray-green blade. He stands against a pale green void, with swirling clouds filling the background; these are outlined in black and orange, with white highlights. The god's face is blue, and his lips and the tip of his nose are red. Marshal Wen's skin is also painted blue, while his hair is red with gold highlights; this is just as he is described in the *Complete Compendium of the Deities of the Three Religions and their Origins (Sanjiao yuanliu soushen faquan),* a text that probably dates to the Yuan dynasty.[10] On his head is a black cap, with a flower decorating the front. This flower is most likely the jade flower *(qionghua)* presented by the Jade Emperor to confer immortality. Epaulets with lion masks rest on his shoulders, and a broad sash around his waist is painted with winged mythical beasts in ink and pale blue and red pigments. A long purple ribbon holds this sash in place. Hanging around the god's neck is a red placard inscribed in ink and gold with the characters *Wuju xiaohan* ("The Carefree Man of the Empyrean"), a name also given to Marshal Wen by the Jade Emperor.[11] It is on the basis of this inscribed placard that the Boston painting can be precisely identified as a depiction of Marshal Wen.

—S. L.

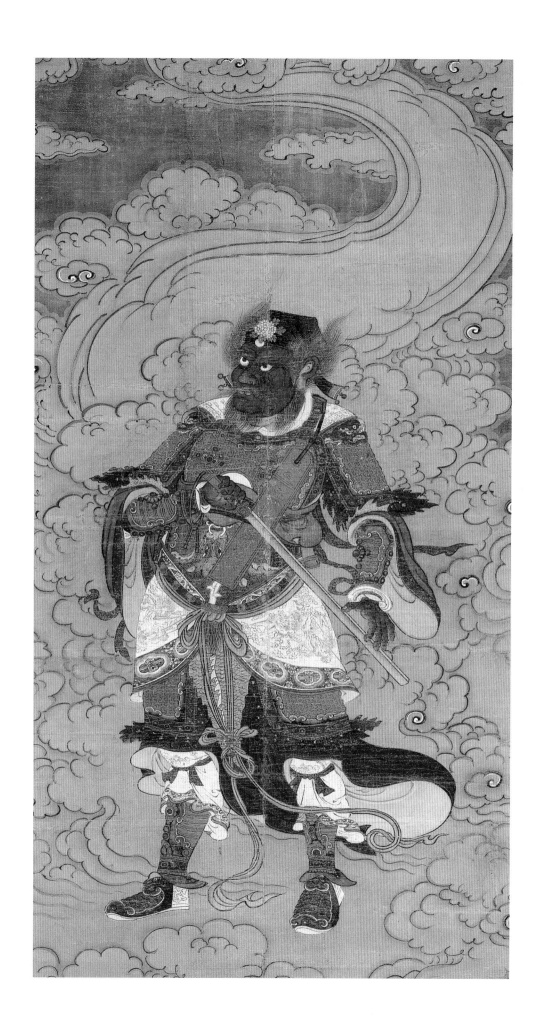

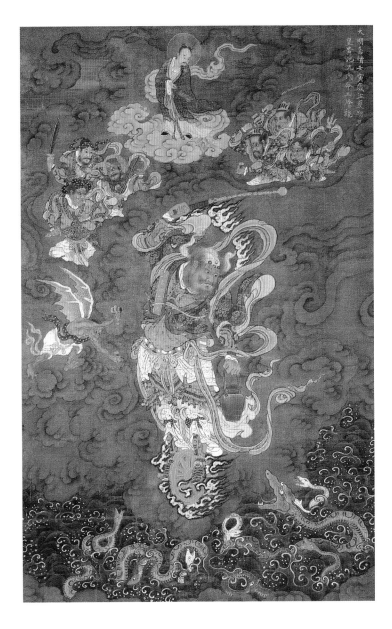

88

Marshal Wang

> Ming dynasty, Jiajing reign, dated 1542
> Hanging scroll; ink and colors on silk
> 97 × 62 cm
> The Metropolitan Museum of Art, New York, Purchase, Bequest
> of Dorothy Graham Bennett (1989.155)

DEPICTING A DEIFIED HERO of the early Tang dynasty (seventh century), this hanging scroll is a rare product of an imperial painting atelier in the Forbidden City during the Jiajing reign (1522–66). The Jiajing emperor was devoted to Taoism, and he had all the Buddhist temples in the palace shut down shortly after he took the throne.[1] This painting depicts the god Marshal Wang (Wang yuanshuai), a god of the popular pantheon known for his ability to crush human villains and malevolent river spirits.[2]

Among billowing clouds, the wrathful god is shown hovering over roiling, white-topped, dark green waves. Among the waves are many writhing snakes. Patches of blue sky, streaked with gold, appear at the top of the scroll. The god is depicted with reddish orange skin. He has wild red hair and fangs, and glowers down at the snakes below. He wears an orange placard over his shoulder, held in place by a rope and inscribed in gold ink: "Red heart, loyalty, and virtue" *(Chixin zhongliang);* this placard was given to him by the Jade Emperor. He stands on a flaming wheel. In one hand he holds a ball on a chain, and in the other a bucket.

At the top of the scroll, a Taoist adept holding a fan stands on a pink cloud. To the right are three gods, two with bird-beaks; these hold a trident, a ball on a chain, and a hammer and spike. To the left are three more gods; these hold swords, and one is shown with a bird's beak and a mustache. Below, near the left margin, a birdlike demon with lavender wings flies behind the central god.

The painting is inscribed at the upper right, "Painted by order of the Imperial concubine *[huang guifei]* Shen, in the beginning of summer of the *renyin* year of Jiajing [1542]." Over this is impressed a large red seal, now illegible and partially trimmed.

—S. L.

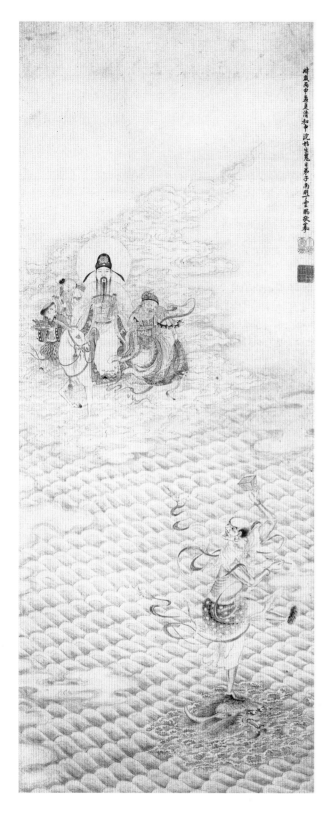

89

DING YUNPENG (ACTIVE C. 1584–1638)
Wenchang, the God of Literature

Ming dynasty, Wanli reign, dated 1596
Hanging scroll; ink on paper
117.5 × 46.4 cm
The British Museum, London (1936.10–9.0129 Add. 170)

ONE OF THE most popular gods in late imperial China was Wenchang, the God of Literature. First worshipped as a snake god known as "the Viper" in Sichuan during the Six Dynasties period (420–589), he rose in prominence until by the Tang dynasty (618–906) he was worshipped as part of the imperial cult.[1] In the Song dynasty (twelfth century) the god revealed himself in anthropomorphic form as a Taoist god, the Divine Lord of Zitong.[2] From the Song onward, Wenchang was widely worshipped by the literati, particularly by candidates in the civil service examinations; he was also venerated for his powers of healing and exorcism.[3] His cult ultimately achieved a national following.

In the *Book of Transformations,* a text revealed to a twelfth-century medium named Liu Ansheng in Chengdu, Sichuan, the god Zitong demonstrates his cosmological origins:

> When Hundun [Primordial Chaos] first divided into opaque
> and clear,
> In the astral quarter of the Southeast the phosphors shone sharp
> and bright.
> In its midst was contained the billowing energies of the Great
> Monad [Taiyi, Supreme Unity].
> I was already in secret correspondence with the quintessence
> of Creation.
> Alone I occupied the stellar palace above the Twin Maidens
> [a constellation],
> Governing the Five Virtues, the quintessence of the Five activities.
> Abruptly tired of dwelling in this desolate region,
> I shed my slough and end my term, the fruit of the Tao achieved.[4]

The British Museum scroll by the late Ming painter Ding Yunpeng depicts Wenchang descending on clouds above an ocean. The god rides on a mule. He is dressed as a scholar-official, wears a peony in his hat, and holds a scroll in his left hand. He has an entourage, consisting of an old man with a book (his attendant Zhuyi, or "Red Robe") and two boys.[5] Below, in the foreground, Wenchang's acolyte Kuixing, a demonic figure holding a writing brush in his right hand and a weight (for measuring the worth of scholars) in his left, rides across the waves on the head of a dragon.[6]

The painting is finely executed in the *baimiao,* or uncolored line drawing technique. It is inscribed, "At the beginning of the middle ten-day [cycle] of the first month of summer in the cyclical year *bingshen* [1596], on the Day that Demons are Born, respectfully copied by Nanyu Ding Yunpeng."

—S. L.

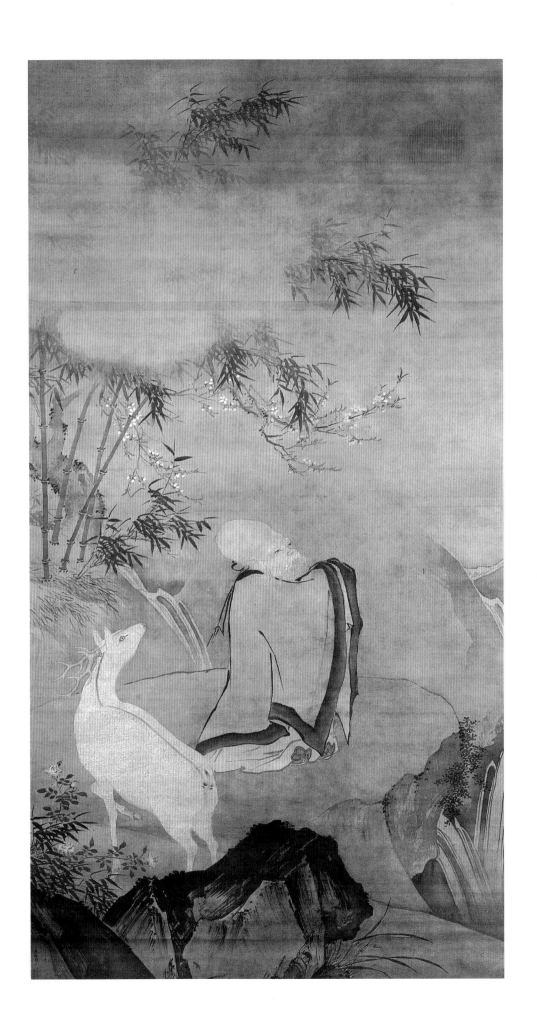

90

Lü Ji (c. 1440–c. 1505)
The Old Man of the Southern [Celestial] Pole

Ming dynasty, late 15th century
Hanging scroll; ink and colors on silk
217 × 114.2 cm
Palace Museum, Beijing

Lü Ji's large hanging scroll depicts Shoulao (or Shouxing), the God of Longevity (also known as the Old Man of the Southern [Celestial] Pole), accompanied by a white deer. The god appears to be bowing to the red sun that hangs in the sky above. On either side are blossoming trees and bamboo. The god is shown with a tall, domed cranium and white whiskers.

According to Sima Qian's *Records of the Historian (Shiji)*, a temple for the worship of the Longevity Star (Shouxing) was first erected by Emperor Qin Shihuangdi.[1] In antiquity, Shouxing corresponded to both an area of the sky bounded by the Lunar Mansions Horn *(Jiao)* and Neck *(Kang)*, and a star corresponding to Canopus, found in a constellation known as *Hu*:

> The Old Man Star *(Laoren xing)* located south of the *Hu* constellation (in the southeastern horizon), also known as *Nan ji* (Southern Pole), appears regularly in late autumn and disappears in early spring. When it is seen, peace prevails (in the nation) and the sovereign is blessed with a long life.[2]

In 736, during the Tang dynasty (618–906), Emperor Xuanzong (r. 712–56) revived imperial worship of Shouxing, and an altar devoted to this god was established in Chang'an (Xi'an).[3] The imperial decree read as follows:

> No virtue is greater than creation, and no happiness is greater than longevity. If there is an object [of longevity worship], why should it not receive ritual sacrifices? Now a memorialist says that in mid-autumn, the sun and moon meet in the Shouxing (Longevity Star) Mansion, which happens to fall within the month of my [Xuanzong's] birth. [He] would like to have it serve as an ancillary god in the sacrifices to She [the God of the Soil]. However, it is inappropriate ritual classification. The Shouxing Mansion governs the lodges of *Jiao* and *Kang*, which are the elders of the 28 *xiu* (lodges). In addition it (Shouxing) is known for [bringing] happiness and longevity. Will this emperor be the only one to enjoy its benefits? Are not the people under heaven desirous of the same? It seems Shouxing worship dates back to the Qin dynasty, which can be said to be old. Henceforth, it is decreed that the government

> agency in charge should set up a special altar of the Shouxing Mansion to conduct ritual ceremonies on the day of One Thousand Autumns *(qianqiu jie)*. It is also decreed that sacrifices should be made to the Old Man Star *(Laoren xing,* or Canopus) and the seven lodges [of the east], including *Jiao* and *Kang*. This should be recorded as the standard practice.[4]

One of the earliest known depictions of Shouxing is in a painting in the Musée Guimet, Paris, entitled *The Star-lords of Good Fortune, Emolument, and Longevity*, dated 1454, and a product of the imperial Ming court (cat. no. 91).[5] From the Ming dynasty onward, Shouxing or Shoulao (Old Longevity) is often seen in the company of the Eight Immortals (Baxian; see cat. no. 118).

This painting is signed in the lower left corner, "The respectful hand of Lü Ji" *(Lü Ji bai shou)*, followed by a seal reading "Seal of Lü Tingzhen of Siming" *(Siming Lü Tingzhen zhi yin)*. A single collector's seal appears in the lower right corner. Lü Ji was one of the leading court painters of the late fifteenth and early sixteenth centuries. A native of Ningbo in Zhejiang province, he was one of the leading masters of bird-and-flower painting at the court of the Hongzhi emperor (r. 1488–1505).[6] Figure paintings by Lü Ji are extremely rare, and this is one of the few known examples.[7]

—S. L.

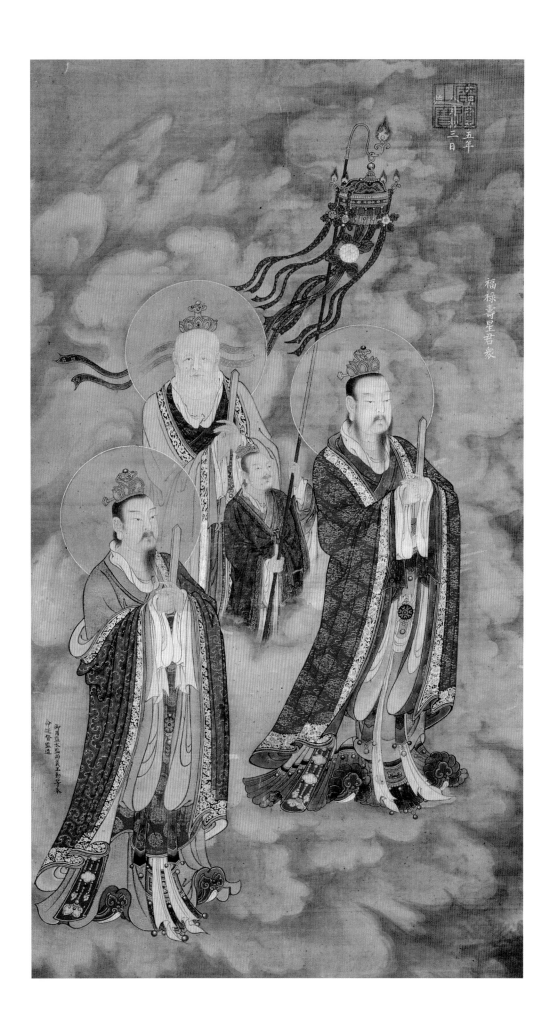

91

The Star-lords of Good Fortune, Emolument, and Longevity

Ming dynasty, Jingtai reign, dated 1454
Hanging scroll; ink, colors, and gold on silk
140 × 78 cm
Musée National des Arts Asiatiques Guimet, Paris (EO 689)

Shown in San Francisco only

WITH THE EXCEPTION of a painting in the Nezu Museum, Tokyo, entitled *The Three Stars Playing Weiqi* and attributed to the Yuan dynasty, the painting of the Three Stars in the Musée Guimet is the earliest known image of this group of gods in Chinese art.[1] Dated to 1454 and created for use in a Water and Land Ritual at the imperial Ming court in the Forbidden City (see cat. nos. 78–81), the scroll depicts a triad that has enjoyed great popularity from the fifteenth century onward: the gods known as Fuxing (Good Fortune Star), Luxing (Emolument Star), and Shouxing (Longevity Star). Of the three gods, the most ancient is (appropriately) Shouxing (or God of Longevity), shown at the upper left as an old man with white hair (see cat. no. 90). In the Musée Guimet scroll, all three gods wear the official caps and hold the tablets of Taoist priests. Accompanying them is a smaller attendant, who holds a small parasol with banners aloft. This group is shown against a background of clouds. A similar depiction of these gods appears in the painting entitled *The Three Stars, Nine Sources of Brightness, Twenty-eight Lunar Mansions, and Twelve Palaces [of the Zodiac]* in the Nelson-Atkins Museum, Kansas City, which may come from the same imperial Ming workshop (see the essay by Stephen Little in this volume, fig. 11). The title of the Musée Guimet painting is inscribed in gold in standard script characters along the right border. At the top right, also in gold, is the date, and an ink inscription at the lower left records the names of the officials who commissioned the painting.

As Mary Fong has shown, the earliest literary evidence for the Three Stars comes from a play entitled *The Festival of the Immortal Officials Fu, Lu, and Shou (Fu Lu Shou xian'guan qinghui)*, written by Zhu Youdun (1379–1439), a grandson of the first Ming emperor, Zhu Yuanzhang (r. 1368–98).[2] In this drama, published in 1443, the Three Stars descend to the mortal world for the lunar New Year's festival. In another play by the same author, *The Eight Immortals Convey Wishes for Longevity at the Turquoise Pond,* the duties of the Three Stars are enumerated as multiplying happiness (Fuxing), conferring emolument or high salary (Luxing), and increasing longevity (Shouxing). Based on the literary and visual evidence, therefore, it would appear that

this group first appeared in the early fifteenth century. As Fong has shown, the gods Fuxing and Luxing have no mythology of their own and no prior history before the early Ming dynasty.[3]

Although these gods are shown in the Musée Guimet painting as Taoist priests, Fong is also correct in pointing out that the Three Stars are not Taoist gods per se.[4] There are, for example, no texts in the Ming Taoist Canon *(Daozang)* devoted to this triad. This is significant because the Taoist Canon was compiled only a decade before the painting of this hanging scroll. The Three Stars appear instead to be gods of popular religion, quite possibly instituted at the imperial level in the early Ming. They do not appear, for example, among the more than three hundred Taoist gods depicted in the early-fourteenth-century murals at the Yongle Gong in southern Shanxi province. The Three Stars have remained gods of popular religion, and their images are among the most commonly encountered today of any Chinese gods.

—S. L.

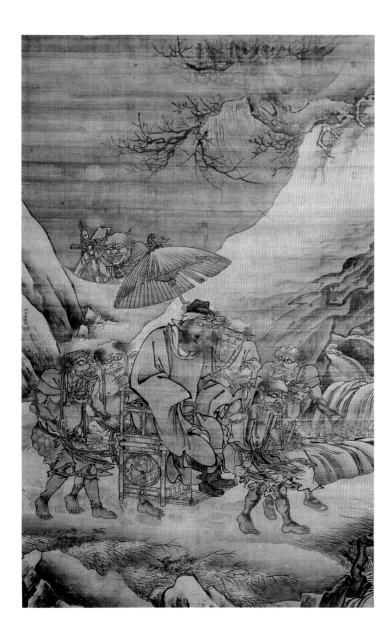

92

DAI JIN (1388–1462)
Zhong Kui Traveling at Night

Ming dynasty, 15th century
Hanging scroll; ink and colors on silk
189.7 × 120.2 cm
Palace Museum, Beijing

ZHONG KUI is one of the most popular gods in traditional
China.[1] Although he emerged in the Tang dynasty as a god of
popular religion at the highest level of society, by the Song dy-
nasty he had been adopted into the religious Taoist pantheon.
The story of Zhong Kui is about a scholar who becomes a
demon-killing ghost, ridding the world of pestilence and evil:

One afternoon in the Kaiyuan era (713–742), Minghuang (Em-
peror Xuanzong), feeling ill after he had returned from a round of
bow-and-arrow practice on Li Shan, fell asleep. He soon saw in a
dream a small-size demon, wearing only knee-length trousers and
one shoe—the other being tied at his waist—and holding a bam-
boo fan, in the act of stealing the favorite consort's embroidered
perfume-bag and his own jade flute. Then, instead of escaping,
the strange being began frolicking around the palace grounds with
the loot. Minghuang therefore approached him and demanded
an explanation. The demon respectfully replied that his name was
Xu Hao and explained that "Xu" stood for "stealing indiscrimi-
nately for the sake of fun" and "Hao" for "replacing man's joys
with sorrows."

Hearing this, the emperor became angry and wanted to call
for his bodyguards. But at that very moment, a large-size demon,
wearing a tattered hat, blue robe, horn waist-belt, and black boots
appeared and nabbed the thief. Immediately afterwards, he pro-
ceeded first to gouge out the victim's eyes, then tore him to pieces
and finally ate him.

When the emperor asked him who he was, the Demon Queller
introduced himself as Zhong Kui, a *jinshi*[2] from Zhongnan, who
ashamed at having failed the next higher degree of examinations
during the Wude era (618–627), had committed suicide by dashing
his head against the palace steps. He further mentioned that be-
cause the emperor Gaozu awarded him an honorable burial of a
court official of the green-robe rank, he had vowed to rid the world
of mischievous demons like Xu Hao. At these words, Minghuang
awoke and found himself fully recovered. Without delay he sum-
moned [the court painter] Wu Daozi and requested him to paint
a portrait of the Demon Queller as he had seen him in his dream.
When it was finished, the emperor examined it carefully and said,
"You and I must have had a similar vision!" And he awarded Wu
one hundred taels of gold.[3]

The long tradition of Zhong Kui paintings is traditionally said
to have begun with this depiction by Wu Daozi in the early eighth
century. By the mid-tenth century, we read that in Sichuan, "Each
year, at winter's end, those in the Hanlin Academy who were
skilled in painting ghosts and spirits customarily presented
paintings of Zhong Kui to the court."[4]

Dai Jin (1388–1462), a professional painter from Hangzhou,
Zhejiang province, was one of the earliest masters of the Zhe
School of Ming painting. The painting is signed along the left
border, "Painted by Dai Jin of West Lake" *(Xihu Dai Jin xie);*
this is followed by a single seal, *Jing'an* (the artist's *hao,* or
nickname).

—S. L.

NOTES

Cat. no. 82

1. Previously published in Priest 1939.
2. On the mechanism of this process, see Hansen 1990: 23–24, 80–104.
3. For a study of similar celestial messengers in Water and Land Ritual paintings, see Gyss-Vermande 1991.

Cat. no. 83

1. See the discussion of Guandi in Maspero 1981: 150–55.
2. In both the twelfth-century album of Taoist gods in the Junkunc Collection, and the Yuan dynasty illustrated Taoist text entitled the *Scripture of the Jade Pivot* (*Yushu jing*, 1333) in the British Library (cat. no. 73), he is labeled as Marshal Guan (Guan Yuanshuai). For the Junkunc album, see Martin 1913.
3. On the multivalent roles played by Guandi, see Duara 1988.
4. Maspero 1981: 153.
5. On these attendants, see Goodrich 1991: 378–79, and Stevens 1997: 147.
6. Judging from the painting's style, the title probably refers to the early Qing dynasty Manchu prince Boggodo (1650–1723), who was the first to hold this title, which was used only by Manchu princes. The title *Heshang qinwang* was not used in the Ming dynasty, indicating that the painting can date only to the early Qing. On Boggodo, see Hummel 1943, vol. 1: 925–27. Boggodo's father, Sose (1629–1655), was the fifth son of Abahai (1592–1643), known to the Manchus as Emperor Taizu (Supreme Ancestor), even though he died before the actual establishment of the Qing dynasty in 1644.

Cat. no. 84

1. Previously published in Gyss-Vermande 1988.
2. Ibid.: 113–19.
3. On the worship of stones as gods, see Little 1999.

Cat. no. 85

1. Johnson 1985: 396.
2. Ibid.: 365–66; see also Hansen 1993: 91.
3. Johnson 1985: 401–02, 410–11.
4. Ibid.: 364.
5. Katz 1995: 61. The Jade Emperor was perceived as the head of the pantheon of popular gods (see cat. no. 33).
6. Zito 1996: 72.
7. Hansen 1993: 91, 108–09 n. 88. See also Haar 1990: 354.
8. Johnson 1985: 373, 370.
9. Katz 1996a: 76.
10. Johnson 1985: 364.
11. Translated in Zito 1996: 78–81.

Cat. no. 86

1. Goodrich 1991: 291–93.
2. DeWoskin and Crump 1996: 51.
3. Kleeman 1994b: 226. According to Allen 1991: 99, the sacred peak to which sacrifices were offered in the Shang dynasty corresponded to Song Shan (Mount Song) in Henan province.
4. Kleeman 1994b: 230–31.
5. Barrett 1996: 54–55.
6. Kleeman 1994b: 230.
7. See Katz 1993: 46.

Cat. no. 87

1. Previously published in Wu 1997: 263.
2. The hagiographical information on Marshal Wen in this entry is largely taken from Katz 1995.
3. Ibid.: 78.
4. Ibid.: 87–88.
5. Ibid.: 123.
6. Ibid.: 88–91, 93.

7. Ibid.: 80–84. On the Shenxiao movement, see ibid.: 33; also Boltz 1987a: 26–37. For other sources on Marshal Wen, see Katz 1995: 93–106.
8. Katz 1995: 93–106. Katz's source here is HY 779.
9. Ibid.: 90.
10. Ibid.: 94.
11. Ibid. For a woodblock print illustration of the god wearing the same inscribed plaque, see ibid.: 96, fig. 3.

Cat. no. 88

1. For a biography of the Jiajing emperor, see Goodrich and Fang 1976, vol. 1: 307–15.
2. Cheng 1996: 220.

Cat. no. 89

1. Kleeman 1993: 48–49. The full "autobiography" of Wen Chang is the focus of Kleeman 1994a.
2. Zitong is a place in Sichuan province; see Kleeman 1993: 52–53. Kleeman has noted that Wenchang's identity as a Taoist god was recognized by the imperial government only in 1316, during the Yuan dynasty (1260–1368); see ibid.: 57. For a Yuan dynasty depiction of Wenchang in the murals of the Yongle Gong Taoist temple in southern Shanxi, see Jin 1997: pl. 97.
3. Wenchang's celestial home is the Wenchang Palace, a constellation situated in immediate proximity to the Northern Dipper *(Beidou)*; see cat. no. 18, and Kleeman 1993: 52–53.
4. The revelation of the *Book of Transformations* to Liu Ansheng began in 1168; see Kleeman 1994a: 86–87.
5. See Stevens 1997: 104.
6. Goodrich 1991: 229.

Cat. no. 90

1. Fong 1983: 160.
2. Ibid., quoting from the *Jinshu* (Dynastic history of the Jin).
3. Xiong 1996: 285.
4. Translation adapted from ibid.: 314–15.
5. An anonymous painting in the Nezu Museum, Tokyo, attributed to the Yuan dynasty, is said to depict the Three Stars, including Shouxing, and if indeed it is pre-Ming in date, it would be the earliest depiction of this god in Chinese painting; see Ebine 1975, no. 21.
6. Yu 1980: 270.
7. For another example, see the handscroll entitled *Birthday Gathering in the Bamboo Garden*, jointly painted by Lü Ji and Lü Wenying, published in Pan 1988; and Yang 1994: pl. 5.

Cat. no. 91

1. Despite the title of the Nezu Museum painting, it is not entirely clear that the scroll depicts the Three Stars (the figures are, however, shown as Taoist priests); see Ebine 1975: no. 21.
2. Fong 1983: 185.
3. Ibid.: 186.
4. Ibid.: 196.

Cat. no. 92

1. On Zhong Kui and his depiction in painting, see Little 1985: 22–41, and Liu Fang-ju 1997. On the image of Zhong Kui as a political symbol, see Lawton 1973: no. 35.
2. The *jinshi* was the highest degree in the civil service examinations in traditional China; it meant "presented scholar" because the successful graduates were presented to the emperor at court. See Miyazaki 1976.
3. Translated from Chen Wenzhu's *Tianzhong ji* (Record of heaven's center; 1589), in Fong 1977: 427–28. The account in the *Tianzhong ji* in turn quotes a lost text, *Tang yishi* (Left-over affairs of the Tang).
4. YZMHL, *juan* 2: 21b–22a.

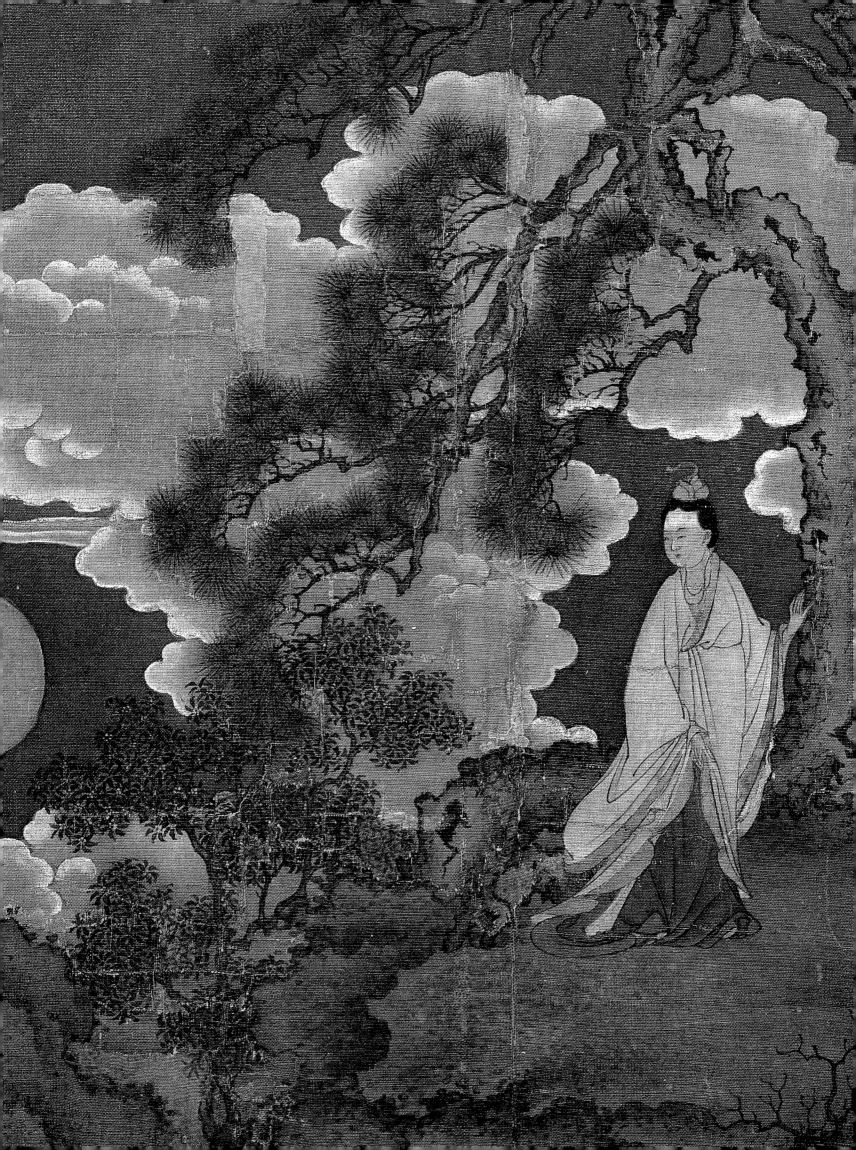

AMONG THE RELIGIONS OF CHINA, Taoism is distinguished by its emphasis on the vital role of the *yin* force—the feminine aspect of the world. In the *Daode jing,* attributed to Laozi, the Tao itself is described in this light:

> The Valley Spirit [i.e., the Tao] never dies.
> It is named the Mysterious Female.
> And the Doorway of the Mysterious Female
> Is the base from which Heaven and Earth sprang.
> It is there within us all the while;
> Draw upon it as you will, it never runs dry.[1]

From a cosmological viewpoint, the *yin* force, which as a complement to the *yang* (male) force symbolizes the feminine aspect of reality, has always been a fundamental element in Taoist belief. *Yin* and *yang* are seen as mutually complementary opposites whose interaction creates all the mechanisms of the universe; one cannot exist without the other.

This section of the exhibition introduces several of the most important goddesses of the Taoist pantheon. These deities personify the essence of the *yin* force, and have a long history in China as protectors of life and dispensers of longevity. As patron deities of women, goddesses such as the Queen Mother of the West (Xiwangmu) or Metal Mother (Jinmu), the Sovereign of the Clouds of Dawn (Bixia yuanjun, the Goddess of Mount Tai, the Sacred Peak of the East), Doumu (the Dipper Mother), Houtu (the Earth Goddess), and Tianhou (the Empress of Heaven, or Mazu) continue to be worshipped in China today. During the course of Chinese history, many of the Taoist deities who transmitted secret teachings to human visionaries have been female. The fourth-century Shangqing (Highest Purity) adept Yang Xi, for example, frequently obtained sacred texts from the divine realm through the intercession of the female realized being *(zhenren)* Wei Huacun.

Throughout the history of religious Taoism, female saints have also played a vital role in both popular and elite worship. Such influential figures as Master Geng, active as an alchemist at the Tang court in the ninth century, and Tanyangzi, a late-sixteenth-century teacher who had a wide following among many of the leading male literati scholar-officials of the late Ming dynasty in south-central China, are exemplary models of the powerful role of the *yin* aspect of being in daily life and belief. From the time of the first Celestial Master sect (second century) onward, both men and women could be ordained into the Taoist clergy. The longevity of this tradition is reflected at the imperial level, where empresses and princesses were regularly ordained as Taoist priestesses from the Tang dynasty (618–906) onward.

Detail, cat. no. 101

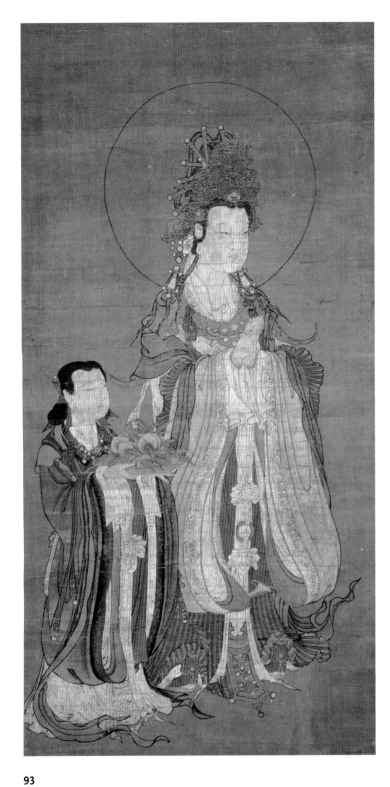

93

93

Blessings for Long Life

> Yuan dynasty (1260–1368)
> Hanging scroll; ink and colors on silk
> 91 × 45.3 cm
> National Palace Museum, Taipei

94

WU WEI (1459–1508)
Female Goddess or Immortal

> Ming dynasty, 15th century
> Hanging scroll; ink on paper
> 162.7 × 63.8 cm
> Shanghai Museum

WHILE UNTITLED, the Taoist goddesses depicted in these two paintings almost certainly are Xiwangmu, the Queen Mother of the West, also known as Jinmu, or Metal Mother.[1] This is suggested by the presence of single phoenixes in the headdresses of both figures; the phoenix has been a key iconographic feature of Xiwangmu since at least the Yuan dynasty (1260–1368), as seen in the murals of the Hall of the Three Purities (Sanqing Dian) at the Eternal Joy Temple (Yongle Gong) in Shanxi.[2] In the National Palace Museum scroll (cat. no. 93), the identification is corroborated by the presence of the peaches held by the jade maiden *(yunü)* at the left; these are the peaches that grow every three thousand years in the Queen Mother's paradise on Mount Kunlun (see cat. no. 27).

One of the oldest female deities of China, Xiwangmu is mentioned in the "Inner Chapters" of the *Zhuangzi* (c. 300 B.C.) as a goddess who "obtained the Tao." She was associated with metal (one of the Five Phases or Elements), autumn, and the west, all aspects of the *yin* force. As a divine personification of *yin,* Xiwangmu was widely worshipped from the Han dynasty (206 B.C.–A.D. 220) onward. She emerged as a full-fledged Taoist goddess in the scriptures of the Shangqing (Highest Purity) school of religious Taoism in the Eastern Jin dynasty (fourth century). In addition to being a patron deity of women, she was a divine teacher who could control the length of people's lives, and was closely associated with the cultivation of virtue and immortality.[3] Significantly, she is still worshipped today in China, Taiwan, and Hong Kong, and among many overseas Chinese communities.[4]

In the National Palace Museum scroll, the goddess is shown standing in a dignified posture, her hands clasped together in a

gesture of worship. This, and the fact that she and her attendant face to the right, suggest that the painting originally belonged to a larger set, with the figures facing images of higher Taoist gods such as the Three Purities (Sanqing; see cat. no. 65–67). The goddess is dressed in elaborate robes, painted with superbly harmonized blue, green, red, pink, and lavender pigments. Her ornate metal crown has a single phoenix at the center. Her attendant holds a tray heavily laden with ripe peaches, ancient symbols of longevity and good fortune. The scroll bears seals of the Qing dynasty Qianlong (r. 1736–95), Jiaqing (r. 1796–1820), and Xuantong (r. 1909–11) emperors.

The painting by the scholar and professional painter Wu Wei (1459–1508) in the Shanghai Museum (see cat. no. 94) presents the goddess as a young woman of extraordinarily refined appearance.[5] This striking characterization of the goddess recalls the exalted description of the Queen Mother in the Six Dynasties period (420–589) text *Esoteric Transmissions Concerning the Martial Thearch of Han (Han Wudi neizhuan),* quoted in the Tang Taoist Du Guangting's *The Primordial Ruler, Metal Mother (Jinmu yuanjun):*

> The Queen Mother rides an imperial carriage of purple clouds, harnessing nine-colored dappled *qilin* [mythical beasts]. Tied around her waist, she wears the whip of the Celestial Realized Ones; as a belt pendant, she has a diamond numinous seal. In her clothing of multi-colored damask with a yellow background, the patterns and variegated colors are bright and fresh. The radiance of metal makes a shimmering gleam. At her waist is a double-bladed sword for dividing phosphors. Knotted flying clouds make a great cord. On top of her head is a great floriate topknot. She wears the crown of the Grand Realized Ones with hanging beaded strings of daybreak. She steps forth on shoes with squared, phoenix-patterned soles of rose-gem. Her age might be about twenty. Her celestial appearance eclipses and puts in the shade all others. She is a realized numinous being.[6]

Wu Wei's scroll is painted in ink alone with sharp tonal contrasts, and wet washes over energetic dry ink outlines. The painting depicts the goddess as detached and mysterious. Wearing voluminous robes, she wears a headdress with a single stylized phoenix in front, and holds a tablet of rank in her hands. Her face is summarily painted with sharp lines of very dry ink. The painting is signed "Xiaoxian" ("Little Immortal"), and bears two of the artist's seals: "Seal of Wu Wei" and "Battalion Commander of the Embroidered Uniform Guard" (a title in the imperial Ming painting academy).

—S. L.

94

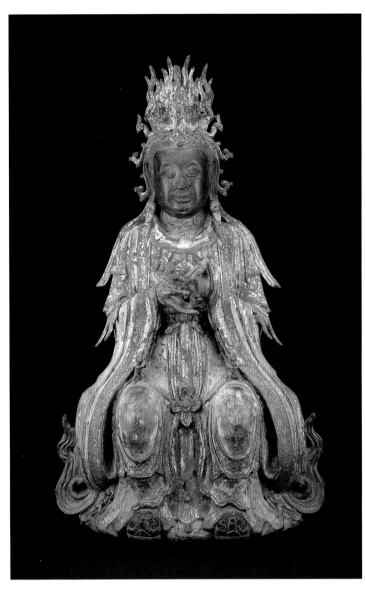

95

95

Sovereign of the Clouds of Dawn

> Ming dynasty, 15th century
> Bronze with traces of pigment
> H. 96.5 cm
> The Art Institute of Chicago, Gift of Mrs. Samuel G. Rautbord
> (1967.333)

96

Saintly Mother Heavenly Immortal of the Eastern Peak

> Ming dynasty, c. 1600
> Hanging scroll; ink, colors, and gold on silk
> 216 × 100 cm
> Musée National des Arts Asiatiques Guimet, Paris (EO 760)

> Shown in Chicago only

ONE OF THE MOST POPULAR Taoist deities from the Ming dynasty onward was Bixia yuanjun, the Sovereign of the Clouds of Dawn.[1] This goddess was the daughter of the male god of Mount Tai (Tai Shan), the easternmost of the Five Sacred Peaks, located in Shandong province. Mount Tai had been a focal point of imperial and popular worship since at least the Qin (221–207 B.C.) and Han (206 B.C.–A.D. 220) dynasties.[2] Not only was the peak closely tied to rites related to the political legitimacy of the emperor, but it was also seen in the medieval period as the gateway to the realm of the dead.[3]

The Palace of the Clouds of Dawn (Bixia Gong), a shrine to the goddess, was built at the top of Mount Tai during the Ming dynasty, and is still a focus of pilgrimage worship.[4] Bixia yuanjun became the most popular female Taoist deity in China during the Ming and Qing dynasties, and unlike her father, was seen as a compassionate deity.[5] Her popularity is widespread today. Many cities in China have temples dedicated to Bixia yuanjun. In Beijing, the Temple of the Eastern Peak (Dongyue Miao) contains a hall dedicted to the goddess, as does the White Cloud Monastery (Baiyun Guan). In Taoist painting and sculpture, she is often accompanied by nine other attendant goddesses, including the Goddess of Children (Zisun niangniang) and the Goddess of Eyesight (Yanguang niangniang).[6]

The official Taoist hagiography of Bixia yuanjun is contained in a text entitled *History of Mount Tai (Tai shi)*, compiled by Zha Zhilong (fl. 1554–86) and included in the Wanli reign (1573–1620) supplement to the Taoist Canon, printed in 1607.[7]

The Art Institute's bronze sculpture of the Sovereign of the Clouds of Dawn (cat. no. 95) can be dated to the early Ming

dynasty (fifteenth century), and was undoubtedly made for use on a Taoist altar. Dignified and imposing, the goddess can be identified by the three phoenixes in her headdress (her standard iconography). With her hands, the goddess forms a sacred gesture, not unlike the Buddhist *mudra* of "turning the Wheel of the Law" (although the position of the hands is reversed). Two small boys stand on her lap.

The brilliant hanging scroll in the Musée Guimet, Paris (cat. no. 96), depicts the Sovereign of the Clouds of Dawn regally seated in her celestial court, accompanied by six female attendants. Bixia yuanjun wears a robe edged with feathers and holds a tablet in both hands. Her headdress contains seven phoenixes. An inscription on the outer mounting records the title: *Saintly Mother Heavenly Immortal of the Eastern Peak (Dongyue tianxian shengmu)*. As Susan Naquin has shown, by 1600 the goddess was widely known by this title.

Many images of Bixia yuanjun survive from the Ming and Qing dynasties. They can almost all be identified by the presence of three, or sometimes more, phoenixes in the deity's headdress (as opposed to images of the Queen Mother of the West, in which the headdress usually has a single phoenix).

—S. L.

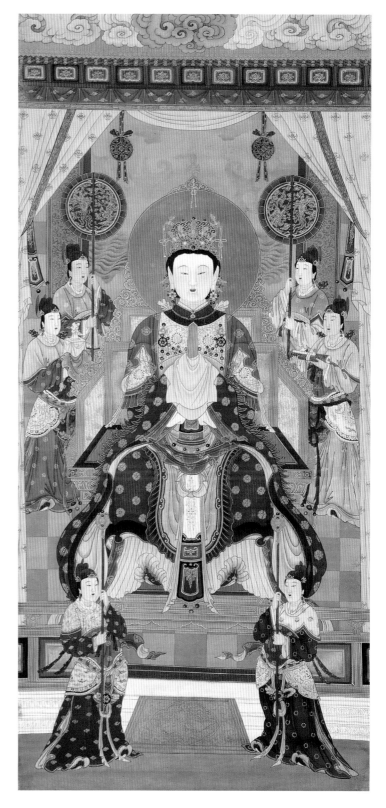

96

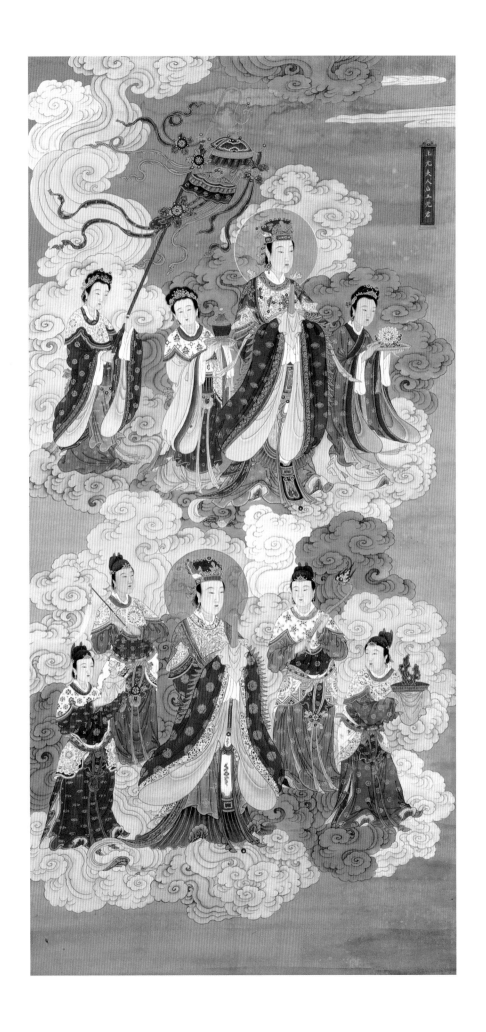

97

The Lady of the Highest Primordial and the Empress of Earth

Ming dynasty, c. 1600
Hanging scroll; ink, colors, and gold on silk
216.5 × 103 cm
Musée National des Arts Asiatiques Guimet, Paris (EO 717)

Shown in San Francisco only

THIS PAINTING was originally made for the Buddhist Water and Land Ritual (see section II.3, "The Taoist Pantheon"). It depicts two female deities, the Lady of the Highest Primordial (Shangyuan furen; above) and the Empress of Earth (Houtu; below), each accompanied by female attendants[1] holding auspicious items such as coral, a mushroom-shaped *ruyi* scepter, and a parasol. They float on multi-colored clouds that descend from above the top border of the painting.

The Lady of the Highest Primordial first came to prominence in the medieval period, and holds a special place in the legends surrounding the Highest Purity scriptures (see cat. no. 55). She is most famous for a medieval tale in which she appears to the Han dynasty emperor Wudi (r. 140–87 B.C.), together with the Queen Mother of the West (Xiwangmu; see cat. no. 26).[2] In addition, she was a teacher of the three Mao brothers, fabled Han dynasty figures who gave their names to Mount Mao, an important Taoist site, and who were seen as patriarchs of the Highest Purity scriptures. Later hagiographies of this goddess[3] still emphasize these medieval legends, but it is clear that she continued to play an active role in the Taoist pantheon in late imperial times.[4]

The Empress of Earth seems to have been worshipped as an earth spirit as early as the sixth century B.C., and is connected by such early texts as the *Zuozhuan* with ancient community altars to the soil *(she)*. Imperial rites to this deity were formalized by Emperor Wu of the Han dynasty in 113 B.C.[5] Although the literal translation of this deity's name suggests that the deity is female, early sources indicate that the name was initially understood as the proper name or title of a male deity who eventually came to be seen as female by the medieval period. This probably resulted from the use of the character for "empress" *(hou)* in the deity's name, and from the popular associations between the earth and

female or *yin* energy (as opposed to the male or *yang* energy associated with the heavens). In addition to her primary role as a divine manifestation of the earth, the Empress of Earth has secondary connotations as a protector spirit of graves and the deceased. Although the Empress of Earth appears here in the context of a Buddhist ritual, she figures prominently in the Taoist pantheon, and is one of the primary deities in the Yuan dynasty murals of the Hall of Three Purities in the Eternal Joy Temple (Yongle Gong) in Shanxi province.[6] It is intriguing to note that in the murals of the Hall of Three Purities, the Empress of Earth is depicted opposite the Metal Mother (a title for the Queen Mother of the West), ancient companion to the Lady of the Highest Primordial, with whom she is shown in the present painting.

The depiction of the Lady of the Highest Primordial with the Empress of Earth in this painting suggests that the former goddess is used to represent the heavens, while the latter represents the earth. Moreover, the Lady of the Highest Primordial serves as a divine matriarchal figure, being called in later times Realized Mother of the Three Heavens,[7] while the Empress of Earth serves as patron protectress of the dead; so, taken together, these two goddesses seem to personify the entirety of human (and cosmic) existence from birth to death. As such, this painting is a particularly evocative expression of the goal of the Water and Land Ritual to address all the spirits of the natural and supernatural worlds—literally, all the spirits of the "water and land."

—S. E.

98

The Dipper Mother

Qing dynasty, 18th century
Dehua porcelain
H. 24.8 cm
Asian Art Museum of San Francisco, The Avery Brundage Collection
(B60 P1362)

IT IS UNCLEAR when worship of the Dipper Mother (Doumu) began, but she did not come to prominence until the late imperial period (beginning in the fifteenth century). There are several short texts concerning this deity in the Taoist Canon, including at least two biographies[1] and a ritual devoted to her[2] from the Ming dynasty (1368–1644). As her name implies, she is the mother of the seven stars of the Northern Dipper (Ursa Major). One of her biographies tells us that in countless ages past, she made a vow to "give birth to sacred children who would assist *qian* and *kun*[3] and aid Great Transformation *(zaohua)*." Later, when she was incarnated as a woman named Lady of Violet Light, consort to a certain King Zhou Yu, she was able to fulfill this vow. On a fine spring day, when all the flowers were in bloom, she was amusing herself in the royal gardens, and decided to bathe in the Pool of Warm Jade and Golden Lotuses. After she disrobed and entered the pool, she suddenly felt "moved," and nine lotus buds in the pool blossomed to reveal nine children.[4] A more elaborate account tells us that when she entered the pool, a "white jade tortoise platform with a precious throne shaped like a sacred *xie* beast"[5] rose out of the waters of the pool. The lady mounted the throne and began to meditate, and the Way (Tao) responded by casting a light that penetrated into the pool, transforming into nine golden lotus buds. After seven days, these lotuses suddenly rose to the heavens, transforming into nine precious towers with nine magical syllables formed from the energies that created them. These nine syllables in turn gave rise to nine stars. The elder of these stars were Violet Tenuity and Celestial August, two important stars in the central northern sky; their younger siblings were the seven stars of Ursa Major.[6]

The Dipper Mother is also identified with the moon, and in particular with the magical elixir concocted by the hare in the moon, associating her with an ancient Chinese myth and another female deity, Chang E (see cat. no. 101). The Dipper Mother dispensed this medicine to the world, curing illnesses and ensuring safe births.[7]

In order to commemorate the birth of the seven stars of the Northern Dipper and their elder siblings, worshippers held a festival called the "Offering of the Nine Luminescences" *(Jiu-guang jiao)* annually on their birthday. The power of this festival to undo the effects of negative *karma* has been likened to "nine suns shining on a mountain of ice."[8] The festival was apparently based on the *Realized Scripture of the Nine Luminescences (Jiu-guang zhenjing)*, a scripture that still exists in the Taoist Canon.[9] This scripture reflects the idea of the "unity of the Three Teachings" of Confucianism, Taoism, and Buddhism that was popular in late imperial China, being devoted to both the supreme Taoist deity, the Celestial Worthy of Primordial Beginning (Yuanshi tianzun), and to the highest deity of Esoteric Buddhism, the Buddha Vairochana. Similarly, the ritual devoted to the Dipper Mother found in the Taoist Canon also invokes both Taoist and Buddhist deities, including Vairochana, who is once again paired with the the Celestial Worthy of Primordial Beginning.[10]

This blending of Buddhist and Taoist elements can also be seen in the figure of the Dipper Mother herself. It is thought that the Dipper Mother was derived from one of the twenty *devas* of Buddhism, Marichi, whose name means, literally, "ray of light." As her name implies, this goddess is intimately connected with stellar phenomena, and she is sometimes depicted holding the sun and moon aloft in two of her hands; the Dipper Mother seen here is also holding the sun and the moon. The vehicle of Marichi is drawn by seven pigs, which suggests the seven stars of Ursa Major, and the Dipper Mother is often similarly depicted with pigs for mounts. In addition, the Chinese transliteration for Marichi, "Molizhi tian," is given as one of the titles for the Dipper Mother in the ritual devoted to her.

This porcelain sculpture of Doumu from the Asian Art Museum of San Francisco sits on a lotus throne. On her head is a crown; she has eighteen arms and a third eye in her forehead. Her hands hold numerous attributes, including sacred weapons and vessels.[11]

The Dipper Mother is still actively worshipped in China today, most notably at the White Cloud Monastery (Baiyun Guan) in Beijing, where there is a chamber dedicated to her.

—S. E.

The Alchemy of Master Geng

Ming dynasty, 16th century (traditionally attributed to the Song
 dynasty, 960–1279)
Hanging scroll; ink on silk
105.3 × 57.7 cm
National Palace Museum, Taipei

THIS PAINTING of a Taoist female alchemist depicts a scene
at the Tang dynasty court in the mid-ninth century. The female
adept known as Master Geng was one of a long tradition of *fang-
shi* ("magicians," or "technicians"—literally "method-masters")
stretching back into the Bronze Age. Although records of female
fangshi are rare, several antecedents are known from the Six
Dynasties period (420–589) and earlier. The presence of such
adepts, male or female, at the imperial courts of China was sig-
nificant because they reflected the virtue of the rulers they served.
Thus, beyond their abilities to create elixirs that would extend the
lives of their patrons, their very presence added to the prestige
of the ruler. Throughout Chinese history emperors and imperial
families have been major sources of patronage for Taoist adepts.
This tradition can be traced to as early as the emperor Qin
Shihuangdi in the third century B.C., long before the advent of
religious Taoism. During the Liang dynasty (502–557), Emperor
Wudi was a great patron of the Taoist alchemist Tao Hongjing
(456–536), despite the fact that Wudi was a devout Buddhist.
The emperor funded a Taoist monastery on Mount Mao (Mao
Shan) for Tao and supported his alchemical experiments.[1]

The story of Master Geng is related in Wu Shu's *Records of
Strange Magician-Technicians Between the Yangzi and Huai Rivers
(Jiang Huai yiren lu),* dated to c. 975:

> Teacher Geng was the daughter of Geng Qian. When she was
> young she was intelligent and beautiful and liked reading books.
> Fond of writing, she sometimes composed praiseworthy poetry,
> but she was also acquainted with Taoist techniques, and could
> control the spirits. She mastered the "art of the yellow and the
> white" (alchemy), with many other strange transformations, mys-
> terious and incomprehensible. No one knew how she acquired all
> this knowledge.
>
> In the Dazhong reign-period (847–859) the emperor, being fond
> of the elegant and fascinated by the strange, summoned her to the
> palace to observe her techniques. She was not added to the pool
> of palace ladies but was given special lodgings and called "Teacher"
> [xiansheng]. When having an audience she always wore green robes
> and held a tablet and when she spoke it was with brilliant elo-

> quence and confident bearing. . . . The Teacher did not often dem-
> onstrate her (divination) techniques, but when she did so the
> results always came out as she predicted. For this the emperor
> valued her all the more.[2]

After once turning mercury into silver for the emperor, Master
Geng was asked to turn snow into silver (this is the scene de-
picted in the National Palace Museum painting):

> On another occasion during heavy snow the emperor asked her
> if she could turn that into silver also. Saying that she could, she
> cut up some hard snow in the form of an ingot and threw it into a
> blazing charcoal fire. The ashes rose up and all was covered over
> with charcoal; then after about the time required to take a meal
> she said it was done, and taking out the red-hot substance, put it
> on the ground to cool, whereupon it brightened and took the form
> of a silver ingot, with the same knife-marks still on it. The under-
> surface, which the fire had reached first, looked like stalactites.
> Later the Teacher made a lot of "snow-silver," so much that she
> presented vessels made of it to the emperor on his birthday. . . .
>
> Later on the Teacher appeared to be pregnant, and told the
> emperor that she would give birth that night to a baby who would
> be a great sage. The emperor caused everything to be prepared,
> but towards midnight there came a violent thunderstorm, and the
> next morning she had regained her normal size, but no baby was
> to be seen. She said that the gods had taken it away and that it
> could not be got back.
>
> The Teacher was fond of wine, and just like other people in love
> affairs and sexual relations. Moreover in the course of time she fell
> ill and died. Formerly the holy immortals often mixed with human
> beings—perhaps she was one of them.[3]

It is worth noting that Master Geng's patron, Emperor
Xuanzong, died from an overdose of cinnabar.[4] The National
Palace Museum scroll depicts Master Geng seated before a
charcoal brazier with the emperor facing her. Several vessels rest
in the charcoal; these appear to be the silver vessels she made
from snow. The painting is executed in ink on silk, and closely
resembles in style the work of the Wu School painter Tang Yin
(1470–1523).[5]

—S. L.

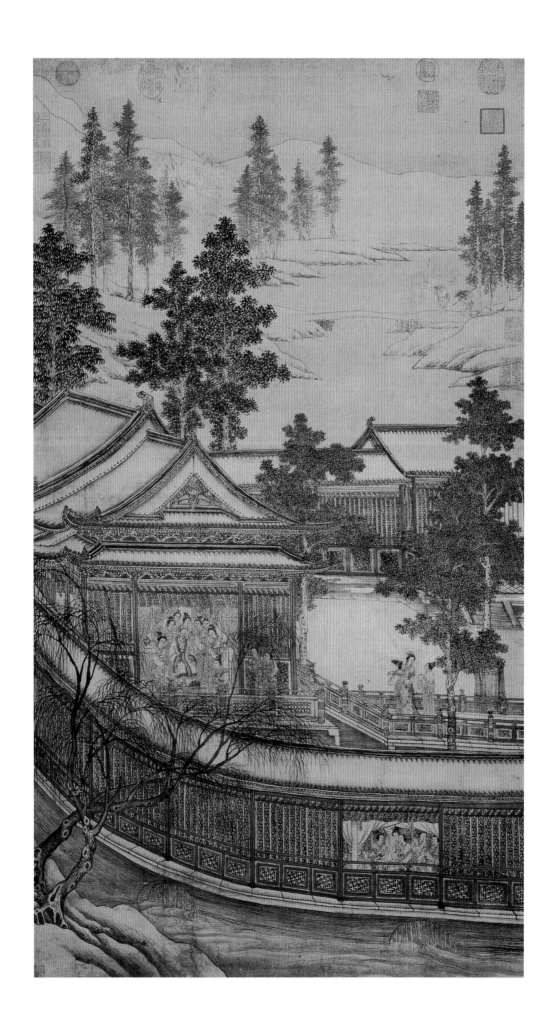

100

You Qiu (active 16th century)
The Immortal Master Tanyangzi

Ming dynasty, Wanli reign, dated 1580
Hanging scroll; ink and colors on silk
118.5 × 57.3 cm
Shanghai Museum

You Qiu's memorial portrait of Tanyangzi (1557–1580) presents an image of one of the most famous female Taoist adepts of the sixteenth century. The scroll was painted only three months after Tanyangzi's ascent to immortality, at the age of twenty-three in the ninth lunar month of 1580. This event was recorded by the scholar Wang Shizhen (1526–1590). As told by Ann Waltner,

> On the ninth day of the ninth lunar month in 1580 a large crowd gathered in Zhitang, a small town in the hinterland of the splendid city of Suzhou, to witness an event they had long anticipated. A young woman, at twenty-three barely more than a girl, the daughter of one of the most prominent families of the region, was deep in a shrine at the grave of her dead fiancé. For years, people had been hearing stories about this young woman, about how she had not eaten grain for five years, about how she had visions of the Buddhist bodhisattva Guanyin and how she had visited the court of the Taoist deity the Queen Mother of the West. Even more surprising were the stories that her father and a circle of his distinguished colleagues had declared themselves to be her disciples. The crowd gathered and she did what she had promised them she would do. According to numerous contemporary accounts, she ascended heavenward in broad daylight and attained immortality.[1]

By the time she attained immortality the young woman had already had an enlightenment experience, after mastering the techniques of Inner Alchemy and creating an internal elixir.[2] Among the sacred texts revered by Tanyangzi were the Buddhist scriptures the *Heart Sutra*, the *Diamond Sutra*, the *Surangama Sutra*, and the *Vimalakirti Sutra*. The Taoist texts she studied included the *Daode jing*, the *Scripture of the Yellow Court* (*Huangting jing*; see cat. no. 128), the *Scripture of the Hidden Contract* (*Yinfu jing*; also known as the *Huangdi yinfu jing*; early seventh century), and the *Realized Scripture of the Numinous Treasure* (*Lingbao zhen jing*).[3] In the sixth lunar month of 1580, shortly before her death, Tanyangzi experienced a vision in which she visited the Queen Mother of the West.[4] This experience, during which esoteric teachings were transmitted to her, lasted several days.

One of the extraordinary aspects of Tanyangzi's brief earthly career is that her followers included numerous elite scholar-officials, beginning with her father, Wang Xijue (1534–1611), who after her death became Grand Secretary at the court of the Wanli emperor (r. 1583–1620). Tanyangzi's biography was written by Wang Shizhen, one of the most cultivated figures in the literary and artistic world of late sixteenth century. What is known about Tanyangzi derives largely from Wang Shizhen's text, which, along with a woodblock illustration of the moment immediately prior to Tanyangzi's ascent to immortality, is found in the *Stories of Exquisite Immortals, New Edition (Xinjian xianyuan jishi)* of 1602, a collection of illustrated biographies of holy women.[5] Tanyangzi's story is also characteristic of later Chinese religion, revealing the syncretic mixing of Taoist, Buddhist, and Confucian teachings.[6]

In the painting Tanyangzi appears as she must have appeared in 1580. She is shown wearing an ochre robe with a pale blue hem, and with a black hat on her head. She holds a ritual sword in her left hand. Her skin is painted with pale white pigment, and her lips are red. The portrait is signed, "Painted by You Qiu of Changzhou, on an auspicious day of the twelfth lunar month of the year *gengchen* [1580] of the Wanli reign." You Qiu was a son-in-law of the Wu School painter Qiu Ying (c. 1495–1552).

According to a poem by Wang Chang (1725–1807), a mural depicting Tanyangzi was also painted by You Qiu on the wall of the saint's shrine at Taicang, near Suzhou.[7] It is likely that the hanging scroll in the Shanghai Museum depicts a similar scene, since the presence of a sword coincides with descriptions of Tanyangzi's final moments.

The inscription by Zhang Tao at the top of the scroll consists of a transcription of Tanyangzi's final Eight Admonitions, and other texts that were said to be by Tanyangzi herself.[8] Among these admonitions was "Do not believe that your teacher [Tanyangzi] was a sorceress outside the Tao who was a specialist in alchemy or sexual techniques."[9] Zhang's inscription is signed, "Respectfully recorded by the disciple Zhang Tao, in the twelfth month of the year *gengchen* [1580]."

—S. L.

101

Chang E, the Moon Goddess

> Late Yuan or early Ming dynasty, 1350/1400
> Fan painting; ink and colors on silk
> 25 × 25 cm
> The Art Institute of Chicago, Samuel M. Nickerson Endowment Fund
> (1947.534)

THIS PAINTING DEPICTS Chang E, the Moon Goddess, also known as Taiyin xingjun (Star-lord of Supreme *Yin*). Chang E was believed to live in the Guanghan Gong (Broad Cold Palace) in the moon. The moon itself was an ancient symbol of the *yin* force, and it is appropriate that its deity was a woman, also a pure manifestation of *yin*. Chang E was said to have stolen the elixir of immortality from her husband, the mythical archer Yi, and taken it to the moon; as a result, she was closely associated with longevity and immortality.[1] She was well established as a popular deity by the Tang dynasty (618–906).[2]

At the time of the Autumn Moon festival, on the night of the full moon in the eighth lunar month, an altar would be set up for worship of the moon and of Chang E. This festival was closely associated with women, since the advent of the full moon in the eighth month signalled the rising *yin* element in the annual cosmological cycle.[3] The following is a description of a sacrifice to the moon as practiced in the early twentieth century:

> Just at the hour when the moon is clear of the treetops and sails like a full-rigged ship into the high heavens, the service begins. . . . One after another the women [of the household] go forward and make their bows. Two candles are lighted. . . . Bundles of incense-sticks are stuck flaming into the family urn, but their light glimmers faintly in the floods of moonshine. The whole service lasts but a few moments. . . .[4]

The Art Institute fan depicts Chang E standing on a rocky plateau.[5] The goddess rests her left hand on the trunk of a pine tree (a symbol of longevity) that grows at the edge of a chasm. Behind the figure, a full moon rises among white clouds in a deep blue sky.

—S. L.

Notes

Introduction

1. Waley 1958: 149.

Cat. nos. 93–94

1. The central figure of cat. no. 93 is identified as the Queen Mother of the West in *Changsheng de shijie* 1996: 79, pl. 24. The definitive study of Xiwangmu is Cahill 1993. The appellation "Metal Mother" appears to have first occurred in the Tang dynasty (618–906); see Cahill 1993: 68.
2. Jin 1997: pls. 140, 150.
3. See Cahill 1986a.
4. See, for example, Stevens 1997: 53.
5. Previously published in *Zhongguo gudai shuhua tumu* 1986–98, vol. 2: 256, no. 1-0445.
6. Translated in Cahill 1993: 81.

Cat. nos. 95–96

1. The title *yuanjun* (literally, "primordial lord") was commonly used in the names of Taoist female gods. For a brief history of the cult of Bixia yuanjun, see Naquin 1992: 334–38.
2. See Bokenkamp 1996b: 251–60 and Chavannes 1910.
3. Bokenkamp 1996b: 252.
4. Boltz 1987a: 297 n. 277.
5. Naquin 1992: 334.
6. Ibid.: 335; see also Goodrich 1964: 62–63, 257–58.
7. Boltz 1987a: 105.

Cat. no. 97

1. Three attendants accompany the Lady of the Highest Primordial, while four accompany the Empress of Earth; this may derive from the association of *yang* (heaven) energy with odd numbers and *yin* (earth) energy with even numbers.
2. See Schipper 1965.
3. For example, see the Yuan hagiography in HY 296, *juan* 3.
4. For example, she is included in a list of goddesses for a ritual petition found in the Song dynasty text HY 1214, *juan* 3; I am grateful to Kristofer Schipper for this citation.
5. Relevant passages from the *Zuozhuan* and the *Hanshu* can be conveniently found in Lu and Luan 1991: 218–25. See also Chavannes 1910: 521–22.
6. Jin 1997.
7. HY 1214, *juan* 3.

Cat. no. 98

1. HY 45 and HY 621; these texts are undated, but they were completed sometime before the compilation of the Taoist Canon in 1444–45.
2. HY 1440; this text is included in the supplement to the Taoist Canon that was added in 1607.
3. These are the first two trigrams (and hexagrams) of the *Book of Changes* (*Yi jing*). They represent the *yang* and *yin* energies of the universe.
4. HY 45.
5. This was a mythical animal resembling a cow that is said to have been able to distinguish the proper from the improper; it was one of the animals used to decorate official robes.
6. HY 621.
7. HY 621.
8. HY 45. The ritual centering on the Mother of the Dipper in HY 1440 also uses this metaphor, which suggests that it shares a common source with HY 45, and may have been inspired by this biography.
9. HY 42 (full title: *Yuqing yuanshi xuanhuang jiuguang zhenjing*).
10. HY 1440. In this instance the Celestial Worthy of Primordial Beginning is called the Highest Imperial of Primordial Beginning.
11. Several other Dehua porcelain sculptures of Doumu are published in Donnelly 1969: pl. 99.

Cat. no. 99

1. Strickmann 1979a: 155–59.
2. Translated in Needham et al. 1976: 169.
3. Ibid.: 170.
4. This emperor is not to be confused with the more famous Emperor Xuanzong (Minghuang) of the early eighth century. Other Tang emperors who died of cinnabar poisoning were Xianzong (r. 805–20), Muzong (r. 820–24), and Wuzong (r. 840–46). Wuzong was responsible for the great anti-Buddhist persecution of 845; see Ch'en 1964: 226–33.
5. See *Changsheng de shijie* 1996: pl. 19.

Cat. no. 100

1. Waltner (forthcoming), chap. 1: "The World of Late Ming China." I am deeply grateful to the author for making this book available to me prior to its publication. Because this event was sacred, and because direct knowledge of it was secret, the details of Tanyangzi's ascent are not recorded by Wang Shizhen, her biographer; see Waltner 1987: 117.
2. Waltner 1987: 113. To her disciple Tu Long, a famous writer and connoisseur, Tanyangzi wrote in the manner of the *Daode jing*:

 > Great beauty is no beauty. Ultimate words are no words. You have heard much of the Tao. The quality of the Tao which prevents it from being abandoned also prevents it from being recorded. Those who are wise do not spontaneously know it. Those who know it don't speak of it. Those who speak of it don't write of it: this is the mystery of the Tao.

3. Ibid.: 115; Waltner (forthcoming), chap. 6: "The Cult of T'an-yang-tzu."
4. Waltner 1987: 115–16.
5. A depiction of Tanyangzi, seated with a snake in the shrine to her dead fiancé, appears in the woodblock-printed version of her story, *Stories of Exquisite Immortals: New Edition (Xinjian xianyuan jishi)*, published in 1602 (reprinted in Wang 1989, vol. 1); see Waltner (forthcoming). The cult of Tanyangzi continued long after her death, well into the Qing dynasty.
6. The Confucian elements in her teachings are clear from her final admonitions, which include the directives "Love and respect your ruler and relatives," "Pity and empathize with widows and orphans," and "Cherish frugality; be moderate in your happiness" (Waltner [forthcoming]).
7. The mural was entitled *Ascending Heavenward in Broad Daylight;* by the mid-Qing dynasty this mural no longer survived.
8. Ann Waltner, private communication, May 14, 1999.
9. Waltner (forthcoming).

Cat. no. 101

1. Xiwangmu, the Queen Mother of the West, was also associated with longevity and immortality. For the traditional story of Chang E, see Soymié 1962.
2. Schafer 1978c: 201–07; see also Goodrich 1991: 213–22. In her guise as the Star-lord of Supreme Yin, the goddess appears with the god of the sun (Taiyang or Supreme Yang) and the deities of the Five Planets in the entourage of the Purple Tenuity Emperor (Ziwei dadi) in the fourteenth-century Taoist murals of the Eternal Joy Temple (Yongle Gong) in Shanxi; see Jin 1997: pls. 19, 48, 62.
3. Burckhardt 1982: 52–54.
4. Bredon and Mitrophanow 1927: 399; for a photograph of a modern "moon altar," see p. 404.
5. Previously published in Little 1996: fig. 13. This fan is similar to several other fans and album leaves that depict Chang E; see *Songren huace* 1979: pl. 2, *Yiyuan duoying* 1989: pl. 13, and Cahill 1961a: pl. 23. The Art Institute's fan bears a seal of the late Qing collector and epigrapher Wu Dacheng (1835–1902).

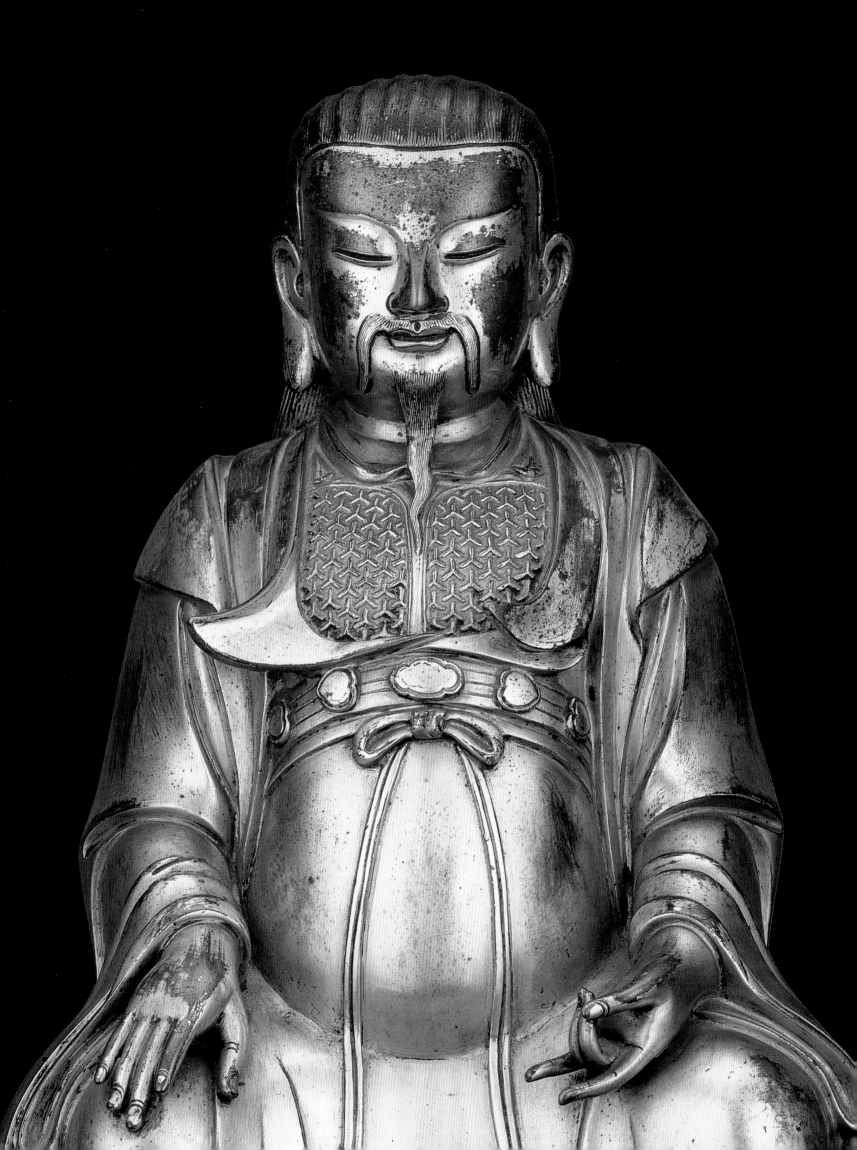

THE ORIGINS OF the Taoist god Zhenwu (Perfected Warrior) can be traced to the late Warring States period (third century B.C.) and Han dynasty (206 B.C.–A.D. 220). In that time, the god was known simply as Xuanwu, or Dark Warrior. Represented by a tortoise entwined by a snake, Xuanwu was the ancient symbol of the north, and as such was visualized as the deity of one of the cardinal directions. In Han dynasty ceramic roof tiles, for example, Xuanwu appears along with the other animal symbols of the directions: the dragon of the east, the tiger of the west, and the bird of the south. In stone sarcophagi of the Northern Wei dynasty (386–534), Xuanwu again appears, often carved onto the foot slab (see cat. no. 102), accompanying the dragon and tiger that appear on the two long sides of the sarcophagus. Textual evidence suggests that a cult devoted solely to Xuanwu developed only in the seventh century, during the early Tang dynasty (618–906).[1]

The transformation of the Dark Warrior (Xuanwu) into the anthropomorphic god known as the Perfected Warrior (Zhenwu) occurred in the early Northern Song dynasty (960–1126).[2] Imperial recognition of this transformation happened during the reign of Song Zhenzong (r. 998–1022), who was deeply devoted to religious Taoism.[3] Zhenzong was the first to build a temple to Zhenwu in the capital of Bianliang (Kaifeng, Henan province), after the miraculous appearance of a tortoise and snake in 1017.[4] Xuanwu's name was changed to Zhenwu at this time, to avoid a taboo on the name of the Song imperial ancestor Zhao Xuanlang. Zhenwu was particularly associated with healing, and is said to have cured Emperor Renzong (r. 1023–64) from illness in 1056. Zhenwu's efficacious power even led the Tangut rulers of the Xixia dynasty (982–1227) to begin worshipping him in the early eleventh century. Two of the earliest surviving images of Zhenwu as an anthropomorphic warrior come from Xixia archaeological contexts. One, in the collection of the State Hermit-age Museum, Saint Petersburg, Russia, is a twelfth-century banner depicting Zhenwu with a tortoise and snake, recovered from the ancient site of Kharakhoto by P. K. Kozlov (1863–1935) in 1909; the other is a twelfth-century silk banner, excavated in 1990 from a ruined Buddhist pagoda in Helan county, Ningxia Autonomous Region.[5]

In 1018, under the Song emperor Zhenzong, Zhenwu obtained the title Perfected Warrior Numinous Response Perfected Lord (Zhenwu lingying zhenjun).[6] Under Song Huizong (r. 1100–25), in 1108, Zhenwu was given the title Marshal Yousheng (Yousheng yuanshuai).[7] The god's title was changed to Emperor (di) during the Yuan dynasty (1260–1368): after 1304 he was known as Supreme Emperor of the Dark Heaven, Primal Sage, and Benevolent Majesty (Xuantian yuansheng renwei shangdi).[8]

It was during the Northern Song dynasty that Zhenwu began to be associated with a powerful group of Taoist celestial marshals known as the Four Saints (Sisheng). Paintings of Zhenwu as Marshal Yousheng are known from the early twelfth century, and a fifteenth-century Ming painting in this exhibition also depicts him as one of the Four Saints (cat. no. 107).[9] These gods were perceived as spirit-guardians of the Taoist faith and of the nation. In contemporary Taoist rituals in southern Taiwan, a separate altar is still often constructed for the Four Saints, and the altar table is called "Wudang Mountain" after Zhenwu's sacred peak Wudang Shan (Mount Wudang) in northwestern Hubei province, an association that began in the Yuan dynasty (1260–1368).[10]

The period of Zhenwu's greatest influence and popularity, however, was the Ming dynasty (1368–1644). The first Ming emperor, Zhu Yuanzhang (Taizu, r. 1368–98), ordered sacrifices to Zhenwu on the god's birthday (the third day of the third lunar month) and the day of his ascension to heaven (the ninth day of the ninth lunar month). It was the third Ming emperor, Zhu Di

(Yongle, r. 1403–24), however, whose personal devotion to Zhenwu led to the greatest rise in the god's national prestige. By this time, the god was seen as the eighty-second transformation (bianhua) of Laozi, and he was enfeoffed at Wudang Shan by the Jade Emperor (Yuhuang).[11] The celestial referents to the god included one of Zhenwu's weapons, the Seven Star Sword of the Three Terraces (Santai qixingjian), which refers to the seven stars of the Northern Dipper and to the powerful constellation called the Three Terraces (Santai), located in immediate proximity to the Dipper.[12] The Yongle emperor was himself famous as a warrior, and in 1403 he usurped the throne from his nephew, the Jianwen emperor. The emperor credited Zhenwu with aiding him in this successful campaign.[13] In 1412 the emperor ordered a massive building campaign on Wudang Shan, Zhenwu's sacred peak, culminating in the construction of the Zixiao Gong (Purple Empyrean Palace; see cat. no. 109). At the top of Wudang Shan a cluster of sacred buildings was built, known as the Purple Forbidden City (Zijincheng)—the same name as the Forbidden City in Beijing. During the Yongle reign, Wudang Shan was renamed Taihe Shan (Mountain of Supreme Harmony), and took precedence over the Five Sacred Peaks, formerly the most important sacred Taoist mountains in China. At several times during the Yongle reign, miraculous manifestations of Zhenwu were seen at the mountain; these are recorded in both the Taoist Canon (see cat. no. 110) and in a large handscroll now owned by the Baiyun Guan (White Cloud Monastery) in Beijing (cat. no. 111).

When Zhu Di moved the imperial capital from Nanjing to Beijing in 1421 and rebuilt the Forbidden City, he constructed a temple to Zhenwu, prominently positioned along the north-south axis of the palace. This temple, the Qin'an Dian (Hall of Imperial Peace), is significantly the northernmost building in the Forbidden City, appropriate given the fact that Zhenwu is god of the northern celestial quadrant. The original temple burned down in the late fifteenth century, and it was subsequently rebuilt during the Jiajing reign (1522–66), a time of devoted patronage of religious Taoism. This temple still stands, situated on its own marble terrace and enclosed by its own wall, at the center of the Imperial Flower Garden (Yuhua Yuan) just inside the Martial Gate (Wu Men) of the Forbidden City. Despite Qing dynasty renovations carried out by the Yongzheng emperor (r. 1723–35), the temple is still dedicated to Zhenwu, and contains three large statues of the god as its primary icons.

It is clear that by the mid-fifteenth century, Zhenwu had become the most important god in the Taoist pantheon, to some extent even supplanting the deified Laozi.[14] No longer just a powerful god of healing and exorcism, Zhenwu was also a celestial protector of the emperor and the state. In the Ming, a popular novel entitled Journey to the North (Beiyou ji) appeared, recounting the story of Zhenwu's apotheosis. Gary Seaman has shown that this novel was possibly created in the context of spirit-writing cults of the period.[15] Imperial patronage of the Zhenwu cult continued through the remainder of the Ming dynasty. As John Lagerwey has written, "All Ming emperors after Chengzu [Yongle] announced their accession to the throne by sending a sacrifice to Zhenwu."[16]

Both painted and sculpted images of Zhenwu proliferated during the Ming dynasty. It is clear from those that survive that the god was worshipped by all levels of society. The dedicatory inscriptions on two fifteenth-century bronze sculptures of Zhenwu (one of which is included in the exhibition; see cat. no. 103) are indicative of the widespread devotion to this god. A small bronze image of Zhenwu in the Museum für Kunst und Gewerbe, Hamburg, bears the following inscription:

> Offered by the Taoist believers (dao xinshi) Wu She, his younger brothers Wu Chan and Wu Si, and their families, who dwell in Hengshan Village at Clear Lake, in Lanxi County, Jinhua Fu [in Zhejiang province, one hundred thirty kilometers southwest of Hangzhou], who manifest their hearts, and have had cast [this] image of the Saint [sheng, i.e., Zhenwu], [for the] Hall of the Jade Maiden and Numinous Official [Yunü lingguan tang], in order to nourish those who pray for auspicious fate and the granting of wishes. Made by Shen Zhongyi of Bianliang [Kaifeng], on an auspicious day in the first month of the jiachen year [1424] of the Yongle reign.[17]

One of the rarest Ming images related to Zhenwu is an unpublished bronze sculpture depicting Wudang Shan, now in the British Museum, London.[18] This work, over one meter in height, depicts the sacred mountain, with the image of Zhenwu riding on the back of an entwined tortoise and snake flying through the air near the top. Included too are images of shrines and devotees, and the five Dragons Kings, ancient gods associated with the mountain, standing at the bottom.[19] It is entirely conceivable that this bronze replica of Wudang Shan functioned as a substitute for the actual mountain in rituals directed toward Zhenwu far from the mountain itself.[20]

Significantly, Zhenwu continued to be worshipped by the Manchu emperors of the Qing dynasty (1644–1911), and he is still worshipped in China today. In the Yanqing Guan, the primary Taoist temple in Kaifeng, for example, an over-life-sized bronze sculpture of the god, dated 1486, is still the central icon of worship.

102

Section of a Sarcophagus with Xuanwu

Northern Wei dynasty, early 6th century
Limestone
55 × 52 cm
Private collection

THIS ELEGANT SCULPTURE was originally the foot slab of the sarcophagus of an aristocrat.[1] On the basis of its style and comparison with excavated examples, the carving can be dated to the late Northern Wei dynasty (386–534), after the capital had moved to Luoyang in Henan province (c. 500–534). The panel depicts Xuanwu, the ancient symbol of the north, in its traditional guise of a tortoise entwined by a snake. In addition, the paired animal symbol is accompanied by a male figure, dressed as a scholar or court official. A similar depiction of the tortoise and snake accompanied by a male figure holding a sword or club, carved in intaglio, is found on the foot slab of the famous Northern Wei sarcophagus in the Nelson-Atkins Museum, Kansas City, dated c. 525.[2] While the significance of this figure is not yet clear, it may represent an early personification of this powerful deity of the north. The background of the sarcophagus panel

is carved with low-relief designs of swirling clouds. There are slight traces of red pigment in the eye of the snake. At the top of the slab is a low tang, for insertion into the top of the sarcophagus.

The symbolism of Xuanwu as the intertwined tortoise and snake emerged by at least the third century B.C. Xuanwu was already worshipped as a deity in the Han dynasty (206 B.C.–A.D. 220), as one of the four gods of the cardinal directions (the others are the dragon of the east, the tiger of the west, and the bird of the south). In early Taoist rituals, these gods were invoked by the priest to protect the sacred space of the altar.[3] Even after the emergence of Zhenwu (Xuanwu) as an anthropomorphic deity in the Northern Song dynasty (960–1126), the tortoise and snake continued to symbolize the god.

—S. L.

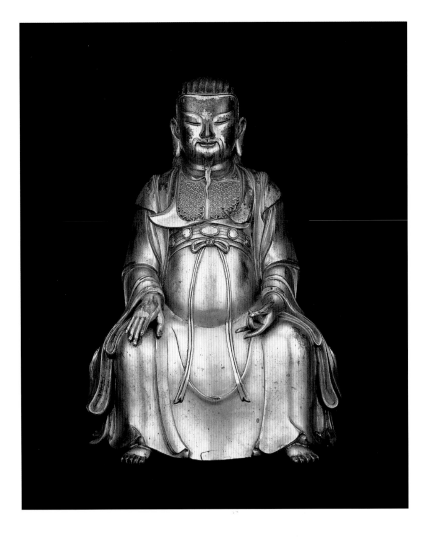

103

CHEN YANQING (ACTIVE EARLY 15TH CENTURY)
Zhenwu, Supreme Emperor of the Dark Heaven

Ming dynasty, Zhengtong reign, dated 1439
Gilt bronze
H. 36.4 cm
The Art Institute of Chicago, Gift of Robert Sonnenschein II
(1950.1054)

THIS SCULPTURE OF ZHENWU is an excellent example of a small-scale image made for personal devotion. The figure conforms to the god's classic iconography, with bare feet and long hair. Zhenwu rests his hands in his lap; the left hand forms a sacred gesture. A dedicatory inscription incised onto the interior surface reads:

> The Great Ming dynasty. The devout Buddhist believer, Meng Zhen of the Shaanxi Regional Military Commission, of the Central Guard of Ganzhou [in modern Gansu], who resides in the city, [with his] family and others, now at Nanjing, vows to cast one statue of the Lofty Zhen[wu], so that above [we may attain] the reward of the Four Kindnesses, and below the aid of the Three Forgivenesses, [also] good fortune and all that we wish for. In the year *jiwei* of the Zhengtong reign [1439], cast by Master Chen Yanqing of Qiantang [Hangzhou], and gilded by Han Ye.

The fact that the donor of this work describes himself as a devout Buddhist, and yet commissions a work depicting a Taoist god, is fully characteristic of Chinese religious belief, in which devotion to different religions presents no apparent conflict.

Two other fifteenth-century gilt-bronze sculptures in North American collections were also made by Chen Yanqing in Hangzhou, Zhejiang province. Both works depict the Celestial Worthy of Primordial Beginning (Yuanshi tianzun), the central of the Three Purities (Sanqing, the highest gods of religious Taoism; see cat. no. 65). The first, bearing an inscription dated 1438, was recently acquired by the Metropolitan Museum of Art, New York; it was made for a temple in Gansu province. The second, in the Royal Ontario Museum, Toronto, is inscribed but undated.[1]

Small-scale devotional sculptures of Zhenwu were widespread during the Ming dynasty, when worship of this god reached its peak. The promotion of Zhenwu by the Yongle emperor (r. 1403–24) led to increasing devotion to the god, both at the imperial level and throughout Chinese society. Zhenwu's popularity is indicated by the enormous number of such images, the majority of which are made of either glazed stoneware or porcelain.

—S. L.

104

Zhenwu, Supreme Emperor of the Dark Heaven

Ming dynasty, 15th/16th century
Bronze with traces of pigments
H. 133 cm
The British Museum, London, Given by
Messrs. Yamanaka (1908.7–25.2)

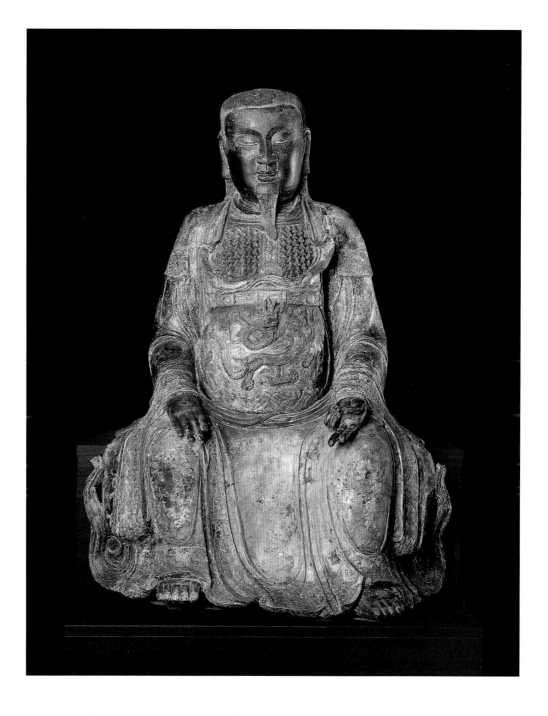

ONE OF THE largest known Ming bronze sculptures of Zhenwu outside of China, this work presents the orthodox image of the Perfected Warrior. Zhenwu sits in a dignified posture befitting his status as a celestial emperor, reflecting the title he received in 1304: Supreme Emperor of the Dark Heaven, Primal Sage, and Benevolent Majesty (Xuantian yuansheng renwei shangdi). The god's long hair is combed straight back and falls to his waist. He wears armor under his robe, with a dragon emblazoned on his breastplate. His feet are bare. He forms a sacred gesture with the two front fingers of his left hand, while his right hand rests in his lap. His eyes were originally inlaid. The armor and robe reveal traces of lacquer and gilding; elsewhere there are traces of pigment on the surface. Zhenwu's robe is decorated in front with a five-clawed dragon; the hem is decorated with clouds in low relief.

A similar but larger bronze sculpture, dated to the twenty-second year of the Chenghua reign (1486), is the central icon of worship in the Yanqing Guan, the primary Taoist temple in Kaifeng, Henan province. In its overall appearance, the British Museum sculpture also resembles smaller-scale images from the fifteenth century in the Museum für Kunst und Gewerbe, Hamburg (dated 1424), and The Art Institute of Chicago (dated 1439; cat. no. 103).

—S. L.

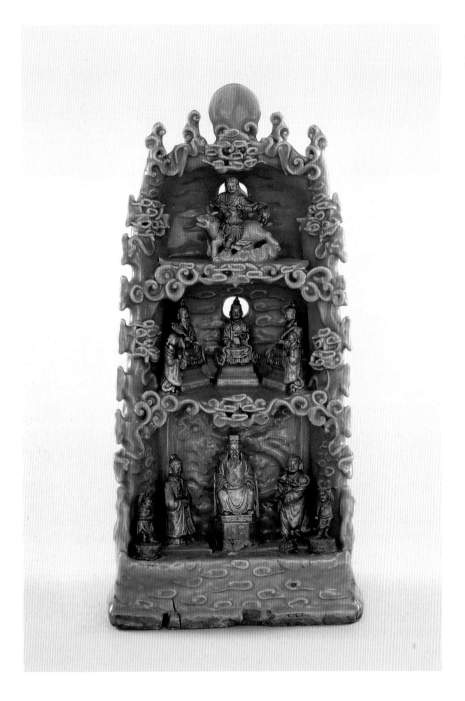

105

Shrine with Zhenwu and Other Taoist Gods

Ming dynasty, Yongle reign, dated 1406
Longquan celadon ware with gilding
H. 49.5 cm
The British Museum, London, Given by Sir Percival
 David (OA 1929.1–14.1)

THIS SHRINE, which incorporates images of the Three Purities (Sanqing; the highest gods of Taoism) with images of Zhenwu, is like hundreds of other shrines made at the Longquan celadon kilns in Zhejiang province.[1] Unlike the majority of such shrines, however, this example has a dated inscription incised into the back, under the glaze: "In the fourth year of the Yongle [reign], in the first month, an auspicious day."

The shrine forms a kind of miniature mountain with three grottos, and a disk, possibly representing the sun, at the top, where the god Zhenwu rides on a mythical beast. He can be identified by his long hair and bare feet. The middle grotto contains the Three Purities (cat. nos. 65–67), comprising the Celes-

tial Worthy of Primordial Beginning (Yuanshi tianzun; center), the Celestial Worthy of Numinous Treasure (Lingbao tianzun, holding a *ruyi* scepter; right), and the Celestial Worthy of the Way and Its Power (Daode tianzun, the deified Laozi, holding a fan; left). A jade maiden *(yunü)* and golden lad *(jintong)* stand in attendance on the Three Purities. The lower grotto depicts the Jade Emperor, seated at the center, with Zhenwu seated to the right, and another female Taoist god seated to the left. Here Zhenwu's identity is confirmed by the turtle and snake intertwined at his feet.

—S. L.

106

*Zhenwu, Supreme Emperor of the
Dark Heaven*

Ming dynasty, mark of Wanli reign
(1573–1620)
Blue and white porcelain
46 × 20 × 15 cm
Museum of Fine Arts, Boston, Gift of Mr. and
Mrs. F. Gordon Morrill (1979.785)

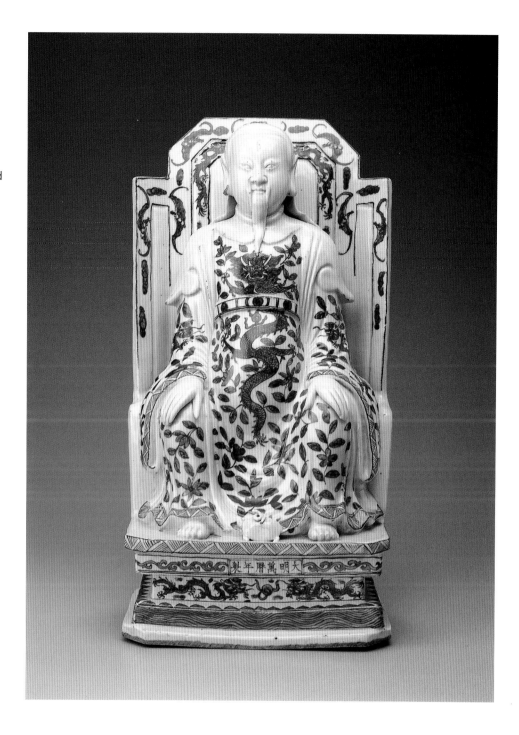

THIS BLUE-AND-WHITE PORCELAIN sculpture of the god Zhenwu, like the gilt-bronze example in the collection of The Art Institute of Chicago (cat. no. 103), was made for personal devotion. The identification of the sculpture as Zhenwu is clear from the presence of an entwined tortoise and snake on the platform in front of the god. The god's long hair and bare feet also conform to his standard iconography. An unusual (but not unknown) feature of this work is the third eye in the god's forehead. The figure's robe is painted with leafy branches and a dragon. A screen behind him is decorated along its border with bats, traditional symbols of good fortune. A six-character reign mark is inscribed in underglaze blue on the front of the stepped base: "Made in the Wanli reign of the Great Ming dynasty" *(Da Ming Wanli nian zhi).*

The production of ceramic images of Zhenwu was very popular during the Ming dynasty. The majority of surviving examples are made of the same lead-glazed porcelaneous stoneware used for imperial and aristocratic roof tiles. Examples in Longquan celadon ware, white Dehua porcelain (blanc de chine), and enameled Cizhou stoneware are also known.[1]

—S. L.

107

The Four Saints: The Perfected Lords Tianpeng, Tianyou, Yisheng, and Xuanwu

From the Treasured Tranquility Temple (Baoning Si), Youyu county,
 Shanxi province
Ming dynasty, c. 1460
Hanging scroll; ink, colors, and gold on silk
119.2 × 62 cm
Shanxi Provincial Museum, Taiyuan

SINCE THE NORTHERN SONG DYNASTY (960–1126), Zhenwu has been included as one of a group of Taoist spirit guardians known as the Four Saints (Sisheng). This painting, from the Treasured Tranquility Temple (Baoning Si) set of paintings on the Water and Land Ritual (*Shuilu zhai;* see cat. nos. 78–81), depicts these exorcistic guardians standing in a group among loosely defined clouds.[1] The two at the top, who resemble the wrathful Wisdom Kings *(mingwang)* of Tantric Buddhism, are Tianpeng and Tianyou. They are divine marshals *(yuanshuai)* who protect Taoism and the state.[2] Tianpeng, at the upper left, has four arms; the upper two arms hold a sword and an ax, the lower two arms hold a *vajra* (stylized thunderbolt) and *ghanta* (bell). Tianyou, at the upper right, has two arms, and holds a box in his hands. At the bottom of the scroll are Zhenwu (Perfected Warrior), on the right, and Yisheng (Respectful Sage), on the left. A similar grouping of the Four Saints appears in the twelfth-century album of Taoist gods in the Stephen Junkunc IV collection.[3]

The group known as the Four Saints first appeared in the Northern Song dynasty (960–1126).[4] According to John Lagerwey, the Four Saints figure in texts of the Orthodox Method Heaven's Heart (Tianxin zhengfa) movement, which originated in the tenth century.[5] The Four Saints were also worshipped as demon-suppressing deities in the Great Rites of Youthful Incipience (Tongchu dafa) movement, founded at the end of the Northern Song dynasty by Yang Xizhan (r. 1101–24).[6] This movement was a revival of the Highest Purity (Shangqing) sect at Mount Mao (Mao Shan) near Nanjing. The *Record of the Listener (Yijian zhi)* by Hong Mai (1123–1202) describes late-twelfth-century (early Southern Song dynasty) shrines to and images of the Four Saints, but in insufficient detail to determine their visual aspect.[7]

Although worship of the Four Saints can be traced to the Northern Song dynasty, the history of several of these gods extends back to the Six Dynasties period, and, in the case of Zhenwu (Xuanwu), to at least the Han dynasty. It was only in the Northern Song dynasty, however, that Xuanwu manifested himself as an anthropomorphic god whose name was changed to Zhenwu (Perfected Warrior).[8] The exorcistic god Tianpeng was invoked with an incantation that is already found in the Shangqing scriptures of the Six Dynasties period.[9] An example of such an incantation has been translated by Michel Strickmann.[10] As Judith Boltz has shown, "the efficacy of reciting the Tianpeng incantation is the subject of three accounts in Du Guanting's *Daojiao lingyan ji.*"[11] Talismans of Tianpeng are illustrated in Yuan Miaozong's *Secret Essentials of the Supreme All-encompassing Reality (Taishang zongzhen biyao;* see cat. no. 52). As Paul Katz has shown, Taoist texts of the Song dynasty depict Tianpeng as an assistant to Zhenwu, Supreme Emperor of the Dark Heaven.[12]

Yisheng, known after 1014 as Yisheng baode zhenjun (Perfected Lord, Respectful Sage of Precious Virtue), was a powerful spirit guardian of the Song state.[13] Yisheng's apotheosis is described in Wang Qinruo's *Biography of [the God] Respectful Sage of Precious Virtue (Yisheng baode zhuan),* a text commissioned by Emperor Zhenzong during the Dazhong xiangfu reign (1008–16).[14] As in the case of Zhenwu, Yisheng was commanded by the Jade Emperor (Yuhuang) to manifest himself in the phenomenal world. According to Boltz, Yisheng was also "perceived as a cosmic agent who enforced the traditional values of the literati class, especially those preparing to serve in public office."[15] In the painting, the feet of both Yisheng and Zhenwu are bare, and both hold swords in their right hands; the image of Yisheng is completely derived from that of Zhenwu. Comparison with the depiction of the Four Saints in the album of Taoist gods in the Junkunc collection further suggests that the figure at the lower left in the Baoning Si painting is Yisheng, also shown with his left hand resting on his right wrist. That variations existed in the depiction of these gods is also clear, however, from the Junkunc album, in which Marshal Tianpeng is shown with three faces and six arms, holding the sun, moon, a bell *(ghanta),* disk, sword, and halberd. Similarly, Marshal Tianyou is shown with two faces and four arms, holding a sword, a flaming wheel *(chakra),* and a bow and arrow.

—S. L.

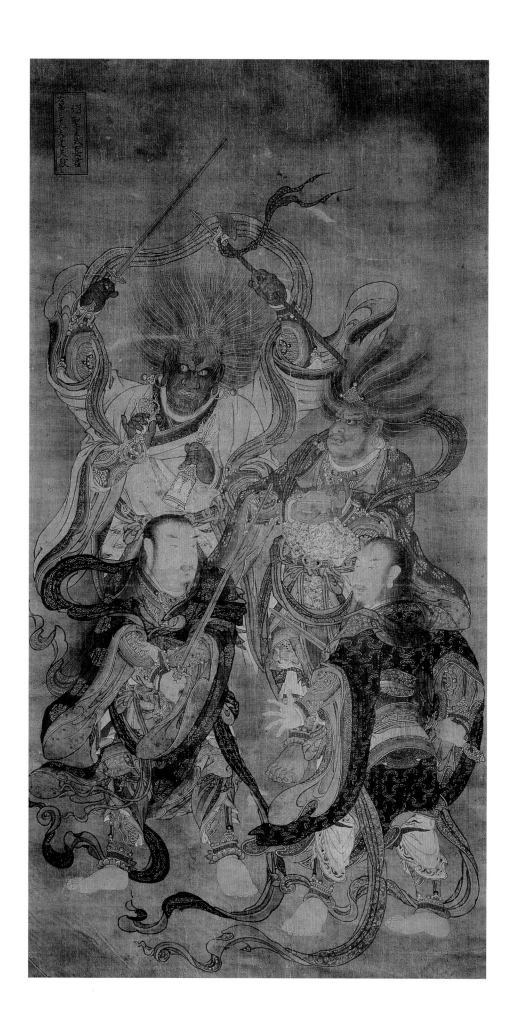

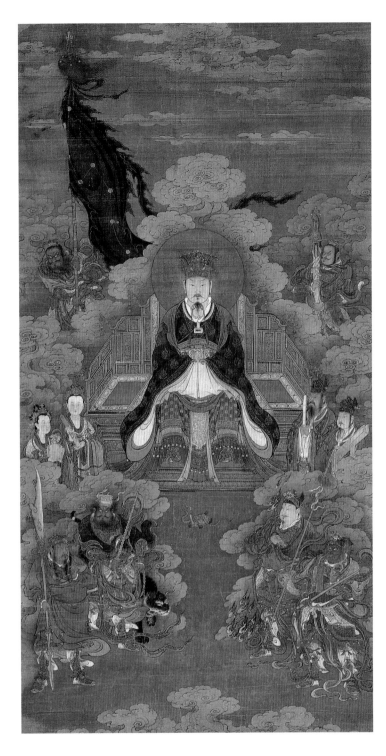

108

Zhenwu and His Court

Yuan dynasty (1260–1368)
Hanging scroll; ink and colors on silk
122.7 × 63.3 cm
Reiun-ji, Tokyo

◉ Important Cultural Property

IN 1304 THE Yuan dynasty emperor Chengzong (r. 1295–1307) granted the Taoist god Zhenwu (Perfected Warrior) the title Supreme Emperor of the Dark Heaven, Primal Sage, and Benevolent Majesty (Xuantian yuansheng renwei shangdi). This was the first time that Zhenwu obtained the title Supreme Emperor *(shangdi).*[1]

The Reiun-ji hanging scroll, painted during the late Yuan dynasty (fourteenth century), presents an image of the god with his celestial court.[2] That the deity is presented as a crowned and enthroned emperor suggests that the painting was created after Chengzong had elevated Zhenwu. The identification of the main figure as Zhenwu is clear from the presence of the intertwined tortoise and snake on the ground in front of the throne. The god and his attendants are shown among swirling reddish clouds, against a blue sky. A transparent halo appears behind Zhenwu's head, and he wears a rectangular locket around his neck. Two martial guardians stand behind the throne. One holds Zhenwu's sword, and the other a banner decorated in gold with the seven stars of the Northern Dipper. Standing on either side of the throne are two female attendants, holding a box and a tablet, and two civil officials, holding a tablet and a bound book.

In the foreground stand four celestial marshals *(yuanshuai).*[3] At the lower left is Marshal Guan (Guan Yu), the Three Kingdoms period (220–280) hero, who was adopted into the Taoist pantheon during the Northern Song dynasty (960–1126; see cat. no. 83).[4] Marshal Guan appears in this guise as early as the twelfth century. He holds his customary attribute, a halberd with a long, curving blade. Next to him stands Marshal Zhao, holding a sword with multiple rings around the blade and a black-and-white tiger on a chain.[5] At the lower right stands Marshal Wen, the eradicator of plagues whose cult emerged in Zhejiang province during the Song dynasty (see cat. no. 87). Behind Marshal Wen stands Marshal Ma, holding a lance with a snake wrapped around the shaft.[6]

The high quality of the Reiun-ji hanging scroll suggests that it was the product of an imperial atelier. The scroll's astonishing state of preservation may be due to its having been kept for at least two centuries by a Buddhist temple in Japan.[7] A similar painting, dating to the fifteenth century (early Ming dynasty), is owned by the Herbert F. Johnson Museum of Art, Cornell University.[8]

—S. L.

109

XIE SHICHEN (1487–AFTER 1567)
Clearing Sky after Snow on the Purple Empyrean Palace at Mount Wudang

Ming dynasty, Jiajing reign, dated 1541
Hanging scroll; ink and colors on silk
198.9 × 98.8 cm
Shanghai Museum

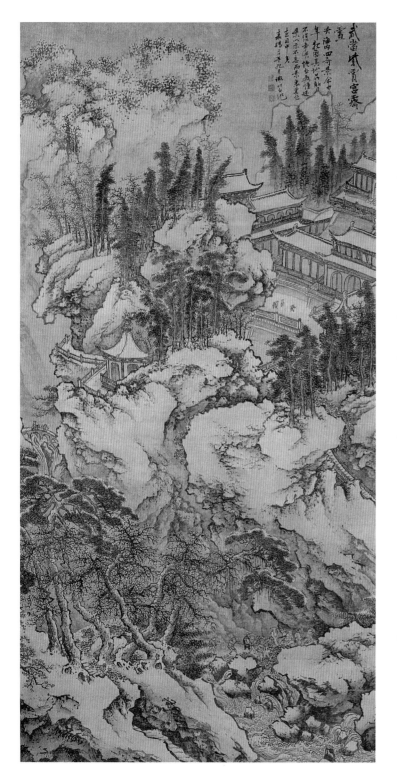

XIE SHICHEN'S PAINTING depicts the Purple Empyrean Palace (Zixiao Gong) on Mount Wudang (Wudang Shan) in Hubei province. The temple was built in 1413 on the orders of the Yongle emperor (r. 1403–24).[1] It is the best-preserved of all the Yongle period buildings at Wudang Shan. The Purple Empyrean Palace is located immediately under the Prince's Cliff (Taizi yan), where Zhenwu gained supremacy over the dark forces of the north.[2] Painted from memory, Xie Shichen's scene of the temple closely resembles the actual site as it appears today. This hall contains statues of the Jade Emperor (Yuhuang), Zhenwu, and other gods.[3]

According to tradition, the immortal Yin Xi, to whom Laozi transmitted the *Daode jing,* had lived at Wudang Shan, and Taoist adepts were associated with the mountain since at least the second century B.C. In the Tang dynasty (618–906), Wudang Shan was listed as one of "Seventy-two Blessed Plots" *(fudi)* by the Taoist Du Guangting (850–933).[4]

John Lagerwey has shown that firmly documented Taoist activity at Wudang Shan can be traced to the twelfth century.[5] During the Yuan dynasty, the temples at Wudang Shan were rebuilt through the influence of the priest Wu Quanjie (1269–1346) (see cat. no. 64).[6] After the construction of the Purple Empyrean Palace in the Yongle period, all subsequent Ming emperors continued to venerate the mountain. At the beginning of every reign, an imperial emissary was sent to Wudang Shan to announce the new emperor's investiture. Among other imperial gifts, an important group of bronze sculptures was given to the Purple Empyrean Palace by the Chenghua emperor in 1479.[7]

Painted on dark silk, Xie Shichen's depiction presents a rare topographical view of the temple. The artist's inscription reads:

> This is [one of] four fantastic scenes within the Four Seas. When I was young I passed through this country [of Wudang Shan]. Now I do not have the strength to do it again. On impulse, inspired by longing to return to the scene, I gave it form in order not to forget it. The scene gradually emerged from within my eyes. In the ninth month of the twentieth year of Jiajing [1541], recorded by Xie Shichen.

At the bottom of the scroll, several travelers with their servants arrive at the cliff below the temple. From a path along a rushing stream, cliffs rise dramatically to the buildings above, perched among boulders and trees.

—S. L.

水湧洪鍾

神留巨木

2

1

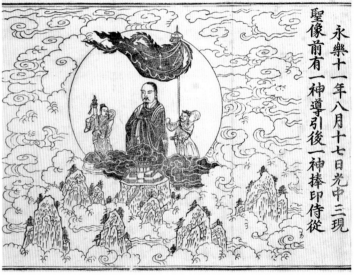

現
天真聖像身衣、十袍披髮而立下有祥雲擁
護

永樂十一年八月十七日光中三現
聖像前有一神導引後一神捧印侍從

4

3

110 (details)

110

Illustrated Record of the Auspicious Responses of the Supreme Emperor of the Dark Heaven to the Great Ming Dynasty

Ming dynasty, Zhengtong reign, 1444–45
Woodblock-illustrated book; ink on paper
35 × 11.3 cm (each page)
Bibliothèque Nationale de France, Paris (Chinois 9546 [952])

111

Miraculous Manifestations of Zhenwu at Wudang Shan

Ming dynasty, 15th century
Handscroll; ink and colors on silk
56 × 85 cm (each section)
White Cloud Monastery (Baiyun Guan), Beijing

MOUNT WUDANG (Wudang Shan) in Hubei province was the traditional center of worship for Zhenwu, the Perfected Warrior, and legend says that he retired from the world on this mountain to cultivate the Way. During the upheaval in the struggle for power at the end of the Yuan dynasty (1260–1368), several of the Taoist temples (literally, *guan*, "observatories," and *gong*, "palaces") dedicated to Zhenwu on Mount Wudang were damaged, and in 1412 the third emperor of the Ming dynasty, Chengzu (the Yongle emperor, r. 1403–24), sponsored a series of restorations and rebuildings.[1] Chengzu sent Marquis Zhang Xin and Commandant-escort Mu Xin to supervise the restorations, giving them a labor force of over two hundred thousand troops. When the restorations were completed, the emperor entrusted the head of the Orthodox Unity (Zhengyi) sect, the forty-fourth Celestial Master, Zhang Yuqing, to appoint his grandson Zhang Biyun and several other prominent Taoist masters to supervise a community of fifty Taoist priests in each of four major temples. Imperial edicts indicate that these restorations were undertaken as a sign of the emperor's devotion to Taoism, as thanks for the aid of the Perfected Warrior in securing the rule of his family, and also in memory of the first Ming emperor, Taizu (r. 1368–98), and his empress, Xiaoci. At the same time, Zhenwu was perceived as a special patron and protector of the Ming ruling house, so these projects carried an additional significance as a renewal of the relationship between the Ming dynasty and its closest ally in the celestial hierarchy.

This woodblock text (cat. no. 110) from the Taoist Canon *(Daozang)* contains illustrations of the miracles that occurred during the restoration projects.[2] These miracles were understood to be portents of the Perfected Warrior's approval for the projects, but they also functioned as political propaganda for

the Ming ruling house, as can be seen immediately in the first illustration to the text. This plate shows people gathering in reverence at the pavilion in which the imperial edict to rebuild the temples on Mount Wudang—inscribed on a "yellow tablet" (yellow being the color for the center in the Five Phase system) —was kept during the restorations. According to the text, the nearby population was so impressed with Emperor Chengzu's devotion and the magnificence of his edict that they came from all the outlying lands to view his illustrious command, "filling the streets and blocking the roads." The pavilion itself was often luminous with spiritual light, and cranes and other magical animals gathered around it.

The second illustration in the scripture shows the appearance of Zhenwu during the reading of an imperial proclamation in honor of the god before the restoration projects were undertaken. On the night this proclamation was read, a black cloud appeared in the clear sky and approached the main temple from the northwest, stopping no more than a meter away from the imperial delegation. Writhing with thunder and lightning, it remained stationary over the temple for some time, and faint images of martial flags could be seen within it. Zhenwu himself appeared above the cloud to accept the emperor's proclamation; then the vision suddenly disappeared, and the sky was once again clear.

The following two illustrations show the appearance of magical plants on the mountain in the spring of 1413 after the restoration projects had begun. The first shows a group of people in the mountains gathering the leaves of *qianlin* or "soaring grove" trees, which are flourishing all over the mountain; these leaves were believed to cure all manner of illnesses. The following illustration shows a group of three people standing outside one of

111 (detail; scene 1)

111 (detail; scene 15)

the temples, staring up in wonder at the fruits of a "betel-plum" tree. According to legend, when the Perfected Warrior was living on Mount Wudang, he took a branch from a plum tree and grafted it onto a betel tree, taking an oath that if he accomplished the Way (Tao) then the branch would flower and produce fruit. The fruit of these trees, which was rare and considered to be an auspicious omen, had already begun to appear in unusual numbers early in the Yongle era (1403–24), in the years 1405–06, but in the spring of 1413 the entire mountain was adorned with the blossoms of this tree, and in the fifth month there was a crop of fruit such as had not been produced since antiquity.

The following two illustrations (shown here) depict Zhenwu's miraculous aid in the construction of the temples. The first (1) shows a giant tree trunk that was found floating upright in the river near the Yellow Crane Tower, a site in Wuchang county, Hubei province, where legend says that a magical being riding a yellow crane once stopped to rest. This four-meter-long trunk, which rose one meter out of the water, was floating suspended in the river, neither embedded in the bottom of the river, which was over five meters deep, nor moving with the current. The trunk was found by men in boats hauling timber to Mount Wudang for the restoration projects, and it was attached to a boat without difficulty and taken to the mountain, where it was used as the central beam in the principal hall of the main temple. The following illustration in the scripture (2) shows the discovery of an ancient temple bell in the river. A group of people traveling along the river was hindered by a violent wind and rainstorm, when suddenly the wind stopped and a giant bell floated to the surface. This bell was taken to Mount Wudang, where it was installed in the main temple.

The next eleven illustrations, two of which are reproduced here (3 and 4), all show appearances of Zhenwu himself in 1413, during the restorations. From the fifth to the eighth lunar months, Zhenwu appeared several times as the temple reconstructions proceeded, sometimes alone, sometimes accompanied by celestial civil and martial attendants bearing his banner, sword, or seal of office. The majority of these manifestations took place over the main temple compound on the highest peak of Mount Wudang, which is shown rising above the clouds, with a long stairway descending from the main entrance in the wall surrounding the temple. In addition, the fourth of these manifestations is depicted over one of the three subsidiary temples, shown farther down the mountain.

The date and authorship of this text are unknown, but it includes the text of an imperial stele commemorating the restoration of the temples at Mount Wudang dated to 1418, and its

tone and contents, as well as its inclusion of several imperial edicts, suggest that it was written largely as a piece of propaganda for the emperor—thus, most likely an imperial commission. This account of miracles is of particular interest since it was written less than three decades before the compilation of the Taoist Canon: the events it recounts were still within living memory when the edition shown here was made.

The remarkable handscroll painting (cat. no. 111) from the Baiyun Guan, Beijing, also depicts manifestations of Zhenwu at Wudang Shan (here called Taihe Shan, or Mountain of Supreme Harmony).[3] A title inscribed on the outer mounting reads, *Wuliang fushou tu* ("Painting of Limitless Good Fortune and Longevity"). The scroll comprises fifteen scenes, each accompanied by an inscription describing the nature and location of various miraculous celestial displays; these inscriptions list the months (but not the year) in which the displays took place.

The first scene has lost its inscription, but the second scene, which depicts concentric rings of multicolored light over Heaven's Column Peak at Wudang Shan, is dated to the first day of the seventh lunar month. The final scene, dated to the thirteenth day of the twelfth lunar month, depicts a manifestation of the black image of Zhenwu over the same peak, accompanied by multicolored clouds and beams of light. The only scenes in the Baiyun Guan handscroll that may correspond to the illustrated text in the Taoist Canon occur in the eighth month: in the handscroll's sixth and seventh scenes, displays of five-colored concentric bands of light appear over Heaven's Column Peak; this is described as occurring thirty-one times on the seventeenth day of the eighth month, and fifteen times between the second day of the eighth month and the twenty-sixth day of the fifth month. The *Illustrated Record* in the Taoist Canon describes actual appearances of Zhenwu at Wudang Shan on the same days. In addition to depicting the varied topography of Wudang Shan, the Baiyun Guan handscroll is extraordinary for its bird's-eye-view depictions of such temple structures as the Jade Emptiness Palace of the Dark Heaven (scenes 3 and 4), the Flying Ascent Terrace (scene 5), and the Palace of the Five Dragons (scene 11). According to tradition, the painting was a gift to the Baiyun Guan from the Yongle emperor.[4] It is conceivable that the scroll was originally longer and consisted of even more scenes than those depicted here.

—S. E./S. L.

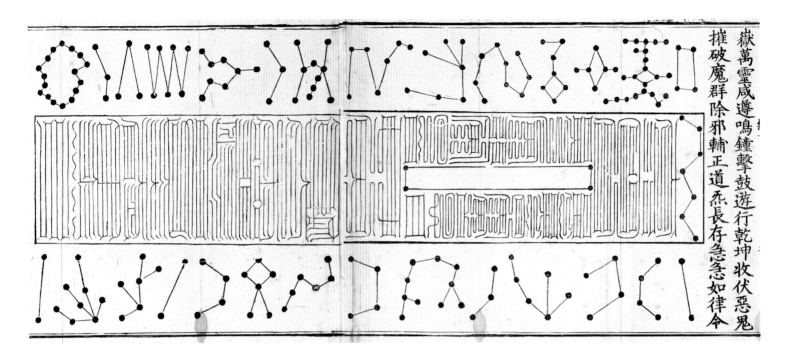

112

Register of the Supreme General, the Great Highest Dark Heaven Perfected Warrior, from the Taoist Canon of the Zhengtong Reign

Ming dynasty, Zhengtong reign, 1444–45
Woodblock-illustrated book; ink on paper
35 × 11.3 cm (each page)
Bibliothèque Nationale de France, Paris (Chinois 9546 [1196])

REGISTERS *(LU)* WERE AMONG the first documents given to a new initiate into a Taoist community by the early Way of the Celestial Masters (Tianshi Dao).[1] They consisted primarily of lists of names of celestial generals who could be called upon for aid, and as a result, early registers were known by such names as "Register of One General," "Register of Ten Generals," and so on. The first of these registers were given to children beginning at the age of seven or eight, and were known as "child" *(tongzi)* registers.[2] Registers were also given to adult initiates, and because their reception was the initial act that distinguished members of the Taoist community from the outside world, the first title given to a Taoist novice was "register student" *(lusheng)*.[3] Registers were intimately connected with talismans *(fu)*, and served a similarly protective function.

The present text is an early Ming dynasty variation on these registers. Although the corpus of Taoist literature had expanded considerably beyond the scope of the early Celestial Masters tradition by the Ming dynasty, this text shows that registers continued to play an important role. This register (cat. no. 112) is dedicated entirely to the martial god Zhenwu, the Perfected Warrior, who is here called Supreme General, drawing a parallel between this deity and the generals of earlier registers. The register begins with an image of Zhenwu, showing standard

elements of his iconography, such as loose hair, bare feet, and the totem animals of the northern region he rules, an entwined tortoise and snake. This image is followed by three magical invocations designed to "suppress," "dispel," and "halt" malignant spirits. These spells describe the most terrifying manifestation of the Perfected Warrior:

> My nose is like a mountain,
> My forceful eyes radiate light,
> My teeth are like a forest of swords,
> In my hands I hold the Seven Stars [of the Northern Dipper,
> or Ursa Major].
> Celestial demons and heterodox ways,
> All manner of malignant spirits,
> When they see me they turn to blood,
> Changing into powdered dust!

After these spells comes the magical talisman of the Perfected Warrior, bordered by the Northern Dipper on the top and surrounded by the Twenty-eight Lunar Mansions. The significance of this talisman is not described in the text, but like the talismans illustrated elsewhere in this catalogue, it would have been used to protect against ghosts and demons. The talisman is followed by a list of spirits under the command of the Perfected Warrior, ranging from generals and warriors to envoys and jade maidens, and including well-known groups such as the six *jia* and *ding* spirits (see cat. no. 57). These latter spirits, who could be called upon in times of need, are a representative sample of the Perfected Warrior's full army, which consisted of some three hundred thousand troops.

The entire register was to be worn on the person of the recipient: "Serve and honor it, and ten thousand spirits will aid and protect you, while all malignant spirits will be dispersed. It will lengthen your years, and you will receive blessings beyond measure!" Taken as a whole, the register was a coordinated program of defense against both natural and supernatural forces, with talisman, spells, and celestial protectors who accompanied the recipient of the register wherever he went and guarded him against the dangers of an uncertain world.

The register itself is followed by a sample ritual for its transmission, which provides considerable information about the provenance of the text. This ritual indicates that the register was

to be received from a representative of the hereditary Celestial Master of Mount Longhu (Longhu Shan, in Jiangxi province), which in the Ming dynasty was the headquarters of the Celestial Masters sect, by this time often called the Orthodox Unity (Zhengyi) sect. The ritual further mentions the forty-second, forty-third, and forty-fourth Celestial Masters by name, and consequently in its present state it was probably composed sometime during the period of the forty-fourth Celestial Master, Zhang Yuqing, who headed the Orthodox Unity sect from 1410 to 1427.[4] As such, it is nearly contemporary with the record of miraculous appearances of the Perfected Warrior on Mount Wudang described elsewhere in this catalogue (see cat. nos. 110–11), and was composed only about three decades before the printing of the edition from the Taoist Canon *(Daozang)* shown here.

—S. E.

113

Zhenwu with the Eight Trigrams, the Northern Dipper, and Talismans

Qing dynasty, 17th or early 18th century
Hanging scroll; ink, colors and gold on silk
59.9 × 42.6 cm
The Art Institute of Chicago, Russell Tyson Endowment (1999.566)

ONE OF THE most important roles of Zhenwu, the Perfected Warrior, was to protect against malevolent spirits. When he was first summoned to take up a post in the celestial hierarchy, the Highest Imperial (Shangdi) ordered him to "subdue the north [the direction of the demon capital of Fengdu] . . . and put a stop to all the wicked demons under the heavens."[1] His first assignment was to battle the demon kings who had risen up as the world became corrupt. During a great battle, these demon kings caused the energies of the trigrams *kan* and *li* (*yin*-water and *yang*-fire energy as manifested in the world; see cat. nos. 58–59) to manifest as a giant tortoise and snake, but the Perfected Warrior used his spiritual might to subjugate them under his feet.[2] After he had subdued the armies of the demon kings, he went to the Old Master (Laozi) so that his military feats could be recognized and his accomplishment of the "proper realized Way [Tao]" would be foretold.[3] The Old Master, however, pointed to the heavens and the earth, saying that there were still many malevolent spirits in the world, and the Perfected Warrior's accomplishment of the Way could not be foretold until the Lord of the Netherworld himself (Yenluowang or Yama) came with the Perfected Warrior before the Old Master to report that there were no longer any souls in the hells. Thereupon, the Perfected Warrior made a vow to take all the wickedness of the world upon himself, until there were no longer any demons or ghosts, or any souls left suffering.[4] As a result, he became the special protector of all those beset by harmful spirits.

The Perfected Warrior is shown here in this role. He is flanked by martial officers, one of whom holds a war-club, while the other bears his standard. Above these officers are the sun and moon, depicted as red and white disks; the officer under the sun is shown with a white face, while the one under the moon is red, balancing the composition of the painting at the same time that they express the idea of *yin* within *yang* and *yang* within *yin*. Below the Perfected Warrior are the tortoise and snake, both totem animals of the north in the Five Phase system (see cat. no. 9) and the manifestations of *yin* and *yang* from the battle story recounted above. Above this scene, the Eight Trigrams are shown in their "Later Heaven" *(Houtian)* arrangement (see cat. no. 14), that is, as manifestations of the energies of *yin* and *yang* in the phenomenal world. The Eight Trigrams surround an image of the Northern Dipper (Ursa Major; see cat. no. 18); above the trigrams is the constellation known as *Santai* (Three Terraces).

The rest of the painting is made up of seventy-two talismans, which are arranged around the Perfected Warrior in a manner reminiscent of Buddhist mandalas. These talismans are composed of stylized star-diagrams and talismanic script, and each talisman is accompanied by an inscription indicating its function. The large majority of these talismans protect against demons; the second talisman, for example, protects against "abnormalities in the shape of pigs, cats, dogs, or all those that eat their own young," while the forty-fifth talisman protects against "old trees that turn into sprites." Other talismans protect against all manner of social, natural, and supernatural disasters, from imprisonment and burglary to plagues and bad dreams. A smaller number of talismans bring good fortune rather than protecting against bad; these help oneself and one's family to live long, prosperous lives, and aid in such pursuits as attaining political office. The wide range of the talismans in the painting reflects the all-encompassing vow of the Perfected Warrior, and his special powers against all kinds of malevolent spirits.

Stylistic features of this hanging scroll suggest that it may have been done outside China, perhaps in Korea. The present mounting is Japanese. At the same time, the content and iconography of the painting are consistent with Chinese images of the Perfected Warrior.

—S. E.

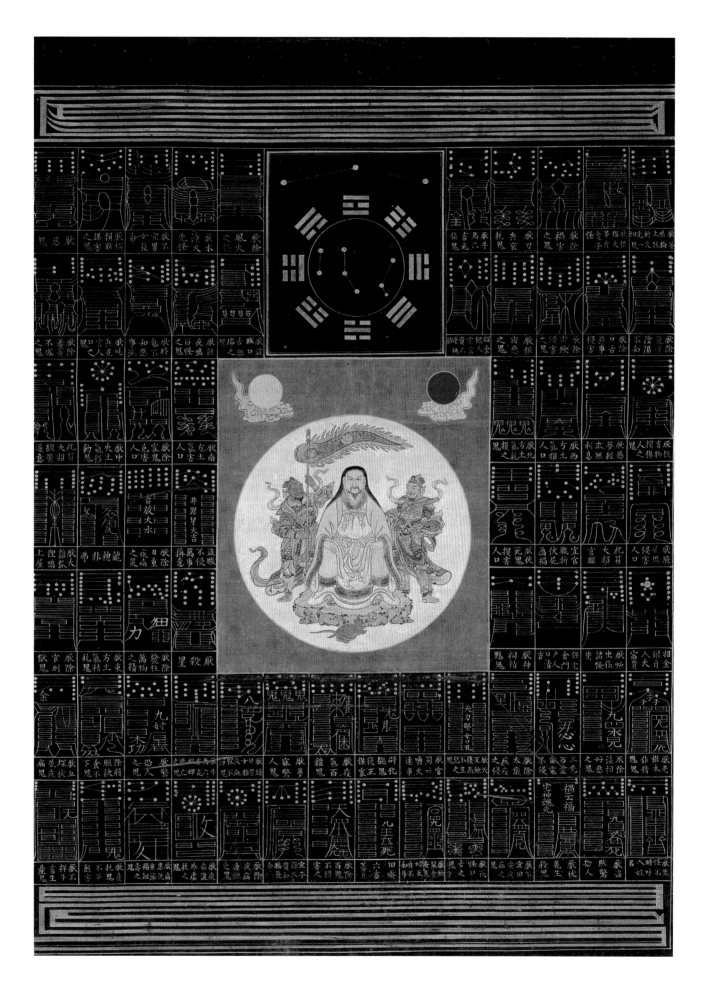

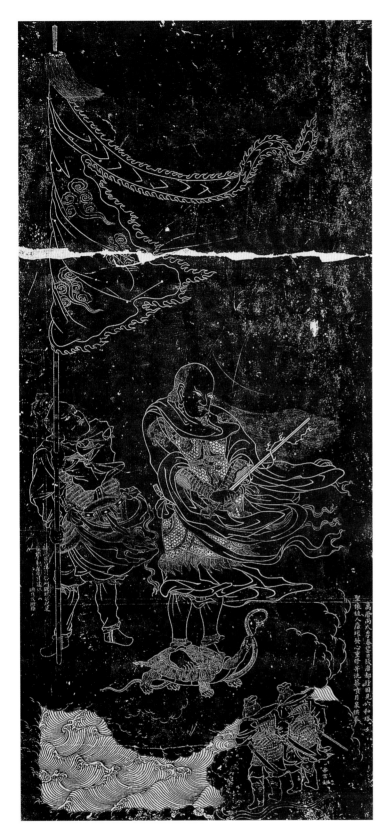

114

Zhenwu, Supreme Emperor of the Dark Heaven

Ink rubbing of a stele from the Six Harmonies Pagoda, Hangzhou,
 Zhejiang province
Ming dynasty, Wanli reign, dated 1586
Hanging scroll; ink on paper
148.6 × 67.6 cm
The Nelson-Atkins Museum of Art, Kansas City, Bequest of
 Laurence Sickman (F88–45/345)

THIS INK RUBBING is taken from a late Ming stone stele, itself based on an earlier stele, now destroyed. The image on the stele depicts Zhenwu, the Perfected Warrior, descending on a black cloud over swirling waves. The god stands on the back of an intertwined tortoise and snake. Zhenwu is shown wearing wind-blown robes over armor, and he brandishes a sword in his right hand. His long hair flies out behind his head, as he stares at the crackling flame that envelops the blade of his sword. Behind him an attendant stands and holds a fluttering banner on which appear stars of the Northern Dipper. Below, in the lower right corner, two martial figures genuflect to the god.

An inscription carved along the right border of the composition reads:

> On the fifteenth day of the first month of spring in the year *bingxu* of the Wanli reign [1586], Zhong Yin of Qiantang [Hangzhou] saw the image of the Saint *[shengxiang]* at the Six Harmonies Pagoda [Liuhe ta], which people had rubbed to ruin. Manifesting his intent, he again restored [the stele], and washed . . . and made [this] offering.

Next to one of the bowing figures below are the characters *Yu Jikan*, apparently a personal name. A damaged inscription along the left border reads in part, "Engraved by Chen Yinglong."

—S. L.

NOTES

Introduction

1. Lagerwey 1992: 295.
2. The most extensive study of Zhenwu's cult to date is Bruyn 1997. See also Grootaers 1952.
3. See S. Cahill 1980.
4. Lagerwey 1992: 295.
5. Piotrovsky 1993: no. 64, and *Guo zhi guibao* 1999: no. 273.
6. Bruyn 1997, vol. 1: 93.
7. Ibid.: 96.
8. Ibid.: 105.
9. The twelfth-century image is contained in the famous album owned by Stephen Junkunc IV, published in Martin 1913.
10. Lagerwey 1987b: 45. See also Lagerwey 1992 and *Wudang Shan* 1991.
11. Lagerwey 1992: 305.
12. Seaman 1987: 142. On the *Santai* asterism, see Andersen 1989–90: 30.
13. Seaman 1987: 25–26.
14. Kohn 1998a: 129–34.
15. Seaman 1987: 1–39 ("Introduction").
16. Lagerwey 1992: 326 n. 2.
17. I am grateful to Dr. Ursula Lienert of the Museum für Kunst und Gewerbe, Hamburg, for giving me the opportunity to study this unpublished sculpture in February 1998.
18. The British Museum, 1990.12-19.1.
19. By the Yuan dynasty, one of the temples on Wudang Shan was the Five Dragon Palace; see Lagerwey 1992: 296. As Lagerwey shows, it was the five Dragon Kings who conveyed to Zhenwu the Jade Emperor's decree of his investiture as a god (321).
20. An analogous practice existed in Japan in the Edo period, of creating miniature earthen images of Mount Fuji in Edo (Tokyo) and elsewhere, to facilitate worship of the peak far from the actual mountain.

Cat. no. 102

1. One of the two long sides of the same sarcophagus, depicting a dragon and accompanying figures, is published in *Treasures of Ancient Chinese Sculpture* 1997: 33–36.
2. The Nelson-Atkins Museum of Art, 33-1543/1–3. Ink rubbings of the two long sides of this sarcophagus are published in *Eight Dynasties of Chinese Painting* 1980: 5, no. 4. The foot-slab is unpublished.
3. On the role of the deities of the four cardinal directions (*si ling*) in Taoist ritual, see Lagerwey 1987b: 44–45.

Cat. no. 103

1. Royal Ontario Museum, Toronto, Dr. Herman Herzog Levy Bequest Fund (991.62.1).

Cat. no. 105

1. Previously published in Vainker 1991: pl. 119.

Cat. no. 106

1. A late Ming sculpture of Zhenwu in Longquan celadon ware is in The Art Institute of Chicago (1924.417). An example in Dehua porcelain, dated to the Kangxi reign (1662–1722), is in the Metropolitan Museum of Art, New York (79.2.481); this votive sculpture has gilt hands, and holes in the face where human facial hair was inserted. A Cizhou stoneware example, painted in overglaze enamels, is in the Burrell Collection, Glasgow (38/520).

Cat. no. 107

1. Previously published in *Baoning si Mingdai shuilu hua* 1988: pl. 78.
2. In ibid., the Four Saints are said to be attendants to Ziwei dadi (Purple Tenuity Emperor), Emperor of the North Polar celestial region.
3. Previously published in Martin 1913. In the Junkunc painting, the Four Saints are accompanied by Cang Jie, the mythical inventor of writing; on this figure, see Chaves 1977: 201–02. On connections between Taoist and Tantric Buddhist ritual, see Boltz 1987a: 264 n. 58.
4. Lagerwey 1987b: 45. In contemporary Taoist rituals in southern Taiwan, a separate altar is often constructed for the Four Saints, and the altar table is called "Wudang Mountain" after Zhenwu's sacred peak in Hubei province.

5. Ibid.: 95, 68.
6. Boltz 1987a: 32.
7. Cited in ibid.: 265 n. 63; for the original text see YJZ: 329, 799, 837.
8. See Major 1985–86: 65–86. Xuanwu was the ancient god and symbol of the north, visualized since the Han dynasty as an entwined tortoise and snake.
9. Boltz 1987a: 32.
10. Strickmann 1980: 228–29.
11. Boltz 1987a: 265 n. 62.
12. Katz 1995: 85 n. 20.
13. Boltz 1987a: 32, 83–86.
14. Ibid.: 83–84.
15. Ibid.: 85.

Cat. no. 108

1. Bruyn 1997, vol. 1: 105.
2. For a detailed discussion of this painting, see Lin 1999: 155–62, fig. 25. Lin dates the painting to the early Ming dynasty (fifteenth century).
3. On the identification of the Taoist marshals in the Reiun-ji painting, see ibid.: 157–58.
4. On Guan Yu as a popular and Taoist god, see Duara 1988: 778–95.
5. Marshal Zhao appears with the same weapon in the twelfth-century Taoist album in the Stephen Junkunc IV collection; published in Martin 1913.
6. The same leaf in the Junkunc Taoist album that depicts Marshal Zhao includes a depiction of Marshal Ma, indicating this third eye and the lance with a snake wrapped around the shaft.
7. The painting's Japanese wooden storage box bears an inscription dated to the fourth year of the Hōreki reign (1754), stating that the painting once belonged to the great painter Kanō Tan'yū (1602–1674).
8. Published in Bruckner 1998: no. 7.

Cat. no. 109

1. Bruyn 1997, vol. 2: 444.
2. Lagerwey 1992: 296, 318.
3. See *Wudang Shan* 1991.
4. Lagerwey 1992: 296. During the Five Dynasties and early Song periods, the Taoist Chen Tuan (872–989) lived on Wudang Shan for twenty years; see Kohn 1990a: 9.
5. Lagerwey 1992: 302.
6. Sun 1981: 225.
7. Lagerwey 1992: 301.

Cat. nos. 110–11

1. For studies of Wudang Shan, see *Wudang Shan* 1991; Lagerwey 1992: 293–332, and Bruyn 1997.
2. HY 958. See also Boltz 1987a: 89–90; and the discussion of this illustrated text in Lin Shengzhi 1999.
3. A similar painting, based on cat. no. 110, is discussed in Wang Yucheng 1999.
4. Wang Yi'er, private communication, December 8, 1999.

Cat. no. 112

1. It is unclear exactly when registers were first used, but they were already a fundamental feature of the Celestial Master church by the early fifth century. See Chen 1985: 351–59, for a detailed account of early registers.
2. For example, see HY 1117, *juan* 4: 5.
3. See Kobayashi 1998: 136–42, for more detail on the early Celestial Master hierarchy.
4. See Zhang's biography in HY 1451, *juan* 3: 29–31.

Cat. no. 113

1. HY 957, *juan* 1: 10.
2. HY 957, *juan* 1: 12.
3. *Shouji*; this term suggests the Buddhist idea of foretelling one's future Buddhahood upon the pronouncement of the bodhisattva vow.
4. HY 957, *juan* 1: 22.

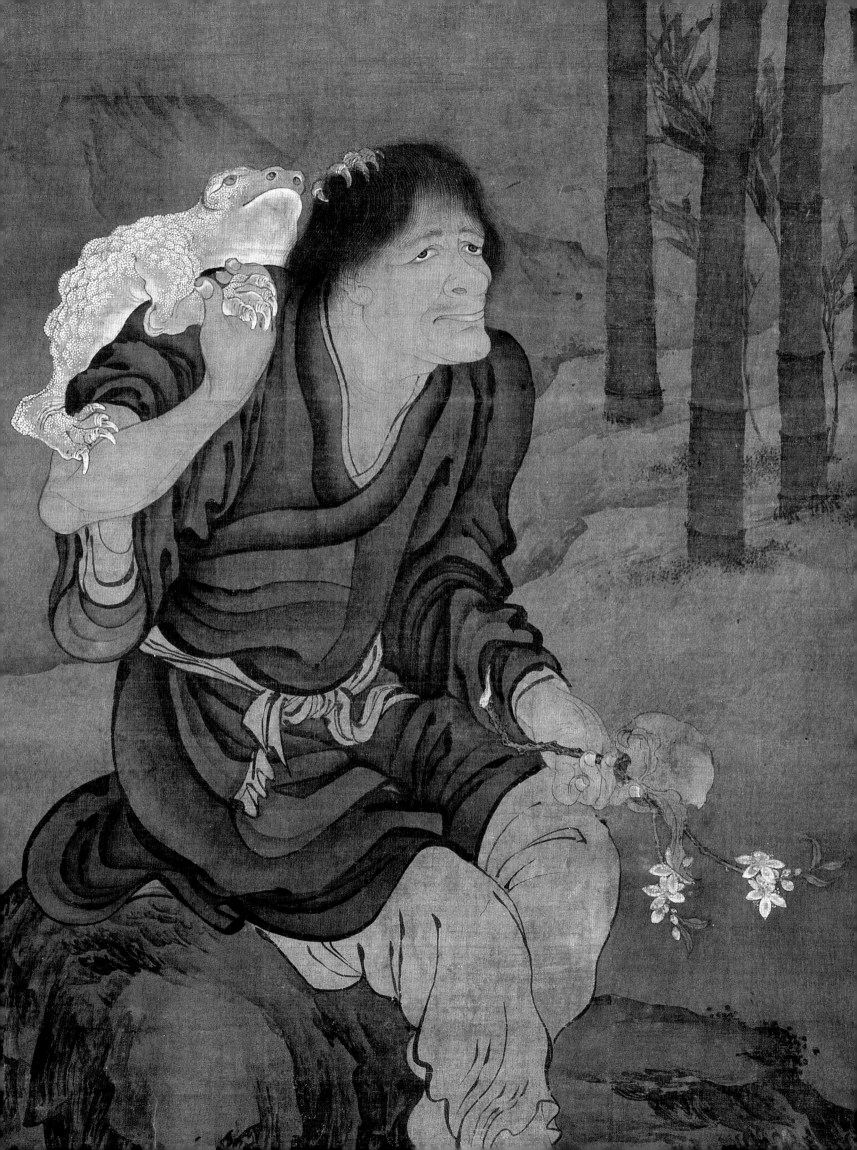

INHERITING AN ANCIENT TRADITION of adepts who, through their own self-cultivation, transcended the bounds of the natural world, religious Taoism developed its own tradition of immortal practitioners of the Tao. This section of the exhibition catalogue explores visual depictions from the Song (960–1279) through Qing (1644–1911) dynasties of the individual's cultivation of moral virtue and perfection, which for those with sufficient faith and discipline led to longevity, immortality, and spiritual union with the Tao.

Included here are paintings of a variety of famous immortal adepts. Among these are Zhongli Quan, Lü Dongbin, Zhang Guolao, and Li Tieguai, all members of the well-known group known as the Eight Immortals, particularly worshipped by the Quanzhen (Complete Realization) sect from the fourteenth century onward. These figures, revered for their spiritual powers and worshipped as divine saints, are among the most popular figures in Taoism. The images shown in this section explore the immortals' exotic mythologies and unconventional behavior. Significantly, the cult of immortals and transcendents is regaining strength today among Taoist believers in China, and some Taoist temples are dedicated to the worship of these figures.[1]

The Taoist concept of immortality is typically fluid. As Kristofer Schipper has written,

> Who are these Immortals? There is no precise way to define them, no method is error-free, no ecclesiastical institution or tradition has ever confirmed their quality, no official canonization has ever distinguished the true Immortals from the false ones. Their stories do not allow a distillation of an exact doctrine, for there is no dogma defining how a body can become one with Tao. Every human being, whether big or small, humble or great, young woman or old man, musician, herbalist, clown, or scholar, may— on the sole condition of finding his or her own mountain—quit the

treadmill of progress towards death and discover the return towards life. It is not even necessary to act intentionally: luck and a certain predisposition may sometimes be the only needed conditions, but nothing is guaranteed. It is necessary, however, to at all times be open and prepared to recognize, at a given moment of one's life, the mountain or the initiating Immortal, which some day is to be found on everyone's life path.[2]

Almost all Taoist immortals began their lives as human beings. Subsequently they underwent a spiritual and physical transformation, resulting in an existence beyond the bounds of *yin* and *yang*. Such beings are traditionally known as *xian*, translated as adept or immortal.[3] Cults of specific immortals are documented from early as the Han dynasty (206 B.C.–A.D. 220), and include both male and female figures. The immortal Wang Ziqiao, for example, was said to have lived in the sixth century B.C. His attainment of immortality was commemorated in a late Han dynasty stele inscription of A.D. 165, and his biography appears in the fourth-century compendium entitled *Biographies of the Divine Immortals (Shenxian zhuan)*, traditionally attributed to the alchemist Ge Hong.[4] A similar late Han stele commemorating the cult of the immortal Fei Zhi, excavated in 1991 near Luoyang, Henan, is included in this exhibition (cat. no. 22).

The immortals have a remarkable function within Taoism. As free spirits who can move with ease between Heaven and Earth, they serve as role models for humanity in their cultivation of moral, spiritual, and bodily perfection, and can intercede on behalf of mortals with the gods and the Tao. Their often unconventional appearance symbolizes their rejection of quotidian norms, and belies their transcendent state of being.

2b 2a

真君告弟子及郡城之父老曰此地為浮州
蛟螭所穴不有以鎮之後且復出為患人莫
之能制也乃役鬼神於牙城南井鑄鐵柱為
永久鎮浮之計

115

Illustrated Biography of the Realized Lord Grand Astrologer Xu, from the Taoist Canon of the Zhengtong Reign

Ming dynasty, Zhengtong reign, 1444–45
Woodblock-printed book
35 × 11.3 cm (each page)
Bibliothèque Nationale de France, Paris (Chinois 9546, 437/1-2)

Xu Xun (239–336)[1] is an important Taoist figure known for his ability to protect against plagues and "flood dragons" *(jiao)*, magical creatures believed to cause natural disasters. His legend brings together three different strands of China's religious and intellectual culture: popular religion, Taoism, and Confucianism.

The first of these forms the earliest, most fundamental stratum of the movement surrounding Xu Xun, who supposedly served as an official during the Jin dynasty (265–420), and is believed to have lived in the area surrounding Western Mountain (Xi Shan, in modern Jiangxi). His cult first developed in this area, and the Jade Prosperity Palace (Yulong Gong) on Western Mountain remained the focal point for worship of Xu throughout the imperial period. The biographies of Xu preserved in the Taoist Canon are primarily made up of local legends from the area around Western Mountain, and are closely linked to both the natural and human geography of the region. Popular worship of Xu continued in this area long after he was incorporated into the Taoist pantheon, co-existing with and often supporting the official Taoist rites performed in the Jade Prosperity Palace. In his *Collected Writings on the Jade Prosperity Palace (Yulong ji)*,[2] the eminent Taoist master Bai Yuchan (1194–1228) described several popular regional traditions around Western Mountain that were still flourishing in the early thirteenth century. For example, there were annual processions in which an image of

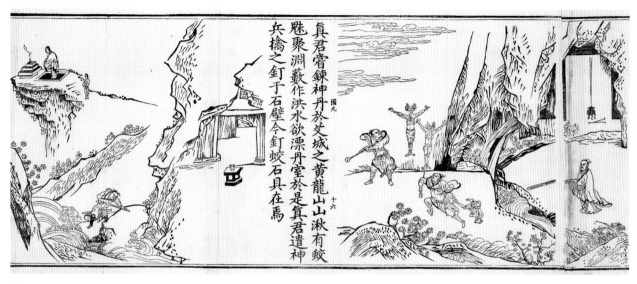

1b 1a

Xu would be paraded through the communities in the region; during these processions, the deity was believed to pay visits to other deities in the area connected with his legend.[3] An image of Xu's son-in-law, Lord Huang, was brought to the Jade Prosperity Palace every autumn to pay his respects, and once every three years an image of Xu was taken to visit his son-in-law and daughter in their temple. Merchants profited from these events, and every year they fought with each other to direct the procession of Lord Huang to their own shops as this deity left the Jade Prosperity Palace, believing that this would bring them good fortune over the next year.

When Xu was taken to visit his son-in-law and daughter, all the villages and towns would prepare offerings of incense to greet the deity as he passed by. During these processions, people singing ancient melodies carried the image of the deity in a palanquin decorated with carvings of a white horse and golden phoenixes, which were thought to be his mounts. People wearing headdresses constructed from bamboo frames with narrow bases and wide tops, and decorated with strips of colored cloth that hung down and covered their foreheads, accompanied the palanquin. Bai Yuchan described these practices as "ancient and strange," and suggested that they may have been remnants of customs dating back to the late fourth or early fifth century.

By the Tang dynasty (618–906), the cult surrounding Xu Xun

was intimately connected with Taoism. Bai indicated that the temple devoted to Xu on Western Mountain was restored by the Taoist master Hu Huichao in the Yongchun reign (682–683). In addition, a biography of Xu Xun from the Tang dynasty tells us that the Taoist rite Great Fast of the Yellow Register *(Huanglu dazhai)* was practiced at this temple.[4] Xu Xun was patronized by both the Tang and Song (960–1279) emperors, and the Song emperors in particular strengthened the ties between Xu's cult and Taoism as he became a national deity. The name of the temple on Western Mountain was changed from Flying Carpet Observatory (Youwei Guan)[5] to Jade Prosperity Observatory (Yulong Guan) by Emperor Zhenzong of the Song (r. 997–1022). Zhenzong based this name on a passage from the Taoist *Scripture of Conveyance (Duren jing),* which by the Song dynasty was already becoming the most important Taoist scripture. This name was further changed to Jade Prosperity Palace of Ten Thousand Longevities (Yulong Wanshou Gong) by Emperor Huizong (r. 1100–25) in 1116, thereby elevating its status. These examples indicate both the close relationship between Taoism and the imperial family during this dynasty and the ability of the Taoist church to mediate between local traditions and the imperially sponsored national religion.

Finally, the cult devoted to Xu Xun also upheld Confucian ideals, in that many of the figures connected with the legend of

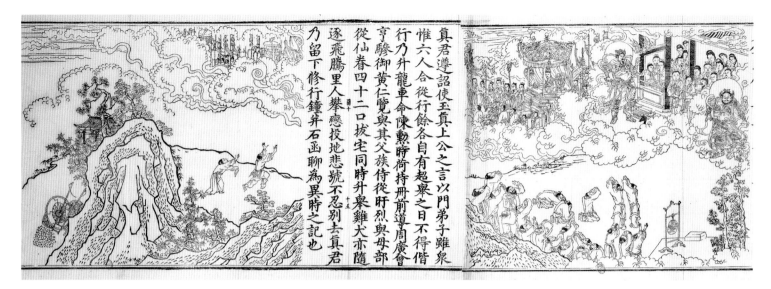

4b 4a

Xu Xun were famous for their filial piety *(xiao)*. In particular, Xu's teacher, Wu Meng, is known as one of the twenty-four paragons of filial piety *(ershisi xiao)*. In the Tang dynasty, the movement surrounding Xu was known as the Way of Filial Piety (Xiaodao), and, in addition to Taoist scriptures, this movement revered the *Classic of Filial Piety (Xiao jing)*, a work attributed to Confucius himself. In the chaos of the twelfth and thirteenth centuries that ensued after Jurchen and then Mongol troops captured north China, the Way of Filial Piety was reborn as the Clear and Bright Way of Loyalty and Filial Piety (Jingming zhongxiao dao), one of the most important Taoist movements of its time. Under the influence of the doctrine of "unity of the Three Teachings" *(Sanjiao yizhi)* of Confucianism, Taoism, and Buddhism, the connections between Taoism and Confucianism were emphasized even more. Consequently, the example of Xu Xun shows the illusory nature of the opposition sometimes imposed upon Taoism and Confucianism, since these two intellectual traditions often shared the same beliefs.

Narrative illustrations of Xu Xun's life existed as early as the Northern Song (960–1126). Bai Yuchan tells us that three of the walls in the front hall of the Jade Prosperity Palace in Jiangxi were painted with scenes from Xu's life, while depictions of the annual processions described above were also painted elsewhere in the temple. These scenes may have provided inspiration for the woodblock illustrations in the present text, which was first completed sometime after 1295.[6] The version shown here, entitled *Illustrated Biography of the Realized Lord Grand Astrologer Xu (Xu taishi zhenjun tuzhuan)*, is contained in the Taoist Canon *(Daozang)* published in 1444–45.

In the first set of illustrations shown here, Xu is preparing an alchemical elixir. This magical operation is said to have been disturbed by flood dragons who tried to flood Xu's chamber, forcing him to incapacitate the flood dragons by nailing them to the side of a cliff. The first illustration (1a) shows Xu standing outside the chamber with an alchemical crucible while his soldiers torture two flood dragons nailed to the cliff. In the second illustration (1b), Xu first stops to pay his respects at the stone chamber where the famous patriarch of alchemy, Ge Xuan (164–244), completed an elixir. He then travels to a stream where he stops to sharpen his stone on a rock. Finally, he climbs a peak, and after making offerings to the Highest Imperial (Shangdi), he consumes the elixir.

In the second set of illustrations, Xu is commanding a group of spirits to prepare an iron pillar that will protect a dragon-infested area.[7] The first illustration (2a) shows a spirit climbing up to the mouth of a giant furnace where the pillar is being made. In the second illustration (2b), the pillar is placed in a well that had provided the flood dragons with access to the village. Xu informs the villagers that as long as the pillar remains upright, they will be safe from flood dragons, but if it ever leans he will return to protect them once again.

In the third set of illustrations, Xu and Wu Meng have employed two dragons to carry the boat in which they are riding. Partway through their journey, they decide to travel through a "cavern-heaven" *(dongtian)*, a paradisiacal dwelling for Taoist adepts that lay under a mountain. The owner of the boat, a common man, has been instructed to keep his eyes shut for the entire journey, but as the boat approaches the cavern-heaven,

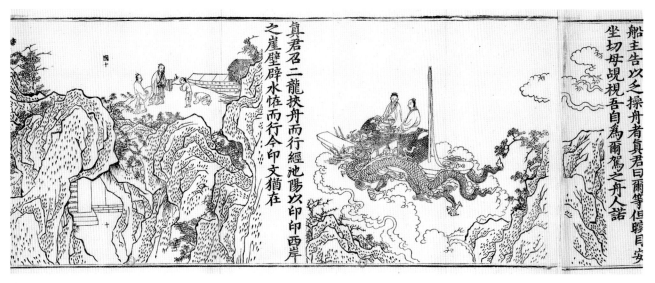

3b 3a

the bottom begins to scrape on the tops of trees, and the owner
of the boat, overcome by concern and curiosity, opens his eyes
to look. The dragons drop the boat and flee from his gaze. The
first illustration (3a) shows the flying boat, and the second illus-
tration (3b) shows the boat stranded on top of the mountain,
while the owner, who has realized Xu and Wu are no ordinary
people, begs these masters to teach him methods for attaining
longevity.

 The final set of illustrations shows Xu's ascent to the celestial
realms. In the first illustration (4a), Xu ascends to the celestial
realms in a magical carriage surrounded by clouds, accompa-
nied by forty-two members of his family, including six disciples.
Supposedly, even the dogs and chickens of the household rose
up with him (see cat. no. 116). Two celestial warriors stand to
either side of Xu's entourage, while villagers bid them farewell.
In the second illustration (4b), two servants, a husband and
wife, who were transporting rice and hence not present when Xu
began his ascent, rush to see him one last time. In their hurry,
they have overturned their rice cart, which can be seen in the left
of the illustration.

 —S. E.

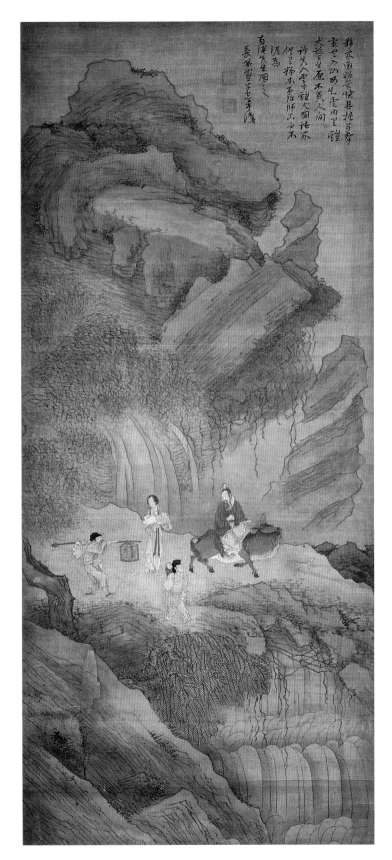

116

Cui Zizhong (d. 1644)
Chickens and Dogs Amid the Clouds

Ming dynasty, early 17th century
Hanging scroll; ink and colors on silk
191.4 × 84 cm
National Palace Museum, Taipei

THIS PAINTING SHOWS the magician-scholar Xu Xun (239–336; see cat. no. 115) traveling with his family on a mountain far from civilization.[1] Xu wears the square cap of a Taoist priest and carries a scroll in his hand. The "chickens and dogs" of the title refer to a dog in front of Xu, humorously imitating the proud step and satisfied look of the ox as he leads the way, and a chicken in a cage on the servant's pole. While these images derive from Xu's biographies, they also allude to chapter 80 of the *Daode jing,* which says that in a well-governed kingdom, people might be so close to another town as to hear its dogs and chickens, but would never venture away from their homes to see it. This allusion emphasizes the reclusive theme of the painting.

Legend says that when Xu Xun ascended to the celestial realms, he was allowed to bring his household—even the chickens and dogs rose to the heavens along with him. The small group shown here accompanying Xu on his departure from earthly life stands in stark contrast to the large celestial entourage that greets Xu and takes him to the heavens in the *Illustrated Biography of the Realized Lord Grand Astrologer Xu* (cat. no. 115), from the Taoist Canon. While the illustrations in that book idealize Xu as a celestial official who triumphantly "rose to the heavens in broad daylight," Cui Zizhong shows him here rather as a hermit scholar who has turned his back on the corrupt world to seek a life of quietude in the mountains. This suggests parallels with famous paragons of virtue such as Bo Yi and Shu Qi, who protested the usurpation of the Shang dynasty by going into seclusion in the mountains, eventually starving to death.

Cui lived in Beijing, where he was famous as a figure painter, using a stylized archaism in his paintings modeled on the works of great masters of the past such as Gu Kaizhi (c. 344–406) and Wu Daozi (eighth century), both of whom were known for their connections with Taoism. Cui's life ended in tragedy; he died of starvation the same year the Manchu rulers of the Qing dynasty took control of China, in 1644.

—S. E.

117

117

Vase with the Eight Immortals

Yuan dynasty, c. 1350
Longquan celadon ware
H. 25.4 cm
Private collection

118

The Eight Immortals, the Three Stars, and the Queen Mother of the West at the Turquoise Pond

Qing dynasty, Qianlong reign (1736–95)
Hanging scroll; ink and colors on *kesi* silk tapestry
182.8 × 104.1 cm
Asian Art Museum of San Francisco, The Avery Brundage Collection (B62 D28)

FROM THE YUAN DYNASTY onward, the Eight Immortals (Baxian) have been the most famous group of Taoist adepts in China.[1] They appear to have emerged as a discrete group during the Jin dynasty (1115–1234) in northern China, and are depicted in the ceramic tomb sculptures decorating the walls of Jin dynasty tombs near Pingyang, Shanxi province, dating to the late twelfth and early thirteenth centuries.[2] The emergence of the Eight Immortals as a group occurred within the context of the Complete Realization (Quanzhen) sect of Taoism, which spread rapidly throughout China during the Jin and Yuan (1260–1368) dynasties. The most famous early depiction of this group is in a mural at the Hall of Purified Yang (Chunyang Dian) at the Eternal Joy Temple (Yongle Gong), the great Quanzhen sect temple at Ruicheng, southern Shanxi province, dating to the

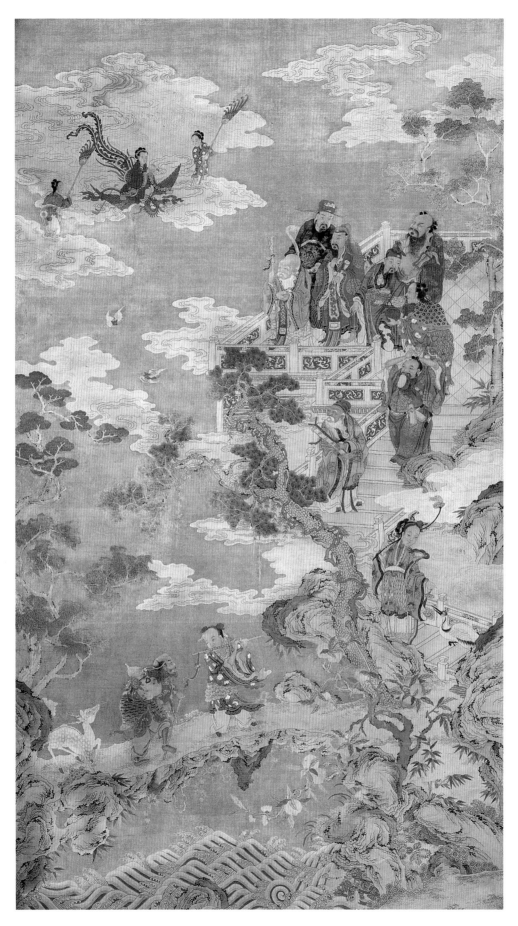

mid-fourteenth century.[3] By the Ming and Qing dynasties, entire temples were dedicated to the Eight Immortals.

The members of the Eight Immortals are Zhongli Quan, Lü Dongbin, Li Tieguai, Zhang Guolao, Han Xiangzi, Cao Guoqiu, Lan Caihe, and He Xian'gu. The majority of these figures were said to have lived during the Tang dynasty (618–906). While the hagiographies of some of the Eight Immortals are straightforward, some appear to conflate different individuals. A thoroughly researched and coherent history of the cult of the Eight Immortals has yet to be written.[4]

Zhongli Quan, said in some sources to have lived in the Han dynasty (206 B.C.–A.D. 220), is considered the leader of the group, and is usually shown as a casually dressed scholar with a large stomach protruding through his partially open robe (see cat. no. 119). His most famous pupil, Lü Dongbin (see cat. nos. 120–22), was a promising scholar who gave up pursuit of an official career after experiencing an entire lifetime of success and failure in a dream induced by meeting Zhongli Quan. Lü Dongbin may be the most popular of the Eight Immortals, and is the subject of many Yuan and Ming dynasty dramas. He is often depicted with a sword, and is sometimes accompanied by his familiar, the spirit of a willow tree. Both Zhongli Quan and Lü Dongbin are among the patron saints of Taoist Inner Alchemy (neidan).

Li Tieguai (cat. no. 125), another very popular member of this group, was a promising Taoist adept whose body was cremated by a disciple while Li's ethereal self visited the deified Laozi. When Li returned after a week-long absence to find his body burned, he appropriated the corpse of a hideous, crippled beggar. Zhang Guolao (cat. no. 123), usually depicted as an old man, was a gifted magician, conforming to the ancient image of the fangshi, or "technique master." He was supposedly already hundreds of years old when summoned to the imperial court of Tang Xuanzong in the early eighth century. In the visual arts, Zhang is often depicted accompanied by his magic mule, which could be folded up like a piece a paper and stuffed into a small bag when not being ridden by his master.

Han Xiangzi was the nephew of the Tang poet Han Yu, and is usually shown as a young boy holding a flute or a "fish-drum." Cao Guoqiu, a tenth-century aristocrat and the patron saint of actors, is often depicted holding a fly-whisk or a pair of castanets; sometimes he is shown asleep, or staring at a taiji diagram. Lan Caihe is depicted as a young man holding the percussion instrument known as jieban (clappers). He Xian'gu, the only female member of the group, is often depicted holding a basket of lingzhi magic mushrooms, peaches, or a lotus flower.

The Eight Immortals are frequently depicted on celadon vases; the Longquan celadon vase shown here (cat. no. 117), dating to the early fourteenth century, is one of the finest known examples of its type. Each of the eight figures is molded in relief in its own panel around the surface of the octagonal vase. When the vase was glazed, the molded panels were covered in a wax resist, resulting in a striking contrast between the reddish-brown color of the ceramic body and the cool green tonality of the iron-oxide celadon glaze. Such vases point to the widespread popularity of the theme of the Eight Immortals by the Yuan dynasty (1260–1368).

From the early Ming dynasty (fifteenth century) on, the Eight Immortals were frequently depicted with Shoulao, the God of Longevity. One of the Three Stars (the gods of longevity, emolument, and good fortune), Shoulao ("Old longevity"), appears to have emerged in his manifestation as an old man with a huge, domed cranium in the late fourteenth or early fifteenth century (see cat. nos. 90–91). Such scenes are commonly encountered on Ming ceramics and other decorative arts from the Jiajing reign (1522–66) onward, and continued to enjoy great popularity during the Qing dynasty.

The superb eighteenth-century kesi silk tapestry from the Asian Art Museum of San Francisco (cat. no. 118) probably dates to the Qing dynasty Qianlong reign (1736–95).[5] Here the Eight Immortals are shown in a fantastic landscape, almost certainly depicting the Turquoise Pond (Yao chi) in the paradise on Mount Kunlun. The waves of the pond are shown below a precarious rock bridge that the immortals ascend on their way to a terrace above, where the Three Stars are already standing. The Queen Mother of the West approaches at the upper left, flying on a phoenix and accompanied by two jade maidens. Such refined kesi weavings may have been made as imperial birthday gifts during the Qianlong reign.

—S. L.

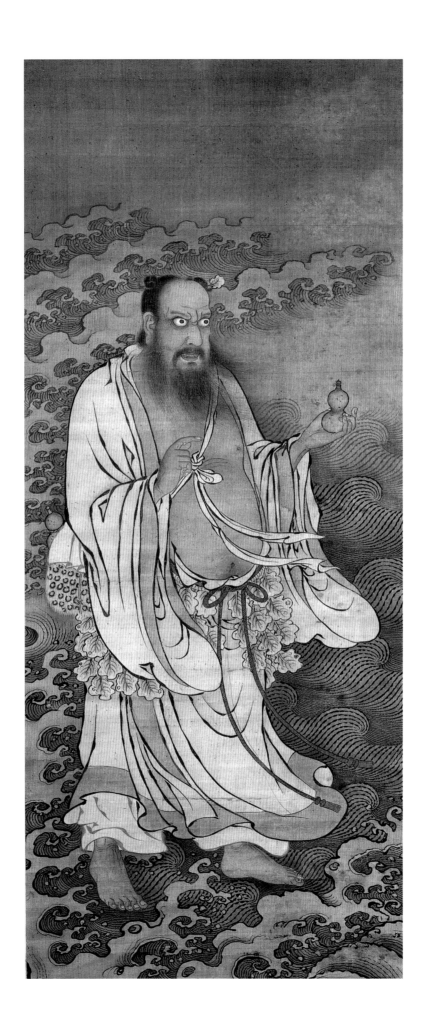

119

ATTRIBUTED TO ZHAO QI (ACTIVE LATE 15TH CENTURY)
The Immortal Zhongli Quan

Ming dynasty, late 15th century
Hanging scroll; ink and colors on silk
134.5 × 57.2 cm
The Cleveland Museum of Art, Purchase from the J. H. Wade Fund
(76.13)

THE TAOIST IMMORTAL Zhongli Quan is generally considered to be the leader of the Eight Immortals (Baxian) and the teacher of Lü Dongbin (see cat. nos. 120–22). While some sources state that he was born during the Han dynasty, others state that "his dates are unknown."[1] His story in the *Complete Biographies of the Assorted Immortals (Liexian quanzhuan)* of 1598 reads in part:

> He [Zhongli Quan] was very strong. During the Han dynasty he served as a great general. Once, when attacking Turfan [in Central Asia], his side lost the advantage. He alone escaped on horseback and rode into a mountain valley. He lost the road, and at night entered a dense forest. There he came upon a barbarian monk, with disheveled hair brushing his forehead. On the monk's body hung a robe of knotted grass. The monk led him for several *li*[2] until they saw a village, and said, "This is where Master Dong-hua attained the Tao.[3] Here you can rest." He then bowed and disappeared.
>
> Zhongli was not inclined to rush into the village. After some time he heard someone say, "This must be the one the blue-eyed barbarian spoke of." He saw an old man wearing a white deerskin and holding a green bramble staff. The old man raised his voice and said, "Is this not the great general Zhongli Quan? Why didn't you spend the night where the monk lives?" Zhongli heard him and was much alarmed for he knew this was no ordinary person.
>
> At that point the place was transformed into a rude lair, and he found himself thinking of Luan birds and cranes [the attributes of immortals]. He then turned his mind to the Tao and begged the old man for the method of transcending the world. Thereupon the old man transmitted to him the Secrets of Extended Life *(chang-sheng)*, the Fiery Transformations of Gold and Cinnabar, and the Green Dragon Sword Technique. Zhongli then took his leave and emerged from his gate. When he turned around and looked back toward the village there was nothing to see.
>
> Later on he encountered the Perfected Being *(zhenren)* Hua-yang who transmitted to him the Interior Elixir of the Spatula and the Fire Talismans of Taiyi [Supreme Unity]. He also met the immortal Wang Xuanfu, from whom he obtained the secrets of

longevity. Traveling through the clouds he arrived in Lu [in Shandong province] and lived in Zoucheng. Once he entered Emptiness and Identity (Kongtong) Mountain, and dwelt at the Peak of the Four Graybeards of Purple-Cinnabar. Again he obtained the Secrets of the Jade Casket, whereupon he became an immortal and left the world.[4]

This painting may originally have been one of a set depicting the Eight Immortals. Zhongli Quan is shown crossing the ocean waves and holding a double gourd in his hand. He has an intense expression and his stomach is bared. Around his waist is a belt of leaves. The waves over which he walks send forth white beads of spray as they break.

Although unsigned, the painting can be confidently attributed to the late-fifteenth-century Zhe School painter Zhao Qi, who worked as a court painter in the Forbidden City during the reign of the Hongzhi emperor (r. 1488–1505).[5]

—S. L.

120

The Taoist Immortal Lü Dongbin

> Yuan dynasty, late 13th/early 14th century
> Hanging scroll; ink and colors on silk
> 110.5 × 44.4 cm
> The Nelson-Atkins Museum of Art, Kansas City, Purchase: Nelson
> Trust (62-25)

121

The Taoist Immortal Lü Dongbin Crossing Lake Dongting

> Southern Song dynasty, mid-13th century
> Fan painting; ink and light color on silk
> 23.1 × 22.6 cm
> Museum of Fine Arts, Boston, Chinese and Japanese Special Fund
> (17.185)

122

The Immortal Lü Dongbin Appearing at the Yueyang Pavilion

> Southern Song dynasty, mid-13th century
> Fan painting; ink and colors on silk
> 23.8 × 25.1 cm
> The Metropolitan Museum of Art, New York, Rogers Fund (17.170.2)

THE TAOIST IMMORTAL Lü Dongbin ("Lü the Cavern-guest") is a patriarch of the Quanzhen (Complete Realization) sect, and is included as one of the famed Eight Immortals (Baxian; see cat. nos. 117–18). Lü is believed to have lived in the late Tang dynasty (618–906), and his following became widespread during the Song Dynasty (960–1279). He is usually depicted in art as a handsome scholar, dressed in a white robe and equipped with a sword. According to mythology, he was widely celebrated as a swordsman, and for his skills in poetry, calligraphy, and the connoisseurship of wine.[1] In addition, he was revered as a specialist in the meditative techniques of *neidan* (Inner Alchemy), and as a healer, exorcist, diviner, and artisan.[2] A well-known example of Lü Dongbin's alchemical poetry reads:

> The water-drinking sea tortoise passes unnoticed,
> The mountain talisman burner is disliked by the demons.
> One grain of millet contains the whole world,
> In a one-quart alchemical vessel boil rivers and mountains.[3]

By the end of the Song dynasty, Lü was worshipped as the patron saint of merchants, pharmacists, ink-makers, and scholars. There are several different accounts of his life, a number of which stress his meeting with the immortal Zhongli Quan (see cat. no. 119). One of the best-known of these stories is "The

121

Yellow-Millet Dream" *(Huangliang meng),* in which Lü falls asleep at an inn while Zhongli prepares some millet for a meal. While asleep, Lü has a dream in which he experiences his entire official career, which ends in failure and disgrace. As Paul Katz has shown, this story became widely known after the publication and performance of the *The Yellow-Millet Dream,* a drama by the Yuan dynasty playwright Ma Zhiyuan (1260–1325).[4] As told in the Yuan compendium the *Illustrated Biographies of the Immortals (Zengxian liexian zhuan),* the story reads:

> Once he [Lü Dongbin] entered into a tavern in Chang'an [Xi'an] to see a Taoist priest, dressed in a gray cap and white gown, spontaneously scribble a poem on a wall. It ran,
>
> > Sit or lie—I always grasp a pot of wine,
> > No need to tell my eyes to see the starry zone.
> > Vast like heaven and like earth, I never have a name,
> > Among so many mortals, I'm scattered and alone.

Impressed and attracted by the Taoist's strange appearance and unusual old age, as well as by the grace and naturalness of his verse, Dongbin bowed to him and inquired his name.

"I am Master Cloudchamber [Zhongli Quan]," he answered. "My home is the Crane Ridge in the Zhongnan Mountains. Would you like to join me in my wanderings?"

Dongbin hesitated to agree to this proposal, so Master Cloudchamber took him to an inn. While he attended to the preparation of a simple meal, Dongbin reclined on a pillow. Soon he became oblivious of his surroundings and fell asleep.

He had a dream. He dreamt that he went up to the capital as a candidate of the imperial examination and passed it at the top of the list. Starting his career as a junior secretary to one of the Boards, he rapidly rose in rank to positions at the Censorate and the Hanlin Academy. Eventually he became a Privy Councillor after he had occupied, in the course of his unbroken success, all the most sought-after and important official posts.

122

Twice he was married, he further dreamt, and both wives belonged to families of wealth and position. Children were born to him. His sons soon took themselves wives, and his daughters left the paternal roof for their husbands' homes. All these events happened before he even reached the age of forty.

Next he found himself Prime Minister for a period of ten years, wielding immense power. This corrupted him. Then suddenly, without warning, he was accused of a grave crime. His home and all his possessions were confiscated, his wife and children separated. He himself, a solitary outcast, was wandering toward his place of banishment beyond the mountains. He found his horse brought to a standstill in a snowstorm and was no longer able to continue the journey.

At this juncture in his dream Dongbin woke with a heavy sigh. Lo and behold! The meal was still being prepared. Laughing at his surprise, Master Cloudchamber intoned a verse.

The yellow millet simmers yet uncooked,
A single dream and you have reached the world beyond!

Dongbin gaped in astonishment. "Sir," he stammered, "how is it you know about my dream?"

"In the dream that just came to you," Master Cloudchamber replied matter-of-factly, "you not only scaled the dizziest heights of splendor but also plumbed the uttermost depths of misery. Fifty years were past and gone in the twinkling of an eye. What you gained was not worth rejoicing over, what you lost was not worth grieving about. Only when people have a great awakening, they know that the world is but one big dream."

Impressed by this incident, Dongbin received spiritual enlightenment. He fell to his knees before the master and entreated him for instruction in the arts of transcending the limitations of this earthly sphere.[5]

One of the earliest known depictions of Lü Dongbin with Zhongli Quan appears in the Hall of Purified Yang (Chunyang Dian) at the Eternal Joy Temple (Yongle Gong), the great Quanzhen sect Taoist temple in southern Shanxi province, built during the thirteenth century and painted during the mid-fourteenth century.[6] Significantly, the Eternal Joy Temple was built at Lü Dongbin's birthplace.[7] The walls of the Hall of Purified Yang are devoted to murals depicting fifty-two scenes from Lü's life.[8] The majority of these scenes are accompanied by cartouches with texts describing the adjacent stories; thirty-seven of these are direct quotes from the *Record of Divine Transformations and Miraculous Powers of the Lord Emperor of Purified Yang (Chunyang dijun shenhua miaotong ji)*, by the Quanzhen Taoist master Miao Shanshi (fl. 1288–1324).[9] The Yuan dynasty portrait of Lü Dongbin from the Nelson-Atkins Museum (cat. no. 120) is slightly older than the Yongle Gong murals, and depicts the immortal as an elegant scholar standing in a pale brown robe tied with a black belt. On his head is a blue hat; a double gourd hangs from his belt. The tip of his magic sword emerges from under his robe.

The Southern Song dynasty fan painting from the Museum of Fine Arts, Boston (cat. no. 121), depicts Lü Dongbin crossing the waves of Lake Dongting in southern China. Painted in ink and light colors on finely woven silk, the brushwork here is fluid and elegant. Placed asymmetrically to one side, the dignified figure projects an impassive expression as he crosses the gentle waves. Lü wears a white robe and a pale blue cap; the sash that ties his robe is also painted pale blue. In their expressive movements and variations in width, the lines that describe the immortal's robe convey the fluid movement of the figure as he crosses the lake. As Wu Tung has suggested, this figure resembles Southern Song paintings of Bodhidharma crossing the Yangzi River on a reed.[10] The fan has no inscription, and has no seals that might help identify the artist. A crease down the middle indicates that the fan was originally mounted with a central wooden or bamboo spine.

While Lü Dongbin was associated with many sites in China, one of the most famous in the popular imagination was the Yueyang Tower (Yueyang Lou) overlooking Lake Dongting in Hunan province. This tower, originally built during the Kaiyuan reign (713–41) of the Tang dynasty, became famous throughout China through the essay written by Fan Zhongyan (989–1052) entitled "The Pavilion of Yueyang" (1046).[11] Lü was often said to have visited the tower to drink wine. An early-twelfth-century account states that there was a portrait of Lü Dongbin in the Yueyang Tower, and according to Hong Mai's *Record of the Listener (Yijianzhi)*, another portrait sculpture of the immortal

existed in the White Crane Temple in the city of Yueyang by 1172.[12] It was in Yueyang that Lü Dongbin encountered spirits of a pine tree and willow tree; these nature deities are depicted on either side of the north door of the Hall of Purified Yang at the Eternal Joy Temple.[13] The association of Lü Dongbin with the Yueyang Tower was even more widespread from the Yuan dynasty onward, with the publication of Ma Zhiyuan's play *Lü Dongbin Thrice Intoxicated at the Yueyang Tower*.[14]

A famous poem attributed to Lü specifically mentions the city of Yueyang:

> In the morning I travel to the North Sea, in the evening to Cangwu,
> In my sleeve is a blue-green snake [the name of Lü's magic sword],
> courageous and rough [is my appearance].
> Thrice I entered Yueyang, but no-one recognized me.
> Singing a song as I flew by Lake Dongting.[15]

The Southern Song fan painting from the Metropolitan Museum of Art entitled *The Immortal Lü Dongbin Appearing at the Yueyang Pavilion* (cat. no. 122) gives visual expression to Lü's association with this site. The anonymous painter has depicted the tower in great detail. A large banner hangs from the second story; on it the characters *Yueyang* are visible. Guests on the second floor, interrupted from their banquet, rush to the balcony, while those on the first floor run outside and point to the upper right, where the figure of Lü Dongbin appears flying through the air. A whitewashed wall at the lower right is covered with graffiti, which includes a depiction of a man riding a mule; next to this is written the cyclical date *dingsi,* which may correspond to 1257. The many scholar-officials gazing up at the flying figure in this painting reflect the enormous appeal of Lü Dongbin among both the common people and the literati. This appeal, which cut across social and economic boundaries, made Lü one of the most famous and popular of all later Taoist immortals.[16]

—S. L.

123

The Immortal Zhang Guolao

> Ming dynasty, 15th century (traditionally attributed to the
> Song dynasty, 960–1279)
> Hanging scroll; ink and colors on silk
> 183.8 × 104.1 cm
> National Palace Museum, Taipei

ZHANG GUOLAO, also known as Zhang Guo, was a historical figure active during the reigns of Empress Wu of the Zhou dynasty (r. 684–705) and Emperor Xuanzong of the Tang (r. 712–56). According to the official *History of the Tang Dynasty*,[1] he was an old man who frequented the mountains in the area of modern Hebei and Shanxi, living as a recluse. He was believed to know secret arts for longevity, and claimed to have lived for several hundred years. Once he was summoned by Empress Wu, but feigned death in order to avoid meeting with her. Later, he was once again seen wandering in the mountains in Hebei, and in 733 Emperor Xuanzong sent an emissary to greet him. Zhang refused this emissary by stopping his breath, appearing dead for some time before he finally revived. However, Xuanzong persisted, and eventually persuaded Zhang to come to the capital, where he was welcomed with great reverence. A handscroll by the Yuan dynasty court painter Ren Renfa (1255–1328) in the Palace Museum, Beijing, depicts this meeting.[2]

While at the capital, Zhang had a number of encounters with the emperor, who continually tested his magical abilities. On two occasions Xuanzong introduced Zhang to men with a special expertise in predicting the ages of others; the first man became confused when he saw Zhang, and the second failed to see him at all, even though they were facing each other. Another time, the emperor had Zhang's rotted teeth knocked out while he was asleep from too much wine; Zhang applied special medicine from a pouch kept near his breast to his gums, and, after another nap, he woke up with shiny white new teeth.

The emperor was so impressed with these events that he decided to marry an imperial princess to Zhang, but Zhang laughed at this proposal, and eventually left the capital for the northern sacred peak, Mount Heng. He nevertheless remained on good terms with the emperor, who gave him several depart-

ing gifts and bestowed upon him the honorary title "Master Who Penetrates Mystery." Xuanzong also established a Taoist temple called the Observatory of Perching on Rose-colored Clouds (Qixia Guan) in Zhang's honor.

Zhang is depicted here as an old man, which corresponds to his description in the *Old Dynastic Records of the Tang*. He is shown as a hermit in the mountains, attended by two jade maidens *(yunü),* common figures in the entourages of high-ranking realized beings *(zhenren).* One maiden places an offering of incense into a censer *(ding)* in front of Zhang, while the other stands behind him, holding a mushroom-shaped *ruyi* scepter. Zhang and his attendants in the lower right are balanced in the upper left by a peach tree, a crane, and other traditional symbols of longevity. The painting bears the seals of the Qing dynasty emperors Qianlong, Jiaqing, and Xuantong.[3]

Zhang is best known as one of the Eight Immortals (see cat. nos. 117–18). This group appears to have first developed out of the Complete Realization (Quanzhen) movement during the Jin dynasty (1115–1234), and includes some of that movement's patriarchs, such as Lü Dongbin, in addition to historical figures such as Zhang from the Tang and Song dynasties. The Eight Immortals were a favorite subject for dramas, novels, and artistic works in the Yuan and Ming dynasties, and are still popular as gods of good fortune and long life today.

—S. E.

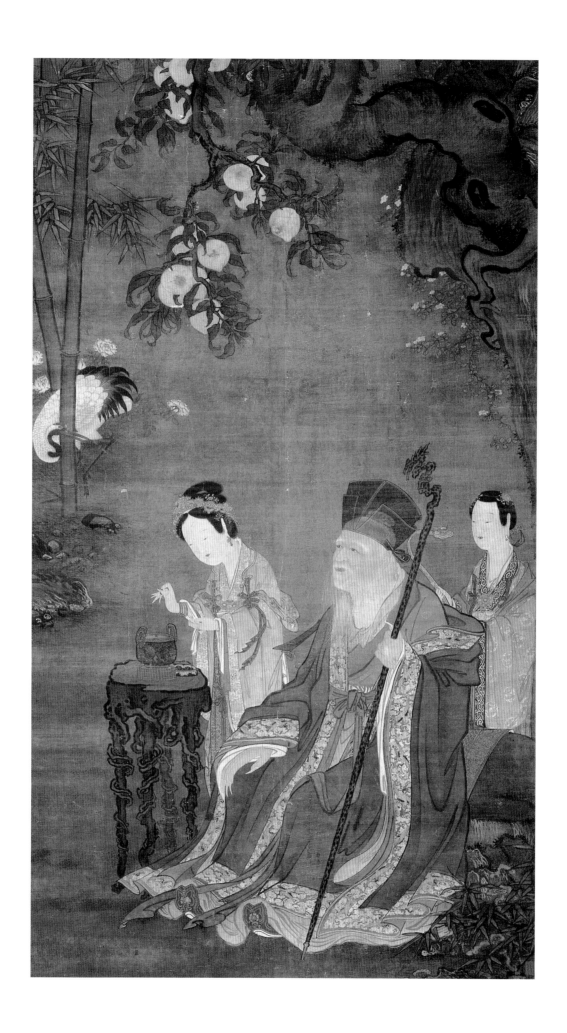

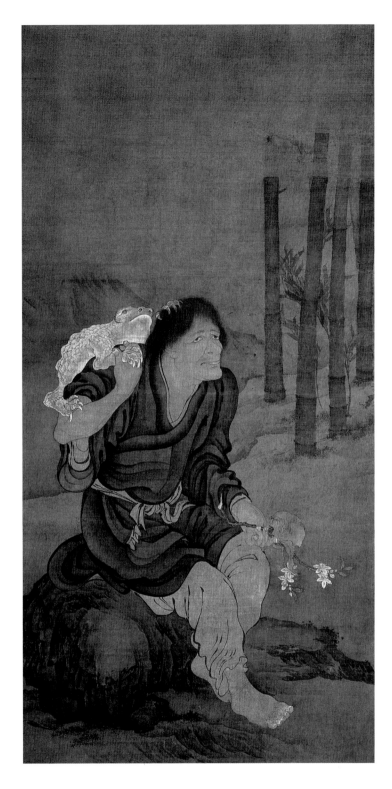

124

YAN HUI (ACTIVE LATE 13TH–EARLY 14TH CENTURY)
The Immortal Liu Haichan

> Yuan dynasty, 13th/14th century
> Hanging scroll; ink and colors on silk
> 161 × 79.8 cm
> Chion-ji, Kyoto

⊙ Important Cultural Property

YAN HUI'S PAINTING of Liu Haichan is one of the earliest known images of this adept. Liu lived during the turmoil of the Five Dynasties period.[1] He served as Grand Councillor for Liu Shouguang, who established himself as emperor in 911, only to be captured and executed shortly thereafter. While serving Liu Shouguang, he was visited by a Taoist using the pseudonym Zhengyangzi (Master Upright Yang), who initiated him into the secrets of Inner Alchemy. At the end of their meeting, Zhengyangzi requested ten eggs and ten coins from Liu; he placed one of the coins on a table and stacked the remaining coins and eggs on top of it, in the shape of a pagoda. Liu marveled at the feat and said, "This is precarious indeed!" Zhengyangzi responded that it was not nearly as precarious as Liu's present life, and then cast aside the coins and departed. Liu realized the danger he was in, and the next day left behind his riches and his post to become a hermit. He became known as Haichanzi (Master Sea Toad), from which the name of Liu Hai or Liu Haichan derives. Legend has it that he also received teachings on Inner Alchemy from Lü Dongbin (see cat. nos. 120–22), and consequently he came to be seen as the fourth patriarch of the Complete Realization (Quanzhen) sect. He is particularly famous as a master of Inner Alchemy, and is sometimes included in the Eight Immortals.

In this painting, Liu sits on a rock next to a bamboo grove and a stream. A three-legged toad, one of Liu's standard iconographical elements, sits on his shoulder. The adept grasps the toad's leg with his right hand, and holds a flowering and fruiting sprig from a peach tree in his left hand (the peach is an ancient symbol of fertility, longevity, and purity).[2] Liu has a quixotic, resigned expression on his face.

—S. L./S. E.

125

Yan Hui (active late 13th–early 14th century)
The Immortal Li Tieguai

Yuan dynasty, late 13th/early 14th century
Hanging scroll; ink and colors on silk
161 × 79.8 cm
Chion-ji, Kyoto

◉ Important Cultural Property

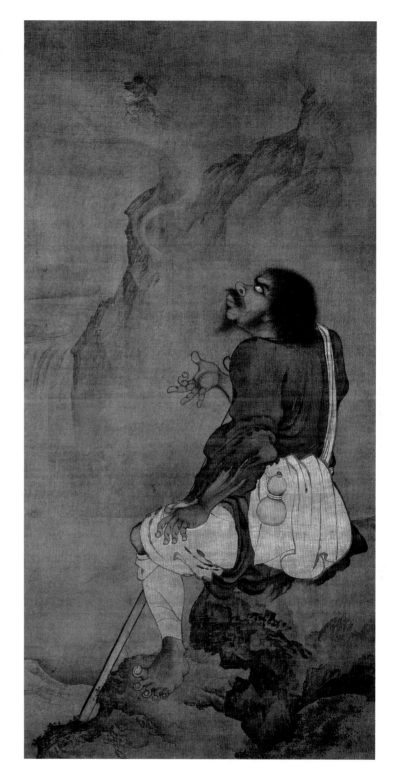

Perhaps the most famous surviving image of Li Tieguai ("Iron-crutch Li"), this painting by Yan Hui depicts the Sui dynasty (581–618) Taoist adept in a mountainous landscape.[1] It is also one of the earliest known images of Li, predating the murals of the Eternal Joy Temple (Yongle Gong) in southern Shanxi province by at least two decades.[2] Sitting on a rocky outcropping by a stream, with a crag and waterfall in the distance, Li glowers up at a miniature, ethereal form of himself that flies heavenward on a cloud. Barefoot and disheveled, he wears a double gourd at his waist—a symbol of the joining of Heaven and Earth in the adept's own body. His crutch leans against the rock on which he sits. Li's bizarre physiognomy and contorted right hand, which appears to have just released the flying figure above, convey his otherworldly persona with arresting clarity.

The Ming dynasty compendium the *Complete Biographies of the Assorted Immortals* (*Liexian quanzhuan*; 1598), compiled by Wang Shizhen, contains the following account of Li Tieguai:

> Li Tieguai had an eminent disposition. He attained the Tao at an early age. While cultivating realization in a mountain cave, Li Laojun [the deified Laozi] and Master Wenqiu [an adept of the Shang dynasty] often descended [from heaven] to his mountain retreat, where they instructed him in Taoist teachings.
>
> One day he was about to attend a meeting with Laojun on Mount Hua [the sacred peak in Shaanxi province]. Li said to his disciple, "My physical body will remain here—if my ethereal soul [*hun*] does not return in seven days, you may cremate my body." On the sixth day the disciple's mother fell ill and he had to rush home, so he cremated the body. On the seventh day Li's spirit returned, but his body was gone and he was not pleased. He thereupon possessed the corpse of a man who had starved to death, and rose up. Because of this, his form is that of a crippled man—but he was not like this originally.[3]

Li Tieguai became one of the most popular of all Taoist adepts, and was one of the Eight Immortals (see cat. nos. 117–18). He is still worshiped in China today (his image appears on the altar of the Eight Immortals Temple in Xi'an).

—S. L.

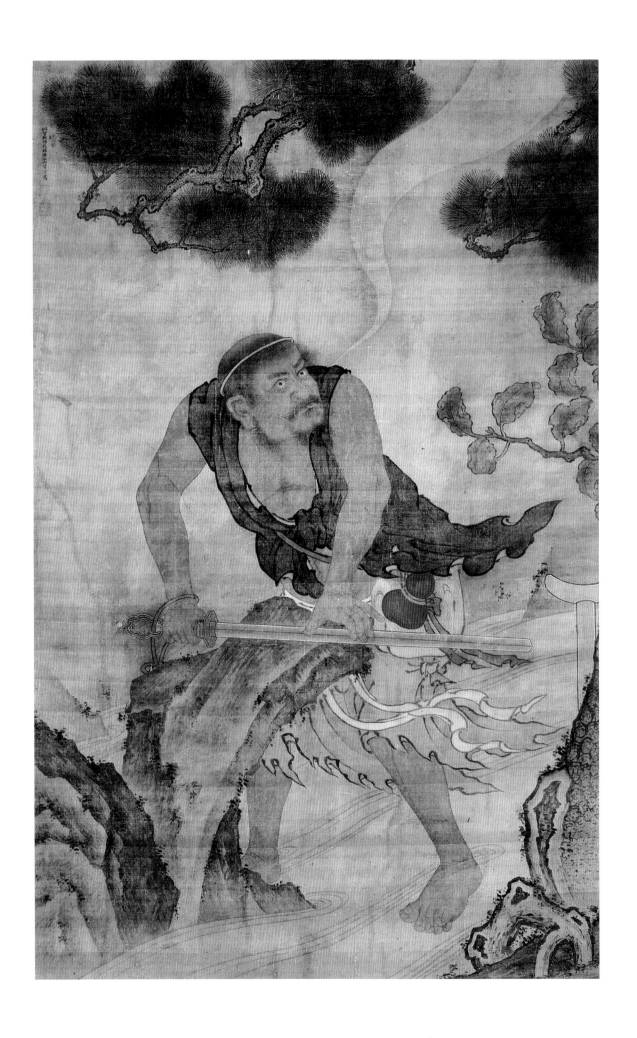

126

HUANG JI (ACTIVE 15TH CENTURY)
Sharpening a Sword

Ming dynasty, 15th century
Hanging scroll; ink, colors, and gold on silk
170.7 × 111 cm
Palace Museum, Beijing

THIS PAINTING DEPICTS the Taoist immortal Li Tieguai sharpening a sword against a stone.[1] Li is identified by his crutch, which leans against a nearby rock. A stream rushes by in the background, and branches of a pine tree loom overhead. The immortal wears a tattered, pale blue-green robe around his waist; his skin is painted with brown pigment. A bright red double gourd hangs from his waist, tied with a blue sash. Around his head is a white headband; his lips are painted with pale red pigment. The astral emanation rising from his torso suggests his ability to transport himself anywhere in time and space (see cat. no. 125).

The significance of this scene is not entirely clear. Howard Rogers has pointed out that the sword is usually associated with Lü Dongbin (see cat. nos. 120, 121) rather than Li Tieguai.[2] Since Huang Ji created this image of Li Tieguai for the imperial Ming court, Rogers's theory that the immortal is shown here as a spirit-guardian of the state may be correct. In religious Taoism, swords were both a standard part of the ritual paraphernalia of Taoist priests (see cat. nos. 58–61), who used them for purification and exorcism, and the powerful attributes of such martial gods as Zhenwu (see cat. no. 114) and Marshal Wen (see cat. no. 87).

The painting is signed in the upper left corner: "Painted by Sanshan Huang Ji, Judge *[zhenhu]* in the Embroidered Uniform Guard, on duty in the Palace of Humane Knowledge" *(Zhi Renzhi Dian Jinyi zhenhu Sanshan Huang Ji xie)*. This is followed by two seals, reading *Kemei* (the artist's *hao,* or nickname) and "Daily approaching the pure and radiant" *(Rijin qingguang)*. The latter seal was used by several court painters in the fifteenth century, and indicates that the artist worked in the immediate presence of the emperor. Very little is known about Huang Ji, and this is his only known surviving work. He was a native of Houguan (now Fuzhou) in Fujian province, and worked at the imperial court in the late fifteenth century.[3] There is a short colophon on the mounting by the Qing dynasty prince Yongxing (1752–1823).[4]

—S. L.

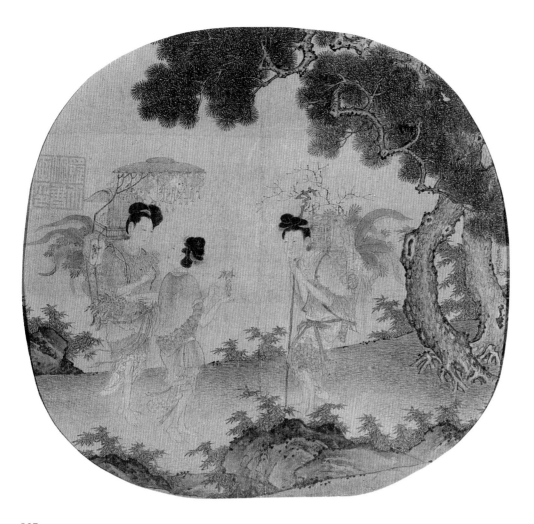

127

SUN JUE
Female Immortals

Ming dynasty, dated 1410(?)
Fan painting; ink and colors on silk
25 × 23.3 cm
Philadelphia Museum of Art: Purchased, Museum funds (29-40-48)

THIS FAN PAINTING depicts three female Taoist adepts, dressed in skirts made of leaves and jackets made of grass. All three figures are shown as young women, their hair neatly arranged and held in place with combs; each is also barefoot. The right figure holds a staff, and has a backpack containing bananas, twigs, and cloth-wrapped bundles. The middle figure holds a strange root figurine with sprigs of leaves in its hands. The left figure has the most elaborate backpack, containing a bamboo-painted fan, a woven parasol with mushrooms, a skull, a double gourd, herbs, and tassels. The adepts walk along a mountain path, next to rocks and a pine tree. These figures re-semble early depictions of the female Taoist adept Magu (Hemp Lady). A Yuan dynasty (1260–1368) painting of Magu in the

Museum of Fine Arts, Boston, depicts this female adept in much the same guise as the figures in the Philadelphia Museum fan—in a mountainous landscape, barefoot, her hair arranged in a topknot, and dressed in a jacket of leaves.[1] A similar group of figures also appears in the Song dynasty handscroll in the Freer Gallery entitled *An Assembly of Immortals,* traditionally attributed to Li Gonglin (1049–1106).[2]

Magu's biography appears in the Jin dynasty text entitled *Biographies of the Divine Immortals (Shenxian zhuan)* by Ge Hong (283–343). Believed to have lived during the reign of Emperor Huan (r. 147–67) of the Han dynasty, Magu was the sister of an adept named Wang Fangping.[3] Her appearance was that of a young woman of eighteen, yet since becoming an adept she was said to have thrice seen the Eastern Ocean turn to mulberry fields, an indication of her transcendence of time.

The fan painting bears a short inscription, partially illegible, along the right border. This includes a cyclical date that may be *gengyin;* given the painting's style, this may correspond to the year 1410. This is followed by an unknown artist's signature, which appears to read *Sun Jue.*

—S. L.

Notes

Introduction

1. For example, the Eight Immortals Temple (Baxian An), the largest Taoist temple in Xi'an, Shaanxi province.
2. Schipper 1993: 164.
3. For discussions of the Taoist concept of immortality, see Robinet 1985–86: 87–105; Kohn 1990b: 622–40; Kristofer Schipper, "The Immortals," in Schipper 1993: 160–82; and Penny (forthcoming).
4. On Wang Ziqiao, see Holzman 1998c, Steuber 1996, and Ebrey 1981: 38–39. Another important source of early stories of immortals is the *Biographies of the Assorted Immortals (Liexian zhuan)*, attributed to the Han dynasty author Liu Xiang; translated in Kaltenmark 1987.

Cat. no. 115

1. These are the dates suggested in Schipper 1985: 822–23. Xu Xun's dates vary in different sources; later biographies claim that he died in 374, at 136 years of age.
2. This work can be found in the *Xiuzhen shishu*, HY 263, *juan* 31–36.
3. The popular practices described here can be found in ibid., *juan* 34.
4. *Xiaodao Wu Xu er zhenjun zhuan*, HY 449. Schipper 1985: 819 dated this text to the ninth century. It is likely to date from the Tang since it uses a name for the temple on Western Mountain that fell out of use when the temple was renamed by Emperor Zhenzong of the Song (see below).
5. The legend surrounding this name is discussed in Schipper 1985. The term "observatory" for Taoist temples supposedly derives from the Tower Observatory *(louguan)*, which Yin Xi ascended to see the ether rising from Laozi as he approached the pass to leave the lands ruled by the Zhou. The continued use of this term suggests the importance of observing stellar phenomena in Taoist practices.
6. Boltz 1987a: 75 points out that this text refers to Xu by a title bestowed upon him in 1295.
7. In the Tang version of the story contained in *Xiaodao Wu Xu er zhenjun zhuan*, HY 449, this pillar forms spontaneously from the blood of a dragon that has just been killed.

Cat. no. 116

1. There are other paintings by Cui with the same theme in the Cleveland Museum of Art and the Palace Museum in Beijing. See Little 1988: 30–31.

Cat. nos. 117–18

1. See Jing 1996.
2. *Pingyang Jinmu zhuandiao* 1999: 308–19.
3. Jin 1997: pl. 236.
4. Compare the very different methodologies used in reconstructing the life of Lü Dongbin in Jing 1996 and Baldrian-Hussein 1986.
5. Previously published in Bartholomew 1995: fig. 22. For similar images, see Fong 1983: 185.

Cat. no. 119

1. XHSP, *juan* 19: 55. The Song emperor Huizong owned what was believed to be an original cursive script handscroll by Zhongli Quan.
2. A *li* is approximately one-third of a mile.
3. Master Donghua or Donghua dijun (the Eastern Floriate Emperor) was a mythical figure, revered as the first patriarch of the Complete Realization (Quanzhen) sect of Taoism.
4. LXQZ, *juan* 3: 6a–b. Translated in Little 1988: no. 6. This account presents the traditional view of Zhongli Quan as accepted in the Ming dynasty.
5. *Eight Dynasties of Chinese Painting* 1980: no. 132. The attribution to Zhao Qi is supported by a similar depiction of the immortal Liu Haichan in the Nezu Museum, Tokyo, which is signed "Zhao Qi" and which bears the seal: "Daily approaching the pure and radiant [i.e., the emperor]" *(Rijin qingguang)*. The same seal was also used by the Hongzhi court painters Lü Ji and Lü Wenying; see Cahill 1978: 108.

Cat. nos. 120–22

1. Baldrian-Hussein 1986: 133. The information that follows is taken largely from this excellent article.
2. See ibid.: 136, for a discussion of *neidan* works ascribed to Lü Dongbin and his teacher Zhongli Quan. Many poems by Lü on the theme of Inner Alchemy are recorded in the *Quan Tang shi* (Complete poems of the Tang dynasty); see QTS: 2095–2105.
3. Translated in Baldrian-Hussein 1986: 138.
4. Katz 1993: 57. For a discussion of *The Yellow Millet Dream*, see Jackson 1983: 97–109.
5. Translated in Kohn 1993: 126–29 (from the Yuan dynasty compilation *Illustrated Biographies of the Immortals [Zengxian liexian zhuan]*). As Baldrian-Hussein points out, one work of Zhongli Quan's calligraphy was recorded in the Northern Song imperial catalogue, the *Xuanhe shupu* (1120); see XHSP, *juan* 19: 55. For another version of the "Yellow Millet Dream" story, see Katz 1996a: 92.
6. Jin 1997: pl. 230. The Hall of Purified Yang murals were completed in 1358 by the muralist Zhu Haogu and his pupils.
7. Katz 1996a: 72.
8. These scenes are discussed in ibid.: 84–91. See also Katz 1999.
9. Ibid.: 75.
10. Wu 1997: 204–05.
11. Translated in Strassberg 1994: 158–59.
12. Cited in Baldrian-Hussein 1986: 155.
13. Jin 1997: pls. 237–38.
14. Jackson 1983: 109–23.
15. For other translations, see Baldrian-Hussein 1986: 158; see also Wai-kam Ho's translation in Lee and Ho 1968: no. 191.
16. Baldrian-Hussein 1986: 165–69; Katz 1993: 53–59.

Cat. no. 123

1. JTS, *juan* 191.
2. See *Zhongguo meishu quanji* 1993: pl. 37.
3. *Changsheng de shijie* 1996: 71.

Cat. no. 124

1. HY 296: 49.5–7.
2. In antiquity peachwood figures and wands were used for exorcism; see Bodde 1975: 131–32, 136–37.

Cat. no. 125

1. This scroll bears two seals of Yan Hui along the upper right border.
2. For the image at the Eternal Joy Temple of Li Tieguai crossing the ocean with the Eight Immortals, see Jin 1997: 246.
3. LXQZ, *juan* 1: 2b.

Cat. no. 126

1. Previously published in Mu 1982: pl. 23, color pl. 7; and *Circa 1492* 1991: no. 289.
2. *Circa 1492* 1991: 436.
3. Mu 1985: 35, 238–39.
4. For the Chinese text of this colophon, see ibid.: 238–39.

Cat. no. 127

1. Wu 1997: no. 148. This work is by Chen Yuexi.
2. Freer Gallery of Art acc. no. 18.13. Several sections of this scroll (although not the one referred to here) are illustrated in Lawton 1973: no. 34.
3. See the biography of Magu translated in Kohn 1993: 355–58.

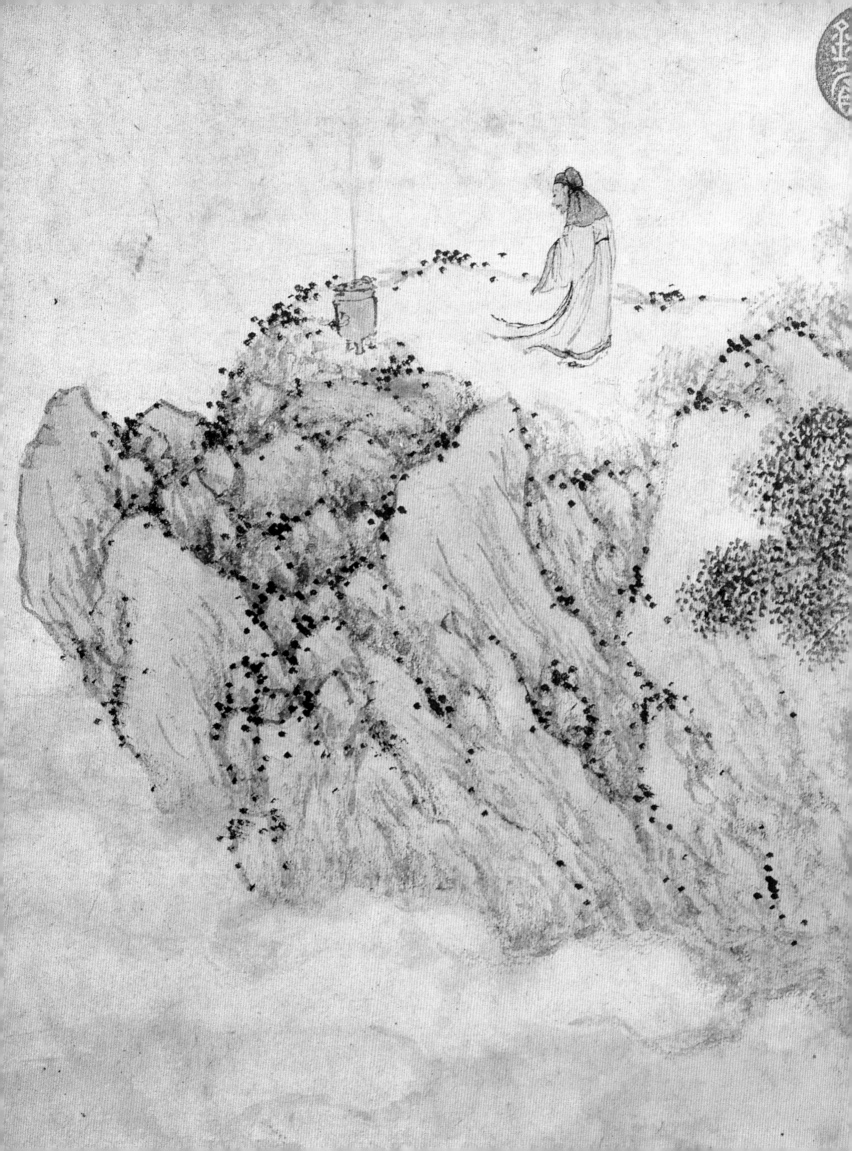

THE MEDITATIVE PRACTICE known as Inner Alchemy *(neidan)* was designed as a means to achieve individual spiritual perfection. Its focus was on visualization and the use of symbols drawn from chemical alchemy *(waidan)* and the *Book of Changes (Yi jing)* to aid the adept in the process of purification, spiritual renewal, and achieving union with the Tao. The techniques of Inner Alchemy were based on two traditions: ancient disciplines of meditation and self-cultivation, and laboratory experiments in the preparation of elixirs that could both physically and spiritually transform the adept. These disciplines required the cultivation of one's moral integrity and spiritual purity; without these, other efforts would fail.

Although elixirs were believed to confer health, longevity, and even immortality, the creation of these elixirs could be expensive and dangerous. Chemical alchemy involved the collection, refinement, and transformation of ingredients such as cinnabar, lead, gold, malachite, sulphur, mica, saltpeter, and orpiment, some of which are extremely toxic. Death often accompanied their ingestion, but with faith in one's spiritual worthiness, it was believed that the adept would immediately rise to heaven. In its fundamental aspect, chemical alchemy concerned the manipulation of time and space. By refining the rare ingredients for elixirs, the adept gained control over *yin* and *yang,* in the end achieving a state of transcendence over phenomenal reality. The astonishing properties of the elixirs mentioned by the alchemist Tao Hongjing (456–536) are suggested by their equally astonishing names: Efflorescence of Langgan, Powder of Liquified Gold, Dragon Foetus, Jade Essence, Gold Elixir, and the Nine-times Cycled.[1]

Inner Alchemy, in contrast, refers to a technique combining meditation and breath control to visualize the creation of the elixir in the inner landscape of the adept's own body. In this mode, the internal energies *(qi)* of the human body were used to create the elixir. When successfully achieved, this visualized elixir transformed the practitioner, who was reborn as a divine, embryonic immortal. As alchemy began to be reinterpreted as an internal process, theorists found an important conceptual model to bridge the outer and inner alchemical traditions in the trigram symbolism developed by Wei Boyang (see cat. no. 130). According to Inner Alchemy, *qian* (three unbroken *yang* lines) and *kun* (three broken *yin* lines) represent the first move away from the undifferentiated oneness at the beginning of the world. After *qian* and *kun* became distinct, they intermingled to form the Eight Trigrams and the Sixty-four Hexagrams of the *Book of Changes (Yi jing)*. Within the body, the *yang* energy of *qian* is manifested by the trigram *li* (a *yin* line enclosed by two *yang* lines), which is represented by the alchemical element mercury and the dragon, while the *yin* energy of *kun* is manifested by the trigram *kan* (a single *yang* line enclosed by two *yin* lines), represented by the alchemical element lead and the tiger.[2] *Kan* and *li* are secondary manifestations of *yin* and *yang,* containing both of these energies within them.

The goal of the inner alchemical process is to join these energies in a symbolic crucible and purify them in the fires of a symbolic furnace in the body. As a result, the inner *yang* line of *kan* is joined with the outer *yang* lines of *li* to reconstitute the trigram *qian,* thereby purifying the energies of the body into a pure *yang* "elixir."[3] This theoretical framework underlies the artworks shown in the following entries, many of which show the specific phases in which the *yin* and *yang* energies of the body are reintegrated into an undifferentiated oneness. Central to these works is the idea that the goal of a Taoist transcendent was not immortality per se, but spiritual perfection and union with the Tao.

Wang Xizhi (307–365)
Scripture of the Yellow Court

Eastern Jin dynasty, dated 356
Ink rubbing of a stone engraving of the Song dynasty (960–1279)
Album; ink on paper
25.2 × 11.2 cm (each page)
Palace Museum, Beijing

The *Scripture of the Yellow Court* (*Huangting jing*) is one of the most difficult of all Taoist scriptures to understand. It describes the different regions inside the body, the deities that inhabit these regions, and the energies (*qi*) and essences (*jing*) that vitalize the body as they circulate through it. These components are all incorporated into an act of meditation, an inner visualization, the primary goal of which is to nourish an embryonic form that enables the meditator to refine the body and gain endless life.[1] The language of this scripture, however, is terse and imagistic, and does not provide keys to understanding the significance of many of the terms that appear within it. This ambiguity has led many scholars to propose that the text may have been more of a memory aid recited during meditation than a meditation manual as such.[2] In addition, there was probably a commentarial tradition, either oral or written, that accompanied this scripture when it was first written—an early tradition now lost.[3]

The version of the *Scripture of the Yellow Court* attributed to Wang Xizhi differs from other editions of the scripture in many important ways. For example, all other editions begin with the statement "Laozi made these heptasyllabic [seven-character] lines while dwelling in reclusion, in order to explain the form of the body and all its spirits," thereby attributing the scripture to Laozi. But this opening is absent from Wang Xizhi's text, and its absence suggests that the identification of Laozi as the author of this scripture may not have been standardized until after the middle of the fourth century. Even if this were the case, however, the scripture was still intimately connected with Laozi and the *Daode jing* by Wang Xizhi's time. Wang's text also contains stylistic variations not found in other editions. In particular, he opens the scripture with four lines of four characters each before changing to heptasyllabic verse, while all other editions are heptasyllabic throughout. This four-character structure shows similarities with passages resembling the *Scripture of the Yellow Court* in the *Master Who Embraces Simplicity* (*Baopuzi*) written by Ge Hong (283–343).[4]

There are in fact two scriptures that bear the name *Scripture of the Yellow Court*, an "inner" (*nei*) scripture[5] and an "outer" (*wai*) one.[6] Wang Xizhi's text corresponds to the outer scripture. The provenance of the inner scripture is fairly clear, since it contains ideas that developed in the Highest Purity scriptures (see cat. no. 55). It was supposedly revealed to the matriarch of the Highest Purity movement, Wei Huacun, in 288, but it may not actually have been composed until revelations were given to Yang Xi (330–386) in 364 by the deified Wei Huacun and a number of other realized beings (*zhenren*).[7] The provenance of the outer scripture, on the other hand, is a matter of some controversy. It is much shorter than the inner scripture, which includes most of the outer scripture, although in altered form. This redundancy has led some scholars to propose that the inner scripture was developed from the earlier, outer scripture,[8] while others have suggested that the outer scripture could just as well be a summarized, "exoteric"[9] version of the older, "esoteric" inner scripture. In any case, the version attributed to Wang Xizhi, which is dated to 356, is the earliest extant text of either version.[10] Consequently, this edition is the oldest primary source for the *Scripture of the Yellow Court*.

Like many aristocrats of the Eastern Jin dynasty, Wang Xizhi, who is commonly regarded as the greatest early Chinese calligrapher, belonged to a family that adhered to the Celestial Master sect of religious Taoism (Tianshi dao).[11] It is widely recognized, for example, that the presence of the character *zhi* in Wang Xizhi's name was an indication of his affiliation with this sect (the same is true of the fourth-century painter Gu Kaizhi).[12] According to the *Jinshu* (*Dynastic history of the Jin*), Wang Xizhi followed Taoist self-cultivation practices, such as the gathering of herbs and minerals for enhancing health and longevity.[13] These activities were carried out in conjunction with his close friend, the adept Xu Mai, whose brother Xu Mi was the principal patron of the early Highest Purity revelations from which the inner version of the *Scripture of the Yellow Court* developed. As Lothar Ledderose has shown, Wang Xizhi was "more than merely superficially involved in Taoist beliefs."[14] In the last years of his life (after 361), Wang is described as "following the arts of the Yellow Emperor (Huangdi) and Laozi."[15]

—S. E./S. L.

者黃庭下有關元前有幽關後有命門噓吸廬外出
入丹田審能行之可長存黃庭中人衣朱衣關門壯籥
蓋兩扉幽關俠之高巍巍丹田之中精氣微玉池清水上
生肥靈根堅志不衰中池有士常衣絳子能見之可不病橫
理長尺約其上子能守之可無恙呼翕廬間以自償保守
完堅身受慶方寸之中謹蓋藏精神還歸老復壯俠
以幽關流下竟養子玉樹令扶疏可用存道不煩不旁迕

靈臺通天臨中野方寸之中至關下玉房之中神門戶
既是公子教我者明堂四達法海員真人子丹當我前
三關之間精氣深子欲不死修崑崙絳宮重樓十二級
宮室之中五采集赤神之子中池立下有長城玄谷邑
生要眇房中急棄捐俗專子精寸田尺宅可治生繫
子長流心安寧觀志流神三奇靈閑暇無事脩太平

129

Classification of Supreme Numinous Treasure Mushrooms, from the Taoist Canon of the Zhengtong Reign

Ming dynasty, Zhengtong reign, dated 1445
Woodblock-printed book; ink on paper
35 × 11.3 cm (each page)
Bibliothèque Nationale de France, Paris (Chinois 9546/1387)

MUSHROOMS PLAYED a vital role in early Taoism. Even before the emergence of religious Taoism, mushrooms were sought for their magical powers. Qin Shihuangdi (r. 221–210 B.C.) and Han Wudi (r. 140–87 B.C.) both sent magicians *(fangshi)* in search of such fungi. Many adepts were said to live on mushrooms; for example, Pengzu, who lived to be over seven hundred years old, ate only mushrooms. According to the *Soushenji (In Search of the Supernatural)* of the early third century,

> Pengzu was a Yin (Shang) dynasty minister whose surname was Qian and who given name was Jian. He was the grandson of Emperor Zhuanxu and the middle child of Luzhong [Ends of the Earth] family. He lived during the Xia and survived until the end of the Shang dynasty—he is said to have been 700 years old. His regular food was the cinnamon fungus (the *lingzhi*).[1]

As Michel Strickmann has shown, the cult of magic mushrooms in China is ancient.[2] Sima Qian's *Records of the Historian (Shiji;* first century B.C.) states that mushrooms were believed to be among the sacred plants that grew on Penglai, one of the isles of the immortals in the Eastern Ocean.[3] Since at least the Han dynasty, the appearance of strange and auspicious mushrooms has portended virtuous emperors:

> During the reign of the emperor Wu, in the year 109 B.C., according to the *History of the Former Han Dynasty,* a mushroom with nine stalks from a single root grew in a room of the summer palace. A general amnesty was proclaimed throughout the empire, and the Song of the Mushroom Chamber was composed. The text of this song has been preserved.[4]

The use of mushrooms that enable the adept to see the numinous world is common in many cultures.[5] In the Six Dynasties period (420–589), as well, mushrooms (specifically "mushrooms that nourish the divine" or *yangshen zhi*) are mentioned as among the numinous plants growing on the isles of the immortals.[6]

One of the earliest discussions of the importance of mushrooms in a Taoist context is in Ge Hong's *Baopuzi (The Master Who Embraces Simplicity)*. In this text, Ge describes several types of mushrooms, including rock, wood, herb, and flesh mushrooms:

> The rock ones are semblances of mushrooms in stone. They grow on famous mountains by the sea. Along island streams there are formations of piled rocks resembling flesh. Those seeming to have head, tail, and four feet are the best. They look like something alive. They are attached to boulders, and prefer high, steep spots, which sometimes render them inaccessible. The red ones resemble coral; the white ones, a slice of fat; the black, wet varnish; the blue, kingfisher feathers; and the yellow, purplish gold. All of them glow in the darkness like ice, being easily visible at night from a distance of three hundred paces.[7]

It is noteworthy that many varieties of mushrooms are in fact luminescent at night, just as described by Ge Hong.

The *Classification of Supreme Numinous Treasure Mushrooms* is believed to have been written during the Song dynasty (960–1279), and is included in the Taoist Canon printed in the mid-fifteenth century. The edition in the Bibliothèque Nationale has a printed frontispiece depicting the Three Purities (Sanqing). A cartouche at the end of the text contains the date: "Zhengtong 10th year [1445], 11th month, 11th day." The text illustrates 126 varieties of mushrooms, some commonplace and others fantastic in form. All are said to confer longevity, to varying degrees. For example:

> The Yellow Jade Mushroom grows on Mount Penglai. Its color is yellow, and its taste bitter. Dongwanggong ate it and became immortal, and lived for 90,000 years. The yellow tiger and yellow fish guard it. It consists of three levels; the lower level has three branches.

Many of the mushrooms in this text are described as being surrounded by multicolored clouds; others have astounding shapes. The text is part of a long tradition of mushroom handbooks, of the type referred to by Ge Hong.[8]

—S. L.

白雲芝

白雲芝有五色圓如鼓上有六子赤色莖亦
赤色味酸食之萬年仙矣

黃玉芝

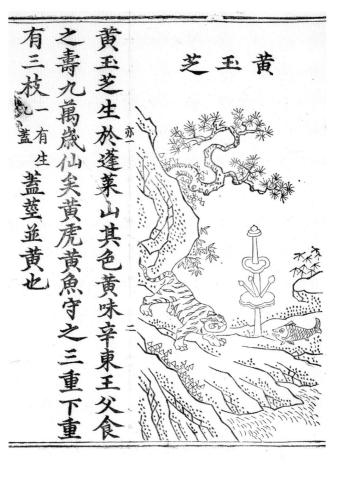

黃玉芝生於蓬萊山其色黃味辛東王父食
之壽九萬歲仙矣黃虎黃魚守之三重下重
有三枝一有生
蓋莖並黃也

金精芝

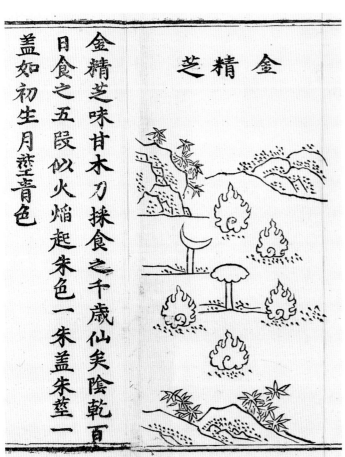

金精芝味甘木刀採食之千歲仙矣陰乾百
日食之五段似火焰起朱色一朱蓋朱莖一
蓋如初生月莖青色

赤精芝

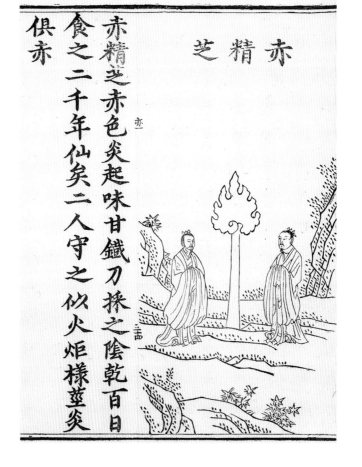

赤精芝赤色炎起味甘鐵刀採之陰乾百日
食之二千年仙矣二人守之似火炬樣莖炎
俱赤

Wᴀɴɢ Sʜɪᴢʜᴇɴ (1526–1590)
The Alchemist Wei Boyang, from the Complete Biographies
of the Assorted Immortals

Ming dynasty, 1600/30
Woodblock-illustrated book; ink on paper
20.7 × 12.6 cm (each page)
Harvard-Yenching Library, Harvard University,
 Cambridge, Massachusetts

Wᴇɪ Bᴏʏᴀɴɢ is a semimythical figure from the Kuaiji area of modern Zhejiang believed to have been active in the middle of the second century. The biography contained in the *Complete Biographies of the Assorted Immortals* is based on the *Biographies of the Divine Immortals (Shenxian zhuan)* by the great Jin dynasty alchemist and scholar Ge Hong (283–343).[1]

According to legend, Wei entered into the mountains with three of his disciples, where he successfully concocted an alchemical elixir. Already doubting the worthiness of two of his disciples, however, Wei devised a trial to test their devotion. He brought along with him a white dog, and when the elixir was completed, he suggested to his disciples that they first test it on the dog. Yet, unbeknownst to his disciples, Wei had set aside some unfinished elixir, knowing that this incomplete elixir was poisonous and would cause whoever consumed it to die. Wei then fed this unfinished, poisonous elixir to the dog, who promptly fell over dead. Nonetheless, apparently unaffected by what had happened, Wei expressed to his disciples his resolve to consume the failed concoction:

> I have turned my back on the paths of the world, and left behind
> my family. If I do not become an adept from this [elixir], I would
> still be ashamed to return home. Life and death are one; I will
> consume it.

Naturally, Wei too died when he took the poisonous elixir. At this point, one of his disciples stated that his master must have had his reasons for taking the elixir, and, putting his faith in his teacher, he also consumed the poisonous elixir and died. The other two disciples refused, however, thinking that it was better to live a few more decades than to risk death for a dubious chance at immortality. After these two faithless students descended from the mountains to make funerary arrangements for their apparently foolhardy companions, Wei, who had actually taken the completed elixir to counteract the effects of the poison, revived, and he proceeded to administer the real elixir to the faithful disciple and to the dog, who were both restored to life.[2]

The present woodblock print illustrates this story, showing Wei and his faithful disciple together with the dog that accompanied them to the magical realms of adepts and realized beings.

As we can see from the above story, Wei practiced chemical alchemy *(waidan)*. However, he was best known in the later imperial period for his influence on the tradition of Inner Alchemy *(neidan)*, which reinterpreted the alchemical process and its terminology as representing an internal physiological and spiritual meditation.[3] Much of Wei's later fame derives from the alchemical treatise attributed to him, the *Contract of the Three Unities of the Zhou Dynasty [Classic of] Changes (Zhouyi cantong qi)*, a work that seems to have begun as a treatise on chemical alchemy in the late Han dynasty.[4] The principal innovation of this text is the use of trigrams from the *Book of Changes (Zhouyi or Yi jing)* to explain the alchemical process, as seen in the opening passage:

> *Qian* and *kun* are the gateway to change *(yi)*, the father and mother
> of the various hexagrams. *Kan* and *li* are the walls, the straight axle
> in the moving hub.

The prominence of imagery from the *Book of Changes* in this work led one of its later commentators, the Five Dynasties writer Peng Xiao, to state: "Master Wei is saying that the cultivation of golden elixir and reverted cinnabar is analogous to [literally, "follows the same road"] the building and transformation [of the world]. Consequently, he relies on the symbols of the *Book of Changes* to discuss it." The symbolic language of the *Zhouyi cantong qi* eventually became one of the primary foundations for later Inner Alchemy, and consequently it is seen as one of China's great spiritual classics.

—S. E.

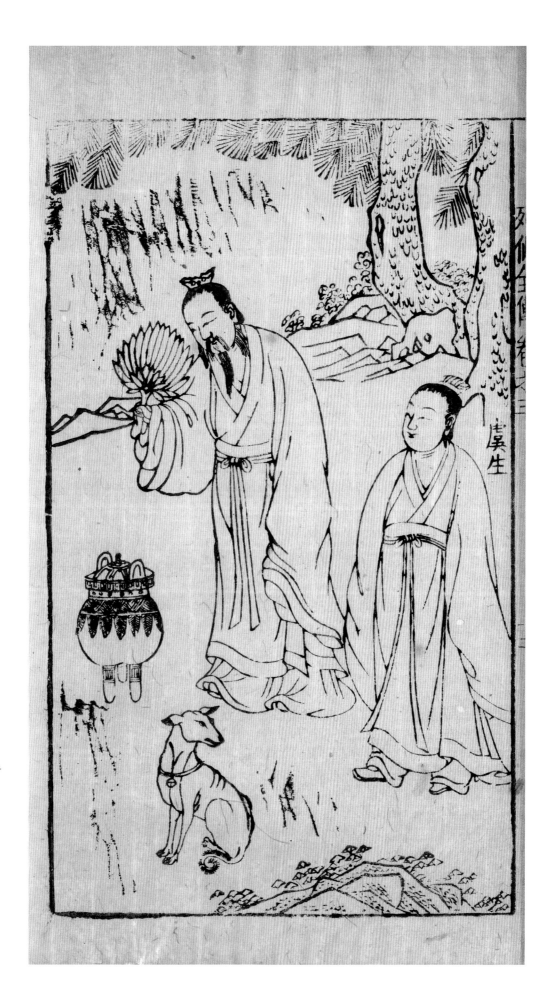

虞生

131

Illustrations of the Sealed Verification of the Golden Elixir of the Reverted Cinnabar

Qing dynasty, 17th/18th centuries
Handscroll; ink and colors on silk
20 × 1,200 cm
White Cloud Monastery (Baiyun Guan), Beijing

THIS HANDSCROLL *(Jinye huandan yinzheng tu)* contains twenty illustrations that depict the "work" of Inner Alchemy from beginning to end. The illustrations are accompanied by poems that sometimes help to explain them, but that are often just as suggestive and cryptic as the images themselves.[1] The author's preface tells us that the images were originally divided into two main groups, "Images of Outer Methods" *(waifa xiang)*, comprising illustrations 1 and 3–10, and "Images of Inner Methods" *(neifa xiang)*, sections 11–19. These groups were supplemented by two separate images (2 and 20), which represent, respectively, the first awareness of differentiated existence, and the final return to undifferentiated oneness. Taken as a whole, the illustrations show the entire alchemical process from the movement out of undifferentiated oneness into the multiplicity of the world, and the return from this multiplicity to oneness through the reintegration of complementary opposites. This process is analogous to the western alchemical principles of coagulation and dissolution.[2] The illustrations in the text (not all shown) are as follows:

1. The Original Root
An empty circle represents the state of undifferentiated oneness (equivalent to the Tao).

2. Startled Awakening
The six paths of reincarnation: in the hells, as a hungry ghost, as an animal, as an *asura* (a kind of lesser spirit), as a human, or as a *deva* (deity). This indicates the development of differentiated existence from the "original root."

3. [The Trigrams] *Qian* and *Kun*
Thirty-six palaces flanked by the sun and moon are on a magical mountain that rises from a square island in the ocean. The square shape of the island indicates that it represents earth (as opposed to the heavens), while the palaces probably represent the thirty-six heavens of Taoist and Buddhist cosmology. This indicates the arising of the entire cosmos from the initial differentiation of *yin* (trigram *kun*) and *yang* (trigram *qian*).

4. Alchemical Vessels
A man, who represents the alchemical furnace and the trigram *qian* (three unbroken *yang* lines), and a woman, who represents the tripod or crucible and the trigram *kun* (three broken *yin* lines), are shown. This indicates the goal of Inner Alchemy to harmonize *yin* and *yang*.

5. Lead and Mercury
A male child in a circle, who represents the alchemical element mercury and the trigram *kan* (one unbroken line between two broken lines), and a female child in a circle, who represents the alchemical element lead and the trigram *li* (one broken line between two unbroken lines), are shown.[3] This suggests the gradual intermingling of *yin* and *yang*.

6. Harmonization
This is a diagram of the twelve earthly branches *(dizhi)* that represent the twelve spatial directions and times of day, connected by lines. This indicates the full development of differentiated space and time, but also the interconnectedness of these differentiations.

7. Realized Land
A palace is shown rising from a lotus encircled by a wall with a single gate; the accompanying poem discusses the difference between "true" or alchemical lead and "ordinary" lead. This and the following illustrations show the beginning of the process of reunification.

8. Selection
An alchemical crucible covered by a sword on a three-tiered altar is depicted. In front of the altar is a toad with three legs, with a ray of light coming from its mouth that envelopes a crane; these are further symbols of *yin* and *yang*.[4] This illustration reintroduces the crucible of illustration 4 as the central theme of the alchemical process.

9. Systematization
This illustration depicts a temple compound with stairs leading to a gateway on the left, a temple building, and a three-tiered altar in the courtyard. The three tiers of the altar represent the heavens, earth, and humanity. Exorcistic swords are placed at the four corners of the altar, and are decorated with hanging mirrors that also serve an exorcistic function. This illustration begins the actual ritual process of refining an alchemical elixir.

10. Support
A central figure that may represent the Northern Dipper (Ursa Major) sits on a three-tiered altar, with a dragon and a tiger descending on the right and left sides. The figure is flanked by two

beings who the poem suggests represent civil and military officials. The meditator assumes the central role of the Northern Dipper, and draws the essences of *yin* (tiger) and *yang* (dragon) into himself.

11. Consuming Cinnabar

A dragon and a tiger[5] sport with a magical pearl over the ocean. The images of reunification are gradually refined.

12. Nine Tripods

These are the nine tripods cast by the Yellow Emperor as signs of his mandate to rule over the nine traditional regions of China, punctuated by five orbs resting on clouds, which may represent the Five Planets or the Five Phases. Symbolically, the meditator assumes the role of the Yellow Emperor uniting the entire (interior) world, and his crucible is transformed into the nine tripods of this mythical figure.

13. Bringing Forth the Fire

The meditator is shown in two conjoined circles, with his back to the viewer. He is surrounded by the eight trigrams. Beneath him is a flaming crucible. The entire image is encircled by depictions of different phases of the moon and several inscriptions. This is the inner mystery of the alchemical process, where the meditator absorbs the Eight Trigrams and refines them (and himself) over time in his inner crucible.

14. Taking Away the Fire

The same two conjoined circles of section 13 are again depicted, but they are now empty. They are surrounded by the "embodiment" *(ti)* trigrams *qian* and *kun* above and below, and the "use" trigrams *kan* and *li* to the right and left. The entire image is encircled by phases of the moon and more inscriptions. The meditator has been reduced to his principal elements, *yin* and *yang,* shown as two conjoined circles and as the "embodiments" (primary manifestations) and "uses" (secondary manifestations) of these two principles in the four most essential trigrams.

15. Adding and Taking Away

A ray of light comes forth from a crucible surrounded by a dragon and tiger and placed on a three-tiered altar. Within the ray of light the three *hun* or *yang* souls of the body rise to the left, while the seven *po* or *yin* souls of the body rise to the right. The accompanying poem says:

> The *yin po*-souls harmonize with lead, daily
> decreasing,
> The *yang hun*-souls combine with mercury,
> growing ever-more vigorous . . .

Adding mercury and taking away lead, entirely by
 means of fire.

The meditator's being is purified of its *yin* elements and becomes pure *yang* energy.

16. Bathing or Purification

An infant hovers on clouds that rise from a crucible on a three-tiered altar. The meditator, now shown as an infant symbolizing pure *yang* energy, undergoes a final purification. Interestingly, this purification is through water *(yin),* in contrast to the previous purification by fire *(yang).*

17. Golden Elixir

A dragon hovers in a fiery atmosphere over a pearl, beneath which is a flaming crucible on a three-tiered altar. The meditator's body has been completely purified into a magical elixir, shown as the dragon and pearl, more symbols of *yang* energy.

18. Embracing the Primordial

A man meditates under a pine tree. Now that the body is purified, conciousness is transformed into pure light through meditation on primordial oneness.

19. Audience with the Primordial

The man rides on clouds that rise from a fire. With body and conciousness both pure, the meditator ascends to meet with primordial oneness.

20. Returning to the Primordial

The empty circle suggests that the meditator has reunited with undifferentiated oneness, completing the cycle.

The handscroll is a Qing dynasty (seventeenth/eighteenth century) copy of a series of illustrations attributed to a Southern Song dynasty (1127–1279) writer using the pseudonym "Master Dragon Eyebrows" (Longmeizi); this author's preface is dated to 1218. The same text can be found in the Ming dynasty Taoist Canon.[6] Little is known of the author, but he claims to have studied under the disciples of a certain realized being named Liu, who in turn appears to have been a student of the famous Zhang Boduan (984–1082). Zhang's *Writing on Awakening to Realization (Wuzhen pian)* is considered to be one of the standard works on the principles of Inner Alchemy.[7] A prefatory note by a later editor named Wang Qidao dated to 1234 further identifies this text with the great Southern Song Taoist scholar Bai Yuchan (1194–1229). There is also an epilogue by a certain Lin Jing dated to 1249, which affirms the lineage of the text as belonging to the school of alchemy known as "Violet Light" *(ziyang)* after Zhang Boduan's pseudonym.

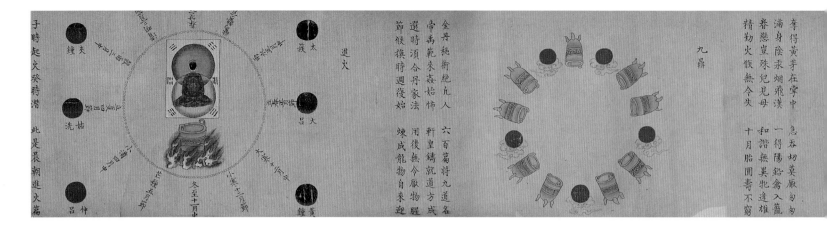

13 12

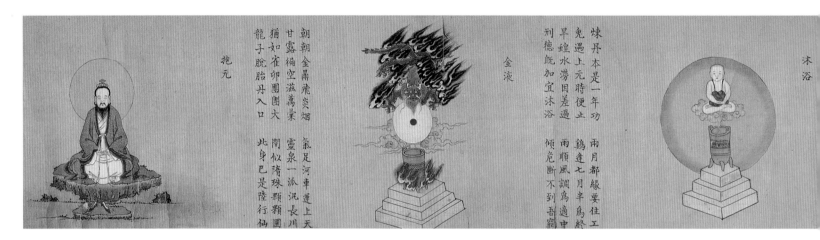

18 17 16

The history of this handscroll and its contents is inextricably linked with the Complete Realization (Quanzhen) sect, even though its alchemical teachings developed independently of this movement. As the Complete Realization sect rose to power in the Yuan dynasty (1260–1368), the lineage from Zhang Boduan to Bai Yuchan was traced back to the Liao dynasty (916–1125) master Liu Haichan (see cat. no. 124), the fourth patriarch of the Complete Realization movement. Although the present text probably predates the formal establishment of this lineage, the image of a three-legged toad in section 8 may already suggest a connection with Liu, since such a toad was often depicted as part of his iconography. The secrets of Inner Alchemy were revealed to Liu by Lü Dongbin (see cat. nos. 120–22), the third patriarch of the Complete Realization sect. By the middle of the Yuan dynasty this lineage came to be known as the "southern" lineage of the Complete Realization sect, in opposition to the "northern" lineage founded by Wang Chongyang (1112–1170), historical founder of the Complete Realization movement.[8]

Since the Yuan dynasty, the headquarters of the northern lineage has been the White Cloud Monastery, where this handscroll is now kept.

—S. E.

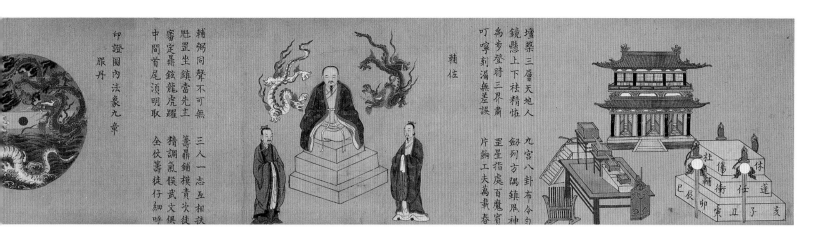

輔佐

壇築三層天地人　九宮八卦布令勻
鏡懸上下祛精惔　劍列方隅鎮尾神
禹步登時三界肅　罡星指處百魔賔
叮嚀刻漏無差誤　片餉工夫萬載春

輔弼同聲不可無　三人一志互相扶
籌鼏鋪模貴次徒　虩虩坐鎮當先主
審定鼎鉉龍虎躍　精調氣候武文俱
中間首尾須明取　全仗善徒仔細呼

印證圓內法象九章
服丹

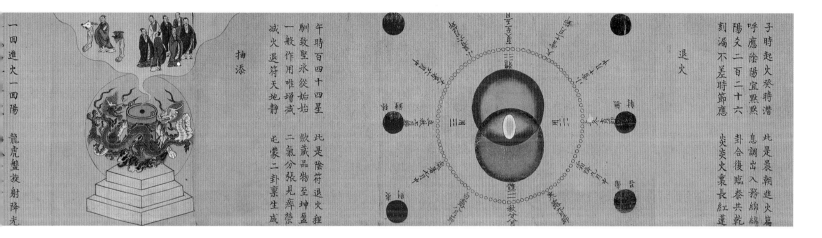

退火

子時起火癸時潛　此是晨朝進火篇
呼應陰陽宜默默　息調出入務綿綿
陽文二百二十六　卦合臨泰共乾
刻漏不差時節應　炎炎火裏長紅蓮

抽添

午時百四十四星　此是陰符退火程
馴致聖永從始始　欲藏品物至坤盈
一般作用唯增減　二氣分張見奔禁
減火退符天地靜　屯蒙二卦稟生成

一四進火一四陽
龍虎盤旋射降光

朝元

功足丹成子脫胎
且迷換面逐輪迴
色身雖已聖難壞
慧照當從定裏開
念念覺圓無一物
頭頭顯露絕纖埃
九年面壁成何事
隻履根盧任去來

還元

形神俱妙道為徒　性命雙圓合太虛
寶詔降時騰鶴駁　玉書拜後駕龍車
仙宦烜赫誰論貴　濁世煎熬且免居
積德勤求終有過　問君何事獨躊躇

南非南兮東非東　一靈妙有素圓通
賢愚本自無分別　九聖何嘗有異同
認赤作朱成性習　呼娘為母熟機鋒
有為一切皆非實　悟取真源空不空

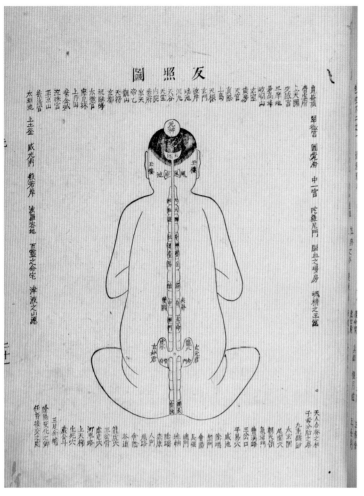

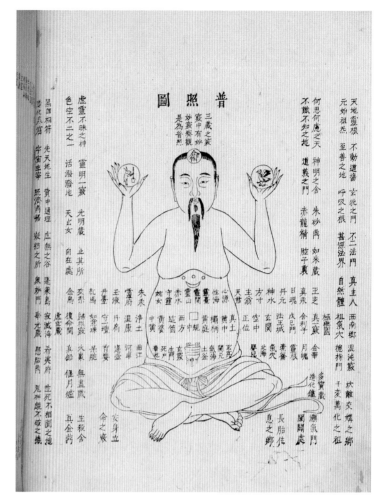

1b

1a

132

Directions for Endowment and Vitality

Ming dynasty, Wanli reign, dated 1615
Woodblock-illustrated book; ink on paper
30.8 × 26.3 cm (each page)
The British Library, London (15113.e.6)

THE *DIRECTIONS FOR ENDOWMENT AND VITALITY* (*Xing-ming guizhi*) is a Ming dynasty treatise on Inner Alchemy, richly illustrated with over fifty diagrams and images.[1] The breadth of its text and illustrations led Joseph Needham to call it "the *Summa* of physiological alchemy [*neidan*]."[2] As its title suggests, the work is principally concerned with the "endowment" (*xing*, often translated as "nature") and "vitality" (*ming*, often translated as "life" or "life-span") of human life. Essentially, *xing* and *ming* together compose the most fundamental energy that animates the human body, and the purpose of this treatise is to return the secondary energies of the body to the primordial purity of this primary energy.

The first and second illustrations shown here (1a and 1b), called the *Illustration of Broad Illumination* and the *Illustration of Reverse Illumination,* show the inner landscape of the body from the front and back. The first depicts a meditator sitting cross-legged. In his left hand he holds a crow enclosed in a circle, an ancient symbol of the sun, and in his right hand a hare enclosed in a circle, the corresponding symbol of the moon. On his forehead a composite character formed from the three-character phrase "to join endowment and vitality" (*he xingming*) is enclosed in another circle. These three circles represent the *yang* and *yin* energies of the body to the left and the right, and their union in the center. The symbolic crucible of Inner Alchemy is shown in the meditator's abdomen, the place of the lowest of the three "cinnabar fields" (*dantian*), which Needham defined in this context as centers of "vital internal warmth."[3] The second illustration shows the spinal cord, which is flanked by the kidneys in the lower body; the kidneys are defined as "dragon fire" on the right, a symbol of *yang* energy within the *yin* side of the body, and "tiger water" on the left, a symbol of *yin* energy within

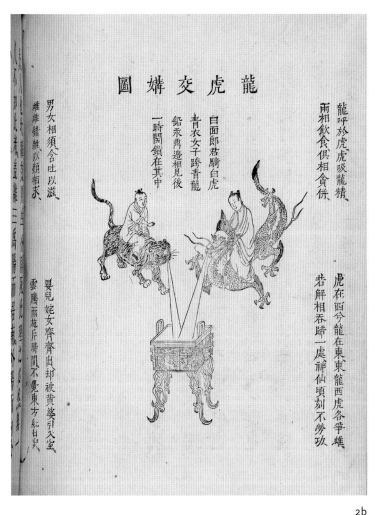

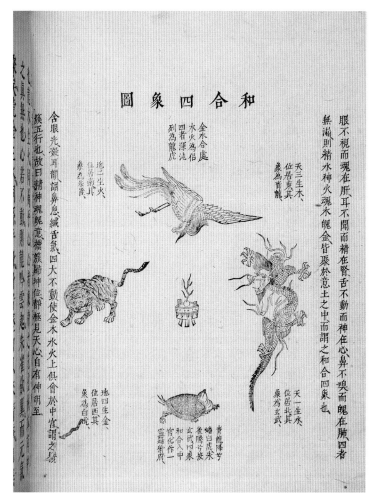

2b

2a

the *yang* side of the body. The top circle in the second illustration, which corresponds to the composite character "to join endowment and vitality" in the first, encloses the character's "primordial spirit" *(yuanshen)*.

The third image (2a) is called the *Illustration of Bringing Together the Four Symbols*. The animals of the five phases (see cat. no. 9) are shown: the Dark Warrior (an entwined tortoise and snake), representing water and the kidneys on the bottom (north); a red bird, representing fire and the heart on the top (south); a blue-green dragon, representing wood and liver on the left, reading the diagram as if facing the viewer [east];[4] and a white tiger representing metal and the lungs on the right (west). These animals are directed towards the alchemical crucible, here labeled "realized will" *(zhenyi)*. The realized will is explained in the text as "the prime of the trigram *qian* [three unbroken *yang* lines], the mother of the heavens and the earth, the root of *yin* and *yang,* the source of water and fire, the ancestor of the sun and moon, the font of the three materials [the heavens, the earth, and humanity], and the progenitor of the Five Phases."

Finally, the fourth illustration (2b) is called *Illustration of the Marriage of the Dragon and the Tiger;* Needham has already pointed out the sexual connotations of this title.[5] A blue-green dragon, symbol of *yang,* and a white tiger, symbol of *yin,* are shown infusing their energies into the alchemical crucible. A girl dressed in blue-green robes rides the dragon, symbol of *yin* within *yang,* while a white-faced boy rides the tiger, symbol of *yang* within *yin.* These images suggest the trigrams *li* (two unbroken *yang* lines enclosing a broken *yin* line) and *kan* (two broken *yin* lines enclosing an unbroken *yang* line), which represent mercury and lead, the two fundamental elements transformed in the inner alchemical operation.

The origins of this book are obscure, but it quotes several Ming dynasty writers, such as Luo Nian'an (1504–1564), so it can be dated to the late sixteenth century. The copy shown here was made during the first printing of the work in 1615. It is attributed to a disciple of a certain Master Yin, about whom very little is known.

—S. E.

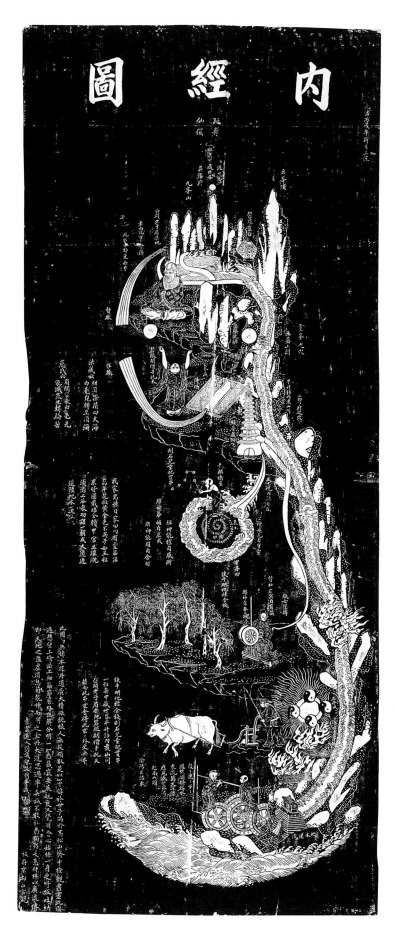

133

Illustration of Inner Circulation

Qing dynasty, 19th century
Ink rubbing; ink on paper
133 × 56 cm
Richard Rosenblum Family Collection,
 Newton Center, Massachusetts

THIS RUBBING, entitled *Illustration of Inner Circulation (Neijing tu),* shows the circulation of bodily energies that create an internal physiological elixir that will give long life, culminating in an ascent to the heavens. It is largely an illustration of two poems, attributed to Lü Dongbin, that are found in their entirety on the left side of the rubbing, and in parts with the specific images they describe.[1]

The rubbing consists of a diagram of the head and torso, seen from the side. The entire diagram is framed on the right by the spinal cord, which connects the lower torso with the cranial cavity. Within the three major sections of the body—the head, the upper torso, and the lower torso, the areas of the three "cinnabar fields" *(dantian)*—complementary images of *yin* and *yang* energy are shown intermingling. Several other images based on inner alchemical principles and visualization techniques can also be seen; of these, the "three passes" of the spinal cord through which energy moves up and down the body—here shown as three gate-towers—are particularly notable.

Beginning in the cranial cavity, there are nine peaks that suggest the "nine palaces" *(jiugong)* of traditional Taoist meditation; these peaks represent the *yang* energy of the upper body. Within these peaks lies a "numinous platform" *(lingtai)* that implies the ultimate goal of alchemy, an audience with representatives of the celestial hierarchy. A stream of "spirit water" *(shenshui)* flows down from these mountains—down the spinal cord—illustrating the idea that "Water flows down from the head and is called 'spirit water,' while realized energy rises from the [lower] cinnabar field and is called 'proper fire.'"[2]

Below the peaks are two dots representing at once the eyes and the sun and moon, symbols of *yang* and *yin* energy. Above the eyes there is a "white-haired old man with eyebrows hanging to the ground"; his robe is covered with stylized versions of the character for long life *(shou).* This man represents the *yin* alchemical element lead, and may have a secondary association with Laozi.[3] Below this man is a "blue-eyed foreign monk with arms raised to the heavens." This monk represents the *yang*

alchemical element mercury, and may have a secondary association with either Bodhidharma or Maitreya.[4] The placement of the *yin* image of the old man over the *yang* image of the young monk implies the idea of *yin* within *yang* and *yang* within *yin,* and the reversal of these energies that is part of the inner alchemical process.

The cranial cavity is framed on the left by the *ren* and *du* energy conduits *(muo),* two of the paths in which energy *(qi)* travels during its circuit through the body. The *du* conduit is the sole conduit that traverses the center of the body from top to bottom, while the *ren* conduit is associated with the womb, giving these conduits a special significance for the inner process.[5]

The middle of the body is dominated by images of the "Weaving Girl" and "Herd Boy" stars, two stars traditionally seen as lovers who meet in the sky once a year. The Weaving Girl represents the kidneys, seat of the element water *(yin)* in the Five Phase system. She sits at a spinning wheel, and a current of energy rises from her to the trachea, shown as a twelve-storied tower that "holds secret explanations." Completing the circuit, a double-current of energy descends from this tower to the Herd Boy, who sits in the middle cinnabar field of the heart, seat of the element fire *(yang)* in the Five Phase system. As Joseph Needham has pointed out, these two images together represent a lesser circulation intermingling the *yin* and *yang* energies of the kidneys and the heart, which corresponds to the greater circulation of the entire body.[6]

The other major internal organs are also indicated in this section by inscriptions, and there are several more symbolic images. Of particular interest is the grove of trees to the side of Weaving Girl. Trees represent the element wood in the Five Phase system, which is associated with the new growth of spring and the rise of *yang* energy from the pinnacle of *yin* in the winter months. Here, however, the proximity of the trees to the Weaving Girl suggests a *yin* correspondence, which brings to mind passages such as "The liver is wood, which flourishes in the west; the lungs are metal, which comes forth from the east—these are the patterns *(li)* of the Five Phases turned upside down."[7] The normal place of wood in the Five Phase system is in the east, while metal is placed in the west; in Inner Alchemy, however, the placement of these elements is reversed in order to refine *yin* and *yang* energies. Moreover, this grove also illustrates a line from one of the poems attributed to Lü Dongbin that talks of "planting golden coins," and in another version of this illustration, the trees are "money trees" that bear coins for fruit.[8] The golden coins of the poem suggest the *yin* element metal, and

consequently the grove of trees represents a secondary union of *yang* wood and *yin* metal that corresponds to the primary union of water and fire described above.

Finally, the Herd Boy holds in his hands the Northern Dipper (Ursa Major), a traditional image of the circumpolar zone of the sky; this image strengthens both the connections between the torso and the stellar regions, already implied by the Weaving Girl and Herd Boy, and the centrality of the middle cinnabar field in the heart.

In the very bottom of the rubbing, we see *yin* water representing the trigram *kan.* The inscription to the right reads, "The waters of *kan* flow in reverse." This reversal is accomplished by a boy and girl (*yang* and *yin,* or *yin* lead and *yang* mercury) operating treadmills that drive the water upward. This water rises to become *yang* fire, which joins with the "spirit water" of the cranial cavity, representing the extraction of the unbroken line of the trigram *kan* to replace the broken line of the trigram *li.* These two trigrams are thereby refined into the pure *yang* energy of the trigram *qian* (three unbroken lines), the elixir of Inner Alchemy.

The alchemical operation itself culminates in the alchemical crucible of the lower cinnabar field, which unites water and fire. The elixir is shown as four interlinked *taiji* symbols, which hover over the crucible, emitting rays of *yang* energy.

The "iron ox" *(tieniu)* to the left of the alchemical crucible is an image drawn from the first line of the poem quoted to the left: "The iron ox ploughs the field, planting golden coins." Needham interprets the ox as follows: "The ox [represents] the beast of evil desire which has to be ridden and controlled by Everyman. . . . the ox is the motive power for the circulation of *chhi* [*qi,* energy] and *i* [*yi,* will] in the body."[9] Accordingly, the ox represents the body itself, and the physical and mental inertia of slothfulness which must be overcome to accomplish the alchemical "work."

The rubbing was taken from a carved wooden tablet (now lost) in the White Cloud Monastery (Baiyun Guan) that was commissioned by Liu Chengyin and completed in 1886. According to the inscription in the lower left corner, the carving was based on a painting Liu saw in a library on a certain Tall Pine Mountain (Gaosong Shan). Other examples of the same theme exist, including a Qing dynasty color painting done in the painting academy of the imperial palace.[10]

—S. E.

134

WEN BOREN (1502–1575)
Spring Dawn at the Elixir Terrace

> Ming dynasty, 16th century
> Handscroll; ink and light colors on paper
> 30.1 × 124.8 cm
> National Palace Museum, Taipei

WEN BOREN WAS a nephew of the famous Ming dynasty painter Wen Zhengming (1470–1559), and one of the leading artists of the Wu School of literati painting.[1] His short handscroll entitled *Spring Dawn at the Elixir Terrace* depicts a mountainous landscape, colored in muted ochre and pale blue pigments.[2] The landscape of cliffs and rounded boulders opens at the left with a balustrade-lined path bordering a stream. Beyond a footbridge, the path disappears behind a cliff, only to reappear in the middle of the scroll, where a boy carries a hoe and a basket of purple mushrooms. Among densely foliated deciduous trees, the path, again bounded by a balustrade, disappears once more into the entrance of a cavern. Beyond this, at the top of a narrow ridge, a thatched roof appears. The painting ends with a depiction of a Taoist adept, standing alone on a promontory surrounded by an ocean of clouds, with a pale mountain range visible in the far distance. The object of the

adept's attention is a crucible that stands on a rock; in this reaction vessel the elixir is being refined. A jet of vapor shoots upward from the crucible's mouth. The painting is signed, "Sketched by Wufeng Wen Boren."

Actual experiments in laboratory alchemy were in fact rare after the Tang dynasty (618–906), owing in part to the great expense of obtaining and preparing the proper ingredients, and in part to the proliferation of the practices of Inner Alchemy.[3] The greatest phase of true laboratory alchemy appears to have taken place during the Eastern Jin (317–420) and Six Dynasties (420–589) periods. In one of his visions of the Perfected Being Lady Wei Huacun, Yang Xi (330–c. 386) was told of the numinous elixirs that dedicated adepts could hope to create:

> Some will cyclically transform in their furnaces the darksome semen *(you jing)* of cinnabar, or refine by the powder method the purple ichor of gold and jade. The Langgan elixir will flow and flower in thick billows; the Eight Gems *(ba qiong)* will soar in cloudlike radiance. The Crimson Fluid will eddy and ripple as the Dragon Foetus *(long tai)* cries out from its secret place. Tiger-Spittle and Phoenix-Brain, Cloud Langgan and Jade Frost, Lunar Liquor of the Supreme Pole *(Taiji yueli)* and Divine Steel of the Three Rings *(sanhuan linggang)*—if a spatulaful of (one of these) is presented to them, their spiritual feathers will spread forth like

pinions. Then will they (be able to) peruse the pattern figured on the Vault of Space, and glow forth in the Chamber of Primal Commencement.[4]

Depictions of the alchemical process in Chinese painting are surprisingly rare. The earliest known examples date to the Yuan dynasty (1260–1368). A painting in the British Museum attributed to Yan Hui (active late thirteenth–early fourteenth century), for example, depicts three of the Eight Immortals (Zhongli Quan, Lü Dongbin, and Li Tieguai) seated around a crucible in which the elixir is being prepared; cast onto the exterior of the reaction vessel are the Eight Trigrams of the *Book of Changes,* symbolizing the cyclical transformations of *yin* and *yang.*[5] Such images are better known from the Ming dynasty, and survive from the hands of such artists as Qian Gu (1508–1578) and Chen Hongshou (1598–1652), in addition to Wen Boren.[6]

Although it would appear that Wen Boren's painting depicts the alchemical preparation of an elixir, it is more likely that it is a visual metaphor for Inner Alchemy *(neidan):* the creation of the elixir within the adept's own body through meditation and visualization. The techniques of Inner Alchemy were widely practiced from the Song dynasty (960–1126) onward, largely supplanting experiments in laboratory alchemy. Nonetheless, as Nathan Sivin has pointed out, the language of both Outer (chemical)

and Inner (visualized) Alchemy was often interchangeable, and it is frequently difficult to tell from Taoist alchemical texts which technique, or body of techniques, is being referred to.[7] That Wen Boren's handscroll is an allegory of Inner Alchemy is corroborated by the presence of an attached colophon in cursive script, written by the late Ming artist and dramatist Xu Wei (1521–1593).[8] This text is written in the classical language of Inner Alchemy, in which the component aspects of the vital energies *(qi)* within the human body are directed toward the creation of the inner elixir, following the symbolism of *yin* and *yang,* the Five Elements (Phases), and the Eight Trigrams.[9]

—S. L.

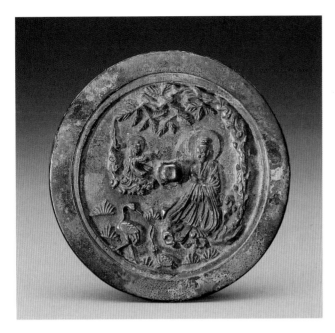

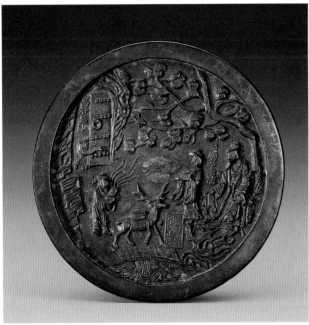

135

Mirror with Taoist Adept under a Pine Tree

Song dynasty (960–1279)
Bronze
D. 14.6 cm
Palace Museum, Beijing

136

Mirror with Taoist Adept in Front of a Cavern-Heaven

Yuan dynasty, Zhishun reign, dated 1331
Bronze
D. 19.9 cm
Palace Museum, Beijing

THE BACKS OF THESE bronze mirrors are cast with designs depicting Taoist adepts obtaining the alchemical elixir. Similar mirrors have been excavated from sites in both northern and southern China, and include examples dating to the Song (960–1279), Jin (1115–1234), and Yuan (1260–1368) dynasties.[1] The decoration of these mirrors tends to follow a fixed format: an adept sits in contemplation under a pine tree, while an attendant approaches, carrying either a vessel containing an elixir or a tray with peaches or other gifts. The adepts are usually accompanied by such animals as a crane, turtle, or deer. Sometimes an attendant or messenger is shown descending from the sky on a cloud, bearing a vessel or tray; sometimes the attendant emerges from the door of a cavern-heaven (*dongtian;* see cat. no. 148). Like the scene depicted in Wen Boren's *Spring Dawn at the Elixir Terrace* (cat. no. 134), these images appear to be allegories of Inner Alchemy.

The Song dynasty mirror (cat. no. 135) depicts a Taoist adept seated under a pine tree. He wears flowing robes, and has a halo behind his head.[2] In the foreground are a tortoise and crane, both symbols of longevity. On the left side, a figure descends on a cloud and offers the adept a vial, presumably containing an elixir.

The second mirror (cat. no. 136) bears a Yuan dynasty date: "Recorded in the *xinwei* year of the Zhishun reign" (i.e., 1331).[3] A bearded adept is shown at the right, seated on a rock under a pine tree. He is accompanied by a female attendant holding a tray; on the tray is what appears to be a tortoise. To the right, a deer, a male attendant holding a jar emitting beams of light, and a crane emerge from the open door of a cavern-heaven. The deer and the figure carrying the vessel cross a short bridge over a stream and approach the adept. An inscription in a cartouche next to the deer reads "Made by He Dezheng of Zhang Commandery in Hongdu [an old name for Nanchang in Jiangxi province]." A third inscription appears inside the door to the cavern-heaven, and reads *Yujun Changsha,* which may be translated, "Lodging with a lord in Changsha." There are similar mirrors in the Baoji Museum, Shaanxi province; the Museum of East Asian Antiquities in Stockholm; and the Museum for Applied Arts, Frankfurt; these, however, have no inscriptions.

—S. L.

Notes

Introduction

1. Strickmann 1979a: 132–33.
2. These associations are complicated by the fact that *kan* and *li* include both *yin* and *yang*, so that they can sometimes be represented by symbols of either principle.
3. Although the emphasis on the reconstruction of *qian* which is sometimes apparent in alchemical texts seems to create a bias towards *yang* energy rather than a balance (or integration) of *yang* and *yin*, the complementary reconstruction of *kun* could also be implied. See, in particular, Needham et al. 1983: 47–67.

Cat. no. 128

1. See Kroll 1996a: 149.
2. See, for example, Schipper 1975, and Robinet 1993: 55–96.
3. There are still later commentaries from the Tang dynasty preserved in the Taoist Canon; see Robinet 1993.
4. Schipper 1975.
5. Full title: *Huangting neijing jing.* The first four stanzas of this version of the *Huangting jing* are translated in Kroll 1996a: 152–55.
6. Full title: *Huangting waijing jing.*
7. For an ink rubbing that transmits Yang Xi's version of the text (preserved in Dong Qichang's *Xihong tang fatie*), see Ledderose 1984: fig. 10.
8. For example, see Schipper 1975.
9. The term "outer" can have the connotation of "exoteric," while the term "inner" can signify "esoteric," although these meanings are not necessarily applicable here.
10. Wang Xizhi's original manuscript of the *Huangting jing* was destroyed during the An Lushan rebellion of 755; see Ledderose 1984: 261.
11. Ibid.: 248.
12. Ibid.
13. Holzman 1997: 308.
14. Ledderose 1984.
15. Holzman 1997: 308. Ledderose 1984: 249, has pointed out that over two hundred cinnabar tablets were excavated from the tomb of Wang Xizhi's cousin Wang Danhu, who was buried near Nanjing in 359; for the original excavation report, see Nanjing shi wenwu baoguan weiyuanhui 1965.

Cat. no. 129

1. DeWoskin and Crump 1996: 2–3.
2. Strickmann 1966: 1–22.
3. Ibid.: 6.
4. Ibid.: 7.
5. For examples of mushroom cults among the native peoples of Alaska and Mexico, see Rudgley 1993: 68–71, 73–74.
6. Needham et al. 1974: 122–23.
7. Ware 1981: 179.
8. Strickmann 1966: 15.

Cat. no. 130

1. This biography is contained in the *Yunji qiqian*, HY 1026, *juan* 109. On the *Complete Biographies of the Assorted Immortals*, see Hu 2000: no. 7.
2. There are similar stories about other alchemy masters from the medieval period; for example, see the *Zhen'gao*, HY 1010, *juan* 5: 8.
3. On the physiological character of Inner Alchemy, see Needham et al. 1983.
4. Pregadio 1995: 155–73, suggests that the *Zhouyi cantong qi* may have had a somewhat more complicated history, beginning as an "apocryphal" *(wei)* commentary to the *Book of Changes*, being reinterpreted as a treatise on outer alchemy in the Six Dynasties, and finally being adopted by theorists of Inner Alchemy in the Tang–Song period.

Cat. no. 131

1. The first seven poems are translated in Kohn 1993: 230–35.
2. See Needham et al. 1983 for a preliminary comparison of Western and Chinese alchemical techniques.
3. Note that this is a reversal of the usual attributions of *kan* and *li; kan* is normally associated with *yin*, female, and lead, while *li* is normally associated with *yang*, male, and mercury (see cat. nos. 58–59). This reversal is explained by the *yang* line within the *yin* trigram *kan*, and the *yin* line within the *yang* trigram *li*, which are being represented here to indicate the presence of *yang* within *yin* and *yin* within *yang*.
4. The three-legged toad is a symbol of the Taoist adept Liu Haichan; see below and cat. no. 124.
5. These are ancient symbols of *yin* and *yang*.
6. HY 151.
7. For a study and translation of this work, see Robinet 1995.
8. The first four patriarchs of both lineages, through Liu Haichan, are the same. Supposedly, Wang took the teachings of these patriarchs and established the northern lineage, while Zhang Boduan used their teachings to develop the southern lineage of Inner Alchemy. In actuality, the teachings of Zhang Boduan developed prior to the Complete Realization sect, and the concept of a "southern lineage" was developed by the Complete Realization sect primarily to incorporate the independent alchemical traditions that had developed out of Zhang's teachings during the Song dynasty.

Cat. no. 132

1. Many of these illustrations, including the ones discussed here, are reproduced in Needham et al. 1983.
2. Ibid.: 229.
3. Ibid.: 38.
4. Alternately, the dragon and tiger could be read as reversed symbols indicating *yin* in *yang* and *yang* in *yin;* see ibid.: 58.
5. Ibid.: 104.

Cat. no. 133

1. Wang 1991–92. The poems can be found in HY 1473, *juan* 4: 16 and *juan* 5: 11.
2. HY 149: 13.
3. *Xiuzhen shishu*, HY 263, *juan* 26: 6, Wang 1991–92, and Needham et al. 1983: 116.
4. *Xiuzhen shishu*, HY 263, *juan* 26: 5, Wang 1991–92, and Needham et al. 1983: 116.
5. The achievement of the inner elixir was often likened to the conception of an inner symbolic fetus or child; see cat. no. 131.
6. Needham et al. 1983: 114.
7. HY 149: 14.
8. This alternate version can be found in Wang 1991–92: 143.
9. Needham et al. 1983: 100; see also Wang 1991–92.
10. Despeux 1994: 48. Despeux also discusses the present image, and translates the inscriptions.

Cat. no. 134

1. On Wen Boren, see J. Cahill 1978: 149–51.
2. Previously published in *Changsheng de shijie* 1996: pl. 21.
3. Sivin 1980: 240.
4. Ibid.: 216.
5. Binyon 1927: pl. 31.
6. Qian Gu's *Cinnabar Clouds of Dawn (Danxia tu)* is published in *Zhongguo gudai shuhua tumu* 1986–98, vol. 1: 83, no. 5-008; an unpublished album leaf by Chen Hongshou depicting a Taoist adept seated under a pine tree in front of a blazing crucible is in the Freer Gallery of Art (acc. no. F80.136a). I am grateful to Steven Allee and Jan Stuart for informing me of the existence of this painting.
7. Sivin 1980: 211.
8. On Xu Wei as a painter, see J. Cahill 1978: 159–63.
9. I am grateful to Shawn Eichman for his draft translation of Xu Wei's colophon.

Cat. nos. 135–36

1. For illustrations of representative examples, see Kong and Liu 1992: 736–42, 860–62.
2. In the recent catalogue of mirrors in the Beijing Palace Museum collection, this figure is mistakenly identified as a Buddha; see *Gugong cangjing* 1996: no. 137.
3. Ibid.: 157.

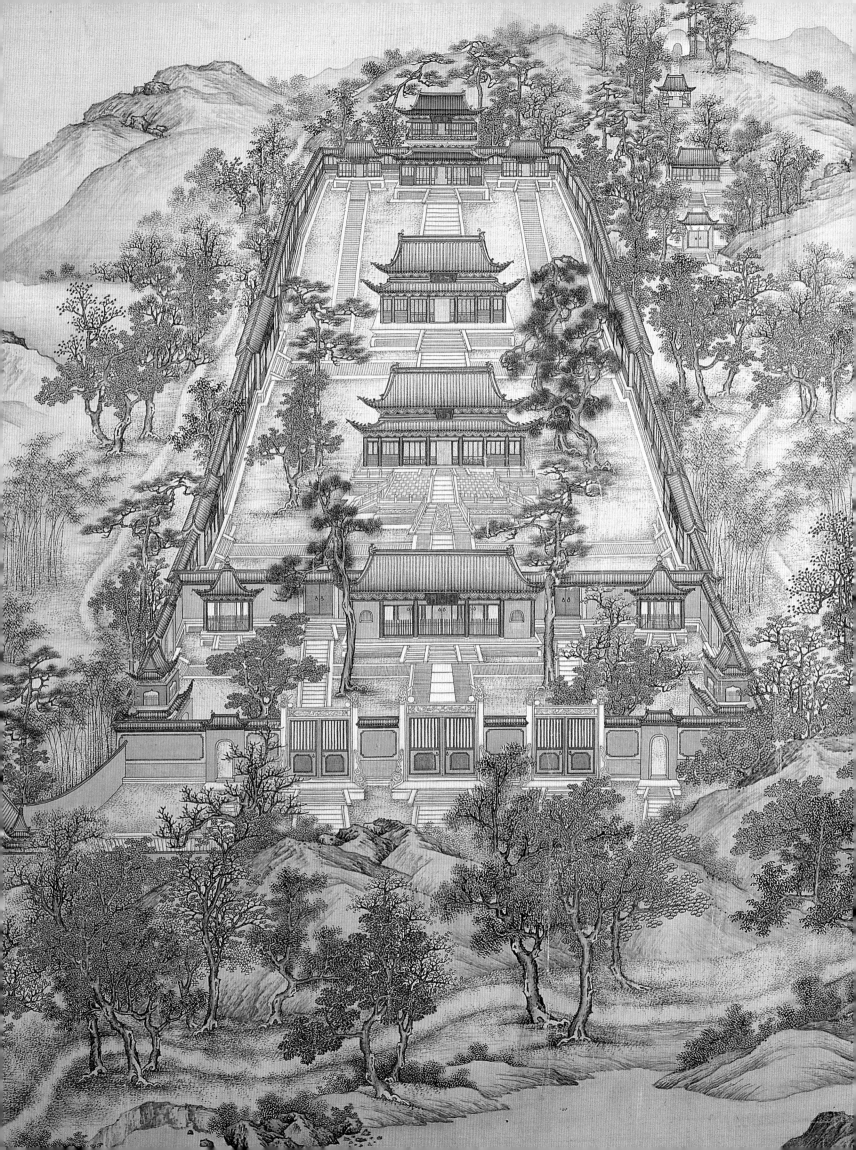

ONE OF THE EARLIEST TEXTS of religious Taoism, the *Scripture of Great Peace (Taiping jing)*, teaches a profound respect for the Earth as a living body. This section of the exhibition catalogue explores the traditional Taoist concept of the natural landscape as sacred and reflecting the inherently divine structure of both the cosmos and the inner human body (i.e., macrocosm and microcosm). The divine correspondence between the outer terrestrial and inner landscape of the human body is a fundamental aspect of Taoist techniques of visualization and Inner Alchemy, and can be seen in such works as the *Illustration of Inner Circulation (Neijing tu;* cat. no. 133), a diagram that originated in the Six Dynasties period (420–589).

This concept of the Earth as a sacred body is often given visual expression in Chinese paintings. The earliest Chinese texts that discuss the theory and practice of landscape painting, for example, emphasize the importance of the artist capturing and conveying the dynamic movement of vital energy *(qi)* that defines and animates the dynamic forms of the earth. The concept of the Earth as sacred is explored here on several levels. First is the concept of the sacred mountain. Mountains are revered throughout Taoist history as places where adepts meditate, pursue alchemy, and encounter immortals and gods. In mountains can be found numinous cavern-heavens *(dongtian)*, mysterious grottoes that are actually gateways to the spirit world. A direct extension of this concept of sacred space is the frequent siting of Taoist temples on or near mountains.

Examples of these concepts of sacred space as illustrated in Chinese painting include Juran's *Seeking the Tao in the Autumn Mountains* (cat. no. 138), Ni Zan's *The Crane Grove* (depicting an outdoor Taoist stone altar; cat. no. 139), Dai Jin's *Seeking the Tao in a Cavern-Heaven* (cat. no. 148), Wen Zhengming's *The Seven Junipers* (a painting of seven trees that are living symbols of the seven stars of the Northern Dipper; cat. no. 147), and a large topographical painting by Guan Huai, a Qing court artist, depicting the Zhengyi (Orthodox Unity) sect temple complex at Dragon and Tiger Mountain (Longhu Shan) in Jiangxi province (cat. no. 151).

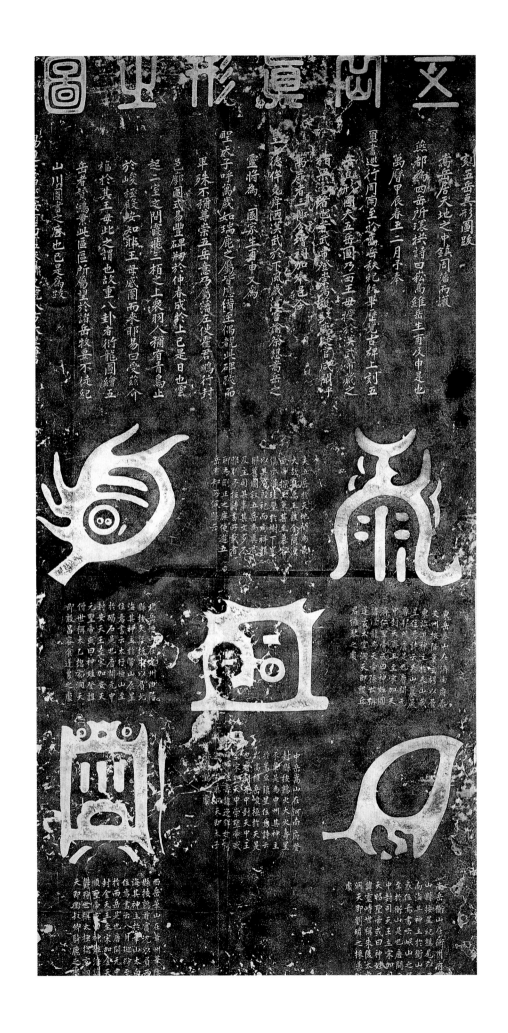

137

Illustration of the True Forms of the Five Sacred Peaks

Rubbing from a stone stele at the Taoist Temple of the Central Peak,
 Mount Song
Ming dynasty, Wanli reign, dated 1604
Hanging scroll; ink on paper
270 × 118 cm
Dengfeng Bureau of Cultural Relics, Henan

TAOIST PRACTITIONERS, and the religious ascetics in China before them, have always had a passion for mountains, rivaled only by that of great nature poets such as Xie Lingyun (385–433). The great patriarch of chemical alchemy Ge Hong (283–343) says the following in his *The Master Who Embraces Simplicity (Baopuzi)*:

> Those who mix medicines, who are avoiding political turmoil or who seek quietude in order to practice the Way, have always gone into the mountains.[1]

However, the very remoteness from civilization that gave mountains their value also made them dangerous places, and Ge Hong continues, "Most of those who do not know the methods for entering mountains encounter troubles and harm." In order to protect themselves from tigers, wolves, and mountain spirits, who would cause tree branches and boulders to fall on unwary travelers and misguide them over precipitous cliffs, Taoists would wear (and sometimes ingest) talismans, believed to imitate the "true forms" *(zhenxing)* of, and thus embody the energy of, the mountains they climbed. These talismans would cause the gods of the mountain to protect their wearer, and lesser spirits to submit to his (or her) commands.

This rubbing was taken from a stone stele kept at the Zhongyue Miao, or Temple of the Central Peak, on Mount Song in Henan province. The temple has a number of stelae illustrating this theme, of which this is the oldest. It shows the "true forms" of the Five Sacred Peaks *(wuyue)* of China. They are as follows: the Eastern Peak of Mount Tai (Shandong province), shown in the upper right, the Southern Peak of Mount Heng (Hunan province), shown in the lower right, the Western Peak of Mount Hua (Shaanxi province), shown in the lower left, the Northern Peak of Mount Heng (Hebei province), shown in the upper left, and the Central Peak of Mount Song (Henan province), shown in the middle. Each "true form" is accompanied by an inscription that tells where the peak is located, which of the Five Planets it corresponds to in the Five Phase system (see cat. no. 17), and what god rules over it. Additional information, such as the

most famous classical reference to the peak, the titles given to its god in the Kaiyuan era (713–41) of the Tang dynasty, and the changes made to the titles in the Song dynasty (960–1279), is also included.

Above the talismans there is an inscription dated to 1604, during the Wanli reign (1573–1620) of the Ming dynasty, by the government official Fang Damei,[2] who served as a Regional Inspector of Henan for the Censorate when this was written. Fang states that the "true forms" of the Five Sacred Peaks were first given to Emperor Wudi of the Han dynasty (r. 140–87 B.C.) by the Queen Mother of the West (Xiwangmu). This statement is based on a medieval legend of Emperor Wudi, wherein he was given sacred scriptures by the Queen Mother of the West and the Lady of the Highest Primordial (see cat. nos. 26, 97). He mounted these scriptures on violet brocade with a coral roller, placed them in a gold case and sealed them in a box of white jade. However, Wudi's nature was too violent and lustful to be suited to the Way, and after becoming disappointed with his progress, the Queen Mother caused all the scriptures, and the building in which they were kept, to be burned. Fortunately, the emperor transmitted a copy of the "true forms" of the Five Peaks to his minister Dong Zhongshu, and all later copies derived from this one.[3] While this story resides in the realm of legend rather than historical fact, the "true forms" existed in some shape by the Jin dynasty (265–420), and are mentioned prominently by Ge Hong, who says, "I have heard Master Zheng [Ge's teacher] say that there are no more significant works on the Way than the *Writ of the Three August* and the *Illustration of the True Forms of the Five Peaks*."[4]

The "true forms" of the Five Peaks seen here were common in both China and Japan, and can also be found on later stelae such as one dated to 1682 in Xi'an, of which the Field Museum in Chicago has a rubbing.[5] At the same time, the Ming dynasty Taoist Canon, which was printed over a century before the present stele, preserves an alternate version of the "true forms" of the Five Peaks;[6] the former are more abstract and talismanic, while the latter resemble maps that highlight areas of sacred significance within each peak.

—S. E.

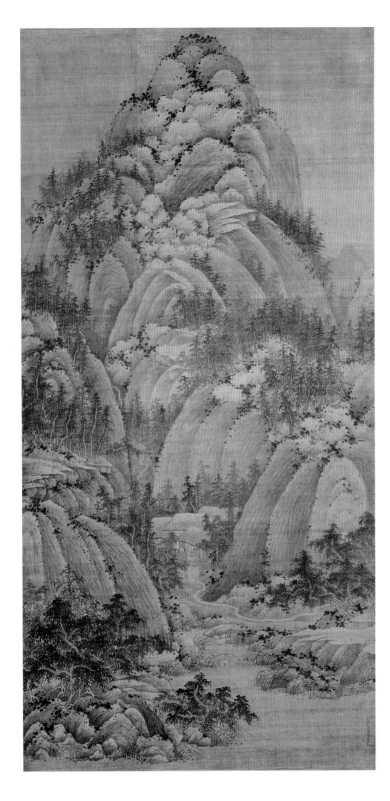

138

JURAN (ACTIVE C. 960–80)
Seeking the Tao in the Autumn Mountains

Northern Song dynasty, 10th century
Hanging scroll; ink on silk
156.2 × 77.2 cm
National Palace Museum, Taipei

JURAN WAS A BUDDHIST MONK active in the tenth century. He worked at the courts of the Southern Tang (923–36) and Northern Song (960–1126) dynasties, in Nanjing and Kaifeng. A pupil of the great landscapist Dong Yuan, Juran became one of the most famous painters in Chinese history. He and his teacher were described as follows by the Northern Song critic Shen Gua (1031–1095) in his *Casual Writings from the Stream of Dreams (Mengqi bitan)* of c. 1090:

> In the Jiangnan area [south of the Yangzi] during the time of the Southern Tang's second ruler [r. 926–34], there was a Director of the Northern Park, Dong Yuan, who excelled in painting and was especially skilled in distant views with autumnal mists. He mainly depicted the real mountains of Jiangnan and did not make brush-drawings of extraordinary heights. After him, the monk Juran of Jianye [Nanjing] followed Yuan's method and fathomed marvelous principles. Generally the brushwork of Yuan and Juran should be viewed at a distance. Their use of the brush is very cursory and if [their paintings are] seen from nearby, they may not seem to resemble the appearance of things; but, if viewed from afar, scenes and objects are clear, and deep feelings and distant thoughts [arise], as if one were gazing on another world.[1]

The title of Juran's *Seeking the Tao in the Autumn Mountains* fully expresses the meaning of this remote and dynamic landscape. Situated in a ravine, sitting under the eave of a thatched dwelling and entertaining a guest, a recluse contemplates the vital energy *(qi)* of the mountains that visibly swirls around his retreat. The landscape in this painting is a symbol of cosmic process, and simultaneously a symbol of the inner spirit-landscape of the human body. "Seeking the Tao" here suggests that the adept is aware of the numinous life-force that creates and gives form to the terrestrial landscape, and of the fact that what seems solid is actually in flux—a flux generated by the flow of *qi* through the earth. These ideas lay at the heart of the Chinese discipline known as *fengshui* (geomancy).

—S. L.

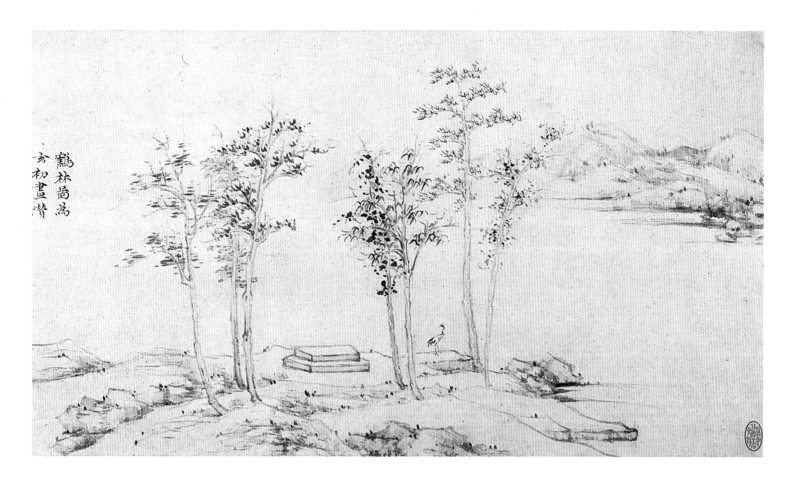

鶴林畫贊
玄初畫贊

139

Ni Zan (1306–1374)
The Crane Grove

> Yuan or early Ming dynasty, c. 1360/74
> Handscroll; ink on paper
> 30.5 × 54 cm
> China National Museum of Fine Arts (Zhongguo Meishu Guan),
> Beijing

A native of Wuxi in Jiangsu province in south-central China, Ni Zan was one of the most famous painters in Chinese history.[1] Ni's family was devoted to the Orthodox Unity (Zhengyi) sect of religious Taoism. Shortly after his birth, Ni's father died. He was subsequently brought up by his half-brother, Ni Zhaokui (1279–1328), who was closely acquainted with the Taoist adept Zhang Yu (see cat. no. 38) of Mount Mao (Mao Shan) and with the priest Wu Quanjie (see cat. no. 64).[2] Ni Zan spent most of his life during the Mongol-ruled Yuan dynasty (1260–1368). As a young man he was widely admired for his poetry, calligraphy, and painting. As the hold of the Mongols weakened in the 1350s, affluent families like Ni Zan's suffered from exorbitant taxation. To escape this burden, Ni gave his estates and most of his possessions to relatives and friends, and lived for nearly twenty years on a houseboat.

The Crane Grove is dedicated to a Taoist priest of the Divine Empyrean (Shenxiao) sect named Zhou Xuanzhen (b. 1328), whose sobriquet was Helin (Crane Grove).[3] This painting is the only surviving work by Ni Zan depicting a Taoist ritual space.[4] At the center of the scroll is a grove of trees with a stone altar *(shi tan)* next to a riverbank. The painting is followed by twenty colophons, including inscriptions by several Yuan scholars and the

Ming artists Wen Zhengming (1470–1559) and Dong Qichang (1555–1636).[5] These colophons are deeply informed by religious Taoism. The Yuan scholar Zheng Cai, for example, writes:

Among the sounds of jade chimes, [you] worship Purple Tenuity,[6]
Wending through the void, the white crane has flown [here] with
 his flock.
We know [from this] that the consort of Heng Shan has arrived,[7]
Is this not the Prince of Mount Gou who has returned?[8]
Close to Heaven, the Jasper Altar has beckoned him to descend,
The moon-born pearl trees are scattered with his coming and
 going.
One admires you, sir, who have attained the Tao and penetrated
 boundless space,
As the five-colored spring clouds cover your robes.[9]

Further evidence that Ni Zan was closely acquainted with Zhou Xuanzhen is provided by a poem in Ni's collected writings, inscribed on a now-lost portrait of the Taoist priest:[10]

Settling in Perfection in the high halls of Purple Emptiness,[11]
He rests his phosphor [chariot] in the mysterious palaces of the
 Utmost Tao.[12]
His sword reflects the bright moon through jade and pearl trees,
His belt ornaments make tinkling sounds in the numinous wind
 of the Seven Star Junipers.
Led by the Purple Luan [bird] and [sounds of] pan-pipes,
He is followed by White Jade Lads.
He is a transformed hermit, manifested like Zuo Yuanfang,[13]
In summoning demons and spirits, he resembles Qi Shaoweng.[14]
Exhaling *yang* and inhaling *yin,* he supports primordial creation,
Enfeoffing mountains and summoning clouds, he employs the
 God of the Soil.
Three plucks of his zither and the hundred gods delight,
The womb-immortal dances in the vastness of the red clouds
 of dawn.[15]

—S. L./S. E.

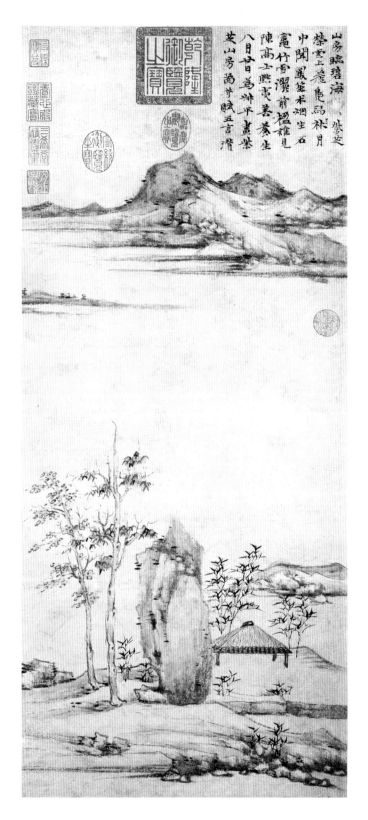

140

NI ZAN (1306–1374)
The Purple Mushroom Mountain Dwelling

Ming dynasty, c. 1370
Hanging scroll; ink on paper
80.5 × 34.8 cm
National Palace Museum, Taipei

WHILE UNDATED, this landscape by Ni Zan can be attributed to the final decade of his life.¹ The phrase "purple mushroom" in the painting's title refers to the Four Sages of Mount Shang (see cat. no. 23). These four hermits of the early Han dynasty lived on mushrooms, and one of them, the alchemist Luli, composed a song known as the "Song of the Purple Mushroom." In the Six Dynasties period (420–589), the Four Sages were perceived as Taoist hermits, and are called *xian* (immortals) in Ge Hong's *The Master Who Embraces Simplicity (Baopuzi).* ²

In his inscription on this painting, Ni Zan alludes to the purple mushrooms of Luli's song:

> The mountain dwelling faces the Jade Sea,
> . . . the Purple Mushrooms are lustrous.³
> Over the clouds, one flies with "duck shoes,"
> In the moon, one hears phoenixes and pipes.
> Wood smoke rises from the stone stove,
> Bamboo and snow are scattered before the columns.
> Who sees noble scholar Chen?
> Serene, he is skilled at nourishing life *(yang sheng).*⁴

The image of the purple mushroom was common in Yuan poetry written by Taoist scholars. A poem by the adept Yu Ji (1272–1348) that refers to the breathing techniques of Inner Alchemy alludes to the purple mushroom as a symbol of self-realization:

> A thousand years, embracing the subtle respiration,
> Moving together with the sun and the moon;
> Looking forward to the time when I will become a yellow-
> haired one,
> Daily awaiting the growth of the purple mushroom.⁵

In their apparent simplicity, Ni Zan's landscapes present a world detached from the social turmoil that shook China in the fourteenth century. Ni's cultivation of his moral integrity at a time when intellectuals were faced with difficult political choices made him a cultural hero during his lifetime. His Taoist orientation is apparent from both his collected writings and the friendships he cultivated with Taoist priests and adepts. He was, for example, a good friend of the great landscape painter Huang Gongwang (1269–1354), a Complete Realization (Quanzhen) adept who was an expert in divination and *fengshui* (geomancy).⁶

—S. L.

141

WU BOLI (ACTIVE LATE 14TH–EARLY 15TH CENTURY)
Dragon Pine

Ming dynasty, late 14th century
Hanging scroll; ink on paper
120.9 × 33.5 cm
The Metropolitan Museum of Art, New York, Edward Elliott Family
 Collection, Gift of Douglas Dillon (1984.475.3)

WU BOLI WAS A Taoist priest who lived in the late Yuan and
early Ming dynasties.[1] Active at the headquarters of the Ortho-
dox Unity (Zhengyi) sect, Wu was closely associated with an-
other Taoist priest of this sect, Fang Congyi (c. 1301–after 1378),
whose work is also represented in this exhibition (cat. no. 143).
Both Wu and Fang lived in the Highest Purity Palace (Shangqing
Gong); this temple is depicted as it appeared in the eighteenth
century in Guan Huai's topographical painting of Dragon and
Tiger Mountain (Longhu Shan; cat. no. 151). In 1406 Wu Boli
was ordered by the Yongle emperor (r. 1403–24) to accompany
the Forty-third Celestial Master *(tianshi)*, Zhang Yuchu (1361–
1410), to search for the immortal Zhang Sanfeng at Mount
Wudang (Wudang Shan) in Hubei province.

As a painter Wu Boli specialized in scenes of withered trees,
bamboo, and stones. While unsigned, Wu's *Dragon Pine* bears
one of the artist's seals. As Chiang I-han has shown in his study
of this scroll, Wu's painting reflects the clear influence of the
tenth-century masters Dong Yuan and Juran (see cat. no. 138).

This scroll bears an inscription at the top by the Celestial
Master Zhang Yuchu. In addition to being the leading Taoist
cleric in China during the early Ming dynasty, Zhang was a
prolific artist, famous for his paintings by the age of fifteen.[2]
Among the collectors' seals on the scroll is the "half-seal" used
as an inventory mark during the early Ming reign of Hongwu
(1368–98).

The ancient pine tree of Wu Boli's painting is a symbol of
longevity, and of the Tao itself. Like the dragon, and similarly
symbolizing the *yang* element, it exists in proximity to water,
symbolizing *yin*. As Wen Fong has shown, the powerful anima-
tion of the tree brings to mind the description of a pine tree by
the tenth-century landscapist Jing Hao:

> Among the trees, one had grown to occupy a huge area by itself.
> Its aged bark was covered with green lichen. It looked as if it were
> a flying dragon riding the sky, or as if it were a coiling dragon aim-
> ing at reaching the Milky Way.[3]

—S. L.

142

Lu Guang (c. 1300–after 1371)
Spring Dawn at the Cinnabar Terrace

Ming dynasty, c. 1369
Hanging scroll; ink on paper
61.3 × 26 cm
The Metropolitan Museum of Art, New York, Edward Elliott Family
 Collection, Purchase, The Dillon Fund Gift (1982.2.2)

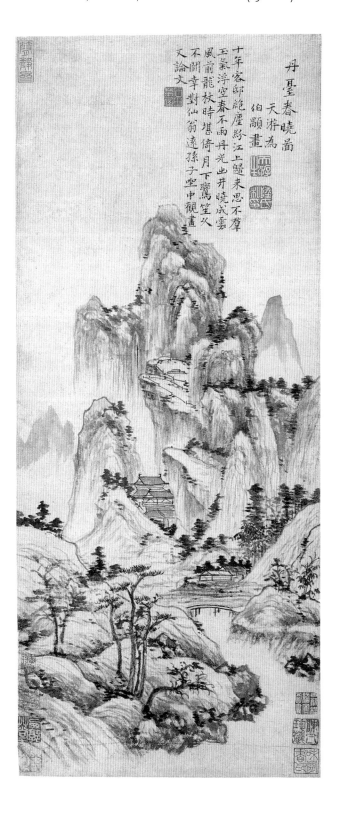

Lu Guang's small hanging scroll depicts a Taoist temple in a mountainous landscape. Recent research suggests that the painting depicts Mount Mao (Mao Shan), an ancient Taoist center near Nanjing in Jiangsu province.[1] Painted in dry monochrome ink, the scroll depicts a towering mountain peak with lesser peaks to either side, at the base of which is a Taoist temple. The "cinnabar terrace" of the painting's title probably refers to the slanted terrace just below the tall central peak. On this terrace, enclosed by a low fence or balustrade, is an outdoor Taoist altar. This type of altar appears in several other paintings of the Yuan and Ming dynasties, including works by Ni Zan and Shao Mi.[2] The character *dan* in the title can mean both cinnabar and elixir. Furthermore, it is likely that the title refers not to the chemical refining of the elixir of immortality, but to Inner Alchemy *(neidan)*, in which the internal energies of the adept's own body are channeled through visualization to create the "inner" elixir.

The artist's inscription, written at the upper right, reads:

> Picture of "Spring Dawn at the Cinnabar Terrace," painted by
> Tianyu [Lu Guang] for Boyong.
>
> Ten years I stayed in guest houses, cut off from the dust and dis-
> order [of the world],
> On the river, returning home, I think of solitude.
> Jade vapors *[yu qi]* float in the Void, in the Spring there is no rain,
> The elixir's glow emerges from the well, becoming clouds at dawn.[3]
> In the wind, from time to time I lean on a dragon staff,
> Under the moon, [I hear] the Luan [bird] and *sheng* [pipes], sounds
> I haven't heard for a long time.
> Rejoicing, I face the old immortal, far away from family.
> Seated in their midst, we examine paintings and discuss literature.

While little is known about Lu Guang's own beliefs with regard to religious Taoism, he is known to have painted this subject more than once, suggesting that, like his contemporaries Huang Gongwang (1269–1354) and Ni Zan (1306–1374), he was aware of and may have practiced the Taoist techniques of Inner Alchemy.[4]

—S. L.

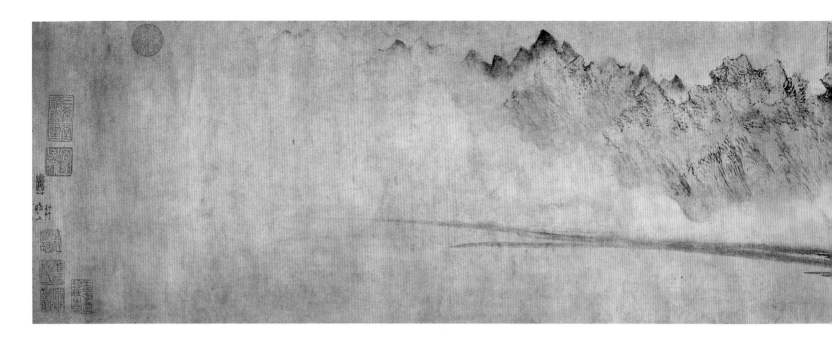

143

FANG CONGYI (C. 1301–AFTER 1378)
Cloudy Mountains

Yuan dynasty, c. 1360
Handscroll; ink and light colors on paper
26.1 × 144.5 cm
The Metropolitan Museum of Art, New York, Purchase, Gift of
 J. Pierpont Morgan, by exchange (1973.121.4)

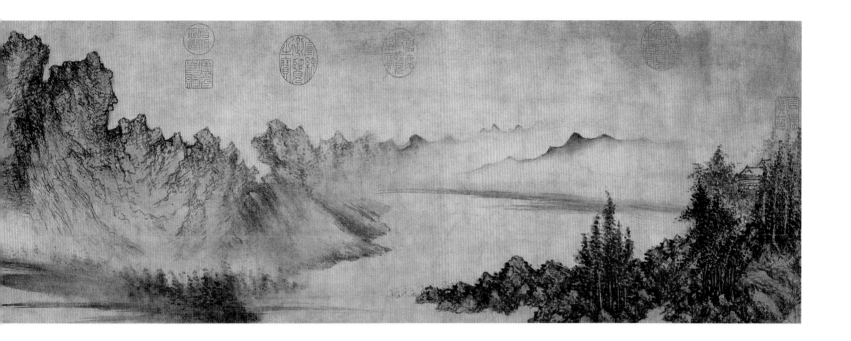

FANG CONGYI was a Taoist priest of the Highest Purity Palace (Shangqing Gong) at Dragon and Tiger Mountain (Longhu Shan; see cat. no. 151), the headquarters of the Orthodox Unity (Zhengyi) sect in Jiangxi province.[1] Although he spent most of his life at Dragon and Tiger Mountain, he worked briefly in Dadu (Beijing) in the 1330s. His nickname was Fanghu (Square Jar), the name of one of the isles of the immortals in the eastern sea (see cat. no. 149). He was known to and admired by many of the leading literati of the Yuan dynasty (1260–1368), including such figures as Song Lian (1310–1381), who wrote several colophons on his paintings.[2] Fang was one of several Yuan Taoist priests who were also painters; among these were the Celestial Master Zhang Yucai (r. 1295–1316) and Deng You (c. 1300–after 1378), a monk who trained at Dragon and Tiger Mountain and later served as abbot of a Taoist temple in Wenzhou, Zhejiang.[3]

Contemporary accounts of Fang Congyi hint at his deeply religious and cultivated persona. The scholar Wei Su (1303–1372), who knew Fang, wrote in a colophon on one of his works:

> Fanghu studied the Tao at Dragon and Tiger Mountain. Undefiled by worldly dust, the workings of his mind are superior. Often he paints landscapes which have an extraordinary flavor. Wuyi, Kuanglu, Heng, Tai, Huabuzhu, these are all mountains which he frequently depicted for me. As for the Immortal Cliffs, it is the place where he habitually sits and passes his leisure time. Moreover, this man voyages beyond the world and is unfathomable. When inspired, he gives spontaneously without even asking your name; otherwise, he will not produce one stroke.[4]

Another Yuan scholar, Li Cun (1281–1354), wrote:

> Fanghu's brush pursues the state of immortality. Accordingly, it gives shape to the shapeless, and returns that which has shape to shapelessness. That this can be done in painting must indeed be the ultimate achievement of art. If Fanghu were not himself an immortal, could he have done this?[5]

Fang Congyi's *Cloudy Mountains,* from the Metropolitan Museum of Art, New York, has been described as "among the most spectacular of Fang's extant works."[6] Beginning with a densely textured spit of land with lush trees and rounded masses of earth, with the elegant roofs of a temple visible at the right, the painting proceeds to depict a long mountain range that turns and twists like a dragon flying through space, only to dissolve completely into empty mist at the end of the scroll. As several scholars have observed, this work strikingly conveys the subtle transformations of solid matter into vital energy *(qi)* and vital energy into solid matter that characterize the workings of the natural world. As Richard Barnhart has written, speaking of another work by Fang, "This kind of almost tangible sense of ongoing process intertwining the natural world, man, and artistic creation might be thought of as the unspoken, underlying meaning of all Yuan scholar-painting, but few succeeded better than Fang Congyi in giving it vivid, direct visual expression."[7]

—S. L.

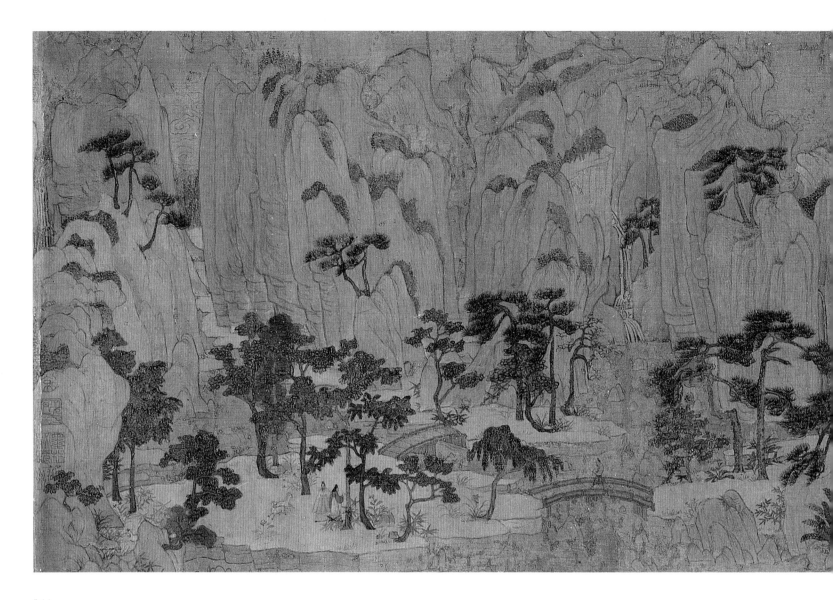

144

CHEN RUYAN (C. 1331–1371)
Mountains of the Immortals

Yuan dynasty, late 14th century
Handscroll; ink and colors on silk
33 × 102.9 cm
The Cleveland Museum of Art, Gift of Mr. and Mrs. A. Dean Perry
(1997.95)

CHEN RUYAN's handscroll presents a classic illustration of an immortals' paradise, as conceived by Taoists from at least the Six Dynasties period onward. Comprising a range of mountains painted in the blue-and-green *(qinglü)* style, the painting depicts a realm far from the dusty world. At the upper right a red-walled Taoist temple nestles in a steeply ascending valley. In a clearing, a realized being *(zhenren)* sits on a carpet next to a *qin* zither and *lingzhi* mushrooms, while watching a young attendant who dances with two cranes. Toward the end of the scroll, two immortal figures walk in another clearing, among auspicious animals and numinous plants. In the air above, another immortal flies on the back of a crane. Waterfalls and clouds are evidence of the mountains' breath, or *qi*.

The presence of azurite (blue) and malachite (green) pigments in the painting alludes both to antique styles of painting and to Taoist elixirs, for both minerals were used in elixirs from at least the Six Dynasties period onward.[1]

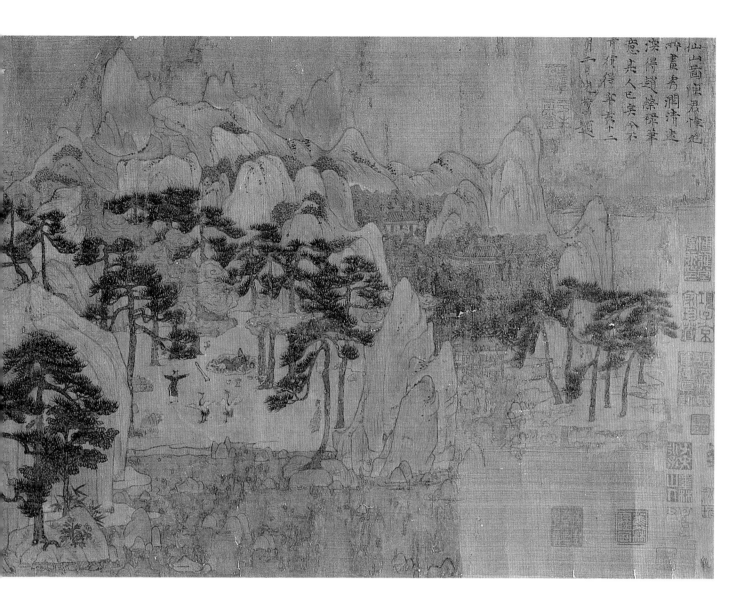

Chen Ruyan lived for most of his life in Suzhou, Jiangsu province.[2] He was a close friend of Ni Zan (1306–1374) and Wang Meng (1308–1385), both of whom were known for their Taoist images (Ni Zan and his family were also supporters of religious Taoism).[3] When the rebel Zhang Shicheng took control of Suzhou toward the end of the Yuan dynasty (1260–1368), Chen Ruyan served as a military advisor to Pan Yuanming, Zhang's brother-in-law. After Zhu Yuanzhang established the Ming dynasty in 1368, Chen traveled to the new capital, Nanjing, and accepted an official post as registrar (jinglu) of Jinan, Shandong province. Due to an unknown offense, Chen Ruyan was executed in the autumn of 1371.

The Cleveland handscroll is unsigned, but bears an inscription by Ni Zan at the upper right:

Mountains of the Immortals was painted by Master Chen Weiyun [Chen Ruyan]. In its rich elegance and pure detachment, he has profoundly captured the brush-spirit of Zhao Ronglu [Zhao Mengfu, 1254–1322]. Who else could have done this? Now one can no longer obtain [his works]. On the second day of the twelfth month of the year xinhai [1371], inscribed by Ni Zan.

Ni's allusion to the works of Zhao Mengfu as the model for Chen Ruyan's painting is born out by such blue-and-green style landscapes by Zhao as The Mind-Landscape of Xie Youyu in the Princeton University Art Museum.[4]

Mountains of the Immortals was Chen Ruyan's best-known painting from the early Ming dynasty onward.[5] The scroll bears seals of Xiang Yuanbian (1525–1590), Zhu Zhichi (late Ming dynasty), Liang Qingbiao (1620–1691), Gao Shiqi (1645–1704), and Lu Xinyuan (1834–1894).[6]

—S. L.

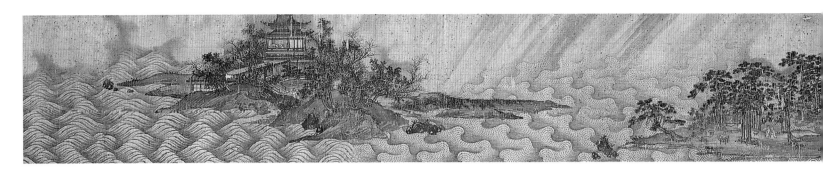

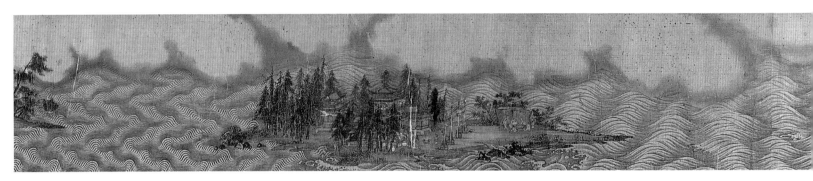

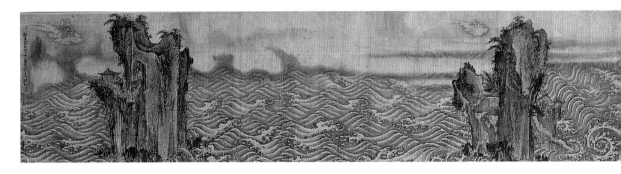

145

Puguang (active c. 1286–1309)
Isles of the Blessed

Yuan dynasty, late 13th/early 14th century
Handscroll; ink and colors on silk
31.5 × 970 cm
Kaikodo, New York

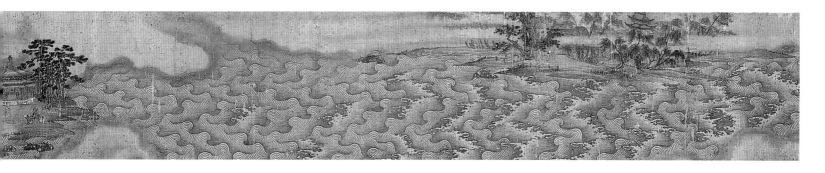

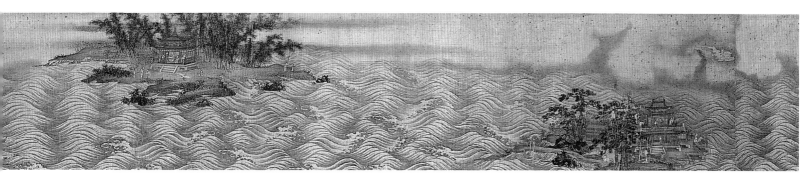

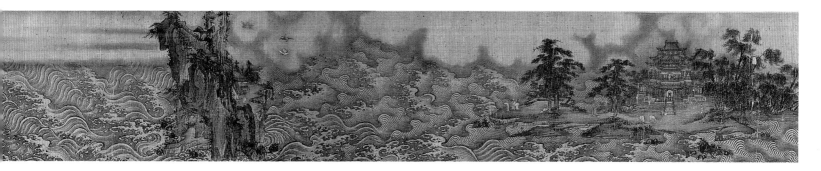

PUGUANG'S *ISLES OF THE BLESSED* depicts an ocean, the mysterious waves of which are alternately tempestuous and calm. Scattered over the surface of the ocean is a chain of islands. The first seven float like rafts on the water, while three at the end, with sheer, unapproachable cliffs, are firmly anchored in the depths. The latter almost certainly represent the immortals' islands known as Fanghu, Yingzhou, and Penglai.[1] Temples and palaces inhabited by Taoist adepts appear on each island. The first seven islands may represent the human realm, while the last three comprise the realm of the perfected beings *(zhenren)* who approach the islands flying on cranes and clouds.

The ocean in this painting is a symbol of transformation. In Taoist thought, change is the fundamental nature of reality. This belief provides the intellectual underpinnings of the ancient *Book of Changes (Yi jing)*, the visual symbolism of which was adopted by Taoism as a way of illustrating the transformations of *yin* and *yang*, symbolized here by the constantly shifting patterns of the waves.[2]

Puguang was a Buddhist monk from Datong, Shanxi province. He was born during the Jin dynasty (1115–1234) and died in the early Yuan dynasty (1260–1368). He knew both Wanyan Shou (1172–1232), a Jin prince and painter, and the painter and calligrapher Zhao Mengfu (1254–1322).[3] Like Zhao, he served as a scholar-official in the early Yuan government. He was particularly famous as a calligrapher.

This handscroll is signed, "Puguang, Chief Academician in the Zhaowen Academy, made in the Moon Pool Meditation Hall." The scroll is characteristic of early Yuan paintings in the lineage of the Southern Song court painter Ma Yuan (active early thirteenth century). Comparison with Ma's *Views of Water* album in the Palace Museum, Beijing, and the *Sketches of Water* attributed to Ma in the National Palace Museum, Taipei, confirms an early Yuan date for the scroll, as Howard Rogers has shown.[4]

—S. L.

146

LENG QIAN (ACTIVE 14TH CENTURY)
Mount Boyue

Yuan dynasty, Zhizheng reign, dated 1343
Hanging scroll; ink on paper
84.4 × 41.4 cm
National Palace Museum, Taipei

LENG QIAN WAS A Taoist master and musician of the Yuan dynasty (1260–1368), and was closely acquainted with the Moslem poet Sadula and the statesman Liu Ji.[1] During the reign of the first Ming emperor, Zhu Yuanzhang (r. 1368–98), Leng was appointed to the post of Chief Musician in the Court of Imperial Sacrifices.[2]

Leng Qian's *Mount Boyue* is one of the earliest surviving travel paintings known in the history of Chinese painting.[3] Painted in dry and heavily textured ink on paper, the work depicts the convoluted landscape of the Yellow Mountains (Huang Shan) in Anhui province (despite its title, which refers to a nearby mountain, also in Anhui). The painting records a trip Leng Qian and Liu Ji took to this geologically fantastic region of Anhui in 1343. Leng's own inscription on the scroll reads in part:

> Onward we went in successive stages for several tens of *li,* and we began to catch sight of Tianmen [the Gate of Heaven, a notch between two slopes of the peak known as Tiandu, the Peak of the Heavenly Citadel, in the Yellow Mountains]. We paid homage to the sacred images and gazed with enjoyment at mountains and rivers. . . . Far-off peaks rose, one above the other, piercing the clouds and joining the heavens. Forest groves spread out before them. I asked one of the locals (what it was) and he answered, Huang Shan. It could be reached in a day's journey, so we set out upon the trek. Along the way we encountered strange pines and wondrous rocks; lofty, majestic peaks and cliffs; flying waterfalls and bubbling streams; . . . emaciated monks and strange beasts; monkey chattering and bird calls. (All of these) lay in my heart and took hold of my imagination. Creeping vines led us to the summit of the mountain. (There was) the Yangzi River all in a ribbon with Jinling [Nanjing] clearly evident. There were great expanses to the north and south, in all directions it was remote and untamed, entirely screened off from my vision. Liu said, "Up ahead we would stray into the mountains of the immortals" *(xian shan).*[4]

In Leng's painting, the actual voyage through the landscape is translated into a single fixed view, yet one that is simultaneously full of dynamic movement. The transition between the human world and the realm of the realized adepts implied in Liu Ji's remark quoted in Leng's inscription recalls the similar transformations of the world described in such ancient texts as Sun Chuo's (320–377) account of ascending the Tiantai Mountains. As Richard Mather has written:

> The "Poetic Essay on Roaming in the Tiantai Mountains" is, at one level, a record of the poet's mystical experience of identity with the non-actual reality embodied in mountains and streams. Much of it is, of course, vivid physical description of the ascent of one of China's most scenic mountains. . . . But the metaphysical level is unmistakably present. After a brief preface, the essay proper begins with a general statement of the Great Void (Taixu) and its manifold activity within the natural world. It proceeds to a specific location of the Tiantai Range in space—in "magic Yue," then clearly implies that its ascent leads beyond space and time.[5]

At the top of the ascent, the poet is "within the realm of Taoist immortals" and "in perfect accord with the Tao."[6] The significance of both Sun Chuo's prose-poem and Leng Qian's painting rests on the ancient Chinese view of certain mountains as sacred pivots that connect Heaven and Earth. This perception certainly characterized the Yellow Mountains of Anhui depicted in Leng's painting, said to be the site where the Yellow Emperor ascended to immortality.

—S. L.

147

WEN ZHENGMING (1470–1559)
The Seven Junipers (The Seven Stars)

Ming dynasty, Jiajing reign, dated 1532
Handscroll; ink on paper
22.8 × 362 cm
The Honolulu Academy of Arts, Gift of Mrs. Carter Galt, 1952 (1666.1)

WEN ZHENGMING'S topographical handscroll depicts seven
juniper trees planted in the year 500 (Liang dynasty) on the
grounds of the Zhidao Guan, a Taoist temple in Changshu (Yu-
shan), Jiangsu province.[1] It is clear from the poem written at the
end of the scroll that the seven ancient trees were perceived as
Taoist immortals, and as representations of the seven stars of
the Northern Dipper, the most powerful constellation in Taoist
cosmology. Like his teacher Shen Zhou (1427–1509), Wen chose
to depict only the upper portions of the trees.[2] In the painting,
the junipers writhe across the surface of the paper, the trunks
and branches interlocked. The brushwork is dry and scumbled,
with occasional passages of wet ink wash and dense dotting.
In its contorted, twisting movements, this work is one of Wen
Zhengming's boldest compositions.

The long poem inscribed by Wen Zhengming after the paint-
ing does not appear among Wen's collected literary works, but
is recorded in the *Gujin tushu jicheng* (1725) as being by Huang
Yun, a native of Kunshan and contemporary of Wen Zheng-
ming.[3] In this poem, the seven junipers are described as being
planted by realized beings *(zhenren),* taking "the form of the
Dipper," and being "arranged like an immortal's altar." The rela-
tionship between the trees and the Northern Dipper is clearly
stated; on one level, the trees are representatives on earth of the
stars of the Northern Dipper, also known as the "seven primes"
(qi yuan; see cat. no. 78). With their strange, ancient shapes, the
trees are compared to "leviathans *(kun)* transformed, soaring
through the sea, or the *Peng* bird quickly striking" (an allusion to
the *Zhuangzi*), and to "the jade trees of Penglai (one of the three
islands of the immortals in the eastern sea)." The scroll has a
colophon by Chen Daofu (1483–1544), also written in 1532.

Wen Zhengming's painting is remarkable for its realistic
depiction of the Seven Junipers of Changshu, which still stand
today in the temple precincts of the Zhidao Guan. In a Taoist
context, the trees are powerful symbols of the divine realm of
the heavens, and of such human virtues as moral integrity.

—S. L.

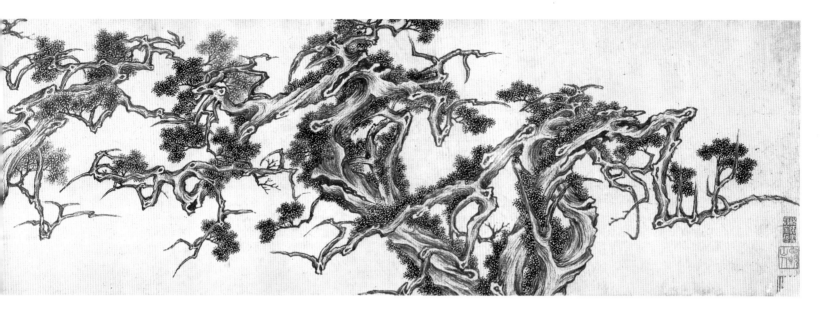

148

DAI JIN (1388–1462)
Seeking the Tao in a Cavern-Heaven

Ming dynasty, 15th century
Hanging scroll; ink and colors on silk
210.5 × 83 cm
Palace Museum, Beijing

DAI JIN WAS ONE of the great professional Zhe School masters of early Ming painting. His painting gives visual form to the ancient Taoist belief in numinous caverns that penetrate within sacred mountains, and that function as gateways to paradise and the realm of the Tao.[1] In the painting, an adept ascends a path among tall pines and towering cliffs toward the entrance of a cavern-heaven *(dongtian)*.[2] The figure has a Taoist cap on his head, visible under his translucent cowl. Within the grotto's opening, a balustrade-lined pathway disappears into the mist. Such scenes are commonly encountered in traditional Chinese painting. In addition to representing a real or idealized space, the cavern-heaven can also represent the sacred interior space of the adept's own body, as visualized through the techniques of Inner Alchemy *(neidan)*.[3]

Although the system of Ten Great Cavern-Heavens and Thirty-six Lesser Cavern-Heavens was codified by the Taoist master Du Guangting (850–933) in the late Tang dynasty, a system of such numinous caverns already existed in the earliest revelations of the Highest Purity (Shangqing) school in the fourth century.[4] Du wrote in the preface to his *Record of Cavern-Heavens, Blessed Places, Ducts, Peaks, and Great Mountains (Dongtian fudi yuedu mingshan ji;* A.D. 901):

> When Heaven and Earth divided and the clear [ethers *(qi)*] separated from the turbid, they fashioned the great rivers by melting and the lofty mountains by congealing. Above they laid out the stellar mansions, below they stored the grotto-heavens. The affairs of each of these being administered by great sages and superior Perfected, they contain divine palaces and spirit residences, jade halls and gold terraces: soaring structures of congealed clouds, formed from solidified ether.[5]

Dai Jin's *Seeking the Tao in a Cavern-Heaven* symbolizes both the veneration of cavern-heavens in the terrestrial landscape and the adept's inner spiritual journey toward achieving the Tao *(cheng dao)*.

—S. L.

WANG YUN WAS a professional painter active in Yangzhou, Jiangsu province, during the Kangxi (1662–1722) and Yongzheng (1723–35) reigns. His depiction of the island known as Fanghu (Square Jar) is one of the finest known depictions of this mythical Taoist paradise.[1] Also known as Fangzhang, Fanghu was one of the sacred islands sought by the first emperor of the Qin dynasty (r. 247–09 B.C.), who longed to become one of the perfected *(zhenren)*. The *Records of the Historian (Shiji)* by Sima Qian (c. 145–c. 86 B.C.) records that a *fangshi* (magician) named Xu Fu, from the state of Qi (in modern Shandong province), convinced the emperor to fund an expedition to find the three "divine islands" *(shen shan)* in the eastern sea.[2] These islands were called Penglai, Fangzhang (Fanghu), and Yingzhou, and were inhabited by immortals *(xian)*.

Fanghu is also mentioned in the *Liezi,* a text attributed to the philosopher of the same name (who lived c. 400 B.C.) that was designated a Taoist classic in the eighth century:[3]

> Within it [the eastern ocean] there are five mountains, called Daiyu, Yuanjiao, Fanghu, Yingzhou, and Penglai.[4] These mountains are thirty thousand miles high, and as many miles round; the tablelands on their summits extend for nine thousand miles. It is seventy thousand miles from one mountain to the next, but they are considered close neighbors. The towers and terraces upon them are all gold and jade, the beasts and birds are all unsullied white; trees of pearl and garnet always grow densely, flowering and bearing fruit which is always luscious, and those who eat of it never grow old and die. The men who dwell there are all of the race of immortal sages *(xian sheng),* who fly, too many to be counted, to and from one mountain to another in a day and a night.[5]

Wang Yun's painting depicts Fanghu rising from an ocean roiling with waves. Surrounded by mysterious vapors, the island is dotted with numinous trees and vegetation, immortals' palaces, and caverns from which waterfalls descend. The mountain is painted with pale blue and green pigments, with pale pink blossoms among the trees. The palace buildings are painted green and red, with gold roofs.[6] At the upper left is a short inscription by the painter, which includes the title *Painting of Fanghu* and the date: "Painted for Helao the Taoist, in a summer month of the year *jimao* [1699], copying a Song [dynasty] artist's original."

—S. L.

149

WANG YUN (1652–1735 OR LATER)
The Fanghu Isle of the Immortals

Qing dynasty, Kangxi reign, dated 1699
Hanging scroll; ink and colors on silk
142 × 60.3 cm
The Nelson-Atkins Museum of Art, Kansas City, Fortieth
 Anniversary Memorial Acquisition Fund (F75-43)

150

YUAN YAO (ACTIVE 1739–80)
Autumn Moon over the Dew Terrace

Qing dynasty, Kangxi reign, dated 1721
Hanging scroll; ink and colors on silk
215 × 137 cm
Museum für Ostasiatische Kunst, Cologne (A89,1)

YUAN YAO'S ELEGANT PAINTING depicts the imperial Jian-zhang palace of the Han dynasty (206 B.C.–A.D. 220), built in the year 104 B.C. by Emperor Wu (r. 140–87 B.C.).[1] Seen bathed in moonlight, a prominent feature is the tall marble terrace at the upper right, topped by a bowl designed to catch dew. Known as the Dew Terrace (Lutai), this structure reflected the belief that an emperor's virtuous reign would be acknowledged by Heaven, which would send down "sweet dew" as a sign of its approval. One of the earliest mentions of this concept is in chapter thirty-two of the *Daode jing,* attributed to Laozi:

> The Tao is constant, but has no name (= fame);
> Although the Uncarved Block is subtle (= small, minute),
> In Heaven and Earth, all submit to it.
> If barons and kings would but possess themselves of it,
> The ten thousand creatures would flock to do them homage;
> Heaven and Earth would conspire to send Sweet Dew.[2]

Mindful of such models, and as a public mark of his virtue, Emperor Wu of the Han built the Dew Terrace within his palace grounds, to demonstrate Heaven's acknowledgment of his right to rule. Similarly, the appearance of mysterious vapors, sponta-neously generated by the sky, was recorded during the reign of Han Guangwu, when the emperor carried out the Feng ritual of legitimation on Mount Tai, in Shandong province, in A.D. 56.[3] In mirror inscriptions of the Six Dynasties period, Taoist feathered beings were said to live on dew, and the image of auspicious dew descending from heaven was associated with Taoist sacred sites as late as the Ming dynasty. In the poem attached to Wen Zhengming's *The Seven Junipers (The Seven Stars)* handscroll (cat. no. 147), for example, sweet dew was said to descend to the temple site because of the presence of the sacred juniper trees, which functioned as a natural altar.

—S. L.

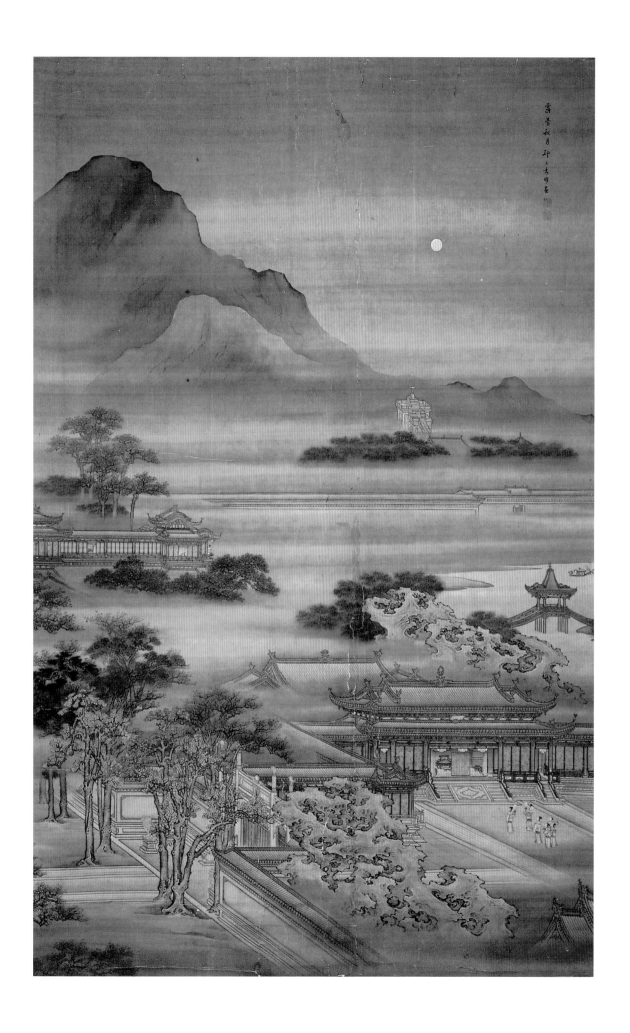

151

Guan Huai (active late 18th century)
Taoist Temples at Dragon and Tiger Mountain

Qing dynasty, late 18th century
Hanging scroll; ink and colors on silk
86.9 × 285.7 cm
Los Angeles County Museum of Art, Gift of Shane and Marilyn Wells
(M.87.269)

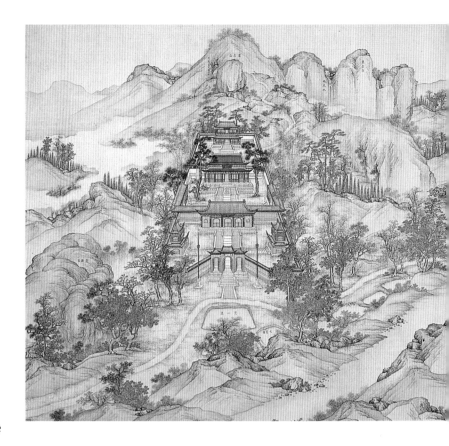

THIS LARGE HANGING SCROLL depicts the headquarters of the Orthodox Unity (Zhengyi) sect at Dragon and Tiger Mountain (Longhu Shan), Jiangxi province. Painted in the late eighteenth century by the court painter Guan Huai, this idealized view may have been commissioned on the occasion of an imperially funded renovation of the temples. Legend states that in the late Han dynasty (second century), the first Celestial Master, Zhang Daoling, refined the elixir of immortality at this site. In the late Tang dynasty, the mountain was listed as one of the "Seventy-two Blessed Plots" *(fudi)* or sacred Taoist sites in China by Du Guangting (850–933).[1] The association of the mountain with the Orthodox Unity sect and the hereditary Celestial Masters can be securely traced to no earlier than the late Southern Song dynasty (thirteenth century).[2] The site was continually occupied as the headquarters of the Zhengyi sect from the Song dynasty until the mid-nineteenth century, when it was destroyed during the Taiping Rebellion.[3] Even after its renovation in the late nineteenth century, the site was again destroyed after 1949, with the coming to power of the Communists under Mao Zedong. It has only recently been renovated again, and today flourishes as one of the most important Taoist sites in China.

Guan Huai's painting depicts Dragon and Tiger Mountain from a bird's-eye-view perspective. Its meticulous technique reveals the influence of both the early Qing dynasty Orthodox School of painting and Giuseppe Castiglione (Lang Shining; 1688–1766), the Italian Jesuit priest who was one of the most popular painters at the courts of the Yongzheng (r. 1723–35) and Qianlong (r. 1736–95) emperors. The temple buildings, with their red columns and orange walls, provide a vibrant contrast to the surrounding landscape, which is painted in ink and pale washes of ochre and green pigment. Blue, green, lavender,

white, and yellow foliage appears throughout the scroll. The painting is signed at the lower left: "Respectfully painted by [your] servant *(chen)*, Guan Huai." Numerous topographical features and buildings within the painting are labeled in carefully inscribed standard script characters. The name Longhu Shan (Dragon and Tiger Mountain), for example, is written on the tall peak at the upper left.

Two temple complexes appear in a mountainous landscape, with a river meandering in the foreground. The buildings of each complex rest on marble platforms or foundations. The first complex, at the right, labeled on the detached gate bordering the river as the Supreme Highest Purity Palace, comprises three main halls within a walled enclosure. This temple is said to have first been built in the late Tang dynasty (ninth century), when it was called the Perfected Immortal Monastery.[4] It underwent renovations in the Northern Song (960–1126), Yuan (1260–1368), Ming (1368–1644), and Qing (1644–1911) dynasties, and was given the name Supreme Highest Purity Palace (Tai Shangqing Gong) in 1687, during the reign of Kangxi (1662–1722). The temple's inner gate is labeled "Dragon and Tiger Gate." In sequence, the three main buildings are labeled "Treasure Hall of the Three Purities," "Perfected Wind Hall," and "Pavilion of Jade Perfection." The second temple complex, at the far left, is

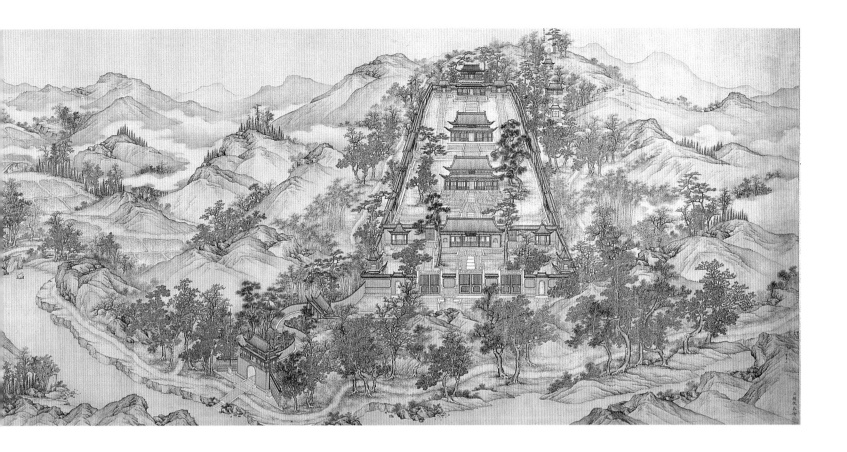

labeled "Monastery of Orthodox Unity" (Zhengyi Guan) on the outer gate. The three main halls of this complex are labeled "Hall of the Numinous Official," "Column Base of the Immortal Lineage," and "Pavilion of the Jade Emperor."

As is typical of sacred Taoist sites, many topographical features around the two temple complexes are also labeled. Along the top of the scroll, a slowly rising hill at the upper right is labeled "Heavenly Response Mountain," near the top of which is an enclosure with a gate, two pavilions, and a cave entrance. The gate is labeled "Hut of Quiet Understanding," the second pavilion "Crane Returning Pavilion," and the domed cave entrance "Cavern Where the Perfected Being Empty Quietude [Xi-jing zhenren] Refined the Elixir." A peak to the upper right of the second temple complex is labeled "Guanyin Summit," a reference to the Buddhist bodhisattva of compassion, while a nearby waterfall is labeled "Horse-tail Water[fall]." Other topographical features in the lower half of the painting include (from right to left) "Dragon Well Mountain," "Prior Heaven Mountain," "Pond of the Seven Stars" (a reference to the seven stars of the Northern Dipper), "Pond of Heavenly Unity," and "Cloud-embroidered Stone." Finally, just near the summit of Longhu Shan, is a cavern entrance labeled "Cavern Where the Perfected Being [Zhang] Daoling Refined the Elixir."

Little is known about Guan Huai, the painter of this scroll. He was a native of Hangzhou, Zhejiang province, who in 1780 passed the *jinshi* civil service examination.[5] Guan eventually rose to the rank of Vice-Minister of the Board of Rites *(libu shilang)*. He excelled at literary composition and landscape painting, in which he worked closely with Dong Gao (1740–1818), another court painter of the late Qianlong period.

—S. L.

Cat. no. 137

1. HY 1177, *juan* 17.
2. Fang's dates are unknown, but he obtained the *jinshi* degree in 1586. He was a native of Zhili (modern Hebei province).
3. This legend is recounted in HY 292, which may date to as early as the fifth century; see also Schipper 1965.
4. HY 1177, *juan* 19.
5. Published in Munakata 1991: 113.
6. For example, see HY 441.

Cat. no. 138

1. Translated by Roderick Whitfield in Bush and Shih 1985: 119.

Cat. no. 139

1. On Ni Zan, see Wang 1967: 15–46.
2. *Yuan si dajia* 1975: 25–26. As Wai-kam Ho has shown, Ni Zan's elder brother "was officially head of the prefectural diocese [of the Zhengyi sect] carrying the imperially consecrated title, *Xuanzhong zhenren* [Perfected Being within Mystery]." See Ho 1968: 111 n. 136.
3. Zhou Xuanzhen was a native of Jiahe, Zhejiang province. He studied to be a Taoist priest at the Purple Emptiness Monastery (Zixu Guan) in Jiaxing, Zhejiang province. In his later years, he moved to the Utmost Tao Monastery (Zhidao Guan) in Changshu, Jiangsu province. In the early Ming dynasty, he was summoned by Ming Taizu to the imperial court in Nanjing; see Min 1994: 672.
4. Previously published in *Zhongguo gudai shuhua tumu* 1986–98, vol. 1: 36, no. 3-003.
5. Other colophons are by Wen Peng (1498–1573), Wen Jia (1501–1583), Mo Shilong (active c. 1552–87), and Cheng Zhengkui (active c. 1630–74).
6. Purple Tenuity (Ziwei) is the name of both the circumpolar zone of the sky (the Purple Tenuity Palace, or Ziwei Gong) and a Taoist god; see cat. no. 76.
7. Heng Shan (Mount Heng), in Hunan province, is the southernmost of the Five Sacred Peaks.
8. The Prince of Mount Guo[shi] was Wang Ziqiao, a famous immortal said to have lived during the reign of King Ling (r. 571–545 B.C.) of the Zhou dynasty. Wang ascended to immortality on the back of a crane from Mount Goushi, near Mount Song (Song Shan) in Henan province. See Kaltenmark 1987: 109–14.
9. Numinous "five-colored clouds" are often signs in Taoist contexts of auspicious and divine portents; see cat. nos. 110–11. This poem is transcribed in Zhao 1998: 77.
10. QBGQJ: 415.
11. This is a reference to the Purple Emptiness Monastery (Zixu Guan) in Jiaxing, Zhejiang province.
12. This is the Utmost Tao Monastery (Zhidao Guan) in Changshu, Jiangsu province, home of the famous Seven Junipers (Seven Stars) painted by Wen Zhengming in 1532 (cat. no. 147).
13. This refers to Zuo Ci, a *fangshi* (magician) at the court of Cao Cao in the Three Kingdoms period; see DeWoskin 1983: 83–86. Zuo Ci was famous for his ability to transform himself into different creatures and to vanish through walls.
14. A reference to Li Shaojun of the state of Qi (in Shandong), a *fangshi* at the court of the Han emperor Wu (r. 140–87 B.C.).
15. The last two lines are an allusion to lines 6–7 of the *Inner Scripture of the Yellow Court* (*Huangting neijing jing*), a text often recited by Zhou Xuanzhen in his last years:

> Three plucks of the zither heart causes the womb-immortal to dance,
> The Nine Energies are translucently clear, emerging from between the mists.

Cat. no. 140

1. Previously published in *Yuan si dajia* 1975: no. 308.
2. Ware 1981: 104, 273. The Four Sages of Mount Shang are often presented as model Confucian hermits, but that they were perceived as models of Taoist self-cultivation is further suggested by their presence in a Song dynasty

(960–1279) monochrome ink handscroll in the Freer Gallery of Art depicting a Taoist paradise populated by immortals; see Lawton 1973: no. 34.
3. The first characters in this line are damaged and illegible.
4. The poem is recorded in QBGQJ: 123.
5. Sun 1981: 239.
6. On Huang Gongwang's involvement with Taoism, see Hay 1978. In 1334 Ni Zan and Huang Gongwang preached together in the Hall of the Three Teachings (Sanjiao Tang) in Suzhou; see Kao 1978: 26. In 1359 Ni Zan inscribed two unambiguously Taoist poems on Huang Gongwang's *Mountains of the Immortals (Xianshan tu)* of 1338, now in the Shanghai Museum; see *Yuan sijia huaji* 1994: pl. 1.

Cat. no. 141

1. See Chiang 1974: 33–35, 51–62.
2. Ibid.: 34.
3. Fong 1992: 475, quoting the translation in Munakata 1974: 11.

Cat. no. 142

1. Munakata 1991: no. 52.
2. See Ni Zan's *The Crane Grove*, which depicts an outdoor Taoist altar, from the Zhongguo Meishu Guan, Beijing (cat. no. 139), and Shao Mi's 1638 *Album of Landscapes Illustrating the Road to Lingjing*, in the Seattle Art Museum, in Munakata 1991: no. 71(d).
3. Given the Taoist language of the inscription, it is possible that the character *jing* (well) in this line refers not to an actual well on earth, but to the Lunar Mansion called Well; see Schafer 1978c: 82.
4. See the biography of Lu Guang by Chu-tsing Li in Goodrich and Fang 1976, vol. 2: 994–95.

Cat. no. 143

1. The definitive study of Fang Congyi is Neill 1981. See also Cahill 1976: 127–28.
2. Sun 1981: 231.
3. Works by both artists are in the Metropolitan Museum of Art, New York; see Fong 1992: pls. 81, 112.
4. Neill 1981: 52.
5. Translated in Barnhart 1983: 166.
6. Neill 1981: 116. The painting is also published in Barnhart 1983: fig. 81, and Fong 1992: pl. 113. See the excellent discussion of this work in Neill 1981: 116–20.
7. Barnhart 1983: 170, speaking of Fang Congyi's *The Romantic Spirit of the Eastern Jin* (dated 1360).

Cat. no. 144

1. Hay 1985: 46–50.
2. MHL, vol. 2: 19. See also Goodrich and Fang 1976, vol. 1: 163–65. For a detailed study of Chen Ruyan, see Brown 1985.
3. See, for example, Ni Zan's *The Crane Grove*, from the Zhongguo Meishu Guan, Beijing (cat. no. 139), and Wang Meng's *Cinnabar Mountains, Ying Ocean*, and *Ge Zhichuan [Ge Hong] Moving his Residence*, published in *Yuan sijia huaji* 1994: pls. 109–10.
4. Fong 1984: no. 6.
5. The scroll is first recorded in YYB, vol. 1: 710 (this edition mistakenly records the title as *Xiannü tu* instead of *Xianshan tu*).
6. See *Eight Dynasties of Chinese Painting* 1980: no. 114.

Cat. no. 145

1. See Rogers 2000: 235. See also cat. no. 149.
2. On the history of the *Book of Changes*, see Shaughnessy 1993.
3. Rogers 2000: 76–77.
4. Ibid.: 233.

Cat. no. 146

1. See T. W. Weng's biography of Leng Qian in Goodrich and Fang 1976, vol. 1: 802–04. On Sadula, see Strassberg 1994: 262–66. On Liu Ji, see Goodrich and Fang, vol. 1: 932–38.

2. *Mingren chuanji ziliao suoyin* 1978: 279. Biographies of Leng Qian are contained in GCXZL, *juan* 118, and MSZ, vol. 8: 5976–78.
3. See the discussions of this work in Ganza 1986 and Cahill 1992: 259–61.
4. Ganza 1986: 10.
5. Mather 1961: 231–32.
6. Ibid.: 232.

Cat. no. 147
1. Ecke 1954: 22; see also Ecke 1965, vol. 3: pl. 55. For a more detailed discussion of this scroll, see Little (forthcoming).
2. Shen Zhou's painting is published in Cahill 1978: pls. 42–43; and in *Circa 1492* 1991: no. 312. Another version, most likely a copy, is published in *Chūgoku kaiga* 1975: pl. 79.
3. Huang Yun's poem is entitled "The Seven Star-Junipers of the Zhidao Temple in Changshu;" see QDGJTSJC, *Caomu, juan* 258: 11a–b. It is not clear whether the poem was composed by Wen Zhengming or Huang Yun. See also Ecke 1954.

Cat. no. 148
1. Previously published in Mu 1982: pl. 58.
2. The symbolism of the grotto is pervasive in religious Taoism. The central ritual altar table, for example, is called a "cavern-table" *(dong'an)*; see Lagerwey 1987b: 37, 39. The Taoist Canon *(Daozang)* is divided into three "Caverns," known as the Caverns of Perfection *(Dongzhen)*, Mystery *(Dongxuan)*, and Divinity *(Dongshen)*.
3. In the realm of Taoist Inner Alchemy, interior became exterior, and vice versa. The cavern-heaven came to symbolize the transformation of the human body into a reaction vessel, "a form of interiorized 'counter-universe'"; see Verellen 1995: 272.
4. Ibid.: 270–76.
5. Ibid.: 272.

Cat. no. 149
1. Previously published in *Eight Dynasties of Chinese Painting* 1980: 257, and Munakata 1991: no. 66.
2. Nienhauser 1994a: 142.
3. On the date of the *Liezi*, see Barrett 1993: 298–308.
4. It was said that the first two of these islands (Daiyu and Yuanjiao) later drifted away because the turtles on whose backs they rested were stolen by a giant.
5. Graham 1960: 97. This passage is found in the chapter entitled "The Questions of Tang" (referring to King Tang of the Shang dynasty). For the Chinese text, see XYLDB: 153–54.
6. An earlier depiction of Fanghu, painted by the Ming Wu School painter Wen Boren in 1563, includes an ornate marble ritual platform as one of the island's architectural features; see Fong et al. 1996: pl. 200.

Cat. no. 150
1. Previously published in Hempel et al. 1992: no. 64.
2. Translated in Waley 1958: 183.
3. Bokenkamp 1996b: 253, 259.

Cat. no. 151
1. *Dongtian shengjing* 1987: 89–90.
2. Schipper 1993: 15.
3. Ibid.: 17.
4. *Dongtian shengjing* 1987: 90.
5. Yu 1980: 1514.

CHINESE NAMES AND TERMS

Abaoji　阿保機

Afang　阿房

An Shigao　安世高

Anhui　安徽

Anyang　安陽

ba qiong　八瓊

Bagua　八卦

Bai Yuchan　白玉蟾

baihu　白虎

baimiao　白描

bairi shengtian　白日升天

Baishi Guan　白石觀

Baiyun Guan　白雲觀

Bajun　巴郡

Balinzuoqi　巴林左旗

bao　寶

Bao Jing　鮑靚

Baoguo Si　寶國寺

Baohe Dian　寶和殿

Baoji　寶雞

Baoning Si　寶寧寺

Baxian　八仙

Baxian An　八仙庵

Beidou　北斗

Beiji　北極

Beijing　北京

Beilin　碑林

Beiyue Miao　北嶽廟

ben mo dao zhi　本末倒致

benming　本命

Bi Yuan　畢沅

bianhua　變化

Bianjing　汴京

Bianliang　汴梁

Bixia Ci　碧霞祠

Bixia Gong　碧霞宮

Bixia yuanjun　碧霞元君

Bo Yi　伯夷

Bo'ai　博愛

boshanlu　博山爐

boshu　帛書

Boyong　伯顒

Boyue Shan　白岳山

bugang　步綱

Buxu　步虛

Cai Bian　蔡卞

Cai Jing　蔡京

Cai Tao　蔡絛

Caishen　財神

Cang Jie　倉頡

canglong　蒼龍

cao　曹

Cao Cao　曹操

Cao Guojiu　曹國舅

Cao Pu　曹鋪

Chan　禪

Chang E　嫦娥

Chang'an　長安

Changbo Shan　釹白山

Changchun Gong　長春宮

Changning　長寧

Changsha　長沙

changsheng　長生

Changsheng dadi　長生大帝

changsheng qingju zhi shu　長生輕舉之術

Changshu　釹熟

Chao Fu　巢父

Chaotian Gong　朝天宮

chen (hour)　辰

chen (servant)　臣

Chen　陳

Chen Daofu (Chen Chun)　陳道復（陳淳）

Chen Guan Huai gong hui　臣關槐恭繪

Chen Hongshou　陳洪綬

Chen Jinggu　陳靖姑

Chen Jiru　陳繼儒

Chen Ma Yuan　臣馬遠

Chen Mu　謹姆

Chen Rong　陳容

Chen Ruyan (Weiyun)　陳汝言（惟允）

Chen Tuan　陳摶

Chen Wenzhu　陳文燭

Chen Yanqing　陳彥清

Chen Yuexi　陳月溪

Chen Zhitian　陳芝田

cheng Dao　成道

Cheng Zhengkui　程正揆

Chengdu　成都

Chengguo wang　成國王

Chenghua　成化

Chenghuang　城隍

chenghuang shen　城隍神

chengwu　成物

Chenxing　辰星

Chifeng　赤峰

Chiming　赤明

chisongzi　赤松子

chixin zhongliang　赤心忠良

Chongfu Gong　崇福宮

Chongqing　重慶

Chongquan　重泉

Chongxuanxue　崇玄學

Chongyang Dian　重陽殿

Chongzhen　崇貞

Chongzhen Gong　崇真宮

Chu　楚

Chu Hui　褚慧

Chuanxi pingyuan　川西平原

Chuanyuzi　傳預子

Chunyang Dian　純陽殿

Chunyou　淳祐

ci　祠

Cixi　慈禧

Cizhou　瓷州

Cui Bo　崔白

Cui Zizhong　崔子忠

Cunsi xiang　存思像

Da Ming huanghou santian jinque yufu shangxian hongci puhui tidao xuanjun　大明皇后三天金闕玉輔上仙宏慈溥惠體道玄君

Da Ming zhonggong huanghou　大明中宮皇后

Da Shangqing Gong　大上清宮

da zhenren　大真人

Dacheng Dian　大成殿

Dachengzi　大成子

Dade　大德

Dadi Shan　大滌山

Dadong　大洞

Dadong fa　大洞法

Dadu　大都

Dai Jin (Wenjin)　戴進（文進）

Dai Miao　岱廟

Daiyu　岱輿

daizhao　待昭

Daliang　大梁

Daming Gong　大明宮

Dantian　丹田

Danyang　丹陽

Dao (Tao)　道

daochang　道場

Daode tianzun　道德天尊

daoguan　道觀

Daoguang　道光

Daojia　道家

Daojiao　到教

daojun　道君

Daojun huangdi　道君皇帝

Daoling zhenren liandan dong　道陵真人煉丹洞

Daolu si　道錄司

daopao 道袍
daoshi 道士
daotan 道壇
Daozang 道藏
Datong 大同
Daxing 大興
Daxiongbao Dian 大雄寶殿
Dazhong xiangfu 大中祥符
de 德
deguang 德光
Dehua 德化
Deng Chun 鄧椿
Deng Yu 鄧宇
Dengfeng xian 登封縣
Dening Dian 德寧殿
deshi 德士
di 帝
Di guan 地官
dian 殿
ding (cauldron) 鼎
ding (cyclical mark, god) 丁
Ding Yunpeng 丁雲鵬
Dingjiazha 丁家閘
dingli 頂禮
dingsi 丁巳
dizhi 地支
dong 洞
Dong Gao 董誥
Dong Qichang 董其昌
Dong Zhongshu 董仲舒
dong'an 洞案
Dongfang Shuo 東方朔
Donghua tian dadi 東華天大帝
Donghuang Taiyi 東皇太乙
dongnan 東南
Dongshen 洞神
dongtian 洞天
Dongting Hu 洞庭湖
Dongwangfu 東王父
Dongwanggong 東王公
Dongwei xiansheng 洞微先生
Dongxiao Gong 洞霄宮
Dongxuan 洞玄
Dongyuan 東圍
Dongyue 東嶽
Dongyue dadi 東嶽大帝
Dongyue Miao 東嶽廟
Dongyue tianxian shengmu 東嶽天
 仙聖母
Dongzhen 洞真
dou (dipper) 斗
Dou (empress) 竇
Doumu 斗母
du 督
Du Guangting 杜光庭

Duan Fang 端方
Duguang 都廣
Dunhuang 敦煌
Duolun 多倫
Ershiba xiu 二十八宿
Ershiba xiu xing jun 二十八宿星君
Erxian Guan 二仙觀
fa 法
Fahua 琺華
Fajia 法家
Falin 法琳
Fan Zhongyan 范仲淹
Fanbao danchang yunü
 梵寶丹昌玉女
Fang Chunnian 方椿年
Fang Congyi (Fanghu)
 方從義（方壺）
Fang Damei 方大美
Fang Xuanling 房玄齡
Fanghu 方壺
fangji 方伎
fangshi 方士
fanguang 返光
Fangzhang 方丈
Fanqi Mile yunü 梵氣彌勒玉女
fawang 法王
Fei Zhi 肥致
Feibu xiang 飛步像
Feiliangui Guan 飛廉桂觀
Feng 封
Feng Abiao 馮阿標
Feng Faxing 馮法興
Feng Wufang 馮毋妨
Feng Yixian 馮義顯
Fengdu 豐都
Fengqiu 鳳丘
fengshui 風水
fengyun leidian 風雲雷電
Fenyang 汾陽
Fosi 佛寺
fu (bat) 蝠
fu (good fortune) 福
fu (talisman) 符
Fu Hao 婦好
Fu Jiang 涪江
fudi 福地
Fujian 福建
Fulushou 福祿壽
Fuqiu 浮丘
Fusang dadi 扶桑大帝
Fuxi 伏羲
Fuxing 福星
Gan De 甘德
Gansu 甘肅
ganying 感應

Ganzhou 贛州
Gao 高
Gao Shiqi 高士奇
Gao Yi Que 高頤闕
Gaodao 高道
Gaodao Liu Yuanran 高道劉元然
Gaoping 高平
Ge 葛
Ge Chaofu 葛巢甫
Ge Hong 葛洪
Ge Xuan 葛玄
gen 艮
Geng Qian 耿謙
Geng Xiansheng 耿先生
gengchen 庚辰
Gengsangzi 庚桑子
gengyin 庚寅
Genyue 艮嶽
gong 宮
gongfu 功夫
Gongxian 鞏縣
Gongzi 龔子
Gou Shan 緱山
Gouchen 句陳
Goushi Shan 緱氏山
Gu Kaizhi 顧愷之
Gu xiansheng 古先生
gua 卦
guan 官
Guan Huai 關槐
Guan Ping 關平
Guan Yu 關羽
Guandi 關帝
Guangchengzi 廣成子
Guangdong 廣東
Guangdu 廣都
Guanghan 廣漢
Guanghan Gong 廣寒宮
Guangong 關公
Guangsheng Si 廣勝寺
Guangshouzi 廣壽子
Guangxi 廣西
Guangxu 光緒
Guangyuan 廣源
Guanmiao mingzhen 觀妙明真
Guansheng 關聖
Guanyin 觀音
Guanyin ding 觀音頂
Gugong 故宮
Gui 鬼
Gui Dao 鬼道
guichou 癸丑
Guixi 檜溪
Guizhou 貴州
Guo Ruoxu 郭若虛

Guo Xi 郭熙
Guo Xiang 郭向
Guo Zhongshu 郭忠恕
Guodian 郭店
guqi 古氣
Gushe 姑射
gusi 古寺
Guye 姑射
Han 漢
Han Feizi 韓非子
Han Gaozu 漢高祖
Han Guangwu di 漢光武帝
Han Huandi 漢桓帝
Han Jingdi 漢景帝
Han Wendi 漢文帝
Han Wudi 漢武帝
Han Xiangzi 韓湘子
Han Xuandi 漢宣帝
Han Yu 韓愈
Han'an 漢安
Han'gu 函谷
Hangzhou 杭州
hanshisan 寒食散
Hanyuan Dian 含元殿
Hanzhong 漢中
Haotian 昊天
He Dezheng 何德正
He Xian'gu 何仙姑
he xingming 合性命
Hebei 河北
Hegui Ting 鶴歸亭
Hejia Shan 何家山
Helao 鶴老
Helin 鶴林
Helin tu 鶴林圖
Henan 河南
Heng Shan (northern sacred peak)
 恆山
Heng Shan (southern sacred peak)
 衡山
Hengshan (village) 橫山
heqi 合氣
Heshi Zhuang Qinwang faxin cheng
 zao 和碩莊親王發心誠造
Hetu 河圖
Hong Mai 洪邁
Hong Xiuquan 洪秀全
Hongdongxian 洪洞縣
Hongdu 洪都
Hongwu 洪武
Hongxi 洪熙
Hongzhi 弘治
hou 后
Hou Jin 後金
Houguan 候官

Houtian 後天
Houtu 后土
Houtu Miao 后土廟
Hu (birthplace of Laozi) 苦
Hu (Sogdian) 胡
hu (tablet) 笏
Hu Chao 胡超
Hu Huichao 胡慧超
Hua Qiao 華僑
Hua Shan 華山
huacai 化財
Huagai xing 華蓋星
huagai zhi zuo 華蓋之坐
huang 皇
Huang Bosi 黃伯思
Huang Chuping 黃初平
Huang Gongjin 黃公瑾
Huang Gongwang 黃公望
huang guifei 皇貴妃
Huang Ji (Kemei) 黃濟（可美）
Huang Quan 黃筌
Huang Shan 黃山
Huang Shang 黃裳
Huang Tingjian 黃庭堅
Huang Xiufu 黃休復
Huang Yun 黃雲
Huangdi 黃帝
Huangfu Mi 皇甫謐
Huangjun 皇君
Huanglao 黃老
Huanglao dao 黃老道
Huanglao zhi dao 黃老之道
Huanglu 黃籙
Huanglu dazhai 黃籙大齋
Huangqing 皇慶
Huanshu Tang 環樞堂
huasheng 化生
Huayan Si 華嚴寺
Huayangxia Guan 華陽下館
Hubei 湖北
Hui 會
Huichang 會昌
huimiao banxue 毀廟辦學
Huizong 徽宗
hun 魂
Hunan 湖南
Hundun 混沌
hunmen 魂門
Hunyuan Dian 混元殿
huoyao 火藥
ji (armrest) 几
Ji (area) 冀
Ji (river) 濟
jia 甲
Jia Shanxiang 賈善翔

Jiajing 嘉靖
Jian mu 建木
Jiang Zicheng 蔣子誠
jiangjun 將軍
Jiangnan 江南
Jiangsu 江蘇
Jiangxi 江西
jiangyi 降衣
Jiangzhou 江州
Jiankang 建康
Jianwen 建文
Jianyang 簡陽
Jianye 建業
Jiao (lunar mansion) 角
jiao (ritual) 醮
jiao (teaching) 教
Jiao Bingzhen 焦秉貞
Jiao Hong 焦竑
jiaoji 交績
jiaozhu 教主
Jiaqing 嘉慶
Jiaxing 嘉興
jiaxu 甲戌
jiayin 甲寅
Jiazhai liushen 家宅六神
Jidu 計都
jie 劫
jie zhang 節杖
jijiu 祭酒
Jin (dynasty, 265–420) 晉
Jin (dynasty, 1115–1234) 金
Jin Ci 晉祠
Jin Yunzhong 金允中
Jinchang 金昌
Jing (area) 荊
jing (essence) 精
Jing (lunar mansion) 井
jing (oratory) 靜
jing (sacred or classic text) 經
Jing Hao 荊浩
Jing Shan 荊山
jingli 經歷
Jingming 淨明
Jingming zhongxiao dao
 淨明忠孝道
Jingquan tongzi 井泉童子
jingshe 精舍
Jingshi 靜室
Jingtai 景泰
Jingtong An 靜通庵
Jingzhen jian 景震劍
Jinhua fu 金華府
Jinjuzha 金俱吒
Jinling 金陵
Jinmu 金母

Jinmu yuanjun 金母元君
Jinshen Dian 謹身殿
jinshi 進士
jintong 金童
Jinyiwei 錦衣衛
Jisi zhi 祭祀治
jiu jie zhang 九節杖
jiugong 九宮
Jiuguang jiao 九光醮
Jiuquan 酒泉
Jiutian shendan 九天神丹
Jiuyao 九曜
Jiuyi Shan 九疑山
Jiuyi xianhou 九疑仙侯
jiuzhou 九洲
jiwei 己未
Jixian Yuan 集賢院
jue 爵
Juran 巨然
Jurong 句容
Kaifeng 開封
Kaiguang tongzi 開光童子
Kaihuang 開皇
Kaiming tongzi 開明童子
Kaiping fu 開平府
Kaiyuan 開元
kan 坎
Kang 亢
Kang Youwei 康有為
Kangxi 康熙
kesi 緙絲
Kongtong Shan 崆峒山
Kongzi Miao 孔子廟
Kou Qianzhi 寇謙之
Kuaiji 會稽
Kuanglu Shan 匡廬山
Kuangye dajiang 曠野大將
Kuixing 魁星
kun (leviathan) 鯤
kun (trigram) 坤
Kunlun 崑崙
Kunlun Shan 崑崙山
Kunning 坤寧
Kunshan 崑山
Lan Caihe 籃采和
Lang Shining 郎世寧
Langgan 琅玕
Langzhong 閬中
Lanxi xian 蘭谿縣
Lao Dao 老道
Laojun 老君
Laoren xing 老人星
Laozi 老子
Laozi huahu 老子化胡
Le Shan 樂山

Leigong 雷公
Leishen 雷神
Leng Qian 冷謙
li (mile) 里
li (trigram) 離
Li 李
Li Bo (Li Bai) 李白
Li Cun 李存
Li Daoqing 李道清
Li Derou 李德柔
Li Di 李迪
Li Dongyang 李東陽
Li Gonglin 李公麟
Li Jie 李誡
Li Laojun 李老君
Li Ling 李零
Li Ping'er 李瓶兒
Li Shan 驪山
Li Shaojun 李少君
Li Song 李嵩
Li Tieguai 李鐵拐
Li Zhi 李鷙
Li Zhong 李忠
Lian Shu 連叔
liandu 鍊度
Liang 梁
Liang Kai 梁楷
Liang Qingbiao 梁清標
Liang Wudi 梁武帝
Liao 遼
Liaoning 遼寧
libu shilang 禮部士郎
Liezi 列子
Lin Jing 林靜
Lin Lingsu 林靈素
Lin Mo 林默
Lin'an 臨安
ling 靈
Lingbao 靈寶
Lingbao jun 靈寶君
Lingbao tianzun 靈寶天尊
Linggan Ci 靈感祠
Lingguan Dian 靈官殿
lingguang 靈光
Lingjing 靈境
lingtai 靈台
lingzhi 靈芝
Lingzu Dian 靈祖殿
Linshui furen 臨水夫人
Lintong 臨潼
Liu 柳
Liu An 劉安
Liu Ansheng 劉安勝
Liu Bei 劉備
Liu Bingzhong 劉秉忠

liu bo 六博
Liu Chengyin 劉誠印
Liu ding shennü 六丁神女
Liu Haichan (Liu Hai, Xuanying, Haichanzi) 劉海蟾（劉海，玄英，海蟾子）
Liu Hunkang 劉混康
Liu Ji 劉基
Liu jia jiangjun 六甲將軍
Liu Ling 劉伶
Liu Sheng 劉勝
Liu Shouguang 劉守光
Liu Song 劉宋
Liu Songnian 劉松年
Liu Xiang 劉向
Liu Xu 劉昫
Liu Yan zhuan 劉焉傳
Liu Yiqing 劉義慶
Liu Yuanran 劉淵然
Liu Zongyuan 柳宗元
Liuhe Ta 六和塔
Long Meizi 龍眉子
long tai 龍胎
Longhan 龍漢
Longhu men 龍虎門
Longhu Shan 龍虎山
Longjing Shan 龍井山
Longmen pai 龍門派
Longqing 龍慶
Longquan 龍泉
Longxu 隆緒
Lou 婁
louguan 樓觀
Louguan Tai 樓觀臺
lu (censer) 爐
lu (register) 籙
Lu (state) 魯
Lu Ban 魯班
Lü Dongbin (Chunyang) 呂洞賓（純陽）
Lu Guang 陸廣
Lü Ji 呂紀
Lü Ji bai shou 呂紀拜手
Lu Shan 蘆山
Lü Wenying 呂文英
Lu Xinyuan 陸心源
Lu Xiujing 陸修靜
Luan 鸞
Luli 角里
Luo Nian'an 羅念菴
Luofu Shan 羅浮山
Luohou 羅睺
Luoshu 洛書
Luoyang 洛陽
Lushan 蘆山

lusheng 籙生
Lutai 露臺
Luxing 祿星
Luyi 鹿邑
Luzhong 陸終
Ma Junxiang 馬君祥
Ma Lin 馬麟
Ma Yuan 馬遠
Ma yuanshuai 馬元帥
Ma Zhiyuan 馬致遠
Magu 麻姑
Mahao 麻濠
Mancheng 滿城
mandao 慢道
Mao 昴
Mao Shan 茅山
Mawangdui 馬王堆
Mawei shui 馬尾水
Mazu 媽祖
Meng Zhen 孟真
mengwen 盟文
Menshen 門神
Mi Fu 米芾
mian 晃
Mianyang 綿陽
miao 廟
Miao Shanshi 苗善時
miaoyi 妙一
mijiao 密教
Min Jiang 岷江
min yi xin xiang 民夷信向
ming 命
Ming 明
Ming Chengzu 明成祖
Ming Renzong 明仁宗
Ming Taizu 明太祖
Minghuang 明皇
Mingtang 明堂
mingwang 明王
Mingyingwang 明應王
mizei 米賊
mo 脈
Mo Shilong 莫是龍
Moli zhi tian 摩利支天
moya keci 摩崖刻辭
Mu Xin 沐昕
Mugong 木公
Nanchang 南昌
Nanji 南極
Nanji dadi 南極大帝
Nanji laoren 南極老人
Nanji tian dijun 南極天帝君
Nanjing 南京
Nanxi 南溪
Nanyang 南陽

nei 內
neidan 內丹
Neiguan xiang 內觀像
Ni Zan 倪瓚
niangniang 娘娘
Niujiaozhai 牛角寨
Niwan 泥丸
Niwan xiang 泥丸像
Nü 女
nüguan 女官
Ouyang Xiu 歐陽修
pailou 牌樓
Pan Dechong 潘德沖
Pan Zhengwei 潘正煒
Pantao hui 蟠桃會
pei zhi 配治
Peng 鵬
Peng Shan 彭山
Peng Xiao 彭曉
Penglai 蓬萊
Pengxian 彭縣
Pengzu 彭祖
Pingcheng 平城
Pingyang 平陽
pipa 琵琶
po 魄
pu 樸
Putian 莆田
Puyang 濮陽
puzuo 鋪作
qi 氣
Qi 齊
Qi Liji 綺里季
Qi Shaoweng 齊少翁
qi yuan 七元
qian 乾
Qian Gu 錢穀
Qian Lezhi 錢樂之
qian shu 錢樹
qianlin 騫林
Qianlong 乾隆
Qianqiu jie 千秋節
Qiantang 錢塘
Qiantian 前天
Qianyuan Si 乾元寺
qilin 麒麟
Qin 秦
Qin Shihuangdi 秦始皇帝
Qin'an Dian 欽安殿
Qing (area) 青
Qing (dynasty, pure) 清
Qingbaixiang 清白鄉
Qingcheng Shan 青城山
Qinghe 清河
Qinghua 青華

qinglong 青龍
qinglu 青綠
Qingxiao Men 青霄門
Qingyang Gong 青羊宮
Qiu Chuji (Changchun) 丘處機（長春）
Qiu Ying 仇英
Qixing tang 七星塘
qiyun shengdong 氣韻生動
Qu Yuan 屈原
Quanzhen 全真
que 闕
Qufu 曲阜
Qunxian gaohui tu 群仙高會圖
Quren 曲仁
Quyang 曲陽
ren 任
Ren Jiyu 任繼愈
Ren Renfa 任仁發
renshou 仁壽
renyin 壬寅
Renzhi Dian 仁智殿
Rijin qingguang 日近清光
Rong Cheng 容成
ru 儒
ruan 阮
Ruan Ji 阮籍
Ruan Xian 阮咸
Ruicheng 芮城
ruyi 如意
Sa Dula 薩都拉
San Mao jun 三茅君
San Qing 三清
sancai 三才
Sandong 三洞
Sandong chiwen zongzhen xianjian 三洞赤文總真仙簡
sanduan shenxian jing 三段神仙鏡
Sangu furen 三姑夫人
Sanguan 三官
Sanhuan linggang 三環靈剛
Sanhuang 三皇
Sanjiao 三教
Sanjiao heyi 三教合一
Sanjiao Tang 三教堂
Sanjiao yizhi 三教一至
Sanqi 三氣
Sanqing 三清
Sanqing Dian 三清殿
Santai 三臺
Santai qixing jian 三臺七星劍
Santian 三天
Santian yufu 三天玉符
santian zhi shi 三天之師
Sanyuan 三元

Shaanxi　陝西
Shan　禪
Shan Tao　山濤
Shandong　山東
Shang　商
Shang Shan　商山
Shang Xi　商喜
Shang Yi　尚義
Shangdi　上帝
Shanghai　上海
Shangjing　上京
Shangmiao　上廟
Shangqing　上清
Shangqing Dian　上清殿
Shangqing Gong　上清宮
Shangqing zhenren　上清真人
Shangyuan　上元
Shangyuan furen　上元夫人
Shangzhen zixu yuanjun
　　上振紫虛元君
Shanxi　山西
Shao Mi　邵彌
Shao Yong　邵永
Shaoxing　紹興
She　社
she huagai zhi zuo　設華蓋之座
shehui　社會
shen (body)　身
Shen (imperial consort)　沈
Shen (lunar mansion)　參
shen (spirit, god)　神
shen dian　神殿
Shen Gua　沈括
shen gui　神龜
shen hua　身化
shen nü　神女
shen ren　神人
shen shan　神山
shen shu　神樹
Shen Yue　沈約
Shen Zhongyi　沈仲義
Shen Zhou　沈周
Shenbao jun　神寶君
sheng (crown of Xiwangmu)
　　繩，勝
sheng (mouth organ)　笙
sheng (saint)　聖
Shengmu　聖母
Shengmu Dian　聖母殿
shengxian　升仙
shengxiang　聖像
shenling　神靈
Shennong　神農
shenshui　神水
Shenxiao　神宵

Shenyang　沈陽
Shenyue Guan　神樂觀
shi (cosmic board)　式
Shi (lunar mansion)　室
shi (origins)　始
shi (teacher, master)　師
Shi jun　師君
Shi Shen　石申
shi tan　石壇
shidafu　士大夫
shi'er gong　十二宮
Shijiazhuang　石家庄
shijie　尸解
Shiziwan　柿子灣
shou　壽
shouji　授記
Shouxing　壽星
shu (pivot)　樞
Shu (Sichuan province)　蜀
Shu Han　蜀漢
Shu Qi　叔齊
Shui guan　水官
Shuilu zhai　水陸齋
Shuishen Miao　水神廟
Shun　舜
Shuping　叔平
Shuyu　叔虞
si　寺
Sichuan　四川
siheyuan　四合院
siling　四靈
Sima Chengzhen　司馬承禎
Sima Guang　司馬光
Sima Qian　司馬遷
Siming Lü Tingzhen zhi yin
　　四明呂廷振之印
Sishen　四神
Sisheng　四聖
Song Defang　宋德方
Song Guangzong　宋光宗
Song Huizong　宋徽宗
Song Lian　宋濂
Song Lizong　宋理宗
Song Ningzong　宋寧宗
Song Renzong　宋仁宗
Song Shan　嵩山
Song Zhenzong　宋真宗
Su Shi (Dongpo)　蘇軾（東坡）
Su Zun　蘇遵
Sui　隋
Sui Wendi　隋文帝
Suiren　燧人
Suixing　歲星
Sun Chuo　孫綽
Sun Jue　孫玨

Sun Simiao　孫思邈
Suzhou　蘇州
tadao　踏道
Tai Shan　泰山
Tai Shangqing Gong　太上清宮
Taibo　太白
Taicang　太倉
Taidan yunü　太丹玉女
Taiding　泰定
Taifu Guan　太符觀
Taihe Shan　太和山
Taiji　太極
Taiji Gong　太極宮
Taiji xianhou　太極仙候
Taiji yueli　太極月醴
Taijiquan　太極拳
Taiping　太平
Taiping Dao　太平道
Taiqing　太清
Taiqing Gong　太清宮
Taiqing xianbo　太清仙伯
Taishang　太上
Taishang dadao jun　太上大道君
Taishang daojun　太上道君
Taishang laojun　太上老君
Taishang wuji dadao haotian yuhuang
　　shangdi　太上無極大道昊天玉皇
　　上帝
Taishang xuanyuan huangdi　太上玄
　　元皇帝
Taisui　太歲
Taitai　太太
Taiwan　臺灣
Taiwei　太微
Taiwei Gong　太微宮
Taiwu　太無
Taixu　太虛
Taixuan dusheng　泰玄都省
Taiyang　太陽
Taiyi　太一（太乙）
Taiyin　太陰
Taiyin xingjun　太陰星君
Taiyuan　太原
Taizhong　臺中
Taizi Yan　太子巖
Taizu　太祖
tan　壇
tanbing　談柄
tang (hall)　堂
Tang (dynasty)　唐
Tang Gaozong　唐高宗
Tang Gongfang　唐公房
Tang Hou　湯皇
Tang Muzong　唐穆宗
Tang Taizong　唐太宗

Tang Wuzong　唐武宗
Tang Xianzong　唐憲宗
Tang Xuanzong　唐玄宗
Tang Yin　唐寅
Tangdi　湯帝
Tanyangzi　曇陽子
Tao Hongjing　陶弘景
ti　體
tian　天
Tian guan　天官
Tian shu　天樞
Tianbao　天寶
Tianbao jun　天寶君
Tianchang Guan　天長觀
Tiandi　天帝
Tiandi hui　天地會
tianding　天丁
Tiandu　天都
Tianhou　天后
Tianhuang　天皇
Tianhuang dadi　天皇大帝
Tianjin　天津
tianjun　天君
tianmen　天門
Tianpeng　天蓬
Tianqing Guan　天清觀
Tianshi (celestial master)　天師
Tianshi (heavenly city)　天市
Tianshi dao　天師道
Tianshi fu　天師府
Tianshun　天順
Tiantai　天台
Tianwen tu　天文圖
tianxian　天仙
Tianxin dafa　天心大法
Tianxin zhengfa　天心正法
Tianyi Chi　天一池
Tianying Shan　天應山
Tianyou　天猷
Tianzhen　天真
Tianzun　天尊
Tiebao　鐵保
tieniu　鐵牛
Tongchu dafa　童初大法
Tongming Dian　通明殿
tongzi　童子
toujian　投簡
toulong　投龍
Tu Long　屠隆
Tudi　土地
Tuo Jiang　沱江
wai　外
waidan　外丹
waidao　外道
waifa xiang　外法像

Wan Shanglie　萬尚烈

Wanfa zongtan　萬法宗壇

wang　王

Wang Anshi　王安石

Wang Ashan　王阿善

Wang Bi　王弼

Wang Chang　王昶

Wang Chongyang (Wang Zhe)　王重陽（王嚞）

Wang Fu　王黼

wang guan　王冠

Wang Laozhi　王老志

Wang Liyong　王利用

Wang Meng　王蒙

Wang Qidao　王啟道

Wang Qin　王勤

Wang Rong　王戎

Wang Shen　王詵

Wang Shizhen　王世貞

Wang Wenqing　王文卿

Wang Xijue　王錫爵

Wang Xizhi　王羲之

Wang Xuanhe　王懸河

Wang Yangming　王陽明

Wang Yun　王雲

Wang Zhe　王嚞

Wang Zhiyuan　王致遠

Wang Ziqiao　王子喬

Wang Zixi　王仔昔

Wanli　萬曆

Wanshou Gong　萬壽宮

Wei (dynasty)　魏

Wei (lunar mansion)　危

Wei (river)　渭

Wei Boyang　魏伯陽

Wei Hanjin　魏漢津

Wei Huacun　魏華存

wei ji　偽技

Wei Su　危素

Wei Taiwudi　魏太武帝

Wei Wenlang　魏文朗

Wei Zheng　魏徵

weichi　尾鴟

Weiming Dong　未明洞

weiqi　圍棋

weishu　緯書

Wen Boren (Wufeng)　文伯仁（五峰）

Wen Jia　文嘉

Wen Peng　文彭

Wen Qiong　溫瓊

Wen Yuanshuai　溫元帥

Wen Zhengming　文徵明

Wenchang　文昌

Wenshui xian　文水縣

Wenwang　文王

Wenzhou　溫州

Wenzi　文子

Wong Tai Sin (Huang daxian)　黃大仙

wu (non-being)　無

Wu (district)　吳

Wu Boli　吳伯理

Wu Chan　吳禪

Wu Cheng　吳澄

Wu Dacheng　吳大澂

Wu Daozi (Wu Daoxuan, Wu Daoshi)　吳道子（吳道玄，吳道士）

Wu Men　武門

Wu Meng　吳猛

Wu Quanjie　吳全節

Wu Rongguang　吳榮光

Wu She　吳捨

Wu Shu　吳淑

Wu Si　吳四

Wu Wei　吳偉

Wuxian　巫咸

Wu Zetian　武則天

Wu Zhuo　吳晫

Wu Zongyuan　武宗元

wuchen　戊辰

Wuchengzi　務成子

Wudang Shan　武當山

Wude　武德

Wudoumi　五斗米

Wudoumi Dao　五斗米道

Wufang wudi Changbo Shan kaitian hongsheng di　五方五帝常白山開天弘聖帝

Wuhan　武漢

Wuji　無極

Wuji Men　無極門

wuju xiaohan　無拘霄漢

Wuren You Qiu　吳人尤求

Wutai Shan　五台山

wuwei zhi shi　無為之事

wuwu　戊午

Wuxi　無錫

Wuxing (five phases)　五行

Wuxing (town)　吳興

Wuxing qiyao zhi xiang　五行七曜之象

Wuyi Shan　武夷山

wuyue　五嶽

Wuyue Dian　五嶽殿

Wuyue Guan　五嶽觀

Wuyue Miao　五嶽廟

Wuyue zhenxing tu　五嶽真形圖

Xi Kang　稽康

Xi mu　西母

Xi Shan　西山

Xia　夏

Xia Gui　夏珪

xia qi　俠氣

Xiahuang　夏黃

xian　仙

Xi'an　西安

xian hua　仙化

xian shan　仙山

xian sheng　仙聖

Xiang Xiu　向秀

Xiang Yuanbian　項元汴

Xiangfu Gong　祥符宮

xianren　仙人

xiansheng　先生

Xiantian　先天

Xiantian shan　先天山

xiantong　仙童

xianyou　仙友

xiao (filial piety)　孝

xiao (pan-pipes)　簫

Xiao Baifang　蕭百芳

Xiaodao　孝道

Xiaokang　孝康

xiaomuzuo　小木作

Xiaoxian　小仙

Xianzong zhushi　仙宗柱石

Xichang　西昌

xie (heterodox)　邪

xie (mythical beast)　獬

Xie He　謝赫

Xie Lingyun　謝靈運

Xie Shichen　謝時臣

Xie Shouhao　謝守灝

Xie Youyu　謝幼輿

Xihu Dai Jin xie　西湖戴進寫

Ximen Qing　西門慶

xin　心

Xindu　新都

xing (inner nature)　性

Xing (star)　星

Xing'an　興安

Xingqing Gong　興慶宮

xinhai　辛亥

Xinjiang　新疆

Xinjin　新津

Xiping　熙平

xiuzhen　修真

Xiwangmu　西王母

Xixia　西夏

Xu (area)　徐

Xu (family)　許

Xu (lunar mansion)　虛

xu (void, emptiness)　虛

Xu Bangda　徐邦達

Xu Daoling　徐道齡

Xu Fu　徐福

Xu Hao　虛耗

Xu Hui　許翽

Xu Jian　許建

Xu Mai　許邁

Xu Mi　許謐

Xu Qin　徐沁

Xu Wei　徐渭

Xu Xun　徐遜

Xu You　許由

Xu Zhichang　徐知常

xuan　玄

Xuanchu　玄初

Xuande　宣德

Xuanhe　宣和

Xuanjiao　玄教

Xuanjiao Yuan　玄教院

Xuanmiao Guan　玄妙觀

Xuannü　玄女

Xuantian shangdi　玄天上帝

Xuantian yuansheng renwei shangdi　玄天元聖仁威上帝

Xuantong　宣統

Xuanwu　玄武

Xuanxiao　玄枵

Xuanxue　玄學

Xuanyuan huangdi　玄元皇帝

Xuanyuan huangdi Miao　玄天皇帝廟

Xuanzhong zhenren　玄中真人

Xujing zhenren liandan dong　虛靜真人煉丹洞

xunlu　薰爐

ya mu　崖墓

Ya'an　雅安

Yan Deyuan　閻德源

Yan Hui　顏輝

Yan Liben　閻立本

Yan Zhenqing　顏真卿

Yanchang　延昌

Yanfu Gong　延福宮

yang (force)　陽

Yang (name)　揚

yang sheng　養生

Yang Weizhen　楊維楨

Yang Xi　楊羲

Yang Xizhen　楊希真

Yangping Shan　陽平山

Yangping Zhi　陽平治

yangshen zhi　養神芝

Yanguang niangniang　眼光娘娘

Yangzhou　揚州

Yangzi　楊子

Yankang　延康

Yanluo wang　閻羅王
yannian shishi　延年石室
Yanqing Guan　延慶觀
Yanyou　延祐
Yao　堯
Yao Boduo　姚伯多
Yao Chi　瑤池
yao qian shu　搖錢樹
Yao Silian　姚思廉
Yaowang Shan　藥王山
yi (idea, intent)　意
Yi (archer)　伊
yi long wan shou yu tian chang cun
　益隆萬壽與天長存
Yin (dynasty)　殷
yin (force)　陰
yin (licentious)　淫
Yin Wencao　尹文操
Yin Xi　尹喜
Yin xiansheng　尹先生
Yin Zifang　陰子方
Yinghuo　熒惑
Yingjing　榮經
Yingtian　應天
Yingzhen Guan　迎真觀
Yingzhou (island)　瀛洲
yinyang　陰陽
Yisheng　翊聖
Yisheng baode zhenjun
　翊聖保德真君
Yixing　一行
Yizhou　益州
yong　用
Yongji　永濟
Yongle　永樂
Yongle Gong　永樂宮
Yongshou Si　永壽寺
Yongxing　永瑆
Yongzheng　雍正
you (being)　有
you (dark, obscure)　幽
you jing　幽精
You Qiu (Fengqiu)　尤求（鳳丘）
you zhi　遊治
Yousheng yuanshuai　佑聖元帥
Youyu xian　右玉縣
Yu (area)　豫
Yu (emperor)　禹
Yu Ji　虞集
Yu Jikan　余吉刊
yu qi　玉氣
yu zhi yu hua bing shu
　御製御畫并書
yuan　緣
Yuan Chengzong　元成宗

Yuan Miaozong　元妙宗
Yuan Mingshan　元明善
Yuan Renzong　元仁宗
Yuan Shizu　元世祖
Yuan Yao　袁耀
Yuanjiao　員嶠
Yuanmiao Guan　元妙觀
yuanqi　元氣
yuanshen　元神
Yuanshi tianzun　元始天尊
Yuanshuai　元帥
Yuanyang tongzi　元陽童子
Yuanyou　元祐
Yubu　禹步
Yuci　榆次
yue (sacred peak)　嶽
Yue (state)　越
yuetai　月台
Yueyang　岳陽
Yueyang Lou　岳陽樓
Yuhuang　玉皇
Yuhuang da tiandi　玉皇大天帝
Yuhuang ge　玉皇閣
Yuhuang Miao　玉皇廟
Yuhuang shi　玉皇士
Yuhuazi　鬱華子
Yujun Changsha　寓君長沙
Yulong Gong　玉隆宮
Yulong wanshou Gong　玉隆萬壽宮
Yunjin shi　雲錦石
Yunnan　雲南
yunü　玉女
Yunü Lingguan Tang　玉女靈感堂
yunzhuan　雲篆
Yuqing　玉清
yuren　羽人
Yushan　虞山
Yuyao　餘姚
Zao wang　灶王
zaohua　造化
zaojing　藻井
Zeng　曾
Zenghou Yi　曾侯乙
Zetian Shengmu Miao　則天聖母廟
zhai　齋
zhai guan　齋館
Zhang (empress)　章
Zhang (lunar mansion)　張
Zhang Biyun　張碧雲
Zhang Boduan　張伯端
Zhang Daoling　張道陵
Zhang Guolao　張果老
Zhang Guoxiang　張國祥
Zhang Heng　張衡
Zhang Hua　張華

Zhang Huang　章潢
Zhang Jiao　張角
Zhang Junfang　張君房
Zhang Liang　張良
Zhang Ling (Daoling)　張陵（道陵）
Zhang Ling xiansheng　張陵先生
Zhang Liusun　張留孫
Zhang Lu (Celestial Master)　張魯
Zhang Lu (Ming painter)　張路
Zhang Pu　張普
Zhang Sanfeng　張三丰
Zhang Sengyou　張僧繇
Zhang Shangying　張商英
Zhang Sheng　張盛
Zhang Shicheng　張士誠
Zhang Sicheng (Taixuan)　張嗣成
　（太玄）
Zhang Suqing　張素卿
Zhang Tianyu　張天雨
Zhang Xin　張信
Zhang Xiu　張脩
Zhang Xuanqing　張玄慶
Zhang Yu (Zhang Tianyu)
　張雨（張天雨）
Zhang Yucai　張與材
Zhang Yuchu　張宇初
Zhang Yuqing　張宇清
Zhang zhenren　張真人
Zhang Zongyan　張宗演
Zhao Boju　趙伯駒
Zhao Daoyi　趙道一
Zhao Ji　趙佶
Zhao Lingrang　趙令穰
Zhao Lingzhi　趙令畤
Zhao Mengfu　趙孟頫
Zhao Qi　趙麒
Zhao Xuanlang　趙玄郎
Zhao yuanshuai　趙元帥
Zhaosheng kangui cishou　照聖康慧
　慈壽
Zhaotong　昭通
Zhe　浙
Zhejiang　浙江
zhen　真
Zhenfeng Dian　真風殿
zhenfu　鎮撫
Zheng Cai　鄭采
Zhengde　正德
Zhengtong　正統
Zhengyangzi　正陽子
Zhengyi　正一
Zhengyi Dao　正一道
Zhengyi fawen　正一法文
Zhengyi Guan　正乙觀
Zhengyi jiaozhu　正一教主

zhenjue　真訣
zhenren　真人
Zhenwu　真武
Zhenwu lingying zhenjun　真五靈應
　真君
zhenxian　真仙
Zhenxian Guan　真仙觀
Zhenxing (Saturn)　鎮星
zhenxing (true form)　真形
Zhenxingzi　真行子
zhenyi　真意
zhi　治
Zhi Renzhi Dian Jinyi zhenfu Sanshan
　Huang Ji xie　直仁智殿錦衣鎮撫
　三山黃濟寫
Zhida　至大
Zhidao Guan　致道觀
Zhili　直隸
Zhinan Gong　指南宮
Zhishun　至順
Zhizheng　至正
Zhong Kui　鍾馗
Zhong Yin　鐘因
Zhongdu　中都
Zhongfeng Mingben　中峰明本
Zhongguo daojiao xiehui　中國道教
　協會
Zhongli Quan　鍾離權
Zhongnan Shan　終南山
zhongzhen　眾真
Zhou　周
Zhou Cang　周倉
Zhou Chen　周臣
Zhou Hui　周暉
Zhou Lingwang　周靈王
Zhou Muwang　周穆王
Zhou Xuanzhen (Xuanchu)　周玄真
　（玄初）
Zhou Yu　周御
Zhuolong Gong　濯龍宮
Zhu Cunli　朱存理
Zhu Di　朱棣
Zhu Haogu　朱好古
Zhu Houzhao　朱厚照
Zhu Yi　朱儀
Zhu Youtang　朱祐樘
Zhu Yuanzhang　朱元璋
Zhu Zhichi　朱之赤
Zhu Zhonglian　朱中楝
zhuan　篆
Zhuang Zhou　莊周
Zhuangzi　莊子
Zhulin qixian　竹林七賢
zhuque　朱雀
Zhurong　祝融

Zhuyi　朱衣

Zi Gong　紫宮

Zijincheng　紫禁城

Zisun niangniang　子孫娘娘

Ziting　紫庭

Zitong　梓潼

Ziwei　紫微

Ziwei Beiji　紫微北極

Ziwei dadi　紫微大帝

Ziwei yuan　紫微垣

Zixiao Gong　紫霄宮

Zixu Guan　紫虛觀

ziyang (violet light)　紫陽

Ziyang (county)　資陽

zizhi　紫芝

Zong Bing　宗炳

Zongmi　宗密

zongshi　總釋

Zongyang Gong　宗陽宮

Zui　嘴

zun　尊

Zunyi　遵義

zuo　座

Zuo Ci　左慈

Zuzhou　祖州

BIBLIOGRAPHY

PRIMARY SOURCES

1. Texts from the Taoist Canon (*Zhengtong Daozang*)

References to texts in the Taoist Canon follow the numbering system of Weng Dujian, compiler, *Daozang zimu yinde* (Combined indices to the authors and titles of books in two collections of Taoist literature; Harvard-Yenching Institute Sinological Index Series, no. 25; Beijing: Yenching University, 1935; reprint, Taipei: Xinwenfeng chubanshe, 1988). For a reprint of the Taoist Canon, see ZDTZ.

HY 1 *Lingbao wuliang duren shangpin miaojing* (Wondrous scripture of supreme rank on the infinite salvation of Numinous Treasure)

HY 42 *Yuqing yuanshi xuanhuang jiuguang zhenjing* (Jade Purity realized scripture on the mysterious yellow nine lights of the Primordial Beginning)

HY 45 *Yuqing wushang lingbao ziran beidou bensheng zhenjing* (Jade Purity unsurpassed Numinous Treasure realized scripture on the so of itself fundamental birth of the Northern Dipper)

HY 56 *Taishang yupei jindang taiji jinshu shangjing* (Supreme highest scripture on the jade girdle and golden crown of the ultimate golden book)

HY 97 *Taishang lingbao zhutian neiyin ziran yuzi* (Supreme Numinous Treasure inner tones of all the heavens and so of themselves jade letters)

HY 149 *Xiuzhen taiji hunyuan tu* (Ultimate undifferentiated prime illustration of cultivating realization)

HY 151 *Jinye huandan yinzheng tu* (Illustrations of the sealed verification of the golden elixir of reverted cinnabar)

HY 167 *Dongxuan lingbao zhenling weiye tu* (Cavern of Mystery Numinous Treasure illustration of the positions and duties of the realized numinous)

HY 263 *Xiuzhen shishu* (Ten books on cultivating realization)

HY 292 *Han Wudi neizhuan* (Inner traditions of the martial thearch of the Han)

HY 296 *Lishi zhenxian tidao tongjian* (Penetrating mirror of successive ages of realized adepts who have embodied the Way)

HY 300 *Huayang Tao yinju zhuan* (Biography of the floriate sunlight Master Tao who lives in retirement)

HY 304 *Mao shan zhi* (Chronicle of Mount Mao)

HY 318 *Dongxuan lingbao ziran jiutian shengshen yuzhang jing* (Cavern of Mystery Numinous Treasure scripture on the jade stanzas of the so of themselves nine heavens that give birth to the spirit)

HY 352 *Taishang dongxuan lingbao chishu yujue miaojing* (Supreme Cavern of Mystery Numinous Treasure wondrous scripture on the jade explanations of the crimson book)

HY 369 *Taishang dongxuan lingbao sanyuan wulian shengshi miaojing* (Supreme Cavern of Mystery Numinous Treasure wondrous scripture on the five refinements of the Three Primes that give life to the corpse)

HY 421 *Dengzhen yinjue* (Hidden explanations on ascending to the realized)

HY 426 *Shangqing taishang basu zhenjing* (Highest Purity supreme realized scripture of the Eight Unadorned)

HY 428 *Taishang feixing jiuchen yujing* (Supreme jade scripture on the flight of the Nine Asterisms)

HY 431 *Shangqing hanxiang jianjian tu* (Highest Purity illustration of the sword and mirrors that hold images)

HY 440 *Xu taishi zhenjun tuzhuan* (Illustrated biography of the grand astrologer realized Lord Xu)

HY 441 *Dongxuan lingbao wuyue guben zhenxing tu* (Cavern of Mystery Numinous Treasure ancient version of the illustration of the true forms of the five sacred peaks)

HY 449 *Xiaodao Wu Xu erzhenjun zhuan* (Biography of the two realized lords Wu and Xu of the Way of Filial Piety)

HY 621 *Taishang xuanling doumu dasheng yuanjun benming yansheng xinjing* (Supreme mysterious numinous heart scripture on the root destiny and extension of life of the great sage primordial lady, the Dipper Mother)

HY 622 *Taishang xuanling beidou benming yansheng zhenjing* (Supreme mysterious numinous realized scripture on the root destiny and extension of life of the Northern Dipper)

HY 624 *Taishang shuo nandou liusi yanshou duren miao jing* (Marvelous scripture of salvation of the Southern Dipper that prolongs life in the six bureaus, spoken by the Most High [Laozi])

HY 625 *Taishang shuo dongdou zhusuan huming miao jing* (Marvelous scripture of the Eastern Dipper that rules over destiny and protects life, spoken by the Most High [Laozi])

HY 626 *Taishang shuo xidou jiming hushen miao jing* (Marvelous scripture of the Western Dipper that records names and protects the body, spoken by the Most High [Laozi])

HY 627 *Taishang shuo zhongdou dakui baoming miaojing* (Wondrous scripture spoken by the Great Highest on the protection of life by the great eminence of the Central Dipper)

HY 664 *Daode zhenjing* (True scripture of the Way and its Power)

HY 671 *Taishang wuji dadao ziran zhenyi wucheng fu shangjing* (Supreme highest scripture of the so of themselves realized one talismans of the five correspondences of the limitless great Way)

HY 680 *Song Huizong yujie daode zhenjing* (Imperial explanation of the realized scripture on the Way and its Power, by Emperor Huizong of the Song dynasty)

HY 681 *Song Huizong daode zhenjing jieyi* (Explanation of the significance of the realized scripture of the Way and its Power, by Emperor Huizong of the Song dynasty)

HY 694 *Daode zhenjing shuyi* (Unobstructed significance of the realized scripture of the Way and its Power)

HY 752 *Shangqing riyue wuxing siyao xingjun xuanzhang* (Mysterious petitions on the star lords of the sun, moon, five phases [five planets], and four luminants, [spoken by the] Most High [Laozi])

HY 769 *Hunyuan shengji* (Record of the obscure primordial sage)

HY 773 *Youlong zhuan* (Biography of the one who seems like a dragon)

HY 802 *Taishang dongshen sanhuang yi* (Supreme Cavern of Divinity protocols of the Three Emperors)

HY 957 *Xuantian shangdi qisheng lu* (Record of the opening of sagehood by the Supreme Emperor of the Dark Heaven)

HY 958 *Daming xuantian shangdi ruiying tulu* (Illustrated record of the auspicious responses of the Supreme Emperor of the Dark Heaven to the great Ming dynasty)

HY 973 *Beidou qiyuan jinxuan yuzhang* (Gold mysterious feathered [immortal] petitions of the seven primes [stars] of the Northern Dipper)

HY 999 *Zhouyi cantong qi fenzhang tongzhen yi* (Significance that penetrates realization of the contract of the Three Unities of the Zhou dynasty changes, divided into stanzas)

HY 1010 *Zhen'gao* (Declarations of the perfected)

HY 1026 *Yunji qiqian* (Seven slips of the cloudy satchel)

HY 1117 *Dongxuan lingbao sandong fengdao kejie yingshi* (Cavern of Mystery Numinous Treasure regulations and precepts of the Three Caverns for the beginning of engagement with venerating the Way)

HY 1130 *Wushang biyao* (Supreme secret essentials)

HY 1131 *Sandong zhunang* (Pearl bag of the Three Caverns)

HY 1177 *Baopuzi neipian* (The master who embraces simplicity, inner chapters)

HY 1196 *Taishang santian neijie jing* (Supreme scripture on the inner elucidation of the Three Heavens)

HY 1203 *Taishang xuantian Zhenwu wushang jiangjun lu* (Supreme register of the unsurpassed general, the Perfected Warrior of the Dark Heaven)

HY 1213 *Sangqing lingbao dafa* (Great law of the Highest Purity Numinous Treasure)

HY 1214 *Daomen dingzhi* (Established system for entrance into the Way)

HY 1268 *Dongxuan lingbao wugan wen* (Cavern of Mystery Numinous Treasure writing on the five responses)

HY 1272 *Gaoshang shenxiao zongshi shoujing shi* (Formulary for the transmission of scriptures according to the patriarchs of the most exalted Divine Empyrean)

HY 1304 *Dongzhen shangqing qingyao zishu jingen zhongjing* (Cavern of Perfection Highest Purity violet book on the azure essentials and collected scriptures on the golden root)

HY 1425 *Xuanshang laojun kaitian jing* (Scripture on the opening of the heavens by the Mysterious Highest Elder Lord)

HY 1440 *Xiantian doumu fenggao xuanke* (Mysterious regulations on the presentation of petitions to the Dipper Mother of the Prior Heaven)

HY 1450 *Huang Ming enming shilu* (Periodic record of the benevolent orders of the august Ming dynasty)

HY 1451 *Han tianshi shijia* (Succession of the Han Celestial Masters)

HY 1473 *Lüzu zhi* (Record of Patriarch Lü)

2. Texts from the Buddhist Canon *(Taishō shinshū daizōkyō)*

References to texts in the Buddhist Canon follow the numbering system of *Taishō shinshū daizōkyō* (Buddhist Canon; Tokyo: Taishō shinshū daizōkyō kankō kai, 1988 reprint of 1924 edition).

T 397 *Da fangdeng daji jing* (Scripture of the great assembly of great doctrinal universality)

T 1299 *Wenshu shili pusa ji zhuxian suoshuo jixiong shiri shan'e xiuyao jing* (Scripture spoken by the Bodhisattva Manjushri and all adepts on the auspiciousness and inauspiciousness of times and days and the goodness and wickedness of the radiances of the Lunar Mansions)

T 1300 *Modeng jiajing* (Scripture of Matangi)

T 1308 *Qiyao rangzai jue* (Explanation on dispelling the disasters of the Seven Radiances)

T 1311 *Fantian huoluo jiuyao* (Brahmanic fire net of the Nine Radiances)

T 2035 *Fozu tongji* (Chronological record of Buddhist patriarchs)

T 2059 *Gaoseng zhuan* (Biographies of eminent monks)

T 2060 *Xu gaoseng zhuan* (Continued biographies of eminent monks)

T 2102 *Hongming ji* (Collection of immense brightness)

T 2103 *Guang hongming ji* (Extensive collection of immense brightness)

T 2110 *Bianzheng lun* (Discourse on distinguishing the orthodox)

T 2145 *Chu sanzang jiji* (Collected records on releasing the Tripitika)

3. Dynastic Histories

JS *Jinshu* (Dynastic history of the Jin). Reprint, Beijing: Zhonghua shuju, 1973.

JTS *Jiu Tangshu* (Old dynastic records of the Tang). Reprint, Beijing: Zhonghua shuju, 1975.

LS *Liangshu* (Dynastic records of the Liang). Reprint, Beijing: Zhonghua shuju, 1973.

LiaoS *Liao shi* (Dynastic history of the Liao). 5 vols. Reprint, Beijing: Zhonghua Press, 1974.

MS *Ming shi* (Dynastic history of the Ming). Reprint, Beijing: Zhongguo shuju, 1974.

SS *Song shi* (Dynastic history of the Song). Reprint, Beijing: Zhonghua shuju, 1977.

SuiS *Suishu* (Dynastic records of the Sui). Reprint, Beijing: Zhonghua shuju, 1973.

XWDS *Xin wudai shi* (New history of the Five Dynasties). Reprint, Beijing: Zhonghua shuju, 1974.

YS *Yuanshi* (Dynastic history of the Yuan). Reprint, Beijing: Zhonghua shuju, 1997.

4. Other

BTL Zhao Lingzhi (1175–1231). *Bintui lu* (Record of the retired guest). 10 *juan*. Songyuan biji congshu edition. Reprint, Shanghai: Shanghai guji chubanshe, 1983.

CB Li Tao (1115–1184). *Xu zizhi tongjian changbian* (Supplement to the long compilation of the penetrating mirror of government). 600 *juan*. Reprint, Taibei: Shijie shuju, 1961.

DYXGL Yu Ji. *Daoyuan xuegu lu* (Record of studying antiquity in the garden of the Way). 1341. Reprint, Shanghai: Shangyu, n.d.

GCXZL Jiao Hong, comp. *Guochao xianzhenglu* (Record of presented evidence of the current dynasty). 1616. Reprint, Shanghai: Shanghai shuju, 1987.

GSZ Huangfu Mi (215–282). *Gaoshi zhuan* (Biographies of exemplary gentlemen). Reprint, Zaixuetang congke, n.d.

HHS Fan Ye. *Hou Han shu* (History of the latter Han). Beijing: Zhonghua shuju, 1965.

HJ Deng Chun. 1167. *Huaji* (Painting continued). Reprinted in *Huashi congshu* (Collected texts on the history of painting), vol. 1: 267–356. Shanghai: Shanghai renmin meishu chubanshe, 1962.

HNZ Liu An, et al. *Huainanzi* (The master of Huainan). Reprint, Beijing: Beijing Yanshan chubanshe, 1995.

HuaJ Tang Hou. 1329. *Hua jian* (The mirror of painting). Reprinted in *Huapin congshu* (Collected texts on the classification of paintings), edited by Yu Anjian, 393–425. Reprint, Shanghai: Shanghai renmin meishu chubanshe, 1982.

HZL Wang Mingqing (1127–after 1214). *Huizhu* (Record of shaking the flywhisk). 20 *juan*. Reprint, Beijing: Zhonghua shuju, 1961.

JLSS Zhou Hui. *Jinling suoshi* (Miscellaneous events of Jinling [Nanjing]). 1610. Reprint, Beijing: Wenxue guji kanxing she, 1955.

JSS Feng Yunpeng and Feng Yunyuan, eds. *Jinshi suo* (On bronzes and jades). 1821.

LX Hong Kuo. *Li xu* (Addendum to *Interpreting Han Clerical Writings*). 1168–69. 3 vols. Reprint, Taipei: Yiwen yinshu guan.

LXABJ Lu You (1125–1210). *Laoxue'an biji* (Brush notes from the old scholar's hut). 10 *juan*. Tang Song shiliao biji edition. Reprint, Beijing: Zhonghua shuju, 1979.

LXQZ Wang Shizhen, comp. *Liexian quanzhuan* (The complete biographies of the assorted immortals). 1598. Reprint, Shanghai: Zhongguo gudai banhua congkan, 1961.

MHL Xu Qin. *Ming hua lu* (Record of Ming [dynasty] painters). 1673. Reprinted in *Huashi congshu* (Collected texts on the history of painting), vol. 2. Taipei: Wenshizhe chubanshe, 1974.

MSZ He Qiaoyuan. *Mingshanzang* (Treasury of famous mountains). 8 vols. 1640. Reprint, Yangzhou: Jiangsu guangling guji keyin chubanshe, 1993.

NSYH Li E. *Nan Song yuan hualu* (Record of paintings of the Southern Song dynasty Painting Academy). 1721. Reprinted in *Huashi congshu* (Collected texts on the history of painting), vol. 3: 1593–1790. Taipei: Wenshizhe chubanshe, 1974.

QBGQJ Ni Zan (1306–1374). *Qingbige quanji* (Complete writings of the pure and secluded pavilion). Reprint, Taipei: Guoli zhongyang tushuguan, 1970.

QDGJTSJC Jiang Ting, et al. *Qinding Gujin tushu jicheng* (Imperially commissioned compendium of diagrams and texts, ancient and modern). 1725.

QHW Yan Kejun, comp. *Quan Han wen* (A complete collection of writings from the Han), vol. 11. Beijing: Commercial Press.

QSS *Quan Song shi* (Complete Song [dynasty] poems). Edited by Fu Xuan-cong. Reprint, Beijing: Beijing daxue chubanshe, 1991.

QTS *Quan Tang shi* (Complete Tang [dynasty] poems). 1707. Reprint, Shang-hai: Shanghai guji chubanshe, 1986.

RZSB Hong Mai (1123–1202). *Rongzhai suibi* (Scattered notes from the studio of appearances). 74 *juan*. Reprint, Shanghai: Shanghai guji chubanshe, 1978.

SGZ Chen Shou. *Sanguo zhi* (Record of the Three Kingdoms). Beijing: Zhonghua shuju, 1959.

SHJ Wu Qizhen. *Shuhua ji* (Record of calligraphy and painting). C. 1677. Reprinted in Lu Fusheng, *Zhongguo shuhua quanshu* (Complete texts on Chinese calligraphy and painting), vol. 8: 1–123. Shanghai: Shang-hai shuhua chubanshe, 1993–97.

SHMN Zhu Cunli (1444–1513). *Shanhu munan* (Coral and munan gems). In *Zhongguo shuhua quanshu* (Complete texts on Chinese calligraphy and painting), edited by Lu Fusheng, vol. 3: 323–465. 11 vols. Shanghai: Shanghai shuhua chubanshe, 1992.

SHY *Song huiyao jigao* (Draft of the collected Song [dynasty] documents). Edited by Xu Song (1781–1848), et al. 460 *juan*. Reprint, Beijing: Zhonghua shuju, 1957.

SQBJ Zhang Zhao, et al. *Shiqu baoji* (Precious satchel of the stone channel). 1745. Reprint, Taipei: National Palace Museum, 1971.

SXJSZ Wu Shushan. *Shaanxi jinshi zhi* (Record of metal and stone [inscrip-tions] of Shaanxi). 32 *juan*. Shike shiliao xinbian edition. Reprint, Taibei: Xinwenfeng, 1977.

SXZ Ge Hong. *Shenxian zhuan* (Biographies of the divine immortals). Changsha: Hunan yiwen shuju, 1894.

TFLSHJ Pan Zhengwei. *Tingfan lou shuhua ji* (Record of calligraphy and paint-ing from the Pavilion of Listening to the Sails). 1843. Reprint, Taipei: Shijie shuju, 1970.

TJCBJSBM Yang Zhongliang (1241–1271). *Tongjian changbian jishi benmo* (Topical history drawn from the continuation of the comprehensive mirrors). 150 *juan*. Guangya shuju, 1983.

TWSCT Cai Tao (d. after 1147). *Tiewei shan cong tan* (Compilation of remarks from Iron-Fence Mountain). 1 *juan*. Reprint, Beijing: Zhonghua shuju, 1983.

WXTK Ma Duanlin (1254–1325). *Wenxian tongkao* (Comprehensive investiga-tion of documents). 348 *juan*. Shitong edition. Shanghai: Commercial Press, 1936.

XHHP *Xuanhe huapu* (Xuanhe painting catalogue). 1125. 20 *juan*. Reprinted in *Huashi congshu* (Collected texts on the history of painting), vol. 1: 357–641. Taipei: Wenshizhe chubanshe, 1974.

XHSP *Xuanhe shupu* (Xuanhe calligraphy catalogue). 1120. 20 *juan*. Reprinted in *Zhongguo shuhua quanshu* (Complete texts on Chinese calligraphy and painting), edited by Lu Fusheng, vol. 2: 4–59. Shanghai: Shanghai shuhua chubanshe, 1993.

XQGJ Liang Shizheng, comp. *Xiqing gujian* (Mirror of antiquity of the West-ern Qing). 1751.

XYLDB *Xinyi Liezi duben* (Study manual for *Liezi*). Taipei: Sanmin shuju, 1985.

XYZDB *Xinyi Zhuangzi duben* (Study manual for *Zhuangzi*). Taipei: Sanmin shuju, 1985.

XZZTJ Bi Yuan (1730–1797), et al. *Xu zizhi tongjian* (Supplement to the com-prehensive mirror in aid of government). 20 *juan*. Reprint, Beijing: Zhonghua shuju, 1957.

YJZ Hong Mai (1123–1202). *Yijianzhi* (Record of the listener). 4 vols. Reprint, Beijing: Zhonghua shuju, 1981.

YYB Du Mu. *Yuyi bian* (Compilation of entertained thoughts). C. 1500. Reprinted in *Meishu congshu* (Collected texts on art), vol. 1: 706–11. 3 vols. 1936. Reprint, Shanghai: Jiangsu guji chubanshe, 1986.

YZFS Lie Jie. *Yingzao fashi* (Building standards). 1145. Reprint, Taipei: Shanwu, 1974.

YZMHL Huang Xiufu. *Yizhou minghua lu* (Record of famous painters of Yizhou [Sichuan]). 1006. Reprinted in *Huashi congshu* (Collected texts on the history of painting), vol. 3: 1375–1432. Taipei: Wenshizhe chubanshe, 1974.

ZHWQN *Zhonghua wuqian nian wenwu jikan* (Five thousand years of Chinese cultural relics). Taipei: Zhonghua wuqian nian wenwu jikan bianji weiyuanhui, 1983–.

ZTDZ *Zhengtong Daozang* (Taoist Canon of the Zhengtong reign). 61 vols. 1444–45. Reprint, Taipei: Xinwenfeng chubanshe, 1988.

ZZTJ Sima Guang, *Zizhi tongjian* (Penetrating mirror of government). Reprint, Shanghai: Shangyu, 1929.

Secondary Sources

Abe, Stanley K. 1996–97. Heterological Visions: Northern Wei Daoist Sculpture from Shaanxi Province. *Cahiers d'Extrême-Asie* 9: 69–84.

Akizuki, Kan'ei. 1978. *Chūgoku kinsei dōkyō no keisei: jōmeidō no kisoteki kenkyū* (The formation of recent Taoism in China: Fundamental research on the Way of Pure Brightness). Tokyo: Sōbunsha.

Allen, Sarah. 1991. *The Shape of the Turtle: Myth, Art, and Cosmos in Early China*. Albany: State University of New York Press.

Allen, Sarah, and Crispin Williams, eds. 2000. *The Guodian Laozi: Proceedings of the International Conference, Dartmouth College, May 1998*. Berkeley: Institute of East Asian Studies.

An, Jinnuo, gen. ed. 1996. *Zhongguo kaogu* (Chinese archaeology). Taipei: Nantian shuju.

Andersen, Poul. 1989–90. The Practice of *Bugang*. *Cahiers d'Extrême-Asie* 5: 15–53.

Avril, Ellen. 1997. *Chinese Art in the Cincinnati Art Museum*. Cincinnati: Cincinnati Art Museum.

Baker, Dwight Condo. 1925. *T'ai Shan: An Account of the Sacred Peak of China*. Shanghai: Commercial Press.

Baldrian-Hussein, Farzeen. 1984. *Procédés secrets du joyau magique: Traité d'alchimie taoïste du XIe siècle*. Paris: Les Deux Océans.

Baldrian-Hussein, Farzeen. 1986. Lü Tung-pin in Northern Sung Literature. *Cahiers d'Extrême-Asie* 2: 133–69.

Baldrian-Hussein, Farzeen. 1996–97. Alchemy and Self-Cultivation in Literary Circles of the Northern Song Dynasty. *Cahiers d'Extrême-Asie* 9: 15–53.

Baldrian, Farzeen, et al. 1987. Taoism: An Overview. In *The Encyclopedia of Religion*, edited by Mircea Eliade, vol. 14: 288–306. New York: MacMillan.

Baoning si Mingdai shuilu hua. 1988. (Ming dynasty Water and Land Ritual paint-ings from the Baoning Temple). Beijing: Wenwu chubanshe.

Barnhart, Richard. 1983. *Along the Border of Heaven*. New York: Metropolitan Museum of Art.

Barnhart, Richard. 1993. *Painters of the Great Ming: The Imperial Court and the Zhe School*. Exh. cat. Dallas: Dallas Museum of Art.

Barnhart, Richard M. 1997. The Five Dynasties and the Song Period, 907–1279. In Yang Xin, et al., *Three Thousand Years of Chinese Painting*, 87–137. New Haven and London: Yale University Press.

Barrett, T. H. 1987. Taoism: History of Study. In *The Encyclopedia of Religion*, edited by Mircea Eliade, vol. 14: 329–32. New York: MacMillan.

Barrett, T. H. 1993. Lieh tzu. In *Early Chinese Texts: A Bibliographical Guide*, edited by Michael Loewe, 298–308. Berkeley: Society for the Study of Early China.

Barrett, T. H. 1996. *Taoism under the T'ang: Religion and Empire during the Golden Age of Chinese History*. London: Wellsweep Press.

Bartholomew, Terese Tse. 1985. Botanical Puns in Chinese Art. *Orientations* (Sep-tember): 18–34.

Beijing Dongyue Temple. 1999. Beijing: Chaoyang wenhua.

Beijing Palace Museum. 1990. *Mingdai Wumen huihua* (Wu School paintings of the Ming dynasty). Hong Kong: Commercial Press.

Bell, Catherine. 1987. T'ao Hung-ching. In *The Encyclopedia of Religion*, edited by Mircea Eliade, vol. 14: 287–88. New York: MacMillan.

Bell, Catherine. 1988. Ritualization of Texts and Textualization of Ritual in the Codification of Taoist Liturgy. *History of Religions* 27, no. 4: 366–92.

Benn, Charles. 1987. Religious Aspects of Emperor Hsüan-tsung's Taoist Ideology. In *Buddhist and Taoist Practice in Medieval Chinese Society*, edited by David W. Chappell, 127–45. Honolulu: University of Hawaii Press.

Benn, Charles D. 1991. *The Cavern-Mystery Tradition: A Taoist Ordination Rite of A.D. 711*. Honolulu: University of Hawaii Press.

Berger, Patricia. 1994. Preserving the Nation: The Political Uses of Tantric Art in China. In Marsha Weidner, et al., *Latter Days of the Law: Images of Chinese Buddhism, 850–1850*, 89–123. Exh. cat. Lawrence, Kansas: Spencer Museum of Art.

Berling, Judith. 1993. Channels of Connection in Sung Religion: The Case of Pai Yü-ch'an. In *Religion and Society in T'ang and Sung China*, edited by Patricia Buckley Ebrey and Peter N. Gregory, 307–33. Honolulu: University of Hawaii Press.

Berling, Judith. 1998. Taoism in Ming Culture. In *The Cambridge History of China*, edited by Denis Twitchett and Frederick W. Mote. Vol. 8, *The Ming Dynasty, 1368–1644*, pt. 2: 953–86. Cambridge: Cambridge University Press.

Bickford, Maggie. 1996. *Ink Plum: The Making of a Chinese Scholar-Painting Genre.* Cambridge: Cambridge University Press.

Binyon, Laurence. 1927. *Chinese Paintings in English Collections.* Paris and Brussels: G. Vanoest.

Bo Songnian. 1998. *Zhao ji.* Beijing: Wenwu chubanshe.

Bodde, Dirk. 1975. *Festivals in Classical China.* Princeton: Princeton University Press.

Bokenkamp, Stephen R. 1983. Sources of the Ling-pao Scriptures. In *Tantric and Taoist Studies in Honour of R. A. Stein*, edited by Michel Strickmann, vol. 2: 434–86. Brussels: Institut Belge des Hautes Etudes Chinoises.

Bokenkamp, Stephen R. 1996a. The Purification Ritual of the Luminous Perfected. In *Religions of China in Practice*, edited by Donald S. Lopez, 268–77. Princeton: Princeton University Press.

Bokenkamp, Stephen R. 1996b. The Record of the Feng and Shan Sacrifices. In *Religions of China in Practice*, edited by Donald S. Lopez, 251–60. Princeton: Princeton University Press.

Bokenkamp, Stephen R. 1996–97. The Yao Boduo Stele as Evidence for the "Dao-Buddhism" of the Early Lingbao Scriptures. *Cahiers d'Extrême-Asie* 9: 55–67.

Bokenkamp, Stephen R. 1997. *Early Daoist Scriptures.* Berkeley: University of California Press.

Boltz, Judith. 1983. Opening the Gates of Purgatory: A Twelfth-Century Taoist Meditation Technique for the Salvation of Lost Souls. In *Tantric and Taoist Studies in Honour of R. A. Stein*, edited by Michel Strickmann, vol. 2: 487–511. Brussels: Institut Belge des Hautes Etudes Chinoises.

Boltz, Judith. 1987a. *A Survey of Taoist Literature: Tenth to Seventeenth Centuries.* China Research Monograph no. 32. Berkeley: Center for East Asian Studies.

Boltz, Judith. 1987b. Taoist Literature. In *The Encyclopedia of Religion*, edited by Mircea Eliade, vol. 14: 317–29. New York: MacMillan.

Boltz, Judith. 1993. Not by the Seal of Office Alone: New Weapons in Battles with the Supernatural. In *Religion and Society in T'ang and Sung China*, edited by Patricia Buckley Ebrey and Peter N. Gregory, 241–305. Honolulu: University of Hawaii Press.

Boltz, William G. 1996. Notes on the Authenticity of the So Tan Manuscript of the Lao-tzu. *Bulletin of the School of Oriental and African Studies, University of London* 59, no. 3: 508–15.

Bredon, Juliet, and Igor Mitrophanow. 1927. *The Moon Year.* Shanghai: Kelly and Walsh.

Brinker, Helmut. 1973–74. Ch'an Portraits in a Landscape. *Archives of Asian Art* 27: 8–29.

Brinker, Helmut, and Eberhard Fischer. 1980. *Treasures from the Rietberg Museum.* Exh. cat. New York: Asia Society.

Broeck, Janet Rinaker ten, and Yiu Tung. 1951. A Taoist Inscription of the Yüan Dynasty: The Tao-chiao Pei. *T'oung Pao* 40: 60–122.

Brown, Claudia. 1985. Ch'en Ju-yen and Late Yuan Painting in Suchou. Ph.D. diss., University of Kansas.

Brown, Jonathan. 1995. *Kings and Connoisseurs: Collecting Art in Seventeenth-Century Europe.* Princeton: Princeton University Press.

Bruckner, Christopher. 1998. *Chinese Imperial Patronage: Treasures from Temples and Palaces.* Exh. cat. London: Asian Art Gallery.

Bruyn, Pierre-Henry de. 1997. Le Wudang Shan: Histoire des récits fondateurs. 2 vols. Ph.D. diss., Université de Paris VII.

Bruyn, Pierre-Henry de. Forthcoming. Taoism in the Ming, 1368–1644. In *Daoism Handbook*, edited by Livia Kohn. Leiden: E. J. Brill.

Bujard, Marianne. 1998. Le joyau de Chen: Culte historique—culte vivant. *Cahiers d'Extrême-Asie* 10: 131–81.

Burckhardt, V. R. 1982. *Chinese Creeds and Customs.* 1953. Reprint, Hong Kong: South China Morning Post.

Bush, Susan, and Hsio-yen Shih. 1985. *Early Chinese Texts on Painting.* Cambridge: Harvard-Yenching Institute.

Cahill, James. 1960. Confucian Elements in the Theory of Painting. In *The Confucian Persuasion*, edited by Arthur F. Wright, 115–40. Stanford: Stanford University Press.

Cahill, James. 1961a. *Chinese Album Leaves in the Freer Gallery of Art.* Exh. cat. Washington, D.C.: Smithsonian Institution.

Cahill, James. 1961b. The Six Laws and How to Read Them. *Ars Orientalis* 4: 372–81.

Cahill, James. 1976. *Hills Beyond a River: Chinese Painting of the Yüan Dynasty, 1279–1368.* New York and Tokyo: Weatherhill.

Cahill, James. 1978. *Parting at the Shore: Chinese Painting of the Early and Middle Ming Dynasty, 1368–1580.* New York and Tokyo: Weatherhill.

Cahill, James. 1980. *An Index of Early Chinese Painters: T'ang, Sung, and Yüan.* Berkeley: University of California Press.

Cahill, James. 1992. Huang Shan Paintings as Pilgrimage Pictures. In *Pilgrims and Sacred Sites in China*, edited by Suan Naquin and Yü Chün-fang, 246–92. Berkeley: University of California Press.

Cahill, James. 1996. The Imperial Painting Academy. In *Possessing the Past*, edited by Wen C. Fong and James C. Y. Watt, 159–200. New York: Metropolitan Museum of Art.

Cahill, Suzanne. 1980. Taoism at the Sung Court: The Heavenly Text Affair of 1008. *Bulletin of Sung–Yüan Studies* 16: 23–44.

Cahill, Suzanne. 1985–86. Reflections on a Metal Mother: Tu Kuang-t'ing's Biography of Hsi Wang Mu. *Journal of Chinese Religions*, nos. 13/14: 127–42.

Cahill, Suzanne. 1986a. Performers and Female Taoist Adepts: Hsi Wang Mu as the Patron Deity of Women in Medieval China. *Journal of the American Oriental Society* 106, no. 1: 155–68.

Cahill, Suzanne. 1986b. The Word Made Bronze: Inscriptions on Medieval Chinese Bronze Mirrors. *Archives of Asian Art* 39: 62–70.

Cahill, Suzanne. 1993. *Transcendence and Divine Passion: The Queen Mother of the West in Medieval China.* Stanford: Stanford University Press.

Cahill, Suzanne. 1994. Boya Plays the Zither: Two Types of Chinese Bronze Mirror in the Donald H. Graham Jr. Collection. In Toru Nakano, et al., *Bronze Mirrors from Ancient China: Donald H. Graham, Jr. Collection*, 50–59. Honolulu: Donald H. Graham Jr.

Cammann, Schuyler. 1961. The Magic Square of Three in Old Chinese Philosophy and Religion. *History of Religions* 1, no. 1: 37–80.

Cammann, Schuyler. 1964. A Ming Dynasty Pantheon Painting. *Archives of the Chinese Art Society of America* 18: 38–47.

Cao Minggang. 1993. *Renjing hutian* (A gourd-heaven in the world of men). Shanghai: Shanghai guji chubanshe.

Cao Wanru. 1990. *Zhongguo gudai ditu ji* (Atlas of ancient Chinese maps). Vol. 1, *Zhanguo–Yuan* (Warring States to Yuan). Beijing: Wenwu chubanshe.

Chai Zejun. 1986. Shanxi gujianzhu gaishu (General discussion of ancient architecture in Shanxi). In *Zhongguo gujianzhu xueshu jiangzuo wenji* (Journal of studies of ancient Chinese architecture), 244–98. Beijing: Zhongguo zhanwang chubanshe.

Chai Zejun. 1989. *Shanxi gujianzhu mujiegou moxing* (Models of ancient Chinese architecture in Shanxi). Beijing: Beijing Yanshan Press.

Chai Zejun, ed. 1997. *Shanxi siguan bihua* (Monastery wall paintings in Shanxi). Beijing: Wenwu chubanshe.

Chan, Alan. 1982. *The Glory and Fall of the Ming Dynasty.* Norman: University of Oklahoma Press.

Chan, Alan. 1991a. The Formation of the Ho-shang Kung Legend. In *Sages and Filial Sons: Mythology and Archaeology in Ancient China*, edited by Julia Ching and R. W. L. Guisso, 101–34. Hong Kong: Chinese University Press.

Chan, Alan K. L. 1991b. *Two Visions of the Way: A Study of the Wang Pi and the Ho-shang-kung Commentaries on the Lao-tzu.* Albany: State University of New York Press.

Chang Kuang-pin. 1976. An Investigation into the Dates of Chang Yü, Wai-shih of Kou-ch'ü, Parts 1 and 2. *National Palace Museum Bulletin* 10, no. 5: 1–13, and no. 6: 1–16.

Chang Kuang-pin. 1992. The Life and Calligraphy of the Taoist Scholar of Yüan—Chang Yü. *International Colloquium on Chinese Art History: Painting and Calligraphy*, vol. 1: 239–78. Taipei: National Palace Museum.

Changsheng de shijie. 1996. *Changsheng de shijie: Daojiao huihua tezhan tulu* (Realm of the immortals: Catalogue of a special exhibition of Taoist paintings). Taipei: National Palace Museum.

Chard, Robert L. 1999. The Imperial Household Cults. In *State and Court Ritual in China,* edited by Joseph P. McDermott, 237–66. Cambridge: Cambridge University Press.

Chavannes, Edouard. 1909/1913. *Mission archéologique dans la Chine septentrionale.* Vol. 1, 1913 (text); vol. 2, 1909 (plates). Paris: Imprimerie Nationale.

Chavannes, Edouard. 1910. *Le T'ai chan: Essai de monographie d'un culte chinois.* Paris: Ernest Leroux.

Chaves, Jonathan. 1977. The Legacy of Ts'ang Chieh: The Written Word as Magic. *Oriental Art* 23, no. 2: 200–215.

Chen Baozhen. 1993. *Song Huizong huihua de meishu tezhi—jianlun qi yuanyuan he yingxiang* (Special artistic features of Song Huizong's paintings, and a discussion of their origins and influences). *Wenshizhe xuebao* (Studies in literature, history, and philosophy) 40: 293–344.

Chen Guofu. 1985. *Daozang yuanliu kao* (Study of the origins of the Taoist Canon). 2 vols. 1963. Reprint, Beijing: Zhonghua shuju.

Chen Huan. 1988. *Daojia jinshi lue* (A record of Taoist inscriptions). Beijing: Wenwu chubanshe.

Ch'en, Kenneth. 1964. *Buddhism in China: A Historical Survey.* Princeton: Princeton University Press.

Chen Shixiang. 1957. Xiang'er laozi daojing dunhuang canjuan lunzheng. *Ts'ing Hua Journal of Chinese Studies* 1, no. 2: 41–62.

Chen Songchang. 1996. *Mawangdui boshu yishu* (Art of the Silk Manuscripts from Mawangdui). Shanghai: Shanghai shudian chubanshe.

Chen Xiandan. 1997. On the Designation "Money Tree." *Orientations* (September): 67–71.

Chen Yinke. 1933. Tianshidao yu binhai diyu zhi guanxi (The relationship between the Way of the Celestial Masters and the coastal regions). *Zhongyang yanjiuyuan Lishi yuyan yanjiusuo jikan* 3, no. 4: 439–66.

Cheng Te-k'un. 1957. *Yin-yang wu-hsing* and Han Art. *Harvard Journal of Asiatic Studies* 20: 162–86.

Cheng Ying. 1996. *Zhongguo shenxian huaxiang ji* (Images of Chinese gods and immortals). Shanghai: Shanghai guji chubanshe.

Chiang I-han. 1973. Teng Yü: A Late 14th Century Taoist Painter and His "Bamboo and Rock." *National Palace Museum Quarterly* 7, no. 4: 9–11, 49–86.

Chiang I-han. 1974. A Taoist Scholar Painter of the Early Ming: Wu Po-li and his "Pine and Rock." *National Palace Museum Quarterly* 8, no. 3: 33–35, 51–62.

Chou Yi-liang. 1945. Tantricism in China. *Harvard Journal of Asiatic Studies* 8: 241–332.

Christie's, London. 1998. *Ming—The Age of Refinement* (November 16).

Christie's, New York. 1995. *Fine Chinese Paintings and Calligraphy* (March 22).

Chūgoku kaiga. 1975. (Chinese painting). 2 vols. Osaka: Osaka Municipal Museum of Art.

Chūgoku no seki-butsu. 1995. (Chinese Buddhist stone sculpture). Exh. cat. Osaka: Osaka Municipal Museum of Art.

Circa 1492. 1991. *Circa 1492: Art in the Age of Discovery.* Exh. cat. Washington, D.C.: National Gallery of Art.

Cohen, Monique, and Nathalie Monet. 1992. *Impressions de Chine.* Exh. cat. Paris: Bibliothèque Nationale.

Cooper, J. C. 1990. *Chinese Alchemy: The Taoist Quest for Immortality.* New York: Sterling Publishing Co.

Daojiao shenxian huaji. 1995. (Paintings of Taoist gods and immortals). Beijing: Huaxia chubanshe.

Daojiao wenwu. 1999. (Cultural artifacts of Taoism). Taipei: National Museum of History.

Datong shi bowu guan. 1978. (Datong Municipal Museum). Datong Jincai Yan Deyuan mu fajue jianbao (Excavation of the Jin dynasty tomb of Yan Deyuan at Datong in Shanxi province). *Wenwu,* no. 4: 1–13.

Davidson, J. Leroy. 1950. The Origin and Early Use of the Ju-i. *Artibus Asiae* 13, no. 4: 239–49.

Davidson, J. Leroy. 1954. *The Lotus Sutra in Chinese Art.* New Haven: Yale University Press.

Dean, Kenneth. 1993. *Taoist Ritual and Popular Cults of Southeast China.* Princeton: Princeton University Press.

Deng Bai. 1985. *Zhao Ji.* Shanghai: Shanghai renmin meishu chubanshe.

Deng Shaoqin. 1949. *Yibu Han li jilu* (A collection of Han dynasty inscriptions from Sichuan). 2 vols. Chengdu: Sichuan daxue.

Despeux, Catherine. 1979. *Zhao Bichen: Traité d'alchimie et de physiologie taoïste.* Paris: Les Deux Océans.

Despeux, Catherine. 1994. *Taoïsme et corps humain.* Paris: Editions de la Maisnie.

Desroches, Jean-Paul. 1994. *Chine des origines: Hommage à Lionel Jacob.* Exh. cat. Paris: Musée National des Arts Asiatiques Guimet.

DeWoskin, Kenneth J. 1982. *A Song for One or Two: Music and the Concept of Art in Early China.* Ann Arbor: University of Michigan, Center for Chinese Studies.

DeWoskin, Kenneth J., trans. 1983. *Doctors, Diviners, and Magicians of Ancient China: Biographies of Fangshi.* New York: Columbia University Press.

DeWoskin, Kenneth J., and J. I. Crump, Jr. 1996. *In Search of the Supernatural: The Written Record.* Stanford: Stanford University Press.

Ding Hesheng [Kenneth Dean] and Zheng Zhenman. 1995. *Fujian zongjiao beiming huibian* (Compilation of religious stelae inscriptions of Fujian). Fuzhou: Fujian renmin chubanshe.

Ding Mingyi. 1984. Cong Xiang Dule jian Zhou Wenwang Fo Dao zaoxiang bei gan beichao Daojiao zaoxiang (A discussion of Taoist images during the Northern Dynasties based on the "Stele of King Wen of the Zhou, Buddhism, and Daoism" established by Qiang Dule). *Wenwu* (Cultural relics), no. 5: 32–43.

Dongtian shenjing. 1987. (Famous centers of Taoism). Beijing: Zhongguo daojiao xiehui.

Donnelly, P. J. 1969. *Blanc de Chine: The Porcelain of Tehua in Fukien.* London: Faber and Faber.

Dragan, Raymond. 1991. The Dragon in Chinese Myth and Ritual: Rites of Passage and Sympathetic Magic. In *Sages and Filial Sons: Mythology and Archaeology in Ancient China,* edited by Julia Ching and R. W. L. Guisso, 135–62. Hong Kong: Chinese University Press.

Duara, Prasanjit. 1988. Superscribing Symbols: The Myth of Guandi, the Chinese God of War. *Journal of Asian Studies* 47: 778–95.

Eberhard, Wolfram. 1957. The Political Function of Astronomy and Astronomers in Han China. In *Chinese Thought and Institutions,* edited by John K. Fairbank, 33–70. Chicago: University of Chicago Press.

Eberhard, Wolfram. 1986. *A Dictionary of Chinese Symbols.* London and New York: Routledge and Kegan Paul.

Ebine Toshio. 1975. *Gendai dōshaku jinbutsuga* (Daoist and Buddhist figure paintings of the Yuan dynasty). Exh. cat. Tokyo: Tokyo National Museum.

Ebrey, Patricia Buckley. 1981. *Chinese Civilization and Society: A Sourcebook.* New York: Free Press.

Ebrey, Patricia. Forthcoming. Taking Out the Grand Carriage: Imperial Spectacle and the Visual Culture of Northern Sung Kai-feng. *Asia Major,* 3rd ser., vol. 12, pt. 1.

Ebrey, Patricia Buckley, and Peter N. Gregory, eds. 1993. *Religion and Society in T'ang and Sung China.* Honolulu: University of Hawaii Press.

Ecke, Gustav. 1965. *Chinese Painting in Hawaii.* 3 vols. Honolulu: University of Hawaii Press.

Ecke, Tseng Yu-ho (see also Tseng Yu-ho). 1954. The Seven Junipers of Wen Cheng-ming. *Archives of the Chinese Art Society of America* 8: 22–30.

Ecke, Betty Tseng Yu-ho (see also Tseng Yu-ho). 1972. Emperor Hui Tsung, the Artist, 1082–1136. Ph.D. diss., New York University.

Eight Dynasties of Chinese Painting. 1980. Exh. cat. Cleveland: Cleveland Museum of Art.

Eiraku-kyu hekiga. 1981. (Eternal Joy Temple wall paintings). Kyoto: China Foreign Languages Press.

Erickson, Susan N. 1992. Boshanlu—Mountain Censers of the Western Han Period: A Typological and Iconological Analysis. *Archives of Asian Art* 45: 6–28.

Erickson, Susan N. 1994. Money Trees of the Eastern Han Dynasty. *Bulletin of the Museum of Far Eastern Antiquities* 66: 5–115.

Feng Guanghong and Wang Jiayou. 1996. Sichuan Daojiao guyin yu shenmi wenzi (Ancient Taoist seals from Sichuan and mysterious writings). *Sichuan wenwu* (Cultural relics of Sichuan) 1: 17–19.

Feng, H. Y. 1936. The Origin of Yü Huang. *Harvard Journal of Asiatic Studies* 1: 242–50.

Feng Yunpeng and Feng Yunyuan. 1934. *Jinshi suo* (An index to bronzes and stone carvings). Shanghai: Shangwu yinshuguan.

Ferguson, John. 1982. *Lidai zhulu huamu* (Paintings recorded in historical catalogues). Reprint of 1933 edition, Taipei: Wenshizhe chubanshe.

Feuchtwang, Stephan. 1992. *The Imperial Metaphor: Popular Religion in China.* London: Routledge and Kegan Paul.

Fong, Mary H. 1977. A Probable Second "Chung Kuei" by Emperor Shun-chih of the Ch'ing Dynasty. *Oriental Art* 23, no. 4: 423–37.

Fong, Mary H. 1983. The Iconography of the Popular Gods of Happiness, Emolument, and Longevity (Fu Lu Shou). *Artibus Asiae* 44, no. 2: 159–99.

Fong, Wen. 1980. *The Great Bronze Age of China.* Exh. cat. New York: The Metropolitan Museum of Art.

Fong, Wen. 1984. *Images of the Mind.* Exh. cat. Princeton: Princeton University Art Museum.

Fong, Wen. 1992. *Beyond Representation: Chinese Painting and Calligraphy, 8th–14th century.* New York: The Metropolitan Museum of Art.

Fong, Wen, et al. 1996. *Possessing the Past: Treasures from the National Palace Museum, Taipei.* Exh. cat. New York: The Metropolitan Museum of Art.

Fracasso, Riccardo. 1993. Shan hai ching (Classic of mountains and seas). In *Early Chinese Texts: A Bibliographical Guide,* edited by Michael Loewe, 357–67. Berkeley: Society for the Study of Early China.

Fu Qinjia. 1998. *Zhongguo Daojiao shi* (A history of Chinese Taoism). Reprint, Beijing: Shangwu yinshu guan.

Fu Shen. 1967. Juran cunshi huaji zhi bijiao yanjiu (A comparative study of the surviving paintings of Juran). *National Palace Museum Quarterly* 2, no. 2: 51–79.

Fu Xinian. 1973. Tang Chang'an Daminggong Hanyuandian yuanzhuang de tantao. *Wenwu* (Cultural relics), no. 7: 30–48.

Fu Xinian. 1981. Fujian de jizuo Songdai jianzhu ji qi yu Riben Liancang "Da Foyang," jianzhu de guanxi (The relationship between Japanese "Great Buddha Style" architecture of the Kamakura period and several Song buildings in Fujian). *Jianzhu xuebao,* no. 4: 68–77.

Fucikova, Eliska, et al. 1997. *Rudolf II and Prague: The Court and the City.* London: Thames and Hudson.

Ganza, Kenneth. 1986. A Landscape by Leng Ch'ien and the Emergence of Travel as a Theme in Fourteenth-century Chinese Painting. *National Palace Museum Bulletin* 21, no. 3: 1–14.

Gao Wen. 1987. *Sichuan Han dai huaxiangshi* (Han dynasty pictorial carvings in Sichuan). Chengdu: Bashu shushe.

Gao Wen. 1997. Sichuan Han dai huaxiang gailun (A general discussion of Han dynasty pictorial art in Sichuan). *Sichuan wenwu* (Cultural relics of Sichuan) no. 4: 21–27.

Gao Wen and Gao Chenggang. 1996. *Zhongguo huaxiang shiguan yishu* (The art of Chinese stone sarcophagi). Taiyuan: Shanxi renmin chubanshe.

Gedalecia, David. 1981. Wu Ch'eng and the Perpetuation of the Classical Heritage in the Yuan. In *China Under Mongol Rule,* edited by John D. Langlois, 186–211. Princeton: Princeton University Press.

Gen jidai no kaiga. 1998. (Yuan dynasty painting). Exh. cat. Nara: Yamato bunkakan.

Glahn, Else. 1975. On the Transmission of the *Ying-tsao fa-shih.* *T'oung Pao* 61, nos. 4/5: 232–65.

Glory of the Court. 1998. *The Glory of the Court: Tang Dynasty Empress Wu and Her Times.* Exh. cat. Tokyo: Tokyo Metropolitan Art Museum.

Gong Tingwan, et al. 1998. *Ba Shu Han dai huaxiang ji* (A collection of Han dynasty pictorial images from Ba and Shu). Beijing: Wenwu chubanshe.

Goodrich, Anne Swann. 1964. *The Peking Temple of the Eastern Peak.* Nagoya: Monumenta Serica.

Goodrich, Anne Swann. 1991. *Peking Paper Gods.* Nettetal: Steyler Verlag.

Goodrich, L. Carrington, and Fang Chao-ying, 1976. *Dictionary of Ming Biography.* 2 vols. New York: Columbia University Press.

Graham, A. C. 1960. *The Book of Lieh-tzu.* London: John Murray.

Graham, A. C. 1998. The Origins of the Legend of Lao Tan. In *Lao-tzu and the Tao-te-ching,* edited by Livia Kohn and Michael LaFargue, 23–40. Albany: State University of New York Press.

Grootaers, Willem. 1952. The Hagiography of the Chinese God Chen-wu. *Folklore Studies* 12, no. 2: 139–82.

Grootaers, Willem. 1995. *The Sanctuaries of a North-China City: A Complete Survey of the Cultic Buildings in the City of Hsüan-hua (Chahar).* Brussels: Institut Belge des Hautes Etudes Chinoises.

Gugong cangjing. 1996. (Mirrors collected by the Palace Museum). Beijing: Zijincheng chubanshe.

Gugong shuhua tulu. 1991. 10 vols. Taipei: National Palace Museum.

Gulik, Robert Hans van. 1941a. *Hsi K'ang and His Poetic Essay on the Lute.* Tokyo: Sophia University.

Gulik, Robert Hans van. 1941b. On the Seal Representing the God of Literature on the Title Page of Old Chinese and Japanese Popular Editions. *Monumenta Nipponica* 4, no. 1: 33–54.

Gulik, Robert Hans van. 1974. *Sexual Life in Ancient China.* Reprint, Leiden: E. J. Brill.

Guo zhi guibao. 1999. (Extraordinary national treasures). Exh. cat. Beijing: Lishi bowuguan.

Guodian Chu mu zhu jian. 1998. (Bamboo tablets from the Chu tomb at Guodian). Beijing: Wenwu chubanshe.

Gyss-Vermande, Caroline. 1988. Démons et merveilles: Vision de la nature dans une peinture liturgique du XVe siècle. *Ars Asiatiques* 43: 106–22.

Gyss-Vermande, Caroline. 1991. Les messagers divins et leur iconographie. *Arts Asiatiques* 46: 96–110.

Haar, Barend J. ter. 1990. The Genesis and Spread of Temple Cults in Fukien. In *Development and Decline of Fukien Province in the 17th and 18th Centuries,* edited by Eduard B. Vermeer, 349–96. Leiden: E. J. Brill.

Hahn, Thomas. 1988. The Standard Taoist Mountain and Related Features of Religious Geography. *Cahiers d'Extrême-Asie* 4: 145–56.

Han Wei and Yin Zhiyi. 1987. Yaoxian Yaowangshan di Daojiao zaoxiangbei (Taoist image-stelae at Yaowangshan in Yaoxian). *Kaogu yu wenwu* 3: 18–26.

Hansen, Valerie. 1990. *Changing Gods in Medieval China, 1127–1276.* Princeton: Princeton University Press.

Hansen, Valerie. 1993. Gods on Walls: A Case of Indian Influence on Chinese Lay Religion? In *Religion and Society in T'ang and Sung China,* edited by Patricia Buckley Ebrey and Peter N. Gregory, 75–113. Honolulu: University of Hawaii Press.

Harada Kinjirō. 1936. *Shina meiga hōkan* (Pageant of Chinese painting). Tokyo: Otsuka kogeisha.

Hargett, James M. 1988–89. Huizong's Magic Marchmount: The Genyue Pleasure Park of Kaifeng. *Monumenta Serica* 38: 1–48.

Harper, Donald J. 1978–79. The Han Cosmic Board *(Shih).* *Early China* 4: 1–10.

Harper, Donald J. 1999. Warring States Natural Philosophy and Occult Thought. In *The Cambridge History of Ancient China, From the Origins of Civilization to 221 B.C.,* edited by Michael Loewe and Edward L. Shaughnessy, 813–84. Cambridge: Cambridge University Press.

Harrist, Robert E., and Wen C. Fong. 1999. *The Embodied Image: Chinese Calligraphy from the John B. Elliott Collection.* Exh. cat. Princeton: Princeton University Art Museum.

Hartman, Charles. 1993. Mountains as Metaphors in T'ang Religious Texts and the Northern Landscape Painting of the Tenth Century. Paper presented at the conference Mountains and the Cultures of Landscape in China, University of California at Santa Barbara, January 13–14.

Hawkes, David. 1959. *Ch'u Tzu: The Songs of the South.* Oxford: Clarendon Press.

Hay, John. 1978. Huang Kung-wang's *Dwelling in the Fu-chun Mountains.* Ph.D. diss., Princeton University.

Hay, John. 1983. The Human Body as a Microcosmic Source of Macrocosmic Values in Calligraphy. In *Theories of the Arts in China,* edited by Susan Bush and Christian Murck, 74–102. Princeton: Princeton University Press.

Hay, John. 1985. *Kernels of Energy, Bones of Earth: The Rock in Chinese Art.* Exh. cat. New York: China Institute.

Hayashi Minao. 1973. Some Considerations of Images on Han Dynasty Mirrors. *Tohogakuho* 44: 1–65.

He Zhiguo. 1991. Shitan Mianyang chutu Dong Han foxiang jiqi xiangguan wenti (A tentative discussion of the newly discovered Eastern Han Buddha images from Mianyang and related issues). *Sichuan wenwu* (Cultural relics of Sichuan) 5: 23–30.

Hempel, Rose, et al. 1992. *Quellen: Das Wasser in der Kunst Ostasiens.* Exh. cat. Hamburg: Museum für Kunst und Gewerbe.

Hennessey, William O., trans. 1981. *Proclaiming Harmony.* Ann Arbor: University of Michigan, Center for Chinese Studies.

Henning, Stanley E. 1997. Chinese Boxing: The Internal Versus External Schools in the Light of History and Theory. *Journal of Asian Martial Arts* 6, no. 3: 11–19.

Higuchi Takayasu. 1979. *Kokyō* (Ancient mirrors). 2 vols. Tokyo: Shinchōsha.

Ho Peng Yoke. 1987. *Li, Qi, and Shu: An Introduction to Science and Civilization in China.* Seattle: University of Washington Press.

Ho Peng Yoke, Goh Thean Chye, and Beha Lim. 1972. *Lu Yu, the Poet-Alchemist.* Canberra: Australian National University.

Ho, Wai-kam. 1968. Chinese Under the Mongols. In Sherman E. Lee and Wai-kam Ho, *Chinese Art Under the Mongols: The Yüan Dynasty.* Exh. cat. Cleveland: Cleveland Museum of Art.

Hok-lam Chan. 1967. Liu Ping-chung (1216–1274): A Buddhist-Taoist Statesman at the Court of Khubilai Khan. *T'oung Pao* 53: 98–146.

Holzman, Donald. 1988. Ts'ao Chih and the Immortals. *Asia Major,* 3rd ser., vol. 1, pt. 1: 15–57.

Holzman, Donald. 1997. On the Authenticity of the "Preface" to the Collection of Poetry Written at the Orchid Pavilion. *Journal of the American Oriental Society* 117, no. 2: 306–11.

Holzman, Donald. 1998a. Immortality-Seeking in Early Chinese Poetry. In Donald Holzman, *Immortals, Festivals and Poetry in Medieval China: Studies in Social and Intellectual History*, 103–18. Aldershot, Hants.: Ashgate Variorum.

Holzman, Donald. 1998b. Songs for the Gods: The Poetry of Popular Religion in Fifth-Century China. In Donald Holzman, *Immortals, Festivals and Poetry in Medieval China: Studies in Social and Intellectual History*, 1–19. Aldershot, Hants.: Ashgate Variorum.

Holzman, Donald. 1998c. The Wang Ziqiao Stele. In Donald Holzman, *Immortals, Festivals and Poetry in Medieval China: Studies in Social and Intellectual History*, 77–83. Aldershot, Hants.: Ashgate Variorum. Originally published in *Rocznik Orientalistyczny* 47, no. 2 (Warsaw, 1991).

Hou Ching-lang. 1979. The Chinese Belief in Baleful Stars. In *Facets of Taoism: Essays in Chinese Religion*, edited by Holmes Welch and Anna Seidel, 193–228. New Haven and London: Yale University Press.

Hu, Philip K. 2000. *Visible Traces: Rare Books and Special Collections from the National Library of China*. Exh. cat. New York: Queens Borough Public Library.

Hu Wenhe. 1994. *Sichuan Daojiao Fojiao shiku yishu* (Daoist and Buddhist cave art of Sichuan). Chengdu: Sichuan renmin chubanshe.

Hubei Provincial Museum. 1989. *Zenghou Yi mu* (The tomb of Marquis Yi of Zeng). 2 vols. Beijing: Wenwu chubanshe.

Hummel, A. W., ed. 1943. *Eminent Chinese of the Ch'ing Period*. 2 vols. Washington, D.C.: U.S. Government Printing Office.

Hunan Provincial Museum. 1984. Hunan Zixing Jin Nanchao mu (Jin and Southern Dynasties tombs of Zixing in Hunan). *Kaobu xuebao* (Studies in archaeology) 3: 335–60.

Huo Wei. 1999. A Study of Mirrors with Images on Three Registers and Related Problems. *Japonology* 19: 35–52.

Ishii, Masako. 1980. *Dōkyōgaku no kenkyū* (Research on the study of Taoism). Tokyo: Kokusho kankōkai.

Ishimatsu Hinako. 1998. The Date of the Wei Wenlang Stele in the Yaowang Shan Museum, Yaoxian, Shaanxi Province, China: A Reexamination of the Northern Wei Shiguang Year One Inscription (in Japanese). *Bukkyo geijutsu* (Buddhist art) 240 (September): 13–32.

Jackson, Barbara K. 1983. The Yuan Dynasty Playwright Ma Chih-yuan and His Dramatic Works. Ph.D. diss., University of Arizona.

Jacobsen, Robert D. 1991. *Imperial Silks of the Ch'ing Dynasty*. Exh. cat. Minneapolis: Minneapolis Institute of Arts.

James, Jean M. 1989. Some Iconographic Problems in Early Daoist–Buddhist Sculptures in China. *Archives of Asian Art* 41: 71–76.

Jan Yun-hua. 1977. The Silk Manuscripts on Taoism. *T'oung Pao* 63, no. 1: 65–84.

Jao Tsung-i. 1955. Wu Jianheng er nian Suo Dan xie ben *Daode jing* can juan kaozheng (The Suo Dan manuscript fragment of the *Daode jing* from the second year of the Jianheng reign of the Wu State). *Journal of Oriental Studies* 2, no. 1: 1–68.

Jenner, W. J. F. 1981. *Memories of Loyang: Yang Hsüan-chih and the Lost Capital 493–534*. Oxford: Clarendon Press.

Jiang Lisheng, ed. 1996. *Yunji qiqian*. Beijing: Huaxia chubanshe.

Jiang Tingxi, et al. 1934. [*Qinding*] *Gujin tushu jicheng* ([Imperially commissioned] compendium of charts and texts, ancient and modern). 1725. Reprint, Shanghai: Zhonghua shuju.

Jin Weinuo, ed. 1997. *Yongle Gong bihua quanji* (Complete wall paintings of the Eternal Joy Temple). Tianjin: Tianjin renmin meishu chubanshe.

Jin Zhongshu. 1966. Lun Bei Song monian zhi chongshang Daojiao, shang (On the veneration of Taoism in the late Northern Song dynasty, part 1). *Xinya xuebao* (New Asia studies) 7, no. 2: 323–414.

Jin Zhongshu. 1967. Lun Bei Song monian zhi chongshang Daojiao, xia (On the veneration of Taoism in the Late Northern Song dynasty, part 2). *Xinya xuebao* (New Asia studies) 8, no. 1: 187–257.

Jing, Anning. 1993. Buddhist-Daoist Struggle and a Pair of "Daoist" Murals, *Bulletin of the Museum of Far Eastern Antiquities*, no. 65: 119–54.

Jing, Anning. 1996. The Eight Immortals: The Transformation of T'ang and Sung Taoist Eccentrics During the Yüan Dynasty. In *Arts of the Sung and Yüan*, 213–29. New York: Metropolitan Museum of Art.

Jing, Anning. 1991. The Yuan Buddhist Mural of the Paradise of Bhaisajyaguru. *Metropolitan Museum Journal* 26: 147–66.

Jing, Anning, 1994. Yongle Palace: The Transformation of the Daoist Pantheon during the Yuan Dynasty, 1260–1368. Ph.D. diss., Princeton University.

Jingmen City Museum. 1997. Jingmen Guodian yihao Chumu (Chu tomb no. 1 at Guodian, Jingmen). *Wenwu* (Cultural relics), no. 7: 35–48.

Jiuquan Shiliuguo mu bihua. 1989. (Wall paintings from a tomb of the Sixteen Kingdoms period in Jiuquan). Beijing: Wenwu chubanshe.

Johnson, David. 1985. The City God Cults of T'ang and Sung China. *Harvard Journal of Asiatic Studies* 45: 363–457.

Johnson, David, ed. 1995. *Ritual and Scripture in Chinese Popular Religion*. Berkeley: Chinese Popular Culture Project.

Kaihua si Songdao bihua. 1983. (Song dynasty murals in Kaihua Temple). Beijing: Wenwu chubanshe.

Kaltenmark, Max. 1969. *Lao Tzu and Taoism*. Stanford: Stanford University Press.

Kaltenmark, Max. 1979. The Ideology of the T'ai-p'ing ching. In *Facets of Taoism: Essays in Chinese Religion*, edited by Holmes Welch and Anna Seidel, 19–52. New Haven: Yale University Press.

Kaltenmark, Max. 1987. *Le Lie-sien Tschouan: Biographies légendaires des immortels taoïstes de l'antiquité*. Paris: Collège de France.

Kamitsuka, Yoshio. 1993. Nanbokuchō jidai no dōkyō zōzō (The making of Taoist images during the Southern and Northern Dynasties period). In *Chūgoku chūsei no bunbutsu* (Material culture in medieval China), edited by Tonami Mamoru, 225–90. Kyoto: Kyoto University, Jinbun kagaku kenkyū jo (Center for Research on the Humanities).

Kamitsuka, Yoshio. 1998. Lao-tzu in Six Dynasties Taoist Sculpture. In *Lao-tzu and the Tao-te-ching*, edited by Livia Kohn and Michael LaFargue, 63–85. Albany: State University of New York Press.

Kang Dianfeng, ed. 1998. *Pilu si bihua* (Murals of the Pilu Temple). Shijiazhuang: Hebei meishu chubanshe.

Kao Musen. 1978. The Problem of "Empty Grove after Rain" and the Style of Ni Tsan's Middle Age. *National Palace Museum Quarterly* 13, no. 1: 15–37.

Katz, Paul R. 1993. The Function of Temple Murals in Imperial China: The Case of the Yung-lo Kung. *Journal of Chinese Religions*, no. 21: 45–68.

Katz, Paul R. 1995. *Demon Hordes and Burning Boats: The Cult of Marshal Wen in Late Imperial Chekiang*. Albany: State University of New York Press.

Katz, Paul R. 1996a. Enlightened Alchemist or Immoral Immortal? The Growth of Lü Dongbin's Cult in Late Imperial China. In *Unruly Gods: Divinity and Society in China*, edited by Meir Shahar and Robert P. Weller, 70–104. Honolulu: University of Hawaii Press.

Katz, Paul R. 1996b. Graven Stones and Sacred Walls: Sources on the Cult of Lü Dongbin at the Palace of Eternal Joy. Paper presented at the University of Pennsylvania, February.

Katz, Paul R. 1999. *Images of the Immortal: The Cult of Lü Dongbin at the Palace of Eternal Joy*. Honolulu: University of Hawaii Press.

Keightley, David N. 1999. The Shang: China's First Historical Dynasty. In *The Cambridge History of Ancient China, From the Origins of Civilization to 221 B.C.*, edited by Michael Loewe and Edward L. Shaughnessy, 232–91. Cambridge: Cambridge University Press.

Kerr, Rose, ed. 1991. *Chinese Art and Design: The T. T. Tsui Gallery of Chinese Art*. London: Victoria and Albert Museum.

Kleeman, Terry. 1993. The Expansion of the Wen-ch'ang Cult. In *Religion and Society in T'ang and Sung China*, edited by Patricia Buckley Ebrey and Peter N. Gregory, 45–73. Honolulu: University of Hawaii Press.

Kleeman, Terry. 1994a. *A God's Own Tale: The Book of Transformations of Wenchang, the Divine Lord of Zitong*. Albany: State University of New York Press.

Kleeman, Terry. 1994b. Mountain Deities in China: The Domestication of the Mountain God and the Subjugation of the Margins. *Journal of the American Oriental Society* 114, no. 2: 226–38.

Kleinbauer, W. E. 1971. *Modern Perspectives in Art History*. New York: Holt, Rinehart and Winston.

Kobayashi Masayoshi. 1990. *Rickuchō dōkyōshi kenkyū* (Research on the history of Taoism in the Six Dynasties). Tokyo: Sōbunsha.

Kobayashi Masayoshi. 1992. The Celestial Masters under the Eastern Jin and Liu-Song Dyansties. *Taoist Resources* 3, no. 2: 17–43.

Kobayashi Masayoshi. 1998. *Chūgoku no dōkyō* (Taoism in China). Tokyo: Sōbunshao.

Kohn, Livia. 1986. A Textbook of Physiognomy: The Tradition of the *Shenxiang quanbian*. *Asian Folklore Studies* 45: 227–58.

Kohn, Livia. 1989a. Taoist Insight Meditation: The Tang Practice of *Neiguan*. In *Taoist Meditation and Longevity Techniques*, edited by Livia Kohn, 193–224. Ann Arbor: University of Michigan, Center for Chinese Studies.

Kohn, Livia, ed. 1989b. *Taoist Meditation and Longevity Techniques*. Ann Arbor: University of Michigan, Center for Chinese Studies.

Kohn, Livia. 1990a. Chen Tuan in History and Legend. *Taoist Resources* 2, no. 1: 8–31.

Kohn, Livia. 1990b. Eternal Life in Taoist Mysticism. *Journal of the American Oriental Society* 110, no. 4: 622–40.

Kohn, Livia. 1990c. Transcending Personality: From Ordinary to Immortal Life. *Taoist Resources* 2, no. 2: 1–22.

Kohn, Livia. 1992. *Early Chinese Mysticism: Philosophy and Soteriology in the Taoist Tradition*. Princeton: Princeton University Press.

Kohn, Livia, ed. 1993. *The Taoist Experience: An Anthology*. Albany: State University of New York Press.

Kohn, Livia. 1997. The Taoist Adoption of the City God. *Ming Qing yanju* (Researches on the Ming and Qing dynasties), 5: 69–108.

Kohn, Livia. 1998a. *God of the Dao: Lord Lao in History and Myth*. Ann Arbor: University of Michigan, Center for Chinese Studies.

Kohn, Livia. 1998b. The Lao-tzu Myth. In *Lao-tzu and the Tao-te-ching*, edited by Livia Kohn and Michael LaFargue, 41–62. Albany: State University of New York Press.

Kohn, Livia, and Michael LaFargue, eds. 1998. *Lao-tzu and the Tao-te-ching*. Albany: State University of New York Press.

Kong Xiangxing and Liu Yiman. 1992. *Zhongguo tongjing tudian* (Illustrated compendium of Chinese bronze mirrors). Beijing: Wenwu chubanshe.

Kroll, Paul. 1978. Szu-ma Ch'eng-chen in T'ang Verse. *Bulletin of the Society for the Study of Chinese Religions*, no. 6: 16–30.

Kroll, Paul. 1996a. Body Gods and Inner Vision: The Scripture of the Yellow Court. In *Religions of China in Practice*, edited by Donald S. Lopez, 149–65. Princeton: Princeton University Press.

Kroll, Paul. 1996b. Seduction Songs of One of the Perfected. In *Religions of China in Practice*, edited by Donald S. Lopez, 180–87. Princeton: Princeton University Press.

Lachman, Charles. 1989. *Evaluations of Sung Dynasty Painters of Renown: Liu Tao-ch'un's Sung-chao ming-hua p'ing*. Monographies du T'oung Pao XVI. Leiden: E. J. Brill.

Lacquerware from the Warring States to the Han Periods Excavated in Hubei Province. 1994. Exh. cat. Hong Kong: Art Gallery, Chinese University of Hong Kong.

Lagerwey, John. 1981. *Wu-shang pi-yao: Somme taoiste de VIe siècle*. Paris: Ecole Française d'Extrême-Orient.

Lagerwey, John. 1987a. The Taoist Religious Community. In *The Encyclopedia of Religion*, edited by Mircea Eliade, vol. 14: 306–17. New York: MacMillan.

Lagerwey, John. 1987b. *Taoist Ritual in Chinese Society and History*. New York: Macmillan.

Lagerwey, John. 1991. *Le continent des esprits*. Brussels: La Renaissance du Livre.

Lagerwey, John. 1992. The Pilgrimage to Wu-tang Shan. In *Pilgrims and Sacred Sites in China*, edited by Susan Naquin and Yü Chün-fang, 293–332. Berkeley: University of California Press.

Lagerwey, John. 1995. Taoist Ritual Space and Dynastic Legitimacy. *Cahiers d'Extrême-Asie* 8: 87–94.

Laing, Ellen Johnston. 1974. Neo-Taoism and the "Seven Sages of the Bamboo Grove" in Chinese Painting. *Artibus Asiae* 36, nos. 1/2: 5–54.

Laing, Ellen Johnston. 1998. Daoist *Qi*, Clouds and Mist in Later Chinese Painting. *Orientations* (April): 32–39.

Lam, Joseph S. C. 1998. *State Sacrifices and Music in Ming China*. Albany: State University of New York Press.

Lauer, Uta. 1999. The Strange, the New, and the Orthodox: Calligraphy of the Ch'an Monk Chung-feng Ming-pen (1262–1323). In *Character and Context in Chinese Calligraphy*, edited by Cary Y. Liu, et al., 233–37. Princeton: Princeton University, Art Museum.

Lawton, Thomas. 1973. *Chinese Figure Painting*. Exh. cat. Washington, D.C.: Smithsonian Institution, Freer Gallery of Art.

Le Blanc, Charles. 1985–86. A Re-Examination of the Myth of Huang-ti. *Journal of Chinese Religions* 13/14: 45–63.

Ledderose, Lothar. 1979. *Mi Fu and the Classical Tradition of Chinese Calligraphy*. Princeton: Princeton University Press.

Ledderose, Lothar. 1983. The Earthly Paradise: Religious Elements in Chinese Landscape Art. In *Theories of the Arts in China*, edited by Susan Bush and Christian Murck, 165–83. Princeton: Princeton University Press.

Ledderose, Lothar. 1984. Some Taoist Elements in the Calligraphy of the Six Dynasties Period. *T'oung Pao* 70: 246–78.

Lee, John. 1991. From Five Elements to Five Agents: *Wu-hsing* in Chinese History. In *Sages and Filial Sons: Mythology and Archaeology in Ancient China*, edited by Julia Ching and R. W. L. Guisso, 163–78. Hong Kong: Chinese University Press.

Lee, Sherman E., and Wai-kam Ho. 1968. *Chinese Art Under the Mongols: The Yüan Dynasty, 1279–1368*. Exh. cat. Cleveland: Cleveland Museum of Art.

Lee, Sherman E., et al. 1998. *China 5,000 Years: Innovation and Transformation in the Arts*. Exh. cat. New York: Guggenheim Museum.

Legeza, Laszlo. 1973. *Tao: The Chinese Philosophy of Time and Change*. London: Thames and Hudson.

Legeza, Laszlo. 1975. *Tao Magic: The Secret Language of Diagrams and Calligraphy*. London: Thames and Hudson.

Lessa, William A. 1968. *Chinese Body Divination: Its Forms, Affinities, and Functions*. Los Angeles: United World.

Li Fengshan. 1960. Shanxi Ruicheng Yongle Gong jiuzhi Song Defang, Pan Dezhong, Lu Lüzu mu fajue jianbao (Excavation report on the tombs of Song Defang, Pan Dezhong, and Lü Dongbin at the former site of Yongle Gong in Ruicheng, Shanxi). *Kaogu* (Archaeology), no. 8: 22–25.

Li Huishu. 1984. Songdai huafeng zhuanbian zhi qiji—Huizong meishu jiaoyu chenggong zhi shili (The turning point in the transformation of painting style in the Song dynasty—The example of the success of Song Huizong's art education). In *Gugong xueshu jikan* (Palace Museum studies journal) 1, no. 4: 71–91.

Li Ling. 1995–96. An Archaeological Study of Taiyi Worship. Translated by Donald Harper. *Early Medieval China* 2: 1–39.

Li Song. 1991. Shaanxi Beichao Daojiao diaoke (Taoist sculptures of the Northern Dynasties from Shaanxi province). *Yishu xue* (Studies of Fine Art) 6 (September): 7–32.

Li Xiaojie. 1999. *Dong Han zhengqu dili* (Eastern Han political geography). Jinan: Shandong jiaoyu chubanshe.

Li Yuming, et al. 1986. *Shanxi gujianzhu tonglan* (Panorama of ancient architecture in Shanxi). Taiyuan: Shanxi People's Press.

Lim, Lucy, et al. 1987. *Stories from China's Past: Han Dynasty Pictorial Tomb Reliefs and Archaeological Objects from Sichuan Province, People's Republic of China*. Exh. cat. San Francisco: Chinese Culture Foundation.

Lin Fu-shih. 1994. Chinese Shamans and Shamanism in the Chiang-nan Area During the Six Dynasties Period, 3rd–6th Century A.D. Ph.D. diss., Princeton University.

Lin Fu-shih. 1995. Religious Taoism and Dreams: An Analysis of the Dream-data Collected in the *Yün-ch'i ch'i-ch'ien*. *Cahiers d'Extrême-Asie* 8: 95–112.

Lin Huiyin and Liang Sicheng. 1935. Jinfen gujianzhu yucha jilüe (Notes on the preliminary investigation of old architecture in the Upper Fen River Valley). *Zhongguo yingzao xueshe huikan* (Journal of studies in Chinese architecture) 5, no. 3: 56–61.

Lin Shengzhi. 1999. Mingdai Daojiao tuxiangxue yanjiu: yi "Xuantian ruiying tu" weili (A study of imaging in Ming dynasty Taoism, concerning the usage of "The auspicious omens of the Dark Emperor"). *Meishu shi yanjiu jikan* 6: 131–94.

Lin Shengzhi. 2000. The Iconography of Daoist Salvation from Hell: Re-Identifying the *Classic of Yellow Court (Huangting Jing)* Handscroll Attributed to Liang Kai. Paper delivered at the 53rd Annual Meeting of the Association of Asian Studies, San Diego, Calif., March 11.

Lin Zhao. 1957. Putian Xuanmiao Guan Sanqing Dian diaocha ji (Report on the investigation of Sanqing Hall of Xuanmiao Abbey in Putian). *Wenwu* (Cultural relics), no. 11: 52–53.

Liscomb, Kathlyn Maurean. 1993. *Learning from Mount Hua: A Chinese Physician's Illustrated Travel Record and Painting Theory*. Cambridge: Cambridge University Press.

Little, Stephen. 1985. The Demon Queller and the Art of Qiu Ying. *Artibus Asiae* 46, nos. 1/2, 5–128.

Little, Stephen. 1988. *Realm of the Immortals: Daoism in the Arts of China*. Exh. cat. Cleveland: Cleveland Museum of Art.

Little, Stephen. 1991–92. Literati Views of the Zhe School. *Oriental Art* 37, no. 4: 192–208.

Little, Stephen. 1996. Early Chinese Paintings in The Art Institute of Chicago. *Museum Studies* 22, no. 1: 37–53.

Little, Stephen. 1998. Buddhist Influence on Taoism and Early Taoist Art in China. In *In the Footsteps of the Buddha: An Iconic Journey from India to China*, 110–15. Exh. cat. Hong Kong: University of Hong Kong.

Little, Stephen. 1999. *Spirit Stones of China: The Ian and Susan Wilson Collection of Chinese Stones, Paintings, and Scholars' Objects.* Exh. cat. Chicago: The Art Institute of Chicago.

Little, Stephen. Forthcoming. *Chinese Paintings in the Honolulu Academy of Arts: Tang through Ming Dynasties.* Honolulu: Honolulu Academy of Arts.

Liu Cunren. 1991. Daozang ben san sheng zhu Daode jing huijian (The Taoist Canon edition of the Illustrated Notes to the Three Sages Commentary to the Daode jing). In *Hefeng tang wenji* (Collected writings of the harmonious wind hall), 223–495. Shanghai: Shanghai guji chubanshe.

Liu Dunzhen. 1935. Suzhou gujianzhu diaocha ji (Record of investigation of ancient architecture in Suzhou). *Zhongguo yingzao xueshe huikan* (Journal of studies in Chinese architecture) 5, no. 3: 21–36.

Liu Fang-ju. 1997. *Yingsui jifu: Yuanzang Zhong Kui minghua de zhan* (Accumulated blessings for greeting the New Year: Exhibition of Zhong Kui paintings in the museum's collection). Exh. cat. Taipei: National Palace Museum.

Liu, Heping. 1997. Painting and Commerce in Northern Song Dynasty China, 960–1126. Ph.D. diss., Yale University.

Liu Tizhi. 1935. *Xiaojiao jinge jinwen taben* (Bronze inscriptions collected by the Xiaojiao Jinge). Beijing: 18 *juan*. n.p.

Liu Ts'un-yan (see also Liu Cunren). 1974. *On the Art of Ruling a Big Country: Views of Three Chinese Emperors.* Canberra: Australia National University Press.

Liu Xixiang. 1980. Henan Bo'aixian faxian Yuandai jianzhu—Tangdidian (Tangdi Hall—Yuan-period architecture uncovered in Bo'ai county, Henan). *Wenwu* (Cultural relics), no. 8: 89–93.

Liu Yanchi. 1988. *The Essential Book of Traditional Chinese Medicine.* Translated by Fang Yingyu and Chen Laidi. 2 vols. New York: Columbia University Press.

Liu Yang. 1997a. Cliff Sculpture: Iconographic Innovations of Tang Daoist Art in Sichuan Province. *Orientations* (September): 85–92.

Liu Yang. 1997b. Manifestation of the Dao: A Study of Daoist Art from the Northern Dynasties to the Tang, 5th–9th Centuries. Ph.D. diss., School of Oriental and African Studies, University of London.

Loehr, Max. 1980. *The Great Painters of China.* London: Phaidon Press.

Loewe, Michael. 1979. *Ways to Paradise: The Chinese Quest for Immortality.* London: George Allen and Unwin.

Loewe, Michael. 1982. *Chinese Ideas of Life and Death.* London: George Allen and Unwin.

Loewe, Michael, ed. 1993. *Early Chinese Texts: A Bibliographical Guide.* Berkeley: Society for the Study of Early China.

Loewe, Michael. 1994. *Divination, Mythology, and Monarchy in Han China.* Cambridge: Cambridge University Press.

Loewe, Michael and Edward L. Shaughnessy, eds. 1999. *The Cambridge History of Ancient China, From the Origins of Civilization to 221 B.C.* Cambridge: Cambridge University Press.

Loon, Piet van der. 1984. *Taoist Books in the Libraries of the Sung Period: A Critical Study and Index.* London: Ithaca Press.

Lopez, Donald S., ed. 1996. *Religions of China in Practice.* Princeton: Princeton University Press.

Lou Yulie. 1992. Yuanshi Daojiao—Wudoumi Dao and Taiping Dao (Primitive Taoism—Wudoumi Dao and Taiping Dao). In *Daojiao yu chuantong wenhua* (Taoism and traditional culture). Beijing: Zhonghua shuju.

Lü Dongbin de gushi. 1981. (Stories of Lü Dongbin). Taipei: Diqiu Press.

Lu Zongli and Luan Baoqun. 1991. *Zhongguo minjian zhushen* (Assorted popular gods of China). Taipei: Xuesheng shuju.

Luo Erhu. 1988. Sichuan yamu di chubu yanjiu (A preliminary study of cliff tombs in Sichuan). *Kaogu xuebao* (Studies in archaeology) 2: 142.

Ma Dezhi. 1987. Tang Chang'ancheng fajue shouhuo (Newly gleaned information from excavation at Tang Chang'an). *Kaogu* (Archaeology), no. 4: 329–62.

Ma Shutian. 1996. *Zhongguo Daojiao zhushen* (The gods of Chinese Taoism). Beijing: Caiji chubanshe.

Ma Ziyun and Shi Anchang. 1993. *Beitie jianding* (The authentication of stelae inscriptions). Guilin: Guangxi shifan daxue chubanshe.

MacKenzie, Colin. 1999. The Zenghou Yi Tomb at Leigudian, Suixian, Hubei Province. In *The Golden Age of Chinese Archaeology: Celebrated Discoveries from the People's Republic of China,* edited by Xiaoneng Yang, 275–315. Exh. cat. Washington, D.C.: National Gallery of Art.

Mailey, Jean. 1978. *Embroidery of Imperial China.* Exh. cat. New York: China Institute.

Major, John. 1985–86. New Light on the Dark Warrior. *Journal of Chinese Religions,* nos. 13/14: 65–86.

Major, John. 1993. *Heaven and Earth in Early Han Thought: Chapters Three, Four, and Five of the Huainanzi.* Albany: State University of New York Press.

Martin, Fredrik Robert. 1913. *Zeichnüngen nach Wu tao-tze aus der gotter- und sagenwelt Chinas.* Munich: F. Bruckmann.

Maspero, Henri. 1981. *Taoism and Chinese Religion.* Translated by Frank A. Kierman. Amherst: University of Massachusetts Press.

Masterpieces from the Osaka Municipal Museum of Art. 1986. Osaka: Osaka Municipal Museum of Art.

Mather, Richard. 1961. The Mystical Ascent of the T'ien-t'ai Mountains: Sun Ch'o's Yu-T'ien-T'ai-Shan Fu. *Monumenta Serica* 20: 226–45.

Mather, Richard. 1976. *Shih-shuo hsin-yü: A New Account of Tales of the World.* Minneapolis: University of Minnesota Press.

Mather, Richard. 1979. K'ou Ch'ien-chih and the Taoist Theocracy at the Northern Wei Court. In *Facets of Taoism: Essays in Chinese Religion,* edited by Holmes Welch and Anna Seidel, 103–22. New Haven and London: Yale University Press.

McNair, Amy. 1998. *The Upright Brush: Yan Zhenqing's Calligraphy and Song Literati Politics.* Honolulu: University of Hawaii Press.

Meng Naichang. 1993. *Daojiao yu Zhongguo liandanshu* (Taoism and Chinese alchemy). Beijing: Yanshan chubanshe.

Mianyang Museum. 1991. Sichuan Mianyang Hejiashan yihao Dong Han yamu qingli jianbao (A brief report on the inventory of Eastern Han cliff tomb no. 1 at Hejiashan, Mianyang). *Wenwu* (Cultural relics) no. 3: 1–8.

Miller, Tracy. Forthcoming. The Jin Shrines: Architecture and Ritual Practice. Ph.D. diss., University of Pennsylvania.

Min Zhiting, et al. 1994. *Daojiao da cidian* (Great encyclopedia of Taoism). Beijing: Huaxia chubanshe.

Mingren chuanji ziliao suoyin. 1978. (Index to Ming biographies). Reprint, Taipei: Wenshizhe chubanshe.

Mingze, Paul Hou. 1930. *Preuves des antiquités de Chine—Ta-Kou-Tchai.* Beijing.

Miyagawa, Torao, ed. 1983. *Chinese Painting.* New York: Weatherhill.

Miyakawa Hisayuki. 1975a. Rin Reiso to Sō no Kisō (Ling Lingsu and Song Huizong). *Tokai daigaku kiyo (bunkaku bu)* (Journal of Tokai University [Humanities Department]) 24: 1–8.

Miyakawa Hisayuki. 1975b. Sō no Kisō to dōkyō (Song Huizong and Taoism). *Tokai daigaku kiyo (bunkaku bu)* (Journal of Tokai University [Humanities Department]) 23: 1–10.

Miyazaki Ichisada. 1976. *China's Examination Hell: The Civil Service Examinations of Imperial China.* Translated by Conrad Schirokauer. New Haven and London: Yale University Press.

Mo Zongjiang. 1945. Shanxi Yuci Yongshousi Yuhuagong (Yuhuagong of Yongshou Monastery in Yuci, Shanxi). *Zhongguo yingzao xueshe huikan* (Journal of studies in Chinese architecture) 7, no. 2: 1–24.

Mokkei (Muqi). 1996. Exh. cat. Tokyo: Gotoh Museum.

Morohashi, Tetsuji. 1966–68. *Dai Kan-Wa jitan* (Great dictionary of Chinese characters). Tokyo: Taishukan.

Morrison, Hedda and Wolfram Eberhard. 1973. *Hua Shan: The Taoist Sacred Mountain in West China.* Hong Kong: Vetch and Lee.

Mote, Frederick W., and Hung-lam Chu. 1988. *Calligraphy and the East Asian Book.* Exh. cat. Princeton: Gest Library.

Mu Yiqin. 1982. *Mingdai gongting yu Zhepai huihua xuanji* (Collection of paintings by Ming court painters and the Zhe school). Beijing: Wenwu chubanshe.

Mu Yiqin. 1985. *Mingdai yuanti Zhepai huihua shiliao* (Historical materials on Ming court painters and the Zhe School). Shanghai: Renmin meishu chubanshe.

Mugitani, Kunio. 1985. Rōshi sōjichū ni tsuite (On the *Laozi xiang'er zhu*). *Tōyō gakuhō* (Eastern studies) 57: 75–107.

Munakata, Kiyohiko. 1974. *Ching Hao's "Pi-fa-chi": A Note on the Art of the Brush.* Ascona, Switz.: Artibus Asiae.

Munakata, Kiyohiko. 1991. *Sacred Mountains in Chinese Art.* Exh. cat. Urbana-Champaign: Krannert Art Museum.

Nakano Toru, et al. 1994. *Bronze Mirrors from Ancient China: Donald H. Graham, Jr. Collection.* Honolulu: Donald H. Graham Jr.

Nakata Yujirō. 1970. *Chūgoku shoron shi* (Compendium of texts on Chinese calligraphy). Tokyo: Nigensha.

Nanjing Museum. 1991. *Sichuan Pengshan Han dai ya mu* (Han dynasty cliff tombs of Pengshan in Sichuan). Beijing: Wenwu chubanshe.

Nanjing shi wenwu baoguan weiyuanhui. 1965. (Nanjing City Bureau for the Protection of Cultural Property). Nanjing Xiangshan Dong Jin Wang Danhu mu he er, sihao mu fajue jianbao (Preliminary report on the excavation of the Eastern Jin tombs of Wang Danhu and of tombs nos. 2 and 4 at Xiangshan, Nanjing). *Wenwu* (Cultural relics), no. 10: 38.

Naquin, Susan. 1992. The Peking Pilgrimage to Miao-feng Shan: Religious Organizations and Sacred Sites. In *Pilgrims and Sacred Sites in China,* edited by Susan Naquin and Yü Chün-fang, 333–77. Berkeley: University of California Press.

Needham, Joseph, and Wang Ling. 1959. *Science and Civilisation in China.* Vol. 3, *Mathematics and the Sciences of the Heavens and the Earth.* Cambridge: Cambridge University Press.

Needham, Joseph, et al. 1965. *Science and Civilisation in China.* Vol. 4, *Physics and Physical Technology.* Pt. 2, *Mechanical Engineering.* Cambridge: Cambridge University Press.

Needham, Joseph, et al. 1974. *Science and Civilisation in China.* Vol. 5, *Chemistry and Chemical Technology.* Pt. 2, *Spagyrical Discovery and Invention: Magisteries of Gold and Immortality.* London: Cambridge University Press.

Needham, Joseph, et al. 1976. *Science and Civilisation in China.* Vol. 5, *Chemistry and Chemical Technology.* Pt. 3, *Spagyrical Discovery and Invention: Historical Survey, from Cinnabar Elixirs to Synthetic Insulin.* London: Cambridge University Press.

Needham, Joseph, et al. 1980. *Science and Civilisation in China.* Vol. 5, *Chemistry and Chemical Technology.* Pt. 4, *Spagyrical Discovery and Invention: Apparatus, Theories and Gifts.* London: Cambridge University Press.

Needham, Joseph, et al. 1983. *Science and Civilisation in China.* Vol. 5, *Chemistry and Chemical Technology.* Pt. 5, *Spagyrical Discovery and Invention: Physiological Alchemy.* London: Cambridge University Press.

Neill, Mary Gardner. 1981. Mountains of the Immortals: The Life and Painting of Fang Ts'ung-i. Ph.D. diss., Yale University.

Nelson, Susan E. 1986. On Through the Beyond: The Peach Blossom Spring as Paradise. *Archives of Asian Art* 39: 23–47.

New Interpretations of Ming and Qing Paintings. 1994. Exh. cat. Shanghai: Shanghai shuhua chubanshe.

Nienhauser, William H., Jr., ed. 1994a. *The Grand Scribe's Records.* Vol. 1, *The Basic Annals of Pre-Han China by Ssu-ma Ch'ien.* Bloomington and Indianapolis: Indiana University Press.

Nienhauser, William H., Jr., ed. 1994b. *The Grand Scribe's Records.* Vol. 7, *The Memoirs of Pre-Han China by Ssu-ma Ch'ien.* Bloomington and Indianapolis: Indiana University Press.

Noguchi Tetsurō, et al., ed. 1994. *Dōkyō jiten* (Dictionary of Taoism). Tokyo: Hiragawa shuppanshao.

Noritada Kubo. 1968a. *Chūgoku no shukyo kaikaku* (Chinese religious reform). Kyoto: Hozokan.

Noritada Kubo. 1968b. Prolegomena on the Study of the Controversies between Buddhists and Taoists in the Yüan Period. *Memoirs of the Research Department of the Toyo Bunko* 26: 39–61.

Ōfuchi Ninji. 1978–79. *Tonkō dōkyō* (Taoist manuscripts from Dunhuang). Vol. 1, *Mokuroku hen,* 1978. Vol. 2, *Zuroku hen,* 1979. Tokyo: Fukutake shoten.

Ōfuchi Ninji. 1979. The Formation of the Taoist Canon. In *Facets of Taoism: Essays in Chinese Religion,* edited by Holmes Welch and Anna Seidel, 253–68. New Haven and London: Yale University Press.

Ōfuchi Ninji. 1991. *Shoki no dōkyō* (Early Taoism). Tokyo: Sōbunshao.

Ōfuchi Ninji. 1997. *Dōkyō to sono kyōten* (Taoism and its scriptures). Tokyo: Sōbunsha.

Ong Hean-tatt. 1999. *Chinese Plant Symbolisms.* Selangor Darul Ehsan, Malaysia: Ong Hean-tatt.

Ono Katsutoshi. 1989. *Chugoku Zui-To Choan jiin shiryo shusei* (Compilation of research materials on Buddhist monasteries in Sui-Tang Chang'an). In *Shiryohen* (Historical materials), vol. 1: 453–470. Kyoto: Hozokan.

Ouyang Zhongshi. 1989. *Zhongguo mingbei zhentie xishang* (The authentication and appreciation of famous stelae and ink rubbings of China). Xi'an: Weilai chubanshe.

Oyanagi Shigeta. 1928. *Hakuunkan-shi* (History of the Baiyun Guan). Tokyo: Toho bunka gakuin, Tokyo kenkyu-jo.

Pan Nai. 1976. Suzhou Nan Song tianwentu bei di kaoshi yu pipan. (Examination and critique of a Southern Song astronomical chart on a stone stele at Suzhou). *Kaogu xuebao* (Studies in archaeology), no. 1: 47–61.

Pan Shenliang. 1988. Lü Wenying, Lü Ji hezuo "Zhuyuan shouji tu" qianxi (The painting *Birthday Celebration in the Bamboo Garden,* a joint work by Lü Wenying and Lü Ji hezuo). *Gugong bowuyuan yuankan* (Palace Museum Monthly) 4: 61–63.

Penny, Benjamin. Forthcoming. Immortals and Transcendence. In *Daoism Handbook,* edited by Livia Kohn. Leiden: E. J. Brill.

Pingyang Jinmu zhuandiao. 1999. (Ceramic sculptures of Jin dynasty tombs at Pingyang). Taiyuan: Shanxi renmin chubanshe.

Piotrovsky, Mikhail, ed. 1993. *Lost Empire of the Silk Road: Buddhist Art from Khara Khoto, X–XIIIth Century.* Exh. cat. Milan: Electa.

Pontynen, Arthur. 1980. The Deification of Laozi in Chinese History and Art. *Oriental Art* 26, no. 2: 192–200.

Pontynen, Arthur. 1983. The Early Development of Taoist Art. Ph.D. Diss., University of Iowa.

Poo Mu-chou. 1990. Ideas Concerning Death and Burial in Pre-Han and Han China. *Asia Major,* 3rd ser., vol. 3, pt. 2: 25–62.

Porkert, Manfred. 1979. *Biographie d'un taoïste légendaire: Tcheou Tseu-yang.* Paris: Collège de France, Institut des Hautes Etudes Chinoises.

Powers, Martin. 1991. *Art and Political Expression in Early China.* New Haven and London: Yale University Press.

Pregadio, Fabrizio. 1995. The Representation of Time in the *Zhouyi cantong qi. Cahiers d'Extrême-Asie* 8: 155–74.

Priest, Alan. 1939. Li Chung Receives a Mandate. *Metropolitan Museum of Art Bulletin* 34, no. 11: 254–57.

Qi Yingtao, et al. 1954. Liangnian lai Shanxi sheng xin faxian de gu jianzhu (Two years of recent discoveries of ancient architecture in Shanxi province). *Wenwu cankao ziliao* (Materials for the investigation of cultural relics), no. 11: 37–84.

Qiao Yun. 1993. *Daojiao jianzhu: Shenxian daoguan* (Taoist architecture: Monasteries of the immortals). Beijing and Taipei: China Building Industry Press and Guangfu Book Company.

Qiao Yun, et al. n.d. Zhongguo gudai jianzhu shi (A history of pre-modern Chinese architecture). Unpublished manuscript.

Qing Xitai. 1992. Zhongguo Daojiao di chansheng, fazhan he yianbian (The emergence, development, and transformation of Chinese Taoism). In *Daojiao yu chuantong wenhua* (Taoism and traditional culture). Beijing: Zhonghua shuju.

Qing Xitai, ed. 1996. *Zhongguo Daojiao shi* (History of Chinese Taoism). 4 vols. Revised ed., Chengdu: Sichuan renmin chubanshe.

Rainey, Lee. 1991. The Queen Mother of the West: An Ancient Chinese Mother Goddess? In *Sages and Filial Sons: Mythology and Archaeology in Ancient China,* edited by Julia Ching and R. W. L. Guisso, 81–100. Hong Kong: Chinese University Press.

Rao Zongyi. 1991. *Laozi Xianger zhu jiaoqian* (An annotated version of the *Xiang'er* Commentary on *Laozi*). Shanggai: Guji chubanshe.

Rawski, Evelyn. 1998. *The Last Emperors: A Social History of Qing Imperial Institutions.* Berkeley: University of California Press.

Rawson, Jessica, ed. 1996. *Mysteries of Ancient China: New Discoveries from the Early Dynasties.* Exh. cat. New York: George Braziller.

Ren Chongyue. 1998. *Song Huizong, Song Qinzong* (The Song emperors Huizong and Qinzong). Changchun: Jilin wenshi chubanshe.

Ren Jiyu. 1990. *Zhongguo Daojiao shi* (History of Taoism in China). Shanghai: Shanghai renmin chubanshe.

Robinet, Isabelle. 1977. *Les commentaires du Tao To King jusqu'au VIIe siècle.* Paris: Collège de France, Institut des Hautes Etudes Chinoises.

Robinet, Isabelle. 1984. *La révélation du Shangqing dans l'histoire du taôisme.* Paris: Ecole Française d'Extrême-Orient.

Robinet, Isabelle. 1985–86. The Taoist Immortal: Jesters of Light and Shadow, Heaven and Earth. *Journal of Chinese Religions,* nos. 13/14: 87–105.

Robinet, Isabelle. 1990. The Place and Meaning of the Notion of Taiji in Taoist Sources Prior to the Ming Dynasty. Translated by Paula A. Wissing. *History of Religions* 29, no. 4: 372–411.

Robinet, Isabelle. 1993. *Taoist Meditation: The Mao-shan Tradition of Great Clarity.* Albany: State University of New York Press.

Robinet, Isabelle. 1995. *Introduction à l'alchimie intérieure taoïste de l'unité et de la multiplicité.* Paris: Cerf.

Robinet, Isabelle. 1997. *Taoism: Growth of a Religion.* Translated by Phyllis Brooks. Stanford: Stanford University Press.

Robson, James. 1995. The Polymorphous Space of the Southern Marchmount. *Cahiers d'Extrême-Asie* 8: 221–64.

Rogers, Howard. 2000. P'u-kuang, "Isles of the Blessed." *Kaikodo Journal* (Spring): 235.

Roth, Harold D. 1993. Chuang tzu. In *Early Chinese Texts: A Bibliographical Guide,* edited by Michael Loewe, 56–66. Berkeley: Society for the Study of Early China.

Roth, Harold D. 1996. The Inner Cultivation Tradition of Early Taoism. In *Religions of China in Practice,* edited by Donald S. Lopez, 123–48. Princeton: Princeton University Press.

Roth, Harold D. 1997. The Yellow Emperor's Guru: A Narrative Analysis from *Chuang Tzu* 11. *Taoist Resources* 7, no. 1: 43–60.

Roth, Harold D. 1998. Early Taoist Wisdom Poetry: The Evidence from Kuo Tian. Paper delivered at the International Convention of Asia Scholars, Leiden, The Netherlands, June 28.

Roth, Harold D. 1999. Who Keeps the Center?—The Meaning of the Kuo Tien *Lao Tzu* Parallels. Paper delivered at the 51st Annual Meeting of the Association for Asian Studies, Boston, March 11.

Rowland, Benjamin. 1951. The Problem of Hui Tsung. *Archives of the Chinese Art Society of America* 5: 5–22.

Rowland, Benjamin. 1954. Hui Tsung and Huang Ch'üan. *Artibus Asiae* 17: 130–34.

Roy, David Tod. 1993. *The Plum in the Golden Vase or Chin P'ing Mei.* Vol. 1, *The Gathering.* Princeton: Princeton University Press.

Rudgley, Richard. 1993. *The Alchemy of Culture: Intoxicants in Society.* London: British Museum Press.

Rufus, W. Carl, and Hsing-chih Tien. 1945. *The Soochow Astronomical Chart.* Ann Arbor: University of Michigan Press.

Ruitenbeek, Klaas. 1999. Mazu, the Patroness of Sailors, in Chinese Pictorial Art. *Artibus Asiae* 58, nos. 3/4: 281–329.

Rupert, Milan, and O. J. Todd. 1935. *Chinese Bronze Mirrors.* Beijing: San Yu Press.

Saso, Michael. 1972. *Taoism and the Rite of Cosmic Renewal.* Pullman: Washington State University Press.

Saso, Michael. 1978. *The Teachings of Taoist Master Chuang.* New Haven and London: Yale University Press.

Schafer, Edward H. 1963. The Last Years of Chang'an. *Oriens Extremus* 10: 133–79.

Schafer, Edward H. 1975. Review of Joseph Needham, et al. *Science and Civilisation in China.* Vol. 5, *Chemistry and Chemical Technology.* Pt. 2, *Spagyrical Discovery and Invention: Magisteries of Gold and Immortality.* London: Cambridge University Press, 1974. *Harvard Journal of Asian Studies* 35: 319–28.

Schafer, Edward H. 1978a. The Jade Woman of Greatest Mystery. *History of Religions* 17: 387–98.

Schafer, Edward H. 1978b. Li Po's Star Power. *Bulletin of the Society for the Study of Chinese Religions* (Fall): 5–15.

Schafer, Edward H. 1978c. *Pacing the Void: T'ang Approaches to the Stars.* Berkeley: University of California Press.

Schafer, Edward H. 1978–79. A T'ang Taoist Mirror. *Early China* 4: 56–59.

Schafer, Edward H. 1983. The Cranes of Mao Shan. In *Tantric and Taoist Studies in Honour of R. A. Stein,* edited by Michel Strickmann, vol. 2: 372–93. Brussels: Institut Belge des Hautes Etudes Chinoises.

Schafer, Edward H. 1985. *Mirages on the Sea of Time: The Taoist Poetry of Ts'ao T'ang.* Berkeley: University of California Press.

Schafer, Edward H. 1985–86. The Snow of Mao Shan: A Cluster of Taoist Images. *Journal of Chinese Religions,* nos. 13/14: 107–26.

Schafer, Edward H. 1986. Transcendental Elder Mao. *Cahiers d'Extrême-Asie* 2: 111–22.

Schafer, Edward H. 1988. Ways of Looking at the Moon Palace. *Asia Major,* 3rd ser., vol. 1, pt. 1: 1–13.

Schafer, Edward H. 1989. *Mao Shan in T'ang Times.* Boulder: Society for the Study of Chinese Religions.

Schipper, Kristofer. 1965. *L'Empereur Wou des Han dans la légende taôiste.* Paris: Ecole Française d'Extrême-Orient.

Schipper, Kristofer. 1975. *Concordance du Houang-t'ing King: Nei-king et Wai-king.* Paris: Ecole Française d'Extrême-Orient.

Schipper, Kristofer. 1985. Taoist Ritual and Local Cults of the T'ang Dynasty. In *Tantric and Taoist Studies in Honour of R. A. Stein,* edited by Michel Strickmann, vol. 3: 812–34. Brussels: Institut Belge des Hautes Etudes Chinoises.

Schipper, Kristofer M. 1989. A Study of Buxu: Taoist Liturgical Hymn and Dance. In *Studies of Taoist Rituals and Music of Today,* edited by Pen-Yeh Tsao and Daniel P. L. Law, 110–20. Hong Kong: Chinese University of Hong Kong Music Department.

Schipper, Kristofer. 1990. The Cult of Pao-sheng ta-ti and its Spreading to Taiwan: A Case Study of *Fen-hsiang.* In *Development and Decline of Fukien Province in the 17th and 18th Centuries,* edited by Eduard B. Vermeer, 397–416. Leiden: E. J. Brill.

Schipper, Kristofer. 1991. Le culte de l'immortel Tang Gongfang. In *Cultes populaires et sociétés asiatiques,* edited by Alain Forest, et al., 59–72. Paris: L'Harmattan.

Schipper, Kristofer. 1993. *The Taoist Body.* Translated by Karen C. Duval. Berkeley: University of California Press.

Schipper, Kristofer. 1995. An Outline of Taoist Ritual. In *Essais sur le rituel,* edited by Anne-Marie Blondeau and Kristofer Schipper, 97–126. Louvain, Belgium: Peeters.

Schipper, Kristofer. 1997. Une stèle taoïste des Han orientaux récemment découverte. In *En suivant le voie royale: Mélanges en hommage à Léon Vandermeersch. Etudes thématiques,* vol. 7: 239–47. Paris: Ecole Française d'Extrême-Orient.

Schlombs, Adele. 1995. *Meisterwerke aus China, Korea, und Japan.* Cologne: Museum für Ostasiatische Kunst.

Schmidt-Glintzer, Helwig. 1989. Zhang Shangying (1043–1122)—An Embarrassing Policy Adviser under the Northern Song. In *Liu Tzu-chien hakushi shoju kinen Sōshi kenkyū ronshū* (Festschrift for Dr. Liu Tzu-chien: Collected essays on studies in Song history), edited by Kinugawa Tsuyoshi, 521–30. Kyoto: Dōsha.

Seaman, Gary. 1987. *Journey to the North.* Berkeley: University of California Press.

Seian hirin. 1966. (The Forest of Stelae, Xi'an). Tokyo: Kōdansha.

Seidel, Anna. 1969a. *La divinisation de Lao Tseu dans le taôisme des Han.* Paris: Ecole Française d'Extrême-Orient.

Seidel, Anna. 1969b. The Image of the Perfect Ruler in Early Taoist Messianism. *History of Religions* 9: 216–47.

Seidel, Anna. 1970. A Taoist Immortal of the Ming Dynasty: Chang San-feng. In *Self and Society in Ming Thought,* edited by Wm. Th. DeBary, 483–531. New York: Columbia University Press.

Seidel, Anna. 1983. Imperial Treasures and Taoist Sacraments: Taoist Roots in the Apocrypha. In *Tantric and Taoist Studies in Honour of R. A. Stein,* edited by Michel Strickmann, vol. 2: 291–371. Brussels: Institut Belge des Hautes Etudes Chinoises.

Seidel, Anna. 1987a. Post-mortem Immortality, or the Taoist Resurrection of the Body. In *Gilgul: Essays on Transformation, Revolution, and Permanence in the History of Religions.* Leiden: E. J. Brill.

Seidel, Anna. 1987b. Traces of Han Religion in Funeral Texts Found in Tombs. In *Dōkyō to Shūkyō Bunka* (Taoism and religious culture), edited by Akuzuki Kan'ei, 21–57. Tokyo: Hirakawa Shuppansha.

Seidel, Anna. 1989–90. Chronicle of Taoist Studies in the West, 1950–1990. *Cahiers d'Extrême-Asie* 5: 223–347.

Seidel, Anna, and Michel Strickmann. 1994. Taoism. In *The New Encyclopaedia Britannica: Macropaedia,* vol. 28: 383–96. Chicago: Encyclopaedia Britannica.

Shaanxi Archaeological Institute and Jiaotong University. 1990. Xi'an Jiaotong daxue Xi Han bihua mu fajue jianbao (Preliminary report on the excavation of the Western Han tomb with murals in Xi'an Jiaotong University). *Kaogu yu wenwu* (Archaeology and cultural relics) 4: 57–63.

Shaanxi chutu tongjing. 1958. (Bronze mirrors unearthed in Shaanxi). Xian: Shaanxi renmin chubanshe.

Shaughnessy, Edward L. 1993. I Ching (Chou I). In *Early Chinese Texts: A Bibliographical Guide,* edited by Michael Loewe, 216–28. Berkeley: Society for the Study of Early China.

Shimizu, Yoshiaki. 1980. Six Narrative Paintings by Yin T'o-lo: Their Symbolic Content. *Archives of Asian Art* 32: 6–25.

Shimizu, Yoshiaki, and Carolyn Wheelwright. 1976. *Japanese Ink Paintings.* Exh. cat. Princeton: Princeton University Art Museum.

Shodō zenshū. 1970–73. (Complete compendium of calligraphy). 24 vols. Tokyo: Chūōkōron-sha.

Sirén, Osvald. 1925. *Chinese Sculpture from the Fifth to the Fourteenth Century.* 4 vols. London: Ernest Benn Ltd.

Sirén, Osvald. 1931. Chinese and Japanese Sculptures and Paintings in the National Museum, Stockholm. London: Edward Goldston.

Sirén, Osvald. 1938. *Early Chinese Paintings from the A. W. Bahr Collection.* London: Chiswick Press.

Sirén, Osvald. 1956–58. *Chinese Painting: Leading Masters and Principles.* 7 vols. London: Lund Humphries.

Sivin, Nathan. 1968. *Chinese Alchemy: Preliminary Studies*. Cambridge: Harvard University Press.

Sivin, Nathan. 1978. On the Word "Taoist" as a Source of Perplexity, With Special Reference to the Relations of Science and Religion in Traditional China. In *History of Religions* 17: 303–30.

Sivin, Nathan. 1980. The Theoretical Background of Elixir Alchemy. In Joseph Needham, *Science and Civilisation in China*. Vol. 5, *Chemistry and Chemical Technology*. Pt. 4, *Spagyrical Discovery and Invention: Apparatus, Theories and Gifts*, 210–323. London: Cambridge University Press.

Skinner, Stephen. 1982. *The Living Earth Manual of Feng-shui: Chinese Geomancy*. London: Arkana.

Smith, Richard J. 1991. Fortune-Tellers and Philosophers: Divination in Traditional Chinese Society. Boulder: Westview Press.

Smith, Thomas E., trans. 1990. Record of the Ten Continents. *Taoist Resources* 2, no. 2: 87–119.

Songren huace. 1979. (Album of paintings by Song artists). Shanghai: Shanghai renmin meishu chubanshe.

Soper, Alexander C. 1949. A Northern Sung Descriptive Catalogue of Paintings. *Journal of the American Oriental Society* 69: 18–33.

Soper, Alexander C. 1951. *Kuo Jo-hsü's Experiences in Painting (T'u-hua chien-wen chih): An Eleventh-Century History of Chinese Painting*. Washington, D.C.: American Council of Learned Societies.

Soper, Alexander C. 1967. The "Jen Shou" Mirrors. *Artibus Asiae* 29, no. 1: 55–66.

Soper, Alexander C. 1980. A New Chinese Tomb Discovery: The Earliest Representation of a Famous Literary Theme. *Artibus Asiae* 42, no. 2: 79–86.

Soymié, Michel. 1962. La lune dans les religions chinoises. In *La Lune: Mythes et rites*, 317–19. Paris: Editions du Seuil.

Stein, Rolf A. 1979. Religious Taoism and Popular Religion from the Second to Seventh Centuries. In *Facets of Taoism*, edited by Holmes Welch and Anna Seidel, 53–81. New Haven and London: Yale University Press.

Stein, Rolf A. 1990. *The World in Miniature: Container Gardens and Dwellings in Far Eastern Religious Thought*. Translated by Phyllis Brooks. Stanford: Stanford University Press.

Steinhardt, Nancy Shatzman. 1984. *Chinese Traditional Architecture*. Exh. cat. New York: China Institute.

Steinhardt, Nancy Shatzman. 1984. The Yuan Dynasty Main Hall: Guangsheng si Lower Monastery and Yongle Gong. In Nancy S. Steinhardt, *Chinese Traditional Architecture*, 127–38. Exh. cat. New York: China Institute.

Steinhardt, Nancy S. 1987. Zhu Haogu Reconsidered: A New Date for the ROM (Royal Ontario Museum) Painting and the Southern Shanxi Buddhist-Taoist Style. *Artibus Asiae* 48, nos. 1/2: 11–16.

Steinhardt, Nancy S. 1988. Towards the Definition of a Yuan Dynasty Hall. *Journal of the Society of Architectural Historians* 47, no. 1: 57–73.

Steinhardt, Nancy S. 1989. Imperial Architecture along the Mongolian Road to Dadu. *Ars Orientalis* 18: 59–93.

Steinhardt, Nancy S. 1997. The Synagogue at Kaifeng: Sino-Judaic Architecture of the Diaspora. In *The Jews of China*, edited by Jonathan Goldstein, 3–21. Armonk, N.Y.: M. E. Sharpe.

Steinhardt, Nancy Shatzman. 1998. The Temple to the Northern Peak in Quyang. *Artibus Asiae* 58, nos. 1/2: 69–90.

Stephenson, F. Richard. 1994. Chinese and Korean Star Maps and Catalogs. In *The History of Cartography*. Vol. 2, bk. 2, *Cartography in the Traditional East and Southeast Asian Societies*, edited by J. B. Harley and David Woodward, 511–78. Chicago and London: University of Chicago Press.

Steuber, Joseph M. 1996. Wang Ziqiao and the Literary Themes of Time and Immortality in Chinese Art. M.A. Thesis, University of Kansas.

Stevens, Keith. 1997. *Chinese Gods: The Unseen World of Spirits and Demons*. London: Collins and Brown.

Strassberg, Richard E. 1994. *Inscribed Landscapes: Travel Writing from Imperial China*. Berkeley: University of California Press.

Strickmann, Michel. 1966. Notes on Mushroom Cults in Ancient China. Unpublished manuscript, Rijksuniversiteit Gent.

Strickmann, Michel. 1977. The Mao-shan Revelations: Taoism and the Aristocracy. *T'oung Pao* 63: 1–64.

Strickmann, Michel. 1978. The Longest Taoist Scripture. *History of Religions* 17, nos. 3/4: 331–54.

Strickmann, Michel. 1979a. On the Alchemy of T'ao Hung-ching. In *Facets of Taoism*, edited by Holmes Welch and Anna Seidel, 123–92. New Haven and London: Yale University Press.

Strickmann, Michel. 1979b. The Taoist Renaissance of the Twelfth Century. Paper presented at the 3rd International Conference of Taoist Studies, Unterageri, Switzerland, Sept. 3–9.

Strickmann, Michel. 1980. History, Anthropology, and Chinese Religion. *Harvard Journal of Asiatic Studies* 40, no. 1: 201–48.

Strickmann, Michel. 1981. *Le taôisme du Mao Chan: Chronique d'une révélation*. Paris: Collège de France, Institut des Hautes Etudes Chinoises.

Strickmann, Michel. 1989. *Chinese Magical Medicine: Therapeutic Rituals*. Paris: Université de Paris X.

Sturman, Peter. 1990. Cranes Above Kaifeng: The Auspicious Image at the Court of Huizong. *Ars Orientalis* 20: 33–68.

Sturman, Peter. 1997. *Mi Fu: Style and the Art of Calligraphy in Northern Song China*. New Haven and London: Yale University Press.

Sun Ji. 1991. *Han dai wuzhi wenhua ziliao tushuo* (An illustrated discussion of Han dynasty material culture). Beijing: Wenwu chubanshe.

Sun K'o-k'uan. 1965. *Song Yuan Daojiao zhi fazhan* (The development of Taoism in the Song and Yuan dynasties). Taibei: Sili Donghai daxue.

Sun K'o-k'uan. 1981. Yü Chi and Southern Taoism during the Yüan Period. In *China Under Mongol Rule*, edited by John D. Langlois, 212–53. Princeton: Princeton University Press.

Sun Xiaochun and Jacob Kistemaker. 1997. *The Chinese Sky During the Han*. Leiden: E. J. Brill.

Sung Yu. 1999. *Selections from the Chinese Collection*. San Diego: San Diego Museum of Art.

Tai Shan. 1981. (Mount Tai). Beijing: Foreign Languages Press.

Takeda, Kazuaki. 1995. *Hoshi mandara no kenkyū* (Studies on the star mandala). Kyoto: Hōzōkan.

Tang Changshou. 1993. *Leshan yamu he Pengshan yamu* (Cliff tombs at Leshan and Pengshan). Chengdu: Dianzi keji daxue chubanshe.

Tang Daijian. 1992. *Songshi "Lin Lingsu zhuan" buzheng* (Supplementary corrections to the "Biography of Lin Lingsu" in the *Song Dynastic History*). *Shijie zongjiao yanjiu* (Studies in world religions) 49: 23–28.

Tang Daijian. 1994. Bei Song Shenxiao Gong jiqi weiyi gouji (Northern Song Divine Empyrean temples and the ceremonies at them). *Zhongguo Daojiao* (Taoism in China) 3: 47–48.

Teiser, Stephen. 1996. Introduction: The Spirits of Chinese Religion. In *Religions of China in Practice*, edited by Donald S. Lopez, 21–25. Princeton: Princeton University Press.

Thiel, Joseph. 1961. Der Streit der Buddhisten und Taoisten zü Mongolen-zeit. *Monumenta Serica* 20: 1–81.

Tibetan Sacred Art. 1993. Exh. cat. Kyoto: Tōji Temple Museum.

Treasures of Ancient Chinese Sculpture. 1997. Taipei: Li Yin Co.

Tseng Yu-ho. 1993. *A History of Chinese Calligraphy*. Hong Kong: Chinese University Press.

Twitchett, Denis, and John K. Fairbank, eds. 1988. *The Cambridge History of China*. Vol. 7, *The Ming Dynasty, 1368–1644, Part 1*. Cambridge: Cambridge University Press.

Unschuld, Paul U. 1995. *Huichun, Rückke in den Frühling: Chinesische Heilkunde in historischen Objekten und Bildern*. Exh. cat. Munich: Prestel Verlag.

Vainker, Shelagh. 1991. *Chinese Pottery and Porcelain from Prehistory to the Present*. London: British Museum.

Verellen, Franciscus. 1989. *Du Guanting (850–933): Taoïste de cour à la fin de la Chine médiévale*. Paris: Institut des Hautes Etudes Chinoises.

Verellen, Franciscus. 1991–92. "Evidential Miracles in Support of Taoism": The Inversion of a Buddhist Apologetic Tradition in Late T'ang Dynasty China. *T'oung Pao* 77/78: 217–63.

Verellen, Franciscus. 1995. The Beyond Within: Grotto-Heavens (*Dongtian*) in Taoist Ritual and Cosmology. *Cahiers d'Extrême-Asie* 8: 265–90.

Waley, Arthur. 1931. *Travels of an Alchemist: The Journey of the Taoist Ch'ang-ch'un from China to the Hindukush at the Summons of Chingiz Khan*. London: George Routledge and Sons.

Waley, Arthur, trans. 1938. *The Analects of Confucius*. London: George Allen and Unwin. Reprint, New York: Vintage Books, n.d.

Waley, Arthur. 1958. *The Way and Its Power: A Study of the Tao Te Ching and Its Place in Chinese Thought*. New York: Grove Press.

Walravens, Hartmut, ed. 1981. *Catalogue of Chinese Rubbings from Field Museum*. Chicago: Field Museum of Natural History.

Waltner, Ann. 1987. T'an-yang-tzu and Wang Shih-chen: Visionary and Bureaucrat in the Late Ming. *Late Imperial China* 8, no. 1: 105–33.

Waltner, Ann. Forthcoming. *The World of a Late Ming Mystic*. Berkeley: University of California Press.

Wang, C. C. 1967. Ni Yunlin zhi hua (The paintings of Ni Yunlin [Ni Zan]). *National Palace Museum Quarterly* 1, no. 3: 19–46.

Wang Chunwu. 1996. *Tianshi Dao ershisizhi kao* (A study of the twenty-four centers of Tianshi Dao). Chengdu: Sichuan daxue chubanshe.

Wang, David Teh-yu. 1991–92. Nei Jing Tu, a Daoist Diagram of the Internal Circulation of Man. *Journal of the Walters Art Gallery* 49/50: 141–58.

Wang Jiugui. 1989. *Zhongguo minjian xinyang ziliao huibian* (Collected materials on Chinese popular culture). 31 vols. Taipei: Xuesheng shuju.

Wang Ka. 1993. *Laozi Daode jing Heshang Gong zhangju* (The Heshang Gong commentary on Laozi's *Daode jing*). Beijing: Zhonghua shuju.

Wang Ming. 1960. *Taiping jing hejiao* (Comparative discussion of the *Taiping jing*). Beijing: Zhonghua shuju.

Wang Ming. 1996. *Baopuzi neipian jiaoshi* (Comparative explanation of the inner chapters of the *Master Who Embraces Simplicity*). 1986. Reprint, Beijing: Zhonghua shuju chubanshe.

Wang, Richard G. 1999. The Taoist Ritual Reflected in the *Chin P'ing Mei*. Paper presented at the Symposium on Chinese Literature in Honor of Professor David Roy, University of Chicago, April 10.

Wang Yi'er. 1994. *Daojiao meishu shishuo* (History of Taoist art). Beijing: Beijing Yanshan chubanshe.

Wang Yucheng. 1993. Dong Han Daofu fanlie (Explanations of some Taoist talismans of the Eastern Han dynasty). *Kaogu* 6: 45–55.

Wang Yucheng. 1998. Luelun kaogu faxian de zaoqi daofu (Introduction to early Taoist talismans from archaeological excavations). *Kaogu* 1: 75–81.

Wang Yucheng. 1999. Ming Yongle caihui *Zhenwu lingying tuce* (The painted album entitled *Numinous Responses of Zhenwu* of the Ming Yongle reign). *Daoyun* (Resonance of the Tao) (Taipei) 4: 10–72.

Ware, James R. 1933. The *Wei Shu* and the *Sui Shu* on Taoism. *Journal of the American Oriental Society* 53: 215–94.

Ware, James R., trans. and ed. 1981. *Alchemy, Medicine, and Religion in the China of A.D. 320: The Nei P'ien of Ko Hung*. Cambridge: MIT Press, 1966. Reprint, New York: Dover.

Watson, Burton, trans. 1961. *Records of the Great Historian of China*. 2 vols. New York: Columbia University Press.

Watson, Burton. 1965. *Su Tung-p'o: Selections from a Song Dynasty Poet*. New York: Columbia University Press.

Watson, Burton, trans. 1968. *The Complete Works of Chuang Tzu*. New York: Columbia University Press.

Watson, James L., and Evelyn S. Rawski, eds. 1988. *Death Ritual in Late Imperial and Modern China*. Berkeley: University of California Press.

Wechsler, Howard. 1985. *Offerings of Jade and Silk*. New Haven and London: Yale University Press.

Wei Shu. 1973. *Liangjing xinji* (New record of the two [Tang] capitals). Reprint, Taipei: Shijie Press.

Weidner, Marsha, ed. 1994. *Latter Days of the Law: Images of Chinese Buddhism, 850–1850*. Exh. cat. Lawrence, Kansas: Spencer Museum of Art.

Welch, Holmes. 1967. *Taoism: The Parting of the Way*. Rev. ed. New York: Beacon Press.

Welch, Holmes, and Anna Seidel, eds. 1979. *Facets of Taoism: Essays in Chinese Religion*. New Haven and London: Yale University Press.

Weng, T. W. 1976. Leng Qian. In L. Carrington Goodrich and Fang Chao-ying, *Dictionary of Ming Biography*, vol. 1: 802–04. New York: Columbia University Press.

Wenley, A. G. 1962. A Chinese Sui Dynasty Mirror. *Artibus Asiae* 25, nos. 2/3: 141–48.

Wey, Nancy. 1974. Mu-ch'i and Zen Painting. Ph.D. diss., University of Chicago.

White, William Charles. 1940. *Chinese Temple Frescoes: A Study of Three Wall-paintings of the Thirteenth Century*. Toronto: University of Toronto Press.

Wilhelm, Richard. 1967. *I Ching or Book of Changes*. 3rd ed. Translated by Cary F. Baynes. Princeton: Princeton University Press.

Wilson, Verity. 1995. Cosmic Raiment: Daoist Traditions of Liturgical Clothing. *Orientations* (May): 42–49.

Wong, Kwan S. 1982. *Masterpieces of Sung and Yüan Dynasty Calligraphy from the John M. Crawford Jr. Collection*. Exh. cat. New York: China Institute.

Wong Shiu-hon. 1979. The Cult of Chang San-feng. *Journal of Oriental Studies* 17, nos. 1/2: 10–53.

Wright, Arthur. 1978. *The Sui Dynasty: The Unification of China, A.D. 581–617*. New York: Alfred A. Knopf.

Wu Hung. 1986. Buddhist Elements in Early Chinese Art. *Artibus Asiae* 47, nos. 3/4: 263–352.

Wu Hung. 1987. Xiwangmu, the Queen Mother of the West. *Orientations* (April): 24–33.

Wu Hung. 1989. *The Wu Liang Shrine: The Ideology of Early Chinese Pictorial Art*. Stanford: Stanford University Press.

Wu Hung. 1994. Beyond the Great Boundary: Funerary Narrative in Early Chinese Art. In *Boundaries in China*, edited by J. Hay, 81–104. London: Reaktion Books.

Wu Liancheng. 1988. Baoning si mingdai shuilu hua. In *Baoning si mingdai shuilu hua*. Beijing: Wenwu chubanshe.

Wu Tung. 1997. *Tales from the Land of Dragons: 1,000 Years of Chinese Painting*. Exh. cat. Boston: Museum of Fine Arts.

Wu Zhuo. 1992. Sichuan zaoqi Fojiao yiwu jiqi niandai yu chuanbo tujing di kaocha (An investigation of early Buddhist remains in Sichuan, their dates and routes of introduction). *Wenwu* (Cultural relics) no. 11: 40–51, 67.

Wudang Shan. 1991. (Mount Wudang). Beijing: Renmin meishu chubanshe.

Wushi nian rucang wenwu jingpin ji. 1999. (Selected gems of cultural relics newly collected in the Palace Museum in the last fifty years). Exh. cat. Beijing: Palace Museum.

Xi Zezong. 1966. Dunhuang xing tu (A star chart from Dunhuang). *Wenwu* (Cultural relics), no. 3: 27–38.

Xian Ming. 1995. Lun Zaoqi Daojiao yiwu yaoqianshu (On money trees—remaining objects of early Taoism). *Sichuan wenwu* (Cultural relics of Sichuan) 5: 10.

Xiao Baifang. 1990a. Cong Daozao ziliao tansuo Song Huizong chong Dao di mudi (Motives for Song Huizong's veneration of Taoism, based on materials in the Taoist Canon). *Daojiao xue tansuo* (Researches in the study of Taoism) 3: 130–83.

Xiao Baifang. 1990b. Song Huizong chong Dao shenhua di tantao (Explorations of Song Huizong's veneration of Taoist myth). *Daojiao xue tansuo* (Researches in the study of Taoism) 3: 95–129.

Xiao Baifang. 1991. Cong Song Huizong chong Dao, shi yishu de juedu guan *Xuanhe huapu* (Perspectives on the *Xuanhe Painting Catalogue* from the viewpoint of Song Huizong's veneration of Taoism and delight in art). *Daojiao xue tansuo* (Researches in the study of Taoism) 4: 122–328.

Xiao Gaoshe. 1991. *Beichao Fodao zaoxiang bei jingxuan* (Selection of Buddhist and Taoist carved stelae of the Northern Dynasties). Tianjin: Tianjin guji chubanshe.

Xie Zhiliu. 1989. *Song Huizong Zhao Ji quanji* (Complete works by Song Huizong, Zhao Ji). Shanghai: Shanghai renmin meishu chubanshe.

Xiong, Victor. 1996. Ritual Innovations and Taoism under Tang Xuanzong. *T'oung Pao* 82, nos. 4/5: 258–316.

Xu Bangda. 1979. Song Huizong Zhao Ji qinbihua yu daibihua de kaobian (Examination of works by the hand of Song Huizong, Zhao Ji, and works by his ghost-painters). *Gugong bowuyuan yuankan* (Palace Museum journal) 1: 62–67.

Xu Bangda. 1984a. *Gu shuhua weihua kaobian* (An investigation into the authenticity of ancient calligraphy and painting). 2 vols. Shanghai: Jiangsu guji chubanshe.

Xu Bangda. 1984b. *Zhongguo huihuashi tulu* (Illustrated history of Chinese painting). 2 vols. Shanghai: Shanghai renmin meishu chubanshe.

Xu Qin. 1974. *Ming hua lu* (Record of Ming painters). 1673. Reprinted in *Huashi congshu* (Compendium of texts on the history of painting), vol. 2. Taipei: Wenshizhe chubanshe.

Yan Shan si Jindai bihua. 1983. (Jin dynasty murals in the Yan Shan Temple). Beijing: Wenwu chubanshe.

Yang Huarong. 1985. Song Huizong yu Daojiao (Song Huizong and Taoism). *Shijie zongjiao yanjiu* (Studies in world religions) 3: 70–79.

Yang Xin. 1994. *Gugong bowuyuan canghua Ming Qing huihua* (Ming and Qing paintings in the Palace Museum collection). Beijing: Zijincheng chubanshe.

Yao Sheng. 1965. Yaoxian shike wenzi lue zhi (Studies on the stone-carved inscriptions of Yaoxian). *Kaogu* (Archaeology) 3: 134–51.

Yao Tao-chung. 1980. Ch'üan-chen: A New Taoist Sect in North China during the Twelfth and Thirteenth Centuries. Ph.D. diss., University of Arizona.

Yao Tao-chung. 1995. Buddhism and Taoism under the Chin. In *China under Jurchen Rule: Essays on Chin Intellectual and Cultural History*, edited by Hoyt Cleveland Tillman and Stephen H. West, 145–80. Albany: State University of New York Press.

Yates, Robin D. S., trans. 1997. *Five Lost Classics: Tao, Huang-Lao, and Yin-yang in Han China.* New York: Ballantine Books.

Yinxu Fu Hao mu. 1980. (The tomb of Lady Hao at Yinxu). Beijing: Wenwu chubanshe.

Yiyuan duoying. 1989. (Plucked flowers from the Garden of Art). Vol. 39.

Yongle Gong. 1964. (Eternal Joy Temple). Beijing: Wenwu chubanshe.

Yongle Gong bihua xuanji. 1958. (Selected wall paintings of the Eternal Joy Temple). Beijing: Wenwu chubanshe.

The Yongle Palace Murals. 1985. Beijing: Foreign Languages Press.

Yoshioka, Yoshitoyo. 1979. Taoist Monastic Life. In *Facets of Taoism,* edited by Holmes Welch and Anna Seidel, 229–52. New Haven and London: Yale University Press.

Yu Jianhua. 1980. *Zhongguo meishujia renming cidian* (Biographical dictionary of Chinese artists). Shanghai: Renmin meishu chubanshe.

Yuan si dajia. 1975. (The four great masters of the Yuan dynasty). Exh. cat. Taipei: National Palace Museum.

Yuan sijia huaji. 1994. (Compilation of paintings by the four masters of the Yuan dynasty). Tianjin: Tianjin renmin meishu chubanshe.

Yuan Zhihong. 1995. *Daojiao shenxian gushi* (Stories of Taoist gods and immortals). Beijing: Huaxia chubanshe.

Yuhas, Louise Ripple. 1979. The Landscape Art of Lu Zhi (1496–1576). Ph.D. diss., University of Michigan.

Zhang Hongxiu, ed. 1993. *Beichao shike yishu* (The art of stone carving of the Northern Dynasties). Xi'an: Shaanxi renmin meishu chubanshe.

Zhang Yuhuan. 1979. Shanxi Yuandai diantang de damu jiegou (Yuan halls of large timber-frame structure in Shanxi). *Kejishi wenji* (Essays on the history of science and technology) 2: 71–106.

Zhang Zhizhe. 1994. *Daojiao wenhua cidian* (Encyclopedia of Daoist culture). Shanghai: Jiangsu guji chubanshe.

Zhao Suna. 1998. *Lidai huihua tishi cun* (Surviving poems inscribed on paintings through the ages). Taiyuan: Shanxi jiaoyu chubanshe.

Zhongguo gudai shuhua tumu. 1986–98. (Illustrated list of ancient Chinese calligraphy and painting). 19 vols. Beijing: Wenwu chubanshe.

Zhongguo meishu quanji. 1988. *Zhongguo meishu quanji: Diaoke bian* (Complete collection of Chinese art: Sculpture). Vol. 3: *Wei Jin Nanbei Chao diaosu* (Sculpture of the Wei, Jin, and Northern and Southern Dynasties). Beijing: Wenwu chubanshe.

Zhongguo meishu quanji. 1993. *Zhongguo meishu quanji: Huihua bian* (Complete collection of Chinese art: Painting). Vol. 5: *Yuandai huihua* (Painting of the Yuan dynasty). Beijing: Wenwu chubanshe.

Zhongguo mingsheng cidian. 1986. (Dictionary of famous places in China). Shanghai: Cishu Publishing Co.

Zhongwen da cidian. 1973. (Great encyclopedia of the Chinese language). 10 vols. Taipei: Chinese Culture University.

Zito, Angelo. 1996. City Gods and Their Magistrates. In *Religions of China in Practice,* edited by Donald S. Lopez, 72–81. Princeton: Princeton University Press.

Zongjiao jianzhu. 1991. (Religious architecture). Vol. 4 of *Zhongguo meishu quanji: Jianzhu yishu bian* (Complete collection of Chinese art: The art of architecture). Beijing: Shinhua shudian.

Zürcher, Erik. 1972. *The Buddhist Conquest of China: The Spread and Adaptation of Buddhism in Early Medieval China.* 1959. Revised reprint, Leiden: E. J. Brill.

Zürcher, Erik. 1980. Buddhist Influence on Early Taoism: A Survey of Scriptural Evidence. *T'oung Pao* 66: 84–147.

CONTRIBUTORS

PATRICIA EBREY is Professor of History and Chinese Studies at the University of Washington, Seattle. A specialist in the social and cultural history of the Song Dynasty (960–1279), she is the author of many publications, including *Chu Hsi's Family Rituals: A Twelfth-Century Chinese Manual for the Performance of Cappings, Weddings, Funerals, and Ancestral Rites* (1991). Among the many books she has contributed to and edited are *Chinese Civilization and Society: A Sourcebook* (1981) and *Religion and Society in T'ang and Sung China* (1996). In 1998–99 she was a visiting professor at the Institute for Advanced Study, Princeton University, researching the career of Emperor Huizong (r. 1100–25) of the Northern Song dynasty.

SHAWN EICHMAN is Exhibition Coordinator for "Taoism and the Arts of China" at The Art Institute of Chicago. He holds M.A. degrees from the University of Hawaii and Waseda University in Tokyo, and received his Ph.D. from the University of Hawaii in 1999. The subject of his doctoral dissertation was Six Dynasties period Taoism, with an emphasis on the Highest Purity scriptures. Before joining the staff of the Art Institute, he spent four years in Japan researching Taoism, supported by a Japanese Ministry of Education (Monbusho) Research Grant.

STEPHEN LITTLE is Pritzker Curator of Asian Art at The Art Institute of Chicago. A specialist in Chinese and Japanese art, he received his Ph.D. from Yale University in the history of art in 1987. He has worked at the Asian Art Museum of San Francisco, the Cleveland Museum of Art, and the Honolulu Academy of Arts. His research interests include Chinese and Japanese painting, Chinese calligraphy, and Chinese and Japanese ceramics. His publications include *Chinese Ceramics of the Transitional Period, 1620–1683* (1983) and *Visions of the Dharma: Japanese Buddhist Paintings and Prints in the Honolulu Academy of Arts* (1991).

KRISTOFER SCHIPPER is Directeur d'Etudes at the Ecole pratique des Hautes Etudes, Sorbonne, Paris, and Professor Emeritus of Chinese History at Leiden University, The Netherlands. An ordained Taoist priest and one of the world's leading authorities on this religion, Schipper has published extensively on Taoism in French, English, Chinese, and Japanese. His writings include *L'empereur Wou des Han dans la legende taoiste* (1965), *Concordance du Houang-t'ing King: Nei-king et Wai-king* (1975), and *Le corps taoiste* (1982; translated in 1993 as *The Taoist Body*).

NANCY SHATZMAN STEINHARDT is professor in the Department of Asian and Middle Eastern Studies at the University of Pennsylvania, and Curator of Chinese Art at the University of Pennsylvania Museum of Archaeology and Anthropology. A leading authority on Chinese traditional architecture, she is the author of *Chinese Traditional Architecture* (1984), *Chinese Imperial City Planning* (1990), and *Liao Architecture* (1997).

WU HUNG is the Harrie Vanderstappen Distinguished Service Professor of Chinese Art at the University of Chicago. Born in Sichuan, China, Wu worked for five years as a curator in the Palace Museum, Beijing, and subsequently received an M.A. in art history at the Central Academy of Art in Beijing. He received his Ph.D. from Harvard University in 1987. Among his many publications are *The Wu Liang Shrine: The Ideology of Early Chinese Pictorial Art* (1989), *The Double Screen: Medium and Representation in Chinese Painting* (1996), and *Transience: Experimental Chinese Art at the End of the Twentieth Century* (1999).

LENDERS TO THE EXHIBITION

Administrative Committee of Cultural Relics, Yanshi, Henan: 22

American Museum of Natural History, New York: 16

Asian Art Museum of San Francisco: 25, 43, 98, 118

The Art Institute of Chicago: 48, 59, 95, 101, 103, 113

Bibliothèque Nationale de France, Paris: 3, 4, 52–56, 58, 110, 112, 115, 129

The British Library, London: 18, 34, 73, 132

The British Museum, London: 89, 104, 105

China National Museum of Fine Arts (Zhongguo Meishu Guan), Beijing: 139

Chion-ji, Kyoto: 124, 125

Cincinnati Art Museum: 23

The Cleveland Museum of Art: 119, 144

Dengfeng Bureau of Cultural Relics, Henan: 137

The Field Museum, Chicago: 5, 41, 42

Forest of Stelae (Beilin) Museum, Xi'an: 30

Harvard-Yenching Library, Harvard University, Cambridge, Massachusetts: 130

Hebei Provincial Museum, Shijiazhuang: 20

Hubei Provincial Museum, Wuhan: 8

The Honolulu Academy of Arts: 147

Kaikodo, New York: 145

Los Angeles County Museum of Art: 151

Luoyang Museum, Henan: 21

The Metropolitan Museum of Art, New York: 7, 13, 82, 88, 122, 141, 142, 143

The Minneapolis Institute of Arts: 49–51

Musée National des Arts Asiatiques Guimet, Paris: 79–81, 84–86, 91, 96, 97

Museum für Ostasiatische Kunst, Cologne: 39, 150

Museum of Fine Arts, Boston: 32, 64, 69–72, 87, 106, 121

Museum Rietberg, Zurich: 15

National Museum of Chinese History, Beijing: 33

National Palace Museum, Taipei: 2, 26, 28, 38, 93, 99, 116, 123, 134, 138, 140, 146

The Nelson-Atkins Museum of Art, Kansas City: 27, 35, 45, 114, 120, 149

Okayama Prefectural Museum of Art: 1

Osaka Municipal Museum of Art: 12, 29, 31

Palace Museum, Beijing: 6, 17, 90, 92, 126, 128, 135, 136, 148

Philadelphia Museum of Art: 127

Plum Blossoms (International) Ltd., Hong Kong: 83

Reiun-ji, Tokyo: 108

Richard Rosenblum Family Collection, Newton Center, Massachusetts: 133

Royal Ontario Museum, Toronto: 46

Arthur M. Sackler Gallery, Smithsonian Institution, Washington, D.C.: 44

Arthur M. Sackler Museum, Harvard University, Cambridge, Massachusetts: 77

San Diego Museum of Art: 57

Shaanxi History Museum, Xi'an: 9

Shanghai Museum: 40, 94, 100, 109

Shanxi Provincial Museum, Taiyuan: 75, 76, 107

Sichuan Provincial Museum, Chengdu: 24, 62

Staatliches Museum für Völkerkunde, Munich: 60, 61, 63

C. V. Starr East Asian Library, Columbia University, New York: 14

Stone Carving Museum, Suzhou: 19

Oscar L. Tang Collection, New York: 78

Tianjin Municipal Art Museum: 36

Tsui Art Foundation, Hong Kong: 68

The University of Chicago Library, East Asian Collection: 11

Victoria and Albert Museum, London: 47

Mr. and Mrs. Wan-go H. C. Weng Collection: 37

White Cloud Monastery (Baiyun Guan), Beijing: 65–67, 111, 131

Private collections (3): 10, 74, 102, 117

PHOTOGRAPHY CREDITS

Unless otherwise stated below, all photographs of works of art included in the exhibition "Taoism and the Arts of China" appear courtesy of the lenders. Copyright credits have been included at the request of lending institutions. Wherever possible, photographs have been credited to the original photographers, regardless of the source of the photograph.

Cover and back cover: © P. S. Rittermann/Photography and Preservation

Frontispiece: © 1992 Asian Art Museum of San Francisco

P. 10: map of China produced by Mapping Specialists, Madison, Wisconsin

STEPHEN LITTLE, "TAOISM AND THE ARTS OF CHINA"
1: from Cahill 1978, pl. 6; 2: from *Guodian Chu mu zhu jian* 1998, pl. 3; 3: from Walravens 1981, p. 488; 5: from *Glory of the Court* 1998, pl. 99; 6: © Museum of Fine Arts, Boston; reproduced with permission; 7: courtesy, Freer Gallery of Art, Smithsonian Institution, Washington, D.C.; reproduced with permission; 8: Shaanxi Slides Studio, Xi'an; 9: photograph by Stephen Little; 10: from Fong 1992, fig. 138; 11: photograph by Robert Newcombe, courtesy, Nelson-Atkins Museum of Art, Kansas City; reproduced with permission.

KRISTOFER SCHIPPER, "TAOISM: THE STORY OF THE WAY"
Frontispiece: photograph by Stephen Little; 1: from *Daojiao shenxian huaji* 1995, pl. 13; 2: from Chen 1996; 3: from *Yuan sijia huaji* 1994, pl. 110; 4: from *Yuan sijia huaji* 1994, pl. 7.

NANCY SHATZMAN STEINHARDT, "TAOIST ARCHITECTURE"
1, 2, 4, 7, 9, 11: University of Pennsylvania Fine Arts Library, courtesy of Nancy Shatzman Steinhardt; 3, 6, 8, 10, 14, 17: photographs by Nancy Shatzman Steinhardt; 5: from *Kaogu*, no. 4 (1987), p. 330, fig. 2; 12: from *Daojiao jianzhu* (Taipei: Kwang Fu Book Co., 1992), pl. 115; 13: from *Wudang Shan* 1991, pl. 7; 15: from *Daojiao jianzhu*, p. 148; 16: photograph by Stephen Little.

WU HUNG, "MAPPING EARLY TAOIST ART: THE VISUAL CULTURE OF WUDOUMI DAO"
1–4: maps by Mapping Specialists, Madison, Wisconsin, based on maps by Wu Hung; 5: photograph by Wu Hung; 6: line drawing by Tang Changshou; 7: from Gong et al. 1998, pl. 287; 8: from Gong et al. 1998, pl. 375; 9: from Gong et al. 1998, pl. 250; 10: from Gong et al. 1998, pl. 479; 11: from Gong et al. 1998, pl. 480; 12: drawings by Feng Guanghong and Wang Jiayou; 13: from Lim 1987, pl. 58; 14: drawing by Wu Hung; 15: from Lim 1987, pl. 59; 16a: drawing by Hayashi Minao; 16b: from *Gugong cangjing* 1996, pl. 55; 17: from *Sichuan Handai shiguan huaxiang ji* 1998, pl. 109; 18: from *Sichuan Handai shiguan huaxiang ji* 1998, pl. 67; 19–21: courtesy of Wu Hung; 22–23: photographs by Wu Hung; 24a–b: from Lim 1987, p. 198; 25: from Wu 1986, fig. 8.

PATRICIA EBREY, "TAOISM AND ART AT THE COURT OF SONG HUIZONG"
1: from Jin 1997, pl. 227; 2: from Fong 1996, pl. 73; 3: © Museum of Fine Arts, Boston; reproduced with permission; 4: from *Zhongguo lidai yishu: huihua bian, shang* (Taipei: Taipei daying baike gufen youxian gongsi, 1995), pl. 218; 5: from *Dafeng tang mingji* (Taipei: Lianjing chuban shiye gongsi, 1978), vol. 1, pl. 8; 6: from *Shina nanga taisei* (1936), vol. 6, pl. 17; 7: from *Kaogu*, no. 3 (1965), pl. 147, fig. 12; 10: from Ecke 1972.

CATALOGUE OF THE EXHIBITION
5, 41, 42: photographs by Michael Tropea; 7: © 1991 The Metropolitan Museum of Art, photograph © 1990 by Malcolm Varon, New York City; 12: © 1995 Osaka Municipal Museum of Art; 13, 82, 88: © 2000 The Metropolitan Museum of Art; 15: © Foto Wettstein & Kauf, Museum Rietberg Zürich; 16: © American Museum of Natural History, New York, photography by Denis Finnin, 1998; 18, 34, 73, 132: by permission of the British Library; 21: Cultural Relics Bureau, Luoyang; 23: photography by P. J. Gates Ltd., 1989; 25, 98: © 1996 Asian Art Museum of San Francisco; 27, 35, 114: © 1999 The Nelson Gallery Foundation, photography by Robert Newcombe; 29, 31: © 1999 Osaka Municipal Museum of Art; 32, 64, 69–72, 87, 106, 121: © 2000 Museum of Fine Arts, Boston; all rights reserved; 37: © Wan-go H. C. Weng; 39, 150: © Rheinisches Bildarchiv, Cologne; 43: © 1982 Asian Art Museum of San Francisco; 45: © The Nelson Gallery Foundation; 47: courtesy of the Trustees of the Victoria and Albert Museum, London; 48: © 1998 The Art Institute of Chicago; 57: © P. S. Rittermann/Photography and Preservation; 59: © 2000 The Art Institute of Chicago, photography by Robert Hashimoto; 60, 61, 63: © by Staatliches Museum für Völkerkunde, Munich; 74: photography © 2000 by John Bigelow Taylor, New York City; 77, 130: photography by David Mathews, © President and Fellows of Harvard College, Harvard University; 79–81, 84–86, 91, 96, 97: © Photo RMN-Thierry Ollivier; 89, 104, 105: © The British Museum; 95: © 1999 The Art Institute of Chicago; 101: © 1995 The Art Institute of Chicago; 103: © 2000 The Art Institute of Chicago, photography by Robert Hashimoto; 113: © 2000 The Art Institute of Chicago; 117: photograph courtesy of Christie's Images; 118: © 1992 Asian Art Museum of San Francisco; 119: © 2000 The Cleveland Museum of Art; 120: © The Nelson Gallery Foundation; 122, 141: © 1991 The Metropolitan Museum of Art, photograph © 1991 by Malcolm Varon, New York City; 133: photography by Greg Heins, Boston, Mass.; 137: Zhongyue Miao, Song Shan, Henan; 142, 143: © 1990 The Metropolitan Museum of Art, photograph © 1990 by Malcolm Varon, New York City; 144: © 1999 The Cleveland Museum of Art; 149: © 1999 The Nelson Gallery Foundation; 151: © 1999 Museum Associates, Los Angeles County Museum of Art.

INDEX

409